Margaret of York, Simon Marmion, and *The Visions of Tondal*

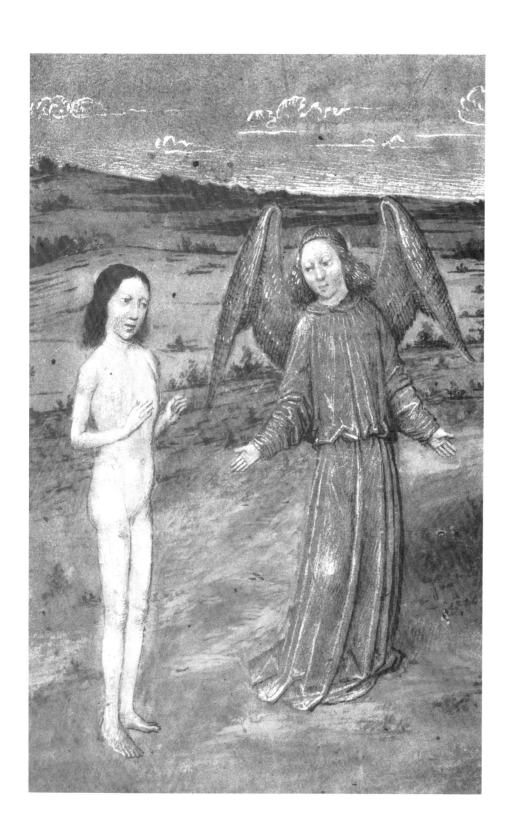

MARGARET OF YORK, SIMON MARMION,
AND
The Visions of Tondal

Thomas Kren, Editor

Papers Delivered at a Symposium

Organized by the Department of Manuscripts of the J. Paul Getty Museum

in collaboration with the Huntington Library and Art Collections

June 21–24, 1990

The J. Paul Getty Museum

Malibu, California

1992

© 1992 The J. Paul Getty Museum
17985 Pacific Coast Highway
Malibu, California 90265-5799
(310) 459-7611
Mailing address:
P.O. Box 2112
Santa Monica, California 90407-2112

Christopher Hudson, Head of Publications
Cynthia Newman Helms, Managing Editor
Deenie Yudell, Design Manager
Karen Schmidt, Production Manager

Project staff:
Manuscript Editor, Sheila Schwartz
Designer, Kurt Hauser
Production Coordinator, Amy Armstrong
Production Artist, Thea Piegdon

Typography by Wilsted & Taylor
Printed by Princeton University Press

Cover: Simon Marmion. *The Cistern of Hell* in
The Visions of Tondal. Malibu, J. Paul Getty
Museum, Ms. 30, fol. 29.

Frontispiece: Simon Marmion. *The Glory of
Virgins and the Nine Orders of Angels* (detail) in *The
Visions of Tondal*. Malibu, J. Paul Getty Museum,
Ms. 30, fol. 42.

Library of Congress Cataloging-in-Publication Data:

Margaret of York, Simon Marmion, and the Visions of Tondal : papers
 delivered at a symposium organized by the Department of Manuscripts
 of the J. Paul Getty Museum in collaboration with the Huntington
 Library and Art Collections, June 21–24, 1990 / Thomas Kren, editor.
 p. cm.
 Includes bibliographical references and index.
 ISBN 0-89236-204-9 (paper) :
 1. Visio Tnugdali—Manuscripts—Congresses. 2. Margaret of York,
Duchess, consort of Charles the Bold, Duke of Burgundy, 1446–1503—
Library—Congresses. 3. Illumination of books and manuscripts,
Flemish—Congresses. 4. Devotional literature, French—Manuscripts—
Congresses. 5. Voyages to the otherworld in literature—
Congresses. 6. Manuscripts, Medieval—France—Burgundy—
Congresses. 7. Voyages to the otherworld in art—Congresses.
8. Marmion, Simon, 1420–1489—Congresses. 9. Visions in literature—
Congresses. I. Kren, Thomas, 1950– . II. J. Paul Getty Museum.
Dept. of Manuscripts. III. Henry E. Huntington Library and Art
Gallery.
PQ1595.V553M37 1991
700'.9'024—dc20 91-33413
 CIP

TABLE OF CONTENTS

FOREWORD

One of our greatest purchases in recent years was the manuscript of *The Visions of Tondal* illuminated for Margaret of York, presumably by Simon Marmion in 1474. Its astonishingly vivid pictures of hell have long fascinated scholars, but until 1987, when we bought it, most of these people had never actually seen the manuscript. To set this right and to commemorate the five hundredth anniversary of Marmion's death, the Department of Manuscripts organized a gathering of scholars who might shed further light not only on this manuscript, but also on Burgundian illumination and book collecting of the era. The library of Margaret of York, the art of Simon Marmion, and the iconography of hell and heaven all seemed worthy of closer investigation, and in fact were already being investigated by scholars here and in Europe. These scholars were invited to participate in a symposium, and other specialists known to be at work on related issues were asked to address pertinent topics. The program of talks that resulted, which took place from June 21 to 24, 1990, is published here.

This event is only one part of a broader program through which the Department of Manuscripts is publishing and exhibiting important manuscripts in the collection, as well as holding scholarly meetings around them, and in general promoting scholarship in this field. It is surprising how many distinguished monuments of manuscript illumination, including some in the Getty Museum's collection, remain little studied. Through such exhibitions and symposia we want to help rectify this situation.

Thomas Kren, Curator of Manuscripts, conceived the symposium and carried out the project with impressive devotion, from planning the program to running the meetings to shepherding these papers through the press. I want to thank him in particular, as well as our twenty speakers and the staff of the Department of Manuscripts, for their contributions to the symposium and to this book.

John Walsh
Director

Preface and Acknowledgments

T his publication contains all the papers presented at a symposium entitled "Margaret of York, Simon Marmion, and *The Visions of Tondal*," held at the Getty Museum and the Huntington Library from June 21 to 24, 1990, in conjunction with the exhibition "*The Visions of Tondal* and Manuscripts from the Time of Margaret of York." The present volume also contains an Appendix that updates the list of manuscripts belonging to Margaret of York. The speakers revised their papers after the symposium, incorporating additional reflections as well as information gleaned during the lively discussions that took place throughout the three days of meetings. *The Visions of Tondal from the Library of Margaret of York*, the publication that accompanied the exhibition, reproduces all the miniatures of the *Tondal* manuscript in full color and is intended to serve as a companion to this symposium volume.

A few words on the editorial practices employed within these pages. No attempt was made to systematize the attributions in the captions to the illustrations; they reflect the view of the author in whose paper they appear. As might be expected, the authors often disagreed on attributions and the interpretation of the evidence. These divergent perspectives also resulted in some intentional inconsistencies among matters of ostensible fact. However, following the convincing argument of Pierre Cockshaw, a number of old-style dates have been indicated throughout this book in new style. Numerous quotations in fifteenth-century French appear throughout this volume. The unpublished transcriptions in my article were kindly reviewed and edited by Geneviève Hasenohr according to the modern standard that she was instrumental in developing. Other quotations and book titles, which for the most part have been previously published, have been left in the older style.

.

A large and complex volume such as this requires above all the cooperation of the authors. I would like to thank our contributors not only for the originality and quality of their work but also for their promptness in meeting tight deadlines. I also gratefully acknowledge the role of those scholars, too numerous to mention, who offered many constructive suggestions on the shape and content of the symposium program.

The symposium and this publication would not have been possible without the wise counsel, support, and advice of colleagues at the Museum: Deborah Gribbon, Associate Director and Chief Curator; Barbara Anderson, Collections Projects Administrator; Charles Passela, Head of Photographic Services; Cathy Klose, Special Events Coordinator; and Stepheny Dirden, Audio/Video Coordinator. At the Huntington Library and Art Collections we are indebted to Robert Skotheim, Director, and Mary Robertson, Curator of Manuscripts, for graciously playing host to one of the symposium sessions and for arranging "The Simon Marmion Hours," an exhibition held simultaneously with the Getty's "*The Visions of Tondal*."

A special thanks is due to the colleagues and Museum staff members whose

contributions helped shape this book. They include the two readers of the essay typescripts, one a historian, the other an art historian, who offered many helpful suggestions on the content and presentation of the papers. I also wish to express my appreciation to the staff of the Getty Publications Department, including Chris Hudson, Head of Publications, Amy Armstrong, Production Coordinator, and especially Cynthia Newman Helms, Managing Editor. They, along with Sheila Schwartz, manuscript editor of this book, displayed boundless wisdom, patience, and determination in carrying out their tasks. Eric Wilson translated several articles from the French. Kurt Hauser provided the elegant design to complement his beautiful work on the exhibition publication. Finally, I would like to thank the dedicated members of the Department of Manuscripts who, over the past several years, have labored long and hard to help organize and administer the symposium and its subsequent publication: Joy Hartnett, Ranee Katzenstein, Jennifer Haley, Kurt Barstow, and Nancy Turner, as well as Peter Kidd and Erik Inglis, who produced the index. Their contribution was, simply stated, enormous.

Thomas Kren

FREQUENTLY CITED SOURCES

Following are the full references for citations abbreviated in the notes to the essays.

Baltimore 1988
Baltimore, Walters Art Gallery. *Time Sanctified: The Book of Hours in Medieval Art and Life.* Exh. cat. by R.S. Wieck, 1988.

Brussels 1959
Brussels, Palais des Beaux-Arts. *Le siècle d'or de la miniature flamande: Le mécénat de Philippe le Bon.* Exh. cat. by L.M.J. Delaissé, 1959.

Brussels 1967a
Brussels, Banque de Bruxelles. *Marguerite de York et son temps.* Exh. cat., 1967.

Brussels 1967b
Brussels, Bibliothèque Royale. *La librairie de Philippe le Bon.* Exh. cat. by G. Dogaer and M. Debae, 1967.

Brussels 1973
Brussels, Bibliothèque Royale. *Le cinquième centenaire de l'imprimerie dans les anciens Pays-Bas.* Exh. cat., 1973.

Brussels 1977
Brussels, Bibliothèque Royale. *Charles le Téméraire: Exposition organisée à l'occasion du cinquième centenaire de sa mort.* Exh. cat. by P. Cockshaw, C. Lemaire, A. Rouzet, et al., 1977.

Chesney 1951
Chesney, K. "Notes on Some Treatises of Devotion Intended for Margaret of York (Ms. Douce 365)." *Medium Aevum* 20 (1951), pp. 11–39.

Corstanje et al. 1982
Corstanje, C. van, Y. Cazaux, J. Decavele, and A. Derolez. *Vita Sanctae Coletae (1381–1447).* Tielt and Leiden, 1982.

Dehaisnes 1892
Dehaisnes, C. *Recherches sur le retable de Saint-Bertin et sur Simon Marmion.* Lille and Valenciennes, 1892.

Dinzelbacher 1981
Dinzelbacher, P. *Vision und Visionsliteratur im Mittelalter* (Monographien zur Geschichte des Mittelalters, 23). Stuttgart, 1981.

Dogaer 1975
Dogaer, G. "Margaretha van York, bibliofiele." *Handelingen van de Koninklijke Kring voor Oudheidkunde, Letteren en Kunst van Mechelen* 79 (1975), pp. 99–111.

Dogaer 1987
Dogaer, G. *Flemish Minature Painting in the 15th and 16th Centuries.* Amsterdam, 1987.

Domínguez Rodríguez 1979
Domínguez Rodríguez, A. *Libros de horas del siglo XV en la Biblioteca Nacional.* Madrid, 1979.

Doutrepont 1909
Doutrepont, G. *La littérature française à la cour des ducs de Bourgogne.* Paris, 1909.

Friedländer 1923
Friedländer, M.J. "Einige Tafelbilder Simon Marmions," *Jahrbuch für Kunstwissenschaft* 1 (1923), pp. 167–70.

Galesloot 1879
Galesloot, L. "Marguerite de York, duchesse douairière de Bourgogne (1468–1503)." *Annales de la Société d'émulation pour l'étude de l'histoire et des antiquités de la Flandre,* 4th ser., 3 (1879), pp. 187–334.

Gardiner 1989
Gardiner, E. *Visions of Heaven and Hell Before Dante.* New York, 1989.

Ghent 1975
Ghent, Bijlokemuseum. *Gent: Duizend jaar kunst en cultuur.* Exh. cat. by A. de Schryver, 1975.

Harthan 1977
Harthan, J.P. *The Book of Hours: With a Historical Survey and Commentary.* New York, 1977; London, 1977, as *Books of Hours and Their Owners.*

Hénault 1907–08
Hénault, M. "Les Marmion (Jehan, Simon, Mille et Colinet): Peintres amiénois du XVe siècle." *Revue archéologique,* 4th ser., 9 (1907), pp. 119–40, 282–304, 410–24; 10 (1908), pp. 108–24.

Hindman 1977
Hindman, S. "The Case of Simon Marmion: Attributions and Documents." *Zeitschrift für Kunstgeschichte* 40 (1977), pp. 185–204.

Hoffman 1969
Hoffman, E.W. "Simon Marmion Re-considered." *Scriptorium* 23, no. 2 (1969), pp. 243–71.

Hoffman 1973
Hoffman, E.W. "Simon Marmion or The Master of the Altarpiece of Saint-Bertin: A Problem in Attribution." *Scriptorium* 27, no. 2 (1973), pp. 263–90.

Hughes 1984
Hughes, M.J. "Margaret of York, Duchess of Burgundy: Diplomat, Patroness, Bibliophile, and Benefactress." *The Private Library,* 3rd ser., 7 (1984), pp. 2–17, 53–78.

Hulin de Loo 1942
Hulin de Loo, G. "Tableaux perdus de Simon Marmion: Ses portraits princiers et l'énigme de sa chandelle." In *Aan Max J. Friedländer, 1867–5 juni 1942: Aangeboden door enkele vrienden en bewonderaars van zijn werk.* The Hague, 1942, pp. 11–19.

Le Goff 1984
Le Goff, J. *The Birth of Purgatory.* A. Goldhammer, trans. Chicago, 1984.

Lieftinck 1969
Lieftinck, G.I. *Boekverluchters uit de omgeving van Maria van Bourgondïe, c. 1475-c. 1485.* Brussels, 1969.

Malibu 1983
Malibu, California, J. Paul Getty Museum. *Renaissance Painting in Manuscripts: Treasures from the British Library.* Exh. cat. edited by T. Kren, with contributions by J. Backhouse, M. Evans, T. Kren, M. Orth, and D.H. Turner, 1983.

Malibu 1990
Malibu, California, J. Paul Getty Museum. *The Visions of Tondal from the Library of Margaret of York.* Exh. cat. by T. Kren and R. Wieck, 1990.

Meiss 1968
Meiss, M. *French Painting in the Time of Jean de Berry: The Boucicaut Master.* London, 1968.

Meiss 1974
Meiss, M. *French Painting in the Time of Jean de Berry: The Limbourgs and Their Contemporaries.* New York, 1974.

Owen 1970
Owen, D.D.R. *The Vision of Hell: Infernal Journeys in Medieval French Literature.* Edinburgh and New York, 1970.

Pächt 1948
Pächt, O. *The Master of Mary of Burgundy.* London, 1948.

Pächt 1979
Pächt, O. "Simon Mormion myt der handt." *Revue de l'art* 46 (1979), pp. 7–15.

11

Pächt/Alexander 1966
Pächt, O., and J.J.G. Alexander. *Illuminated Manuscripts in the Bodleian Library. 1: German, Dutch, Flemish, French and Spanish Schools.* Oxford, 1966.

Palmer 1982
Palmer, N.F. *"Visio Tnugdali": The German and Dutch Translations and Their Circulation in the Later Middle Ages.* Munich and Zurich, 1982.

Picard/de Pontfarcy 1989
Picard, J.-M., trans. *The Vision of Tnugdal.* Introduction by Y. de Pontfarcy. Dublin, 1989.

Prevenier/Blockmans 1985
Prevenier, W., and W. Blockmans. *The Burgundian Netherlands.* Antwerp, 1985.

Ring 1949
Ring, G. *A Century of French Painting 1400–1500.* London, 1949.

De Schryver/Unterkircher 1969
Schryver, A. de. *Gebetbuch Karl des Kühnen vel potius Stundenbuch der Maria von Burgund: Codex Vindobonensis 1857 der Österreichischen Nationalbibliothek.* Codicological introduction by F. Unterkircher. Graz, 1969.

Stecher 1882–91
Stecher, J., ed. *Oeuvres de Jean Lemaire de Belges.* 4 vols. Louvain, 1882–91.

Sterling 1981
Sterling, C. "Un nouveau tableau de Simon Marmion." *Revue d'art canadienne/Canadian Art Review* 8 (1981), pp. 3–18.

Sweeny 1972
Sweeny, B. *John G. Johnson Collection: Catalogue of Flemish and Dutch Paintings.* Philadelphia, 1972.

Thorpe 1976
Thorpe, J. *Book of Hours: Illuminations by Simon Marmion* [in the Huntington Library]. San Marino, California [1976].

Van Buren 1975
Van Buren, A. "The Master of Mary of Burgundy and His Colleagues: The State of Research and Questions of Method." *Zeitschrift für Kunstgeschichte* 38 (1975), pp. 286–309.

Vaughan 1973
Vaughan, R. *Charles the Bold: The Last Valois Duke of Burgundy.* London, 1973.

Vienna 1987
Vienna, Österreichische Nationalbibliothek. *Flämische Buchmalerei: Handschriftenschätze aus dem Burgunderreich.* Exh. cat. by D. Thoss, 1987.

Wagner 1882
Wagner, A. *Visio Tnugdali, lateinisch und altdeutsch.* Erlangen, 1882.

Weightman 1989
Weightman, C. *Margaret of York, Duchess of Burgundy, 1446–1503.* Gloucester and New York, 1989.

Winkler 1913
Winkler, F. "Simon Marmion als Miniaturmaler." *Jahrbuch der Preussischen Kunstsammlungen* 34 (1913), pp. 251–80.

Winkler 1923
Winkler, F. "Die nordfranzösische Malerei im 15. Jahrhundert und ihr Verhältnis zur altniederländischen Malerei." In *Belgische Kunstdenkmäler*, vol. 1. P. Clemen, ed. Munich, 1923, pp. 247–68.

Winkler 1925
Winkler, F. *Die flämische Buchmalerei des XV. und XVI. Jahrhunderts.* Leipzig, 1925.

INTRODUCTION*

The symposium papers gathered in this volume celebrate the Getty Museum's acquisition of the only illuminated copy of *The Visions of Tondal*. The symposium was organized in conjunction with a public exhibition of the manuscript in 1990, which offered scholars an occasion to view it for the first time and to begin sharing impressions of a book that has hitherto been almost inaccessible.[1] Accordingly, we felt that the symposium talks should deal with issues that would offer some historical perspectives on the manuscript. Thus the papers first deal with the book's patron, Margaret of York, Duchess of Burgundy, and the library for which she commissioned the *Tondal*.[2] Her books included mostly devotional and inspirational treatises, a number of them splendidly illuminated. The second topic concerns the text of *The Visions of Tondal* itself, its iconography, and the tradition of illustrated infernal visions. The third area of discussion is the art of the illuminator of the manuscript. *The Visions of Tondal* is widely ascribed to the painter and illuminator Simon Marmion (d. 1489), who executed a number of manuscripts and paintings for the ruling house of Burgundy.

The topics presented here range across art historical and broader cultural issues. As a result, not every aspect of Margaret and her library, late medieval illustrated infernal visions, the Getty *Visions of Tondal*, or the art attributed to Simon Marmion could receive comprehensive treatment within the confines of twenty thirty-minute papers. Moreover, although some research was specifically commissioned for the symposium, it is in the nature of such events to be shaped by the current scholarly concerns of each participant. This introduction will endeavor to provide historical and historiographic background and to offer a framework for the papers that follow. Some aspects of the general topics are treated more fully here than others, and an idea or two not developed in the papers is briefly introduced. Finally, although an attempt was made to include papers that complement and build upon one another, it should not be surprising that opposing viewpoints occasionally emerge. At the conclusion of this introduction, some areas for further research are proposed.

Though Margaret's library, as we know it today, consists of only about two dozen volumes, her manuscript patronage has attracted the interest of scholars, especially art historians, since the nineteenth century.[3] Not only did Margaret commission some of the most beautiful of all Burgundian manuscripts, but her books were produced during a pivotal decade in the Flemish Burgundian tradition. During the 1470s, the naturalistic style of painting in oils that had been perfected earlier in the century by Jan van Eyck and Rogier van der Weyden was imitated (in tempera) and ultimately synthesized by manuscript illuminators, resulting in a new pictorial vocabulary for the decoration of the book. Best described by Otto Pächt, the hallmarks of this style were the luminous naturalism of both miniature and border. These borders, conceived illusionistically with meticulously observed flowers, insects, and other flora and fauna painted as if strewn across brightly colored grounds, became

the signature of the new style.[4] One of its two earliest dated examples, a breviary (Appendix no. 20), was made for Margaret, probably in 1476 or shortly before, while the second, the register of the guild of Saint Anne, though not made for her, contains her portrait (Appendix no. 28). It is datable to 1476. Winkler, Pächt, and other scholars have written with great sensitivity about these books.[5] Margaret's *Visions of Tondal* further enhances the art historical interest of her collection.

Thus, despite its small size, the library of Margaret of York has become one of the best-known libraries of a medieval woman. This renown is in part also due to Margaret's status as the most important female patron during the great era of Flemish Burgundian bibliophilia in the second half of the fifteenth century. Isabella of Portugal, consort of the Burgundian duke, Philip the Good, was duchess during the several decades that Philip built his library. Although she may have been more active in government than Margaret, no comparable bibliophilic holdings for her have come down to us.[6] Several attempts have been made at reconstructing Margaret's library, despite the lack of an inventory, and it has also been featured in an exhibition.[7] The discussion of her books, however, has largely focused on their innovative stylistic character. For this reason, the present introduction and the papers published here consider other aspects of both Margaret and her library. They look at Margaret's life as duchess and her family history; at the devotional and bibliophilic traditions of English and Burgundian culture; at her selection of titles in the context of late medieval libraries; at the portraits in her books; and at some of the individual books and their decorative programs.

The facts of Margaret's life, recorded in two modern biographies, are firmly established.[8] Born to Richard, Duke of York, and Cicely Neville, in 1446, the sixth of twelve children, she was only fourteen when her father was killed in the course of his campaign to gain the English throne. The following year, in 1461, her brother succeeded in deposing King Henry VI and became Edward IV. Among the new king's immediate tasks was the arrangement of suitable marriages for his siblings. Though Margaret had to wait seven years for a match, she fared exceptionally well. Charles, Count of Charolais and son of Duke Philip, sought a new spouse following the death in 1465 of his second wife, Isabella of Bourbon. As the inevitable day of succession to his father's office drew nearer, Charles needed to produce a male heir and a political alliance that would suit his dynastic ambitions. From two previous marriages he had only a single child, Mary of Burgundy. Margaret was a politically attractive choice, because Charles feared the French and wanted to prevent an alliance between her brother and Louis XI. Furthermore, her mother's fecundity had been amply demonstrated. After several years of negotiations, Margaret and Charles were wed in July 1468, in the most famous and sumptuous wedding of the era.

This celebration offered Margaret not only her first meeting with Charles, who had become duke the previous year, but also a stunning introduction to the fabled splendors of the Burgundian court. Indeed, the tales of their wedding have come to epitomize the extravagant expression of courtly and chivalric ideals during the later Middle Ages.[9] Charles sought to surpass in pomp and circumstance all other court festivities of his age, including those staged by his father, by arranging an unrivaled show of the wealth and power of the ruling house of Burgundy. The elaborate pageants, processions, performances, tournaments, and banquets were, moreover, feasts for the eye, as the chroniclers of the time proclaimed. Their decorations represented the labors of seventy-five artists and artisans, including some, such as Hugo van der Goes and Jacques Daret, whose fame continues to the present day.[10] The Burgundians succeeded in gathering to their side some of the most extraordinary artistic talent in Europe. Although Edward IV from the outset of his reign endeavored to supply his court with its own pageantry and splendor, it is not likely that his sister had ever participated in a court event on the scale of her wedding; nor would she have seen artistic displays of the quality that greeted her arrival in Bruges.[11]

At the end of the festivities, Charles left to attend to business in his territories to the north; within a month, he was headed south to face the French army. Due to

his almost constant military campaigns and the distribution of government offices throughout the realm, he was rarely in one place for long. As he traveled, Charles was known to keep women at arm's length, saying that he would rather have his counselors and financial officers nearby than women.[12] Only in the first few years of their marriage did Margaret and Charles see each other with relative frequency.[13] Their efforts to produce a male heir, however, failed.

For the first three to four years of her married life, Margaret participated little in government; she did, however, travel throughout her husband's territories. In addition to Bruges, she visited Ghent, Brussels, Hesdin, Mons, and other towns.[14] Many of these cities were seats of government and ducal residences, and her visits were celebrated with triumphal entries and festivals, often scheduled to coincide with particular celebrations of the Church.[15] These travels would have gradually acquainted Margaret with the workings of the government, its ceremonial trappings, and probably also with such prized possessions as the ducal library, most of which was housed in the ducal residences at Hesdin, Bruges, and Brussels.

Duke Philip had formed one of the great libraries of Europe, which came to include close to a thousand volumes, the majority commissioned in the last quarter century of his life.[16] The texts covered ancient history, medieval chronicles and romances, didactic and theological writings, philosophy, lives of the saints, and liturgical and devotional books. But the largest and most lavish were histories, chronicles, and romances—folio volumes with scores, even hundreds of miniatures. Prominent among them were chronicles of the regions under his rule, histories and legends that pertained to his ancestors and their domains, and tales of rulers whom he held up as models and heroes. Thus the imagery of these books offered a rich complement, albeit for a smaller, more exclusive audience, to the manifold visual display and propaganda of court ceremony, with its banners and tapestries, its *tableaux vivants* and processions.

During the period of her first travels as duchess, Margaret may also have encountered a number of books originally commissioned by Philip that were being completed posthumously under the patronage of Charles. The text of the *Histoire de Charles Martel* (Brussels, Bibliothèque Royale, Ms. 6-9) was written in four volumes by David Aubert in Brussels between 1463 and 1465; the initials supplied by Pol Fruit for volume three were paid for in 1467; and the miniatures, executed in Bruges by Loyset Liédet, were paid for by Duke Charles in 1472.[17] Not long before his death in 1467, Philip had commissioned Simon Marmion to illustrate a lavish breviary.[18] Duke Charles continued the project and the final payments for the work were made in 1470. Did Margaret have an opportunity to view this richly illuminated book or, during the course of her travels, meet the artist? Could she have seen Marmion's portrait of Charles and his late wife, Isabella of Bourbon?[19] In the previous decade, Aubert, probably assisted by his workshop, had written many books for Philip, but none for Charles. Of all those involved in the book trade, Aubert had one of the strongest associations with the ducal family.[20] Eventually he would write and, presumably, edit some of Margaret's finest books. He may also have translated some of the texts for her. Did he try to obtain her patronage? The earliest record of Margaret's patronage of the book trade is her support for Aubert's colleague William Caxton at the time Caxton was preparing an English translation of Raoul Lefèvre's *Le recueil des histoires de Troie* in 1471.[21]

We do not know exactly when Margaret started to acquire her own library. It may have been during her involvement with Caxton or when she was given a lavish manuscript, perhaps on the occasion of her wedding, a ceremonial entry into one of her towns, or while she was presiding over the special feast of a particular church. She would have learned quickly that a luxury manuscript was not necessarily purely for reading, as demonstrated by her splendid gifts of *La vie de Sainte Colette* to the Poor Clares in Ghent and a lavish *Faits d'Alexandre le Grand*, perhaps to Sir John Donne, who was in the service of Edward IV.[22]

What is important here is that illuminated texts already played a role in the

lively culture of court life. Philip's bibliophilia encouraged a fashion within his own family and among his courtiers for richly decorated books. Among these collectors were his bastard sons, Anthony and David (the latter Bishop of Utrecht), members of the Croy family, and Louis de Gruuthuse. Edward IV would eventually join those admirers, who sought to a remarkable degree to acquire the same and similar texts as Philip had owned.[23] Most of Edward's non-liturgical books were illuminated in Flemish workshops. The flowering of manuscript illumination in Brussels, Ghent, Bruges, Valenciennes, and neighboring towns was thus supported by enthusiastic patronage at the court of Burgundy, and before long at other European courts.

Margaret was duchess less than nine years, until January 1477, and most of the dated books she commissioned belong to this period; few of her books postdate Charles's death.[24] Margaret's library concentrated on devotional and religious writings, some of which overlap those in the vastly larger ducal library that belonged first to Philip and then to Charles. But Margaret's choice of subject matter reflected more than her personal piety.[25] While Philip's most lavish books seem to reflect in one way or another his political and dynastic concerns, Margaret's books may be related to her role as duchess and to the expectations of a woman of her rank. Our emerging understanding of late medieval women both as bibliophiles and as practitioners of lay piety suggests that spiritual values and devotional practice were expected to play a strong and distinctive role in the lives of noblewomen.[26] Whereas the depictions of Philip and Charles in their books often show a mighty ruler ceremoniously presiding at his court, those of Margaret emphasize the spiritual life. She is represented most often engaged in pious activities: reading her devotions (fig. 17); performing the Seven Acts of Mercy (fig. 2); as witness to the resurrected Christ (fig. 16); with Charles as witness to a vision of Saint Colette (fig. 6); or in prayer before the Brussels church of Saint Gudule (fig. 14).

This gallery of depictions of Margaret's devotional, visionary, charitable, and symbolic religious activities, while original—even seminal—also shows behavior befitting a lady of Margaret's rank. An account of her mother Cicely's rigorous devotional practices is preserved in a household ordinance which, as Armstrong has observed, is recorded "as if the aim . . . was to place on record a devout method of life as a precedent for other noble ladies."[27] As in the illuminated portraits of the Burgundian dukes, the miniatures of Margaret reveal her self-image, and they demonstrate her piety to the intimate circle that had the pleasure of beholding her books.[28] We can well imagine *The Visions of Tondal* or another text of religious instruction being read to her, as books of religious instruction were read to her mother. But just as one of the most impressive surviving portraits of Philip, the dedication miniature in the *Grandes Chroniques de France*, was presented to him by a particularly devoted courtier, Guillaume Fillastre, Abbot of Saint Bertin and Bishop of Toul,[29] Margaret's portraits probably also represent an image that the noblewomen in her retinue desired to see in her. While Margaret's books record a sophisticated, contemplative, and above all genuine spirituality, they also reveal a consciousness of the moral responsibility that would be expected of a duchess of Burgundy.[30]

The predominance of devotional works in Margaret's library also parallels that in the libraries of other fourteenth- and fifteenth-century noblewomen. Susan Groag Bell notes, for example, that fully three-quarters of the thirty-three books owned by Isabella of Bavaria were books of hours or books of devotion.[31] Even more striking, among the thirty books commissioned by Mahaut, Countess of Artois, between 1300 and 1330, were three books of hours, an illuminated prayer roll, several Bibles, several copies of the *Lives of the Saints*, plus *Lives of the Church Fathers*, *Miracles of Our Lady*, and Boethius's *Consolation of Philosophy* in French.[32] And certainly one of the most familiar places to find representations of medieval women of this period is in the miniatures in their books of hours, where they often appear reciting their devotions before the Virgin.[33]

So Margaret's love of books of piety is not wholly surprising. As Bell has pointed out, women played an important role in the education of the young; Margaret, upon

her marriage, acquired an eleven-year-old stepdaughter, with whom she became very close.[34] *Le livre des trois vertus*, written by Christine de Pisan in Paris at the beginning of the century, advises that daughters should learn to read from books of hours and, after mastering them, from books of devotion, contemplation, and morality.[35] (It bears noting that Margaret's illuminated devotional and religious texts dramatically outnumbered her books of hours.) There is evidence to suggest that Margaret's own spirituality may have been nurtured as a child in a related manner. What we know of Duchess Cicely's devotional practice dates largely to the end of her long life, but it most likely reflects what she would have taught her children.[36] Cicely maintained a collection of books that sustained a rich and highly disciplined religious life, including not only prayer books and liturgical texts, but books to foster pious contemplation: the mystical writings of Saint Catherine of Siena, of Saint Bridget, and of the blessed Mathilde of Hackeborn; meditations on the life and passion of Christ; writings ascribed to Saint Bonaventure.[37] Devotional and meditational readings, or at least the practice of hearing these texts read, was a fixture of Cicely's day.

Unfortunately, we have no comparable documentation for Margaret's devotional habits, her thoughts and character—indeed, the books themselves comprise most of our evidence. Why was a richly illuminated copy of *The Visions of Tondal* important for Margaret, especially since the text had rarely, if ever, been illustrated? What religious predilections and personal circumstances do Margaret's books reflect? The papers in this volume approach the problem from varying perspectives, but all take Margaret's books as their point of departure. Wim Blockmans considers Margaret's *Visions of Tondal* and her library in the context of her life at the Burgundian court during her years as duchess. The meaning of manuscript portraits of Margaret is treated by Jeffrey Chipps Smith in the context of ducal portraiture in Burgundian book illumination. Pierre Cockshaw discusses the character of Margaret's library as the product of a female patron and revises the dates of some of her books. Nigel Morgan examines in detail the selection of devotional and religious texts among Margaret's books against the background of late medieval English and Burgundian libraries.

The focus then turns to individual books in the duchess's cabinet and aspects of their decoration. Suzanne Lewis discusses Margaret's most lavish manuscript, the *Apocalypse*, with its distinctive cycle of seventy-nine miniatures, and some of the artist's transformations of Apocalypse imagery. Walter Cahn treats an entirely different type of illuminated text, a rare Flemish guide to the pilgrimage churches of Rome, which was probably purchased rather than commissioned. Albert Derolez adds a new manuscript and a new dimension to our understanding of Margaret as bibliophile by introducing a copy of a humanist text, *In Trogi Pompei historias libri* XLIV, which Margaret presented to Maximilian of Austria. Then her historic patronage of Caxton is examined by Martin Lowry, who looks at the relationship of the English tradesman-scribe-translator-printer to the manuscript- and book-producing milieu that served the Burgundian court.

Finally, Margaret's patronage deserves to be looked at briefly in the context of the growing English court taste for Flemish book illumination and paintings.[38] It represents the earliest significant manifestation of this taste as well as the most splendid. Since the late fourteenth century, Flemish tapestries and other objects of Netherlandish origin had graced the households of English kings. However, Edward IV's interest in the extravagant trappings of the Burgundian court, as exemplified by the purchase of costly Flemish tapestries at the time of Margaret's wedding, marks a new era. Then, in 1471, Edward spent a brief period of exile in the Bruges residence of Louis de Gruuthuse, the illustrious bibliophile, with whom he maintained contact for years. On this stay, however, Edward was so impressed by the ritual and organization of the Burgundian court that shortly thereafter he commissioned the duke's master of ceremonies, Olivier de la Marche, to describe for him the workings of the Burgundian household.[39] To what extent do Margaret's books also reflect her brother's enthusiasm for the culture of the Burgundian court, a taste that would extend to

his courtiers and eventually to a new generation of English rulers? If Margaret helped to spark her brother's interest in lavish books as a necessity of regal court culture, she would have been one among several powerful individuals who could have influenced him. Gruuthuse, of course, was another, and Scot McKendrick has recently proposed how he might have played a role in the king's book acquisitions.[40] Moreover, for the fifteen years following Margaret's marriage, members of Edward's household commissioned or purchased important Flemish paintings and illumination. Among them was Sir John Donne, who acquired a splendid triptych by Hans Memling and several Flemish illuminated manuscripts, including the one noted above, which he may have received directly from Margaret and Mary.[41] William, Lord Hastings, Edward's loyal friend and chamberlain, acquired two books illuminated by the Master of Mary of Burgundy and his collaborators, artists who decorated several books owned by Margaret.[42] It has been recently proposed that one of these was actually commissioned for the young Edward V.[43] Thus a significant number of the most beautiful Flemish illuminated manuscripts produced from the mid-1470s to the early 1480s, arguably the most brilliant decade in the history of Flemish illumination, were commissioned by Margaret or a member of the English royal household.

We still do not have a clear picture of when Edward's book collecting activities began, but like Margaret's, they seem to have been most intense for only a couple of years, in his case in 1479 and 1480.[44] After 1468 and until Edward's death in 1483, Margaret continued to have contact with her brother and his retainers, and he with the Burgundian court. Indeed, she continued to play a role in English affairs for the rest of her life.[45] After working extensively for Margaret during the 1470s, especially around 1475 and 1476, David Aubert and his workshop were responsible for several books that the king acquired a few years later.[46] One of these, containing a pair of meditational texts, could have been illuminated by an assistant or collaborator of one of Margaret's artists.[47] Moreover, in the summer of 1480, at the height of Edward's interest in books, Margaret visited London. And the sparse Royal Wardrobe Accounts for that year list not only payments for such books, but also expenses for numerous aspects of Margaret's visit. Nevertheless, the evidence suggesting that Margaret played a role in the formation of Edward's library is ambiguous. Clearly, some of the king's closest associates were also collectors of Flemish illuminated manuscripts and paintings. Edward's choice of Flemish books was different from Margaret's, emphasizing secular texts, especially the histories and romances that the Burgundian dukes admired, and the two siblings for the most part employed different illuminators and scribes. Margaret's books are the more individual and beautiful. They earn for her a place as one of the first important English patrons of Flemish book illumination, a burgeoning taste that would result over the next several generations in the import of distinguished Flemish illuminators and painters to England.[48]

An Irish monk named Marcus wrote *The Visions of Tondal* in Latin around 1149 in Regensburg and dedicated his work to the abbess "G." Its text relates the story of a wealthy knight (known variously as Tondal, Tundal, or, in Latin, Tnugdal) who takes ill at a dinner and passes out. In this dreamlike state, his soul leaves his body and embarks on a journey through hell, purgatory, and heaven. His harrowing adventures and inspirational encounters teach him the wages of sins and the need for penitence.[49] The book enjoyed broad popularity throughout Europe and, as Roger Wieck points out, was especially widely read in the fifteenth century, from which date numerous manuscript and printed copies of the text, including some in a variety of French translations.[50] The Getty manuscript appears to represent a unique translation (like its companion, *The Vision of the Soul of Guy de Thurno*). Margaret's ownership of the book may also be unique within the Burgundian court: no extant documents indicate that the libraries of Philip, Charles, or Cicely contained a copy of the text.

What interests us here is the fact that among more than two hundred surviving

manuscripts of this text in fifteen languages, only Margaret's copy was illuminated. Moreover, the other popular infernal visions, such as *Saint Patrick's Purgatory* and *The Vision of Saint Paul*, were also rarely illuminated. Some illuminated copies of the latter, however, may shed light on the place of Margaret's *Tondal* manuscript in her cabinet of books. At least one Picard and two English Gothic illuminated examples of *The Vision of Saint Paul* survive.[51] They testify to the popularity of infernal vision literature particularly in England throughout the Middle Ages.[52] And in the case of both English examples the illuminated *Saint Paul* follows immediately upon a richly illuminated *Apocalypse*. Thus each of the two vision texts, which treat related theological concerns, belong to a single codex. In the library of Margaret of York, the *Apocalypse* (Appendix no. 19) and *The Visions of Tondal* are not only the two most elaborately illuminated and handsome volumes, but their dimensions, rulings, and scribe are identical, while their decorated borders are related in style.[53] They were probably produced within a year or so of each other. Although clearly not intended to be bound together, their physical similarity and textual relationship suggest that, at the least, their makers recognized them as appropriate companions among the duchess's books.

The Getty's *Vision of the Soul of Guy de Thurno*, with only one miniature, matches the *Tondal* even more closely in border style and illumination; the two books were definitely designed as companions. Even the two original titles correspond in their use of the word "vision": *La vision de l'âme de Guy de Thurno* and *Les visions du chevalier Tondal*. This cannot be an accidental correspondence, since the Getty *Thurno* is the unique example among surviving copies of the text which employs "vision" in its title. In Latin it was commonly *De spiritu guidonis*; the various other French titles include *Dialogue entre l'esprit de Guy de Turno et le prieur . . .* and *Le livre de l'esprit de Guy de Turno*—but never *vision*. The two manuscripts have distinct colophons, but their dates of execution are only one month apart, the *Thurno* being February 1 and the *Tondal* March 1475.[54] Perhaps due to their slim proportions as well as their related subject matter, they were also originally part of the same codex—when first rediscovered in the nineteenth century, they were bound together. In either form, they complement Margaret's deluxe illuminated *Apocalypse*, a type of book that had long been popular with English patrons.

If the text of *The Visions of Tondal* was only illuminated in one pictorial cycle, to what extent could it have influenced the pictorial imagery of hell, especially in the later Middle Ages? A splendid example, representing Lucifer on an iron grate, spewing forth bodies of the damned, is the miniature by the Limbourg brothers for the Office of the Dead in the Très Riches Heures of the Duke de Berry.[55] A number of other miniatures have been linked with the text, including the hell-paradise scene from the Salting Hours (fig. 143), until now attributed to Simon Marmion.[56] Hindman called it a pastiche of various sections of *The Visions of Tondal*;[57] however, during the symposium, Peter Dinzelbacher raised doubts about the relationship Hindman found of individual motifs to the Tondal text—"a bridge over a sea of monsters, the pit of hell, the high wall, and the green field." The same and/or related motifs appear in a number of other infernal vision texts, and this example suggests the difficulty in establishing firm links among them. There is still no published study that systematically examines the influence of *The Visions of Tondal* on the visual arts of the Middle Ages.

Not surprisingly, scholars have frequently tried to identify sources for the fertile infernal imagery of Hieronymus Bosch in *The Visions of Tondal*; a wide range of vignettes and figures in Bosch's paintings have been linked with Marcus's text.[58] Moreover, several Boschian paintings from the sixteenth century are actually inscribed *Visio Tondalii*.[59] Among suggested links between Bosch's works and *The Visions of Tondal* is the motif in the *Garden of Earthly Delights* (Prado, Madrid) of the bird that eats human souls and then excretes them. But Bosch's bird and the defecation motif depart in sufficient detail from the *Tondal* text (which describes the beast that devours unchaste priests and nuns) as to make the connection very loose.[60] Though

Bosch's beast does seem birdlike, especially in the shape of its head and beak, it lacks the wings and the long neck described in the text, as well as the iron claws. Moreover, the activities and the character of the figures beneath Bosch's beast do not correspond well with those described by the text as defecated onto the ice. If Bosch did follow the text, it was merely as a point of departure, from which he then took license. As Nigel Palmer has observed, Boschian motifs are frequently too general (or perhaps sometimes too specific) to be firmly linked with this text, including those derivative paintings that are nevertheless inscribed as representing Tondal's visions.[61]

Margaret's manuscript and Bosch's visions of hell do, however, reflect a broader phenomenon of late medieval art and culture that is discussed in some of the papers presented here. In the second section of this volume, Peter Dinzelbacher introduces the Latin text of *The Visions of Tondal* and its author, considers its relationship to the popular genre of infernal visions, and the significance of the French and other vernacular translations. Roger Wieck analyzes the iconographic program of Getty Ms. 30, both in the context of the manuscript's unique French translation and the changing eschatology of the medieval Church. During the fifteenth century, especially in its late years, infernal vision imagery was extremely popular throughout Northern Europe. As Nigel Palmer points out, the first illustrated printed texts of the *Tondal* story appeared within a decade of the Getty manuscript, in Speyer (circa 1483–84), after which there were reprints and new editions for more than a generation. Dagmar Eichberger takes a broad look at types of infernal imagery in French illuminated manuscripts of the second half of the fifteenth century, while I focus on a particular infernal tale, *The Vision of Lazarus*, which became popular at this time. In his discussion of the illustrated printed *Visions of Tondal*, Nigel Palmer also examines how its infernal imagery came to be combined with that of other textual sources. These essays may not fully explain *why* Margaret chose *The Visions of Tondal* as one of her most lavish illuminated texts, but they make the choice seem less idiosyncratic. It appears to reflect not merely the English love for adventurous and inspirational narratives of a journey through hell, but also the growing preoccupation with infernal imagery—and its meaning for devotion and meditation—in late fifteenth-century Europe.

The third section of papers deals with Simon Marmion and related artists. It is to Marmion that the miniatures of the Getty *Visions of Tondal* and *Vision of the Soul of Guy de Thurno* are ascribed, on the basis of stylistic and circumstantial evidence.[62] In 1955, these miniatures were first associated with the distinctive body of manuscript illuminations and paintings attributed to Marmion,[63] an oeuvre that had been defined convincingly by Friedrich Winkler forty years earlier. Though supplemented over the decades by new discoveries, Winkler's is still the most useful corpus.[64] Nevertheless, scholars acknowledge that not a single work has been connected beyond question to Marmion by a signature or document.[65] Moreover, in recent decades some authorities have questioned the plausibility of attributing the Winkler group to Marmion.[66] One of them, Antoine de Schryver, here offers further reflections on his previously published contributions to the problem. In the publication that accompanied the Getty exhibition, I indicated some of the pictorial characteristics that argue in favor of attributing the two Getty manuscripts to the artist who painted the Saint Bertin altarpiece and illuminated *La fleur des histoires*, "La Flora" Hours, and other masterpieces.[67] As background to the third group of essays, I shall elaborate that discussion, presenting in the process what is known about Marmion from the documents and early sources, and the circumstantial evidence that has led scholars to associate his name with this oeuvre, which constitutes some of the most original and splendid manuscript illuminations of the fifteenth century.

Fundamental to the reconstruction of the oeuvre, as well as the one masterwork that scholars have most eagerly attempted to attribute to Marmion, are the famous painted wings of the altarpiece in silver gilt and precious stones made for the abbey

of Saint Bertin in Saint-Omer. The documents of payment for the altar survive—at least for the now-lost metalwork portion executed between 1454 and 1458.[68] They identify its patron, Guillaume Fillastre, the above-mentioned Abbot of Saint Bertin and Bishop of Toul and courtier of Philip the Good. None of the sources identifies any of the artists involved in the creation of the altarpiece, but Dom Charles de Witte (d. 1807), in his history of the abbey, mentioned that Fillastre had the retable of the main altar made at Valenciennes. Although he offers no source for this remark,[69] his study is based on exhaustive archival research. Dehaisnes argued that de Witte's citation must refer to the entire altarpiece—not just to the main portion in metalwork but also to the enormous wings.[70] Although de Witte's comment has not gone unchallenged,[71] it need not be wholly discounted. Valenciennes would still be an appropriate artistic center to consider when attempting to localize the activity of the painter of the altar wings.

In 1866 Michiels had already attributed the wings to Marmion.[72] In fact, this artist was the most famous—and the only truly renowned—painter from fifteenth-century Valenciennes. What we know of the facts of Marmion's life, and what we do not know, would seem to fit the circumstances of the Saint-Omer commission. The son of Jean, a decorative painter and sculptor from Amiens, Simon appears to have been born in Amiens and during the late 1440s to have taken over certain of his father's responsibilities as a decorative painter.[73] He was still living there in 1454 when two significant events occurred. He was engaged by the Burgundian court to work on the decorations for Philip the Bold's famous Banquet of the Pheasant—the only artist from Amiens in the group—and he received a civic commission, for an altarpiece depicting the Crucifixion, with Saint John "et autres personnages" for the Court of Justice in Amiens; this latter is the earliest account of a painting by Marmion.[74] There is no further mention of Marmion in the archives until 1458, when he was residing in Valenciennes and purchased various rental properties there.[75] This indicates that between 1454 and 1458 he had moved to Valenciennes, where he seems to have resided for the rest of his life. He died on Christmas Day, 1489. The accounts of 1458 also provide the first indication of the artist's growing financial prosperity. A few years later, he played a crucial role in the founding of the guild of Saint Luke in Valenciennes and painted an altarpiece for its chapel in 1463.[76] By 1465, but probably much earlier, he was commissioned to paint the portrait of Charles the Bold, then Count of Charolais, and Isabella of Bourbon.[77] In 1465 he married Jeanne de Quaroube, the daughter of one of the wealthiest and most respected citizens of Valenciennes.[78]

Marmion came to be Valenciennes's most celebrated painter of the age. The praises heaped upon him at his death confirm his artistic reputation, and they continued to be sung over the next hundred years. The prolix epitaph written for him by the poet Jean Molinet (d. 1507), Canon of Notre-Dame de la Salle at Valenciennes and chronicler of the reign of Philip the Fair, son of Mary of Burgundy, mentions the remarkable verisimilitude of Marmion's art and the range of his subject matter, drawn from life.[79] When listing the things he painted (and, by implication, illuminated) Molinet spares no detail: "Sky, sun, fire, air, ocean, visible land, metal, animals, red, brown, and green garments, woods, wheat, fields, prairies" ("toutte rien pingible").[80] He makes several references to the fact that Marmion was both illuminator and painter—he illuminated books, executed easel paintings, decorated chapels, and painted altars.[81] Although on the one hand the epitaph represents a type of rhetorical description that reflected the slowly emerging humanist sensibility in Burgundian letters, on the other it well characterizes the finest oil painting in Flanders and France in the fifteenth century, including the Saint Bertin altarpiece.[82] Molinet also points out that Marmion's art enjoyed the admiration of the ruling class: it was "the joy and consolation of emperors, kings, counts, and marquesses."[83] As late as the second half of the sixteenth century the theologian and historian Johannes Molanus calls Marmion "the very illustrious painter,"[84] while Guicciardini extolled him as "an excellent painter and man of letters."[85]

In 1503 the poet Jean Lemaire, in "La couronne margaritique," praises Marmion as "prince d'enluminure" in the context of praise for artists who were active primarily as painters: Jan van Eyck, Rogier van der Weyden, Hugo van der Goes, and Dirk Bouts.[86] Only Jean Fouquet among the artists in Lemaire's list was active to a comparable degree as both an illuminator and a painter. In short, what Jan van Eyck was to Bruges, Rogier to Brussels, and Bouts to Louvain, Marmion was to Valenciennes: the eminent painter of the town. And his reputation survived a long time after his death. If the Saint Bertin altar wings were in fact produced in Valenciennes—which would make them the best Valenciennes paintings of the fifteenth century—then Marmion is the most likely candidate for their authorship.[87]

Marmion seems to have enjoyed a particularly strong reputation as an illuminator, which is significant for our argument. Along with the literary evidence of Lemaire's remarks, and those of Molinet and others, there is one document of Marmion's activity as an illuminator. The final payment for the large and lavishly decorated breviary that Philip the Good commissioned from Marmion in 1467 was made on behalf of Charles the Bold to "Simon Marmion, enlumineur" in 1470.[88] This major commission, for which Sandra Hindman proposes here to identify several surviving minatures, was no doubt one of numerous important commissions for illumination that the artist received over a period of decades. Moreover, Marmion surely trained other illuminators, since Marie Marmionne, who also enjoyed a reputation as an illuminator, was probably his daughter.[89]

In fifteenth-century Burgundian territories, nearly all the major painters (if one may judge by the surviving works alone) worked—and were renowned—primarily as easel painters, even if such artists as Jan van Eyck and Gerard David may have also illuminated a few manuscripts.[90] If one looks at the works of the major illuminators of the fifteenth century, most of whom are anonymous today, relatively few paintings—and few of any quality—may be connected with their styles.[91] Marmion, therefore, was and remains unusual: the only Burgundian artist in the fifteenth- and sixteenth-century sources who was as highly regarded an illuminator as painter; and the artist to whom the only substantial single corpus of Burgundian paintings and manuscripts is attributed.[92]

The attribution of the works in the Winkler group to Marmion is further advanced by considering them in the light of documentary evidence concerning Marmion, factual information about the works themselves, and other historical data. The documents confirm that Marmion worked for Philip at the Banquet of the Pheasant; that he painted portraits of Charles and Isabella of Bourbon; and that he executed a breviary for Philip and Charles. From early in his career Marmion thus enjoyed artistic patronage from the duke himself and from the young Count of Charolais. Although we cannot identify any book in the corpus as an express commission from Philip, the duke nevertheless owned several of the finest and most ambitious of these manuscripts.[93] And the Lehman *Lamentation* (fig. 237) was certainly painted for Charles and Margaret, whose coat of arms appears on the back of the panel.[94] Given the documentary evidence of ducal patronage, is it not likely that Marmion was also the recipient of major commissions from members of the duke's entourage? Guillaume Fillastre, the Abbot of Saint Bertin, was a favorite of Philip and owed much of his success to him.[95] Fillastre not only commissioned the Saint Bertin altarpiece, but also the *Grandes Chroniques de France*—one of the greatest of all Burgundian illuminated manuscripts and a masterpiece of the Winkler corpus. Significantly, he ordered the *Grandes Chroniques* as a gift for Philip the Good.[96] The Portuguese Vasco da Lucena, who translated into French several texts for Charles and Margaret, bequeathed a *Madonna* by Marmion to the hospital in Louvain in 1512.[97] Finally, as most scholars have generally agreed, the dates of manuscripts and paintings in the Winkler corpus accord with the documented dates of Marmion's activity.

Let us now return to the Saint Bertin altarpiece. Was it painted in Valenciennes? Charles Sterling, who convincingly added a small panel of the *Mass of Saint Gregory* (fig. 244) to the corpus, noted that the inscription in the latter painting is

written in the dialect of Picardy, which was spoken in Valenciennes.[98] Further, the contributors to this volume introduce a variety of new evidence that supports the localization of the Winkler corpus to the region. Until now, there has been relatively little consideration of the places where these manuscripts were illuminated and how collaborations between different artists actually functioned. Winkler showed that the artist he called Marmion collaborated with illuminators who seemed to work in such Flemish towns as Bruges and Ghent.[99] And, as already noted, the two Getty manuscripts attributed to Marmion were written in Ghent. However, as Gregory Clark argues, most of the books of hours in the corpus seem to have been produced farther south, in the diocese of Cambrai, in which Valenciennes is located.[100] Bodo Brinkmann observes that Marmion could have executed minatures in Valenciennes for books otherwise produced in Flemish cities.[101] Finally, although Molinet emphasizes that Marmion was an influential artist, few examples of that influence have until now been firmly identified.[102] The contributions of Clark and Anne-Marie Legaré to the present volume rectify this lack. Both authors provide significant examples of works produced under the influence of the style of those in the Winkler group. That these examples were executed in the Cambrai diocese and the province of Hainaut further indicates that our artist more likely came from an artistic center such as Valenciennes than from a Flemish or Brabantine town. The Master of Antoine Rolin, who was responsible for many of these miniatures, is shown by Legaré to have been a major illuminator as well as a close follower of Marmion. This in turn makes it more probable that the altar wings of Saint Bertin were painted in Valenciennes and, following our argument, that their painter was Simon Marmion.

The panel paintings of Marmion have never been studied with sufficient care. Except for the Saint Bertin altarpiece, interest in them has been limited, in part because the artist was a more prolific illuminator than painter, but perhaps also because Winkler was less perceptive about the paintings.[103] Several papers in this volume therefore look more closely at the paintings. Starting with the Saint Bertin altarpiece, Rainald Grosshans and Maryan Ainsworth define the working methods of Marmion, particularly in regard to underdrawing. Ainsworth then goes on to reevaluate some accepted attributions.[104] As a result of these efforts, we may begin to have a clearer idea of Marmion's activity as a painter.

There are other areas of research on our three topics equally deserving of careful study, and I take the opportunity here to propose a few. The first is the relationship of Margaret's library to that of other medieval noblewomen such as her counterpart, Charlotte of Savoy, Queen of France,[105] and to women of the middle class. Also overdue for more intensive study is David Aubert, the scribe and editor of manuscripts for the Burgundian household for two decades.[106] Did he play a role in the selection of Margaret's books? During the symposium, Roger Wieck suggested that Aubert may have been the translator of *The Visions of Tondal*. And the iconography and meaning of miniatures in many of Margaret's other books deserve to be examined more closely. Finally, Anne van Buren and other scholars, during the course of symposium discussion sessions, proposed that Vienna 1857, with its celebrated portrait of Mary of Burgundy, could have been commissioned by Margaret for her stepdaughter. It is a matter that merits further investigation.

As noted above, a systematic investigation of the work of Bosch and his followers in relationship to the *Tondal* remains to be undertaken. And although it seemed appropriate to focus as closely as possible on Burgundian, English, and French culture, it became apparent during the symposium that a discussion of the Getty *Tondal* manuscript in relationship to contemporaneous illuminated copies of Dante's *Commedia*, the narrative it most closely anticipates, would have proven worthwhile.

Many other questions concerning the corpus of manuscripts and paintings attributed to Marmion deserve more analytical consideration. Reservations about the attribution of the corpus have been expressed continuously since the time of Dehaisnes, but with greater urgency beginning in the late 1960s by de Schryver and

Hoffman, and subsequently by Hindman and Dogaer.[107] The same scholars expressed doubts about the stylistic unity of Winkler's corpus. De Schryver attributed a group of books of hours to an anonymous, probably Ghent, artist whom he called the Louthe Master.[108] Hoffman broke up the corpus into the works of at least three artists.[109] Hindman saw a variety of hands,[110] while Dogaer recognized only two.[111] Although the miniatures of *The Visions of Tondal* appear to me entirely by one hand, in the Berlaymont Hours (Huntington Library, San Marino, HM. 1173), also in the Winkler group, the *Annunciation to the Shepherds* (fol. 44), though in the same style, is clearly not by the same hand as the other miniatures, but by an assistant.[112] We know that artists had assistants at this time, and since Marmion's father, brother, and nephew were painters and his daughter was known as an illuminator, one can imagine where he found his collaborators.[113] In addition, several documents refer to the artist's "varlets,"[114] who, on one level or another, assisted the painter.

An exhibition of the corpus of works attributed to Marmion would help settle some of these questions. Is more than one generation of artists responsible for the Winkler corpus? Or, as I believe (along with Pächt, Sterling, Clark, and others), is there a definable evolution in the Marmion style from the 1450s on that may account for some of the stylistic discrepancies? An exhibition would provide the best opportunity for evaluating this issue and for looking more closely at the artist, his workshop, and any of his other collaborators.

Many of the major works by the artist have not been easily accessible and hence not well studied. The most obvious among these are *The Visions of Tondal* and the *Grandes Chroniques de France*. Marmion's key work of the eighties, the full-page miniatures in the book of hours called "La Flora" in Naples, has been seen by few specialists in the field.[115] Moreover, de Schryver reminds us of another major manuscript illuminated by Marmion, also for Margaret of York, a *Vie de Sainte Catherine* (fig. 129).[116] Its thirteen miniatures have a similar format and border style to *The Visions of Tondal*, and the text seems also to have been written by David Aubert. The present location of this manuscript, with its imposing decoration, has not been traced, but it represents an important and unusual commission for our artist. Was it once bound together with Getty 30 and 31? These monuments, largely overlooked in the literature of the last generation, remain crucial to an understanding of the artist and infinitely enrich the measure of his achievement. In addition to the works themselves, a review of the documents, including a more thorough investigation of de Witte's history of the abbey of Saint Bertin, is in order, as is, ultimately, a new monograph and catalogue raisonné. It is hoped that the insights introduced about the artist in this volume will show that these projects are both feasible and timely.

Thomas Kren

Notes

* I would like to thank Scot McKendrick, Janet Backhouse, Bodo Brinkmann, Craig Harbison, and Ranee Katzenstein for their careful readings of this paper and numerous helpful suggestions.

1 The exhibition, entitled *The Visions of Tondal and Manuscripts from the Time of Margaret of York* (April 17–July 2, 1990), was accompanied by a publication; see Malibu 1990.

2 See Appendix, pp. 259–65, "The Library of Margaret of York and Some Related Books."

3 Some of the treasures in Margaret's library were originally described by Galesloot 1879, pp. 239, 244–45, 254–68. Most of the subsequent discussions were undertaken by art historians, notably Pächt 1948, pp. 20–24, 62–64; Delaissé, in Brussels 1959, nos. 191–99, pp. 150–51; Dogaer, in Brussels 1967a, pp. 13–14, with a small group of the manuscripts, pp. 30–40; and Dogaer 1975, pp. 99–108, with a list of the manuscripts, pp. 109–11. See also Hughes 1984, which revises the older lists, and Weightman 1989, pp. 198–217.

4 Pächt 1948, pp. 23–33.

5 Winkler, "Studien zur Geschichte der nied-
 erländischen Minaturmalerei des xv. und
 xvi. Jahrhunderts," *Jahrbuch der kunsthisto-
 rischen Sammlungen des allerhöchsten Kaisers-
 hauses in Wien* 32 (1915), pp. 282–88; Wink-
 ler 1925, pp. 103–13; Pächt 1948; Lieftinck
 1969.

6 On Isabella, see Jeffrey Chipps Smith's es-
 say, pp. 48–49, below.

7 Brussels 1967a. For other reconstructions of
 Margaret's library, see Dogaer 1975; Hughes
 1984, pp. 53–78; and the Appendix to this
 volume.

8 L. Hommel, *Marguerite d'York ou la duchesse
 Junon* (Paris, 1959), and Weightman 1989.

9 See especially Weightman 1989, pp. 30–60.

10 On the triumphal entry staged for Margaret
 on this occasion, see R. Lievens, "De blijde
 inkomst van Margaretha van York," *Vlan-
 deren* 188 (1982), pp. 171–73.

11 See the chapter "Court Life and Patronage of
 the Arts," in C. Ross, *Edward IV* (London,
 1991), pp. 257–77. S. McKendrick, "Ed-
 ward IV: An English Royal Collector of
 Netherlandish Tapestries," *Burlington Mag-
 azine* 129 (1987), pp. 521–24, has shown that
 Edward acquired some fine Flemish tapes-
 tries shortly before Margaret's marriage.

12 Vaughan 1973, pp. 158–59.

13 Weightman 1989, p. 72.

14 Ibid., p. 75.

15 Ibid.

16 See, among others, C. Gaspar, *Philippe le Bon
 et ses beaux livres* (Brussels, 1944); Brussels
 1959; Brussels 1967b.

17 Brussels 1959, nos. 144–47.

18 Hénault 1907–08, vol. 9, p. 416; Hindman
 1977, pp. 198–202.

19 Hénault 1907–08, vol. 9, p. 423.

20 See, for example, Brussels 1959, nos. 95–97,
 142–46, 148, 174, 176, 179, 182a, 182b.

21 On Caxton and Margaret, see Martin Low-
 ry's essay in the present volume.

22 Appendix nos. 24, 27.

23 J. Backhouse, "Founders of the Royal Li-
 brary: Edward IV and Henry VII as Collec-
 tors of Illuminated Manuscripts," in D. Wil-
 liams, ed., *England in the Fifteenth Century*
 (Proceedings of the 1986 Harlaxton Sympo-
 sium), (Woodbridge, 1987), pp. 24–32.

24 Appendix nos. 14, 25, and perhaps 17.

25 See also the essay by Jeffrey Chipps Smith
 in this volume.

26 On female bibliophiles of the Middle Ages,
 see S.G. Bell, "Medieval Women Book
 Owners: Arbiters of Lay Piety and Ambas-
 sadors of Culture," *Signs* 7 (1982), pp. 742–
 68.

27 C.A.J. Armstrong, "The Piety of Cicely,
 Duchess of York: A Study in Late Medieval
 Culture," in C.A.J. Armstrong, ed., *En-
 gland, France, and Burgundy in the Fifteenth
 Century* (London, 1983), p. 140.

28 See also the views of Smith, esp. pp. 50, 52,
 54, below.

29 Leningrad, Saltykov-Shchedrin Library, Ms.
 88. S. Reinach, "Un manuscrit de la biblio-
 thèque de Philippe le Bon à Saint-
 Petersbourg," *Fondation Eugène Piot: Monu-
 ments et mémoires* 11 (1904), pp. 1–79, and *Les
 Grandes Chroniques de France* (Leningrad,
 1980; text in Russian and French).

30 See also Smith, p. 54, below.

31 Bell (note 26), p. 750.

32 Ibid., and J.-M. Richard, "Les livres de Ma-
 haut: Comtesse d'Artois et de Bourgogne,"
 Revue des questions historiques 9 (1886), pp.
 235–41.

33 A typical example is the *Donor Presented by an
 Angel to the Virgin* in a book of hours from the
 Boucicaut workshop, Paris, Bibliothèque
 Nationale, Ms. lat. 1161, fol. 290; Meiss
 1968, fig. 204. Significantly, this practice
 reaches its culmination in the portrait,
 presumably of Mary of Burgundy, reading
 her devotions before the Virgin and Child
 and other supplicants in a church, Vienna,
 Österreichische Nationalbibliothek, Cod.
 1857, fol. 14v (fig. 22); Bell (note 26), fig. 12.
 The book was certainly executed in the
 1470s and, as several symposium partici-
 pants suggested, possibly under Margaret's
 patronage.

34 Bell (note 26), pp. 755–56.

35 *Le livre des trois vertus*, circa 1405, book 1,
 part 15; M.P. Cosman, ed., C.C. Williard,
 trans., *A Medieval Woman's Mirror of Honor:
 The Treasury of the City of Ladies* (New York,
 1989), p. 104; the passage is mentioned by
 Bell (note 26), p. 756.

36 Armstrong (note 27), p. 140, n. 11.

37 Ibid., pp. 141–42, 147–48, 150–52.

38 We still know little about the English royal
 library before the 1470s and await the pub-
 lication of new research by Jenny Stratford
 on its origins.

39 Olivier de la Marche, *L'état de la maison du
 duc Charles de Bourgogne dict le Hardy* (1473);
 see G. Kipling, "Henry VII and the Origins
 of Tudor Patronage," in G.F. Lytle and S.
 Orgel, eds., *Patronage in the Renaissance*
 (Princeton, 1981), pp. 118–19.

40 S. McKendrick, "*Le Grande Histoire Cesar*
 and the Manuscripts of Edward IV," *English
 Manuscript Studies, 1100–1700* 2 (1990), pp.
 120–28.

41 The Memling is London, National Gallery,
 6275; see K.B. McFarlane, *Hans Memling*
 (Oxford, 1971), pp. 1–6; the manuscripts in-
 clude London, British Library, Royal Mss.
 16 F V and 20 B II; Backhouse (note 23), p.
 31.

42 London, British Library, Add. Ms. 54782;
 D.H. Turner, *The Hastings Hours* (London,
 1983). Madrid, Museo Lazaro-Galdiano,
 Ms. 15503; Lieftinck 1969, vol. 1, pp. 109–
 25, vol. 2, figs. 165–201, and O. Pächt, "Die
 niederländischen Stundenbücher des Lord
 Hastings," in J.P. Gumbert and M.J.M. de
 Haan, eds., *Litterae textuales. Miniatures,
 Scripts, Collections: Essays Presented to G.I.
 Lieftinck* (Amsterdam, 1976), vol. 4, pp.
 29–32.

43 P. Tudor-Craig, "The Hours of Edward IV
 and William Lord Hastings: British Library
 Ms. Add. 54782," in *England in the Fifteenth
 Century* (note 23), pp. 351–69.

44 See Backhouse (note 23), esp. pp. 26–29.

45 Weightman 1989, pp. 127–81.

46 Backhouse (note 23), p. 26. Kipling (note
 39), p. 118, states that Margaret "undoubt-
 edly supplied Edward with many of his
 books," but this is far from certain. It would
 be helpful to know more specifically about
 Margaret's relationship to the development
 of the English Royal Library.

47 Backhouse (note 23), pp. 28–29. However,
 Backhouse proposes (p. 26) that it was a gift
 to the king from Margaret, since it resembles
 some of Margaret's books and was written by
 David Aubert (*Vita Christi* and *La vengeance de
 la mort Jhesu Crist*, British Library, Royal Ms.
 16 G III).

48 A number of them, such as Gerard Horen-
 bout, were well-known Flemish illumina-
 tors; some were children of Horenbout or of
 Simon Bening, another famous illuminator.
 See L. Campbell, *The Early Flemish Pictures
 in the Collection of Her Majesty the Queen* (Cam-
 bridge, 1985), pp. xv–xxx, and L. Campbell
 and S. Foister, "Gerard, Lucas, and Susanna
 Horenbout," *Burlington Magazine* 128 (1986),
 pp. 719–27.

49 For the modern literature on this richly stud-
 ied text, see Owen 1970; Dinzelbacher 1981;
 Palmer 1982; and the bibliography in Malibu
 1990, p. 62.

50 Malibu 1990, p. 3.

51 Toulouse, Bibliothèque Municipale, Ms.
 815; A. Auriol, "Descente de Saint Paul dans
 l'Enfer," in *Les trésors des bibliothèques de
 France*, vol. 3 (Paris, 1930), pp. 131–46, and
 P. Mayer, "La descente de Saint Paul en En-
 fer: Poème français composé en Angleterre,"
 Romania 24 (1895), pp. 357–75. Cambridge,
 Corpus Christi College, Ms. 20; L.F. San-
 dler, *Gothic Manuscripts 1285–1385* (A Survey
 of Manuscripts Illuminated in the British

Isles, 5) (London, 1986), no. 103. *Le verger de Soulas*, Paris, Bibliothèque Nationale, Ms. fr. 9220; J. Porcher, *Les manuscrits à peintures en France du XIIIe au XVIe siècle*, exh. cat. (Bibliothèque Nationale, Paris, 1955), no. 66.

52 See, for example, Owen 1970, pp. 51–81.

53 The relationship is pointed out by Suzanne Lewis, p. 77, below. Morgan Library, M. 484: 362×260 mm; justification, 248/235×177/165 mm; two columns, twenty-eight lines per page; *The Visions of Tondal*, J. Paul Getty Museum, Ms. 30: 364×262 mm; justification, 244/233×168/164 mm, two columns, twenty-eight lines per page. David Aubert signed and dated Ms. 30, and he is widely acknowledged as the scribe of M. 484.

54 For the significance of this date in terms of the modern calendar, see Pierre Cockshaw's essay, pp. 58–59, below. His calculations indicate that the date given in Malibu 1990, pp. 1, 31, 61, and elsewhere (e.g., Brussels 1959, no. 191) appears to be in error. For a discussion of a thematic link between the two *Vision* texts, see Roger Wieck's essay, p. 126, below.

55 Meiss 1974, p. 176, fig. 581.

56 Hindman 1977, p. 193; on the attribution of the miniature, see Bodo Brinkmann's essay, pp. 184–86 and n. 17, below. Concerning its relationship to the text, see Dagmar Eichberger's essay, p. 134, below.

57 Hindman 1977, p. 193; Antoine de Schryver, pp. 176–77, below, proposes one other miniature from a book of hours as being inspired by *The Visions of Tondal*.

58 An extensive bibliography of the scholarly commentary on this subject appears in Palmer 1982, p. 218. To which should be added, among others: C.D. Cuttler, "Two Aspects of Bosch's Hell Imagery," *Scriptorium* 23 (1969), pp. 316, 318–19, with mention of Margaret's manuscript, p. 318, fig. 107; D. Bax, *Hieronymus Bosch and Lucas Cranach: Two Last Judgment Triptychs: Description and Exposition* (*Verhandelingen der Koninklijke Nederlandse Akademie van Wetenschappen. Afdeling Letterkunde*, n.s. 117) (Amsterdam, Oxford, and New York, 1983), pp. 378–79.

59 See especially O.K. Bach, "Bosch's Vision of Tondalys," *The Denver Art Museum Quarterly* (Spring 1949), n.p., and R. van Holten, "Hieronymus Bosch und die Vision des Tondalus," *Konsthistorisk tidskrift* 28 (1959), pp. 106–08, fig. 4.

60 C. de Tolnay, *Hieronymus Bosch* (Basel, 1937), p. 69, n. 112 (2nd ed., Baden-Baden, 1966, p. 361); R.L. McGrath, "Satan and Bosch: The *Visio Tundali* and the Monastic Vices," *Gazette des Beaux-Arts* 71 (1968), pp. 45–50, fig. 1; Cuttler (note 58), p. 316. See also de Schryver, pp. 179–80, n. 32, below.

61 Palmer 1982, p. 218.

62 Malibu 1990, pp. 1, 20–36.

63 *Illuminated Calligraphic Manuscripts*, exh. cat. (Harvard College Library, Cambridge, Massachusetts, 1955), nos. 88, 89: "Considered by Erwin Panofsky to be in the circle, perhaps, of Simon Marmion." E.M. Hoffman, "Simon Marmion," Ph.D. diss., Courtauld Institute, University of London, 1958, as by Marmion; Brussels 1959, no. 191, as "in the style of Simon Marmion."

64 Winkler 1913 and Winkler 1925, p. 40; Winkler 1923 is less reliable on the paintings. A more extensive list of attributions, though no more reliable, is supplied by Ring 1949, nos. 170–88; see also Sterling 1981, pp. 3–18; de Schryver's essay, in the present volume, and especially the appendix to Ainsworth's essay, pp. 256, below.

65 Dehaisnes 1892, p. 55; Hénault 1907–08, vol. 9, esp. pp. 282–90, and, more recently, de Schryver/Unterkircher 1969, pp. 145–55, Hoffman 1973, pp. 263–71, and Hindman 1977, p. 187. Otto Pächt (Pächt 1979) discovered a splendid fifteenth-century drawing of a hoopoe bird in the Österreichische Nationalbibliothek with an inscription added in an early sixteenth-century hand: "Simon Mormion myt der handt." He makes a subtle and perceptive argument for attributing the drawing to Marmion, although its style has little to do with the miniatures and paintings in the Winkler group. However, I have not seen all the visual evidence that Pächt relates to the drawing and do not feel qualified at this juncture to evaluate it.

66 De Schryver/Unterkircher 1969, pp. 149–55; M. Davies, *National Gallery Catalogues: Early Netherlandish School* (London, 1968), p. 85; Hoffman 1973; Hindman 1973; Dogaer 1987, pp. 51–55, 141–43.

67 Malibu 1990, pp. 19–36.

68 Dehaisnes 1892, p. 133, and Hénault 1907–08, vol. 9, pp. 412–14.

69 C. de Witte, *Grande cartulaire de l'abbaye de Saint-Bertin*, Saint-Omer, Bibliothèque Communale, Ms. 803; cited by Dehaisnes 1892, p. 26ff. According to Michiels, the *Cartulaire* reports that the retable was made by an "ouvrier de Valenciennes"; A. Michiels, *Histoire de la peinture flamande*, vol. 3 (Paris, 1866), p. 379. Martin Davies has published a transcription of the pertinent passage in de Witte: ". . . Guillaume Fillastre . . . fit faire à Valenciennes . . . [dans le sanctuaire de son église abbatiale de Saint-Bertin le très riche et superbe retable d'autel] . . . ," in M. Davies, *The National Gallery London* (Les primitifs flamands. I: Corpus de la peinture des anciens Pays-Bas méridionaux au quinzième siècle, 3) (Brussels, 1970), pp. 25–26.

70 Dehaisnes 1892, p. 37.

71 See Hénault 1907–08, vol. 9, p. 285; Hoffman 1973, pp. 266–67; de Schryver, N. 6, below.

72 Michiels (note 69) made the connection between Marmion and the reference in the *Grande cartulaire* to the making of the altarpiece at Valenciennes, but Dehaisnes offers the more systematic analysis of the problems.

73 Dehaisnes 1892, pp. 61, 64, and Hénault 1907–08, vol. 9, pp. 410–11.

74 Hénault 1907–08, vol. 9, p. 412.

75 Ibid., pp. 126–27; vol. 10, pp. 413–14.

76 Ibid., vol. 9, pp. 127, 414–15; Dehaisnes 1892, p. 65, basing his account on Louis de la Fontaine, *Antiquités de la ville de Valenciennes*, Valenciennes, Bibliothèque Municipale, Ms. 529, fol. 228.

77 Dehaisnes 1892, pp. 95–96, citing Louis de la Fontaine, *Antiquités de la ville de Valenciennes*, vol. 2, fol. 214 and flyleaf, Douai, Bibliothèque Municipale. Our assertion is based on a sixteenth-century Latin inscription that accompanied a now-lost miniature copy of the double portrait. Hubert Cailleau made the copy in 1552. However, Dehaisnes suggests that Marmion painted the portrait in 1473, in which case the inscription must be in error, and the female portrait would depict Margaret herself. This would represent the only concrete evidence of her relationship with Marmion (see Brussels 1977, p. 44). On the other hand, Dehaisnes does not make clear the basis for his dating, and I am inclined to accept the inscription as accurate.

78 Hénault 1907–08, vol. 9, pp. 127–28, 415–16.

79 Quoted by Dehaisnes 1892, pp. 71–75.

80 Ibid., p. 73.

81 Ibid., p. 74.

82 In this connection Sterling 1981, p. 12, relates Molinet's description of Marmion's palette of black, green, and white to the colors in his painting of the *Mass of Saint Gregory* (Toronto, Art Gallery of Ontario).

83 Dehaisnes 1892, p. 74.

84 Cited in reference to a painting mentioned in the will of Vasco da Lucena; P.F.X. de Ram, ed., *Joannis Molanus in Academia Iovaniensis s. theologiae doctoris et professoris historiae Lovaniensum libri XIV* (Brussels, 1861), vol. 2, p. 870.

85 L. Guicciardini, *Descrittione di tutti i Paesi Bassi, altrimenti detti Germania Inferiore* (Antwerp, 1588), p. 378.

86 Stecher 1882–91, vol. 4, p. 162.

87 Further evidence of Marmion's reputation in the early sixteenth century was brought to light by Otto Pächt with his publication of the drawing of a hoopoe bird (see note 65, above). That such a remarkable study from life would be attributed to Marmion not only

agrees with Molinet's praise (or de la Fontaine's, for that matter) of the verisimilitude of Marmion's art, but also suggests that he enjoyed a considerable reputation within a few decades after his death.

88 Hénault 1907–08, vol. 9, pp. 416, 419, and Hindman 1977, pp. 198–202.

89 Stecher 1882–91, vol. 4, p. 159. The documents show that Simon had a daughter, Maryon Marmion, whom Hénault connects with Lemaire's Marie Marmionne; Hénault 1907–08, vol. 9, pp. 129–30; vol. 10, p. 113.

90 David seems to have produced miniatures and had associations with the bookmakers' guild, but his biographers do not even mention, much less praise, his activity as an illuminator; see Malibu 1983, pp. 42–46, and for the extensive bibliography on David as an illuminator, p. 48, n. 28 and n. 30. The late Otto Pächt made several additional attributions to David among the miniatures in the Österreichische Nationalbibliothek; see Vienna 1987, nos. 68, 77. On the other hand, Fouquet, whose activity as an illuminator is well documented, enjoyed a reputation in the critical literature of the fifteenth and sixteenth centuries largely as a painter; see C. Schaefer, *Recherches sur l'iconologie et la stylistique de l'art de Jean Fouquet* (Lille, 1972), vol. 2, documents v, XXIV, XXV, XXIX. In Jean Lemaire's *Plainte du desiré*, Fouquet is, however, mentioned between two artists known to have worked as illuminators, Marmion and Poyet; see Schaefer, vol. 2, p. 80.

91 This quickly becomes clear from a perusal of Dogaer 1987. Maryan Ainsworth has pointed out stylistic links between the Brussels illuminator Dreux Jean and the Brussels painter the Master of Saint Gudule in "*St. Catherine, Disputing with the Philosophers*: An Early Work by the Master of St. Gudule," *Bulletin of the Allen Memorial Art Museum* 32 (1974–75), pp. 24–28; these proposed connections, however, need closer study.

92 Although the number of paintings is relatively small today, the quality and importance of, for example, the works in Berlin and in the Lehman Collection are difficult to ignore.

93 *Grandes Chroniques de France* (see note 29, above); *La fleur des histoires*, Brussels, Bibliothèque Royale, Ms. 9231–32; Pontifical of Sens, Brussels, Bibliothèque Royale, Ms. 9215.

94 See Ainsworth, pp. 248–50, below, and her n. 10 for further bibliography.

95 E.W. Hoffman, "A Reconstruction and Reinterpretation of Guillaume Fillastre's Altarpiece of St.-Bertin," *Art Bulletin* 60 (1978), p. 693.

96 Reinach (note 29).

97 De Ram (note 84), p. 870.

98 Sterling 1981, pp. 8–9.

99 Winkler 1925, pp. 103, 159, 178, 189.

100 See Clark, pp. 204–05, below.

101 See Brinkmann, pp. 187–93, below.

102 "Aultres, voyantz mes traictz et mon linaige / Ont, après moy, leurs oeuvres patronnez . . ."; quoted by Dehaisnes 1892, p. 73. See also Gregory Clark's essay, pp. 206–07, below, and the essay by Anne-Marie Legaré.

103 See n. 64, above, and Winkler, "Simon Marmion," *Pantheon* 13 (1934), pp. 65–72.

104 Study of the underdrawing of the manuscripts may also prove fruitful. Preliminary examination of the *Tondal* miniatures at the Getty Museum by infrared reflectography revealed a significant *pentimento*. In the miniature with the beast Acheron (fol. 17), a mountain was first sketched and likely also painted, at the left, apparently in reference to the passage, "The knight had never seen a mountain of that size." It was then painted out, almost certainly for aesthetic reasons, to blacken the background and thereby heighten the glow of flame in the mouth of Acheron.

105 L. Delisle, *Le cabinet des manuscrits de la Bibliothèque imperiale* (Paris, 1868), vol. 1, pp. 91–94; M. Tuetey, "Inventaire des biens de Charlotte de Savoie," *Bibliothèque de l'Ecole des Chartes* 27 (1864–65), pp. 338–66, 423–42; P. Kilre, "The Intellectual Interests Reflected in Libraries of the Fourteenth and Fifteenth Centuries," *Journal of the History of Ideas* 7 (1946), pp. 271–72. Gabrielle de la Tour, Countess of Montpénsier, owned more than two hundred volumes at her death in 1474; see Bell (note 26), p. 750; A. de Boislisle, *Annuaire bulletin de la Société de l'histoire de France* 17 (1880), pp. 297–306; also Smith, p. 55, n. 11, below.

106 For manuscripts written by or attributed to Aubert, see Brussels 1959, nos. 95–97, 141–46, 148, 160(?), 172, 174, 179–82, 191–95, 197(?), 200(?).

107 See note 65, above. For a lucid rebuttal of the arguments that question the attribution of the Winkler corpus to Marmion, see especially Sterling 1981, pp. 4–8, n. 10, and Pächt 1979, pp. 13–15, with further bibliography.

108 De Schryver/Unterkircher 1969, pp. 149–55.

109 Hoffman 1973, pp. 272–75.

110 Hindman 1977, pp. 185, 203–04.

111 Dogaer 1987, pp. 51–55, 140–43.

112 Malibu 1983, fig. 4b.

113 For a related suggestion, see de Schryver, pp. 179–81, below.

114 Hénault 1907–08, vol. 9, p. 415.

115 The basic study is still J. Courcelle-Ladmirant, "Le bréviaire flamand dit 'La Flora' de la Bibliothèque Nationale de Naples," *Bulletin de l'Institut historique belge de Rome* 20 (1939), pp. 223–33. Nicole Reynaud is currently studying the *Grandes Chroniques*.

116 See p. 177, below. De Schryver had mentioned but not illustrated this in Ghent 1975, p. 25, with further bibliography.

The Devotion of a Lonely Duchess

Wim Blockmans

I
n the last days of June 1468, the Estates of Flanders assembled in the sea-
port town of Sluis (L'Ecluse) to welcome their new princess, Margaret of
York, sister of King Edward IV of England. They could see a bright future
ahead. For the first time in more than thirty years, a newly sealed trade agreement
between England and Burgundy secured a stable relationship between these two
closely linked economic partners. Although this commercial intercourse was merely
a welcome fringe benefit to the Burgundian and English princes, who were more
concerned with political alliances, it was of prime importance to the prosperity of
both countries.[1]

In fact, the past three decades had been extraordinarily prosperous for the
Netherlands, described by the contemporary chronicler Philippe de Commynes as
the Land of Promise. King Edward's chancellor, announcing Margaret's marriage be-
fore the English Parliament, hailed Duke Charles of Burgundy as "oon of the mygh-
tyest Princez of the World that bereth no crowne." During the protracted negotia-
tions, King Edward had tried to arrange a double marriage, wherein his brother, the
Duke of Clarence, would become the spouse of ten-year-old Mary, the sole heiress
to Duke Charles. Edward saw the alliance primarily as support for his endeavors to
recover the duchies of Normandy and Gascony. In view of the tensions between
France and Burgundy over Picardy, Liège, Guelders, and several other areas of con-
flict, a strong linkage with England seemed to serve the duke's interests as well,
notwithstanding his own Lancastrian descent and sympathies. King Edward was
elected to the chivalric Order of the Golden Fleece in May 1468, an honor recipro-
cated a year later when Duke Charles was made a Knight of the Garter.[2]

The Burgundian subjects probably welcomed Margaret for a different reason:
the third wife of their duke brought new hope for a male heir. Charles's first spouse
had died childless at seventeen; his second, Isabella of Bourbon, had borne only
Mary after three years of marriage, even though both parents seemed quite attached
to each other and lived together most of the eleven years of their marriage. The ab-
sence of a male heir made the future rather uncertain, since the dynastic links had
consequences for trade relations and economic opportunities. During nearly eighty
years of Burgundian rule in the Netherlands, the region's subjects had nourished an
increasingly strong sympathy toward the dynasty and thus preferred its continuity.
The duke himself noted this hope in a letter to the city of Valenciennes, when he
recommended Margaret as "bien tailliee pour avoir generation de prince du pays."[3]

To mark his third wedding, Duke Charles organized the most magnificent fes-
tivities. The ceremony took place in the small harbor town of Damme, halfway be-
tween Sluis and Bruges, on Sunday, July 3, 1468, after which the couple made their
processional entry into Bruges. The people performed pageants and *tableaux vivants*
representing famous biblical, historical, and mythological couples: Adam and Eve,
King Alexander and Cleopatra, Esther and Ahasuerus, Solomon and the Queen of

Sheba, and the lovers of the Song of Songs. Guilds and crafts marched in a procession, wearing their colorful tunics and carrying standards. For nine days, a great tournament called *L'arbre d'or* was held in the market place. Elaborate reports circulated on the sequence of processions, banquets, and jousts—among them three in French, two in English, one of which was printed three times, one in Latin, and one in Flemish, the latter two finding their way to Strasbourg and Lübeck, respectively. The conspicuous display of gold and silver plate, the dozens of tapestries with propagandistic representations, splendidly decorated halls, complicated mechanical ornaments, and the most extravagant *entremets* were obviously meant to impress all the participants. From the bishops, courtiers, and foreign tradesmen to the simple Bruges craftsmen, all were spectators and participants alike in a huge theatrical performance that displayed the power and riches of the Burgundian dynasty to all the Christian world.[4]

One may wonder why no pictorial representation of this glorious event has come down to us, apart from the statues of Charles and Margaret on the Damme town hall facade. No miniatures such as those for Philip the Good's entry into Ghent in 1458, offered to him by a local patrician; no tapestries; nothing like the series of fifty-three colored pen drawings illustrating the Latin account of the entry of Philip the Fair and Joanna of Castille into Brussels in 1496 or the illustrated description immediately printed for Prince Charles's entry into Bruges in 1515. Obviously, this tradition of pictorial commemoration, as initiated by the court, was a later development.[5]

These welcoming festivities must have deeply impressed the twenty-two-year-old Margaret of York. After all, England was at that time far less developed than the Netherlands, of which the cosmopolitan Bruges was the finest city. Her brother, King Edward, had only recently usurped the throne and faced serious financial difficulties in providing her wedding gift, which was in fact never entirely paid off.[6] The English court certainly could not compete with the splendor the Burgundians so lavishly displayed to compensate for their status as dukes rather than as kings. During his exile in Bruges in 1470–71, King Edward was so impressed by the library of his host, Louis de Gruuthuse, Governor of Holland and Zeeland, that he ordered copies of some twenty of his manuscripts. Needless to say, the duke's library, of which Edward could see only a part in the Hesdin castle, was of far greater importance. This treasure must have fascinated Margaret as well.[7] I will here try to situate Margaret's interest in manuscripts within her political and personal life, aiming at a better understanding of the motives for art patronage and a deeper insight into her personality.

Political Activities

How did Margaret experience everyday life, once her initial astonishment had passed? During the first six months of their married life, duke and duchess were together for only twenty-one days. During the next two years, they saw each other for ninety-six and 145 days, respectively, and in 1471 even less frequently. Early in 1472, they regularly resided at short distances from each other, the duke visiting Margaret once or twice a week as he pleased. In 1473 and 1474, they met only for about ten to fifteen days, and in July 1475 they were together for the last time, a visit of a few days.[8]

Charles's mother, the dowager Duchess Isabella of Portugal, who had often dealt with Anglo-Burgundian relations, including the negotiations for the marriage, may have introduced Margaret to her new role.[9] This mainly consisted in securing good relations with England and in representing the duke during his absence. The expulsion of Edward in 1470 required Margaret to mediate between her rival brothers and to help secure Edward's return to power. Certainly the most prominent presence in Margaret's married life was that of her stepdaughter, Mary, just eleven years younger than she. Margaret and Mary, who did not accompany the belligerent duke on his incessant campaigns, lived in the many castles the duke possessed in Bur-

gundian cities and territories. Most of the time, they lived in the Ten Walle castle in Ghent, reconstructed in 1473. Short trips were made to Bruges, Brussels,[10] Calais—where Margaret met with King Edward—and The Hague. A clear testimony of Mary's high esteem for her stepmother is to be read in the introduction to the act of January 30, 1477, in which Mary reinstated her stepmother's dowry:

> . . . nous ayans parfaicte congnoissance que nostre tres chiere dame et belle mere, madame Marguerite, duchesse de Bourgoingne, vesve de feu nostre tres chier seigneur et pere que Dieu absoille, s'est conduite envers nostre dit seigneur et pere par grande prudence, obeissance et singuliere amitié et aussi envers nostre personne et noz paiz et seignouries en si entiere et parfaicte amour et bienvueillance que jamais ne le pourions envers elle a souffisance remerir ne recongnoistre; considerans aussi que depuis la dure fortune avenue a nostredit feu seigneur et pere et qu'il estoit bruyt courant entre pluseurs de son trespas et depuis la certaineté d'icelui, elle s'est liberalement et cordialement offerte et declaree de nous aidier, porter et favoriser en tous noz affaires de toute sa puissance [et que des maintenant elle s'est grandement employee envers tres hault et tres puissant prince, notre tres chier seigneur et cousin le roy d'Angleterre pour obtenir qu'il soit en nostre ayde et qu'il entretiengne les aliances et confederacions perpetuelles d'entre lui et nostre dit feu seigneur et pere]. . . .[11]

From 1475 onward, during the duke's lengthy absences, Margaret played a certain political role. She led the resistance against a French invasion of Artois and negotiated with the Flemish cities for the mobilization of troops. In September 1475, she requested 18,000 ryders from the cities—this in addition to the 40,000 ryders she had been granted in 1468, to be paid over a period of sixteen years, and the special grants she received for the loss of her personal belongings in a fire in the castle of Male in 1472. Even though the Flemings had already made extraordinary financial sacrifices, they nevertheless agreed to half the amount the duchess now requested. This compliance is to be interpreted as evidence of a distinctly positive attitude toward Margaret, despite the probability that the money went to support the duke's warfare.[12]

In April 1476, the catastrophic wars against the Swiss drove Duke Charles to demand even more from his subjects. Therefore, he made Margaret and Mary preside over two assemblies of the Estates General of the Netherlands, held in Ghent, where the chancellor had to request new military appropriations. The opposition to the seemingly unlimited demands of the duke was at that stage so fierce that even Margaret's proposal to mediate could not generate any further support for Charles's obviously failing campaigns.[13]

The news of the terrible defeat near Nancy on January 5, 1477, spread slowly in the Netherlands; it took a full week to reach Flanders, where Margaret and Mary resided. On January 15, they took action, again jointly. They wrote to the central Chambre des Comptes at Mechlin, urging the officers to continue their normal activities, notwithstanding certain "rumors" about the duke's presumed retreat. They also summoned the Estates of Luxembourg, the province that was the closest to the war-struck region. On January 18, Margaret and Mary protested in an emotional letter to King Louis of France against the formal claim to the city of Saint-Quentin made by his troops. They claimed to have several indications that the duke was still alive. Three days later, they jointly summoned the Estates General to Ghent, to discuss "all urgent affairs." It was only by accident that a servant of Charles's bastard brother, Anthony, returning from the battlefield where his master was held captive, revealed the duke's death to Margaret and Mary, assuming they had already been informed. On January 24, they publicly announced the news in a series of letters, admitting that the duke's warfare had laid too heavy a burden on his subjects, which they promised to alleviate soon. They went into mourning on January 25.[14]

In these days of uncertainty, the duchess and the heiress were constantly assisted by the chancellor, the president of the Chambre des Comptes, and six delegates of the Estates of Flanders. From January 28 onward, Mary acted alone, nominating Adolf of Ravenstein as her lieutenant general and revising the terms of Margaret's dowry. The fact that the number of Margaret's lordships as foreseen in the marriage contract was not only confirmed but extended, even though the wedding gift was not fully paid off, can be seen as evidence of the intimate relations between Mary and her stepmother.[15] Margaret had to retreat now to her cities Oudenaarde and Mechlin, since King Louis of France had created suspicions among the Flemings about Margaret's political interference. From there, she still exercised a decisive influence on Mary's matrimonial choice. The kings of France and England each wanted to find a husband for Europe's richest heiress in their own courts, but both put forward unsuitable candidates who were in rivalry with each other. Margaret rejected candidates presented by an embassy sent by her brother and instead urged him to help her resist the French invasion. She decided that the emperor's son, Maximilian, about whom Duke Charles had been negotiating for years, would be the right consort for Mary. An embassy from Emperor Frederick III, on its way to Ghent, paid a more than ceremonial visit to Margaret in Mechlin in April,[16] and Mary and Maximilian were married later that year. Margaret's relations with Maximilian would remain cordial for the rest of their lives, as evidenced by the fact that he protected her from all problems she had with her dowry.[17] She was also the godmother of both his children, Philip and Margaret. In 1480, Maximilian sent her on a delicate diplomatic mission to her brother, who was then an ally of the King of France. She negotiated an alliance between England and Burgundy, which included the marriage between Philip and Edward's daughter, Anne, the granting of economic advantages, and the levy of six thousand English archers for the war against France.[18] The miniature in David Aubert's transcription of Jean Miélot's translation of *Romuléon*, dated 1480, which mentions Edward IV's device *Gy tens*, seems to represent Margaret of York mediating between her brother and the emperor (fig. 1). The manuscript, in which appear Edward's arms, may well have been offered to him by Margaret on this occasion.[19]

Mary's accidental death in 1482 must have been, from an emotional viewpoint, a great loss to Margaret. Moreover, it introduced a decade-long internal war in Flanders that affected her personally. The Three Members of Flanders—the college representing the whole country through the three largest cities—refused to recognize Maximilian as regent for his son, referring to the stipulations of his marriage contract of 1477. They considered void Mary's last will since it was drawn up without their

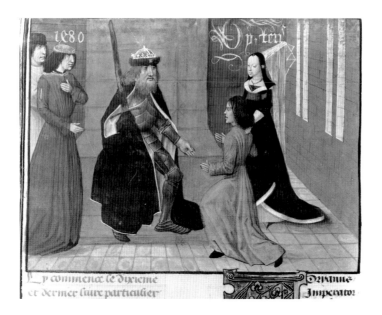

Figure 1.
Master of the White Inscriptions. *Margaret of York and Edward IV (?)*, in Jean Miélot, *Romuléon*. London, British Library, Royal Ms. 19 E V, fol 367v. Reproduced by kind permission of the British Library Board.

consent and likewise opposed the lordships of Flemish cities Mary had granted to Margaret, which exceeded those stipulated in her stepmother's 1468 marriage contract. The conflict concentrated on the appointment of officers in the cities belonging to Margaret's disputed dowry, which the Members in 1482 considered to be their prerogative.[20] It was Maximilian's victory in 1485 that affirmed Margaret's rights.

When the revolt broke out again and Maximilian was held captive for three and a half months in Bruges early in 1488, Margaret called on Emperor Frederick III for help, and she took care of Maximilian's son and heir, Philip the Fair.[21] She welcomed his daughter, Margaret, after her dismissal from the French court in 1493. Margaret of York's residence in Mechlin thus became a princely court, where Philip's children would be educated when he sailed off to Spain in 1501. Her godchild, Margaret, continued this tradition when she chose residence in Mechlin as a widowed governess in 1507.[22]

From 1486 to 1495, the conflicts about the English crown again had repercussions on relations between England and the Netherlands. Since Maximilian, probably at the instigation of Margaret, supported Perkin Warbeck as legitimate King of England, Henry VII forbade all trade with the Netherlands. It required hard negotiations to bring relations back to normal; a trade agreement was finally sealed in 1496. In this context, Margaret's and Maximilian's dynastic motivations, including her wish to restore her own dynasty to the English throne, rightfully were put aside.[23]

Summarizing Margaret's political career, we have to distinguish between her eight and a half years as duchess and the twenty-six years she spent as dowager. As duchess, her role was politically limited to the representation of her absent spouse in the years 1475 to 1477. Paradoxical as it appears, Margaret seems to have had more influence and initiative as a dowager, owing to her intimate relations with Mary, Maximilian, and their children. In this respect, widows were more independent than married women, especially dowagers closely related to royal dynasties. This explains the prominent role of widows as governesses in the Netherlands during a large part of the sixteenth century. Margaret of Austria, daughter of Maximilian and Mary of Burgundy, was the first in this remarkable series of women who turned their personal misfortunes into political advantages. Margaret of York was their model, as her residence, household, and library passed on to her heirs.

Misfortune followed Margaret of York. Not only did her spouse and her beloved stepdaughter die young, but her new country fell into civil war and economic recession, as did her native land, where all her brothers and nephews died violently, the York family was removed from the throne and persecuted, and relations between England and Burgundy were disrupted. None of the hopes people cherished at the time of her wedding in 1468 became reality, especially the hope for an heir to continue the glorious dynasty of Burgundy.

Art Patronage and Charity

Did Margaret's art patronage and personal devotion reflect in any way the dramatic events that marked her life? The outlines of princely artistic patronage outside Italy are often difficult to draw with precision, because patronage in the North was more intimately bound up with devotion and charity on the one hand, and social status on the other. Thus, in the absence of those contracts or other documents concerning the relationship between artist and client which have sometimes proven useful in the study of Italian patronage, it is often difficult to determine the extent of a Northern European patron's actual influence on the form and content of a work of art.[24] Women especially were not expected to display a pronounced personal taste because their patronage was usually strictly limited to the devotional sphere. So it was absolutely normal for noble ladies to possess some richly illuminated and decorated books of hours, as Eustache Deschamps mentions in his *Miroir*:

Heures me fault de Nostre Dame

Si comme il appartient a fame

Venue de noble paraige.[25]

We will see, however, that Margaret went far beyond the traditional role taken by her predecessors.

What we know about Margaret's building activities is that she ordered the reconstruction of her castle in Binche (1477–80), which accounted for twenty-three percent of her expenses in that demesne in 1477–78.[26] She had rebuilt the house she bought in Mons in 1480 and the hôtel in Mechlin that she had acquired from the Bishop of Cambrai, John of Burgundy, another bastard of Philip the Good. The accounts of her domains in Mechlin mention a yearly pension, paid from 1480 to 1490, to

> maister Anthoine Keldermans, tailleur de pierres demourant a Malines, lequel
> madite dame par ses lettres patentes [. . .] a retenu son maistre des euvres de
> machonnerie de ses hostelz, maisons, fortresses, aux gaiges et pension de douze
> livres du pris de 40 gros monnaie de Flandres par an.

This fixed sum was rather symbolic since it represented the equivalent of sixty working days for an ordinary master mason, or one-fifth of Margaret's collector's yearly revenue. Her jam maker got a pension of 73 lb., three times as much as the famous architect, but the architect's yearly pension was nevertheless a remarkable act of patronage.[27]

Several churches received works of religious art from Margaret. In 1480, she donated to Saint Ursmer in her city of Binche a reliquary of the Holy Cross with figures in enamel, decorated with pearls and gems. The Binche chapter received from her embroidered chasubles and tunics and liturgical books, one of which was signed with her autograph (Appendix no. 27a). In 1472, she offered an altar antependium to the chapter of Saint Waudru in Mons. This saint was particularly revered by women, who sought her intercession in pregnancy by putting on her belt.[28] Saint John's in Ghent was endowed with a stained glass window in 1487, probably to celebrate the tenth anniversary of Charles's funerary service, held there in August 1477. Similarily, Margaret offered Our Lady in Bruges a stained glass window representing the duke and duchess kneeling in prayer; ten years later, she presented another window to Saint Rombout's in Mechlin.[29]

Such gifts certainly were not exceptional for a princess of her time. Margaret's charitable works perhaps reveal more about her personality. In the famous manuscript compiled by Nicolas Finet on her commission, *Benoit seront les miséricordieux*, one of the two miniatures represents her performing the Seven Acts of Mercy (fig. 2). She helped hospitals in Binche in 1478–80, donating 30 lb. par. "que madite dame de sa benigne grace a donné pour Dieu et en aulmosne pour l'augmentation dudit lieu et soustenement des povres membres de Dieu qui journellement y sourviennent esont secourus." A cloister near Binche twice received 22 lb. par. "en consideration et regart a la povrete d'icelle eglise et couvent et au grant nombre de personnes qui y sont a entretenir pour oeuvre de pitié et en aulmosne. . . ." The wording in these domain accounts reveals the strong personal motivation of the dowager to help the sick and the poor. Further, Margaret's chaplain, Renault le Viel, received 24 lb. par. for entering the Franciscan Observants. However, these gifts represented no more than 1.27 percent of the receipts of the Binche domain.[30]

The domain accounts of Mechlin reveal special charitable expenditures in the years 1481 and 1482. At this time, rye was selling there at 72 s. per viertel, in contrast to normal years such as 1477 and 1484, when it sold at 16 s. The increase of 450 percent is symbolic of difficulties all over Europe. To offset the high price, Margaret ordered the distribution of about one-third of the annual rye yields from her Mechlin domains, which amounted to 3480 litres—sufficient for the yearly bread consumption of about ten people. Again, the account's wording is touching: "par mandement et ordonnance de madite dame avoir baillié et delivré en aucuns secreetz lieux dise-

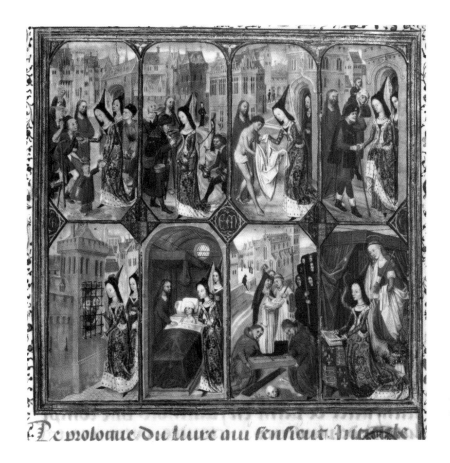

Figure 2.
Master of Girart de Roussillon (or workshop). *Margaret of York Performing the Seven Acts of Mercy*, in Nicolas Finet, *Benoit seront les miséricordieux*. Brussels, Bibliothèque Royale, Ms. 9296, fol. 1.

teux pour le vivre et sustentacion des povres membres de Dieu le nombre et quantité de 43 et demye fertailles [3480 litres] de seggle." Since this terminology appears in the accounts of various of Margaret's agents working in domains situated at a considerable distance from one another, the similarity in some of the wording between the Binche and Mechlin documents can only be ascribed to the personal intervention of Margaret herself. In the following year, 1482, when grain prices were just as high, Margaret ordered even more rye, namely 45 viertel (= "fertailles").[31] This was to be distributed, however, not to any poor man but to her secretary, master Loys Conroy, and to her *argentier*, Hyppolite Berthoz, who was certainly not poverty stricken, since he was able to commission a triptych by Dirk Bouts.[32] In the late eighties, when grain prices rose sharply again, no further distributions to the poor are mentioned. Margaret's charity obviously had its own priorities and limits.

A specific form of charity still requires our attention. From December 1478 onward, Margaret paid a priest in Binche 24 lb. par. a year for the nourishment and education of a boy, then approximatively five years old, "que madame a mis a demourer en son hostel et illec acheté sa table." She paid separately for his clothing and eventually for a surgeon when the boy broke his leg. In the same year, she installed in the convent of Saint Agnes at Ghent—with which she enjoyed special relations—the count of Saint Pol's orphan daughter, Jeanne, who later took the veil there. In 1485, Margaret founded in two of her houses in Mons an asylum for repentant prostitutes, providing them with a good education; she continued to protect her foundation. In Ghent, she paid to have a child educated by the Brothers of Saint Jerome. At that time, their cloister was a very active workshop for manuscripts. The Rupelmonde domain account of 1499 mentions the payment of 704 lb. par. to a Pieter van Temple "pour les employer au proufit d'un josne enfant angloix que madicte dame a baillie a nourrir."[33] This sum equaled a maintenance of 44 lb. par. per year for sixteen years. Caring for children's education, especially for orphans, was one of the Seven Acts of Mercy. The remarkable number of children Margaret helped in her immediate environment, which surely must have been higher than the examples quoted, may be connected to the fact that she bore no children herself.

During her life as dowager, Margaret was highly involved in religious affairs, primarily the reformation of convents toward the observance of stricter rules. She especially favored the observant Augustinian and Franciscan Orders and continued the Burgundian tradition of support for the Carthusians. Her sphere of influence was clearly determined by personal contacts, especially with the Bishop of Cambrai, Henri de Berghes, to whose diocese Mechlin belonged and who had been Margaret's court chaplain since 1479.[34] His brother, John III of Berghes, lord of Bergen op Zoom, was a knight of the Order of the Golden Fleece, which Henri served as chancellor (fig. 3). Their sister, Elisabeth, supervised the school of the Bethany convent at Mechlin, which belonged to the Windesheim congregation. There is no indication, however, that Margaret had any special relation with the *Devotio Moderna*. She possessed in her own library only one text by Thomas à Kempis, *Imitation de Jesus Christ*.[35]

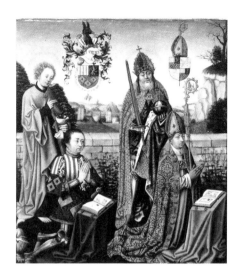

Figure 3.
Anonymous master. *John and Henri de Berghes with Their Patron Saints*, left panel of a triptych. Bergen op Zoom, Markiezenhof.

In Louvain in 1479, Margaret initiated the reform that led the hospitalers to Augustinian rule, and in 1496 she drove out unworthy Dominicans and introduced new monks who adopted that rule. She also reformed the Beghards of Louvain into Franciscans of the Third Order (Observants). In Mechlin in 1480, she managed, not without resistance, to convert the Blijdenberg nunnery into an Augustinian cloister. She succeeded in this endeavor with the help of Bishop Henri de Berghes and the cloister at Groenendaal, near Brussels, which belonged to the Windesheim congregation. On her visit to England in 1480, she insisted on the foundation of a Grey Friars convent, to which she donated a gradual (Appendix no. 25). Similarly, the dowager founded nunneries of the Poor Clares in Brielle in Holland in 1483 and in Mechlin in 1501, where she participated in the inaugural procession. In 1498 she founded a convent of nuns following the Augustinian rule in Binche. In Ghent, she financed the building of a new convent devoted to Saint Agnes. In 1501, she brought the secular clergy of Oudenaarde back to discipline, again with the help of Henri de Berghes. All these interventions occurred in cities belonging to her dowry or in those where she had residences (Louvain and Mons). It is equally significant that she wanted to be buried in the cloister of the Recollects, the reformed Franciscan nuns, at Mechlin.[36]

Margaret's actions were set in a time of decay in many religious institutions in the Netherlands. She firmly backed a reformist movement, stressing the strict observance of monastic rules, respecting absolute poverty, and concentrating on the spiritual life. As dame of Voorne in Holland, she had the right to appoint twelve canons to the chapter of Saint Catherine, and she was renowned for nominating only priests in whose fine education and proper morality she could be confident. Besides the Observant Franciscans and the Augustinians, she favored the Carthusians and the Brothers of Saint Jerome, who were prolific scribes. To the Carthusian monasteries at Louvain and Scheut, near Brussels, she donated one cell. Her preference

Figure 4.
Master of Margaret of York (or workshop). *Revival of a Dead Child*, in Pierre de Vaux, *La vie de Sainte Colette*. Ghent, Convent of the Poor Clares, Ms. 8, fol. 137r.

Figure 5.
Master of Margaret of York (or workshop). *Rescue of a Pregnant Woman*, in Pierre de Vaux, *La vie de Sainte Colette*. Ghent, Convent of the Poor Clares, Ms. 8, fol. 145r.

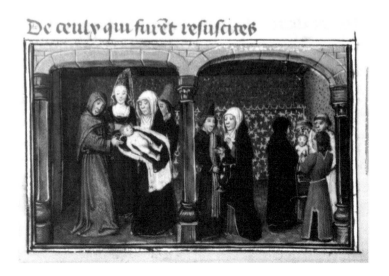

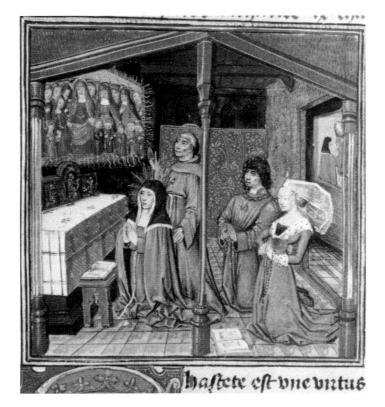

for the Poor Clares originated in Ghent, where Saint Colette of Corbie founded her first convent, organized according to the original rules of poverty of Saint Francis and Saint Clare. Six years after Colette's death at the Ghent convent in 1447, the process of beatification began. For this purpose, her biography was prepared by her confessor, the Franciscan Pierre de Vaux. Colette started her reform in 1408 after having "had visions and heard voices." In one of these visions, Saint Anne appeared to her; the saint was surrounded by her glorious progeny. Although she married three men in succession, Saint Anne attained sanctity by serving the Church together with her descendants. This inspired Colette and launched her firm devotion to Saint Anne.[37]

Margaret's strong support for the Poor Clares is evidenced by her donation to their convent at Ghent of a manuscript of Pierre de Vaux's *Vie de Sainte Colette* of 166 folios, brilliantly illuminated with twenty-five miniatures and six historiated initials ascribed to two artists (Appendix no. 27). Each of the miniatures covers an episode in the saint's life (figs. 4, 5). On the front page, angels hold the coats of arms of Charles and Margaret, who are portrayed on fol. 40v as praying spectators at Saint Colette's vision of Saint Anne (fig. 6). In two places, the manuscript has a banderole with Margaret's device, *Bien en aviengne*; her coat of arms (fig. 7) appears twice, once with the initials C and M, which are repeated, with flint and steel, the symbols of Burgundy, in three initials. The handwriting, the miniatures, and the original binding are undoubtedly Flemish work. Margaret's inscription on the last page asks the nuns to pray for her and for her salvation (see fig. 66). De Vaux's *Vie de Sainte Colette* became immediately popular; in 1450 the Franciscans commissioned a translation into Latin, and in 1451 the prior of Saint Bavo in Ghent produced a Flemish version. Duke Philip the Good owned a copy dated about 1460 (Brussels, Bibliothèque Royale, Ms. 10980), with two illuminated pages, which may have served as the model for the magnificent Ghent manuscript. This work evidently never belonged to Margaret's private library.

Margaret's founding of Poor Clares convents in Brielle and Mechlin thus becomes perfectly understandable in light of her special devotion to the saint, formed in Ghent, where the duchess was living at the time of her donation of the *Vie de Sainte Colette*. Saint Colette had interceded at some miraculous births and was thus especially revered by pregnant women and those hoping for pregnancy—which surely encouraged Margaret's devotion to the saint. Margaret's devotion to Saint Anne can

be attributed to related circumstances, especially in Ghent. In the second half of the century, the city saw a revival of Saint Anne's cult. This revival has been connected with the disastrous Ghent war against Duke Philip the Good, which ended in 1453, with great loss of life among the citizens. Second and third marriages and renewed childbearing were advocated by the authorities through the cult of Saint Anne. An altar for her at Ghent was mentioned as early as 1305, located in a chapel in the Saint Nicholas church, the most central parish. In 1445 and 1470, the city magistrate registered new statutes for the guild of Saint Anne. In 1473, Duchess Margaret was enlisted as a member, and in 1476 Mary of Burgundy followed suit. This occasioned the production of a new register of the guild, now in Windsor Castle (Appendix no. 28), with a remarkable frontispiece miniature displaying both women praying before the altar of Saint Anne (fig. 8). The central part of the triptych above it seems to represent the *Annunciation to Joachim and Anne*. The theme of pregnancy is again very obvious.

The miniature further represents the arms of the five duchies and twelve other lordships held by Charles the Bold since late 1475. Margaret's and Mary's arms are repeated, hanging above the altar and draped over their prie-dieux. Mary's hanging coat of arms, however, is half blank, a reference to her projected but not yet formalized engagement. The CM initials appear twice in the border, Margaret's device four times. Three men in the left lower border clearly represent the dean, the bailiff, and a board member of the guild for the year beginning on August 15, 1476; it was they who commissioned the register, as is to be read on fol. 6. The person holding a book

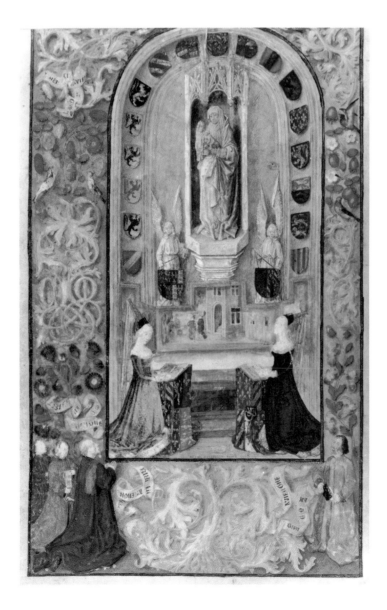

Figure 8.
Workshop of the Master of Mary of Burgundy. *Margaret of York and Mary of Burgundy Praying Before the Altar of Saint Anne in the Church of Saint Nicholas in Ghent*, in the register of the guild of Saint Anne at Ghent. Windsor Castle, Royal Library, no shelf mark, fol. 2. © 1990 Her Majesty Queen Elizabeth II.

in the lower border to the right probably is the guild's chaplain. The register itself opens with the names of the prominent members, in golden letters on red, starting with Margaret and Mary and followed by forty-nine people, more than half of them women, belonging to the dynasty and the court: Anne of Burgundy, Lady Ravenstein, Guillaume de Lalaing, first chaplain Philip Sydon, Mathijs de Hane (Coquel), tenor in the court chapel, and further regional officeholders. The miniature and the first part of the list of members (up to fol. 5v) must thus have been produced between mid-August 1476 and January 24, 1477, when Charles's death was officially announced at Ghent, an event which is emotionally referred to on fol 6. The verso then cites twenty-six names, among them the guild officers for the year 1477–78. The register was updated, in a rather disorderly form, with the names of new members until 1578, the date of the instauration of the Calvinist Republic in Ghent.[38] The manuscript itself makes it very clear that it was related to Margaret (and Mary) only insofar as they were honored as prominent members and probably donors to the guild.

From 1472 on, both Margaret and Mary were registered as members of yet another pious Ghent guild, that of Saint Barbara, to whom an altar and a chapel had been consecrated as early as 1366 in the same church of Saint Nicholas that contained the 1305 altar of Saint Anne. The guild statutes were approved by the city magistrate in 1456. Saint Barbara was the patroness of those confronted with sudden death who still hoped to receive the sacrament. She was often represented with Margaret of Antioch, patron of pregnant women and unprotected infants.[39]

Margaret's subsidies to the Ghent Saint Agnes convent—dedicated to the fourth-century saint—again reveal a special preference for a figure revered as the patron of young women and children. Another Saint Agnes, of Montepulciano, belonged to the mid-thirteenth-century reformers who, like Clare and Francis, were inspired by Saint Augustine. The coherence in Margaret's devotion is striking. It almost always involves children, childbearing, and family. Even her donation of 100 lb. for the foundation of a chapel of Saint George at Ghent in 1498 falls into this category, for it refers to her loyalty to Duke Charles, who especially venerated this saint, patron of the Order of the Garter.[40]

Manuscripts and Personal Devotion

Margaret commissioned a number of manuscripts during her nine years as duchess, but her interest weakened significantly during her longer period as dowager. Moreover, after 1477 she seems to have acquired relatively few books. How passionate a bibliophile was she then? Although her native English dynasty had no special interest in manuscripts, she did become deeply involved in the very strong Burgundian tradition of manuscript patronage. But since, as a dowager, she acquired no more manuscripts for herself, her interest in the field must have been tied to her official position. Among the manuscripts linked with her personally, it is necessary to distinguish between those she merely owned at some time and those she commissioned. Among the manuscripts bearing her signature, two were made for Duke Philip the Good— Jean Mansel's *La fleur des histoires* (Appendix no. 16), written in 1455–60, and a manuscript with works by Jean Gerson, Jacobus van Gruytrode, and Thomas à Kempis (Appendix no. 15), copied by David Aubert in 1462. The first of these was eventually passed on to Margaret and the second was probably a gift; thus they do not necessarily express her personal taste.[41]

More revealing in this respect are the manuscripts she commissioned for herself. A typical example of her personal acquisitions is *Benoit seront les miséricordieux*. In the colophon, Margaret's almoner, Nicolas Finet, canon in Cambrai, explains that on express commission from the duchess he compiled texts from the Bible and the Fathers of the Church that he found in the Carthusian monastery at Hérinnes in Hainaut. This manuscript contains two miniatures, one the famous Seven Acts of Mercy, the other depicting Margaret surrounded by the four Fathers, with Brussels monu-

ments in the background (see figs. 2, 14).[42] The Brussels setting may well be a reference to the fact that Duke John II of Brabant and his wife, Margaret of York, who died in 1333, were buried in the church of Saint Gudule.

Clearly belonging to Margaret's personal readings as well was an ascetic dialogue between Christ and Margaret, also written by Nicolas Finet, which carries her autograph at the end.[43] In a similar vein is the devotional miscellany containing, among other texts, Thomas à Kempis's *Bonne et necessaire doctrine de toute nostre foy*, with the duke's and the duchess's arms on the frontispiece and Margaret's portrait in a miniature.[44] Here she kneels before an altar with the Trinity, the Father holding the Son on his knees (see fig. 19). This precedes a dominical prayer of the king's daughter in which the Pater Noster serves as a metaphor that expresses Margaret's wish to see her real Father, God:

> Quant seray-je mise en Sa salle royale et en Son palais imperial, je qui suis
> durement emprisonnee et de toutes pars de guerre avironnee, je qui sui fille de
> Roy . . . ?

The collection of works by Jean Gerson, with the initials CM in the prologue and a signed inscription reading "ce livre cy est a tres haulte, tres excellente et puissante princesse Madame Marguerite d'York," also represented Margaret's personal readings.[45] In addition, she may have possessed Augustine's *Contemplation pour attraire la personne de Dieu* and the *Meditations*, then attributed to Saint Bernard, along with several other wide-ranging devotional texts.[46]

Margaret's choice of devotional texts was far from original but nevertheless went beyond the purely liturgical books most ladies of her status possessed. Several texts were credited to famous authors such as Seneca and Gerson, although they were in fact either much earlier or much later anonymous treatises that had been circulating in various vernacular translations since the fourteenth century. Sometimes it is apparent that a text has been "personalized" for Margaret. In *La garde du coeur et de l'ame* (Appendix no. 8[f]), a long paragraph recounting the fruitless sieges by the enemies of the fortress of the heart, found in other French versions, was omitted by David Aubert. Is this omission a delicate avoidance of any reference to Charles the Bold's failed twelve-month siege of Neuss? In *Le miroir des pecheurs* (Appendix 8[i]), the translator added numerous popular comments that also appeared in the copy made for Anthony, Charles's bastard brother.[47]

The accent in these compilations was on the text rather than on the illustrations, in sharp contrast to the tradition prevailing among the Burgundian dukes and their followers. Most of Margaret's manuscripts contained only few miniatures: one each in *La vision de l'âme de Guy de Thurno*, Boethius's *La consolation de philosophie*, Finet's *Le dialogue . . . à Jésus Christ*, and Frère Laurent's *La somme le roi*; two in Finet's *Benoit seront les miséricordieux*; three each in the Brussels volume of Gerson's writings; four each in the Oxford volume of moral and religious treatises and the *Bible moralisée*; and five in the compilation of moral treatises now in Brussels (see Appendix nos. 4, 7, 2, 6, 1, 3, 8, 22, and 21, respectively).

Against these nine devotional manuscripts with a maximum of five miniatures each, there were only three books, all of them narrative, with a considerably higher number of miniatures: seventy-nine in the *Apocalypse*, twenty in *Les visions du chevalier Tondal*, and thirteen in *La vie de Sainte Catherine* (Appendix nos. 19, 5, and 18, respectively).[48]

By contrast, breviaries, books of hours, and many historical works were richly illustrated. What is striking in the books commissioned by Margaret is the high number of portrait miniatures: seven represent her alone and four—all intended for other owners—show her with Charles, Mary, or King Edward IV (see figs. 1, 6, 8). She is usually depicted kneeling in prayer (see figs. 17, 19), twice in a presentation scene, including William Caxton's woodcut (see figs. 21, 67), once performing the Acts of Mercy (fig. 2), and once negotiating (fig. 1). She clearly favored such representations in books—and also in stained glass—over panel painting.

A manuscript such as *La vie de Sainte Colette* was probably commissioned by the duchess to present to the Ghent convent that still owns it. In this same category are a liturgical book donated to the Binche chapter and bearing an autograph (Appendix no. 27a); Quintus Curtius Rufus's *Les faits d'Alexandre le Grand*, which Margaret and Mary offered, with their signatures, to an English lord, probably Sir John Donne (Appendix no. 24); and the Escorial manuscript of Justinus, *In Trogi Pompei historias* . . . , which Margaret gave to Maximilian (Appendix no. 26).[49]

Since earlier publications did not sufficiently distinguish the different functions of manuscripts related to Margaret of York, they are enumerated in five categories in the Appendix beginning on p. 259. It has to be stressed that the presence of a portrait miniature and other symbols of the duchess (initials, device, arms, daisies) do not necessarily indicate that she commissioned the book or that she did so for her own library. An autograph at the end can indicate either her dedication, her commission, or property.

From the list, it appears that Margaret of York owned no fewer than twenty-four manuscripts, of which at least eight were produced at her express request. The two historical works were acquired through the ducal family (Appendix nos. 11, 16). Apart from six liturgical books, which cannot all be classified with certainty (Appendix nos. 10, 20, 23, 25, 27a), she owned a large collection of devotional and moral treatises that were without exception inspired by and drawn from the Valois tradition. The translators and scribes—David Aubert, Jean Miélot, Vasco da Lucena, Charles Soillot, and Nicolas Finet—all belonged to the Burgundian court under Dukes Philip and Charles; the same texts existed in the duke's library and in those of close relatives like Anthony, or councillors like Louis de Gruuthuse.

How original then was Margaret's library? Was she really the bibliophile she is heralded as?[50] The total of twenty-four manuscripts is not impressive compared to the almost one thousand her consort inherited. Of course, Charles did not add many more books to the collection formed by his three predecessors, and the difference in social status has to be taken into account: men acquired more books than women. In addition, nobles and women acquired more in the vernacular and clerics more in Latin. The Abbot of Saint Bavo at Ghent, Duke Philip's bastard son, Raphael de Marcatellis, owned more than two hundred books, of which eighty were richly produced, with his coat of arms, device, and the intertwined letters LYS. Miniatures, however, appear only in a small number of them. Like his contemporary colleagues Philippe Conrault of Saint Peter's at Ghent and Jan Crabbe of Ten Duinen, most of the abbot's books were in Latin, with accents on classical history, philosophy, literature, Italian humanism, and scientific works.[51] Some canons of Margaret's time owned libraries of more than one hundred books, and the two largest collections had 347 and 321 titles, respectively. Law, theology, poetry, ethics, natural sciences, history, rhethoric, and grammar were the predominant categories. A rare record of around 1500 of a Bruges merchant of Genovese origin, Jan Adorne, indicates that he owned thirty-four books, of which twenty-five were in Latin, six in French, and three in Flemish. His interests comprised classical and vernacular literature, science, history, and devotional texts.[52] The 1423 inventory of Duchess Margaret of Bavaria's impressive library shows her lively interest in French novels, partly borrowed from Duke John's collection. Queen Isabella of Castile founded a library in the San Juan de los Reyes monastery in Toledo in 1474. The 1503 inventory mentions 201 books in various fields—sciences, classical authors, history, poetry, ascetic mysticism, and games. This bibliophile queen donated twenty books to Margaret of Austria after she had become a widow.[53]

Compared to all these libraries, Margaret of York's was small, limited, and traditional in its selection, and exclusively in French. Nevertheless, considering that it was strictly a private library for her own use, it displayed a lively interest in what practical theology of her time had to offer. It is the more remarkable, therefore, that as a widow she seems to have stopped acquiring books. Those she still commissioned were intended as presents for recipients outside the Netherlands. Furthermore,

eleven of the manuscripts related to Margaret of York, among which she commissioned five, were produced at Ghent, and five of those come with certainty from David Aubert's workshop in the years 1475 and 1476.[54] This concentrated period of active and focused acquisitions coincides with the years of Margaret's greatest participation in political life as representative of her absent consort. Although the difficult political situation put her under increasing pressure, she was nearly always alone, since the duke was occupied with ever-failing military campaigns. She must have realized in these years that her marriage would remain childless. It was under these circumstances that Margaret became, for a brief period, a very active commissioner of books, appropriating the Burgundian tradition and environment. The choice in the form and content of her commissions is remarkably homogeneous and reveals her most private thoughts and feelings to an extraordinary degree.

With these insights into Margaret's attitude toward manuscripts, we can begin to situate *The Visions of Tondal*. It must be considered along with another of her manuscripts, the *Bible moralisée* decorated with the arms of the duke and the duchess. This latter manuscript includes the *Purgatoire de Saint Patrice* (Appendix no. 22 [f]). Like *The Visions of Tondal*, this tale of Irish origin was extremely popular and was translated into Latin, French, Dutch, German, and Italian. The legend was comparable to that of Tondal, whose journey, however, had not been voluntary; he was sent to hell as a punishment for being "so confident in his good looks, and in his strength, that to the salvation of his soul he never gave a thought." In his journey to heaven, Tondal encountered King Conchober and King Donatus, who had been "great enemies," but "made peace between themselves and repented. . . ." King Conchober vowed to "enter religious life," and King Donatus "gave away all that he had to the poor." The next stage in heaven that Tondal visits is that of the Faithfully Married.[55]

In the Netherlands, both *Saint Patrick's Purgatory* and *The Visions of Tondal* enjoyed great popularity—eight manuscripts in Dutch of each text have come down to us. Excellent Latin versions of both texts could be found in Utrecht about 1460. In five of the Dutch manuscripts, the works appear together, twice in conjunction with a Dutch translation of *La vision de l'âme de Guy de Thurno*, the tale that David Aubert produced for Margaret of York just one month before completing the *Tondal*. There are four different Dutch translations of the *Tondal*, which was first printed in Antwerp around 1482. It is remarkable that these five manuscripts belong to compilations for typical female devotion and that the documented first owners are two lay women, a Beguine, the Saint Agnes convent at Maaseik, and the convent of the Bethlehem Sisters at Nijmegen. Women typically read vernacular devotional texts. French copies of *Saint Patrick's Purgatory* number at least twenty-five, while *The Visions of Tondal* in French exists in fourteen manuscripts with ten different translations. An interpolation in a Jean Gerson manuscript containing a program of reading for the seven days of the week prescribed the *The Visions of Tondal* for Fridays, *La vision de l'âme* and the Apocalypse on other days. Margaret may have followed such advice.[56]

Three further pieces of evidence concerning Margaret's personal devotion must still be considered.

1. During Duke Charles's siege of the small Rhineland town of Neuss, which lasted from July 1474 to June 1475, Margaret sent him as a Christmas gift a splendid dais under a canopy, gold above and below, richly embroidered with the arms of Burgundy, an object that amazed the Milanese ambassador. This gift must have flattered Charles's taste for luxury. At the very beginning of the siege, Margaret had traveled with Charles from Brussels to Maastricht, and then went on alone to Aachen to donate her splendid wedding crown to the statue of the Virgin in the cathedral. The symbolism of this remarkable act is twofold. The Virgin, of course, symbolized motherhood. On a political level, Aachen was the place where the German kings had been crowned; although negotiations the previous year to bestow royal dignity on Duke Charles had failed, he remained ambitious. Margaret's crown in Aachen can be understood as a yet another expression of her husband's claim.[57]

2. In 1475, Margaret went to see the relics of Saint Gummar in the city of Lier,

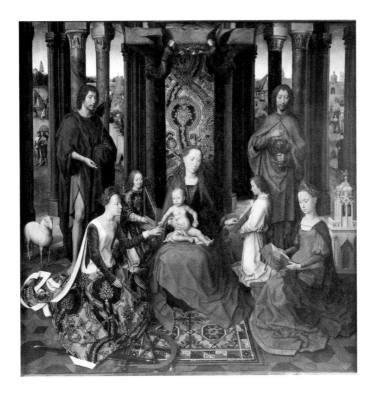

Figure 9.
Hans Memling. *The Mystic Marriage of Saint Catherine*, oil on canvas. Bruges, Memling Museum, O.S.J.175.I. © A. C. L. Brussels.

near Mechlin. The occasion for this visit may have been the completion of the transept of the church, directed by Jan II Keldermans. The Augustinian Black Sisters had a chapel in the church.[58] Margaret also visited nearby relics of the saint. The local chapter offered her a *vita* of the saint in a parchment manuscript. She probably became familiar with the Gummar cult in Ghent, where an altar in the Saint Nicholas church was devoted to him, close to those of Saint Barbara and Saint Anne. Margaret became a member of guilds devoted to both saints in 1472 and 1473, respectively. In 1496 she arranged to have Philip the Fair's marriage to Joanna of Castile celebrated in Saint Gummar. As dowager, she returned to Lier on October 11, 1477, to participate in the annual procession of Saint Gummar, who was especially worshiped by the unhappily married.[59]

3. Memling's famous painting *The Mystic Marriage of Saint Catherine* shows two ladies in adoration (fig. 9). A strong tradition identifies the left figure, representing Saint Catherine, as Mary of Burgundy, and the one on the right, Saint Barbara, as Margaret. The duchess's veneration for both saints can be confirmed in other ways. She retained patronage rights over the chapter of Saint Catherine in Voorne, and there may have been a *Life of Saint Catherine* among the works she commissioned from David Aubert at Ghent in 1475 and 1476 (Appendix no. 18). Catherine was revered as the protectress of young girls and married women, and especially of the distressed. Both Margaret and Mary were, as noted, members of the guild of Saint Barbara at Ghent. It seems plausible, therefore, that the two saints in Memling's painting bear portraits of Margaret and Mary. The association fits well with all the duchess's devotional pratices. Moreover, recent excavations of Mary of Burgundy's remains in Bruges have proven that her skull matches the head on the statue on her tomb in the Church of Our Lady, giving us evidence of her physical appearance.[60]

Let us try to bring together all these observations. Margaret was an active bibliophile as a duchess, but as a dowager she invested almost exclusively in religious reform and in charity, even if the amount of her donations did not meet the standards set by King Donatus in Tondal's vision. She paid special attention to the education of orphans and saw to the education of the children born to Mary and Philip the Fair—both concerns possible compensations for her own childless state. That she would never bear children probably seemed ineluctable by 1472, after which time the duke met her only rarely. Her intense devotion to the Virgin and Saints Colette, Anne,

Barbara, Catherine, Agnes, and Gummar, not to mention her patron saint, Margaret of Antioch, all point in the same direction: Margaret of York's marriage to Charles turned out to be an unhappy one because they did not have any children. The duke kept an ever-increasing distance from his wife, being engaged totally, even obsessively, in warfare. Since Margaret so clearly selected her commissions of manuscripts for specific functions, and even had personal adaptations made, I would suggest that she read *The Visions of Tondal* with a highly subjective eye. The year 1474–75, in which the manuscript was completed, was also the time of the siege of Neuss and Charles's almost complete neglect of his spouse. *The Visions* deal with an all too worldly knight who is taught to focus on the welfare of his soul and especially on making peace with his enemy and devoting himself to charity and a faithful marriage. The manuscript is so extensively illuminated that it takes an outstanding place in the category of personal readings Margaret commissioned. Who else could be addressed by this subtle message than the chivalrous duke himself? *The Visions of Tondal* may thus have functioned as an ultimate attempt by lonely Margaret, at least in her prayers, to persuade her spouse to leave his belligerent life full of false appearances and to turn to spiritual values, as she did herself.

Notes

1 M.-R. Thielemans, *Bourgogne et Angleterre: Relations politiques et économiques entre les Pays-Bas bourguignons et l'Angleterre 1435–1468* (Brussels, 1966), pp. 411–24; W.P. Blockmans, ed., *Handelingen van de Leden en van de Staten van Vlaanderen, 1467–1477* (Brussels, 1971), pp. 28–29.

2 Vaughan 1973, pp. 44–48, 60; Prevenier/Blockmans 1985, pp. 191–96; Weightman 1989, pp. 30–45, 90.

3 Weightman 1989, pp. 63–65.

4 J. Bartier, *Charles le Téméraire* (Brussels, 1970), pp. 114–16; Vaughan 1973, pp. 49–53; Weightman 1989, pp. 47–60.

5 E. Dhanens, "De Blijde Inkomst van Filips de Goede in 1458 en de plastische kunsten te Gent," *Academiae Analecta: Mededelingen van de Koninklijke Academie voor Wetenschappen, Letteren en Schone Kunsten van België. Klasse der Schone Kunsten* 48 (1987), pp. 53–89. For the 1496 entry, see Prevenier/Blockmans 1985, p. 275, and Berlin, Kupferstichkabinett, 78 D 5. For Charles's entry of 1515, see J. Jacquot, "Panorama des fêtes et cérémonies du règne: Evolution des thèmes et des styles," *Fêtes de la Renaissance. II: Fêtes et cérémonies au temps de Charles Quint* (Paris, 1960), pp. 413–91, esp. 413–18 and pls. XL-XLI, with references to Vienna, Österreichische Nationalbibliothek, Cod. 2591, and the edition printed by Gilles de Gourmont (Paris, 1515).

6 S. Dauchy, "Le douaire de Marguerite d'York, la minorité de Philippe le Beau et le Parlement de Paris 1477–1494," *Bulletin de la Commission royale d'histoire* 155 (1989), pp. 51–55, 78–79; Vaughan 1973, p. 258, reports that the Medici bank at Bruges, directed by

Tommaso Portinari, had to advance to King Edward the first installment of 50,000 crowns. In March 1477, Duchess Mary restored to Margaret the part of her dowry that had been paid and cancelled the payments due on the balance.

7 Weightman 1989, pp. 88–95.

8 Vaughan 1973, pp. 158–59; Weightman 1989, p. 72.

9 Vaughan 1973, pp. 234–35.

10 In November 1474, the Four Members of Flanders visited Margaret and Mary, who had both been sick in Brussels, where they resided from July to December of that year; see Blockmans (note 1), pp. 231–33; H. Vander Linden, *Itinéraires de Charles, duc de Bourgogne, Marguerite d'York et Marie de Bourgogne, 1467–1477* (Brussels, 1936), pp. 63–64.

11 Dauchy (note 6), p. 65, repeated with some minor modifications in the act of March 10, 1477, from which the last phrase between brackets was taken; Dauchy, pp. 76–77.

12 Blockmans (note 1), pp. 245–48; idem, *De volksvertegenwoordiging in Vlaanderen in de overgang van middeleeuwen naar nieuwe tijden, 1384–1506* (Brussels, 1978), pp. 614–15. All the principalities offered special grants for the duchess's losses in Male: Brabant, 4000 ryders (equivalent to 48 Flemish groats each); Valenciennes, 14,000 lbs. (= 20 groats); see A. Pinchart, *Inventaire des Archives des Chambres des Comptes*, vol. 3 (Brussels, 1900), pp. 15, 394–95, 407–08. The duchess had stayed at Male castle from January 29 to May 2, 1472; Vander Linden (note 10), pp. 37–40.

13 R. Wellens, *Les Etats Généraux des Pays-Bas des origines à la fin du règne de Philippe le Beau, 1464–1506* (Heule, 1974), pp. 144–52.

14 M.-A. Arnould, "Les lendemains de Nancy dans les 'Pays de par deçà' (janvier-avril 1477)," in W.P. Blockmans, ed., *1477: Le privilège général et les privilèges régionaux de Marie de Bourgogne pour les Pays-Bas* (Kortrijk and Heule, 1985), pp. 1–18.

15 Dauchy (note 6), pp. 64–80.

16 Y. Cazaux, *Marie de Bourgogne* (Paris, 1967), pp. 240–51.

17 Dauchy (note 6), pp. 112–16; see also Albert Derolez's essay, p. 101, below.

18 Weightman 1989, pp. 134–39.

19 London, British Library, Royal Ms. 19 E V (418 leaves, 10 miniatures, marginal decoration), fol. 367v. In the text, the emperor is Trajan, the kneeling man Hadrian.

20 W.P. Blockmans, "Autocratie ou polyarchie? La lutte pour le pouvoir politique en Flandre de 1482 à 1492, d'après des documents inédits," *Bulletin de la Commission royale d'histoire* 140 (1974), pp. 257–368; Dauchy (note 6), pp. 56–63, 80–116.

21 R. Wellens, "La révolte brugeoise de 1488," *Handelingen van het Genootschap "Société d'Emulation" te Brugge* 102 (1965) pp. 5–52; idem (note 13), pp. 199–213; Weightman 1989, pp. 164–65.

22 Weightman 1989, pp. 167, 191–97.

23 Ibid., pp. 169–83; H.J. Smit, *Bronnen tot de geschiedenis van den handel met Engeland, Schotland en Ierland. II: 1485–1585* (The Hague, 1942), no. 74, document of September 18, 1493, trade boycott; no. 96, trade agreement of February 24, 1496.

24 This issue is discussed in P. Burke, *The Italian Renaissance: Culture and Society in Italy*, rev. ed. (Princeton, 1987), esp. pp. 88–93.

25 Quoted in Chesney 1951, p. 36.

26 Brussels, Algemeen Rijksarchief, Rekenkamer (hereafter cited as BARA Rk), nos. 8838–40. In 1477–78, the building expenses amounted to 696 lb. out of total expenses of 3024 lb., 17 s., 5 d.par. Margaret's *argentier*, Hyppolite de Berthoz, was given 1916 lb., 10 s., 4 d.par. (fols. 41v–47r, 56v). R. Wellens, "Travaux de restauration au château de la Salle à Binche sous Philippe le Beau et Marguerite d'York," *Annales du Cercle archéologique de Mons* 63 (1958) p. 131ff.

27 BARA Rk, no. 11613, fol. 11r (first mention) and yearly repetitions further in that volume. The master mason's daily salary at Mechlin was 12 den.brab. in summer and 10 in winter from 1433 to 1488, 13½ and 12, respectively, from 1489 onward; see E. Scholliers, "Salaires à Malines aux XVe et XVIe siècles," in C. Verlinden et al., eds., *Documents pour l'histoire des prix et salaires en Flandre et en Brabant*, vol. 2b (Bruges, 1965), pp. 1279, 1246. The maximum wages per year would thus be about 45 lb. (= 40 groats; 3 d.brab. = 2 Flemish groats). For the jam maker, see Weightman 1989, p. 125, who does not mention which pounds were meant. If it were pounds parisis (= 20 Flemish groats), the jam maker's pension was three times that of Keldermans.

28 In this context, see also the cults of Saint Elizabeth and Saint Walburga in G. Buschan, *Über Medizinzauber und Heilkunst im Leben der Völker* (Berlin, 1942), pp. 148–49.

29 Galesloot 1879, pp. 217–18, 237–38, 243.

30 BARA Rk, no. 8839, fol. 39v (quotations); no. 8840, fols. 39v, 58r.

31 BARA Rk, no. 11613, fol. 15r, for the quotation from the account for June 24, 1481, to January 5, 1482. For the required minimal bread consumption, see W.P. Blockmans and W. Prevenier, "Poverty in Flanders and Brabant from the Fourteenth to the Mid-Sixteenth Century: Sources and Problems," *Acta Historiae Neerlandicae* 10 (1976), pp. 20–22. An Antwerp viertel measured about 80 litres. One adult normally needed about 335 litres per year.

32 Left panel with portraits of the donor and his wife ascribed to Hugo van der Goes.

33 BARA Rk, no. 8839, fol. 39v; no. 8840, fol. 58r; Weightman 1989, p. 201; Galesloot 1879, p. 237; E. Dhanens, "Le scriptorium des Hiéronymites à Gand," *Scriptorium* 23 (1969), pp. 361–79; BARA Rk, no. 7544, fol. 9v.

34 Bergen op Zoom, Gemeentelijke Archiefdienst, Archieven Raad en Rekenkamer van de Markiezen, no. 110, dated June 18, 1478. As the archivist W.A. van Ham kindly mentioned to me, in 1481–82 Margaret bought a house named "huis van Wedergraete" on the Koudenberg at Brussels, in the neighborhood of the court and other noble houses such as that of the Ravenstein family; it had belonged to the Bergen family, to which she sold it again in 1483; see BARA, Diverse Manuscripten, no. 236, fols. 137–38, 151.

35 Two copies of the text were in Margaret's library: Valenciennes, Bibliothèque Municipale, Ms. 240 (Appendix no. 15[e]); Brussels, Bibliothèque Royale, Ms. 9272–76 (Appendix no. 21[b]). For further discussion of Margaret's involvement in religious affairs, see Nigel Morgan's essay in the present volume.

36 W. Kohl, E. Persoons, and A.G. Weiler, eds., *Monasticon Windeshemense: Archives et bibliothèques de Belgique*, special issue no. 16, 3 vols. (Brussels, 1976, 1980), vol. 1, pp. 64–65; in vol. 3, pp. 47 and 141, Margaret of York prompted the formation of a visiting committee to reform a convent near Paris in 1495; E. de Moreau and A. de Ghellinck, *Histoire de l'Eglise en Belgique. Tome complémentaire: Circonscriptions ecclésiastiques, chapitres, abbayes, couvents en Belgique avant 1559* (Brussels, 1948), pp. 474, 488–89; Galesloot 1879, pp. 212–37; C. Morlion, "De vroegste geschiedenis van het Gentse St. Agneete convent (1434–1454)," *Handelingen van de Maatschappij voor Geschiedenis en Oudheidkunde te Gent* 38 (1984), pp. 31–33; W. Lourdaux, "Het boekenbezit en het boekengebruik bij de Moderne Devoten," in *Contributions à l'histoire des bibliothèques et de la lecture aux Pays-Bas avant 1600*, as *Archives et bibliothèques de Belgique*, special issue no. 11 (Brussels, 1974), pp. 272–73; idem, "Les Dévots Modernes, rénovateurs de la vie intellectuelle," *Bijdragen en mededelingen voor de geschiedenis der Nederlanden* 95 (1980), pp. 279–97. Our remarks about the *Devotio Moderna* are at variance with Weightman 1989, p. 198.

37 Corstanje et al. 1982, pp. 145–53; E. Dhanens, "Een 'Maagschap van de H. Anna' in het derde kwart van de 15de eeuw?" *Academiae Analecta: Mededelingen van de Koninklijke Academie voor Wetenschappen, Letteren en Schone Kunsten van België. Klasse der Schone Kunsten* 48 (1987), pp. 118–19.

38 Dhanens (note 37), p. 116; A. de Schryver, in Ghent 1975, vol. 2, pp. 374–75; P. Trio, *De Gentse broederschappen (1182–1580): Ontstaan, naamgeving, materiële uitrusting, structuur, opheffing, en bronnen* (Ghent, 1990), pp. 125–32. The manuscript may well have been taken to England by a refugee after the Spanish reconquest of Ghent in 1584.

39 Trio (note 38), pp. 133–35, and D.H. Farmer, ed., *The Oxford Dictionary of Saints* (Oxford, 1978).

40 Galesloot 1879, p. 237.

41 In preparing this essay, I used Nigel Morgan's draft list of devotional texts, presented at the symposium. This list is now incorporated into the Appendix of the present volume.

42 Brussels, Bibliothèque Royale, Ms. 9296; see Appendix no. 1.

43 London, British Library, Add. Ms. 7970; see Appendix no. 2. The frontispiece miniature represents the duchess, her coat of arms, and the initials CM. An autograph note at the end dedicates the manuscript to Jeanne van Halewijn, lady of Wassenaar, in 1500.

44 Brussels, Bibliothèque Royale, Ms. 9272–76; see Appendix no. 21.

45 Brussels, Bibliothèque Royale, Ms. 9305–06; see Appendix no. 3.

46 Brussels, Bibliothèque Royale, Ms. 9272–76; see Appendix no. 21.

47 Chesney 1951, pp. 27, 32–39.

48 De Schryver, in Ghent 1975, p. 331, esp. n. 25.

49 See Albert Derolez's essay in the present volume for the Justinus text.

50 In recent literature, see Dogaer 1975; Hughes 1984; Weightman 1989, chap. 7.

51 A. Derolez, *The Library of Raphael de Marcatellis, Abbot of St. Bavon's, Ghent, 1437–1508* (Ghent, 1979).

52 R. de Keyser, "Het boekenbezit en het boekengebruik in de seculiere kapittels van de Zuidelijke Nederlanden tijdens de Middeleeuwen," *Contributions à l'histoire des bibliothèques* (note 36), pp. 9–68; A. Derolez, *Corpus catalogorum Belgii. De middeleeuwse catalogi der Zuidelijke Nederlanden. I: Provincie West-Vlaanderen* (Brussels, 1966), pp. 123–37.

53 For Margaret of Bavaria, see J. Barrois, *Bibliothèque protypographique* (Paris, 1830), p. 114ff; for Isabella of Castile, A. Sarriá Rueda et al., *Les rois bibliophiles* (Brussels, 1985), p. 77.

54 Many authors, following Dogaer and Hughes, mistakenly ignore the calendrical style in the Burgundian Netherlands, which begins the year at Easter. Thus February and March 1474 (old style) have to be read as 1475 (new style), since Easter that year fell on April 10.

55 Malibu 1990, pp. 55–56.

56 The manuscript traditions and Dutch texts of both *Saint Patrick's Purgatory* and *Tondal's Visions* have been studied by R. Verdeyen and J. Endepols, *Tondalus' Visioen en St. Patricius' Vagevuur* (The Hague and Ghent, 1914–17), vol. 1, pp. 110–15, 133–62, 276–86, 298–310. A recent and far more thorough study is Palmer 1982 , pp. 1, 97–130, 363–76.

57 Vaughan 1973, pp. 69–70; Vander Linden (note 10), pp. 62–63.

58 K. Breugelmans et al., *Lier. historische stedenatlas* (Brussels, 1990), pp. 92, 97.

59 Galesloot 1879, p. 244. For the life and cult of Gummar, see J. Pycke, in R. Aubert, ed., *Dictionnaire d'histoire et de géographie ecclésiastiques*, vol. 21 (Paris, 1986), pp. 562–64, s.v. "Gommaire."

60 P.A. Janssens, "De identificatie van de hertogin Maria van Bourgondië," *Verhandelingen van de Koninklijke Academie voor Geneeskunde van België* 43 (1981), pp. 213–70.

MARGARET OF YORK AND THE BURGUNDIAN
PORTRAIT TRADITION

Jeffrey Chipps Smith

W hen Margaret of York married Charles the Bold, Duke of Burgundy, in 1468, she entered a court famed for its cultural brilliance, where artistic patronage was dominated by men. Prior to Margaret of York, seen here in the Louvre painting (fig. 10) made in 1468 or 1469, the history of Burgundian portraiture focuses almost exclusively on the four Valois dukes.[1] The number of contemporary manuscript portraits of Margaret of Flanders, Margaret of Bavaria, and Isabella of Portugal is very small.[2] I shall argue here that Margaret of York was the first Burgundian duchess to develop a distinctive portrait image, one that shows diverse aspects of her religious character: her devoutness, her spirituality, and her charity. To effect this portrayal, she borrowed to a degree from the Burgundian prototypes provided by the dukes, but also created wholly new iconographies.

In order to provide a context for the innovations in the manuscript portraits of Margaret of York, we must briefly consider earlier Burgundian portraiture. If Margaret of York depended in part on her husband, Charles, to shape her own image, Charles himself drew upon the tradition developed by his father. Representations of Philip were to be seen in dozens of manuscripts, stained glass windows, sculptures, and paintings. Among the miniatures, there are only a few portrait types. Most common are the scenes where an author or translator presents his work to Philip or where a courtier presents a book that he commissioned to the duke. In such miniatures, the duke is generally standing or seated amid his courtiers. In the frontispiece to Philip's splendid *Roman de Girart de Roussillon* (fig. 11), Jean Wauquelin, editor of the text, kneels to present the book to the duke.[3] Philip, the cultured prince and ideal ruler, sits enthroned, the focal point of this all-male gathering and the master of the lands indicated on the armorial tapestry. He is accompanied by Charles the Bold and some knights of the Golden Fleece. At left stand Chancellor Nicolas Rolin, Bishop Jean Chevrot, a third man, perhaps Guy Guilbaut, Philip's treasurer, and other court administrators—in short, representatives of society's three estates. Philip is shown surrounded by wise counsel, in accordance with biblical advice such as Proverbs 1: 5 and that in medieval texts for the instruction of princes.

Images of the duke appear in a broad variety of texts in his library, the majority being secular, including tales of Burgundian heroes such as Girart, chronicles of provinces under ducal rule, books on governing, and ancient histories. A variation on these presentation miniatures shows the avid ruler-patron dropping in on his scribes.[4] A third, much smaller category of ducal portraits in manuscripts depicts the duke in prayer, either in his chapel or before an image of a venerated saint or a Gospel scene. These portraits appear in devotional treatises and liturgical books.[5]

How does Charles appear in manuscript illumination? In the presentation miniature in the *Roman de Girart de Roussillon*, Charles, who like Philip is dressed in black, mimics and indeed completes his father's gesture as he touches the codex. Like other aspects of this miniature, the source is Proverbs, here 1: 8: "My son, hear

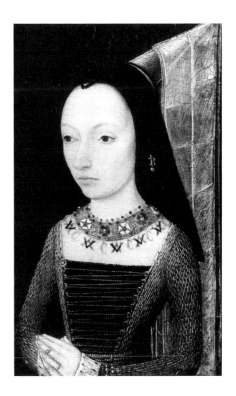

Figure 10.
Anonymous master. *Portrait of Margaret of York*, oil on canvas. Paris, Musée du Louvre. Photo courtesy Réunion des Musées Nationaux, Paris.

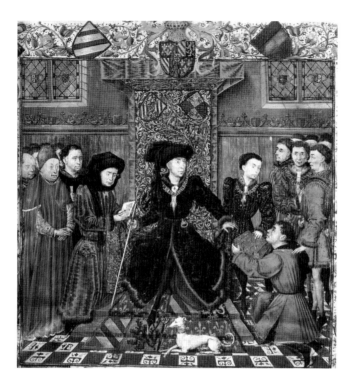

Figure 11.
Master of Girart de Roussillon. *Jean Wauquelin Presents the Book to Philip the Good*, in *Roman de Girart de Roussillon*. Vienna, Österreichische Nationalbibliothek, Cod. 2549, fol. 6.

the instruction of thy father." Charles is being groomed to govern by watching his father's example and by participating in the cultural and political life of the court. As he began to commission his own manuscripts and to determine his own iconographic types, he had a broad range of models upon which to build. There are fewer portraits of Charles than Philip because Charles ruled for a much briefer period, but they include new formulas that seem to reflect his own personality and character. For example, like his father, Charles appears in presentation miniatures of works he commissioned. Yet he also appears in a number of scenes where he is playing a particular political role or simply governing. These include presiding over the meeting of the Golden Fleece; presenting ordinances of the household to members of his staff; receiving the oath of fidelity from his military captains; and kneeling in prayer in a devotional manuscript and a prayer book.[6] The portraits in the second and third categories serve as frontispieces in collections of ordinances that Charles had issued. Charles was a strong administrator at home and his military engagements never ceased. Indeed, military ordinances constitute one of his most significant contributions to European political life over the next century.[7]

What tradition of female portrait types would Margaret of York have found when she arrived in the Low Countries? Between 1468 and 1471, Margaret spent considerable time with her mother-in-law, Isabella of Portugal. Although the dowager duchess could advise her on courtly and spiritual matters, her appreciation for the pictorial arts was limited. In her forty years at the Burgundian court, Isabella failed to develop a personal artistic identity.[8] Rogier van der Weyden portrayed Isabella on a few occasions, as in the now lost Batalha altarpiece, where she knelt in prayer opposite Philip and Charles, or the *Deposition* panel at the J. Paul Getty Museum. Despite her interest in literature, Isabella does not appear in any of the manuscripts that she commissioned and only very rarely in those of her husband, such as the stylized depictions in the Breviary of Philip the Good in Brussels (fig. 12).[9]

Charles's two previous wives left a scant portrait legacy. No portraits are known of Catherine of France, who died at seventeen in 1446. Isabella of Bourbon, who enjoyed a happy marriage from 1454 until her death in 1465, is recorded in a few, usually undistinguished, images. In a detached miniature (fig. 13) from a book of hours, now in Copenhagen, Isabella stares at Charles, who gazes at the *vera ikon* floating in the sky.[10] But it is the coat of arms and not the artist's talent that permits us to identify her. Another illuminated portrait of Isabella adoring the Virgin, which

was kept in a box, was listed in the 1516 inventory of Margaret of Austria's collection in Mechlin. Like most of the Burgundian princesses, Isabella of Bourbon appears in the *Recueil d'Arras* and in a few other, much later portraits of dubious accuracy. The best-known representation, albeit highly idealized, appears in her tomb, erected by her daughter, Mary of Burgundy, in Saint Michael's in Antwerp in 1476. Nor could the English or the French courts provide sufficient models for Margaret of York.[11] The occasional scene of a noblewoman at prayer hardly represents a strong personal iconography. Moreover, the opportunities Margaret had for commissioning portraits were relatively small, compared to her husband and father-in-law. She was neither a patron of literature on the scale of Philip, nor did she play the kind of role in government and policymaking that resulted, for example, in Charles's celebrated ordinances.

It is against this artistic and cultural backdrop that the nine portraits of Margaret in thirty books that she owned or are associated with her patronage seem so remarkable.[12] While my use of the term portrait is sometimes relative since physiognomic accuracy was never the illuminators' artistic purpose, a clear image of how the duchess wished to be viewed does emerge. The emphasis, as we shall see, is decidedly different from that in the manuscript portraits of either Philip or Charles. Philip's manuscript portraits reflect his patronage and love of books, while Charles's, though on a more modest scale, represent his conscientiousness as an administrator and his innovations in governing. Margaret, in contrast, builds upon the traditional image of the devout noblewoman, as in the typical scene of a lady at prayer before the Virgin, but sometimes incorporates ideas from ducal prototypes as well as other pictorial traditions.

When we examine each of Margaret's portraits more closely, some new themes come to light. The two most famous portraits appear in *Benoit seront les miséricordieux* in Brussels (figs. 2 and 14), a devotional text extolling the Seven Acts of Mercy.[13] It was written for Margaret by her almoner, Nicolas Finet, and illuminated in Brussels by the Girart de Roussillon Master or another artist in his circle. On fol. 1 are eight scenes, including seven portraits of Margaret performing the Seven Acts of Mercy advocated by Christ in Matthew 25: 35–39. The duchess moves through the Brabantine setting as she offers alms, clothing, drink, and food to the needy. Below, she visits prisoners and the infirm while also praying for the dead. In each scene Christ observes her pious actions. As Wim Blockmans demonstrates in the present volume, Margaret's actual deeds of charity were numerous. At the center of the illumination are her coat of arms and the monogram CM for Charles and Margaret. These remind us that Margaret, as Duchess of Burgundy, recognized her special obligation to assist her needy subjects. Although the Seven Acts of Mercy was a popular theme of Christian devotion, literature, and even theater, I know of no comparable iconography in Burgundian ducal portraiture or among female patrons up to this time.[14]

In the miniature on fol. 17 (fig. 14), the duchess kneels at her prayer bench with Saint Margaret. The Church Fathers, Jerome, Gregory, Ambrose, and Augustine, point to the symbolic Gothic church at center—Saint Gudule in Brussels—and advise Margaret on the true path of a Christian life. The duchess was especially interested in the writings of Augustine, selections from which begin immediately below this miniature. Behind Saint Gudule, views of Notre Dame du Sablon, a gate, and the town hall have been magically relocated northward to the upper corners of the miniature. Margaret's position seems bound by the flanking walls to a spot south of Saint Gudule—a spot that in the 1470s belonged within or immediately adjoined the precinct of the great Coudenberg, or ducal palace. This setting is hardly accidental. Margaret is depicted as the Duchess of Burgundy and perhaps also as the vicaress of Christ, guardian of the church and her people.[15]

The political significance of these two miniatures is suggested by certain ruler images of Charles the Bold. The most specific is a military *Ordinance* miniature (fig. 15), now in Montpellier, with an image of the crucified Christ at top and Charles below.[16] Dressed half in armor as a knight and half in the ermine robe of a prince,

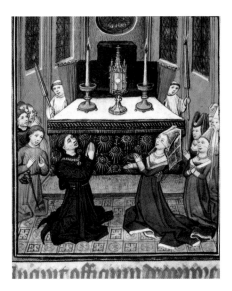

Figure 12.
Willem Vrelant (or workshop). *Philip the Good and Isabella of Portugal in Prayer*, in the Breviary of Philip the Good. Brussels, Bibliothèque Royale, Ms. 9026, fol. 258.

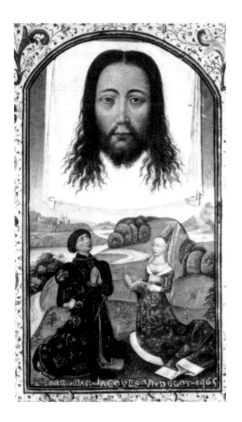

Figure 13.
Willem Vrelant (or workshop). *Charles the Bold and Isabella de Bourbon in Prayer*, detached miniature from a book of hours. Copenhagen, Kongelige Bibliotek, Ms. GKS 1612, fol. 1v.

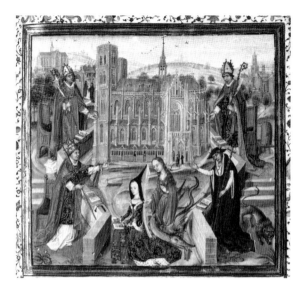

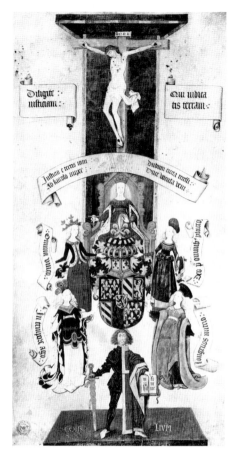

Charles holds the sword of justice and a Bible, on which is inscribed Christ's mono-gram and the text "Nihil sine me." That is, Charles is nothing without Christ since it is from the Lord that his power and authority as vicar stem. Between Charles and the cross are Justice, enthroned, Truth, Wisdom, Chastity, and Sobriety; the moral lessons of these Virtues, along with the advice to take counsel (*consi/lium* is inscribed on either side of Charles's legs), ensured that Charles would be the ideal ruler and judge.

Did not Margaret also have important moral responsibilities—and authority—as duchess? In another of her manuscripts, *Le dialogue de la duchesse de Bourgogne à Jésus Christ*, Christ urges her, specifically as the Duchess of Burgundy and sister of the King of England, to devote herself to spiritual concerns.[17] In *Le dialogue*, com-posed by Nicolas Finet, the artist of the Brussels *Benoit* miniature contributed the single miniature (fig. 16) in which Christ visits Margaret in her bedroom. She kneels on a rug or pillow rather than at the prayer bench more customary in contempora-neous revelation scenes.[18] This heightens the immediacy and reminds us that, how-ever mystical, this is indeed a dialogue. In the text, Christ praises Margaret's piety, instructs her in devotion, and warns her to avoid the pride that often accompanies noble titles. The iconography of this scene is related to that of *Christ Appearing to His Mother*, and Margaret's pose recalls that of Mary Magdalene in *Noli me tangere* images. Like the Magdalene, Margaret is shown as a witness to the resurrected Christ. Her coat of arms and the CM monograms in the miniature and the border again stress her role as Duchess of Burgundy.[19] The question arises whether Margaret chose to be depicted in this way, or whether Finet, whose text exhorted her to follow a certain spiritual path, proposed the iconography.

Like her mother-in-law, Margaret took special interest in the Poor Clares and sometime during the early 1470s commissioned a sumptuous edition of Pierre de Vaux's *Vie de Sainte Colette*, which she presented to the convent of the Poor Clares in Ghent.[20] Among the twenty-five half-page miniatures is the only extant portrait of Margaret with her husband (fig. 6),[21] and the likeness of Margaret seems to be the closest of all the examples to a true portrait. This is the only miniature that reveals the long blonde hair that, in other representations, is hidden by a wimple. Charles and Margaret, who is presumably inspired by the text that rests before her, together witness Saint Colette's own vision of the thrice-married Saint Anne and her large family. The miracle, which demonstrated that three marriages would not make the participants any less worthy of the Lord, had special significance for the ducal couple since Margaret was Charles's third wife and they eagerly sought children. Margaret and Charles would seem to be asking the Lord's blessing for the fruitfulness of their marriage.[22] The holy Colette, who died at this Ghent convent, had close ties with the ducal family, which had fought unsuccessfully for her canonization.[23]

Figure 14.
Master of Girart de Roussillon (or workshop). *Margaret of York Kneeling before the Church of Saint Gudule*, in Nicolas Finet, *Benoit seront les miséricordieux*. Brussels, Bibliothèque Royale, Ms. 9296, fol. 17.

Figure 15.
Anonymous master. *Charles the Bold as Vicar of Christ*, in *Ordinance Book of Charles the Bold*. Montpellier, Bibliothèque Municipale, Fonds C. Cavalier, no. 216.

Figure 16.
Master of Girart de Roussillon (or workshop). *Margaret of York and the Resurrected Christ*, in Nicolas Finet, *Le dialogue de la duchesse de Bourgogne à Jésus Christ*. London, British Library, Add. Ms. 7970, fol.1v. Reproduced by kind permission of the British Library Board.

By 1474, the date of the Getty *Tondal* and *Vision of the Soul of Guy de Thurno*, Margaret had initiated a special artistic association with the scribe David Aubert, who recently had moved to Ghent. By 1477 she owned at least six of the luxurious manuscripts that he had transcribed. One of these is the book of moral and religious treatises, comprising nine edifying texts, now in Oxford.[24] On fol. 115 (fig. 17), the artist depicts the duchess under a canopy kneeling at her prayer bench. Before her are a manuscript and a painting of Christ. Margaret is accompanied by two other women, one of whom might be her stepdaughter, who also resided in Ghent at this time. While the miniature could reflect actual devotional practice at the court, it also strongly recalls the scene of Philip the Good at mass in his *Traité sur l'oraison dominicale* in Brussels (fig. 18).[25] The duke recites his Pater Noster within the private, canopied chapel. Like Margaret, he has a manuscript and a painted icon before him, in this case, a diptych, and members of his entourage stand to the right. Either Margaret or Aubert could easily have known this earlier manuscript and suggested its use as a model.

In the four manuscripts discussed so far and in the rather derivative miniature

Figure 17.
Master of Mary of Burgundy (or circle). *Margaret of York at Prayer*, in a book of moral and religious treatises. Oxford, Bodleian Library, Ms. Douce 365, fol. 115.

Figure 18.
Attributed to Jean Le Tavernier. *Philip the Good at Mass*, in *Traité sur l'oraison dominicale*. Brussels, Bibliothèque Royale, Ms. 9092, fol. 9.

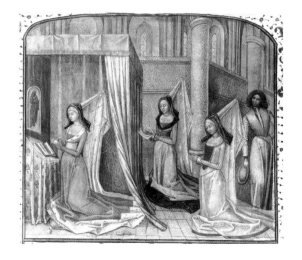

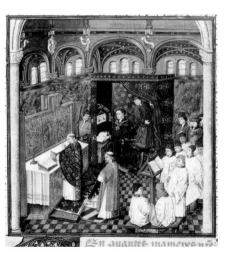

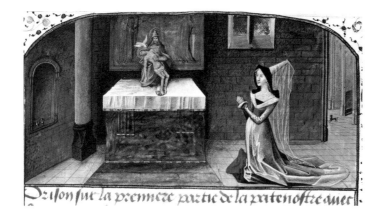

Figure 19.
Master of Mary of Burgundy (?). *Margaret of York at Prayer*, in a book of moral treatises. Brussels, Bibliothèque Royale, Ms. 9272–76, fol. 182.

of the duchess in another compendium of moral treatises in Brussels (fig. 19), the portraits of Margaret of York consistently show her engaged in spiritual pursuits.[26] If the resulting image of a devout noblewoman is hardly novel for the late Middle Ages, the iconographic variety of the portraits is. She is shown not merely saying her devotions or venerating the Trinity, but performing pious acts sanctioned by the Church and in prayer before one of the major churches of the realm. Moreover, the miniature that presents Margaret and Charles as witnesses to the miracle of Saint Anne in *La vie de Sainte Colette* was specifically intended to show the Lord's blessing for the new marriage of the twice-widowed Charles. The individual portraits of Charles the Bold depict him as a patron of culture, leader of his loyal knights, and wise administrator. Margaret, however, is portrayed as a devout and pious duchess: setting an example, as in the Seven Acts of Mercy; showing her personal relationship with Christ; and underscoring her patronage of an important church. Whether Margaret herself or an adviser was responsible for this iconography, she emerges as a duchess possessing a powerful spirituality that, by extension, offers an appropriate model for her subjects.

In addition to her religious manuscripts, Margaret had a modest taste for secular texts. William Caxton informed his readers that it was the duchess who requested that he show her his incomplete English translation of Raoul Lefèvre's *Recueil des histoires de Troie*.[27] After suggesting certain corrections, she supported Caxton in Ghent and in Cologne while he finished the project. Caxton goes on to say that he decided to publish his translation because he had promised copies to so many acquaintances. Thus in 1473 or 1474 Margaret became the benefactor of the first book printed in English. To celebrate the event, either Caxton or the duchess commissioned the engraved presentation scene, attributed to an artist in the circle of the Master of Mary of Burgundy, which survives in the unique impression now in the Huntington Library (see fig. 67).[28]

Presentation scenes, while common in Burgundian manuscripts, were heretofore exclusively male events, as in the frontispiece of the *Roman de Girart de Roussillon* (fig. 11). Comparable representations in which codices are being given to women are quite rare but can be found, for instance, in a few Christine de Pisan manuscripts.[29] Thus when the artist devised his composition for the Caxton frontispiece, he relied heavily upon examples made for Charles the Bold, such as the frontispiece of *Les faits d'Alexandre le Grand* in Paris (fig. 20).[30] While Margaret's chamber may not be as elaborate as her husband's, and she stands rather than sits, numerous compositional similarities are apparent. At the feet of each recipient is a monkey; a cupboard or table at left displays costly vessels; and both Margaret and Charles are surrounded by onlookers paying varying degrees of attention to the ceremony. In Margaret's scene, a woman at left holds a lapdog, the female counterpart to the hawk held by the courtier in the left foreground of Charles's miniature. The chimney behind the bench in the engraving is decorated with the CM monogram and Margaret's motto. The most significant difference between these two scenes is Margaret's lack of a throne, which specifically reflects Charles's office as ruler. There was no Burgundian court tradition of representing the duchesses enthroned alone. This print

Figure 20.
Loyset Liédet. *Vasco da Lucena Presents His Translation to Charles the Bold*, in *Les faits d'Alexandre le Grand*. Paris, Bibliothèque Nationale, Ms. fr. 22457, fol. 1.

has further art historical significance as being either the oldest or second-oldest engraved portrait of a noble.[31]

In 1476 the illuminator of the Oxford miniatures created a second presentation miniature for the duchess in a manuscript now in Jena (fig. 21).[32] The scribe David Aubert kneels and hands Margaret his copy of a French translation of Boethius's *Consolation of Philosophy*.[33] Margaret wears essentially the same ermine-trimmed dress seen in the Caxton engraving, and appears in the courtyard of her palace. Such exterior locations, though rare, are known in examples from the library of Charles the Bold.[34] The miniature also calls to mind a scene where an author (David Aubert?) presents a transcription of the *Composition de la Sainte Ecriture* to Philip the Good, who is, however, enthroned rather than standing.[35]

Although Charles the Bold's death in 1477 appears to have virtually ended Margaret's manuscript patronage, at least one additional manuscript portrait of Margaret

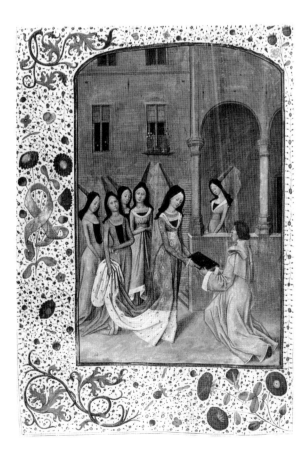

Figure 21.
Master of Mary of Burgundy. *David Aubert Presents the Book to Margaret of York*, in Boethius, *La consolation de philosophie*. Jena, Universitätsbibliothek, Ms. El. f. 85, fol. 13v.

exists from her dowager period. In 1477 the deans of the guild of Saint Anne in Ghent commissioned a new membership register, now at Windsor Castle.[36] The opening miniature (see fig. 8) honors Margaret, on the left, and Mary of Burgundy, both of whom were members and benefactors of the guild. They kneel in the church of Saint Nicholas before the guild's altar, with its statue of Saint Anne and the Virgin and the painted retable. Angels hold the arms of Margaret and Mary while those of Charles the Bold ornament the frame. In addition to kneeling guild officials, the margins are filled with daisies (*marguerites*), Margaret and Charles's CM monogram, and her motto, repeated four times. Although this ceremonial portrait miniature was paid for and kept by the guild, the portrayal of the princesses as devout rulers is consistent with the pattern seen in Margaret's own illuminations.

In the aftermath of Charles's death at Nancy, Margaret of York devoted all her attention to holding together the Burgundian realm for her stepdaughter and to arranging Mary's marriage to Maximilian of Austria.[37] For political reasons, Margaret moved to Mechlin, where she would reside until her death in 1503. Her financial situation was difficult largely because her dowry remained unpaid. Only after she sold her palace in Mechlin to her ward, Philip the Fair, in 1485 did she have funds for commissioning the occasional work of art. In 1487, for instance, she ordered a stained glass window with portraits of herself and Charles the Bold that was placed in the transept of Saint Rombout in Mechlin.[38]

I think there is an explanation for the brevity of Margaret's patronage of manuscripts that goes beyond financial constraints and also helps to explain the significance of her portraits. As duchess, Margaret held a high public position and had very specific expectations imposed on her. Following Charles's death, her role at court changed and her patronage ceased. Since she subsequently commissioned only one more manuscript for herself, a book of hours dated 1488 that was formerly in Metz,[39] I believe that her manuscript commissions were linked directly to her conception of the special obligations accompanying her office. Both her books and the portraits they contain offer a sophisticated testament to the spirituality and devoutness of a duchess. After 1477, Margaret's responsibility to set a spiritual example diminished.[40]

The significance of Margaret's patronage is twofold. In contrast to her Burgundian predecessors, she commissioned not only a broad range of religious and devotional texts but also a series of portraits within them that represent her as a strongly religious duchess. And a small number of these scenes convey an image of her Christian responsibility as the ducal consort. Few of these likenesses even approach true portraiture, but they create a vivid image of Margaret that is more distinctive than those of any earlier princesses. Just as Philip's portraits show him primarily as a patron of culture, and Charles is presented as an authoritative but conscientious ruler, Margaret's portraits seem to suggest a quasi-official spiritual role. For these images, Margaret and her artists borrowed from the abundant portraits in devotional and presentation miniatures available in the ducal library. Yet there are also some original scenes, such as those showing Margaret performing the Seven Acts of Mercy and Christ appearing in her chamber.

The second significant aspect of Margaret's manuscript commissions is that they made her the model that Mary of Burgundy and later Margaret of Austria, who inherited much of her namesake's library, would emulate.[41] Both shared her love of sumptuously illuminated manuscripts and benefited from the iconographic innovations in female portraiture that Margaret initiated. When viewing the famous miniature in the Hours of Mary of Burgundy in Vienna (fig. 22), which may include a portrait of Margaret of York kneeling before the Virgin, it is difficult not to see the English princess's influence.[42] Margaret of York was one of the fifteenth century's most distinctive, if still modest, bibliophiles. What treasures might she have commissioned had Charles not been killed at Nancy?

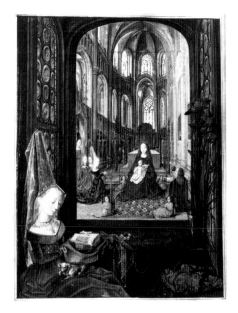

Figure 22.
Master of Mary of Burgundy. *Mary of Burgundy (?) at Prayer*, in the Hours of Mary of Burgundy. Vienna, Österreichische Nationalbibliothek, Cod. 1857, fol. 14v.

Notes

1 H. Adhémar, *Le Musée National du Louvre, Paris* (Les primitifs flamands. I: Corpus de la peinture des anciens Pays-Bas méridionaux au quinzième siècle, 5) (Brussels, 1962), pp. 11–19; at the Getty "Visions of Tondal" symposium, Maryan Ainsworth mentioned that this portrait is now sometimes attributed to Simon Marmion, who is discussed at length in other papers in this volume. The present paper excludes several panel portraits (New York, Bruges, etc.) that are sometimes claimed, in my opinion incorrectly, to represent the duchess. On the portraits of the other dukes, see P. de Winter, "The Patronage of Philippe le Hardi, Duke of Burgundy (1364–1404)," Ph.D. diss., New York University, 1976, pp. 749–869; C. Sterling, "La peinture de portrait à la cour de Bourgogne au début du XVe siècle," *Critica d'Arte* 6 (1959), pp. 289–312; R. van Luttervelt, "Les portraits de Philippe le Bon," *Les arts plastiques* 5 (October–November 1951), pp. 182–96; J.C. Smith, "The Artistic Patronage of Philip the Good, Duke of Burgundy (1419–1467)," Ph.D. diss., Columbia University, New York, 1979, pp. 279–331; and Brussels 1977, pp. 40–67.

2 The only manuscript portrait of Margaret of Flanders is posthumous; see P.M. de Winter, *La bibliothèque de Philippe le Hardi, duc de Bourgogne (1364–1404): Etudes sur les manuscrits à peintures d'une collection princière à l'époque du "style gothique international"* (Paris, 1985), fig. 6. The article by Jane Friedman, "A New Look at the Imagery of Isabella of Portugal," *Source* 1, no. 4 (1982), pp. 9–12, includes a number of examples that are posthumous and likely have little to do with Isabella's conception of herself.

3 Vienna, Österreichische Nationalbibliothek, Cod. 2549, fol. 6. There are numerous other presentation miniatures featuring Philip the Good in his books. Some examples are illustrated in Brussels 1967b, figs. 1, 41–43, 47, 49, 59, 61.

4 See, e.g., fol. 104v in Christine de Pisan, *L'épitre d'Othea*, Brussels, Bibliothèque Royale, Ms. 9392; Brussels 1967b, no. 121, pl. 58.

5 See, e.g., Brussels 1967b, figs. 46, 47, 57.

6 Brussels 1977 and Malibu 1983, pp. 13–16, figs. 1a–1c. The devotional manuscript is Margaret's collection of moral treatises in Brussels, Bibliothèque Royale, Ms. 9272–76, fol. 55, and the prayer book is J. Paul Getty Museum, Ms. 37, fols. 1v, 6, 68.

7 Vaughan 1973, pp. 204–05.

8 W. Devreker, "Isabella van Portugal," *Spiegel historiael* (March 1977), pp. 130–36, and Smith (note 1), pp. 181–84, 320–25, with an analysis of the betrothal portrait of Isabella that Jan van Eyck made in Aviz, Portugal, on January 13, 1429, and sent in two copies to Duke Philip in Flanders. For a brief discussion of society's expectations of a noblewoman, see J. Krynen, *Idéal du prince et pouvoir royal en France à la fin du moyen âge (1380–1440)* (Paris, 1981), pp. 139–41, and Friedman (note 2), pp. 9–12.

9 Brussels, Bibliothèque Royale, Ms. 9026, fols. 258 and 425; V. Leroquais, *Le bréviaire de Philippe le Bon* (Paris, 1929), pp. 122–27, pls. XII, XIV.

10 Copenhagen, Kongelige Bibliotek, GKS Ms. 1612, fol. 1v—placed in another book of hours; Leroquais (note 9), pp. 155–57. For the portraits cited in the rest of the paragraph, see A. Le Glay, *Correspondance de Maximilian I et de Marguerite d'Autriche*, vol. 2 (Paris, 1839), p. 481; K.L. Belkin, *The Costume Book* (Corpus Rubenianum Ludwig Burchard, 24) (London, 1978), fig. 36; Prevenier/Blockmans 1985, fig. 283.

11 However, the portraits of Charlotte of Savoy, wife of Louis XI of France, deserve closer investigation. As dauphin, Louis resided at the court of Duke Philip between 1456 and 1461, marrying Charlotte in 1457. In fact, Charlotte had a much larger library than Margaret, and she patronized such leading French illuminators as Jean Colombe. A splendid portrait of Louis and Charlotte was executed—significantly, by one of Margaret's Ghent artists, the Master of the Older Prayer Book of Maximilian—in a *Legend of Saint Adrian* (Vienna, Österreichische Nationalbibliothek, Cod. ser. nova 2619, fol. 3v; Vienna 1987, no. 19, fig. 10); see also n. 105 in Thomas Kren's introduction to the present volume.

12 Margaret's portraits have been discussed summarily in L. Hommel, *Marguerite d'York ou la duchesse Junon* (Paris, 1959); Brussels 1967a; Dogaer 1975; Hughes 1984; Weightman 1989.

13 Brussels, Bibliothèque Royale, Ms. 9296; Brussels 1977, no. 18, with additional literature. Before the sixteenth century there was no clear pictorial tradition in Flanders for the Seven Acts of Mercy. Vrancke van der Stockt, a follower of Rogier van der Weyden, includes the Acts of Mercy in his *Last Judgment* altarpiece (Valencia, Ayuntamiento). It is possible that Rogier created a model that inspired both our illuminator and van der Stockt; see M. J. Friedländer, *Early Netherlandish Painting*, vol. 2 (New York and Washington, 1967), no. 101, pl. 114.

14 M. Smeyers, "De Zeven Werken van Barmhartigheid en de Zeven Sacramenten: Een Leuvenstoneelspeel van 1455," in M. Smeyers, ed., *Leuvens Palet: Arca lovanienensis artes atque historiae reserans documenta*, jaarboek 18 (1989), pp. 143–69. For discussions of the subject in English fifteenth-century stained glass and wall paintings, see n. 83 in Nigel Morgan's essay in the present volume. See also M. Flynn, "Charitable Ritual in Late Medieval and Early Modern Spain," *Sixteenth Century Journal* 26 (1985), pp. 335–48, and P.L. Roberts, "Cornelius Buys the Elder's *Seven Works of Mercy*: An Exemplar of Confraternal Art from Early Sixteenth-Century Northern Europe," *Renaissance and Reformation* 13 (1989), pp. 135–50.

15 The word vicar in relation to rulers was commonly cited in medieval mirrors of princes. For instance, Origen (d. 254) wrote, "What Christ is by nature, is achieved by those whom . . . he has placed as his vicars, through the image"; E. Kantorowicz, "Deus per naturam, Deus per gratiam—A Note on Medieval Political Theology," *Harvard Theological Review* 45 (1952), p. 266. In her *Livre du corps de policie*, Christine de Pisan defined the tasks of the "bon prince comme vicaire de Dieu en terre" as, among others, defending the church and maintaining peace; cited in R.H. Lucas, ed., *Christine de Pisan: Le Livre du corps de policie* (Geneva, 1967), p. 17.

16 Montpellier, Bibliothèque Municipale, Fonds C. Cavalier, no. 216; A. Perrault-Dabot, "Un portrait de Charles le Téméraire, miniature inédite du XVe siècle," *Bulletin archéologique du Comité des travaux historiques et scientifiques* (1894), pp. 432–44.

17 London, British Library, Add. Ms. 7970; Pächt 1948, pl. 1, and Hughes 1984, pp. 62, 64.

18 C. Harbison, "Vision and Meditations in Early Flemish Painting," *Simiolus* 15 (1985), pp. 87–118.

19 The closest stylistic analogy to Margaret's miniature is the scene of *Christ Appearing to His Mother* in Rogier van der Weyden's Miraflores altarpiece in Berlin; see Friedländer (note 13), no. 1a, pl. 3. This painting is now accepted as Rogier's original.

20 Ms. 8; P. Bergmans, "Marguerite d'York et les pauvres Claires de Gand," *Bulletin de la Société d'histoire et d'archéologie de Gand* 18 (1910), pp. 271–84, and Corstanje et al. 1982. Philip the Good owned two copies of this *Vita*; see Brussels 1967b, nos. 74–75.

21 Several participants in "The Visions of Tondal" symposium wondered whether the man and woman at the center and left of *Tondal Suffers a Seizure at Dinner* (Malibu, J. Paul Getty Museum, Ms. 30, fol. 7) might not be Charles and Margaret. This is unlikely for several reasons. The man wears a collar but not the Golden Fleece collar that was obligatory for all depictions of Charles. In the text, the figures are identified as Lord Tondal and the wife of his host, thus not a couple. Any attempt to see Tondal as a model for Charles the Bold is implausible, since the

duke hardly would have accepted such a rebuke of his moral character. See Malibu 1990, p. 38, pl. 1.

22 Corstanje et al. 1982, p. 218.

23 Philip the Good and his mother, Margaret of Bavaria, aided Saint Colette in establishing new convents and, after her death in 1447, pushed for her canonization; see Doutrepont 1909, p. 226.

24 Oxford, Bodleian Library, Ms. Douce 365; Pächt 1948, p. 63, and A.G. and W.O. Hassall, *Treasures from the Bodleian Library* (London, 1976), pp. 141–42, pl. 33. Several of Margaret's manuscripts that Pächt attributed to the Master of Mary of Burgundy are now assigned loosely to artists probably active in Ghent; see A. de Schryver, in Ghent 1975, pp. 369–75.

25 Brussels, Bibliothèque Royale, Ms. 9092, fol. 9; Brussels 1967b, no. 62, and Smith (note 1), pp. 203–04.

26 Brussels, Bibliothèque Royale, Ms. 9272-76, fol. 182; Brussels 1977, no. 17.

27 Pächt 1948, p. 62; Brussels 1973, pp. 166–69; *William Caxton: An Exhibition to Commemorate the Quincentenary of the Introduction of Printing into England*, exh. cat. (British Library, London, 1976), pp. 24, 30–33. For an interesting discussion of the relationship, or lack thereof, between Margaret and Caxton, see Martin Lowry's essay in the present volume.

28 While examining the print with me at the Huntington Library, Roger Wieck correctly observed that Margaret seems to hold two volumes. In contrast to normal Burgundian presentation scenes, these volumes apparently are unbound. Such differences might suggest that the engraving was conceived by Caxton rather than the duchess.

29 S. L. Hindman, *Christine de Pizan's "Epistre Othéa"* (Toronto, 1986), figs. 4 and 66.

30 Paris, Bibliothèque Nationale, Ms. fr. 22457, fol. 1; Prevenier/Blockmans 1985, fig. 279.

31 F. Anzelewsky, "An Unidentified Portrait of King Edward IV," *Burlington Magazine* 109 (1967), pp. 702–05.

32 Jena, Universitätsbibliothek, Ms. El. f. 85, fol. 13v; Pächt 1948, p. 63.

33 This particular manuscript was translated by Jean de Meun (d. 1305). Although most presentation miniatures depict translators and authors, editors also occasionally appear.

34 Ghillebert de Lannoy, *L'instruction d'un jeune prince*, Paris, Bibliothèque de l'Arsenal, Ms. 5104, fol. 14; Winkler 1925, pl. 34.

35 Brussels, Bibliothèque Royale, Ms. 9017; L.M.J. Delaissé, *Miniatures médiévales de la Librairie de Bourgogne au Cabinet des manuscrits de la Bibliothèque royale de Belgique* (Geneva, 1959), p. 177.

36 Windsor Castle, Royal Library, no shelf mark; Ghent 1975, pp. 374–75.

37 Weightman 1989, pp. 102–26.

38 Hommel (note 12), p. 169. In conversation at "The Visions of Tondal" symposium, Wim Blockmans mentioned that Margaret ordered another window for Saint John (Saint Bavo) in Ghent in the same year.

39 Metz, Bibliothèque Municipale, Ms. 1255 (Salis 104); discussed briefly in Morgan, pp. 64–65, below.

40 There exists one further manuscript, dated 1480, with a miniature said to include Margaret's portrait. Edward IV's copy of *Roruléon*, now in London (British Library, Royal Ms. 19 E V), includes a scene (fol. 367v) in which the king, in the role of Hadrian, is being introduced to Emperor Trajan by his wife, Plotina (see fig. 1). Is this woman, dressed in Burgundian attire, Margaret of York? The portrait of Edward is accurate, while the woman's is rather generic. The illuminations are Flemish and the text recalls the Burgundian *lettre bâtarde* used by David Aubert and others in the court circle. Although Margaret is not mentioned in the book's text, it is possible that she presented the *Roruléon* to her brother during her lengthy stay in England in 1480. See G.F. Warner and J.P. Gilson, *British Museum: Catalogue of Western Manuscripts in the Old Royal and King's Collections*, vol. 2 (London, 1921), pp. 348–49; P. Durrieu, *La miniature flamande au temps des ducs de Bourgogne (1415–1530)* (Brussels and Paris, 1921), p. 78, pl. LXV; Weightman 1989, pp. 134–39, with ill. on 138.

41 *La bibliothèque de Marguerite d'Autriche*, exh. cat. (Bibliothèque Royale, Brussels, 1940), esp. pp. 13 and 26–27; J. Duverger, "Voorstellingen van Margareta van Oostenrijk in tekeningen, prenten en boekillustratie," *Bijdragen tot de geschiedenis van de grafische kunst opgedragen aan Prof. Dr. Louis Lebeer ter gelegenheid van zijn tachtigste verjaardag* (Antwerp, 1975), pp. 95–114; M. Debae, *La librairie de Marguerite d'Autriche*, exh. cat. (Bibliothèque Royale, Brussels, 1987), pp. 133, 137, 139, 153, 157, 159, 162.

42 Österreichische Nationalbibliothek, Cod. 1857, fol. 14v; Pächt 1948, pp. 64–65, pl. 12. Bodo Brinkmann, in conversation at "The Visions of Tondal" symposium, pointed out that this book bears none of the usual coats of arms or marks of ownership, and asked whether the princess kneeling in the foreground is really Margaret, rather than Mary of Burgundy, as she is usually identified.

Some Remarks on the Character and Content of the Library of Margaret of York

Pierre Cockshaw

Lay libraries began to appear in the Burgundian Netherlands in the fourteenth century but came into full flower in the fifteenth—not only libraries of princes and princesses and other nobility, but also of the bourgeoisie and even craftsmen. In addition to monasteries or bishops' palaces, books could now be found in the homes of private individuals, albeit in a reduced number and of a limited genre, such as books of hours, breviaries, and missals. It was at the end of the fourteenth century that such individual collectors emerged, for the first time since antiquity; these were people who formed libraries by collecting manuscripts and who needed books in their daily lives—to study, to contemplate, or quite simply to read for pleasure.

From this group, however, I am excluding the professional libraries of lawyers, legal scholars, doctors, and theologians; in a word, the libraries of specialists who used their books the way craftsmen used their hammers, planes, and compasses. Because—and this is a problem that has been given little study—wherever there are authors, whether poets, novelists, chroniclers, moralists, or mystics, there are also readers. Who were these readers? What did they collect?[1] One is tempted to answer: books essential for their content or else works that a bibliophile would wish to own. But the answer is not so self-evident. Consider the case of the Valois (Charles V, Jean de Berry, Philip the Bold). Among the numerous books of hours, breviaries, and other illuminated religious works in the library, a number were received as gifts. Could not some of these have been received with a smile and then quickly relegated to an obscure shelf?

In order to know and better understand the mentality and intellectual outlook of fourteenth- and fifteenth-century readers, perhaps we should examine the libraries of women instead. More often than not, women did not have a profession and their status prevented them from receiving gifts of manuscripts other than from their husbands or close relatives. In these more voluntary collections, we would hope to find a reflection of the lay society of the time—of what people were reading and thus what people were thinking about. There are, unfortunately, few studies devoted to this type of library. Moreover, such studies are most often devoted to the libraries of princesses and queens, rather than of bourgeois women.[2] Finally, we are in possession of only a few inventories of libraries (and these were often compiled posthumously), and their content has most often been reconstructed by means of marks of ownership.

What libraries are available to us within the framework of this study? We have preserved the posthumous inventories of the libraries of the dukes of Burgundy from Philip the Bold in the fourteenth century to Maximilian of Austria,[3] but what do we know of the libraries of their wives? For Margaret of Flanders, wife of Philip the Bold, we have a posthumous inventory in which her manuscripts are mentioned;[4] the same holds true for Margaret of Hainaut, wife of John the Fearless. As for Philip the Good,

among his three wives (let us exclude here his mistresses—important, perhaps, but without any known libraries), we find Michèle, who died young and without any known manuscripts in her possession; Bonne d'Artois, similarly with no record of personally owned books; and, finally, Isabella of Portugal. Isabella seems to have played a not insignificant role in introducing humanism into the Burgundian Netherlands;[5] she favored translations of texts, but as yet no manuscript has been identified that was presented either as a gift or commissioned by her. Moreover, the inventory of her possessions made after her death mentions neither manuscripts nor books.[6]

Charles the Bold also had three wives: Catherine, daughter of Charles VII, who died at age seventeen, too young to have been able to put together a library; the same holds true for his second wife, Isabella of Bourbon. The situation is different, however, with regard to his third wife, Margaret of York, for whom we have been able to reconstruct a rich library of twenty or so volumes thanks to the presence in extant manuscripts of a coat of arms, a motto, or a signature by her own hand. Even this listing is incomplete and can be supplemented with archival references.[7] It is the contents of this library that I would like to examine in order to try to determine if, as a whole, it offers a particular coherence, style, and taste, both literary and moral.[8]

Three things are immediately apparent: this library contained no texts in English;[9] Margaret seems to have had a special fondness for devotional manuscripts; and she loved them above all when they were sumptuously illuminated and precious.[10] If we examine the manuscripts in her library, we cannot help marveling at their richness.[11] All of them are written on parchment; in every case, they contain miniatures.

If we note the provenance of Margaret's manuscripts or their destinations, two were actually acquired from the library of the dukes of Burgundy (nos. 15, 16), and four, commissioned by the duchess, are thought to have been her gifts to others (nos. 24–27a).[12] (Numbers here and below are those of the Appendix.) Eight manuscripts in the library seem certainly to have been commissioned by Margaret for her own use, but in my view it is likely that so were most of her other books.

In order to identify her manuscripts, the duchess added her impaled arms of Burgundy and England (with the exception of nos. 3, 4, 5, 15, 16, 20), often accompanied by her motto, *Bien en aviengne*,[13] where at times the E's or the N's are drawn backwards (nos. 1, 2, 4–7, 11, 14, 20, 22, 27). This motto, often inscribed around a vase, is normally accompanied by the initials C[harles] and M[argaret], sometimes joined by a love knot (nos. 1–5, 18, 20, 27). There are also seven miniatures in these works in which the duchess had herself depicted, at times along with the duke (nos. 1 [in two instances], 2, 7, 8, 21, 27).

Added to these imposing marks of ownership is Margaret's own signature, which she liked to put on her manuscripts. Her signature, or a handwritten notation, can be found no fewer than nine times (nos. 1, 3, 11, 12, 15, 16, 24, 26, 27). In other instances, we find instead a colophon stating that the manuscript was commissioned by the duchess.[14] Such colophons appear in five manuscripts where, along with the name of the duchess, the date, the place of execution, and the name of the scribe are given:

No. 4.	February 1, 1474	Ghent	David Aubert
No. 5.	March 1474	Ghent	David Aubert
No. 6.	1475	Ghent	David Aubert
No. 7.	1476	Ghent	David Aubert
No. 8.	March 1475	Ghent	David Aubert

There is no doubt as to the scribe, David Aubert,[15] nor as to the place—Ghent, where Margaret often stayed. But we are less certain about the dates recorded. In interpreting the dates entered in these colophons, scholars seem to have forgotten that in the Burgundian Netherlands, at the end of the Middle Ages, the new year always began at Easter. If we conclude, for no. 4, that February 1, 1474, ought to be

read as 1475 (new style), then it follows that no. 5, which in the past was combined with no. 4, ought to be dated March 1475. In 1474, Easter fell on April 10.

Finally, there remains no. 8, dated March 1475. In that year, Easter was celebrated on March 26. Consequently, I believe that the manuscript should be dated 1476 (new style), since the colophon does not bear the notation "after Easter." Thus the chronology of the dated manuscripts can be established as follows:

February 1475	(no. 4)
March 1475	(no. 5)
1475	(no. 6)
March 1476	(no. 8)
1476	(no. 7)

The other manuscripts are not dated, but scholars are mostly in agreement in placing them between 1468 and 1477. This would lead us to assume that after 1477, Margaret of York no longer acquired any manuscripts.[16]

Scholars have not given a clear explanation for the cutoff date of 1477, but I believe their conviction is based on the impaled arms in the manuscripts, which lead us to assume the presence of a husband—thus before Charles's death in 1477.[17] R. Laurent, however, in his unpublished thesis, points out that the personal seal that Margaret of York used continually from 1476 to 1503 can be described as an impaled shield first for Burgundy and secondly for England (see fig. 7).[18] Consequently, nothing allows us to assert that Margaret of York stopped commissioning or buying books after 1477.[19]

But it is time to turn to the contents of Margaret's library. We have already indicated the absence of any text in English;[20] we can also add that there were no texts in Latin. Indeed, on numerous occasions, the manuscripts give evidence that the collected texts are written in French because they are reserved for women:

> Sans le tres devot et solemnel office divin en quoy se occupoit jour et nuit monseigneur saint Bernard, nostre bon pere et solonnel docteur, quant il cessoit de composer, il se occupoit en meditation salutaire, desquelles il escripsi une grant partie pour induire les gens oiseux en necessaire occupation espirituele. Mais pour ce que pluseurs non clercs, femmes et aultres simples gens, tant convers comme seculiers n'entendent pas latin et sont frustrez de tel edifice espirituel, je, non obstant mon ignorance, en absence de plus souffisant me suit ingeré et enhardi d'extraire et translater de latin en francois partie de celles meditations pour l'instruction des plus ignorans . . . (Brussels, Bibliothèque Royale, Ms. 9272–76, fol. 216v; Appendix no. 21).

> La cause d'escripre en françois et a gens simples [i.e., women] de la maniere de contemplacion et comment clergie n'est mie du tout necessaire a gens contemplatifs (Brussels, Bibliothèque Royale, Ms. 9305–06, fol. 30; Appendix no. 3).

> Aucuns se pourroient esmerveiller pourquoy de sy haulte matere comme est de parler de la vie contemplative, je veul escripre en françois plus qu'en latin et plus aux femmes que aux hommes . . . (ibid., fol. 76).

> Et pourtant que sont faiz pour simples non clers, ilz sont miz tous en françois sans y mesler aucun latin car telles gens ne l'entenderoient point; sont mis aussi en langage groz et commun sans haulte no soubtille matiere ou maniere de parler affin que chascun les puist legierement entendre . . . (Oxford, Bodleian Library, Ms. Douce 365, fol. 63; Appendix no. 8).

Let us now move on to the seventy-three included texts in the duchess's twenty-four manuscripts. Rare among them are books whose writing or translation she commissioned. We find only three examples, as indicated in the prefaces: the two treatises that Nicolas Finet, Margaret's almoner, translated and assembled for his noble penitent, *Benoit seront les miséricordieux* (no. 1) and *Le dialogue de la duchesse de Bourgogne à Jésus Christ* (no. 2), as well as Saint Augustine, *Contemplation pour attraire la personne de Dieu* (no. 29).[21]

The rest of Margaret's library includes a series of books that pertain to revelation.[22] First of all, there is the *Apocalypse* (no. 19) as well as *La somme le roi* by Frère Laurent, "traitant de vices et vertuz par maniere de ampliation sur les visions de l'apocalipse saint Jehan" (no. 6). To these can be added a section in *Benoit seront les miséricordieux* "Vision et ressussitaction d'un chevalier," adapted from Saint Gregory (no. 1, fol. 137v) and a few books stemming from the rich Irish tradition: the *Purgatoire de Saint Patrice* (no. 22[f]) and *The Visions of Tondal* (no. 5), and one of Provençal origin, *La vision de l'âme de Guy de Thurno* (no. 4). With the exception of the last they are books that have in common an initial scene evoking "la mort apparente du visionnaire, l'apparition de son guide surnaturel et la psychomachie des anges et des démons."[23] Curiously, although older titles recounting these visions are found in Margaret's library, the duchess did not appear to have possessed more recent titles, such as the *Voie d'infer et de paradis* by Jean de la Motte or the *Pèlerinage de l'âme* by Guillaume de Deguileville.

Another category consists of moral works or works of moral and religious reflection. Here we can include a significant number of anonymous writings: a *Bible moralisée* (no. 22) and, within it, a *Moralitez des philosophes* (no. 22[b]), *Des douze jeusnes que tous chretiens doibvent jeusner* (no. 22[g]), *La Passion Jesus Christ* (no. 22[c]), *Pourquoi l'en doibt plus tost jeusner le venredi* (no. 22[h]); in another compendium (no. 6[g]), *Aucuns bons motifs des sains de paradis*. These represent only a few selections among many.

There are also a number of writings by the great French theologian Jean Gerson, which include the *Traictie de mendicite spirituelle* (nos. 3[a], 21[c]), *La montaigne de contemplacion* (no. 3[b]), *La medicine de l'ame* (no. 3[c]), *L'abbaye du Saint Esprit* (no. 8[a]), and two *Sermons sur la Passion* (no. 15c).

There are writings by the author then believed to be Saint Bernard, represented by *Le miroir des pecheurs* (no. 8[i]) and some *Meditations* (no. 21[e]), and others by Robert Grosseteste, *Chasteau d'amour* (no. 22[k]), Saint John Chrysostom, *Reparation du pecheur* (no. 21[j]), Boethius, *La consolation de philosophie* (no. 7), and Peter of Luxembourg, *Traitie* (no. 8[b]). Another important religious text is the life of the blessed Colette, whose canonization was promoted by the Burgundian household: Pierre de Vaux, *La vie de Sainte Colette* (no. 27). The duchess's modest group of liturgical and devotional books includes two books of hours (nos. 13, 14), a breviary (no. 20), and a gradual (no. 25). There was also a relatively small number of historical works: *Les chroniques des comtes de Flandre* (no. 11), *Les faits d'Alexandre le Grand* by Quintus Curtius Rufus (no. 24), and *La fleur des histoires* by Jean Mansel (no. 16).

A more detailed examination of the contents of this library should consider the relationship between the text and the illustrations, which seems to me fundamental in this case.[24] Why do certain works contain an opening miniature whereas others do not? Why is it that at times every book in a treatise is decorated with a miniature, whereas in the same codex other treatises have no illustrations whatsoever?

Another problem is that of the table of contents (or chapters).[25] In general with Margaret of York's manuscripts, this table does not always identify all the texts contained in the codex (nos. 3, 6, and 8). Finally, a rather original table appears to be shown in no. 3, because each time it mentions the title of the work it adds the first words of the text.

Can we then, in conclusion, draw the portrait of a princess by means of what she read? Our principle observation is the great number of religious and moral works in this library. If certain of the books mentioned are the work of mystics (*Imitation*

de Jésus Christ) and others belong to exegetical literature (Saint Bernard, Jean Gerson, Saint John Chrysostom), the majority of the texts nonetheless belongs to an elementary, almost magical religion: *Des douze jeusnes que tous chretiens doibvent jeusner*, *Lamentacion de la personne qui se trouve en l'article de la mort* (no. 21[g]), or *Pourquoi l'en doibt plus tost jeusner le venredi*. It is, in general, a rather uninspired moral literature.

There was only one humanist text in Margaret's library, and poetical or literary works are entirely absent. The overriding impression is that the duchess, so active in the realm of politics, was content to participate humbly in the simplest religious movements of her time. She did not wish to be an intellectual or a humanist; nor was she curious about culture; instead, she simply wished to be devout—with simplicity, with faith, and with devotion.[26]

Notes

1 In this regard, see P.-Y. Badel, *Le "Roman de la Rose" au XIVe siècle: Etude de la réception de l'oeuvre* (Geneva, 1980).

2 One can find information with regard to books owned by women at the end of the Middle Ages in P. Cockshaw, "Que lisait-on à Tournai à la fin du moyen âge?," *Scriptorium* (in press).

3 See J. Barrois, *Bibliothèque protypographique ou librairies des fils du roi Jean, Charles V, Jean de Berry, Philippe de Bourgogne et les siens* (Paris, 1830), and G. Doutrepont, *Inventaire de la "librairie" de Philippe le Bon (1420)* (Brussels, 1906).

4 M. J. Hughes, "The Library of Philip the Bold and Margaret of Flanders, First Valois Duke and Duchess of Burgundy," *Journal of Medieval History* 4 (1978), pp. 145–88, and P. M. de Winter, *La bibliothèque de Philippe le Hardi, duc de Bourgogne (1364–1404): Etude sur les manuscrits à peintures d'une collection princière à l'époque du "style gothique international"* (Paris, 1985), pp. 142–74.

5 See C. C. Willard, "Isabel of Portugal and the French Translation of the *Triunfo de las doñas*," *Revue belge de philologie et d'histoire* 43 (1965), pp. 961–69; idem, "Isabel of Portugal, Patroness of Humanism?," *Miscellanea di studi e ricerche sul quattrocento francese* (Turin, 1966), pp. 519–44.

 Margaret of York seems to have retained some of Isabella's "intellectual" staff for her own service. Thus Vasco da Lucena, about whom Olivier de la Marche writes in his *Mémoires:* "que n'ay je, par don de grace, la clergie, la memoire ou l'entendement de ce vertueux et recommandé escuyer, Vas de Lusane, portungalois, eschanson a present de madame Marguerite d'Angleterre, ducesse douairiere de Bourgoingne . . ."; Olivier de la Marche, *Mémoires*, H. Beaune and J. d'Arbaumont, eds. (Paris, 1883), vol. 1, pp. 14–15.

6 But perhaps this inventory is only partial; see M. Sommé, "Le testament d'Isabelle de Portugal et la dévotion moderne," *Publica-*

tions du Centre européen d'études bourguignonnes (XIV-XVIe siècles) 29 (1989), pp. 27–45.

7 At the time of her visit to Lier in 1475, the canons of the collegiate church presented the duchess with a *Vie de Saint Gommaire* on parchment (Appendix no. 9); the widow of Guillaume Hugonet, Chancellor of Burgundy, sold her two breviaries (Appendix no. 23) after the death of the duke and presented her with a third one as a gift (Appendix no. 10; Brussels, Archives Générales du Royaume, CC 50698, fols. 39v-40v): "A ma tres redoubtee dame madame la duchesse Marguerite, le XVIe jour de juillet oudit an LXXVII, deux volumes de breviaire en parchemin enluminez d'or et d'azur, ystoriez, couvers de velours noir chascun a deux fermeaux, lesquelz luy furent delivrez en presence de monseigneur Dirlan son chevalier d'honneur offrant en payer la somme de cincq cens livres de XL gros la livre ou de rendre lesdis deux breviaires, lesquelz lui sont demourez. Et de ladicte somme, rien n'a esté receu desdis deux volumes; ladicte dame fait recepte oudit chapitre des livres folio IIII.

 [Margin:]

 —Mon dit seigneur Dairlan a confessé que lesdis livres ont esté baillez a madicte dame la duchesse ainsi que contient le texte mais il ne scet se ce fut en don ou autrement.

 —Si soit recouvré l'argent ou les breviaires. A elle, que luy a esté donné par madicte dame de Saillant du gré et consentement de monseigneur le cardinal de Mascon et par sa letre escripte de sa main, ung petit breviaire moult bel, jadis donné a feu mon dit seigneur par maistre Nicolas de Ruter, duquel breviaire ladicte dame fait recepte cy devant audit chapitre folio IIII.

 [Margin:]

 —Monseigneur Dirlain rapporte que ledit breviaire a esté doné ainsi que contient le texte.

 —Soit veue la letre de monseigneur de Mascon."

 The donor became, for Galesloot 1879, p. 265, "une dame fixée à Malines," whom he goes on to identify as the widow of

Chancellor Hugonet; for Dogaer 1975, p. 107, no. 47, "ontving ze enige breviers ten geschenke." Hughes 1984, p. 59, writes: "Three richly illuminated breviaries which Margaret of York received from a woman in Malines. One [Galesloot stated] has been offered to Duke Charles by the widow of chancellor Guillaume Hugonet."

Finally, in the *Livre des basses danses*, probably made for Margaret of Austria, dance no. 5, "La Margarite," is, according to certain authors, an allusion to Margaret of York.

8 The other contemporary library of a woman is that of Charlotte of Savoy, wife of Louis XI, the inventory of which was drawn up in 1484 after her death. Here we find references to approximately 130 manuscripts, virtually all of them in French, which cover a diverse number of fields: religion, moral literature, novels, the lives of saints; see L. Delisle, *Histoire générale de Paris: Le cabinet des manuscrits de la Bibliothèque impériale* (Paris, 1868), vol. 1, pp. 91–94. But was this a personal library or one that she had inherited?

9 William Caxton's translation of Raoul Lefèvre's famous *Le recueil des histoires de Troie*, however, is said to have been finished at the invitation of the duchess. A unicum of this edition, moreover, is decorated with an engraving showing Caxton presenting his work to the duchess (see fig. 67); see Brussels 1973, no. 82.

Caxton tells us in his preface that he had begun to translate the work of Lefèvre, but had given up after having translated five or six gatherings. It was the duchess who, having summoned him for other matters, learned of this translation. She asked to see it and is said to have suggested several corrections before she then commissioned him to continue; the translation was completed in Cologne on September 19, 1471.

Charles the Bold seems not to have possessed any printed books. But Guillaume Hugonet, his chancellor, owned incunables, since they appear in the inventory of his estate made after his death. To write that "Margaret was the first at the Burgundian court to possess [an incunable]" (Kren, in Malibu 1990, p. 17) seems to me to be excessive. Moreover, nothing proves that the duchess possessed a copy of the translation by Caxton. It was even assumed that the engraving in the incunable at the Huntington Library was inspired by the miniature of the presentation of the manuscript that Caxton gave to the duchess.

10 ". . . her small library . . . [contained] a number of the most beautiful Flemish illuminated manuscripts made during the 1470s" (Kren, in Malibu 1990, p. 9). "She commissioned a group of sumptuous manuscripts . . . chronicles, religious tracts and moral treatises" (Pächt 1948, p. 20).

11 Due to negligence in the execution, Brussels, Bibliothèque Royale, Ms. 9272–76 (Appendix no. 21) is exceptional in this regard, with an error in the painting of an initial (fol. 217) or the omission of painted initials (fols. 25, 102v, 137, 245).

12 Here we can add the manuscripts that Duchess Margaret presented to the collegiate church of Saint Ursmer in Binche in 1480, "livres de chant sur l'un desquels son nom était écrit de sa main," according to Galesloot 1879, p. 243, who cites L. Devillers. In 1473 she had already made a gift of manuscripts to the Dominicans of Mechlin, and in 1497 she gave financial aid to rebuild the Franciscan library in the same city, which had been destroyed by a fire.

13 P. Marot has read this motto to be "Bien en la Vierge," in "Manuscrits de la bibliothèque de Metz, supplément," *Catalogue général des manuscrits des bibliothèques publiques de France*, vol. 48 (Paris, 1933), p. 421.

14 In these colophons, Margaret calls herself Duchess of "Loheraine" (no. 7, 1476; no. 8, March 1476) and Countess of "Vaudemont" (no. 8, March 1476). I am not aware that Charles the Bold used any of these titles.

15 No. 6: "David Aubert, manu propria"; no. 7: "David Aubert, manu propria"; no. 5: "son tres petit, indigne escripvain"; no. 4: "son escripvain"; no. 8: "son escripvain indigne."

16 Only Doutrepont 1909, p. 234, attributes to Margaret the possession of a manuscript copied by David Aubert in 1479, a *Vita Christi* (London, British Library, Royal Ms. 16 G III). Unfortunately, the manuscript does not seem to contain any mark of ownership.

17 "Il [the manuscript of *La vie de Sainte Colette*] a été écrit entre 1468 date du mariage de Charles le Téméraire et de Marguerite d'York, et 1477, année de la mort du duc" (Corstanje et al. 1982, p. 77). ". . . ce bréviaire [Cambridge] qui fut exécuté pour Marguerite d'York du vivant de son époux, le duc de Bourgogne" (Delaissé, in Brussels 1959, p. 156). Other scholars identify the impaled arms of Burgundy and England as the arms of Charles the Bold (L. Dorez, *Les manuscrits de la bibliothèque de Lord Leicester à Holkham Hall, Norfolk* [Paris, 1908], p. 90) or the joint arms of the duke and duchess (Galesloot 1879, p. 259, and F. Lyna, *Les principaux manuscrits à peintures de la Bibliothèque royale de Belgique*, vol. 3 [Brussels, 1989], p. 174). Even more surprising is the description of these arms in Christie's, London, May 26–27, 1965, lot 195, pp. 40–41 (Appendix no. 13), where these impaled arms are first identified as being those of the duke, then as those of the duchess: "a shield with the arms of Charles the Bold (Burgundy impaling England) . . . shield with arms of Margaret of York as Duchess of Burgundy (Burgundy impaling England)." In Hughes 1984, p. 58, it becomes "a shield with arms of Charles the Bold after his marriage to Margaret of York."

18 R. Laurent, "Les sceaux des princes territoriaux belges du Xe siècle à 1482," Ph.D. diss., Université Libre de Bruxelles, 1990, pp. 648–49.

19 For another point of view, see Jeffrey Chipps Smith's essay, p. 53, above.

20 Weightman 1989, p. 205: "It is not surprising that she had no books in English since most of the books written for the nobility, even in England, were still in French."

21 According to P. Meyer, "Recherches sur l'épopée française," *Bibliothèque de l'Ecole des Chartes* 28 (1867), p. 305, n. 3, we should add several *opuscula* of the Oxford manuscript (no. 8) that are said to be the work of David Aubert.

22 H. Braet has nicely called these works "Les visions de l'invisible" in *Apocalypses et voyages dans l'au-delà* (Paris, 1987), p. 405.

23 Ibid., p. 416.

24 See, for example, the essays in the present volume by Suzanne Lewis, Walter Cahn, and Roger S. Wieck.

25 These tables of contents, moreover, are not originally foliated in the manuscripts, except for nos. 4 and 5.

26 D. Gallet-Guerne, *Vasque de Lucène* (Geneva, 1974), p. 19, seems to me to describe perfectly the library of Margaret of York when she writes that "l'ensemble reflète l'approfondissement de la piété laïque dans ces régions septentrionales où le premier humanisme avait pris souvent un aspect mystique."

Texts of Devotion and Religious Instruction
Associated with Margaret of York

Nigel Morgan

O f the twenty-four manuscripts which can be connected with Margaret of
York, eighteen contain texts of religious instruction or devotion. They pro-
vide one of the best examples of a late medieval library intended for the
spiritual edification of a member of the nobility. The contents of these books raise
questions concerning the various functions of their texts. Some could be termed con-
ventional and popular reading, whereas others contain texts indicating the tastes of
a more discriminating reader who required, or at least was given, works of a more
sophisticated nature for spiritual instruction. Of course, it is far from certain that
Margaret actually read these books in their entirety. But whether she chose them
herself or, more likely, had them chosen for her by some spiritual adviser or chaplain,
perhaps her almoner, Nicolas Finet, they present an interesting example of a small
library considered appropriate for a person of her rank and pious inclination. Al-
though Margaret may appear as a woman of shrewd judgment, hardened by her in-
volvment in the difficult politics of Burgundy, it must be concluded from many pieces
of evidence that she was also enthusiastic in matters of her personal religion.[1]

The manuscripts associated with Margaret of York have recently been listed
by Georges Dogaer and Muriel Hughes.[2] To their lists, three manuscripts can be
added: Brunetto Latini, *Le livre de trésor* in Saint-Quentin (Appendix no. 12); a guide
to the pilgrimage churches of Rome at Yale University (Appendix no. 17); and *La vie
de Sainte Catherine* in the translation of Jean Miélot (Appendix no. 18).[3] Useful though
the lists of Dogaer and Hughes are, their descriptions of the manuscripts do not pro-
vide a complete account of the books' contents, and in some cases give misleading
or inaccurate titles of the texts and their authors. The Appendix beginning on p. 257
includes the complete contents of each manuscript.[4] The inspiration for this paper
was an article by Kathleen Chesney which discussed in exhaustive detail the texts
in one of Margaret of York's books of devotional works, Oxford, Bodleian Library,
Ms. Douce 365.[5] In comparison with Chesney's exemplary study, my contribution
presents a more general assessment of the duchess's books, without attempting to
list all the comparative texts in other manuscripts.[6]

In the list of books in the Appendix, there are a few texts which, although made
under Margaret's patronage, were not personal possessions, but seem to have been
commissioned by her for the religious institutions she patronized. One is the frag-
ment of a gradual, inserted into British Library, Arundel Ms. 71, a copy of Charles
Soillot's *Le livre de félicité en vie* (Appendix no. 25). The surviving leaf (fol. 9) has the
text for the first Sunday in Advent. Margaret probably had the gradual made for the
Observant Friars of Greenwich, as a note on the leaf records her gift of the book to
them.[7] The gradual, being a book for public liturgy rather than for private reading,
strictly speaking does not come within the category of texts of devotion and religious
instruction. Her gift of the book only provides evidence for her interest in the Grey
Friars; it does not testify to her taste in private religious texts.[8]

Two other books which seem to have been intended as gifts for religious institutions reveal Margaret's devotion to Saint Colette and Saint Anne.[9] Her devotion to Saint Anne was expressed in her patronage of the guild of Saint Anne at Saint Nicholas in Ghent, to which she donated an illuminated register, now in the Royal Library at Windsor Castle (Appendix no. 28). This guild had also been patronized by Philip the Good, Isabella of Portugal, Charles the Bold and his first wife, Catherine. The cult was of great importance in Ghent because since the twelfth century Saint Nicholas had possessed a relic of Saint Anne.[10] In the Windsor manuscript, Margaret and her stepdaughter, Mary of Burgundy, are shown kneeling before the altar of the chapel of the guild (see fig. 8). Margaret's devotion to Saint Anne to some extent may have followed the precedent set by former members of the ducal family. She may also have had a personal devotion to the saint, who was a patroness of childless women.[11]

An illustrated *Vie de Sainte Colette*, written by Pierre de Vaux, was presented to the Poor Clares of Ghent, with illuminations that included depictions of Charles and Margaret (Appendix no. 27).[12] The duchess's devotion to Saint Colette, whose body at that time rested at Ghent, again followed ducal tradition, in this case of Philip the Good and Isabella of Portugal, and, as with Saint Anne, Margaret very probably perceived this devotion as one expected of members of the ducal family.[13] It would have been extremely unlikely that she had known anything of Saint Colette before she arrived in Flanders. The saint, as a reformer of the Franciscan nuns, had given impetus to the founding of new houses at Hesdin, Ghent, and Antwerp.[14] Margaret patronized the Poor Clares at Ghent, which reveals the same preference for the reformed Franciscan order as does her patronage of the newly introduced Observant Friars at Greenwich.[15]

Two of Margaret's books formerly belonged to her husband, Charles, and her father-in-law, Philip the Good. Charles owned a book of hours now in a private collection (Appendix no. 13).[16] The manuscript from the library of Philip the Good, dated 1462 and now in Valenciennes, contains a compilation of devotional writings by Jean Gerson, Jacobus van Gruytrode, Thomas à Kempis, and Saint Bonaventure (Appendix no. 15).[17] Since the foliation begins on fol. 211 and the volume is designated as part 2, there must have been a preceding volume. The contents fit in well with Margaret's other books, and she may have appropriated the manuscript from the ducal library. Thomas à Kempis's *Imitation of Christ* text is also found in another of her manuscripts, Brussels, Bibliothèque Royale, Ms. 9272–76, a compilation of moral treatises (Appendix no. 21[b]).

Three manuscripts recorded in Margaret's possession no longer exist. *La vie de Saint Gommaire* (Appendix no. 9) is only known from a textual source as a presentation to Margaret by the canons of the collegiate church of Saint Gommaire at Lier in 1475.[18] It indicates her interest in Saint Gummar, patron of unhappy marriages, to whose church she made visits.[19] Two further books were lost or destroyed in the last war. The first, a devotional miscellany in Leningrad, was returned to Warsaw in the 1930s, but could not be traced after the end of the war (Appendix no. 29). It was an important collection of devotional texts, and there is no published full description of its contents.[20] Another major loss is Margaret's book of hours, once in Metz, Bibliothèque Municipale, Ms. 1255 (Salis 104), and destroyed in a bombing raid in 1944, again before a full description of its contents had been published (Appendix no. 14).[21] It had come to the municipal library from the collection of Freiherr Numa de Salis.[22] This book of hours had the arms of Margaret of York and her motto *Bien en aviengne* and it was richly decorated with fifty-four miniatures.[23] The very brief published descriptions record that it was of the use of Rome, and that it contained chronological tables, presumably Easter tables, beginning in the year 1488. The Metz hours could perhaps therefore be dated to 1488, and would thus be much later than Margaret's other manuscripts, which were made between her marriage in 1468 and Charles's death in 1477. Its loss is greatly to be regretted because the other book of hours she owned, already mentioned, was originally made for her husband and his

second wife, Isabella of Bourbon.[24] The shield on fol. 34v has the arms of England impaling those of Burgundy, but those of England are painted over an earlier blazon, very probably that of Charles's former wife. On an added page with a miniature of Saint Susanna and accompanying prayer, the arms of Burgundy impaling England are set in a lozenge. This heraldic arrangement suggests that the Susanna page is an addition made for Margaret after Charles's death. This book of hours thus gives little information about any particular choice of saints or forms of devotion that might have been favored by Margaret herself, save for the addition of the Susanna miniature and prayer. It is perhaps revealing, in view of the difficulties of her marriage in its later years and her subsequent life as a single woman, that Margaret should have chosen Susanna, patroness of virtuous chastity, for the sole addition to the book.[25]

Several of Margaret's manuscripts are of conventional and popular texts in vernacular translation which were found in the libraries of many lay people in England, Flanders, and France in the fifteenth century.[26] Comparisons with English book collections are of particular relevance as Margaret's taste in books of religious instruction and devotion could in many aspects have been formed in England before her marriage to Charles at the age of twenty-two. Even if her books were in the main selected for her by her Burgundian chaplain, she may already have been familiar with many of them from instruction by her chaplains in England, and she may have specifically requested copies of certain texts. She was surely introduced to new reading material in Flanders, above all, the works of Gerson, contained in several of her books, which do not seem to have been read by the laity in England. Many other of her texts find parallels in libraries of English lay patrons, both of the higher aristocracy and the bourgeoisie. The English nobility patronized book production in the fifteenth century—fairly extensive collections of books are mentioned in their wills or inventories—so that by the time Margaret came to Flanders she almost certainly had been introduced to a range of devotional and instructional reading.[27]

First among the conventional texts are the liturgical books, the two books of hours mentioned earlier, and her breviary now in Saint John's College, Cambridge (Appendix no. 20). If the Metz Hours had survived, we would perhaps have some information about any unusual devotions Margaret may have had. It was of the use of Rome, but it is highly likely that she also possessed an hours of the English use of Sarum—the same use found in her breviary. In her early life she would have been familiar with the use of Sarum and very probably would have continued to favor it when she was in Flanders—as her breviary demonstrates.[28] Many lay people in fifteenth-century England, Flanders, and France possessed a full breviary as well as a book of hours. This does not of course mean that they consistently read the full daily office, but rather that they sometimes read parts of the office or followed it at the public liturgy in church or chapel. It must be inferred from the large number of breviaries mentioned in the wills of lay people that they did actually make some use of such books.[29]

Another equally popular category of text in Margaret's library was that of religious instruction. Works of this type included *La somme le roi* (Appendix no. 6), the *Apocalypse* (Appendix no. 19), the *Lucidaire*, Robert Grosseteste's *Château d'amour*, the *Purgatoire de Saint Patrice* (all three combined with an extract from the *Bible moralisée*, Appendix no. 22[e, k, f]), *La vision de l'âme de Guy de Thurno* (Appendix no. 4), and *Les visions du chevalier Tondal* (Appendix no. 5). These are all old texts written in the late twelfth, thirteenth, and early fourteenth centuries. Margaret's versions are in French, and in England they existed in lay libraries in Latin, French, and Middle English. Copies of the *Lucidaire*, *La somme le roi*, and *Château d'amour* were in Philip the Good's library.[30] The texts are all part of that instructional literature on matters of doctrine, belief, and morality intended to better educate the laity in their faith. Some of them heavily emphasize sin and the need for penance in order to encourage and instruct people to make confession. As is well known, the production of such texts was stimulated by the emphasis on pastoral education and the sacrament of penance given by the Fourth Lateran Council in 1215.[31] Most of the texts were

written from the late twelfth century through the mid-fourteenth, and they continued to be essential items in the library of a devout lay person until the end of the Middle Ages. A good example of a full program of education of this sort is laid out in the *Memoriale credencium*, a fifteenth-century Middle English text of religious instruction, which represents the sort of education advocated in Flanders and France as well as in England.[32] It has sections on the Ten Commandments, the Seven Deadly Sins, penance, tribulation, the Temptations of Worldly Things, the Lord's Prayer, the Seven Virtues, and, finally, meditation and contemplation. The section on tribulation is concerned with the problems and sufferings of life, and asks why God puts men and women to the test with these trials. Meditation is defined as knowledge of oneself, and contemplation as knowledge of God. As Margaret of York's various manuscripts are examined, it will become apparent that her library presents a similarly integrated and comprehensive program of instruction in all these matters.

In her choice of such reading material, Margaret, doubtless under the guidance of one of her chaplains, followed convention. To take the *La somme le roi* (Appendix no. 6) as an example. It was written in 1280 by Frère Laurent, the Dominican confessor of Philip III of France,[33] and proliferated in vernacular translations and adaptations. In England it was translated into Middle English as the *Ayenbyt of Inwyt* (The Gnawing of Conscience) and also was adapted into other versions.[34] Margaret's copy (Brussels 9106) is one of these "adaptations" with interpolated material.[35] Its title is revealing: *Ce livre intitule la somme de perfection, compile sur le contenu de l'Apocalipse*. An Apocalypse with commentary was of course also among her books (Appendix no. 19). That part of the *Somme de perfection* derived from the *Somme le roi* contains sections on the Ten Commandments, the Pater Noster, the Seven Deadly Sins, death, and the Seven Gifts of the Holy Spirit. Among the twenty other short treatises in Brussels 9106 are texts on confession, the body and the soul, the order of the Mass, Rutebeuf's poem on the Ave Maria, the love of God, the sayings of Saint Paul, tribulation, the Antichrist, the fifteen signs preceding the Last Judgment, and the pains of hell.[36]

Robert Grosseteste's *Château d'amour*, included in Brussels 9030-37 (Appendix no. 22[k]), presents the story of the history of salvation from the Fall through Christ's act of redemption to the Last Judgment. Part of the text presents an allegory of a castle besieged by the world, the flesh, and the devil. The castle is the body of the Virgin Mary in which Christ dwells, and the defendants of the castle are Christ, its constable, Charity, and the Virtues.[37]

Also in Brussels 9030-37 is the equally popular *Lucidaire*, an excerpted version of the *Elucidarium* of Honorius Augustodunensis.[38] Several French versions exist of this text, and in England the Anglo-Norman version of Peter of Peckham, written in 1267, was the most popular.[39] The work is a sort of catechism, with sections on God, the angels, the devil, man, sin, the Incarnation, grace, the Virtues, the Gifts of the Holy Spirit, the Ten Commandments, the sacraments, and, finally, hell and heaven.

This *Lucidaire* text is occasionally combined in England with the text of the illustrated Apocalypse with commentary, usually in Peter of Peckham's version, the *Lumiere as lais*.[40] Margaret's expanded version of *La somme le roi* was also compiled in relation to the Apocalypse, as its title indicates. The Apocalypse with its didactic commentary was also a book of religious instruction and had been designed as such in the mid-thirteenth century. Margaret of York had the non-Berengaudus French commentary, which first appeared circa 1250 in the Anglo-Norman text of the English illustrated *Apocalypse*, Bibliothèque Nationale, Ms. fr. 403.[41] This commentary presents teachings on the history of salvation, sin, predestination, the Last Judgment, and heaven and hell. The addition of pictures to such a text is a creation of thirteenth-century England, and copies of the thirteenth-century versions continued to be made until the end of the Middle Ages. Margaret of York would almost certainly have been familiar with such a book in her early life in England, but it would also have been in the libraries of people of her status in Flanders. Her husband, Charles, possessed one, and there was also a copy in Philip the Good's library.[42] Al-

though the entertaining pictures of the visionary journey of Saint John may seem to us the most important part of these books, the purpose of the pictures was doubtless to stimulate the reader's interest in the more serious instruction contained in the commentary text.[43] Moreover, the pictures of these visions could help to lift the reader into a state of meditation in the visionary sense.[44] Lastly, the dramatic pictures could act as mnemonic devices to help remember the doctrinal teaching of the commentary.

The Apocalypse with commentary, then, is essentially a teaching book on sin, salvation, judgment, heaven, and hell. There are three other popular texts in Margaret's library which are concerned with the same issues, and one of them presents a more exact teaching on purgatory. These are the *Purgatoire de Saint Patrice*, *La vision de l'âme de Guy de Thurno*, and *Les visions du chevalier Tondal*. To this type of literature could also be added the tract on the pains of hell in Margaret's *Somme le roi* manuscript. The *Purgatoire de Saint Patrice* and *The Visions of Tondal* originated in twelfth-century Latin texts.[45] *The Vision of the Soul of Guy de Thurno* was written around 1323, again in Latin, probably by the Dominican Johannes Gobius, the original Latin title being *De anima Guidonis* or *De spiritu Guidonis*.[46] It was soon translated both into French, as in Margaret of York's manuscript, and into Middle English, as the *Gast of Gy* (Ghost of Guy).[47] Its popularity in England in the late fifteenth century is suggested by the early printed edition by Richard Pynson of 1492.[48] The purpose of the three texts in Margaret's library was of course to teach on hell, purgatory, and heaven and to provide entertaining stories whose moralizing message is repentance of sins and the need for confession. Among Margaret's texts, there are also treatises on confession and the examination of conscience (*Traitie de confession*, Appendix no. 22[i], *Comment l'on doit se confesser*, Appendix 6[d]). The penitent could thus avoid the pains of hell and shorten the sojourn in purgatory before the soul attained the bliss of heaven. The texts of *Saint Patrick's Purgatory* and *Tondal* present their moralizing messages in the form of visions doubtless because that genre provided an attractive, indeed sensational, way of teaching Church doctrine. *The Vision of the Soul of Guy de Thurno* is the most developed on the teaching of purgatory. Written in 1323, it postdates the more precise definition of purgatory given by the Second Council of Lyons in 1274.[49]

The concern with sin, penance, death, and judgment is evident in the text entitled *Le miroir des pecheurs*, included in Douce 365 (Appendix no. 8[i]). It is a French version of the Latin *Speculum peccatoris* attributed to a variety of authors, including Augustine and Bernard, which also exists in a Middle English translation.[50] In addition, two of the Gerson texts in other manuscripts deal with the same issues: *Lamentacion de la personne qui se trouve en l'article de la mort* and *La medicine de l'ame* (Appendix nos. 21[d, g], 3[c]).[51] Another work treating repentance and forgiveness is the *Reparation du pecheur*, a translation of the *De reparatione lapsi* of Saint John Chrysostom (Appendix no. 21[j]).[52] This text was translated for Philip the Good by Alard, canon of Leuze, and its existence in the ducal library probably resulted in another copy being made for Margaret of York.[53] It is included in Margaret's volume of moral treatises, but is otherwise rarely found in fifteenth-century book collections.

As a final example of this literature on sin and penance, there is the recently discovered guide to the pilgrimage churches of Rome (Appendix no. 17), whose main purpose is to advertise the indulgences connected with these churches available both at home and abroad.[54] It follows a tradition of accounts of the pilgrimage churches in Rome, such as the *Stacions of Rome*, which first appear in the late fourteenth century.[55] In the 1470s, exactly contemporary with Margaret of York's manuscript copy, a printed guidebook appeared that specifically concentrates on the indulgences offered by the main churches of Rome. Margaret's guidebook is in fact a *Liber indulgentiarum*, a popular text in printed books.[56]

In addition to the texts written specifically for religious instruction, there are a number of works on morality by, or attributed to, the authors of antiquity or late antiquity, some reworked or even substantially invented as new compositions in the

Middle Ages. These include the *Moralitez des philosophes*, two works attributed to Seneca—*Des quatres vertus cardinalz* and *Des remedes de fortune*—and *La consolacion de philosophie* of Boethius. Although not specifically Christian in content, all are in part concerned with the problems of the moral life, of tribulation, and of predestination. The *Moralitez des philosophes* (Appendix no. 22[b]) is a French adaptation of the *Moralium dogma philosophorum* of William of Conches. It has extracts from Solomon and the philosophers of antiquity on the conduct of life, morality, and fortune.[57] The *Quatres vertus cardinalz* (Appendix no. 8[h]) is a work on Christian moral life centered on the four Cardinal Virtues, written by the sixth-century Martin, Archbishop of Braga, and supposedly based on a lost work by Seneca.[58] The *Remedes de fortune* attributed to Seneca (Appendix no. 8[g]) is in a fourteenth-century French version made for Charles V by Jacques Bauchant.[59] It is concerned with the tribulations which confront man in life, thoughts on death in various situations, on exile, on poverty, on enemies, and other situations of distress.[60]

The same discussions of "tribulation" appear in the widely read *Consolation of Philosophy* by Boethius (Appendix no. 7). One of the few late antique books continually popular throughout the Middle Ages, it was translated into the vernacular and provided with glosses by adapters and translators.[61] Although he was a Christian, Boethius does not raise specific issues of Christian theology throughout the book. Rather, he offers a philosophical account of the difficulties of life, of predestination and mortality, and the consolation offered by philosophy.[62] The work exists in numerous early printed book versions, in Latin as well as French and English.[63]

Related to these older works on "tribulation" is *Les douze fleurs de tribulation* (Appendix no. 8[e]), attributed to Peter of Blois (circa 1135–1212) but probably not by him. This text is sometimes called the *Livre de tribulacion* and from this French version it was translated into Middle English.[64]

The main emphasis of the texts discussed so far is on doctrinal instruction, tribulations, the moral life, sin, penance, and judgment. A second related group of texts in Margaret's library concentrates on that obsessional theme of late medieval spiritual writing, the relationship between the soul and the body. The concern was, above all, for the care of the heart and the healthy state of the soul, contrasted with the vileness of the body and the vanity of all worldly things. A heart loving earthly treasures would, as Matthew taught, repel the love of God.[65] These texts on the body, heart, and soul include the *Meditations*, then believed to be by Saint Bernard, now recognized as a thirteenth-century compilation;[66] the text appears in the devotional miscellany formerly in Leningrad (Appendix no. 29[b]) and in Brussels 9272–76 (Appendix no. 21[e]). Among other such texts in Margaret's library are those in the *Miroir d'humilité*, part 2 (Appendix no. 15): a French adaptation, sometimes wrongly attributed to Gerson, of Latin texts by the Carthusian Jacobus van Gruytrode, *Specula omnis status humanae vitae*, part 4 (sometimes entitled *Speculum aureum animae peccatricis*), and Saint Bonaventure's *Soliloquium de quator mentalibus exercitius*.[67] Three other texts among Margaret's books focus on the themes of vanity and the welfare of the soul: the *Admonestement de vivre contre la vanite de ce monde* (Appendix no. 21[i]), whose authorship I have not been able to determine; *La garde du coeur et de l'ame* (Appendix no. 8[f]), once thought to be from a Latin original by Gerard of Liège, but recently attributed to the thirteenth-century Dominican Hugh of Saint Cher;[68] and *L'abbaye du Saint Esprit* (Appendix no. 8[a]).

Some of these texts are more common than others in the book collections of the laity. The so-called *Meditations of Saint Bernard* (*Meditationes piissimae de cognitione humanae conditionis*), translated into both French and Middle English, was immensely popular, and it also exists in early printed book editions.[69] The *Meditations* begins by considering the dignity and nobility of the soul and contrasts it with the vileness of the body. Then follows a section on forms of prayer, another on the condition of the human heart, and a discussion of the struggle of the soul against man's three great enemies, the world, the flesh, and the devil. The title of the Gerard of Liège (or, rather, Hugh of Saint Cher) text, the *Care of the Heart and the Soul*, gives

a good idea of its contents. The Jacobus van Gruytrode and Bonaventure texts advise the reader to despise the world, possessions, and the body, to reflect on sins, on death, and the eventual decay of the flesh, the pains of hell, and the joys of heaven. *L'abbaye du Saint Esprit* is a French version of a thirteenth-century Latin text, *Abbacia de Sancto Spiritu*. The first French translation, of the late thirteenth century, was entitled *La sainte abbaye*. It was translated into Middle English as the *Abbey of the Holy Ghost*, frequently ascribed (erroneously) to Richard Rolle.[70] It is an allegory concerned with the care of the soul, with prayer and meditation, and to some degree also with sin. The allegory is in terms of an abbey, its nuns, and those who serve the abbey.[71] The popularity of the text in England is attested by two early printed editions of 1496 and 1500 by Wynkyn de Worde.[72] Several other short texts in Margaret's books deal with these themes.

The third category, Margaret's devotional books, contains more unusual texts on prayer, meditation, and contemplation, although some fit into well-established popular genres of spiritual writing. Some, like Nicolas Finet's *Benoit seront les miséricordieux* (Appendix no. 1) and *Le dialogue de la duchesse de Bourgogne à Jésus Christ* (Appendix no. 2), were written specifically at Margaret's request, and presumably directly reflect her devotional interests.[73] Others are relatively recent spiritual writings, such as the texts by Jean Gerson, those supposedly by Saint Peter of Luxembourg, and those by Thomas à Kempis. Still others are texts rarely found in book collections of the laity; in this category are translations from Saint Augustine and Saint Bernard done for Margaret by Vasco da Lucena in the lost Leningrad manuscript.[74] The text supposedly by Augustine, *Contemplation pour attraire la personne de Dieu*, cannot be precisely defined because no description of the Leningrad manuscript gives the incipit.[75] The *Traite de l'amour de Dieu* of Saint Bernard was presumably a translation of *De diligendo Deo*,[76] a text that requires some depth of understanding for a lay reader. It is concerned with the four steps of ascent to the love of God, and if Margaret was in any way involved in commissioning the translation of this text, she had a taste for fairly advanced writings on prayer and meditation.

Of the modern spiritual texts the most significant are those by Jean Gerson. Nobody in England among the laity seems to have read Gerson, and Margaret must have been introduced to his writings by some spiritual adviser or friend at the Burgundian court. Duke Philip the Good had two books containing two of Gerson's works, the *Mendicité spirituelle* and the *Sermons de la Passion*.[77] Margaret's texts include these two, and all the French texts by Gerson among her books are those he wrote specifically to instruct lay people in prayer, meditation, and contemplation: *La medicine de l'ame, Meditation de la mort, Traictie de mendicite spirituelle, La montaigne de contemplacion*, and the *Sermons sur la Passion* (Appendix nos. 21[d, g, c], 3[a, b, c], 15[c]).[78] These works which Margaret had, with slightly different titles, were directed to readers not versed in theology who wanted instruction in a well-developed life of prayer and ways to meditate and contemplate. Gerson is teaching in simple terms the sort of life of prayer which fourteenth-century mystics describe on a more advanced level. Gerson also discusses the familiar soul and body theme, a theme much in evidence in other works in Margaret's books.

The main work of Saint Peter of Luxembourg is his little-studied *Livret*, of which no modern edition exists. Included in Douce 365 (Appendix no. 8[c]), it is a text concerned with prayer, penance, confession, and precepts on good living.[79] The other text attributed to him in Douce 365 (Appendix 8[b]) may be by a different author. Margaret must have been introduced to the writings of Peter of Luxembourg when in Flanders, for his works seem not to have been read in England.

Brief mention must be made of Margaret's reading of Thomas à Kempis's *Imitation of Christ*, perhaps the only proper *Devotio Moderna* text she possessed. Books 1–3 appear in two of her manuscripts, Brussels 9272–76 and Valenciennes 240.[80] Valenciennes 240 (Appendix 15[e]) is the French translation made in 1447 by a religious at the request of Bernard d'Armagnac, comte de la Marche. In Brussels 9272–76 (Appendix 21[b]), the title claims that the translation was done for Philip the Good

in the same year. This claim seems to be erroneous and very probably resulted from confusing Philip the Good's ownership of the Valenciennes copy of the 1447 translation with his commission of a translation in that year.[81] It seems unlikely that both Bernard d'Armagnac and Philip the Good had the work translated at exactly the same time.

Nicolas Finet's *Dialogue de la duchesse de Bourgogne à Jésus Christ* (Appendix no. 2) is part of the tradition of dialogues in which Christ speaks directly to the reader.[82] In both the text and miniature, the emphasized closeness of Christ, physically present in the picture in Margaret's chamber (see fig. 16), is of course very much part of fifteenth-century devotion, whether specifically the *Devotio Moderna* or more generally derived from the fourteenth-century writings of English and German mystics. The other text made at Margaret's request by Nicolas Finet, *Benoit seront les miséricordieux* (Appendix no. 1), can serve as a conclusion and summary of some of the points made in this essay. The Seven Acts of Mercy are presented as the center of Christian life, and Margaret is shown in the miniature on fol. 1 performing them, observed by Christ himself, who is present in each scene (see fig. 2). The biblical passage describing the Acts of Mercy immediately precedes the account in Matthew 25: 31–46 of the Last Judgment and the separation of the sheep from the goats, and thus has particular relevance for the fate of the soul. Scenes like those in Margaret's book are common in English fifteenth-century stained glass and wall painting.[83] The subject may also have been common in Flanders and France although few examples survive. The Acts of Mercy, the theme of Finet's treatise, again emphasize the judgment of the soul, whether it will be deemed worthy of an eventual place in heaven, possibly after a lengthy period in purgatory, or condemned to the torments of hell. Sin, repentance, confession, judgment, the unworthiness of the body, the contempt of the world, the care of the soul and heart, the development of attitudes of meditation and contemplation—all these are pervasive themes in Margaret's texts.

This survey of the duchess's religious instruction and devotional texts yields some general conclusions about her taste in texts and the degree of her piety. It can only be assumed that she did in fact read most of them, but it is impossible to be certain about the role she played in requesting specific texts. The bulk of them represent conventional, well-established spiritual reading in England, France, and Flanders. Parallels have frequently been drawn with the reading material of fifteenth-century England because we know more about the texts and their ownership in that country than in Flanders or France. Although conventional, the texts in Margaret's books contain many of the most beneficial writings of this nature of the later Middle Ages, and she was certainly provided with a very sound and comprehensive library. One group of books covers religious instruction in matters of doctrine, the awareness of sin, the need for repentance and confession. Another deals with the state of the soul, the sentiments of the heart, and contempt for the body and the world. A third group provides advice on the ways to approach prayer and contemplation. In this last category, although some of the texts are well-established popular late medieval reading, others are more unusual. Apart from these latter, Margaret's choice of reading matter could have been determined in England, perhaps under the influence of her pious mother, Cicely. The inclusion of works popular in England, such as the *Abbey of the Holy Ghost*, Grosseteste's *Château d'amour*, the series of tracts attached to Margaret's *Somme le roi*, which occur in the *Tretyse of Love*,[84] and the extract from the life of the English Saint Edmund appended to her *Apocalypse* (Appendix no. 19[b]), all provide some evidence that she may have played a part in the choice of her texts.[85] Indeed, many of them find parallels in the libraries of aristocratic English men and women of the late fourteenth and fifteenth centuries.[86]

Margaret's comprehensive library suggests that, like her mother, she may genuinely have been very devout. She possessed texts which would help her overcome the troubles and temptations of the world, the flesh, and the devil. Perhaps her pious reading provided some comfort for the trials of her worldly life: her forced involve-

ment in difficult politics, her unhappy marriage, and her childlessness.[87] Neverthe-less, Margaret's piety may have been overemphasized or overestimated because of the predominance of religious literature among her books. Fifteenth-century librar-ies of many lay people show an overwhelming majority of spiritual works. For a per-son such as the duchess, the interior religious life could, however, have been of great importance, and, if instructed by these texts, may well have have been highly de-veloped in terms of meditation and contemplation.[88] For her mother, Cicely, Duch-ess of York, and Margaret's contemporaries Lady Margaret Hungerford and Lady Margaret Beaufort, the fairly detailed accounts of their devotional lives leave no doubt as to their genuine piety.[89] In none of these cases did the writers describing their devotions have any particular reason to falsify or reduce to conventional plati-tudes the lives of their patrons.[90] For all these ladies, the troubles of life in the world were perhaps to some degree assuaged by the care of their souls and hearts, a care made available to them through an abundance of eloquent words and sound advice in their pious books.

Notes

1 For studies of Margaret's religious patronage, see Galesloot 1879, pp. 229–46, 324–28; Weightman 1989, pp. 197–203; and Wim Blockmans's essay, pp. 33–39, above.

2 Dogaer 1975 and Hughes 1984. Margaret's books are also discussed, but not systemati-cally listed, by Galesloot 1879, pp. 254–68; Cockshaw, in Brussels 1977, pp. 17–18, nos. 15–20; L. Hellinga, "Caxton and the Biblio-philes," in *XIe Congrès international des biblio-philes* (Brussels, 1981), pp. 18–27; Weight-man 1989, pp. 204–09. Margaret's patronage is also covered in Brussels 1967a. Those of her books in the Bibliothèque Royale, Brus-sels, are fully described in F. Lyna, *Les prin-cipaux manuscrits à peintures de la Bibliothèque Royale de Belgique*, vol. 3 (Brussels, 1989), pp. 157–60, 168–79.

3 The Brunetto Latini in Saint-Quentin was described as long ago as 1885 in the *Catalogue général des manuscrits des bibliothèques pub-liques de France*, vol. 3 (Paris, 1885), p. 247, as one of Margaret of York's books but es-caped notice until recently. I am grateful to Claudine Lemaire and Pierre Cockshaw for drawing my attention to the manuscript. The best description is that in F.C. Car-mody, *Li Livres dou tresor de Brunetto Latini* (Berkeley, 1948), p. LIV. For recent literature on Brunetto Latini and a listing of manu-scripts, see also J.B. Holloway, *Brunetto La-tini: An Analytic Bibliography* (London, 1986), p. 25. The Saint-Quentin manuscript con-tains only book 1, and therefore lacks the main section of the work concerning the moral life, which is in book 2. Book 1 con-tains a substantial section on biblical history, but is mainly concerned with cosmography and the world of nature. The guide to the pil-grimage churches of Rome appeared in Soth-eby's, London, June 22, 1982, lot 59, and is fully described in the catalogue and in Wal-ter Cahn's essay in the present volume. The *Vie de Sainte Catherine* was brought to my at-tention by Antoine de Schryver in his paper

at the Getty Museum "Visions of Tondal" symposium in June 1990. He had mentioned it briefly in Ghent 1975, p. 331. In 1902 it was in the Waziers Collection; see *Congrès ar-chéologique et historique tenu à Bruges, compte rendu*, part 3 (1902), pp. 33–34.

4 Omitted in the Appendix are only a few texts that contain a few lines each.

5 Chesney 1951, giving extensive lists of com-parative manuscripts containing the texts. My own study only attempts to list some comparisons of fifteenth-century manu-scripts in Burgundian and English libraries. I also mention pre-1500 printed editions of the works where they exist.

6 This will be an easier task when the 1960–80 supplement of R. Bossuat, *Manuel biblio-graphique de la littérature française du moyen âge*, and D. Poirion et al., *La littérature fran-çaise aux XIVe et XVe siècles* (Grundriss der ro-manischen Literaturen des Mittelalters, 8/2) are published. Both are expected in the near future. The recently published commentary volume contains an excellent survey by G. Hasenohr, "La littérature religieuse," in D. Poirion, ed., *La littérature française aux XIVe et XVe siècles* (Grundriss der romanischen Liter-aturen des Mittelalters, 8/1) (Heidelberg, 1988), pp. 266–305. It is hoped that the ac-companying volume of documentation will soon follow. For the texts in French vernac-ular written before 1300, see H. R. Jauss et al., *La littérature didactique, allégorique et sa-tirique* (Grundriss der romanischen Litera-turen des Mittelalters, 6/1, 6/2) (Heidelberg, 1968–70).

7 The note reads: "This booke was the booke called the Graile given unto the Graie Ob-servant Friers of Greenwich by Margaret Duchess of Bourgoine, sister unto King Ed-ward 4. The booke was made beyond the seas." For references to Arundel Ms. 71, see note 16, below.

8 For Margaret's patronage of the Observants of Greenwich, see A.G. Little, "Introduction of the Observant Friars into England," *Proceedings of the British Academy* 10 (1921–23), pp. 459–60. Her interest in the reformed Franciscans is also evidenced by her patronage of the convent of the Poor Clares in Ghent. For a general discussion, see Weightman 1989, pp. 200–01.

9 Her devotion to these saints is discussed further in Blockmans, pp. 36–38, above.

10 P.V. Charland, *Le culte de Ste. Anne en occident de 1400 à nos jours* (Québec, 1921), pp. 110–11.

11 This aspect of Margaret's devotion to Saint Anne is discussed further in Blockmans, p. 37, above.

12 For a complete facsimile and discussion of the book, see Corstanje et al. 1982.

13 Philip the Good's library contained two copies of the *Vie de Sainte Colette* by Pierre de Vaux: Brussels, Bibliothèque Royale, Mss. 6408 and 10980. For these, see Brussels 1967b, nos. 74, 75. The relics of Saint Colette were removed from Ghent in the eighteenth century when Emperor Joseph II suppressed several religious houses in Flanders. They were taken to Poligny in the Jura to the convent of the Poor Clares, where they rest to this day.

14 Prevenier/Blockmans 1985, p. 249.

15 See P. Bergmans, "Marguerite d'York et les pauvres Claires de Gand," *Bulletin de la Société d'histoire et d'archéologie de Gand* 18 (1910), pp. 271–84. For Margaret's interest in the Observants of Greenwich, see note 8, above.

16 The book of hours is described, discussed, and reproduced in D. Farquhar, *Creation and Imitation: The Work of a Fifteenth-Century Manuscript Illuminator* (Fort Lauderdale, 1976), pp. 88–96, 141–44, pls. 70–77, 79. Another of Charles's books, *Le livre de félicité en vie* by Charles Soillot, British Library, Arundel Ms. 71, has been listed by Dogaer 1975 and Hughes 1984 as being one of Margaret's books, probably because it contained the inserted leaf from the gradual that Margaret had made for the Grey Friars of Greenwich. Hellinga (note 2), p. 21, n. 13, has pointed out that this is incorrect. The leaf was inserted in this book presumably when it came into the Arundel collection (it is now mounted separately). The text of *Le livre de félicité* is discussed by M.-L. Polain, "Le débat de Félicité par Charles Soillot," *De gulden passer* 4 (1926), pp. 49–74, and Brussels 1977, no. 2. The book was made for Charles when he was still Count of Charolais, as the dedication at the beginning makes clear.

17 The contents of this manuscript will be discussed below.

18 The presentation is discussed by Galesloot 1879, pp. 244–45.

19 See Blockmans, p. 42, above.

20 A brief description is given by A. de Laborde, *Les principaux manuscrits à peintures conservés dans l'ancienne Bibliothèque impériale publique de Saint-Petersbourg* (Paris, 1938), vol. 1, pp. 109–10. No further detail is given in the earlier description of French manuscripts in Leningrad by G. Bertrand, "Catalogue des manuscrits français de la bibliothèque de Saint Petersbourg," *Revue des Sociétés savantes* 6 (1873), p. 408.

21 Pierre Marot, in *Catalogue général des manuscrits des bibliothèques publiques de France*, vol. 48 (Paris, 1933), p. 421.

22 F.X. Kraus, "Horae Metenses: Die Handschriftensammlung des Freiherrn Louis Numa de Salis," *Jahrbücher des Vereins von Altertumsfreunde im Rheinlande* 68 (1880), p. 80. See also the description by Abbé Paulus, "Supplément au catalogue des manuscrits de la Bibliothèque de la Ville de Metz (Collection Salis)," *Le bibliographe moderne* 7 (1903), p. 414, no. 104.

23 Ibid. Kraus notes that the fifty-four miniatures were in grisaille. As far as I have been able to discover, no photographs or manuscript descriptions survive of the book.

24 I have not seen this manuscript and have relied upon the observations on the heraldry by Farquhar (note 16), pp. 91–93.

25 This observation would concur with Blockmans's view that Margaret's devotion to Susanna as well as to Anne, Colette, and Gummar directly reflects her personal life in respect of her childlessness and unhappy marriage.

26 For English libraries of the fifteenth century, see M. Deanesley, "Vernacular Books in England in the Fourteenth and Fifteenth Centuries," *Modern Language Review* 15 (1920), pp. 349–58; A. I. Doyle, "A Survey of the Origins and Circulation of Theological Writings in English in the 14th, 15th and Early 16th Centuries with Special Consideration of the Part of the Clergy Therein," Ph.D. diss., Cambridge University, 1953; idem, "Books Connected with the Vere Family and Barking Abbey," *Transactions of the Essex Archaeological Society* 25 (1955–58), pp. 222–43; S.H. Cavanaugh, "A Study of Books Privately Owned in England 1300–1450," Ph.D. diss., University of Pennsylvania, Philadelphia, 1980; H.M. Carey, "Devout Literate Laypeople and the Pursuit of the Mixed Life in Later Medieval England," *Journal of Religious History* 14 (1987), pp. 361–81. For France and Flanders, see Doutrepont 1909. A full list of the extensive library of Gabrielle de la Tour d'Auvergne, comtesse de Montpensier, in 1474, has been published by the duc de la Tremoïlle, "Inventaire des bijoux, vêtements, manuscrits et objets précieux appartenant à la comtesse de Montpensier (1474)," *Annuaire-Bulletin de la Société de l'histoire de France* 17 (1880), pp. 297–309. For the importance of vernacular translations of religious literature, see G. Hasenohr, "Place et rôle des traductions dans la pastorale française du XVe siècle," in G. Contamine, ed., *Traduction et traducteurs au moyen âge* (Paris, 1989), pp. 265–75. In this paper, I have restricted comparisons to English and French material. It is possible that comparisons with spiritual and devotional texts in the Flemish language are also of relevance, but this is beyond the scope of the present paper and my own expertise.

27 Cavanaugh (note 26) has studied English libraries up to the middle of the fifteenth century. A great deal, above all in wills, remains unpublished, and for the period 1450–1530 there has been no equivalent search of printed sources to that made by Cavanaugh for the period 1300–1450. The work of Ian Doyle, much regrettably unpublished, has contributed a great deal to our understanding of the problems of private book ownership in late medieval England. Useful are two recent essays: K. Harris, "Patrons, Buyers and Owners: The Evidence for Ownership and the Rôle of Book Owners in Book Production and the Book Trade," and V. Gillespie, "Vernacular Books of Religion," both in J. Griffiths and D. Pearsall, eds., *Book Production and Publishing in Britain 1375–1475* (Cambridge, 1989), pp. 163–200, 317–44.

28 The Hours of the Virgin, the main text in the book of hours, and also the Office of the Dead, are of course contained in the breviary, and the duchess could have used her Sarum breviary for reading these texts.

29 See Cavanaugh (note 26), passim, for lay people owning a "portiforium," the word more commonly used than "breviarium."

30 *Lucidaire*: Brussels, Bibliothèque Royale, Ms. 10574–85. *La somme le roi*: Brussels, Bibliothèque Royale, Mss. 9544, 10320, 11041, 11206–07. *Château d'amour*: Brussels, Bibliothèque Royale, Ms. 10747 (a thirteenth-century copy). On these, see Brussels 1967b, nos. 46–49, 84, 144.

31 On such texts, see L.E. Boyle, "The Fourth Lateran Council and Manuals of Popular Theology," in T.J. Heffernan, ed., *The Popular Literature of Medieval England* (Knoxville, 1985), pp. 30–43, and N. Bériou, "Autour de Latran IV (1215): La naissance de la confession moderne et sa diffusion," in Groupe de la Bussière, *Pratiques de la confession* (Paris, 1983), pp. 73–94.

32 The text is published by J.H.L. Kengen, *Memoriale credencium* (Nijmegen, 1979), pp. 27–33, with a complete listing of the sections of the text. See also R. Hanna, "The Text of Memoriale Credencium," *Neophilologus* 67 (1983), pp. 284–92.

33 The contents are summarized in detail by C.V. Langlois, *La vie en France au moyen âge. IV: La vie spirituelle* (Paris, 1928), pp. 123–98. Unfortunately, there is no edition of the original text. The problem of adaptations and expansions of the text is discussed by E. Brayer, "Contenu, structure et combinaisons du Miroir du Monde et de la Somme le Roi," *Romania* 79 (1958), pp. 1–38, 433–70, and W.N. Francis, *The Book of Vices and Virtues* (Early English Text Society, o.s. 217) (1942), pp. xi–xl.

34 For a discussion of these with bibliography, see R. Raymo, "Works of Religious Philosophical Instruction," in A.E. Hartung, ed., *A Manual of Writings in Middle English 1050–1500*, vol. 7 (New Haven, 1986), pp. 2258–62, 2479–82. The work was printed by Caxton in 1486 in an English version with the title *The Royal Book*; see E.G. Duff, *English Fifteenth-Century Books* (London, 1917), no. 366.

35 Brayer (note 33), p. 466, in her discussion of adapted versions, mentions Margaret of York's manuscript as one of two in "Rédaction v." The other is Brussels, Bibliothèque Royale, Ms. 9544. Unfortunately, Brayer does not discuss the full contents of Margaret's book. A good, complete description of the manuscript is given in Brussels 1973, no. 16. Although *La somme le roi* appears early in Flemish in three printed editions (Delft, 1478; Hasselt, 1481; Haarlem, 1484), the only French version before 1500 seems to be that printed by Antoine Vérard, circa 1490. On these versions, see L. Polain, *Catalogue des livres imprimés au quinzième siècle des bibliothèques de Belgique*, vol. 3 (Brussels, 1932), nos. 2443–45, and *Short-Title Catalogue of Books Printed in France and of French Books Printed in Other Countries from 1470 to 1600 Now in the British Museum* (London, 1924), p. 403 (*La somme des vices et vertus*).

36 Of these texts, Rutebeuf's *Ave Maria* (Appendix no. 6[r]) is edited in E. Faral and J. Bastin, *Oeuvres complètes de Rutebeuf* (Paris, 1960), vol. 2, pp. 240–44. Some of these and other texts in this manuscript (e.g., Albert of Cologne, *Neufs articles*, *Des branches du pommier*, *Dits de Saint Pol*, *Signes de l'amour de Nostre Seigneur*, *Six maistres de tribulation*, Appendix nos. 6[o, m, p, n, q]) have been discussed by J.H. Fisher, "Continental Associations for the Ancrene Riwle," *Publications of the Modern Language Association* 64 (1949), pp. 1182–83, as also occurring in the late fifteenth-century Middle English *Tretyse of Love*, a paraphrase of the early thirteenth-century *Ancrene Riwle* with additions. The text of that work has been published with an edition of the French texts in Margaret of York's manuscript by J.H. Fisher, *The Tretyse of Love* (Early English Text Society, o.s. 223) (1951), pp. xiv–xvi, 131–45. These correspondences show the interrelationships which evidently existed at the time between the devotional literature read in Flanders and England. On *Des branches du pommier*, see also K. Christ, "Le livre du paumier," *Festschrift H. Degering* (Leipzig, 1926), pp. 57–81, with mention of Brussels 9106 on p. 60. Another French translation of the *Six maistres de tribulation* is published by E. Vansteenberghe, "Quelques écrits de Jean Gerson: Textes inédits et études," *Revue des sciences religieuses* 15 (1935), pp. 543–51. The work is not by Gerson, as pointed out by M. Lieberman, "Gersoniana," *Romania* 78 (1957), pp. 169–73. The texts on the Antichrist, the fifteen signs, and the pains of hell represent a tradition of French vernacular versions going back to the thirteenth century or earlier, for which see Jauss et al. (note 6), vol. 6/2, pp. 232–39.

37 For the text, see J. Murray, *Le Château d'amour de Robert Grosseteste, evêque de Lincoln* (Paris, 1918). The Middle English version is published by K. Sajavaara, *The Middle English Translations of Robert Grosseteste's Château d'Amour* (Helsinki, 1967). The work is discussed by Raymo (note 34), pp. 2337–39, 2542–45; Jauss et al. (note 6), vol. 6/2, pp. 216–17; R.D. Cornelius, *The Figurative Castle* (Bryn Mawr, 1930), pp. 44–46.

38 The Latin text and its derivations are discussed by Y. Lefevre, *L'Elucidarium et les Lucidaires* (Paris, 1953). For an interesting analysis of the work, see A. Gurevich, "The Elucidarium: Popular Theology and Folk Religiosity in the Middle Ages," in A. Gurevich, *Medieval Popular Culture: Problems of Belief and Perception* (Cambridge, 1988), pp. 153–75.

39 I have not determined which of the French versions is contained in Margaret of York's book. Neither the redaction of Peter of Peckham nor that in the other French versions has been published. The full contents of Peter of Peckham's *Lumiere as lais* are summarized in Langlois (note 33), pp. 66–122. An English version was printed by Wynkyn de Worde in 1507; see A.W. Pollard and G.R. Redgrave, *A Short-Title Catalogue of Books Printed in England, Scotland and Ireland 1475–1640*, 2nd rev. ed. (London, 1986), p. 596, listed among the works of Honorius Augustodunensis. A French version entitled *Lucidaire* was published before 1500 in Rouen, but not dated; see Polain (note 35), no. 2527.

40 Examples are Brussels, Bibliothèque Royale, Ms. II. 282; Cambridge, University Library, Ms. Gg.1.1; London, British Library, Royal Ms. 15 D II. For descriptions and bibliography on these manuscripts, see R.K. Emmerson and S. Lewis, "Census and Bibliography of Medieval Manuscripts Containing Apocalypse Illustrations, ca. 800–1500, II," *Traditio* 41 (1985), nos. 40, 51, 74; for the Brussels and London copies, L.F. Sandler, *Gothic Manuscripts 1285–1385* (A Survey of Manuscripts Illuminated in the British Isles, 5) (London, 1986), nos. 34, 55.

41 The text was published by L. Delisle and P. Meyer, *L'Apocalypse en français au XIIIe siècle* (Paris, 1900) with Margaret of York's *Apocalypse* mentioned on p. CXXXVI; the authors had been unable to study it as it was then in private hands. For recent bibliography on Margaret's *Apocalypse*, see Emmerson and Lewis (note 40), no. 89. A transcription of the text and facsimile is also available in Y. Otaka and H. Fukui, *Apocalypse (Bibliothèque Nationale, fonds français 403)* (Osaka, 1981). The content and sources of the non-Berengaudus commentary are discussed in J.C. Fox, "The Earliest French Apocalypse and Commentary," *Modern Language Review* 7 (1912), pp. 447–68, and G. Breder, *Die lateinische Vorlage des altfranzösischen Apokalypsenkommentars des 13. Jahrhunderts (Paris, B.N. MS. FR. 403)* (Münster, 1960). The commentary more commonly found in English and French illustrated Apocalypses is excerpted from that of Berengaudus, written c. 1100.

42 The *Apocalypse* of Philip the Good, Dresden, Sächsische Landesbibliothek, Ms. Oc. 49, is an early fourteenth-century French copy. Charles's copy is in New York, Pierpont Morgan Library, M. 68. The two books are described in Emmerson and Lewis (note 40), nos. 54, 87.

43 The didactic functions of the illustrated Apocalypse with commentary are discussed in N. Morgan, *The Lambeth Apocalypse: Manuscript 209 in the Lambeth Palace Library* (London, 1990), commentary volume, which also contains a transcription and translation of the Berengaudus version of the commentary text.

44 This aspect is discussed in Suzanne Lewis's essay, pp. 84–86 below. Although I would agree that the illustrated Apocalypse could be used for meditation, I do not view that to be its primary purpose, which was for religious education.

45 For *Saint Patrick's Purgatory* and *The Visions of Tondal*, see Palmer 1982, and R. Mearns, *The Vision of Tundale* (Heidelberg, 1985) for the Middle English text. See also Peter Dinzelbacher's essay in the present volume for *The Visions of Tondal*. The medieval French versions are listed, with bibliography, in Jauss et al. (note 6), vol. 6/2, pp. 246–51, and the Middle English versions in F.A. Foster, "Legends of the After-Life," in J. Burke Severs, ed., *A Manual of Writings in Middle English 1050–1500*, vol. 2 (Hamden, 1970), pp. 452–57, 645–69.

46 On the text of *De spiritu Guidonis*, see H. Brandes, "Guido von Alet," *Jahrbuch des Vereins für niederdeutsche Sprachforschung* 13 (1887), pp. 81–96, and Palmer 1982, pp. 404–06.

47 See the edition by R.H. Bowers, *The Gast of Gy* (Leipzig, 1938), and the listing by F.L. Utley, "Dialogues, Debates and Catechisms," in A.E. Hartung, ed., *A Manual of Writings in Middle English 1050–1500*, vol. 3 (New Haven, 1972), pp. 698–700, 864–65. Versions are also printed by C. Horstmann, *Yorkshire Writers: Richard Rolle of Hampole and His Followers* (London, 1896), vol. 2, pp. 292–333. The *Gast of Gy* and other Middle English visionary texts for instruction on purgatory are interestingly discussed by G. Keiser, "The Progress of Purgatory: Visions of the Afterlife in Later Middle English Literature," *Analecta Cartusiana* 117, part 3 (1987), pp. 72–100, and G.R. Keiser, "St. Jerome and the Brigittines: Visions of the Afterlife in Fifteenth-Century England," in D. Williams, ed., *England in the Fifteenth Century* (Proceedings of the 1986 Harlaxton Symposium) (Woodbridge, Suffolk, 1987), pp. 143–52. Keiser also discusses a related fifteenth-century Middle English teaching text on purgatory, as does M.P. Harley, *A Revelation of Purgatory by an Unknown Fifteenth-Century Woman Visionary* (Lewiston, 1985).

48 Duff (note 34), no. 169. There seems to be no equivalent printed book of the French version of the text. There was a Latin version printed in Delft in 1486; see Polain (note 35), vol. 2, no. 1664.

49 On the doctrine of purgatory in the Middle Ages, see Le Goff 1984, with pp. 284–86 dealing with the definition at the Second Council of Lyons.

50 For the French version, see Chesney 1951, pp. 32–39, and G.A. Brunelli, "Le Miroueur des Pecheurs, edizione del volgarizzamento francese di un 'Ars moriendi et bene vivendi' già attribuita a Jean Gerson, 'Speculum peccatorum,' stabilita sui mss. francesi e sulle edizione gotiche della Bibl. Nazionale di Parigi," *Miscellanea del Centro di studi medievali*, 2nd ser. (Pubblicazione dell'Università Cattolica del Sacro Cuore, 62) (Milan, 1958), pp. 167–207. This edition unfortunately does not use Margaret of York's text in Douce 365. The content is discussed by G.A. Brunelli, "Una 'Ars moriendi et bene vivendi' nella Francia del sec. xv," *Studi francesi* 5 (1958), pp. 177–89. Some of the manuscripts of this text are accompanied by illustrations, reproduced in that article. For the Middle English version, see Horstmann (note 47), vol. 2, pp. 436–40; H.E. Allen, *Writings Ascribed to Richard Rolle, Hermit of Hampole* (London, 1927), pp. 353–54; P.S. Jolliffe, *A Check-List of Middle English Prose Writings of Spiritual Guidance* (Toronto, 1974), p. 81. Jolliffe lists twenty-two extant manuscripts. The Latin text on which the French and English translations were based is printed in Migne, *Patrologia latina*, vol. 40, cols. 983–92. I have not seen the text entitled *Speculum peccatoris*, printed in Poitiers in 1480; see *Short-Title Catalogue* (note 35), p. 407.

51 The *Lamentacion* is often inserted in texts of Gerson's *Mendicité spirituelle*. For the original texts, see P. Glorieux, ed., *Jean Gerson: Oeuvres complètes*, vol. 7 (Paris, 1966), pp. 269–72, 404–07.

52 The work had been translated from the Greek early in the Middle Ages; see J.-P. Bouhot, "Traductions latines de Jean Chrysostome du Ve au XVIe siècles," in Contamine (note 26), p. 32. The Latin text is printed in J. Dumortier, *Jean Chrysostome: à Théodore* (Paris, 1966), pp. 257–322.

53 Doutrepont 1909, p. 228.

54 The contents of this book are discussed at length in Walter Cahn's essay in the present volume.

55 See C.K. Zacher, "Travel and Geographical Writings," in Hartung (note 34), pp. 2239, 2452, for the manuscripts and bibliography. An equivalent text in French is British Library, Add. Ms. 25105, fols. 74–76v.

56 This literature is well discussed by J.R. Hulbert, "Some Medieval Advertisements of Rome," *Modern Philology* 20 (1923), pp. 403–24; C. Huelsen, *Mirabilia Romae: Ein römisches Pilgerbuch des 15. Jahrhundert in deutscher Sprache* (Berlin, 1925); L. Schudt, *Le guide di Roma* (Vienna, 1930), pp. 20, 185–90; C.E. Woodruff, ed., *A Fifteenth Century Guide-Book to the Principal Churches of Rome Compiled c. 1470 by William Brewyn* (London, 1933); E.S. de Beer, "The Stacions of Rome," *Notes and Queries* 184 (1943),

pp. 126–30. Copies of the 1470–80 editions of the Latin version in the British Library are IA. 17592, IA. 17593, IA. 17621, and C.9.a.22.

57 On the text, see J. Holmberg, *Das Moralium dogma philosophorum des Guillaume de Conches, lateinisch, altfranzösisch und mittelniederfränkisch* (Uppsala, 1929), and J.-C. Payen, "Le Livre de philosophie et moralité d'Alard de Cambrai," *Romania* 87 (1966), pp. 145–74.

58 The work and its French fifteenth-century translation are fully discussed by H. Haselbach, *Sénèque des IIII vertus: La Formula honestae vitae de Martin de Braga (pseudo-Sénèque) traduite et glosée par Jean Courtecuisse (1403)* (Berne, 1975), with frequent mention of the version in Margaret of York's manuscript Douce 365. The problem of the identity of the translator is discussed by G. di Stefano, "Claude de Seyssel, Jean Courtecuisse, Laurent de Premierfait o Jean Trousseau? Appunti sull'autore di una traduzione inedita della pseudo-Seneca," *Studi francesi* 28 (1966), pp. 76–80. In addition, see Chesney 1951, pp. 31–32. The Latin text exists in numerous early printed versions, but apparently there is only the 1491 Vérard edition of Jean Courtecuisse's French translation; on these, see Polain (note 35), vol. 3, nos. 3494–98, and *Short-Title Catalogue* (note 35), p. 398.

59 See Chesney 1951, pp. 28–31, and R.H. Lucas, "Mediaeval French Translations of the Latin Classics to 1500," *Speculum* 45 (1970), pp. 245–46. For a discussion of Jacques Bauchant's translation, see L. Delisle, *Recherches sur la librairie de Charles V* (Paris, 1907), vol. 2, pp. 88–91. There is a more famous and more popular work of Petrarch with the same title, based on the Seneca text and also translated into French: L. Delisle, "Anciennes traductions françaises du traité de Pétrarque sur les Remèdes de l'une et l'autre fortune," *Notices et extraits des manuscrits de la Bibliothèque nationale* 34 (1891), pp. 273–301; N. Mann, "La fortune de Pétrarque en France: Recherches sur le 'De Remediis,'" *Studi francesi* 37 (1969), pp. 1–15. For a unique Middle English version of the Petrarch text and discussion of the content of both works, see F.N.M. Diekstra, *A Dialogue Between Reason and Adversity* (Assen, 1968).

60 The nineteen titles of the sections of the Latin version are listed by Diekstra (note 59), pp. 35–36.

61 The French versions are exhaustively described by G.M. Cropp, "Les manuscrits du Livre de Boèce de Consolacion," *Revue d'histoire des textes* 12–13 (1982–83), pp. 263–352, with an exemplary account of Margaret of York's manuscript on pp. 294–96. Her manuscript has an interpolated gloss, as occurs in several versions; see G.M. Cropp, "Le Livre de Boèce de Consolacion: From Translation to Glossed Text," in A.J. Minnis, ed., *The Medieval Boethius: Studies in the Vernacular Translations of de Consolatione Philosophiae* (Woodbridge, Suffolk, 1987), pp. 32–62. For the English translations, see M. Science, *Boethius: De Consolatione Philoso-*

phiae translated by John Walton, Canon of Oseney (Early English Text Society, o.s. 170) (1927).

62 Brief but interesting analyses of the work are given by C.S. Lewis, *The Discarded Image* (Cambridge, 1964), pp. 77–89, and V.E. Watts, trans., *Boethius: The Consolation of Philosophy* (London, 1969), pp. 18–31.

63 For Caxton's English version, printed before 1479, see Duff (note 34), no. 47. For the editions of Jean de Meun's French version by Colard Mansion, printed at Bruges in 1477, and by Antoine Vérard in Paris in 1494, and an undated book printed at Lyons before 1500, see M. Pellechet, *Catalogue général des incunables des bibliothèques publiques de France*, vol. 2 (Paris, 1905), nos. 2549–50, and Polain (note 35), vol. 1, nos. 746–48.

64 The French text remains unedited, but is discussed in A. Auer, *Leidenstheologie im Spätmittelalter* (Sankt Ottilien, 1952), pp. 1–71. The manuscripts of the Middle English text are treated in A. Barratt, *The Book of Tribulation* (Heidelberg, 1983), p. 18, which supplements the comments of Chesney 1951, pp. 22–26. See also Raymo (note 34), pp. 2295, 2521, and D. Gray, "Books of Comfort," in G. Kratzmann and J. Simpson, eds., *Medieval English Religious and Ethical Literature: Essays in Honour of G.H. Russell* (Woodbridge, 1986), pp. 209–21. The Middle English versions of treatises on tribulation are also printed in Horstmann (note 47), pp. 45–60, 389–406, and listed by Jolliffe (note 50), pp. 115–19. Jolliffe lists over forty manuscripts. A version was printed by Wynkyn de Worde in 1499, *The Twelve Profits of Tribulation*, for which see Duff (note 34), no. 400. For the original Latin text attributed to Peter of Blois, see G. Hendrix, "Kleine queste naar de auteur van de Duodecim utilitatibus tribulationum," *Ons geestelijk erf* 56 (1982), pp. 109–24.

65 Matthew 6: 19–21: "Lay not up to yourselves treasures on earth: where the rust and moth consume, and where thieves break through and steal. But lay up to yourselves treasures in heaven: where neither the rust nor the moth doth consume, and where thieves do not break through, nor steal. For where thy treasure is, there is thy heart also."

66 Surprisingly, this extremely popular text has been very little studied. The best accounts are G. Raciti, "L'autore del De spiritu et anima," *Rivista di filosofia neoscolastica* 53 (1961), pp. 385–401, and R. Bultot, "Les 'Meditationes' pseudo-Bernardines sur la connaissance de la condition humaine," *Sacris erudiri* 15 (1964), pp. 256–92. The Latin text, *Meditationes piissimae de cognitione humanae conditionis*, is in Migne, *Patrologia latina*, vol. 184, cols. 485–508. For arguments against Raciti's attribution of the *Meditations* to Peter Comestor, see D. Luscombe, "Peter Comestor," in K. Walsh and D. Wood, eds., *The Bible in the Medieval World: Essays in Memory of Beryl Smalley* (Oxford, 1985), pp. 125–26. A version in Middle English was published by Wynkyn de Worde in 1496

and has been recently published in facsimile: *Medytacons of Saynt Bernarde, Westmestre, Wynkyn de Worde, 1496* (Amsterdam, 1977). Although there were numerous Latin editions printed in France, only two were published in French: Pellechet (note 63), no. 2123, and *Short-Title Catalogue of Books* (note 35), p. 49, the latter being Vérard's edition of circa 1507.

67 It was earlier thought that the text in Valenciennes 240 was a version of Innocent III's *De miseria humane conditionis*, from which work are quoted the opening lines of the Valenciennes manuscript; see J. Mangeart, *Catalogue descriptif et raisonné des manuscrits de la Bibliothèque de Valenciennes* (Paris, 1860), p. 233. Jacobus van Gruytrode's text certainly shows some influence from Innocent III's text but cannot be considered a paraphrase of it. The Latin text by Jacobus is printed in Dionysius Cartusianus, *Opera omnia*, vol. 42 (Tournai, 1913), pp. 765–94. The text of Innocent III, which occurs in numerous manuscripts and early printed editions, is well published and discussed. See M. Maccarrone, *Lotharii Cardinalis (Innocent III) De miseria humane conditionis* (Rome, 1955); M. Maccarrone and K.V. Sinclair, "New Manuscripts of Lothario's Treatise, De miseria humane conditionis," *Italia medioevale e umanistica* 4 (1961), pp. 167–73; D.R. Howard, "Thirty New Manuscripts of Pope Innocent III's De miseria humanae conditionis (De contemptu mundi)," *Manuscripta* 7 (1963), pp. 31–35; R. Bultot, "Mépris du monde, misère et dignité de l'homme dans la pensée d'Innocent III," *Cahiers de civilisation médiévale* 4 (1961), pp. 441–56. The *Soliloquium* of Saint Bonaventure is published in Saint Bonaventure, *Opera omnia*, vol. 8 (Quaracchi, 1898), pp. 28–67, and in English translation in J. de Vinck, trans., *The Works of Saint Bonaventure*, vol. 3 (Paterson, New Jersey, 1966), pp. 33–129. Although the work exists in several early printed Latin editions, it does not appear before 1500 in French or English. There are, however, three editions in Flemish of 1487, 1496, and 1499; see Polain (note 35), vol. 1, nos. 819–21. The French text of the *Miroir d'humilité*, which seems to exist in more than one version, remains unedited. Hasenohr (note 6), pp. 280, 285, mentions a text of that name compiled for Philip the Good. The *Miroir de l'âme pecheresse*, the translation of Jacobus van Gruytrode's text, appears in Philip the Good's manuscript of 1451, Brussels, Bibliothèque Royale, Ms. 11123; see Brussels 1967b, no. 58. The *Catalogue général des manuscrits des bibliothèques publiques de France*, vol. 25 (Paris, 1894), p. 295, is incorrect in considering Madrid, Biblioteca Nacional, Ms. Vit. 25–2 to be the first volume of the Valenciennes manuscript, whose foliation begins on fol. 211 and which was evidently a second volume of a larger work (see p. 64, above). The correction was made by L.M.J. Delaissé, in Brussels 1959, no. 142. For a description of the Madrid manuscript, see P. Durrieu, "Manuscrits d'Espagne," *Bibliothèque de l'Ecole des Chartes* 54 (1893), pp. 274–76. For Jacobus van Gruytrode, see M. Verjans, "Jacobus van Gruitrode," *Ons geestelijk erf* 5 (1931),

pp. 435–70, and the article in the *Dictionnaire de spiritualité*, vol. 8, part 1, cols. 36–38. The French version of his work, entitled the *Mirouer d'or de l'ame pecheresse*, exists in printed editions of 1484 and three others before 1500; see Pellechet (note 63), nos. 4326–29. The Latin version of the text exists in numerous editions, attesting to the immense popularity of the work, which is almost always ascribed to Dionysius the Carthusian.

68 G. Hendrix, "Hugh of St. Cher O.P.: Author of Two Texts Attributed to the Thirteenth-century Cistercian, Gerard of Liège," *Cîteaux* 31 (1980), pp. 343–56; idem, "Les postillae de Hugues de Saint-Cher et le traité De doctrina cordis," *Recherches de théologie ancienne et médiévale* 47 (1980), pp. 114–30; idem, "Onderzoek naar het oeuvre van 'Gerardus Leodiensis,'" *Ons geestelijk erf* 56 (1982), pp. 300–41. The Middle English version has been edited by M.B. Candon, "The Doctrine of the Heart," Ph.D. diss., Fordham University, New York, 1963. The French version remains unedited. The Latin text is printed and discussed by A. Wilmart, "Gerard de Liège: Un traité inédit de l'amour de Dieu," *Revue d'ascétique et de mystique* 12 (1931), pp. 349–430.

69 Duff (note 34), nos. 41, 42, for Wynkyn de Worde's English editions printed in 1496 and 1499. *Short-Title Catalogue* (note 35), p. 49, for Vérard's circa 1507 edition of the text in French.

70 Chesney 1951, pp. 13–17. The text of the Middle English version is given by G.G. Perry, *Religious Pieces in Prose and Verse* (Early English Text Society, o.s. 26) (1867), pp. 51–62, and N. Blake, *Middle English Religious Prose* (London, 1972), pp. 88–102. The nature of the text is discussed by Allen (note 50), pp. 335–43, and P. Consacro, "The Author of the Abbey of the Holy Ghost: A Popularizer of the Mixed Life," *Fourteenth-Century English Mystics Newsletter* 2 (1976), pp. 15–20. See also J.W. Conlee, "The Abbey of the Holy Ghost and the Eight Ghostly Dwelling Places of Huntington Library HM 744," *Medium Aevum* 44 (1974), pp. 137–44, and G. Keiser, "To Knawe God Almyghtyn: Robert Thornton's Devotional Book," *Analecta Cartusiana* 106 (1984), pp. 111, 115–18. The text of the English version exists in early printed editions; see C.F. Bühler, "The First Edition of the Abbey of the Holy Ghost," *Studies in Bibliography* 6 (1954), pp. 101–06. For the numerous English manuscripts, see Jolliffe (note 50), pp. 94–95, and Raymo (note 34), pp. 2340–41, 2545–47.

71 This type of allegory and the *Abbey of the Holy Ghost* are discussed by Cornelius (note 37), pp. 52–55.

72 Duff (note 34), nos 1, 2. The French version of the text does not seem to exist in an early printed book.

73 Neither the *Benoit seront les miséricordieux* nor the *Dialogue de la duchesse de Bourgogne à Jésus Christ* has been published, nor has any study been devoted to their contents.

74 See D. Gallet-Guerne, *Vasque de Lucène* (Geneva, 1974), pp. 18–20.

75 It was probably the text of that title translated from the *Manuale* attributed to Augustine, published in Migne, *Patrologia latina*, vol. 40, cols. 951–68. It is discussed by A. Wilmart, *Auteurs spirituels et textes dévots du moyen âge latin* (Paris, 1932), p. 195, and G. Esnos, "Les traductions médiévales françaises et italiennes des Soliloques attribués à St. Augustin," *Mélanges d'archéologie et d'histoire de l'Ecole française à Rome* 79 (1967), pp. 299–370; the *Contemplation* text appears in several manuscripts next to the text of the *Soliloques*. For arguments attributing the *Manuale* to Peter Comestor, see Raciti (note 66) and, for arguments against the attribution, Luscombe (note 66), pp. 125–26.

76 The Latin text is printed in Migne, *Patrologia latina*, vol. 134, cols. 973–1000. Presumably this is the text by Saint Bernard, and not *De diligendo Deo* attributed to Saint Augustine (Migne, vol. 40, cols. 847–64), but probably a twelfth-century compilation. See Raciti (note 66) and Luscombe (note 66).

77 Brussels, Bibliothèque Royale, Mss. 9081–82, 10308. On these, see Brussels 1967b, nos. 60, 65.

78 For Gerson's original texts, see Glorieux (note 51), pp. xi, xiv, xv, xviii, 16–55, 220–80, 269–72, 404–07; part 2, 1968, pp. vii, 449–93. These editions do not provide collations with Margaret of York's texts, which may have different readings and interpolations. On these writings, see also M.-J. Pinet, *La Montaigne de contemplacion et la Mendicité spirituelle de Jehan Gerson: Etude de deux opuscules français de Gerson sur la prière* (Lyons, 1927). Of the French works of Gerson in Margaret's library, only the *Mendicité spirituelle* exists in early printed books, whereas his Latin works exist in many printed editions. For the *Mendicité spirituelle* printed in Paris in 1500, see Pellechet (note 63), no. 5183.

79 For Saint Peter of Luxembourg's writings, see Chesney 1951, pp. 19–21. She does not mention the listings of manuscripts containing his works by C. Wahlund, "Hel. Peter af Luxemburg," *Studier i modern språk-vetenskap* 4 (1908), pp. 29–37. See also the mention of Peter's works in G. Hasenohr, "La vie quotidienne de la femme vue par l'Eglise: L'enseignement des journées chrétiennes de la fin du moyen âge," in *Frau und spätmittelalterlicher Alltag: Internationaler Kongress Krems an der Donau 1984* (Österreichische Akademie der Wissenschaften, Philosophisch-Historische Klasse, Sitzungsberichte, 473) (Vienna, 1986), pp. 58–59, 66, 68–70, 73, 81–83. The comtesse Gabrielle de la Tour d'Auvergne (d. 1474) had a copy of the *Livret* in her library; see de la Tremoïlle (note 26), p. 305. For 1492 and 1505 printed editions, see Wahlund (as above), p. 33.

80 These two manuscripts are discussed by P.E. Puyol, *Descriptions bibliographiques des manuscrits et des principales éditions du livre De*

imitatione Christi (Paris, 1898), pp. 468–70. A French edition of the work was printed by Michel Lenoir, Paris, 1500; see Polain (note 35), vol. 2, no. 2073. Puyol, p. 463, also mentions a Paris edition of 1493. At the same time, translations of the work were being made into Middle English; see J.K. Ingram, *The Earliest English Translation of De Imitatione Christi* (Early English Text Society, o.s. 63) (1893), and R. Lovatt, "The Imitation of Christ in Late Medieval England," *Transactions of the Royal Historical Society*, 5th ser., 18 (1968), pp. 97–121.

81 *Thomas à Kempis et la dévotion moderne*, exh. cat. (Bibliothèque Royale, Brussels, 1971), no. 52, considers that the translation in Ms. 9272–76 may be by Nicolas Finet. The same text exists in Brussels, Bibliothèque Royale, Ms. 10321 of circa 1490. On these manuscripts, see S.G. Axters, *De imitatione Christi: Een handschrifteninventaris* (Kempen, 1971), p. 40.

82 On these in Middle English versions, see Utley (note 47), pp. 679–83, 838–41.

83 For the subject in parish churches in Norfolk and Suffolk, see C. Woodforde, *The Norwich School of Glass-Painting in the Fifteenth Century* (Oxford, 1950), pp. 193–96. For a general discussion of the popularity of the theme in English wall painting, see A. Caiger-Smith, *English Medieval Wall Painting* (Oxford, 1963), pp. 53–55.

84 On these, see the publications by Fisher cited in note 36, above.

85 There is, of course, in the case of the *Tretyse of Love* the issue of interrelationships between such religious literature in England and Flanders at a period when cultural contacts were close. On the general situation, see C.A.J. Armstrong, "L'échange culturel entre les cours d'Angleterre et de Bourgogne à l'époque de Charles le Téméraire," in C.A.J. Armstrong, ed., *England, France, and Burgundy in the Fifteenth Century* (London, 1983), pp. 403–17.

86 See Cavanaugh (note 26), under the names of the owners for examples of ownership of the following texts: *Antichrist, Avenement de* (Philippa de Coucy, Sibilla de Felton); *Apocalypse* (Alice Bassett, Joanna Bishopstone, Henry Scrope, Cecilia Welles, Thomas of Woodstock); Boethius, *Consolation of Philosophy* (Elizabeth Berkeley, John Brichele, Richard Stowe, Thomas of Woodstock); *Gast of Gy* (Wilmot Cameek); *Lucidaire* (Thomas of Woodstock); *Meditations of Saint Bernard* (John Fastolf, Robert Norwich, Thomas of Woodstock); *Saint Patrick's Purgatory* (Eleanor Purdeley); Grosseteste, *Château d'Amour* (Walter Hungerford); Seneca, *De IV virtutibus, De remediis fortuitorum* (John Carpenter); *La somme le roi* (John Carpenter); tribulation books (Lewis Clifford, Thomas of Woodstock, Elizabeth Vache); Virtues and Vices books (Margaret Coutenay, John Fastolf, Agnes Stapilton, Thomas of Woodstock). For ownership of such texts by the Vere family, see Doyle 1955–58 (note 26), p. 226 (*Twelve Profits of Tribulation, La somme le roi*).

87 See Blockmans, pp. 42–44, above.

88 Regrettably, there seems to be no account of Margaret's daily routine as exists for her mother, Cicely, and contemporaries Lady Margaret Hungerford and Lady Margaret Beaufort. It is significant that Margaret of York possessed a text instructing such a routine, *Du gouvernement cotidien* (Appendix no. 8[d]). This text and others of a similar nature are discussed in the brilliant article by Hasenohr (note 79), pp. 19–101. Although such texts on daily devotions seem to have been written for women, it should not be concluded that the religion of devout women differed substantially from that of devout men. For a text on daily devotions written for a man, see the excellent study of W.A. Pantin, "Instructions for a Devout and Literate Layman," in J.J.G. Alexander and M.T. Gibson, eds., *Essays Presented to R.W. Hunt* (Oxford, 1976), pp. 398–422. An interesting account of how these books of spiritual miscellanies were used in the late Middle Ages is V. Gillespie, "Lukynge in haly bukes: Lectio in some Late Medieval Spiritual Miscellanies," *Analecta Cartusiana* 106, part 2 (1984), pp. 1–27.

89 For Cicely, C.A.J. Armstrong, "The Piety of Cicely, Duchess of York: A Study in Late Medieval Culture," in D. Woodruff, ed., *Essays for Hilaire Belloc* (New York, 1942), pp. 73–94; for Lady Margaret Hungerford, M.A. Hicks, "The Piety of Lady Margaret Hungerford (d. 1478)," *Journal of Ecclesiastical History* 38 (1987), pp. 19–38; for Lady Margaret Beaufort, M.G. Underwood, "Politics and Piety in the Household of Lady Margaret Beaufort," *Journal of Ecclesiastical History* 38 (1987), pp. 39–52.

90 The contemporary account of Lady Margaret Beaufort's devotional practices is by her chaplain, Saint John Fisher, later to be among the first martyrs of the Reformation in England, on the occasion of the month's mind of his patroness after her death in 1509, and was printed by Wynkyn de Worde; see J.E.B. Mayor, *The English Works of John Fisher, Bishop of Rochester* (Early English Text Society, o.s. 27) (1876), pp. 289–310. This is one of the best accounts of the sort of life of prayer, religious observance, and charity that was practiced by a pious noble lady of the period. Lady Margaret (1443–1509), the mother of Henry VII, was an exact contemporary of Margaret of York. Margaret Beaufort's reading of French devotional texts may have included works by Gerson and other authors read by Margaret of York, but we will never know what these books were. It is said of her, "As for medytacyon, she had dyvers bokes in Frensshe, wherwith she wolde occupy herselfe when she was wery of prayer"; Mayor, p. 295.

THE *APOCALYPSE* OF MARGARET OF YORK

Suzanne Lewis

A mong the many extraordinary manuscripts produced for Margaret of York, her richly illuminated *Apocalypse* bears special witness to the distinctive character of her book patronage.[1] Written around 1475 by the renowned editor and scribe David Aubert, the large and impressive manuscript in the Pierpont Morgan Library represents one of the last innovative redactions of a Gothic tradition that originated in England in the mid-thirteenth century.[2] Although Margaret's *Apocalypse* was probably commissioned during the duke's lifetime, the appearance of her arms on the shield suspended from the bottom frame on fol. 10 (fig. 23), without the joint heraldry, mottoes, and love-knotted initials CM so frequently encountered in her books from this period, suggests that the book was designed for the private devotional use of the duchess.[3] In the following remarks I shall attempt to account for some of the most striking transformations of medieval Apocalypse imagery in Margaret's book. What did the designer intend by them, and how might the new picture cycle have been "read" and experienced by the book's first owner?

Morgan 484 comprises a glossed French prose version of the Apocalypse, similar to that in Bibliothèque Nationale, fr. 403,[4] preceded by a table of rubrics and prologues and followed by two chapters of the *Golden Legend* relating to Saint Edmund, the Anglo-Saxon king martyred by the Danes. Written in two columns of twenty-eight lines of bold Gothic *lettre bâtarde* characteristic of the calligrapher David Aubert, the manuscript has the same dimensions and layout as *The Visions of Tondal* and *The Vision of the Soul of Guy de Thurno*, made for the duchess in Ghent in 1474.[5] However, the layout of the text and illustrations as well as the border patterns more closely resemble the group of grisaille-illuminated books written for Margaret of York by David Aubert between 1475 and 1477, which includes the elegant Boethius manuscript in Jena, in which the dedication page shows the celebrated scribe presenting his work to the duchess (see fig. 21).[6] In Morgan 484 each text division is headed by a tinted grisaille miniature, usually spanning both columns, within a segmented arched frame outlined in a thin gold line. The heavily rubricated text is enclosed within a similar frame that descends directly from the miniature above, as in Brussels 9272–76, thus binding the text and miniature within a single frame that separates them from the surrounding border. Probably designed by a specialist or *vignateur*, the same decorative framework appears in the margins of all the monochrome miniatures emanating from the Ghent workshop of the Master of Mary of Burgundy in the late 1470s.[7]

Probably painted in Ghent around 1475, Morgan 484's tinted grisaille miniatures can be attributed to a master within the circle of the Master of Mary of Burgundy.[8] Characteristically dominated by a luminous atmospheric light playing over the surfaces and through the spaces of both natural and supernatural landscapes, the tonal grays are suffused by pale colors, with dark blue skies, ocher grounds, and highlights of drapery and clouds picked out in white or gold. While the long oval heads

Figure 23.
Circle of the Master of Mary of Burgundy.
Saint Paul and Saint John, in the *Apocalypse* of
Margaret of York. New York, Pierpont Morgan
Library, M. 484, fol. 10.

framed in fine shaggy hair often resemble those of the Master of Moral Treatises,
the figures are stockier and broad-shouldered, forming heavily rounded volumetric
shapes covered in thick, often corrugated drapery folds modeled in strong chiar-
oscuro. The closest stylistic analogues can be found in the four tinted grisaille min-
iatures made for the duchess's collection of devotional texts in Brussels 9030–37,
which have been variously attributed to the Master of Moral Treatises and an imi-
tator of Alexander Bening.[9] Deep illusionistic spatial recessions are developed in the
landscape settings, but the figures tend to limit their activity to the foreground, only
rarely venturing back into the eerily lit gloom of the middle or far distances. Thus
the heavily modeled figures near the edge of the frame serve to mediate the conflict-
ing spatial claims of the text below and the deep atmospheric spaces that recede into
illusionistic depth behind the surface of the page beyond the frame.

Perhaps harking back to a thirteenth-century English model similar to fr. 403,
in which framed, half-page tinted outline drawings similarly stand above two col-
umns of text, the tinted grisaille of Morgan 484 continues an earlier Gothic tradition
of suppressing color to a suggestion rather than statement of hue. As image and script
stand together within a single frame, the fifteenth-century illustrations can still be
perceived by the reader as extensions of the monochromatic world of the text. In
contrast with the calligraphic line drawings in earlier Gothic *Apocalypses*, however,
the effect of the miniatures in Margaret's book is visually more complex. The mono-
chrome tonal gradations are relieved throughout by passages of tinted color, giving
the effect of the first perceptions of hue through the murky gloom of a dawning light,
thus evoking John's visions as literally "seen through a glass darkly." Although gri-
saille is used in isolated miniatures made for a number of books commissioned by
the duchess in this period, the choice of monochrome heightened with touches of
color for a long sequence of seventy-seven narrative pictures illustrating a glossed
text might have been inspired by the grisaille illustrations for the Book of Revelation

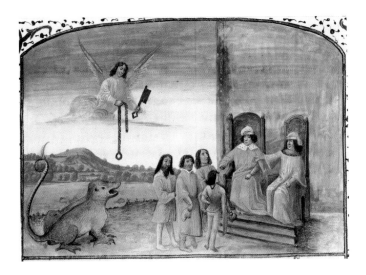

Figure 24.
Circle of the Master of Mary of Burgundy.
Dragon Enchained and the First Resurrection, in
the *Apocalypse* of Margaret of York. New York,
Pierpont Morgan Library, M. 484, fol. 100.

included in the copy of the *Bible moralisée* then in the ducal library and now in the Bibliothèque Nationale.[10] However, the Duke de Berry's early fifteenth-century *Apocalypse* (Morgan 133), with its dramatic juxtapositions of grisaille figures against brilliantly colored grounds, represents an equally compelling precedent that could have been known to the designer.[11]

From the great library amassed by Duke Philip the Good we can document three surviving fourteenth-century illustrated *Apocalypses*: Dresden 49, fr. 13096, and that in fr. 167, Jean le Bon's *Bible moralisée*.[12] But only a few traces of these manuscripts can be recognized in the remarkably fresh and imaginative new cycle devised for Margaret of York's book. Occasionally, we encounter eccentric compressions of textual narrative from the Dresden exemplar, such as the distinctive but peculiar merger of the Dragon Enchained with the First Resurrection (fig. 24).[13] The angel holding the key and chain hovers belatedly over a snarling dragon who, in his gratuitously extended moments of freedom, menaces the resurrected souls now standing before two enthroned judges. While the paratactic relationship of the two events implied by the text's conjunction "and" is conveyed by their left-to-right pictorial juxtaposition, the angel's failure to lock up the dragon contradicts the intention of the text's past tense, resulting in an eerie suspension of time and an absence of closure that leaves the satanic power of the dragon still at large for a thousand years. However, a more straightforward iconographic resonance from a fourteenth-century model can be cited, for example, in the representation of the Fifth Seal, which copies a conventional configuration, such as that given in New College 65, with its symmetrical disposition of two angels holding priestly pallia above the waiting martyrs.[14]

The First Horseman (fig. 25) reaching for a crown extended by a hand from heaven also suggests a reference to the distinctive iconography in Dresden 49 or in the earlier mid-thirteenth-century English version in fr. 403, which in this period had been acquired by Louis de Gruuthuse of Bruges, many of whose manuscripts were copied for the ducal library.[15] Although rare among Gothic *Apocalypse* illustrations of this passage, the gesture could also have been directly generated by the text, "This crown was given to him." Indeed, the singularly innovative representation of the rider's mount literally stepping out of the pages of the huge book lying on the ground at the right responds to an aberrant variation of the text unique to Margaret's manuscript, which reads "a white horse is coming out of the book" ("ung tout blanc cheval . . . ussir du livre"). An embryonic or incipient stage in the formulation of this remarkable deviation can be seen in the *Apocalypse* of Charles the Bold (fig. 26),[16] where the rider plunges from a cloud in which the Lamb opens the book, while at the same time the leaves turn, as if by an unseen hand, in John's codex lying in the foreground. The Second and Third Horsemen are then combined in a single illustration in which the Second similarly emerges from an open book. But the textual order of the figures is reversed, so that the Second Horseman, who raises his sword

Figure 25.
Circle of the Master of Mary of Burgundy.
First Horseman, in the *Apocalypse* of Margaret
of York. New York, Pierpont Morgan Library,
M. 484, fol. 33v.

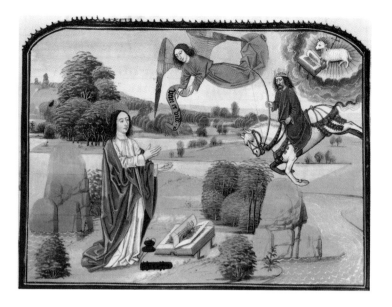

Figure 26.
Circle of Loyset Liédet (?). *First Horseman*, in New Testament Lections and the *Apocalypse* of Charles the Bold. New York, Pierpont Morgan Library, M. 68, fol. 174.

over two murderers and their victims, is aligned above the glossing text that informs the reader that the rider's sword signifies the earthly power he has been given.

Although Margaret's spiritual meditations on the Apocalypse were clearly meant to be evoked and sustained by the picture cycle, her devotions were nevertheless first mediated through reading. In contrast with the roles of dreamer or writer assigned to John in traditional Gothic images, as in the thirteenth-century Lambeth *Apocalypse* (fig. 27),[17] the exile on Patmos (fig. 28) is characterized as a reader who is interrupted by the angel trumpeting the command to write, which signals to the reader-viewer that the visions are already encoded within the book. In emulation of Saint John, the reader is thus invited to experience "revelation" through reading and seeing an unfolding narrative cycle of texts and images. As in the *Apocalypse* of Charles the Bold, the experience of reading and spiritual imagination are closely linked throughout the long cycle of illustrations.[18] Thus John no longer writes or transmits the Letters to the Seven Churches of Asia (fig. 29) as, for example, in the Douce *Apocalypse* of circa 1270,[19] but serves as the passive receptor of the Lord's commands and conduit of divine messages to which he has access only through the open book on his lap. As in the Vienna book of hours (see fig. 22) made around 1477 for Margaret's stepdaughter, Mary of Burgundy,[20] the duchess is offered a series of images that seem to encourage an imaginative merger of her present experience of reading the text with the content of its discourse.

In Margaret's *Apocalypse*, the importance of books and reading becomes almost

Figure 27.
Anonymous workshop. *John on Patmos*, in the Lambeth *Apocalypse*. London, Lambeth Palace Library, Ms. 209, fol. 1. Photo courtesy the Conway Library, Courtauld Institute of Art, and Lambeth Palace Library.

Figure 28.
Circle of the Master of Mary of Burgundy. *John on Patmos*, in the *Apocalypse* of Margaret of York. New York, Pierpont Morgan Library, M. 484, fol. 14.

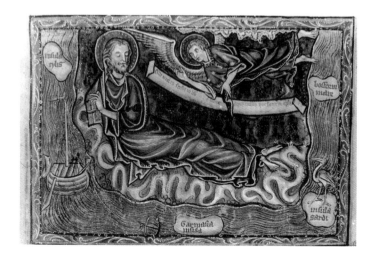

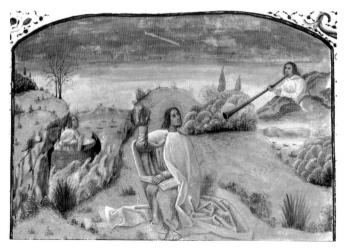

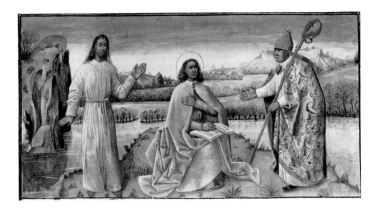

Figure 29.
Circle of the Master of Mary of Burgundy.
Letter to the Church of Thyatira, in the *Apocalypse*
of Margaret of York. New York, Pierpont
Morgan Library, M. 484, fol. 20.

obsessive, as suggested by the extraordinary transformation of the traditional Gothic representation of the *Last Judgment* (fig. 30) into a floating archival library. In contrast with the conventional formulation exemplified by the Eton *Apocalypse* (fig. 31),[21] a chorus of giant chronicles now dominates the celestial space, dwarfing the distant Lord, as the turning pages reveal the recorded deeds by which the waiting resurrected dead will be judged. While the smoke-filled inferno gives up its dead on the right, the four kneeling figures in the foreground create an awesome tension of hope and dread as their fate literally unfolds in the weighty tomes suspended above them, reminding the duchess of the salvific power of the book similarly opened before her.

In fourteenth- and fifteenth-century vernacular *Apocalypses*, iconographical innovations frequently occur in response to freshly literal readings of the text. The picture cycle in Margaret of York's manuscript constitutes a brilliant but typical witness to the vitality of invention still provoked by this text in the late Middle Ages. Somewhat resembling the fourteenth-century English version in Spencer 57, the angel with the book in Revelation 10 first appears in visually verbatim attire, partially "dressed in a cloud" (fol. 51v).[22] In a precedent-breaking instance of textual literalism, Margaret's seven-headed Dragon vomits water from *all* his mouths as he pursues the Woman in the Sun, who eludes his battery of threatening liquid tongues by gliding safely out of reach on a small gondola formed by the crescent moon (fol. 63).[23] In an extremely torturous pictorial reading of "the seven heads [of the beast] are the seven hills, and the woman is sitting on them," we see the Harlot of Babylon (fig.

Figure 30.
Circle of the Master of Mary of Burgundy.
Last Judgment, in the *Apocalypse* of Margaret of
York. New York, Pierpont Morgan Library,
M. 484, fol. 103v.

Figure 31.
Anonymous workshop. *Last Judgment*, in the
Eton *Apocalypse*. Windsor, Eton College,
Ms. 177, p. 93. Reproduced by permission of
the Provost and Fellows of Eton College and
the Conway Library, Courtauld Institute
of Art.

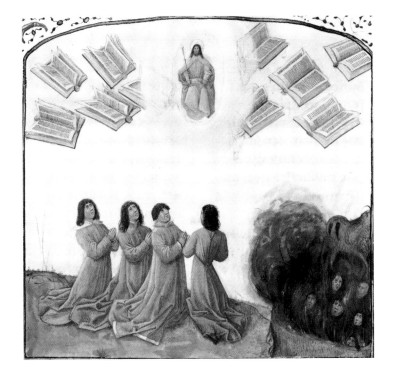

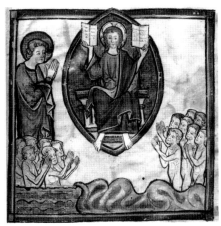

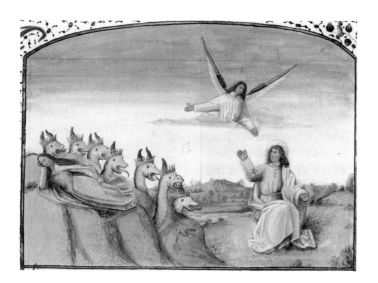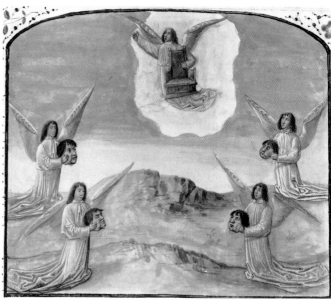

32) awkwardly stretched across three of the hills, from which seven bestial heads emerge, snarling at John as he listens to the angel explain their symbolism. In a scrupulous graphic rendering of the simile "beautiful as a bride" (21: 2), a crowned woman stands at the portal of the Heavenly Jerusalem (fol. 105), constituting a textual image developed in the same vein but more simply than the early fifteenth-century verbatim transcription in Chantilly 28.[24] However, the most eccentric new pictorial reading of the text occurs in the illustration of the Four Winds (fig. 33), where the designer responds literally to a unique corruption of the text: "I saw another angel, and he was carrying the *throne* of the living God," *siege* having been written in place of *sceau* (seal). Departing radically from the more traditional but nevertheless inventive Gothic iconography exemplified in the thirteenth-century Getty *Apocalypse* (fig. 34),[25] where a winged messenger bears a scroll "sealed" with a flaming sunburst, Morgan 484's angel dutifully carries a heavy, high-backed throne with as much panache as he can muster as he rises within the break in the clouds. Coupled with the example of the Horsemen leaping out of their books, nothing could offer more persuasive evidence that the text of Margaret's *Apocalypse* was actually read exactly as it had been written by David Aubert when the iconography of the pictures was being laid out, perhaps under the tutelage of one of the duchess's spiritual advisers.

In a similar vein, the designer of Margaret's *Apocalypse* continues an older Gothic tradition of pictorial exegesis whereby images acquire interpretive components not present in the text. The miniature of the Fourth Horseman (fig. 35) can serve as a solitary but remarkably complex example of this phenomenon. In a literal response to the text, the rider appears in the guise of a rotting corpse, an image not

Figure 32.
Circle of the Master of Mary of Burgundy. *Harlot of Babylon Lying on the Hills of Rome*, in the *Apocalypse* of Margaret of York. New York, Pierpont Morgan Library, M. 484, fol. 85v.

Figure 33.
Circle of the Master of Mary of Burgundy. *Four Winds*, in the *Apocalypse* of Margaret of York. New York, Pierpont Morgan Library, M. 484, fol. 39.

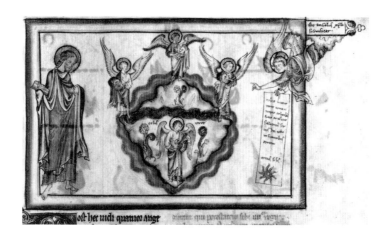

Figure 34.
Anonymous workshop. *Four Winds*, in the Getty *Apocalypse*. Malibu, J. Paul Getty Museum, Ms. Ludwig III 1, fol. 9.

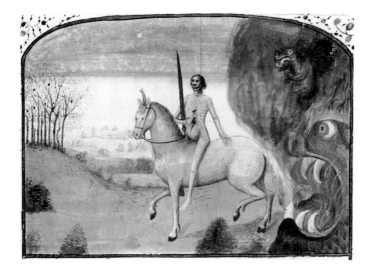

Figure 35.
Circle of the Master of Mary of Burgundy.
Fourth Horseman, in the *Apocalypse* of Margaret
of York. New York, Pierpont Morgan Library,
M. 484, fol. 35v.

far removed from the widely known tradition quoted in the Duke de Berry's version.[26] However, the pale horse has sprouted a single small horn for which there is no iconographical precedent. Nor is an explanation immediately forthcoming from the gloss, which reads, "The horse signifies hypocrites, and the devil who rules over them is called Death, because through them he can more easily deceive the others."[27] The horse's newly acquired appendage, however, would have been readily recognized by a fifteenth-century viewer as the little horn of Daniel 7: 7–8, which served as a conventional symbol for the Antichrist in late medieval eschatological texts.[28] Here its meaning is logically grafted onto an image explicated in the gloss as the devil in his role as the great deceiver. An obvious analogy between the apocalyptic horse and little-horned beast can be drawn from their respective fourth positions in the visionary sequences of the Books of Revelation and Daniel. But another, more compelling connection can be found in the old Berengaudus Apocalypse commentary, still circulating in the fifteenth century, as attested by the vernacular version in the Duke de Berry's *Apocalypse*, Morgan 133, where the fourth horse is said to pertain to the Antichrist.[29]

In a few isolated cases, the designer of Margaret's book revised traditional Apocalypse illustrations to accommodate them to the devotional interests of the book's owner. In the *Adoration of the Lamb* (fig. 36), for example, the conventional mandorla-enframed figure of the enthroned Lord has been expanded to include two figures seated together, forming a familiar medieval configuration of the Trinity based on Psalm 109 ("The Lord said to the lord: Sit at my right hand").[30] The new modification of the Apocalypse iconography can be seen as a response to Margaret's

Figure 36.
Circle of the Master of Mary of Burgundy.
Adoration of the Lamb, in the *Apocalypse* of
Margaret of York. New York, Pierpont Morgan
Library, M. 484, fol. 31.

Figure 36a.
Circle of the Master of Mary of Burgundy.
The Tree of Life, in the *Apocalypse* of Margaret
of York. New York, Pierpont Morgan Library,
M. 484, fol. 114v.

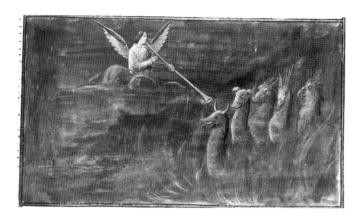

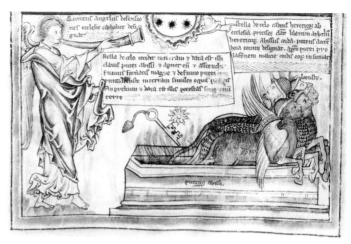

special veneration of the Trinity, documented in a contemporary representation of the duchess kneeling before an altar on which the Trinity appears in an alternative formulation of the Throne of Mercy or *Gnadenstuhl* (see fig. 19).[31] The self-reflexive devotional image appears on the folio following the text of Jean Gerson's *Traictie de mendicite spirituelle*, which ends with a short exposition on the special power of the soul's meditation on the Trinity.[32]

Toward the end of Margaret's *Apocalypse* an entirely new illustration of the Tree of Life (fig. 36a) supplants the traditional representation of the River of Life, presumably prompted by the commentary's references to the cross, and at the same time appealing to the duchess's interest in the cult of Holy Cross.[33] The gloss reads, "On the two sides of the tree of life are those saved in paradise by faith in the cross" (fol. 115).[34] Margaret's Tree of Life stands in isolated splendor within the walled precinct of the Heavenly Jerusalem. Because the tree has been placed off the central axis, out of alignment with the throne of God, and the left side is overweighted by the presence of both John and the angel, the empty space at the right appears to be reserved for the reader who can identify herself in the gloss as one of those saved by the cross, thus balancing the spiritual equation within the visionary image.

Although Margaret's devotion was focused largely on traditional objects of spiritual contemplation, she was also attracted to more exotic aspects of pious meditation, as revealed in *The Visions of Tondal*. The miniatures depicting the horrific demons encountered by the Irish knight in his visionary peregrination into the infernal regions could well have inspired the pre-Boschian inventions of such terrifying hybrid creatures as the Locusts in Morgan 484 (fig. 37). Breaking with the conventional Gothic formula, here exemplified by Morgan 524 (fig. 38),[35] the Locusts become

Figure 37.
Circle of the Master of Mary of Burgundy. *Fifth Trumpet and Locusts*, in the *Apocalypse* of Margaret of York. New York, Pierpont Morgan Library, M. 484, fol. 47.

Figure 38.
Anonymous workshop. *Fifth Trumpet and Locusts*, in the Morgan *Apocalypse*. New York, Pierpont Morgan Library, M. 524, fol. 5.

Figure 39.
Circle of the Master of Mary of Burgundy. *Locusts*, in the *Apocalypse* of Margaret of York. New York, Pierpont Morgan Library, M. 484, fol. 48v.

Figure 40.
Anonymous workshop. *Locusts*, in an *Apocalypse*. Oxford, Bodleian Library, Ms. Selden Supra 57, fol. 69.

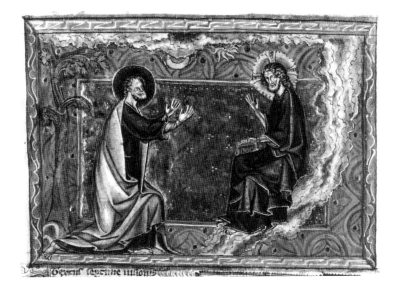

giant-horned and bird-headed phantoms whose eyes, teeth, and sharp beaks give off a menacing phosphorescence in the murky darkness as they emerge from the flames of the abyss.[36] In the next frame (fig. 39), instead of eagerly galloping across the page, as in the fourteenth-century Selden *Apocalypse* (fig. 40), the Locusts have been transmogrified into strangely placid beasts standing motionless in a pasture. Grotesquely silhouetted against the bucolic landscape, three of the powerful hybrid creatures, resembling plow horses with women's heads, gaze out of the frame at the reader, as if in a hallucinatory nightmare.

Within the context of the private, silent reading of the Apocalypse in the later Middle Ages, the picture cycle in Margaret's manuscript was designed to engender an intensely personal, self-reflexive meditative experience. As in the fourteenth-century book made for Lady Johanna de Bohun,[37] the penultimate miniature comprises an aberrant spectral image of the Lord standing alone, the pictorial embodiment of a singular charismatic voice (fol. 117v). With one hand raised in a speaking gesture while the other holds an open book denoting the text, "I have sent my angel to make these revelations to you," Christ addresses the reader rather than Saint John as the direct recipient of the vision. In the traditional Gothic iconography for the last image in the cycle, the seer is represented kneeling before the Lord, as in the thirteenth-century Gulbenkian *Apocalypse* (fig. 41).[38] But Margaret's picture cycle ends uniquely with an image of the Second Coming (fig. 42) accompanying the last gloss on the text, "I shall indeed be with you soon." Here the reader sees the Lord enthroned within a luminous aureole, displaying his wounds, as he descends upon the earth, whose trees and mountains mark a horizon already darkened by smoke from the waiting inferno below. Instead of seeing John gaze at the Lord, as in the Gulbenkian manuscript, the reader is given direct access to his vision. The page opens itself before her eyes, and its transparency reveals John's ultimate, privileged experience in the more imminent dimension implied by the perspectival image beyond the frame. The tall columnar format of the miniature distances the vision but at the same time seems to guide the frontal figure as he descends, so that the Lord is perceived to approach the reader slowly and gently but inexorably head on, reminding her to be prepared for the hour of the Lord's Second Coming. This hour, as the expanded gloss warns, no one knows, "not even the angels of heaven, nor the patriarchs, prophets, apostles, martyrs and confessors, but only the very holy Trinity of heaven"—to whom Margaret gave special devotion.[39]

Margaret of York's richly but eccentrically illuminated *Apocalypse* constitutes an important component in her personal collection of books used for private, meditative reading. Following the example of her mother, the pious Cicely Neville, the duchess centered her spiritual life on the regime of the *Devotio Moderna*, calling for personal study and contemplation as well as daily worship and prayer.[40] While her

Figure 41.
Anonymous workshop. *John Adores the Lord*, in the Gulbenkian *Apocalypse*. Lisbon, Calouste Gulbenkian Museum, Ms. L.A. 139, fol. 76v. Photo courtesy the Conway Library, Courtauld Institute of Art, London, and the Gulbenkian Museum.

Figure 42.
Circle of the Master of Mary of Burgundy. *Second Coming*, in the *Apocalypse* of Margaret of York. New York, Pierpont Morgan Library, M. 484, fol. 119.

devotion was primarily private and solitary, as demonstrated in her portrait in Brussels 9272–76 (see fig. 19), it was important that her prayers and meditation be observed and emulated by the court, as we see in the illustration in Douce 365 (see fig. 17). Thus the very large dimensions of Margaret's *Apocalypse*, as well as those of her manuscripts of moral treatises, *La somme le roi*, *The Visions of Tondal*, and *The Vision of the Soul of Guy de Thurno*, suggest a similarly quasi-public context for their devotional reading. The self-reflexive representations of Margaret kneeling in prayer before carved or painted sacred images in her books of moral instruction find resonances of a more concrete order in her illustrated *Apocalypse*. Indeed, the last images in Morgan 484 generate for the reader an experience comparable to the direct vision evoked in the dedication miniature of Nicolas Finet's *Le dialogue . . . à Jésus Christ*, fol. 1v (see fig. 16), in which the resurrected Christ appears to the duchess in her chamber.[41] Responding in a "beatifique vision sans couverture" to Margaret's prayer that he "illuminate her inner eyes" ("Mon dieu mon creator et mon redemptor enluminate mes yeulx interiores"), Christ informs her that he is the Lord of the Apocalypse ("Je suis celluy qui ay dit en lapocalipse").[42] Margaret's contemplation of the Second Coming in the last *Apocalypse* miniature (fig. 42) can further be seen as a response to Jean Gerson's reminder, included in her collections of moral treatises, of the Lord's sudden, unannounced, and secret descent to the soul.[43] In Morgan 484's concluding images of the Lord directly approaching and addressing the reader, Margaret is invited, as Christ had urged in Finet's imaginary dialogue with the duchess, to "considere dont maintenant et pense quelle gloire et quelle beatitude plus que dire ne se peult est et sera de moy veoyz face a face en ma divinite."[44]

Notes

1 On Margaret of York's collection of books, see Brussels 1967a, pp. 13–14, 330–33; Dogaer 1975; Hughes 1984; Weightman 1989, pp. 204–12.

2 New York, Pierpont Morgan Library, M. 484 (Appendix no. 19): 124 fols., 360×260 mm; 79 framed illustrations in tinted grisaille. Formerly in the collections of Prince Galitzin, Rev. T. Williams, P.A. Hanrott, Dr. G.H.S. Johnson of the Oxford Observatory (1839–42), and Alfred H. Huth. Glossed Apocalypse in Norman-Picard dialect in two columns of 28 lines in *lettres bâtardes*, with long rubrics introducing each text division (fols. 1–119v); two chapters from the *Golden Legend* of Jacobus de Voragine, as *La vie de Saint Edmonde le Martyr*. Burnished gold titles. Rubric foliation shows four leaves missing at the beginning of the manuscript. Quire structure somewhat irregular: I^{10-2}, II10, III6, IV10, V^6, VI10, VII6, VIII8, IX6, X-XIV8, XV $^{6-1}$. See *Catalogue of the Famous Library of Printed Books, Illuminated Manuscripts . . . Collected by Henry Huth . . . and Augmented by His Son, Alfred H. Huth* (London, 1911), vol. 1, p. 40; M. R. James, *The Apocalypse in Art* (The Schweich Lectures of the British Academy) (London, 1931), pp. 12, 73, no. 49; *Exhibition of Illuminated Manuscripts Held at the New York Public Library*, exh. cat. (Pierpont Morgan Library, New York, 1934), p. 49, no. 105; S. de Ricci and W.J. Wilson, *Census of Medieval and Renaissance Manuscripts in the United States and Canada*, vol. 2 (New York,

1937), pp. 1457–58; Pächt 1948, pp. 62–63, no. 2; Brussels 1959, p. 156, no. 199; Ghent 1975, no. 606, pp. 370–71; Dogaer 1975, p. 111; Hughes 1984, p. 56, no. 2; R.K. Emmerson and S. Lewis, "Census and Bibliography of Medieval Manuscripts Containing Apocalypse Illustrations, ca. 800–1500, II," *Traditio* 41 (1985), p. 396, no. 89. On the thirteenth-century English Gothic Apocalypse picture cycles, see G. Henderson, "Studies in English Manuscript Illumination, II," *Journal of the Warburg and Courtauld Institutes* 30 (1967), pp. 117–37; N. Morgan, *Early Gothic Manuscripts. II: 1250–1285* (A Survey of Manuscripts Illuminated in the British Isles, 4, pt. 2) (London, 1988), pp. 16–19; S. Lewis, "Exegesis and Illustration in Thirteenth-Century English Apocalypses," in B. McGinn and R. Emmerson, eds., *The Apocalypse in the Middle Ages* (Ithaca, 1992, in press). The formulation and dissemination of the text cycles will be fully analyzed in my *Reading Images: The Gothic Illustrated Apocalypse and Its 13th-Century Archetypes*, now in preparation.

3 Margaret's arms, comprising those of England dimidiated by those of Burgundy, also occur in Margaret's copies of Nicolas Finet, *Le dialogue . . . à Jésus Christ* (Appendix no. 2), London, British Library, Add. Ms. 7970, fol. 1v, where an emblazoned shield is suspended on a strap by an angel in the left margin; the volume of moral and religious treaties (Appendix no. 8), Oxford, Bodleian

Library, Ms. Douce 365, fol. 155, where the arms of the duchess have been added in the margin; and *La somme le roi* (Appendix no. 6), Brussels, Bibliothèque Royale, Ms. 9106, fol. 9. In a book of hours dating before 1468 (Christie's, London, May 26–27, 1965, lot 195; Appendix no. 13), a shield with Margaret's arms appears on an inserted leaf at the end of the manuscript, while the letter M is repeated four times in the frame of the miniature and text. Unlike many of her books, however, the Morgan *Apocalypse* does not bear Margaret's signature on the last folio.

4 For the glossed text, see L. Delisle and P. Meyer, *L'Apocalypse en français au XIIIe siècle* (Paris, 1900), pp. 1–131; a more recent redaction is given in Y. Otaka and H. Fukui, *Apocalypse (Bibliothèque Nationale, fonds français 403)* (Osaka, 1981), pp. 113–58.

5 Malibu, J. Paul Getty Museum, Mss. 30 and 31 (Appendix nos. 4, 5); see "Acquisitions/ 1987," *GettyMusJ* 16 (1988), pp. 150–54, nos. 17–18; Malibu 1990, p. 61. For specific data on the relationship of these three manuscripts, see Thomas Kren's introduction, p. 19 and n. 53, above.

6 Jena, Universitätsbibliothek, Ms. El. f. 85, fol. 13v (Appendix no. 7); Brussels 1959, p. 154. Like this manuscript, however, Margaret's other grisaille manuscripts contain only a dedication page or as few as four miniatures, as in Brussels, Bibliothèque Royale, Ms. 9030–37 (Appendix no. 22), or five, as in Douce 365 and Brussels, Bibliothèque Royale, Ms. 9272–76 (Appendix no. 21).

7 As pointed out by Pächt 1948, p. 24.

8 Ibid., pp. 20, 62–63, nos. 2–6, where the miniatures are attributed to the Master himself. However, the framed illustrations can probably no longer be regarded as the Master's early work; see Van Buren 1975, p. 289, citing the work of Lieftinck 1969. Cf. also Dogaer 1987, pp. 145–49.

9 See Brussels 1977, pp. 99–100, no. 20. Also close in style are the miniatures in Margaret's *La somme le roi* (Brussels 9106) and the volume of moral treatises (Brussels 9272–76), from which the Ghent disciple of the Master of Mary of Burgundy has been named; see Brussels 1977, nos. 16–17.

10 Paris, Bibliothèque Nationale, Ms. fr. 167; see A. de Laborde, *La Bible moralisée illustrée* (Paris, 1911–27), vol. 5, pp. 92–102, pls. 724–38; F. Avril, "Un chef d'oeuvre de l'enluminure sous le règne de Jean le Bon: La Bible moralisée, manuscrit français de la Bibliothèque Nationale," *Fondation Eugène Piot: Monuments et mémoires* 58 (1972), pp. 95–125; R.K. Emmerson and S. Lewis, "Census and Bibliography of Medieval Manuscripts Containing Apocalypse Illustrations, ca. 800–1500, III," *Traditio* 42 (1986), pp. 462–63, no. 156.

11 See Meiss 1974, pp. 252–56, 298–303; Emmerson and Lewis (note 2), pp. 395–96, no. 87.

12 Dresden, Sächsische Landesbibliothek, Ms. Oc. 49; see R. Bruck, *Die Malereien in den Handschriften des Königreichs Sachsen* (Dresden, 1906), pp. 129–44; Emmerson and Lewis (note 2), pp. 378–79, no. 54. Paris, Bibliothèque Nationale, Ms. fr. 13096; see S. Lewis, "The Apocalypse of Isabella of France: Paris, Bibl. Nat. Ms. fr. 13096," *Art Bulletin* 72 (1990), pp. 224–60. On Ms. fr. 167, see note 10, above.

13 On fol. 48 in Dresden 49, an angel flying with a key at the left holds the dragon by a chain around its neck. As in Morgan 484, the dragon snarls at the judges seated on the right. An identical representation is given in British Library, Add. Ms. 38118, fol. 39. Other distinctive text divisions from Dresden 49 can be seen in Morgan 484's merger of the Sixth Trumpet and the Army of Beasts on fol. 49v, as well as the isolation of the Majesty for 4: 6–8 on fol. 27v.

14 Oxford, New College, Ms. 65, fol. 23; Emmerson and Lewis (note 2), p. 403, no. 102. However, the iconography appears only in the English versions, such as Lambeth 75, fr. 9574, Bodleian Ms. Selden Supra 38, fol. 58, and in the Queen Mary group headed by British Library, Royal Ms. 19 B XV.

15 Bibliothèque Nationale, Ms. fr. 403, fol. 7v; see Otaka and Fukui (note 4), p. 32; F. Avril and P. Stirnemann, *Manuscrits enluminés d'origine insulaire de la Bibliothèque Nationale* (Paris, 1987), pp. 79–80, no. 123; Morgan (note 2), pp. 63–64, no. 103; S. Lewis, "The Enigma of Fr. 403 and the Compilation of a Thirteenth-Century English Illustrated Apocalypse," *Gesta* 29 (1990), pp. 31–43.

16 Pierpont Morgan Library, M. 68, fol. 174; see Emmerson and Lewis (note 2), p. 395, no. 87.

17 London, Lambeth Palace Library, Ms. 209, fol. 1; see Morgan (note 2), pp. 101–05, no. 126; idem, *The Lambeth Apocalypse: Manuscript 209 in Lambeth Palace Library* (London, 1990). The dominant image of the seer on Patmos persists into the late fifteenth century, as witnessed by its appearance in the Breviary of Queen Isabella of Castile, British Library, Add. Ms. 18851, fol. 309; see Malibu 1983, pp. 40–48, pl. v.

18 On fol. 149 of Morgan 68, John is shown seated on the island, holding an open codex on his lap, while the pages turn in another book on the ground at his right; the evangelist looks up from his book to acknowledge the presence of the angel who hovers above, trumpeting the command to write ("scribe").

19 Bodleian Library, Ms. Douce 180, p. 8; see P. Klein, *Endzeiterwartung und Ritterideologie: Die englischen Bilderapokalypsen der Frühgotik und MS Douce 180* (Graz, 1983), facsimile.

20 Vienna, Österreichische Nationalbibliothek, Cod. 1857, fol. 14v; see F. Unterkircher, *Burgundisches Brevier: Die schönsten Miniaturen aus dem Stundenbuch der Maria von Burgund, Codex Vindobonensis 1857* (Graz, 1974), p. 34, and Harthan 1977, pp. 110–13.

21 See Morgan (note 2), pp. 119–22, no. 137.

22 See W.M. Voelkle, *The Pierpont Morgan Library. Masterpieces of Medieval Painting: The Art of Illumination* (Chicago, 1980), p. 27, microfiche 6G6. On New York Public Library, Ms. Spencer 57, see Emmerson and Lewis (note 2), p. 398, no. 91.

23 Cf. fr. 403, fol. 21v; Otaka and Fukui (note 4), p. 60.

24 Chantilly, Musée Condé, Ms. 28, fol. 117v; see Meiss 1974, pp. 252–55, 296–98, and Emmerson and Lewis (note 2), pp. 377–78, no. 52.

25 J. Paul Getty Museum, Ms. Ludwig III 1, fol. 9; see A. von Euw and J. Plotzek, *Die Handschriften der Sammlung Ludwig*, vol. 1 (Cologne, 1979), pp. 191–98, and Emmerson and Lewis (note 2), p. 392, no. 80.

26 Pierpont Morgan Library, M. 133, fol. 13v; see Voelkle (note 22), pp. 8–9, microfiche 3B4.

27 "Par le cheval paille sont signifiee les ypocrites e le dyable quy en eulz regne si est nomine mort, pour tant que par les ypocrites le deable puelt trop mieulx decepvoir les autres car lennemy denfer de tant quil est plus prive de la personne soit bonne ou autre de tant poeult il plus nuire et greuer a toute heure"; compare the variant text in Delisle and Meyer (note 4), p. 29.

28 R.K. Emmerson, *Antichrist in the Middle Ages: A Study of Medieval Apocalypticism, Art, and Literature* (Seattle, 1981), pp. 21, 44, 180–81.

29 Berengaudus, *Expositio in Apocalypsin, PL* 17, col. 920: "Videntur haec quae de equite quarto dicuntur ad Antichristum pertinere."

30 On the iconography of the Trinity in Psalm 109, see W. Braunfels, "Dreifaltigkeit," in E. Kirschbaum et al., eds., *Lexikon der christlichen Ikonographie*, vol. 1 (Rome and Freiburg, 1968), col. 533. A similar revision occurs in Morgan 484's representation of *John Consoled by the Elder* (fol. 30), where an identical pair of Christological figures is enthroned within a celestial mandorla.

31 Brussels 9272–76 (Appendix no. 21), fol. 184; Brussels 1959, p. 155, no. 196, pl. 8; Brussels 1977, p. 97, no. 17. On the iconography of the Throne of Mercy, see Braunfels (note 30), col. 535.

32 Jean Gerson, *La mendicité spirituelle*, in P. Glorieux, ed., *Oeuvres complètes*, vol. 7 (Paris, 1966), pp. 279–80: "Meditacion de l'ame envers la Trinite divine pour avoir especialment force en vertus et bonne vie. . . . Si t'aprestes maintenant en ceste glorieuse solempnité de la Trinite benoite, affin que par la puissance du pere, en la sapience du filz et pour la boute et doulceur du saint esperit, tu ayes force, constance et perseverance de bien ouvrer." This text is given in

Brussels 9272–76, fols. 165–181v, and in Brussels 9305–06 (Appendix no. 3), fols. 7–75v, both under the title *Traictie de mendicite spirituelle* (*Le secret parlement de l'homme comtemplatifz a son ame a l'omme sur la poverte et mendicite espirituelle*. Both manuscripts bear Margaret's arms and signature; see J. van den Gheyn, *Catalogue des manuscrits de la Bibliothèque royale de Belgique*, vol. 3 (Brussels, 1903), pp. 88–89, no. 1694, and p. 512, no. 2491; also M.-J. Pinet, *La Montaigne de contemplacion et la Mendicité spirituelle de Jehan Gerson: Etude de deux opuscules français de Gerson sur la prière* (Lyons, 1927).

33 See Weightman 1989, pp. 201–02.

34 "Et de ces deux pars fut larbre de vye. Car de lune partie et de lautre ya des saulvez en paradis par la foy de la croiz"; see Delisle and Meyer (note 4), p. 125.

35 Pierpont Morgan Library, M. 524, fol. 5; see Morgan (note 2), pp. 92–94, no. 122.

36 Another resonance of Margaret's *Tondal* manuscript can be seen in Morgan 484's aberrant representation of the Heavenly Jerusalem (fol. 112v) as a high, buttressed stone masonry wall, reminiscent of the celestial wall encountered by the angel and Tondal's soul, which is described in clearly apocalyptic terms as having the same twelve precious stones; see Malibu 1990, p. 59, pl. 20.

37 Oxford, New College, Ms. 65, fol. 88; see Lewis (note 12), fig. 43.

38 Lisbon, Calouste Gulbenkian Museum, Ms. L.A. 139, fol. 76v; see Morgan (note 2), pp. 108–10, no. 128, and S. Lewis, "Tractatus adversus Judaeos in the Gulbenkian Apocalypse," *Art Bulletin* 68 (1986), pp. 343–66.

39 "De cest iourz ne de ceste heure nulz ne e seit non pas les angeles du chiel ne le sceuent pas ne les patriarches ne les prophetes ne les appostres ne les martirs ne les confesseurs de paradis fors seulement la tressainte trinite du chiel." Delisle and Meyer (note 4), pp. 130–31, do not give this text.

40 See Weightman 1989, pp. 198–99.

41 Attributed to the Girart de Roussillon Master, circa 1470; see Appendix no. 2; Pächt 1948, pp. 13 and 69, pl. 1; Dogaer 1975, p. 110. In his dedication, Finet states that he composed the work at the request of the duchess. The dialogic text is set out with rubrics identifying the two speakers. In one speech, Christ calls Margaret "ma fille" and reminds her of her powerful position as sister of Edward, King of England, and wife of Charles, Duke of Burgundy, and urges her to devote herself to spiritual concerns.

42 Fols. 5, 7, 128.

43 Gerson, *La mendicité spirituelle*, in Glorieux (note 32), p. 279: "Or pleust a Dieu que ie peusse paravant savoir l'eure quant il daigneroit descendre en moy. Que n'envoye il aucun des messagiers par avent affin que ie fuce toute preste et appareillee a le recevoir deneument, sainttement et honestement comme il appartient. Car il vient aucun foiz si secretement et heurte a l'uys quant je suy si deproveue et occuppee ailleurs, qu'il s'est parti ainsoiz que ie puisse li venir au devant et le recevoir appertement." On Gerson's texts in Brussels 9305–06 and 9272–76, see note 32, above.

44 Fols. 128v–29; see note 41, above.

MARGARET OF YORK'S GUIDE TO THE PILGRIMAGE
CHURCHES OF ROME

Walter Cahn

T he rather modest purpose of the following remarks is to introduce and
briefly discuss a manuscript that represents a recent addition to our knowl-
edge of Margaret of York's library. This manuscript (Appendix no. 17), for-
merly in the possession of a Swedish collector, was acquired by the Beinecke Rare
Book and Manuscript Library at Yale University in 1982.[1] It is a pilgrims' guide to
the churches of Rome or, more accurately, an enumeration of the seven major Roman
churches, accompanied by detailed lists of indulgences that the pilgrim could gain
from visiting them as well as lesser sanctuaries of the city. The volume consists of
forty-seven vellum folios, measuring a mere 127×88 mm, and now equipped with a
red morocco binding with gold stamps datable in the later seventeenth century. The
opening page features in the lower margin Margaret's coat of arms, which crosses the
royal arms of England with those of Burgundy (fig. 43). The text is written in a reg-
ular *lettre bâtarde*, and the opening heading in red furnishes a rough description of
the contents: "Sensieut une bonne information pour tous ceulx et celles quy ont la
grace de acquerir par tout ou ilz soyent les pardons et indulgences quy sont a Rome
tout au long de l'an."

The all-encompassing address to "ceulx et celles" (all men and all women)
might lead one to conclude that the manuscript was not made for Margaret, and the
text elsewhere uses only masculine plural or generally neutral forms in order to in-
struct the reader ("ceulx qui auront," "ils le feraient."). There is also no colophon
or anything else in the text that ties the work to the duchess in an explicit way. This
leads to the conjecture that Margaret acquired the manuscript ready-made and
merely had her coat of arms added—in a slightly erratic way, as can be observed—
when it came into her possession.[2] This supposition is reinforced by the existence
of a second manuscript containing the same text and illuminated in the same work-
shop, though not in an identical manner (compare figs. 45 and 46, 48 and 49, 50 and
51), today preserved in the Biblioteca Reale at Turin. The Turin codex, which is a
little larger in size and contains some additional prayers and one more miniature,
bears the ex libris of King Victor Emmanuel II (1861–78), but does not present any
evidence of earlier owners.[3] It is thus conceivable that we have in these two copies
of the pilgrims' guide part of a serial production of such manuals that was offered by
the atelier to an aristocratic clientele. The text, of course, provides information of a
highly specific and standardized nature, and the anonymous model from which it was
copied or compiled probably contained the general "unisex" forms of address, which
the scribe of the Beinecke and Turin manuscripts left unchanged.

Following the heading, the guide informs the pilgrim that there are in Rome a
great number of churches and lesser chapels ("eglises et chapelles secondaires et
moins principales"), a total of some 1050 holy places, according to another pamphlet
of this kind.[4] But the seven principal churches claim special attention, and they are
provided with pictures, designated by the first seven letters of the alphabet. As we

shall see, these letters function as an ingenious indexing system that greatly facilitates the use of the book. In the promotion of the seven churches, the guidebook is in agreement with the recommendations of the pilgrimage literature of the time. In the early Middle Ages, the basilicas of Saint Peter and San Paolo fuori le mura, sheltering the tombs of the apostles, were most eagerly visited. Around 1100, the list of major churches grew to three and then four, with the addition first of Santa Maria Maggiore and then of San Giovanni in Laterano. The more or less canonical series of seven principal churches was reached in the later Middle Ages with the inclusion of San Lorenzo fuori le mura, San Sebastiano, and Santa Croce in Gerusalemme.[5]

Margaret's guidebook and the Turin manuscript present these in the usual order, beginning with San Giovanni in Laterano, designated with the letter A, which appears above a brown-framed miniature of John the Evangelist holding a sacrificial cup of wine and standing near an altar in the choir of a Gothic church (fig. 44). This and the other six miniatures are entirely unconcerned with the physical appearance of the buildings that the guide recommends to the Roman pilgrim. The church in question is instead personified for the reader by an image of its patron saint. A visit is said to procure for the pilgrim a forty-eight-year pardon from the fire of purgatory, an equal number of dispensations from weekly Friday penitential fasts, and forgiveness of one-third of one's sins. The text mentions the baptistery of the Lateran, where a further remission of sins can be obtained, and the chapel of the Sancta Sanctorum, which preserves steps from the house of Pontius Pilate in Jerusalem. Whoever climbs these steps is promised nine additional years of pardon from the pains of purgatory and additional remission of sins. The guide also helpfully assures the reader that on the authority of Pope Boniface, whoever visits the church "par devotion et peregrinacion" will not have to go to Jerusalem or to Santiago de Compostela—the major competing shrines for the pilgrimage traffic—in order to earn the same spiritual favors.

Saint Peter's, designated by the letter B above the frame, is introduced in the guide by a representation of the apostle bearing his conventional attributes, the keys and an open book (fig. 45). He stands on a grassy, stippled patch of ground, his bulk overshadowing a distinctly Northern setting marked by a pair of half-timbered houses and the choir of a late Gothic church. The reader is informed that there are a total of 109 altars in Saint Peter's, visits to each of which offer a pardon of eighteen years, and generous indulgences are promised to visitors of the place where the apos-

Figure 43.
Opening page with the coat of arms of Margaret of York, in a guide to the pilgrimage churches of Rome. New Haven, Yale University, Beinecke Rare Book and Manuscript Library, Ms. 639, fol. 4.

Figure 44.
Workshop of the Master of Edward IV (?). *San Giovanni in Laterano*, in a guide to the pilgrimage churches of Rome. New Haven, Yale University, Beinecke Rare Book and Manuscript Library, Ms. 639, fol. 5.

Figure 45.
Workshop of the Master of Edward IV (?). *Saint Peter's*, in a guide to the pilgrimage churches of Rome. New Haven, Yale University, Beinecke Rare Book and Manuscript Library, Ms. 639, fol. 8.

tle was imprisoned and to those who climb the steps leading up to the church. San Paolo fuori le mura, the third church and C in the alphabetical sequence, has a miniature composed in much the same manner, the standing apostle with the instrument of his martyrdom camped in a spacious landscape closed off in the middle distance by symmetrically positioned buildings of contrasting design (fig. 47). Santa Maria Maggiore—D in the series—features the Virgin and Child seated on a grassy knoll in front of the choir and open porch of the church (fig. 48). The text which follows enumerates in the now familiar way the tariff of indulgences attached to the venerable basilica. It makes a point of citing here as well the other Marian churches of Rome, and also mentions a then fairly recently established attraction for the pilgrim, which is of some interest for the dating of the text model used by the scribe. This is the plenary remission of sins promised on the eve of the Feast of the Ascension (May 9), when the translation of the body of Saint Jerome from Bethlehem to Santa Maria Maggiore was celebrated. The guidebook credits the institution of the indulgence to the Humanist pope Pius II, who did indeed lend his authority to the grant of this indulgence, establishing it in perpetuity in bulls dated 1459 and 1464.[6]

The information on the fifth church—E—is prefaced by a miniature of the titular saint, Lawrence (fig. 50). Garbed in his customary deacon's vestments, he carries his attribute, the grill, and stands, absorbed in prayer, within a church interior illuminated by the artist's formulaic diaper-patterned, leaded glass windows. Beyond its own ample allotment of indulgences, San Lorenzo advertised a special attraction: that every single visit occurring on a Wednesday would liberate a soul from purgatory. Somewhat more obscurely, the guide promises to anyone who enters the church through its southern door and traverses the space from one side to the other a full remission of sins. San Sebastiano, identified with the letter F, is announced by an image of its patron enduring his martyrdom in a pleasant sylvan setting graced by a vaguely Romanesque church (fig. 52). At San Sebastiano, the pilgrim is advised of the indulgences attached to a visit to the "spelonque et fosse du pape Calixte," the ancient catacombs of San Callisto that lie not far from the church. Santa Croce, designated with the letter G and the last of the Roman sanctuaries on the list, is represented by an image of Saint Helena bearing the cross which, according to legend, she was alleged to have discovered in Jerusalem (fig. 53). The guidebook mentions the chapel under the church with its celebrated relic of the True Cross, where Helena's body is also said to lie. It was evidently a place not to be missed, since the visit

Figure 46.
Workshop of the Master of Edward IV(?). *Saint Peter's*, in a guide to the pilgrimage churches of Rome. Turin, Biblioteca Reale, Ms. Varia 81, fol. 9v.

Figure 47.
Workshop of the Master of Edward IV (?). *San Paolo fuori le mura*, in a guide to the pilgrimage churches of Rome. New Haven, Yale University, Beinecke Rare Book and Manuscript Library, Ms. 639, fol. 10.

Figure 48.
Workshop of the Master of Edward IV (?). *Santa Maria Maggiore*, in a guide to the pilgrimage churches of Rome. New Haven, Yale University, Beinecke Rare Book and Manuscript Library, Ms. 639, fol. 12v.

a·iiij.e eglise principale
de rome est ditte saincte
marie maiour la ou il y a
aussi ·xlviii·ans de pardon

a ·v.e eglise est
ditte de saint lau
rene la ou il y a

a·cinquiesme eglise
est ditte leglise saint
laurens la ou il y a to9
ses iours·xlviii·ans de pard9.

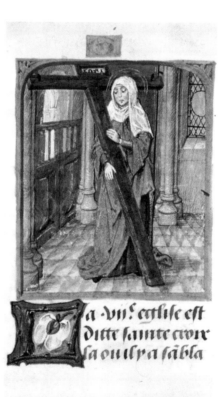

a·vi.e eglise est
ditte de saint
sebastian la ou

a·vii.e eglise est
ditte saincte croix
la ou il y a sabla

Figure 49.
Workshop of the Master of Edward IV (?).
Santa Maria Maggiore, in a guide to the
pilgrimage churches of Rome. Turin, Biblio-
teca Reale, Ms. Varia 81, fol. 12v.

Figure 50.
Workshop of the Master of Edward IV (?).
San Lorenzo fuori le mura, in a guide to
the pilgrimage churches of Rome. New
Haven, Yale University, Beinecke Rare Book
and Manuscript Library, Ms. 639, fol. 14v.

Figure 51.
Workshop of the Master of Edward IV (?).
San Lorenzo fuori le mura, in a guide to
the pilgrimage churches of Rome. Turin,
Biblioteca Reale, Ms. Varia 81, fol. 14.

Figure 52.
Workshop of the Master of Edward IV (?).
San Sebastiano, in a guide to the pilgrimage
churches of Rome. New Haven, Yale Univer-
sity, Beinecke Rare Book and Manuscript
Library, Ms. 639, fol. 14v.

Figure 53.
Workshop of the Master of Edward IV (?).
Santa Croce in Gerusalemme, in a guide to the
pilgrimage churches of Rome. New Haven,
Yale University, Beinecke Rare Book and
Manuscript Library, Ms. 639, fol. 18v.

entitled one to a pardon of a thousand years (twelve hundred on Wednesdays), an
impressive figure even by the generous standards by which the spiritual treasure be-
stowed by Christ on Peter and his successors was being disbursed.

There will be little disagreement with the observation that these images do not
derive from a tradition of topographical representation. What the painter provided
were miniatures drawn from the pictorial patrimony of devotional books, chiefly
books of hours and, in particular, the images associated in these manuscripts with
the special prayers or suffrages.[7] Such books were probably the customary fare that
the artist supplied, and when faced with what must have been a far less familiar as-

signment he responded as seemed appropriate in the light of his professional formation and experience. A single illustration will help to make this point, which does not require extended demonstration. In the portraits of Saint Lawrence and Saint Helena (figs. 50, 53), who are shown in church interiors, the placement of the figure before a narrow wall or pier draped with an honorific cloth hanging at the center of the composition restates a familiar device, here exemplified in the *memoria* of Saint David of Wales in the Hastings Hours, a work thought to be of Ghent origin and datable in the late 1470s (fig. 54).[8] Suffrage pictures of saints in landscape settings, like the images of Saint Peter and Saint Sebastian in the manuscript, are of course a major staple of the genre. The normal floriated borders that accompany such miniatures in fifteenth-century devotional books are omitted in the guidebook, but the substitution of a frame to simulate a painted panel or an altarpiece has parallels in contemporaneous book illumination. This observation suggests, however, that the painter's evocation of suffrage pictures in prayer books was more than a matter of habit or convenience. The allusion effects a denial of the practical purpose of the guide, so as to bring pilgrimage within the orbit of private devotional practice.[9]

Where and when in Margaret's Flemish domains the manuscript was made, on the other hand, remains an unsettled question. The painter's style does have some ties with the body of illumination associated with the workshop of the Master of Edward IV, whose oeuvre was reconstituted around the *Bible historiale* made for that English royal patron in 1479, likely at Bruges.[10] Some elements of the illumination in the guidebook, such as the loose, stippled modeling, or the painter's fondness for a kind of all-purpose polygonal chapel with diaper-patterned windows, whose panes are here and there picturesquely broken, are duplicated in a late fifteenth-century book of hours in the Walters Art Gallery that has been connected with this workshop (figs. 45, 48, 55).[11] But the precise contours of the workshop's activity, recently enlarged and revised by G. Dogaer, still remain somewhat uncertain and in need of better definition.

After the seven principal churches, Margaret's guidebook concerns itself with the churches of Rome where stations were made throughout the year as part of the ancient processional liturgy of the city. First are listed the stations for the Lenten season, followed by the schedule for the period from Easter to Advent, and finally the stations made on saints' feast days. In this second section of the manuscript (fols. 22v–45v), the indexing system already noted comes into play. A typical set of pages shows, in succession, the time of the stations and where they are to take place, followed at the right edge of the text column by an alphabetical reference (fig. 56). Although the stational liturgy embraced a fair number of the churches of Rome, these

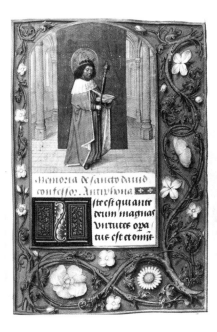

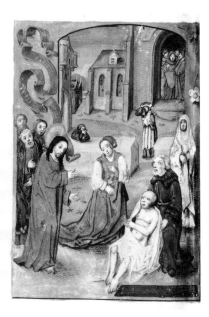

Figure 54.
Master of the Older Prayer Book of Maximilian. *Saint David*, in the Hastings Hours. London, British Library, Add. Ms. 54782, fol. 40. Reproduced by kind permission of the British Library Board.

Figure 55.
Workshop of the Master of Edward IV. *Raising of Lazarus*, in a book of hours. Baltimore, Walters Art Gallery, Ms. W. 435, fol. 128v.

Figure 56.
Set of pages showing alphabetical references, in a guide to the pilgrimage churches of Rome. New Haven, Yale University, Beinecke Rare Book and Manuscript Library, Ms. 639, fol. 29.

letters refer only to the principal seven sanctuaries represented by illuminations, the others, as the introductory text indicates, being subsumed under them ("Neantmoins il nen y a que sept principales cy aprez representees et par les sept premieres lettre de labece signees dessoubs lesquelles sont toutes les aultres secondaires contenues"). The reason for this, made clear in the closing instructions, is that the guidebook, surprising as this may seem, was designed for the reader who did not intend to leave home. Such readers could, the text explains, nevertheless receive the very same spiritual benefits promised to pilgrims who made the journey to Rome. This could be done by checking the day and the church where the station was to take place, turning the pages of the guidebook to the painting designated by the letter of the alphabet, and reciting before it one of the Seven Penitential Psalms or another prayer ("aulcune priere ou oraison") to gain the desired pardon. Whatever else needed to be done, readers were to do it, and they would be satisfied ("Et sil y a austre chose a faire ou a dire quy soit contenu en leur grace et lettre ilz le feront et se conformeront a la ditte lettre et grace tant quilz pourront car les graces valent autant comme leur teneur contient et comprent et non plus").

The idea of a guidebook for stay-at-homes, of a pilgrimage transposed from a physical journey to a distant sanctuary into an act of private devotion, is a symptom of the conflicting attitudes that voyages to distant holy places inspired in the high and later Middle Ages. While pilgrimages remained an immensely popular form of piety, moralists increasingly criticized them as occasions for sin and as selfish and wasteful expenditures of money that could be better devoted to charitable works at home.[12] Margaret is very likely to have come into contact with this current of criticism, which was amplified around her by the reforming ideals of the *Devotio Moderna*.[13] For princes in a position of political authority, there was the added consideration that absences from one's domains, especially lengthy ones, could be dangerous to order and stability, and were thus judged to be irresponsible. The thirteenth-century life of Saint Edward the Confessor relates that this Anglo-Saxon king had made a solemn vow to go on a pilgrimage to Rome. But the clergy, the magnates of the realm, and the people protested against this plan, pointing out that it would imperil the kingdom: he had no heirs, the journey would be risky, and his failure to return would expose them to harm from hostile neighbors. They therefore persuaded Edward to send an embassy to the pope, asking for release from his vow and offering instead to build a great church at Westminster.[14]

There were thus good reasons for resisting the attractions of Rome and seeking

other ways to earn its fabled indulgences. In the late fourteenth century, Pope Urban IV and his successor, Boniface IX, began the process of issuing dispensations, some of them to individuals, but also to corporate entities like monastic orders, or even the inhabitants of entire territories.[15] These privileges stipulated that on the occasion of the regular Roman jubilee celebrations, it would be possible to obtain the indulgences attached to the pilgrimage by visiting designated churches in one's own diocese, confessing one's sins, and giving alms in an amount at least equal to the cost of the journey to Rome. Half the sums collected were to be made available to the Roman basilicas, the other half to meet the needs of the local religious community. Various cities in Northern Europe thus came to have their own designated seven churches that marked out an itinerary for substitute pilgrimages. Such groups of seven pilgrimage churches are known to have existed at Trier, at Liège, and at Mechlin, among other places.[16]

The faithful could also obtain indulgences by making a circuit of seven altars in a particular church. Such circuits might be marked by paintings designed, as in Margaret's guidebook, to evoke the seven major churches of Rome. The Dutch scholar Henri L.M. Defoer has called attention to an early sixteenth-century panel preserved in the Rijksmuseum Het Catharijneconvent at Utrecht, which was evidently made for just this purpose (fig. 57).[17] The work shows Saint John standing before a massive and rather fanciful San Giovanni in Laterano. At the upper right, the letter A, rendered in gold, is visible, providing a decisive clue about the function of the panel. What may be the remnant of another cycle of paintings for a Roman pilgrimage to be performed in a church at home is represented by two late fifteenth-century panels of Lower Rhenish origin, one preserved in the Wallraf-Richartz-Museum in Cologne, the other in the Erzbischöfliches Diözesan-Museum in the same city (figs. 58–59).[18] One of these paintings shows the Virgin and Child; the other, which is in poorer condition, Christ on the cross. Both subjects are depicted in front of large and turreted Romanesque churches of similar, though not identical design, and the panels have been described as two halves of a diptych. This is not impossible, but Defoer has made the plausible suggestion that these formal, highly idiomatic compositions might be images of Roman churches, the Wallraf-Richartz

Figure 57.
Anonymous Dutch master. *San Giovanni in Laterano*. Utrecht, Rijksmuseum Het Catharijneconvent. Photo courtesy Stichting Het Catharijneconvent.

Figure 58.
Lower Rhenish artist. *Virgin and Child*. Cologne, Wallraf-Richartz Museum. Photo courtesy Rheinisches Bildarchiv.

Figure 59.
Lower Rhenish artist. *Crucifixion*. Cologne, Erzbischöfliches Diözesan Museum. Photo courtesy Rheinisches Bildarchiv.

panel Santa Maria Maggiore, its companion Santa Croce in Gerusalemme.

The most substantial ensemble of Roman pilgrimage pictures to survive is the series of paintings executed between 1499 and 1504 by Hans Holbein the Elder, Hans Burgkmair, and the anonymous hand identified by the monogram LF for the Dominican convent of Saint Catherine at Augsburg, now preserved in the Staatsgalerie (figs. 60–61).[19] The nuns of the Augsburg Katherinenkloster had obtained an indulgence privilege from Pope Innocent VIII in 1484 (or 1487), which was subsequently confirmed by Julius II. The paintings, which were commissioned by different nuns in the convent, were displayed in the chapter house, and pilgrims desiring to obtain the Roman indulgences were required to recite prayers specified by the prioress in three designated places within the convent.

The institution of processional rituals as substitute pilgrimages is a large subject that would require extended discussion. An evident parallel of the Roman circuit that must be mentioned, however, is the Jerusalem pilgrimage that could be accomplished vicariously at home through a symbolic itinerary of the Stations of the Cross within a church or outdoors, an itinerary that marked seven or sometimes fourteen moments of the Passion of Christ.[20] The early history of this devotion is still somewhat obscure, but it is generally believed to have developed toward the middle and the second half of the fifteenth century. The series of seven reliefs carved by the Nuremberg sculptor Adam Kraft in 1508 for a Stations of the Cross that led from one of the gates of the city to the cemetery of Saint John is sometimes cited as an illustration of the artistic significance that the theme could attain in one of the initial moments of its great popularity.[21] The Roman and Jerusalem pilgrimage rituals of Northern churches thus could be said to have been contemporaneous phenomena that took root, so to speak, on the same historical soil. Yet while the Roman pilgrimage focused on churches and their saintly patrons, the Jerusalem itinerary reenacted the climactic events of the Gospels, which painting and sculpture rendered not merely in a mnemonic fashion, but with a deeply empathetic coloration. Perhaps for this reason, the Stations of the Cross achieved a permanent place in Catholic devotional practice, while the symbolic pilgrimage to Rome in Northern churches remained by comparison of relatively minor significance.

It is easy to see the connections between Margaret's guidebook and these developments. Yet the substitute pilgrimage proposed by the guidebook is not a perambulation around a designated set of landmarks, architectural or pictorial, but a wholly imaginary voyage, to be accomplished in one's armchair. This aspect of the work is not entirely novel, since it figures in an older manual of this kind, published

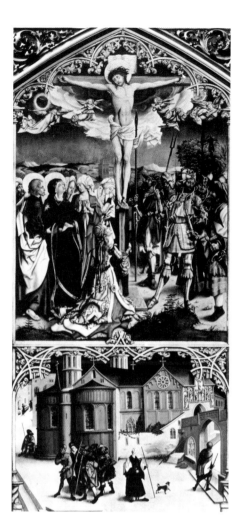

Figure 60.
Hans Burgkmair. *Santa Croce in Gerusalemme* (detail). Augsburg, Staatsgalerie. Photo courtesy Bildarchiv Marburg/Art Resource, N.Y.

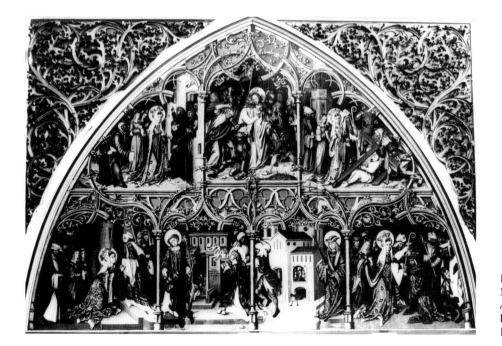

Figure 61.
Monogrammist L. F. *San Lorenzo fuori le mura and San Sebastiano*. Augsburg, Staatsgalerie. Photo courtesy Bildarchiv Marburg/Art Resource, N.Y.

among Gerson's works and written for the benefit of those who could not attend the Roman jubilee.[22] The work recommends that the would-be pilgrim recite the Pater Noster ten times daily for the ten leagues that he would expect to cover on his way to Rome. Upon completion of the imaginary journey, he was to visit a local church once a day and give alms equal to the offerings he would have made in Rome, assuring himself thereby the benefits of an actual pilgrimage. The original feature of Margaret's guidebook, in the present state of my research at least, seems to be its use of images in order to simulate the journey. This feature brings into play a conception of the miniatures in the manuscript as *Ablassbilder* (indulgence pictures), images, that is to say, invested with a redemptive power capable of being transmitted to the prayerful spectator, no matter where situated, by way of copies.[23] It cannot be a mere coincidence that the most famous of the holy images were icons of Roman churches—the *Man of Sorrows* of Santa Croce in Gerusalemme, which promised the unheard-of release of fourteen thousand years from the pains of purgatory,[24] and the *vera ikon*, the celebrated imprint of Christ's features preserved in Saint Peter's.[25] Representations of these holy images, along with the required prayers to be recited in their presence, appear in late medieval books of hours and thus entered without strain into the fabric of private and sedentary devotion.

A recent author judges Margaret's piety to have been deep and serious,[26] though whether she availed herself of the spiritual riches offered so freely by the guidebook, and with what regularity, cannot be known for sure. The question "with what regularity" is pertinent, since it implies that the vicarious voyage to Rome could be made on a regular basis, indeed at will, and thus with a potentially near limitless enjoyment of the benefits attached to the journey. That Margaret profited from these advantages seems very likely, for with the exception of a single visit she made to the tomb of Thomas à Becket at Canterbury prior to her marriage to Charles the Bold in 1468, she never traveled again to distant places in search of salvation.[27]

Notes

1 Ms. 639. Formerly collection of Sven Ericsson, Stockholm; Sotheby's, London, *Catalogue of Western Manuscripts and Miniatures*, June 22, 1982, lot 59. Forty-seven leaves, 127×88 mm. Collation: 1+2², 3–7⁸, 8²+1. A partly erased inscription of the late fifteenth or sixteenth century, read under ultraviolet light, yields the following: "bonne sante [?] et . . . Jacques de hen . . ." or, according to the Sotheby's catalogue, "bonne fayte et a bonne . . . Jacques de h . . . ing" (flyleaf). The manuscript has been the subject of seminar reports by Minott Kerr and Kathleen Liles in classes on book illumination that I have taught at Yale University. I am indebted to their excellent work, and I have also benefited from the assistance and suggestions of Robert G. Babcock, the curator of Early Books and Manuscripts at the Beinecke Library, Jeffrey Chipps Smith, Bodo Brinkmann, and Chiara Passanti.

2 Weightman 1989, p. 229, n. 87, makes a brief mention of the manuscript, speculates that the arms might have been "a later addition designed to make the book more valuable." This is not altogether impossible, but a careful examination of the manuscript yielded no strong evidence in favor of this view.

3 Turin, Biblioteca Reale, Ms. Varia 81. Forty leaves, 170×110 mm. The manuscript, which seems to be unpublished, was brought to my attention by Bodo Brinkmann. The guidebook occupies fols. 7–40. The additional miniature (fol. 1) shows Veronica displaying the Holy Face and precedes the prayer *Salve sancta facies*. The rendering of the architectural settings in the Turin copy is generally more elaborate and refined, as well as possibly somewhat more advanced in style. A fuller discussion of the relationship between the two manuscripts remains to be undertaken.

4 *Indulgentiae ecclesiarum urbis Romae* (Rome, A. Rot, circa 1471–74), unpaginated.

5 On the constitution of the seven principal churches of Rome, see N. Paulus, *Geschichte des Ablasses im Mittelalter* (Paderborn, 1923), vol. 3, pp. 274–81, and *Wallfahrt kennt keine Grenzen*, exh. cat. (Bayerisches Nationalmuseum, Munich, 1984), pp. 100–07.

6 E.F. Rice, Jr., *Saint Jerome in the Renaissance* (Baltimore, 1985), p. 64.

7 On the illustration of suffrages, see Baltimore 1988, pp. 111–23.

8 London, British Library, Add. Ms. 54782;
 Malibu 1983, pp. 21–30, no. 3.

9 On this aspect of pilgrimage, see J. Sump-
 tion, *Pilgrimage: An Image of Medieval Religion*
 (London, 1975) p. 289ff., and D.R. Howard,
 *Writers and Pilgrims: Medieval Pilgrimage Nar-
 ratives and Their Posterity* (Berkeley and Los
 Angeles, 1980), p. 118.

10 Winkler 1925, p. 137, and Dogaer 1987, p.
 117.

11 Baltimore, Walters Art Gallery, Ms. W. 435;
 Baltimore 1988, p. 217, no. 102.

12 G. Constable, "Opposition to Pilgrimage in
 the Middle Ages," *Mélanges G. Fransen* (Stu-
 dia Gratiana, 19) (Rome, 1976), pp. 126–46.
 For pilgrimage in the later Middle Ages, see
 Sumption (note 9), p. 257ff., and F. Rapp,
 "Les pèlerinages dans la vie religieuse de
 l'occident médiéval aux XIVe et XVe siècles,"
 in F. Raphaël et al., eds., *Les pèlerinages dans
 l'antiquité biblique et classique à l'occident mé-
 diéval* (Université de Strasbourg, Sciences
 Humaines. Centre de Recherches d'histoire
 des religions. Etudes d'histoire des reli-
 gions, 1) (Paris, 1973), pp. 119–60.

13 Weightman 1989, p. 198ff.

14 K.Y. Wallace, ed., *La estoire de Seint Aedward
 le Rei* (Anglo-Norman Text Society, 41)
 (London, 1983), p. 222. The scene of council
 between the king and the barons is illus-
 trated in the Cambridge manuscript of the
 work (University Library, Ms. Ee 3. 59, fols.
 13–13v); see N. Morgan, *Early Gothic Manu-
 scripts. II: 1250–1285* (A Survey of Manu-
 scripts Illuminated in the British Isles, 4, pt.
 2) (London, 1988), pp. 94–98, no. 123.

15 Paulus (note 5), p. 181ff.

16 F. Rémy, *Les grandes indulgences pontificales
 aux Pays-Bas à la fin du moyen âge, 1300–1531*
 (Louvain, 1928), p. 35ff. For the seven
 churches of Trier, see J. Enen, *Medulla ges-
 torum Treverensis* (Trier, 1514; ed. P.J.A.
 Schmitz, Regensburg, 1845), pp. 83–84. A
 circuit of seven churches at Strasbourg is de-
 scribed in the *Peregrinus* of J. Geiler von Kais-
 ersberg; see E. Vansteenberghe, "Quelques
 écrits de Jean Gerson: Textes inédits et
 études," *Revue des sciences religieuses* 14
 (1934), p. 389, n. 1.

17 H.L.M. Defoer, "Een laat-gotisch schilder-
 ijtje met Sint-Jan voor het verdienen van de
 aflaten van de zeven hoofdkerken van
 Rome," *Antiek* 16 (1981), pp. 316–20. The
 painting, inv. ABM s. 37, was given to the
 museum by Mgr. G.W. van Heukelem; see
 *Catalogus schilderijen Aartsbischoppelijk Mu-
 seum Utrecht* (Utrecht, 1948), p. 114. Defoer,
 who was unaware of the existence of the Bei-
 necke manuscript, published a guide, *Die
 costelijke scat der gheestelijker rijdoem*, printed
 by Hugo Jansz. van Woerden, Amsterdam,
 1519, which contains woodcuts of the seven
 churches designated by letters in the same
 fashion as Margaret's guidebook. This sug-
 gests a wider diffusion of this type of pilgrim-
 age guide.

18 Defoer (note 17); W. Schulten, *Kostbarkeiten
 in Köln*, exh. cat. (Erzbischöfliches Diöz-
 esan-Museum, Cologne, 1978), nos. 222–23.
 The Wallraf-Richartz panel is inventoried in
 I. Hiller, H. Vey, and T. Falk, *Katalog der
 deutschen und niederländischen Gemälde bis
 1550 . . . im Wallraf-Richartz-Museum* (Co-
 logne, 1969), pp. 108–09, no. 338.

19 *Hans Holbein der Ältere und die Kunst der Spät-
 gotik*, exh. cat. (Staatsgalerie Augsburg,
 1965), pp. 71–73, no. 28, and pp. 142–45,
 nos. 151–52, and G. Goldberg, C.A. Salm,
 and G. Scheffler, *Staatsgalerie Augsburg: Städ-
 tische Kunstsammlungen: Altdeutsche Gemälde*,
 vol. 1 (Munich, 1978), pp. 129–58.

20 K. Eckmann, *Kleine Geschichte des Kreuzweges*
 (Regensburg, 1968).

21 W. Schwemmer, *Adam Kraft* (Nuremberg,
 1958), pp. 34–35. The use of the pavement
 labyrinths in French Gothic cathedrals as
 "Chemins de Jerusalem" may be another in-
 stance of such a substitute pilgrimage. This
 practice, however, is only documented for
 Chartres; see M.J. Bulteau, *Monographie de
 la cathédrale de Chartres* (Chartres, 1877–92),
 vol. 3, pp. 43–54, and H. Kern, *Labyrinthe*
 (Munich, 1982), pp. 225–26.

22 Sumption (note 9), pp. 300–01, and J. Wim-
 pheling, ed., *Opera Gersonii* (Strasbourg, J.
 Knobloch, 1502), vol. 4, p. lxx. The French
 translation, of which three manuscripts are
 known, was published under the title *Pèler-
 inage spirituel* by Vansteenberghe (note 16),
 pp. 387–95. M. Lieberman, "Gersoniana,"
 Romania 78 (1957), pp. 158–66, demon-
 strates that it is not by Gerson, but his view
 that it was likely composed at Oxford in 1423
 is not particularly well-founded.

23 See the article "Ablass," in *Reallexikon zur
 deutschen Kunstgeschichte*, vol. 1 (Stuttgart,
 1937), pp. 78–81, and S. Ringbom, "'Maria
 in sole' and the Virgin of the Rosary," *Journal
 of the Warburg and Courtauld Institutes* 25
 (1962), pp. 326–30.

24 On this subject, see U. Westfehling, *Die
 Messe Gregors des Grossen: Vision, Kunst, Real-
 ität*, exh. cat. (Schnütgen-Museum, Co-
 logne, 1982), p. 26.

25 O. Pächt, "The 'Avignon Diptych' and Its
 Eastern Ancestry," in M. Meiss, ed., *De ar-
 tibus opuscula XL: Essays in Honor of Erwin
 Panofsky* (New York, 1961), pp. 402–21, and
 H. Belting, "Die Reaktion der Kunst des 13.
 Jahrhunderts auf den Import von Reliquien
 und Ikonen," in H. Belting, ed., *Il Medio
 Oriente e l'Occidente nell'arte del XIII secolo* (Bo-
 logna, 1979), pp. 45–46.

26 Weightman 1989, p. 196ff. The character of
 Margaret's piety is well analyzed in Wim
 Blockmans's essay, pp. 33–39, above.

27 Weightman 1989, p. 47.

A RENAISSANCE MANUSCRIPT IN THE HANDS OF MARGARET OF YORK[1]

Albert Derolez

A few years ago, while studying Quattrocento manuscripts in the library of the Escorial, my eye fell on a composite codex, containing in one binding two originally separate manuscripts of Justinus. The first had a signature that represents the starting point for the present study and has thrown new light on Margaret of York as a bibliophile.

Escorial Ms. e.III.22 (Appendix no. 26) is a parchment codex of 180 folios, measuring 260×185 mm, in a standard Escorial binding.[2] It contains two copies of the well-known, if not highly esteemed, work by the Roman author Justinus, *In Trogi Pompei historias libri XLIV*. Both transcriptions date from the fifteenth century and were made in Italy, but whereas the first is in humanistic script, the second is written in a heavy *gotica rotunda*. The latter's decoration consists of beautiful flourish initials in Italian style and a large white vine-stem initial in a most unusual framing in black ink (fol. 99). On fol. 178 is the colophon: "Explicit liber Iustini abbreviatoris Trogi Pompei, finitus die Mercurii, decimo mensis Iunii milesimo quadringentesimo trigesimo secundo, decima inditione. Deo laus." The date June 10, 1432, does not apply to the first copy of the Justinus text, the only one which will be dealt with here and which is a few decades younger.[3]

This first section (fols. 1–98), by its script as well as its decoration, is a pure specimen of Renaissance manuscript production. The leaves are grouped in quinions (quires of ten folios), marked on their last pages by horizontal catchwords, placed toward the right in the lower margin under the text block; these catchwords are framed in extensive decorative penwork. The ruling, for a single column of text, is quite simple: it has double vertical lines at both sides of the text area, traced in lead, and thirty-five short horizontal lines traced in pale brown ink. Its dimensions are circa 173×105 mm. This ruling type is widely diffused in Italian Renaissance manuscripts, occurring in nearly a quarter of them, so that it provides almost no clue as to the origin of the manuscript. It can only be noted that the type seems to be less well represented in Florence, Naples, and the Veneto than in other regions.[4] There are thirty-four lines of script on each page, the copyist beginning below the top line.

The script is a very regular, upright, and broad humanistic cursive, written in brown ink. Its characteristics are: cursive *a*; *e* with a long, nearly horizontal final stroke; long vertical ascenders and descenders ending in dot-shaped serifs (inclusive of the long *s* and *f*); a total absence of loops; the use of *ij* for *ii*; an unusual *r*; round *s* at the end of words; and a generally disconnected ductus and rare ligatures (*ae*, *ct*, *st*, and the ampersand); among the abbreviations, *que* is peculiar, consisting of a sign shaped like a 3 attached to the right of the descender of the *q*.

The manuscript is lavishly decorated but unfinished, since the rubrics are missing. The decoration comprises various types of initials and a full border on fol. 1. The initials are mostly of the classical *bianchi girari* type, but at the opening of the preface (fol. 1) there is a large, colored strapwork (*intrecci colorati*) initial on a rectangular background of gold. The border, on the same page, shows developed *bianchi girari* ornament between two gold frames (fig. 62). The use of different decorative

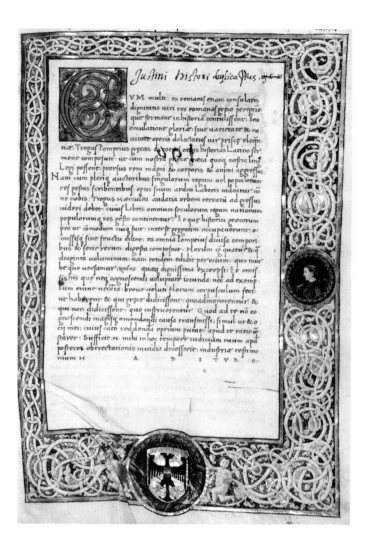

Figure 62.
Opening of the preface showing strapwork initial and border, in Justinus, *In Trogi Pompei historias libri XLIV.* Madrid, Biblioteca del Escorial, Ms. e.III.22, fol. 1. Photo courtesy Patrimonio Nacional, Madrid.

patterns on the same page for initial and border is rarely seen in Italian Renaissance manuscripts. In the middle of the right-hand border is a beautiful medallion with the portrait of a laureled Roman author (either Pompeius Trogus or Justinus, fig. 63) holding a book, and in the middle of the lower border is a similar but larger medallion, held by two kneeling putti and containing the coat of arms discussed below (fig. 64). Both medallions are rendered with a gold circle, within which is painted a laurel wreath that forms the frame for the picture inside.

The author portrait as well as the charming putti are of superior quality but have not yet been related to a known artist or workshop. Considering both script and decoration, the manuscript dates from the third quarter of the fifteenth century, most probably 1465–70, and was certainly made in Ferrara, as Professor Albinia de la Mare has kindly pointed out to me.

The coat of arms is *or* with a double-headed eagle *sable*, holding a shield *gules* with fess *argent*. The execution is not very careful and it looks as if these arms were painted at a later date, perhaps over another coat of arms. The double-headed eagle relates to the Holy Roman Empire, while the escutcheon contains the Hapsburg arms. The coat of arms consequently belongs to a Hapsburg emperor.[5] Before we pursue his identity, we must turn to the last text page (fol. 96v) and the inscription it carries.

The text of Justinus ends halfway down the page. Somewhat lower, in the middle, is the word FINIS, followed on the next line by four words in a clumsily traced gothic cursive: "Voter lealle mere Margarete" (fig. 65). The irregular script, by an obviously untrained hand, as well as the wording recall a similar inscription in a well-known Gothic manuscript of about the same period from Flanders: *La vie de Sainte Colette* by Pierre de Vaux, belonging to the convent of the Poor Clares in Ghent (Appendix no. 27). This richly illuminated manuscript contains the monograms, device,

Figure 63.
Detail of border with portrait of a Roman author (either Pompeius Trogus or Justinus), in Justinus, *In Trogi Pompei historias libri XLIV.* Madrid, Biblioteca del Escorial, Ms. e.III.22, fol. 1. Photo courtesy Patrimonio Nacional, Madrid.

Figure 64.
Detail of border with coat of arms of Emperor Maximilian, in Justinus, *In Trogi Pompei historias libri* XLIV. Madrid, Biblioteca del Escorial, Ms. e.III.22, fol. 1. Photo courtesy Patrimonio Nacional, Madrid.

coat of arms, and portraits of Charles the Bold, Duke of Burgundy, and his third wife, Margaret of York.[6] At an unknown date, but certainly after her husband's tragic death, Margaret gave the book to the Poor Clares, and it has been at their convent ever since. The donation is attested to by the autograph inscription at the end of the codex (fol. 163; fig. 66): "Votre loyale fylle Margarete d'Angleterre, pryez pour elle et pour son salut."

Even a superficial comparison of this text with that in the Justinus manuscript shows that they are by the same hand and serve similar functions as *ex-dono* inscriptions.[7] In the Ghent manuscript, the duchess calls herself "your loyal daughter," i.e., she obviously considers herself a spiritual daughter of the convent of the Poor Clares, to which she gives the book. The term "your loyal mother Margaret" in the Escorial codex, on the other hand, can only have been addressed to her stepdaughter, Mary of Burgundy, and/or to Mary's husband, Maximilian of Austria. It is well known that Margaret remained on friendly terms with Mary and Maximilian and that her friendship with the latter seems to have lasted until her death in 1503.

Since Margaret of York, as far as we know, had never been in Italy, she either commissioned the Justinus codex from an agent in Italy or bought it in Flanders from an Italian dealer. Given the language, the character of the text, and the style of the codex, she can hardly have acquired it for her own use, but rather with the intention of presenting it to Mary and Maximilian, or more likely to Maximilian alone. It is difficult to determine at what time or for what occasion this gift was made. Maximilian could not properly have carried the imperial coat of arms before the death of his father, Emperor Frederick III, in 1493. It was probably about this time that Margaret presented the manuscript to her son-in-law. Mary of Burgundy had been dead for more than a decade and, moreover, a codex on such a subject cannot have been intended for her.

Pompeius Trogus's extensive world history in forty-four books is lost. Written in the last decades of the first century B.C., it began with the Assyrians and ended

Figure 65.
Final text page showing inscription by Margaret of York, in Justinus, *In Trogi Pompei historias libri* XLIV. Madrid, Biblioteca del Escorial, Ms. e.III.22, fol. 96v. Photo courtesy Patrimonio Nacional, Madrid.

Figure 66.
Inscription by Margaret of York, in Pierre de Vaux, *La vie de Sainte Colette*. Ghent, Convent of the Poor Clares, Ms. 8, fol. 163.

with Emperor Augustus. Its title—*Historiae Philippicae*—suggests that the work focused on the history of the Macedonian monarchy and the Hellenistic kingdoms. In the second or third century A.D., it was epitomized by an otherwise unknown author, Marcus Justinianus Justinus, and this epitome has come down to us in numerous manuscripts. It was a favored schoolbook in the Middle Ages and remained extremely popular during the Italian Renaissance.[8] So Margaret may have thought that Maximilian would be pleased to possess this classic world history. Produced in Italy and written in Latin, it was certainly a fitting present for a young prince who expected to rule the Holy Roman Empire.

What happened to the book after Maximilian had his coat of arms painted in the border of fol. 1 is not known. It is not mentioned in the extant inventories of Maximilian's library,[9] and we cannot trace its whereabouts between the early sixteenth century and its appearance in the Escorial library. Antolín's catalogue of the Latin manuscripts in the Escorial says that the codex belonged to Don Diego Hurtado de Mendoza, who in 1575 bequeathed his entire library to King Philip II of Spain.[10] This provenance is probably accurate only for the second Justinus copy in the present-day binding, which Mendoza may have acquired while serving as Philip's ambassador in Venice and Rome. The first copy, studied here, no doubt reached the Escorial through the descendants of Emperor Maximilian on the throne of Spain: Philip the Fair or Charles V or Philip II. Since both manuscripts were of approximately the same size and not too bulky, it may have seemed advantageous to unite them in one binding at the time all the Escorial manuscripts were uniformly rebound.

Notes

1 This paper is a result of one of the library research trips that I have been able to make throughout Europe thanks to generous grants from the Belgian Fonds National de la Recherche Scientifique. The photographs of the Escorial manuscript illustrating this paper have kindly been provided by the Patrimonio Nacional in Madrid, which also graciously granted me permission to reproduce them.

2 Description of the manuscript in G. Antolín, *Catálogo de los códices latinos de la Real Biblioteca del Escorial*, vol. 2 (Madrid, 1911), pp. 84–86. It is recorded in J. Domínguez Bordona, *Manuscritos con pinturas: Notas para un inventario de los conservados en colecciones públicas y particulares de España* (Madrid, 1933), vol. 2, no. 1342. Both authors fail to mention the *ex-dono* inscription discussed in the present paper.

3 Domínguez Bordona (note 2) erroneously gives the date 1432 for the entire manuscript.

4 A. Derolez, *Codicologie des manuscrits en écriture humanistique sur parchemin* (Bibliologia, 5) (Turnhout, 1984), pp. 95–100. The ruling in the Escorial manuscript is type 31 in my system.

5 Dr. Eva Irblich, Professor K.G. Van Acker, and Dr. Ernest Warlop have been extremely helpful in identifying the coat of arms and the period in which it could be used.

6 See Corstanje et al. 1982, esp. pp. 149–53.

7 Autograph signatures of Margaret of York also appear in other manuscripts, always at the end of the text, and they all are in the same characteristic handwriting. See Brussels, Bibliothèque Royale, Ms. 9233 (Appendix no. 16), "Margarete d'Angeltare"; Brussels, Bibliothèque Royale, Ms. 9305-06 (Appendix no. 3), "Margarete de Yorke"; Holkham Hall, Library of the Earl of Leicester, Ms. 659 (Appendix no. 11), "Margarete d'Angleterre"; London, British Library, Royal Ms. 15 D IV (Appendix no. 24), "Foryet not har that ys on of your treu frendes. Margarete of York," followed by a French inscription by Mary of Burgundy; Valenciennes, Bibliothèque Municipale, Ms. 240 (Appendix no. 15), "Margarete d'Engleterre."

8 F. Rühl, *Die Verbreitung des Justinus im Mittelalter* (Leipzig, 1871), and M. Manitius, *Handschriften antiker Autoren in mittelalterlichen Bibliothekskatalogen* (Beiheft zum Zentralblatt für Bibliothekswesen, 67) (Leipzig, 1935), pp. 76–78.

9 T. Gottlieb, *Büchersammlung Kaiser Maximilians I., mit einer Einleitung über älteren Bücherbesitz im Hause Habsburg* (Die ambraser Handschriften: Beitrag zur Geschichte der Wiener Hofbibliothek, 1) (Leipzig, 1900).

10 G. Antolín, *Catálogo de los códices latinos de la Real Biblioteca del Escorial*, vol. 1 (Madrid, 1910), pp. xxxvi–xl.

SISTER OR COUNTRY COUSIN? THE HUNTINGTON
RECUYELL AND THE GETTY *TONDAL*

Martin Lowry

D avid Aubert signed the colophons of the two components of the *Tondal* manuscript "en la ville de Gand" in February and March of 1474. He had been busy since 1456 in the ambience of the ducal court, translating and transcribing, cataloguing the library in 1467, setting his name to so many manuscripts that some critics have wondered whether he could have written them all himself or may sometimes have used his name simply to identify his atelier.[1] England's pioneer printer William Caxton wrote of completing his translation of *The Recuyell of the Historyes of Troye* on September 19, 1471, and we know from the calculations of Norman Blake that his second publication, *The Game of Chesse*, appeared on March 31, 1474. The printed edition of *The Recuyell of the Historyes of Troye*, with its elaborate dedication to Margaret of York, must therefore have appeared some time beforehand, though hardly before the latter part of 1473, if we allow time for Caxton to have learned the technique of printing after completing his translation. Caxton wrote that the translation had been "begonne in Brugis and contynued in Gaunt."[2] Most critics have agreed in attributing the frontispiece of the copy presented to Margaret of York, which shows her receiving the book from the hands of Caxton, to the artist known as the Master of Mary of Burgundy or to his circle (fig. 67). Above the hearth in the background of his illustration he set the CM (Charles and Margaret) monogram used by Simon Marmion in the lower margin of the *Tondal* manuscript. The anonymous Master or a close associate was also responsible for the illustration (see fig. 17) in Bodleian Library, Ms. Douce 365, a selection of moral treatises copied for Margaret, again by David Aubert, during 1475.[3]

We are clearly dealing with a cluster of books, produced within a space of months rather than years, by the same group of artists for the same patroness. But the true relationship of the books and the persons to one another opens up a succession of questions. Some are of little more than a teasing antiquarian interest. We should like to know whether the kneeling figure presenting the book is in any sense a portrait of Caxton, the first of any printer, or a merely conventional puppet. But this leads to broader issues. Does Caxton's claim in his prologue—that Margaret made some constructive comments on the first draft of his translation from Raoul Lefèvre's *Recueil* and urged him to continue with it—show that he, like David Aubert, was accepted in the literary circles of the Burgundian court? If he was, what wider inferences should we make about the links between early printing and the culture of contemporary European courts?

Evidence accumulated in the latter part of the nineteenth century seemed to prove that the courts of the Renaissance at first distanced themselves from the printed text. The best-known and most widely quoted opinion is that of the Florentine bookseller Vespasiano da Bisticci, who thought that even "one printed book would have been ashamed" in the company of the Duke of Urbino's library.[4] Though his choice of words was less pointed, David Aubert gave every bit as fastidious an

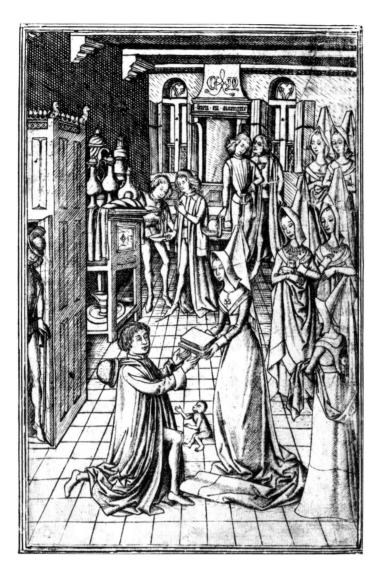

Figure 67.
Master of Mary of Burgundy or his circle.
Caxton Presenting His Translation to Margaret of York (engraved frontispiece), in Raoul Lefèvre, *The Recuyell of the Historyes of Troye* (Bruges, William Caxton, 1473–74). San Marino, Huntington Library.

impression of the tastes of Philip the Good, Duke of Burgundy, in his prologue to *Histoire abrégé des empereurs*: "accustomed to having the ancient histories read to him daily, he wished to have a library without equal, and so from his earliest age he has kept in his employ many translators, great clerks, expert orators, historians and writers, working in several countries. . . ." Anne van Buren has in fact been able to prove that Jean Wauquelin altered the program of illuminations in his manuscripts of the *Chroniques de Hainaut* after a consultation with Duke Philip about a Burgundian success against the Turks at Rhodes in 1449. The meeting of ruler and scholar is documented in official records.[5]

Aubert and Vespasiano were of course biased commentators, anxious to give the impression of belonging to an exclusive circle. But their attitudes do appear to be confirmed in detail by the behavior of the princes and courtiers of the fifteenth century. Borso d'Este, *signore* of Ferrara, ordered six hundred new goatskins to expand his library in 1470, while his council was turning down a request from Clement Donati for permission to bring eight presses from Rome. The Bible of Borso d'Este or the Book of Hours of Andrea Gualenghi and Orsino d'Este stand among the great achievements of Renaissance illumination.[6] Yet only about a hundred editions appeared in Ferrara before 1500, nearly half of them printed by Andreas de Belfortis, who was still active as a scribe in 1495.[7] Florence, the city of the Medici, had only a modest printing industry when it threw the Medici out in 1494. In the next six years, it produced around 150 editions, as many as had appeared in the previous quarter century. A connection between the collapse of the court circle and the rise of printing seems inescapable.[8]

Against this background, it is not surprising that two of the leading authorities

on Caxton, Norman Blake and Lotte Hellinga, have tended to draw a sharp distinction between the culture of the court and the culture of the marketplace, where they situate Caxton. Caxton's whole career, it is argued, was in commerce. He began his translation of the *Recuyell* on March 1, 1468/69, and we know from the signature of Caxton's fellow ambassador, John Russell, in a copy of Cicero's *De oratore* that Peter Schoeffer's texts were by then filtering down from Mainz to the Low Countries. Caxton's real aim was the untapped market for vernacular texts in England. He admits as much in the epilogue to book 2 of the *Recuyell*, where he speaks of having promised copies to "dyverce gentilmen."[9] The meeting with Margaret, at which she is supposed to have encouraged Caxton to push ahead with his translation of the *Recuyell*, is probably a polite fiction conjured out of other, much more mundane encounters in which they discussed cloth prices. Hellinga shrewdly observes that the *Recuyell* is not only the one printed text, but the one secular text, with which Margaret's name is linked. Lambeth Palace Library, Ms. 265, which was copied from Caxton's printed edition of the *Dictes and Sayings of the Philosophers* for presentation to Edward IV, seems to confirm that the printed book was not accepted in the highest social circles.[10] According to this interpretation, everything portrayed by the illustration in the Huntington *Recuyell*, or suggested by Caxton's prologues and epilogues to the edition, should be treated as a mixture of fantasy with wishful thinking, all conjured up in the interest of publicity. His real aim was to sell many books to "dyverce gentilmen," not present special copies to princesses. And as if to sharpen doubts about the authenticity of the scene portrayed in the Huntington *Recuyell*, discussion during the Getty symposium revealed that no evidence can be found that the engraving formed part of the volume before 1800. It could be no more than a conventional presentation scene, bound in to add value to a rare volume.

But it is one thing to say that princes and their courtiers set the highest value on finely illuminated manuscripts: it is going a good deal further to imply, as Vespasiano did, that they despised anything less. Several printed editions were in fact dedicated to the Duke of Urbino, and it is probable that his librarian financed printers. The apparent indifference of the Este dukes of Ferrara looks much less striking in the light of Luigi Balsamo's recent discovery that vast consignments of printed texts were imported from nearby centers such as Venice or Bologna.[11] Perhaps the books were intended for the university rather than the court. But connections between the two were so close that the division may be artificial. It is also dangerously easy to read the structured hierarchy of a seventeenth-century court back into the fifteenth. Conditioned by Voltaire's comparison of the age of Lorenzo de' Medici to that of Louis XIV, we tend unthinkingly to extend Colbert's lists of salaried pensionaries and favored monopolists back into the Quattrocento. And an embryo of that system probably did exist. The Limbourg Brothers and Jan van Eyck were dignified by the title *valets de chambre* to the dukes of Berry and Burgundy; Raoul Lefèvre, who compiled the French version of the *Recuyell*, was chaplain to the Order of the Golden Fleece, and cases such as his seem at first sight to bear out Aubert's claim that Duke Philip kept writers "in his employ" just because they were writers.[12]

But the peripatetic courts of the later Middle Ages were still a long way from Versailles. Most of those who wrote or painted were court functionaries who happened to write or paint rather than writers or painters who were rewarded with a court function, and they were never more than a tiny minority of those who served the literary and artistic needs of the courts. Though Georges Doutrepont listed seventeen manuscripts, many consisting of several volumes, which were copied by David Aubert for the Duke or Duchess of Burgundy between 1456 and 1479, he was unable to establish any formal relationship between the writer and the court. Wauquelin apparently kept a shop in Mons and produced himself at court when business made it necessary.[13] In contemporary Ferrara, favored illuminators such as Taddeo Crivelli or Giorgio Tedesco might be retained by the court for long periods, and even allocated rooms in the ducal palace to work on a commission. But this did not stop them from keeping stalls in the piazza or accepting work from visitors, such as the Venetian

visdomino Leonardo Sanudo, whose manuscript of Augustine's *De civitate Dei* was decorated by Giorgio in 1458.[14] The courts were very large customers, with long purses, and needs which might, on occasions such as the marriage of Duke Charles to Margaret, mean summoning every available painter and craftsman from every town within reach.[15] But they were still customers, not separate worlds supplying their own needs and dictating their own tastes to the rest of society. For the services they required, ducal secretaries and men of fashion went into the marketplace, along with foreign merchants, abbots, or the representatives of cathedral chapters, and sized up the work of craftsmen. The marketplace might ape the manners of the court, but the style of the court depended on the skills available in the marketplace. In 1450 Colart Mansion, "epscrivain, libraire, et bourgeois de Bruges," was paid 54 livres by the treasurer of Philip the Good for a copy of *Romuléon*. By 1475 he was a printer; but he continued to work as a scribe, and accepted commissions from dignitaries such as Philippe de Crèvecoeur or Louis de Gruuthuse in the 1480s.[16]

Figure 68.
Endboards of Douce 365. Reproduced from G. Pollard, "The Names of Some English Fifteenth-Century Binders," *Library*, ser. 5, 25 (1970), pl. VI.

David Aubert came from Hesdin, and his private life is closed to us. But we can reconstruct the world of Colart in some detail from the published records of the scribes' guild of Saint John the Evangelist in Bruges, which he joined at its inception in 1457 and served loyally for three decades. From a core of about forty-five names, the little confraternity grew steadily until it numbered eighty-seven members in 1488. It was a thoroughly normal center of civic piety, requiring an entry fee of 1 gros and 2 pounds of wax. It recorded the usual payment on candles and altar cloths for its chapel or masses for its deceased members, revealed in its list of members how craft and court could mingle, and how the craft could accommodate itself to new developments. A strong element of continuity was provided by men like Colart or the van der Gaveres, a family of binders represented by at least three names over four decades. Though there is no systematic record of who fulfilled what function, there seems to have been a rough balance of "scriver" (scribes) to "verlichter" (illuminators), with a slightly smaller number of binders and parchmenters. Those with a professional interest in books—chaplains and schoolmasters, for example—were able to join. But there was also a steady flow of twelve or fourteen new recruits each year, including several described as knights, and other less likely individuals, such as "the wife of Jan the embroiderer," or Philibert Poitevin, "barber to my lord of Monferrat." By the early 1460s "Ians de prentere," who may have dealt in block-books or single-leaf woodcuts of the saints, had made his appearance.[17] Some of these people may have been on the fringe of the court; most were craftsmen plying their trades for hire from stalls like the one Colart rented from the dean and chapter of Saint Donation in 1478, near the gate of the cloister.[18] Close collaboration was required by the nature of the trade, which demanded that sheets be passed quickly from the scribe to the illuminator to the binder, and by the functioning of the guild, which required existing members to act as sponsors for newcomers.

The guild of Saint John shows that the contact between craft and court which Caxton described in his prologues and epilogues to the *Recuyell* was not simply a figment of his salesman's imagination. And the evidence of his own books suggests that when he came to England in 1476 he brought more than his presses and his commercial ambition: he brought a fragment of the Bruges literary world too. Boston Public Library, Ms. 1519, once owned by a "William Caston," may or may not have been "a book from Caxton's library"; and the colophon of British Library, Royal Ms. 19 A XI, which is exactly echoed, even to the date, in the prologue to Caxton's edition of the same text, *Mirror of the World*, does not necessarily prove that the printer had handled the manuscript.[19] But these scraps can now be supplemented by more substantial material from two manuscripts in the Lyell collection of the Bodleian. Both are French texts popular in the Burgundian court circle and subsequently published by Caxton: Ms. Lyell 47, containing Frère Laurent's *La somme le roi*, and Ms. Lyell 48, Jean Miélot's translation of the *Dialogus de nobilitate*. Both are written in a Brugeois hand, with its characteristic broad strokes, tapering ascenders, and extravagant marginal flourishes in the form of patterns or faces. Neither could be de-

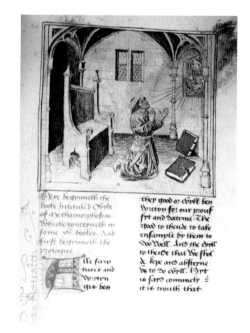

Figure 69.
The Caxton Master. *Ovid Receiving His Poetic Inspiration*, in Ovid, *Metamorphoses*, translated by William Caxton. Cambridge, Magdalene College, Old Library, Ms. F. 4.34, fol. 16. Reproduced by permission of the Master and Fellows of Magdalene College.

scribed as a sumptuous manuscript, for both are modest in size and lack illustration. But Ms. 47 carries on its front paste-down a series of notes, in English, recording the expenses of producing the book; and its endboards are decorated with a rectangular pattern of fleur-de-lys, surrounded by lines of dragons, each enclosed within a triangle.[20] The same tools were used to impress the same motifs, much more carefully, on the endboards of Douce 365, Margaret of York's volume of devotional tracts (fig. 68). They appear again in the work of a Westminster binder, thirteen of whose surviving thirty-six bindings were editions printed by Caxton. The London stationers had established a guild similar to that of Saint John of Bruges as early as 1373. They clearly expected the same close collaboration of the related crafts of scribe and binder. In any case, a binder's tools rarely changed hands, first because they were not valuable enough, second because they were the trademark by which he identified himself. There is nothing to show whether the notes on the endboard of Lyell 47 are those of an English buyer in Bruges, a London stationer commissioning a book for resale, or indeed of Caxton himself. But in the costing of "140 grete letters of ii poynts [lines], 1 grete letter of iiii poynts, 35 parafiss, the vellom, and the binding," we can watch the interlocking functions of the guild and follow the progress of the volume from parchmenter to "scriver" and from "scriver" to binder. The immigrant binder has been plausibly identified as the "Jacobus Bookbynder" who paid rent on the shop next to that of Caxton and Wynkyn de Worde in the later 1490s and took the shop over himself in 1506. Had one of the van der Gaveres decided, along with Caxton, that Bruges was no longer a safe place to ply his trade?[21]

Evidence of a somewhat different kind for the interaction of court society and the market is offered by the two-volume English translation of Ovid's *Metamorphoses*, now in the Pepysian Library of Magdalene College, Cambridge. The second volume, which has been in the library since 1724, carries the colophon "translated and fynysshed by me William Caxton at Westmestre the xxii day of Appryll the yere of Oure Lord MiiiiCiiiixx" at the conclusion of the last six books. On the same folio, the name "Audley Seeley" is inscribed in a slightly later hand, and on the first folio of the volume the single word "Lumley" appears in a cursive hand of the later sixteenth or early seventeenth century. John Lord Lumley, who died in 1609, had inherited the library of the earls of Arundel, and in 1483 Caxton had dedicated his edition of *The Golden Legend* to William FitzAlan, Earl of Arundel, under a prologue which mentioned Ovid's *Metamorphoses* among his published works. This gives us a possible provenance for the manuscript but leaves many problems open. The first volume, which emerged in one of the sales of the Phillipps Collection, was reunited with its companion in 1966. Both volumes contain large spaces at the beginning of each book for an appropriate illustration, but only in the first four books did the illuminator have time to work.[22]

Three of these four illuminations—of Ovid receiving his poetic inspiration (fig. 69), of Phaeton falling from the chariot of the sun, and of Cadmus plowing—tell a story similar to that of the binder's tools used on the Lyell manuscripts. The artist worked in a medium like that favored by the Master of Mary of Burgundy—a pen-and-ink grisaille, lightly touched with color. A fourth illustration, of the story of Pyramus and Thisbe, appears to be the work of a different artist. For whatever reasons the first illuminator's work was interrupted, he evidently had no difficulty in finding commissions elsewhere in English society, since later illustrations ascribed to him appear in a *Mirror of the World*, owned by the London merchant Thomas Kypping, now Ms. Bodley 283 (fig. 70), and in the celebrated *Beauchamp Pageants*, which record the life of the Earl of Warwick and comrade of Henry V and were commissioned, probably by the earl's daughter, Anne, in the mid-1480s (fig. 71). The figures illustrating the Seven Deadly Sins in the Bodleian manuscript are clearly based on Burgundian models, and this has led Kathleen Scott to the conclusion that the anonymous master had come across from Bruges with Caxton in the later 1470s.[23]

The identity of the illustrator of the Pepysian *Ovid* with that of the *Beauchamp Pageants* is not unchallengeable, and even if we do accept it, there is no way of know-

Figure 70.
The Caxton Master. *Avarice*, in *Mirror of the World*. Oxford, Bodleian Library, Ms. Bodley 283, fol. 59.

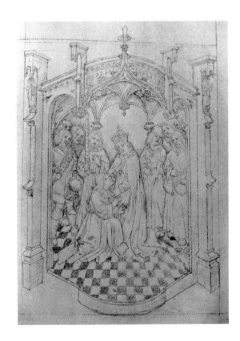

Figure 71.
The Caxton Master. *The Knighting of Richard Beauchamp*, in *Beauchamp Pageants*. London, British Library, Cotton Ms. Julius E IV, fol. 2. By kind permission of the British Library Board.

ing how the artist had been rated in the Low Countries since no work earlier than the *Ovid* has yet been attributed to him. The identity of the scribe raises more serious problems. The colophon reads "translated and fynysshed by me William Caxton," which could mean that Caxton copied the text himself. Though the word "fynysshed" is more ambiguous than "written," which might completely convince us, it is worth reflecting that Caxton frequently used "fynysshed" in the colophons of his printed texts and that there is nothing inherently unlikely in a printer turning scribe. Colart Mansion drifted to and fro between the pen and the press. In spite of this, I simply cannot accept the idea that Caxton was able to double, like Aubert, as translator and calligrapher, then add the role of publisher as well. Even if we assume that much of the work on the *Ovid* manuscript was done in Bruges, bibliographies agree in attributing around twenty printed books to Caxton between his return to England in the autumn of 1476 and the spring of 1480, when the colophon to the Pepysian *Ovid* was written. I cannot claim to have attempted a word-by-word collation of the manuscript text with printed editions. But even in the few pages that I have examined there are a sufficient number of different spellings to make one suspect a different brain behind the hand. We find "profyte" for the "proufyte" or "prouffyte" of *Royal Book* and *Game of Chesse*; "paynems" for the "paynyns" of *Morte d'Arthur*; "to gyder" as two words rather than one, as in *Aesop*. Perhaps most significant of all, the letterform "p" is used for "th," and no such form is represented in any of Caxton's types.

In his introduction to *The Golden Legend*, Caxton implies that he had indeed printed an *Ovid*.[24] But no trace of a copy survives, and the Pepsyian manuscript was never intended as printer's copy. In design, it is closely related to the two Lyell manuscripts examined earlier. The script is somewhat larger, as only thirty lines rather than forty are included in each column. The Brugeois letterforms are exactly the same, with the addition in the *Ovid* of a few specifically English forms such as the "p" for "th" mentioned above. The letters on the top line of each column are extended into the upper margin in a series of decorative flourishes which closely resemble those of Lyell 47. The *cadeaux* of virtuoso penmanship, with faces emerging out of fantastic patterns, are there too. The list of native English scribes thoroughly acquainted with the techniques of the most fashionable Burgundian copyists cannot have been very long. If Caxton did not possess those skills himself, he had the services of someone who did.

Most intriguing of all is the testimony of the text. Though there were many versions of the *Ovide moralisé* in circulation, Caxton's translation can be related to only a small group. The earliest, now in the Vatican, Ms. Reg. 1686, is the archetype and was prepared for King René of Anjou by an anonymous Norman monk in 1467–68. From this, or a copy, derived the apographs Bibliothèque Nationale, Ms. fr. 137, which belonged to Louis de Gruuthuse; Hermitage, Ms. Fr. F. V. XIV. I, which belonged to Louis's brother-in-law, Wolfart de Borssele; and British Library, Royal Ms. 17 E IV, which was copied for Edward IV. The king's enforced stay with Louis de Gruuthuse in 1470 had acquainted him with the charm of the Burgundian book arts, and he began to assemble his own library soon after his successful return to England. Of this group, only the Leningrad and London manuscripts carry the lengthy introduction incorporated by Caxton in his English translation. Whether or not Caxton had access to the royal library himself, he had clearly had access to the same sources of copy.[25]

We should like to know whether the Pepysian *Ovid* is a Caxton autograph as much as we should like to know whether the Huntington *Recuyell* presents a true likeness of Caxton. But these bibliographical details perhaps matter less than the coherent historical pattern into which they fit, along with the two Lyell manuscripts and Douce 365. A series of tracks leads from Caxton's editions, or from manuscripts prepared in his circle, to the finest books prepared for the dukes of Burgundy and their courtiers. There are too many of these tracks intersecting too closely for their coincidence to be merely a matter of chance. Binding, illustration, script, and text

all tell the same story. When Caxton left Bruges in the late summer of 1476 he was not just a printer but the focal point of a group of craftsmen similar to those who had formed the guild of Saint John and were equipped to handle every stage of book production at its most sophisticated level. The roles played both by Caxton and the courts he served closely resembled those played by contemporary Italian courts and the printers who worked in their ambience. Printing was not an isolated and despised method of mass-producing books: it formed a new component in an old system that continued to flourish. Bibliographers have often noted how prone early printers were to claim that they had "written" a text "in bronze." Caxton took the claim to continuity one stage further by claiming that he had "fynysshed"—in terms that implied "printed"—a book in manuscript.

Notes

1 Doutrepont 1909, esp. pp. 31, 492–93.

2 The most accessible version of Caxton's introduction to the translation is in N. Blake, *Caxton's Own Prose* (London, 1973), p. 99. Blake's dating of *The Game of Chesse* to the calendar year 1474 allows the *Recuyell* to be moved further back; see his "Dating the First Books Printed in English," *Gutenberg Jahrbuch* (1978), pp. 43–50. This dating removes some of the difficulties in the account of G. Painter, *William Caxton: A Quincentenary Biography of England's First Printer* (London, 1976), pp. 59–60.

3 The attribution is accepted by O. Pächt, "The Master of Mary of Burgundy," *Burlington Magazine* 85 (1945), pp. 295–300, and the compilers of *William Caxton: An Exhibition to Commemorate the Quincentenary of the Introduction of Printing into England*, exh. cat. (British Library, London, 1976), p. 32. It is questioned by Van Buren 1975, p. 289, n. 21, and implicitly by T. Kren, in Malibu 1983, pp. 27–30, and fig. 3i, where the illustrations of Douce 365 are attributed to a member of the Master's circle.

4 W. George and E. Waters, trans., *Renaissance Princes, Popes, and Prelates: The Vespasiano Memoirs* (New York, 1963), p. 104. For the use of the argument, see E.P. Goldschmidt, *The Printed Book of the Renaissance*, 2nd ed. (Amsterdam, 1966), p. 3, and V. Scholderer, "Printing at Ferrara in the Fifteenth Century," in D.E. Rhodes, ed., *Fifty Essays in Fifteenth- and Sixteenth-Century Bibliography* (Amsterdam, 1960), p. 91.

5 Brussels, Bibliothèque Royale, Ms. 1462, quoted by H. Michel, *L'imprimeur Colart Mansion et le Boccace de la Bibliothèque d'Amiens* (Paris, 1925), p. 4; A. van Buren, "New Evidence for Jean Wauquelin's Activity in the *Chroniques de Hainaut* and for the Date of the Miniatures," *Scriptorium* 26 (1972), pp. 249–68.

6 The Bible of Borso d'Este, Modena, Biblioteca Estense, VG. 12 (lat. 422–23); G. Bertoni, *Il maggior miniatore della Bibbia di Borso d'Este: Taddeo Crivelli* (Modena, 1925). The Hours of Andrea Gualenghi and Orsino d'Este is J. Paul Getty Museum, Ms. Ludwig IX 13. On Borso's order for goatskins, G. Bertoni, *La Biblioteca Estense e la cultura ferrarese ai tempi del duca Ercole I* (Turin, 1903), p. 24; on Donati's petition, Scholderer (note 4), pp. 91–92.

7 For de Belfortis's career, see Scholderer (note 4), pp. 91–92.

8 For this connection, see R. Ridolfi, *La stampa in Firenze nel secolo XV* (Florence, 1957), p. 14f.

9 Blake (note 2), pp. 97–100. Russell's *Cicero* is described in J. Oates, *A Catalogue of the Fifteenth-Century Books in the University Library, Cambridge* (Cambridge, 1954), p. 65, no. 28. Blake's views have been developed in several places: *Caxton and His World* (London, 1969), p. 46 ("Caxton resigned from the governorship of the English merchant adventurers in order to devote his time to printing"); "Continuity and Change in Caxton's Prologues and Epilogues: The Bruges Period," *Gutenberg Jahrbuch* (1979), p. 73 (Caxton's relationship with Margaret of York was probably fictitious); "Continuity and Change in Caxton's Prologues and Epilogues: Westminster," *Gutenberg Jahrbuch* (1980), p. 39 (Caxton creates the impression that his relationship with Earl Rivers was "closer than was in fact the case").

10 On this manuscript, see L. Hellinga, *Caxton in Focus: The Beginning of Printing in England* (London, 1982), pp. 77–80; on the *Recuyell*, her "Caxton and the Bibliophiles," in *XIe Congrès international des bibliophiles* (Brussels, 1981), pp. 39–64.

11 Works dedicated to Federigo include Galeottus Martius, *Refutatio objectorum in librum De Homine* (Venice, Jacobus Rubeus, 1476) and Georgius Merula, *Ennarationes Satyrarum Juvenalis* (Venice, Gabrielis Petri, 1478). On both, see *Catalogue of Books Printed in the Fifteenth Century Now in the British Museum*, vol. 5 (London, 1935), pp. 203, 215. For

comment, see C. Clough, "Federigo da Montefeltro's Patronage of the Arts, 1468–1482," *Journal of the Warburg and Courtauld Institutes* 36 (1973), pp. 137–38; L. Balsamo, "Commercio librario attraverso Ferrara fra 1476 e 1481," *La Bibliofilia* 85 (1983), pp. 277–98.

12 Meiss 1974, p. 77, and R. Vaughan, *Philip the Good* (London, 1970), pp. 154–55. Compare J. Thuillier, "Reflexions sur la politique artistique de Colbert," in J. Favier, ed., *Un nouveau Colbert: Actes du colloque pour le trecentenaire de la mort de Colbert* (Paris, 1985), pp. 275–86.

13 Doutrepont 1909, pp. 264–71, and Van Buren 1975, pp. 250–51.

14 Bertoni 1925 (note 6), p. 43. A series of commissions passed by Leonardo Sanudo to "Zorzi todesco miniador sta in Castel vecchio" from August 17, 1458, is recorded in Archivio di Stato, Venice, Giudici di petition, busta 955, fol. 162. Material on Leonardo has been assembled by R. and M. Rouse, "Nicolaus Gupalatinus and the Arrival of Print in Italy," *La Bibliofilia* 88 (1986), pp. 231–33.

15 See the accounts published by A. de Laborde, *Les ducs de Bourgogne: Etudes* (Paris, 1854), pp. 319–81.

16 Michel (note 5), pp. 4, 7–10. See also L. Sheppard, "New Light on Caxton and Colart Mansion," *Signature*, n.s. 15 (1952), pp. 28–39; W. and L. Hellinga, *Colart Mansion* (Amsterdam, 1963). P. Saenger, "Colart Mansion and the Evolution of the Printed Book," *Library Quarterly* 45 (1975), pp. 405–18, has suggested that the mechanics of printing may have had a certain fascination for courtiers.

17 W.H.J. Weale, "Documents inédits sur les enlumineurs de Bruges," *Le Beffroi* 4 (1872–73), pp. 238–337, 257, for Jacobus van der Gavere, and 261 for "Ians de prentere." On possible interpretations of the term "prentere," see A. Hind, *An Introduction to a History of Woodcut*, 2nd ed. (New York, 1963), vol. 1, p. 81.

18 Michel (note 5), p. 52, appendix, document 2.

19 For the Boston manuscript, see H. McCusker, "A Book from Caxton's Library," *More Books*, ser. 6, 15 (1940), pp. 278–84. N. Blake, "The Mirror of the World and MS Royal 19 A XI," *Notes and Queries* 212 (1967), pp. 205–07, doubts whether "Caston" is the same person as the printer.

20 Detailed description in A. de la Mare, *Catalogue of the Collection of Medieval Manuscripts Bequeathed to the Bodleian Library by James P.R. Lyell* (Oxford, 1971), pp. 126–30.

21 G. Pollard, "The Company of Stationers before 1557," *Library*, ser. 4, 18 (1937), pp. 6–7, 14; G. Pollard, "The Names of Some English Fifteenth-Century Binders," *Library*, ser. 5, 25 (1970), pp. 205–07; *William Caxton Quincentenary* (note 3), pp. 90–93. H. Nixon,

"Caxton and Bookbinding," *Journal of the Printing Historical Society* 11 (1975–76), pp. 93–113, believes that the stamps used on Douce 365 were not the same as those subsequently used in England. M. Foot-Romme, "Influence from the Netherlands on Bookbinding in England during the Late Fifteenth and Early Sixteenth Centuries," in *XIe Congrès* (note 10), pp. 39–64, considers that the stamps may have been cut in England after designs brought by Caxton, but does not discuss Lyell 47.

22 Background given in J.A.W. Bennett's introduction to Kathleen Scott, *The Caxton Master and His Patrons* (Cambridge, 1976), pp. ix–xvii: facsimile edition, *The Metamorphoses of Ovid Translated by William Caxton, 1480* (New York, 1968).

23 The attributions are traced out by Scott (note 22).

24 Blake 1973 (note 2), p. 89.

25 H. Norgard, "Sankt Ovid," *Fund og Forskning* 10 (1963), pp. 7–26, and Brussels 1973, pp. 228–38.

THE LATIN *VISIO TNUGDALI* AND ITS FRENCH TRANSLATIONS

Peter Dinzelbacher

T he literary genre of ecstatic otherworld voyages enjoyed great popularity during the Middle Ages, especially during the twelfth century. This genre, and the place of *The Visions of Tondal* within it, will be the subject of the first part of this paper.[1] The second part focuses on the monk Marcus, author of the *Tondal* text, the literary qualities of that text, and the reasons for its enthusiastic reception. The numerous French translations, including the Getty manuscript, will then be examined in relation to the Latin original, as will some idiosyncrasies of the French redaction in the Getty text. A discussion of the didactic function of such an unusual illuminated manuscript concludes the essay.

Visionary Journeys as a Literary Genre

Most of the texts in this genre have not survived.[2] From classical antiquity, we have only the vision of Er in Plato's *Politeia* (which was to become the model for Cicero's *Somnium Scipionis*) and some similar accounts by Plutarch in his *Moralia*. It was not, however, these Greek and Roman visionaries who became the protagonists of otherworld journeys in the Western tradition, but the apostle Paul, who hinted in a letter to the church at Corinth that he had been privileged with a visit to heaven, "whether in the body, I know not, or out of the body, I know not."[3] This passage obviously accounts for the wide acceptance later gained by the apocryphal *Visio Sancti Pauli*, a forgery written in third-century Egypt. In its description of the realms of the dead, we find both the epic structure typical of all medieval visits to heaven, purgatory, and hell, with its non-sequential movement from one eschatological place to the next, and many of the cruel punishments to which the souls of the wicked are exposed.[4]

During the early Middle Ages an increasing number of similar voyages to the otherworld were written; in my opinion, most of them are records of real near-death experiences, though stylized and rendered in the pattern of the *Visio Pauli* or incorporating phrases taken from the *Dialogues* of (Pseudo-?) Gregory the Great or interpolated by amanuenses and copyists. Many of these accounts have come down to us as inserts in chronicles or as parts of *vitae* and letters, but from the *Visio Baronti* (678/79) onward, records of such revelations also form an independent species of text, i.e., a distinct literary genre.

The twelfth century clearly marks the climax in the production of these texts. From this period date both the longest and the most stylistically elaborate accounts of visions of the beyond. This proliferation is illustrated in the following list, which contains only the major texts.[5] Many shorter ones have also been preserved (several can be read in the Latin *vitae* of the persons who experienced the visions, e.g., Elisabeth of Schönau, Christine the Admirable, Hildegard of Bingen).

Early twelfth century	Ailsi (England)
circa 1117	Albericus de Septem Fratribus (Italy)

1125	Orm (England)
1130	Henricus de Aharin (Germany)
1143/47	Guillelmus (England)
1147	Johannes de Leodico (Belgium)
1148	Tnugdalus (Ireland)
circa 1150	Oenus (Ireland)
1161	Gundelinus (England)
circa 1170	anonymous knight (Ireland)
1179	Sinuinus (England)
1189	Godescalcus (Germany)
1196	Edmundus de Eynsham (England)
1197	Rannveig (Iceland)
1206	Thurkill (England)
1223	Adam de Kendall (Scotland)

The *Tondal* text is thus only one among a large number of otherworld visions that originated all across twelfth-century Europe. It is evident even from this abbreviated list that northwest Europe, especially England and Ireland, was foremost in the production of accounts of such visionary experiences. Moreover, the texts share certain features: all the seers except for Rannveig, a priest's concubine, were men; whereas in the early Middle Ages most of the visionaries were monks, in the twelfth century about half were laymen, whether knights or peasants; all the accounts of the hereafter describe in great detail the eschatological regions of punishment, in most cases purgatory, dealing only briefly, if at all, with heaven or paradise.

After about 1200, the popularity of these texts as an independent genre came to a somewhat abrupt end. From the thirteenth century on, visions of the beyond normally appear in three different contexts: as part of the *dona gratiarum* recounted in the life of a saint (usually female), such as Ida of Nivelles, Gerardesca of Pisa, Colette of Corbie; in a *liber revelationum* like those of Hadewijch, Mechthild of Magdeburg, and Bridget of Sweden; or in a combination of these two genres, exemplified by the *Vita et revelationes* of Agnes Blannbekin.[6] One major vision of the otherworld, the Norwegian *Draumkvaede*, though probably dating from the thirteenth century,[7] is only known to us in the form of an orally transmitted *legendevise*, which was not written down before the middle of the nineteenth century, though it has been republished many times since.

In the later Middle Ages, new accounts of ecstatic visits to the realms of the souls were rare, and few were copied into separate manuscripts—the revelation of purgatory written by an anonymous Englishwoman and dated 1422 is exceptional.[8] There appears to have been, however, a small-scale revival of eschatological visions in fifteenth-century Italy: Francesca of Rome (d. 1440) experiences, apart from countless mystical visions, long raptures in a Dantesque "inferno" and "purgatorio."[9] Other ecstatics, among them the children Blasius (1450) and Isabetta di Luigi (1467),[10] give accounts of purgatory and paradise, as do some of the *sante vive* of the Renaissance.

Visio Tnugdali: Author and Text

From the viewpoint of both its literary quality and its later reception, the *Visio Tnugdali* may be regarded as the most important otherworld vision of the high Middle Ages, a status reflected in the number of studies devoted to it by modern scholars. Only the revelations of Hildegard of Bingen have attracted similar attention, albeit for very different reasons (Catholic hagiolatry and, recently, feminism). Nonetheless, all the modern histories of medieval Latin literature accessible to me ignore this text, as they ignore the genre itself—an eloquent proof of the persistent tendency among most medievalists to consider visionary literature as of marginal significance.[11] Three scholarly editions of the Latin *Tondal* are, however, available,[12] the

first one by Oscar Schade (1869) from a single manuscript;[13] the second (the only critical one) by Albrecht Wagner in 1882, who used seven early manuscripts;[14] and the third, by Peter Cahill, published in 1983, which is only a reprint of Wagner's text, "pending a new critical edition."[15] The facts about the origin and meaning of our text have been adequately summarized recently by de Pontfarcy.[16]

Turning to the text, there is no reason to doubt the author's account of how the knight Tondal reported his near-death experience to him in their native tongue and how he was later asked by the abbess G[isila] of Regensburg to translate it into the idiom of the "litterati" and "litteratae." Given the fact that both Tondal and his amanuensis Marcus are known solely from the work in question, it would not make any sense to deny what they claim, i.e., that in 1148 an otherwise unknown knight named Tnugdal had a vision of the otherworld and that early in 1149 Marcus wrote it down as a "fidus interpres" "prout nobis ipse, qui viderat, eandem visionem retulit."[17] This does not mean, however, as is clear from internal evidence, that Marcus did not also make use of the literary conventions taken for granted in medieval paraenetic writings (e.g., the invention of speeches) and the pious didactic aim of the text (for which latter purpose were supplied punishments for sins that the seer "forgot"). So it is highly probable that the long passages concerning both the pains of sinners and the glory of the religious can at least in part be accounted for by the fact that Marcus was a monk. Moreover, if the inferred date of Tondal's vision—November 3–6, 1148[18]—is correct, the knight cannot have seen Archbishop Malachy of Armagh in paradise, since this saint died in Clairvaux on November 1, which Tondal could not have known so quickly.

We know little about "frater Marcus."[19] He was an Irishman, but from which of the island's monasteries? He was an admirer of Saint Bernard, but had he met him personally? Was he a member of the old Benedictine Order or rather a Cistercian?[20] M.-O. Garrigues has recently tried to identify him with Honorius of Autun, a similarly enigmatic figure, though the hypothesis seems to me based on very weak evidence.[21] There is not a single manuscript that assigns the *Tondal* to Honorius rather than to Marcus; and many manuscripts are anonymous. Why should the monk have published this particular text under the name of Marcus, but all his other writings under that of Honorius? The accidental linguistic similarities between the *Visio* and Honorius's works, discerned by Garrigues on the basis of her method of stylistical comparison, only infer, in my opinion, that both writers had a similar training in a monastic school and that they possibly came from a similar monastic ambience. Using Garrigues's method, it would not be too difficult to "prove," for instance, that Saint Bernard himself had been the author of our text—a claim indeed made in one of the French translations ("Ceste vision escrit S. Bernars quant il escrit la uie saint Malachie. . . . Et par certain la puet on croire. . . ."[22]) and in the Catalan version ("La Visio del Monestir de Clares Valls"[23]). Garrigues's conclusion—"Par tendresse ou par jeu [!], peut-être Honorius au seuil de la mort a-t-il réincarné dans une fable hautement morale le fantôme de sa jeunesse dissipée"—is thus highly speculative in its untenable identification of the author with his protagonist.

Whoever the author, it was certainly not his fame, as it was with the apocryphal *Visio Pauli*, that accounted for the immense circulation of the *Visio Tnugdali*. We know of about 170 Latin manuscripts and a considerable number of vernacular redactions.[24] We thus have to explain why this particular description of the hereafter received more widespread interest in the Middle Ages than any other twelfth-century account of a similar vision.

There is, first of all, the remarkably creative imagination of Tondal and brother Marcus. Although the visions of Godescalcus and Thurkill, for example, are also fantastic and well told, the level of invention in the *Visio Tnugdali* remains unequaled. An abundance of graphic details, though most of an overtly sadistic nature, characterizes Tondal's vision. One can hardly forget the "shadowy valley covered by the fog of death,"[25] hermetically locked by an iron lid "burning with unusual brightness," where a "multitude of most miserable souls" is burned and liquified, only to be re-

stored to new torment; or the "very narrow and long bridge" whose surface "was also pierced with very sharp iron nails, which slashed the feet of all those crossing, so that no one's foot, if he or she touched it a single time, could avoid them" (across this bridge Tondal has to lead the wild cow).[26] There is the beast vomiting the fornicators' souls into the frozen swamp of ice, the souls waxing pregnant with vipers churning them from inside; or the Dantesque prince of shadows, the burning tormentor tormented himself on his iron grille, fettered by flaming iron bonds and writhing unceasingly. These images, reminiscent in their bizarreness of scenes in the Old Irish epics, are obviously products of what has been called the Celtic genius, as are also the popular and frightening stories about Saint Brendan's voyage and about Saint Patrick's Purgatory.[27] It is of little consequence that Marcus's latinity lacks the idiosyncrasies typical of most Hiberno-Latin writers.[28] If there were not the equally famous archetype of immortal love in the legend of Tristan and Isolde (if indeed it is of Celtic origin), the major contribution of that "Celtic genius" to medieval literature—or rather mentality—would be the archetype of immortal fear. Perhaps Friedrich Heer was not so wrong in assuming that without this tradition of fantastic punishments imagined in an "ecclesiastical hell," the real concentration camps would not have been possible.[29]

Certainly the *Visio Tnugdali*, like other writings of the genre, did not only lead to a salutary meditation on the Last Things, but also provided "serious entertainment" for medieval readers or listeners, an aspect that has been aptly stressed by T.C. Gardner.[30] For *The Vision of Tondal*, this is demonstrated by the fact that the English translations have often been bound together with romances in a single volume.[31] There were many "entertaining" functions of such a story: imagining one's enemies as the victims of the pains of the underworld must have afforded as much satisfaction as watching public executions;[32] on the other hand, imagining oneself transported into the glory of paradise must have provided a needed escape from the dire problems of reality.

The responses of Tondal when faced with the diverse and dreadful situations he encounters are often closer to psychological reality than those recorded by other visionaries. Let one example suffice. When the soul has to leave Tondal's body, it fears something unknown, longs to return to the body, and hears the cruel fiends approaching. Many records of similar near-death experiences have been collected by modern psychologists and surgeons dealing with thanatology who describe the phenomenon of a soul leaving its body and visiting another world in neutral terms, whereas medieval seers and amanuenses gave the phenomenon an immediate religious interpretation.[33]

Marcus presented such fascinating subject matter in a fascinating language— the stylistic quality of his narration is obvious. A lively text results from shifts between reportorial narration and dramatic dialogue; from the contrast in the speeches between reasoning and emotion; from the examination of the individual realms of the beyond;[34] and from the pertinent poetic comparisons, which reflect a knowledge of Virgil.[35] Even the distribution of biblical quotations is not casual: they increase in number as the paradisaic regions approach.[36] The visionary exposes his feelings of fear and of hope, the demons strike a note of irony, and the angel shows both contempt and compassion. It is always exciting to follow Tondal, whether he is afraid, as he remains for most of the text, or is rejoicing at the end, whereas it is sometimes rather tedious to accompany, for example, Albericus or Edmundus on their eschatological journeys because of the comparatively monotonous texture of their visions.

Another feature that might have appealed to the medieval reader in particular is connected with the charismatic's social status. The fate of a protagonist who did not belong to the clergy (as did most earlier charismatics) but was a member of an important social class would certainly have been of heightened interest to lay readers. *The Visions of Tondal* was therefore to be found in the libraries of many laymen. One may compare the popularity of *Saint Patrick's Purgatory*, the second major Irish tale about the visit of a knight to the underworld: during the central and late Middle Ages,

many peers followed Owein's example by undertaking a pilgrimage to Lough Derg.

Purgatory is the key word in explaining another factor that led to the success of *The Visions of Tondal*: the text proved to be in line with the evolution of eschatology taking place during the high Middle Ages, when purgatory became more and more accepted as an intermediary location between hell and paradise.[37] The word "purgatorium" does not appear in Marcus's account, but the places located above the nethermost hell, though still classified as infernal, show a purgatorial character because their inhabitants have either the hope or the knowledge of salvation.[38] This purgatory is twofold, one part belonging, as usual, to the infernal regions (the souls awaiting judgment) and another—a Celtic idiosyncrasy[39]—to the paradisaic (the "mali non valde" and "boni non valde"). Thus *The Visions of Tondal* "represents, especially in the fullness of its purgatorial teaching, the newer eschatological views . . . of the movement of reform."[40] This was understood by the translator into whose hands the Duchess of Burgundy put the Latin *Visio*, as well as by most other translators of the late Middle Ages[41] and by Martin Luther.[42] Margaret's translator states that the knight is to see both "les tourmens denfer. Et ainsi les peines de purgatoire" (fol. 7).

Translations of the *Visio Tnugdali*

One of the effects of the "emergence of secular civilization" was the increasing number of translations of all types of texts into the vernacular. Revelation literature was no exception, but the critical fortunes of the *Visio Tnugdali* can be called extraordinary. The following translations survive, either in prose or verse: Anglo-Norman, Belorussian, Catalan, Czech, Dutch, English, German, Irish, Icelandic, Italian, Portuguese, Provençal, Serbo-Croatian, Spanish, and Swedish.[43] One also has to consider works that contain reminiscences or quotations from the *Visio*. Palmer has compiled a list of Latin chronicles and didactic writings that cite Marcus's text;[44] but there are also allusions to it that make no mention of Tondal's name. For example, the famous mystic Mechthild of Magdeburg was granted a vision of the purgation of bad priests: they are eaten by the devils, digested into the lake of fire, cooked, eaten again, and so on[45]—obviously an appropriation of Tondal's beast devouring the souls of sinful monks and nuns.[46]

A compilation of extant manuscripts has been made only for the German and Dutch translations; it is not possible to determine exactly how many different versions actually exist in each of the aforementioned tongues. Palmer counted twelve prose and two verse translations into German and Dutch, most of them dating from the fifteenth century (the same century in which half the Latin codices were written). A close study of the French translations would probably bring to light more than the eight versions known to D.D.R. Owen, because he did not examine all the relevant manuscripts.[47] Following is a list of these French translations—all but the first in prose:[48]

> fragmentary Anglo-Norman poem in alexandrines (thirteenth century)
> northeast France (fourteenth century)
> southeast France (fourteenth century)
> Jean de Vignay (circa 1335), based on the abridged variant given
> > by Vincent of Beauvais, *Speculum historiale*, 28, 88–104
> northeast France (before 1443)
> a translation omitting the vision of paradise entirely (fifteenth century)
> Regnauld le Queux, in his *Baratre infernal* (1480), also omitting
> > the vision of paradise, based on Vincent of Beauvais
> Provençal, in a manuscript dating from 1466, entitled *Vision de Godalh* [*sic*!]

Compared to the number of extant French versions of the *Visio Pauli*, *Saint Patrick's Purgatory*, and the legend of Saint Brendan, the circulation of the *Visio Tnugdali* was relatively modest.[49] One reason for the limited number of vernacular manuscipts

in France is that there were relatively few Latin manuscripts: among the 165 Latin codices listed by Palmer only ten are located in French libraries (there is a further one: Troyes, Bibliothèque Municipale, Ms. 946, fols. 50-68v, twelfth century); and only five can be documented as in France in the Middle Ages.[50]

The Middle French[51] translation of the *Visio* made for Margaret of York was not included in Owen's study, though R. Verdeyen in 1920 had regretted that this "manuscrit a disparu au fond d'une bibliothèque inconnue et je ne suis pas parvenu à en retrouver la trace."[52] As far as one can judge from the two texts printed by Friedel and Meyer (the only French versions as yet published) and the succinct descriptions given by Owen, none of these translations represents the original copy of the duchess's book. This text, compared with other vernacular versions of Tondal's revelation, is unique in the translator's unusual stress on the noble descent of the protagonist: "ch[ev]allier tondal grant seigneur en sa te[er]re dirlande Scant non pas moult loing du noble et puissa[n]t roiaulme de bretaigne la grant," the latter being a remark *ad personam ducatricis*. Tondal is "puissant" (as is the "tres puissante princhesse—Madame marguerite de yorch" (fol. 43v), addressed as "messire," "monseigneur" (fols. 4, 8v) and "grant seign[eu]r" (fols. 6v, 7). Whenever his name appears, it is rarely without reference to his precise social status as "chevallier." In the original account, Tondal is "vir nobilis," "genere nobili," and "curialiter nutritus" only at the beginning of the narration.[53] His visionary experience is even called an "auenture" (fol. 10) by the translator, as if it had been the courtly "queste" of an Arthurian romance (the structural parallels between these two kinds of texts have already been noted).[54]

"Le livre dun ch[ev]allier et grant seigneur en yrlande" is one of the finest examples of noble piety in the fifteenth century, a time when the devotion of both the clergy and the laity was focused on a few major themes: the Infancy and the Passion of Christ, the compassion of the Virgin, the poor souls in purgatory, and the four "novissima"—death, judgment, heaven, and hell. Most of these meditative themes had become popular in Western Christianity only from the so-called turning point of the central Middle Ages onward,[55] with Bernard of Clairvaux as an influential forerunner. Along with an interest in new religious themes, this period also saw the introduction of a new method of meditation, propagated especially by the Pseudo-Bonaventura (circa 1300): pictorial meditation. Contemplatives were invited, *expressis verbis*, to imagine themselves as participants in the scenes of sacred history. This device of imaginative identification was not only employed in mental prayer but also in the works of art commissioned by the devout: often in late Gothic art the donor is integrated into the sacred scene depicted.[56] Pictures were used more and more frequently as devices in meditation—many a saint's life from the late Middle Ages tells of mystical experiences occurring in front of a crucifix or image of the cross, and figures appearing in a vision are explicitly likened to those seen in a fresco.[57] It is this combination of a catechesis by word and by picture that was particularly esteemed by the faithful of the fifteenth century.[58] And this is precisely what illuminated manuscripts such as Margaret's *Tondal* and later printed volumes with woodcuts could offer: a pictorial narrative that invites readers to imagine themselves in the place of the hero. Meditating on the sinner's pains, the reader, also a sinner, would gain spiritual profit because Tondal's fate "vault gra[n]dement pour les peche[ur]s chastoyer Et pour les coeurs humains esmouuoir aux oeuures de pitie et misericorde . . ." (fol. 7v). The fact that Margaret of York was indeed frequently moved to perform the Seven Acts of Mercy is not merely stated in the frontispiece of her book *Benoit seront les miséricordieux*, but is also demonstrated by many entries in the accounts of her domains.[59] *Cum grano salis*, one may conclude that, as so often in the "age of faith,"[60] a vision had led to concrete deeds.[61]

Notes

1 The following studies of the *Tondal* text do not appear in the fairly extensive bibliographies found in Palmer 1982 and Picard/de Pontfarcy 1989. Although there was no occasion to cite them in the notes to the present essay, they remain essential contributions to the literature and are presented here, in chronological order, for the sake of completeness.

W. A. Craigie, "The Vision of Tundale," *Scottish Review* 26 (1895), pp. 92–113; J. Koopmans, "Tondalus Visioen," *Tweemaandelijke tijdschrift voor letteren, kunst, wetenschapen, politiek* 50 (1901), pp. 42–60; L. Guercio, *Di alcuni rapporti tra le visioni medievali e la Divina Commedia* (Rome, 1909), pp. 76–103; H. Röckelein, *Otloh, Gottschalk, Tnugdal: Individuelle und kollektive Visionsmuster des Hochmittelalters* (Frankfurt, 1987); N. F. Palmer, "Niederrheinischer Tundalus," *Die deutsche Literatur des Mittelalters: Verfasserlexikon* 5 (Berlin and New York, 1987), cols. 1000f.; idem, "Die Handschrift der niederrheinischen 'Tundalus-Bruchstücke,'" *Zeitschrift für deutsche Philologie*, suppl. (1989), pp. 115–31.

2 See, most recently, P. Dinzelbacher, "Jenseitsvisionen," in *Enzyklopädie des Märchens* (Göttingen, in press).

3 2 Cor. 12: 1–5.

4 P. Dinzelbacher, "Die Visio Pauli," *Mittellateinisches Jahrbuch* (1992; in press).

5 A more complete list, including the editions, can be found in P. Dinzelbacher, *Revelationes* (Typologie des sources du moyen âge occidental) (Turnhout, 1990), pp. 86–108.

6 Ibid., and P. Dinzelbacher, "Die 'Vita et Revelationes' der Wiener Begine Agnes Blannbekin (+1315) im Rahmen der Viten- und Offenbarungsliteratur ihrer Zeit," in P. Dinzelbacher and D. Bauer, eds., *Frauenmystik im Mittelalter* (Ostfildern, 1985), pp. 152–77.

7 P. Dinzelbacher, "Zur Entstehung von Draumkvaede," *Skandinavistik* 10 (1980), pp. 89–96.

8 M.P. Harley, ed., *A Revelation of Purgatory by an Unknown Fifteenth-Century Woman Visionary* (Lewiston, 1985).

9 See G. Picasso et al., eds., *Una santa tutta romana* (Siena, 1984).

10 P. Dinzelbacher, "La visione di Isabetta di Luigi, perugina: Testo inedito del quattrocento in volgare," in C. Roccaro, ed., *Le 'visiones' nella cultura medievale* (Palermo, in press).

11 Even K. Bertau's valuable study, *Deutsche Literatur im europäischen Mittelalter*, 2 vols. (Munich, 1973), is no exception. Perhaps the

situation will change in the future, considering the recent interest Jacques Le Goff and Aron Gurevich have shown in this kind of historical source. Among other studies of medieval Latin literature that take no account of visionary texts, see M. Manitius, *Geschichte der lateinischen Literatur des Mittelalters*, vol. 3 (Munich, 1931); J. de Ghellinck, *L'essor de la littérature latine au XIIe siècle*, vol. 2 (Brussels, 1955); L. Alfonsi, *La letteratura latina medievale* (Florence, 1972); R. Düchting, "Die mittellateinische Literatur," in *Neues Handbuch der Literaturwissenschaft*, vol. 7 (1981), pp. 487–512.

12 Picard/de Pontfarcy 1989, p. 11, indicate only one such edition.

13 O. Schade, ed., *Visio Tnugdali* (Halle, 1869).

14 Wagner 1882.

15 P. Cahill, ed., *Duggals leiðsla* (Reykjavík, 1983), p. xcvii.

16 Picard/de Pontfarcy 1989. Another recent translation into modern English, Gardiner 1989, perhaps better recaptures the "flavor" of the original text.

17 Wagner 1882, p. 4/25.

18 Picard/de Pontfarcy 1989, p. 25.

19 Wagner 1882, p. 3/2.

20 That Marcus was a Cistercian (a possibility proposed, though unsuccessfully, by A. Voigt, review of Wagner 1882, in *Zeitschrift für deutsches Altertum* 26 [1882], pp. 350–68), cannot be discounted. Citations in the *Visio Tnugdali* from the *Regula monasteriorum* do not, as some scholars hold, prove Marcus's Benedictine origins, since the Cistercians aimed expressly at following the Rule of Saint Benedict *ad apicem*. Moreover, in *De praecepto et dispensatione*, the great Cistercian Saint Bernard offers what amounts to a commentary on the Rule. Apart from that, in those years there were many cases of a "transitus" of Benedictine monks to the reformers, the most famous example being William of Saint Thierry. Ruadhan addresses himself to the knight as his patron, not to the monk, as correctly noted in Palmer, review of Spilling (note 35, below), in *Zeitschrift für deutsches Altertum* 106 (1977), pp. 156–61, and Picard/de Pontfarcy 1989, p. 82f.

21 M.-O. Garrigues, "L'auteur de la 'Visio Tnugdali,'" *Studia monastica* 29 (1987), pp. 19–62. Garrigues claims that N. Palmer "pense que . . . la vision est pratiquement anonyme" (p. 23, n. 18), referring to Palmer's "Bruder Marcus," *Die deutsche Literatur des Mittelalters: Verfasserlexikon* 5 (Berlin and New York, 1985), cols. 1231–33. However, Palmer does not really make that claim. Many other points in Garrigues's essay are

rather speculative, e.g. (p. 35), that the Old English (!) Genesis might have been a model for Honorius-Marcus.

22 V.-H. Friedel and K. Meyer, eds., *La Vision de Tondale* (Paris, 1907), p. 57.

23 R. Miquel y Planas, *Llegendes de l'altra vida* (Barcelona, 1914), p. 35.

24 The fullest account is Palmer 1982. See my review in *Beiträge zur Geschichte der deutschen Sprache und Literatur* 107 (1985), pp. 144–48.

25 Gardiner 1989, p. 155.

26 Ibid., p. 162.

27 P. Dinzelbacher, "Der Anteil der keltischen Phantasie an den mittelalterlichen Jenseitsvorstellungen," in U. Müller, ed., *Irischkeltische Mystik nördlich der Alpen* (Salzburg, 1989), pp. 19–31. See also D. Edel, "De Keltische traditie: De verkenning van de andere wereld," *Utrechtse bijdragen tot de medievistiek* 6 (1986), pp. 98–121.

28 The best-known, albeit difficult, example of these Hiberno-Latin writings is the miscellany entitled *Hisperica famina*; see M. Herren in *Lexikon des Mittelalters* 5/1 (1990), col. 40.

29 F. Heer, *Abschied von Höllen und Himmeln* (Esslingen, 1970), p. 142.

30 T.C. Gardner, "The Theater of Hell," Ph.D. diss., University of California, Berkeley, 1976, pp. 35–83.

31 E. Gardiner, "The Vision of Tundale: A Critical Edition of the M.E. Text," Ph.D. diss., Fordham University, New York, 1980, p. 28f.

32 See, e.g., J. Huizinga, *The Waning of the Middle Ages* (Harmondsworth, 1972), p. 11f., and R. van Dülmen, "Das Schauspiel des Todes," in R. van Dülmen, ed., *Volkskultur* (Frankfurt, 1984), pp. 203–45, 417–23.

33 C. Zaleski, *Otherworld Journeys: Accounts of Near-Death Experience in Medieval and Modern Times* (New York and Oxford, 1987), and P. Dinzelbacher, *An der Schwelle zum Jenseits: Sterbevisionen im interkulturellen Vergleich* (Freiburg i. Br., 1989).

34 De Pontfarcy, in Picard/de Pontfarcy 1989, p. 65ff., underlines the symbolic structure of the vision, which she believes to have been created by the use of certain numbers to rule its composition; however, one should bear in mind the skeptical standpoint of E. Hellgardt, *Zum Problem symbolbestimmter und formalästhetischer Zahlenkompositionen in mittelalterlicher Literatur* (Munich, 1973). If Marcus really wished "to give a cosmic dimension to his creation" (de Pontfarcy, p.

67), it certainly could not have been recognized by the medieval reader or listener unless he counted the text line by line.

35 Cf. H. Spilling, *Die Visio Tnugdali: Eigenart und Stellung in der mittelalterlichen Visionsliteratur bis zum Ende des 12. Jahrhunderts* (Münchner Beiträge zur Mediävistik und Renaissance Forschung, 21) (Munich, 1975), pp. 189, 191, and J.C.D. Marshall, "Three Problems in the Vision of Tundal," *Medium Aevum* 44 (1975), pp. 14–22.

36 Spilling (note 35), p. 195.

37 Apart from some problems of detail, the main conclusions of Le Goff 1984 seem to be valid; see my review in *Ons geestelijk erf* 61 (1987), pp. 278–82.

38 This region has been misinterpreted by Le Goff 1984. The real hell obviously begins only with the "tortor Vulcanus" (Wagner 1882, p. 30ff.) when the angel says: "Ista via ducit ad mortem" (Wagner 1882, p. 30/18) because hell used to be called the "mors secunda" (cf. Rev. 20: 14).

39 St. J.D. Seymour, *Irish Visions of the Other-World* (London, 1930), p. 160.

40 Ibid., p. 154.

41 Palmer 1982, pp. 27f., 205, 216f., 233, 243, 276f., 347f.

42 *Martin Luther, Werke. Kritische Gesamtausgabe* (Weimar, 1883ff.), vol. 32, p. 502f.

43 Palmer 1982, p. 430ff.

44 Ibid., p. 19ff.

45 *Das Fliessende Licht der Gottheit*, 5, 14, in P. Dinzelbacher, *Mittelalterliche Visionsliteratur* (Darmstadt, 1989), pp. 159, 162f.

46 Wagner 1882, p. 27f. See also P.W. Tax, "Die grosse Himmelsschau Mechthilds von Magdeburg und ihre Höllenvision," *Zeitschrift für deutsches Altertum* 108 (1979), pp. 112–37.

47 Five more French translations are cited by Palmer 1982, p. 17, n. 26.

48 Owen 1970, p. 62ff., 118ff., 254, and H.R. Jauss et al., *La littérature didactique, allégorique et satirique* (Grundriss der romanischen Literaturen des Mittelalters 6/2) (Heidelberg, 1970), pp. 249–51.

49 Owen 1970, p. 123.

50 Palmer 1982, p. 15.

51 Not Old French, as claimed in Malibu 1990, p. 61. The transition period from Old to Middle French is—at the latest—the second quarter of the fourteenth century.

52 R. Verdeyen, "A propos de la Vision de Tondale," *Nuovi studi medievali* 1 (1923–24), pp. 228–54.

53 Wagner 1882, p. 6.

54 See p. 114, above.

55 See P. Dinzelbacher, "Das bernhardinische Zeitalter als Achsenzeit der europäischen Geschichte," in press.

56 F. O. Büttner, *Imitatio pietatis* (Berlin, 1983).

57 See P. Dinzelbacher, "Bildende Kunst," in P. Dinzelbacher, ed., *Wörterbuch der Mystik* (Stuttgart, 1989), pp. 59–61.

58 See, for example, P. Dinzelbacher, "Das Fegefeuer in der mittelalterlichen Schrift- und Bild-Katechese," in D. Bauer and D. Harmening, eds., *Religiöse Laienbildung und Ketzerabwehr im Mittelalter* (Würzburg, in press).

59 C.A.J. Armstrong, "The Piety of Cicely, Duchess of York: A Study in Late Medieval Culture," in D. Woodruff, ed., *Essays for Hilaire Belloc* (New York, 1942), pp. 68–91.

60 Dinzelbacher (note 45), pp. 1–15.

61 My thanks are due to Dr. Franz Wöhrer, who kindly corrected the English of my paper.

Margaret of York's *Visions of Tondal*

Relationship of the Miniatures to a Text Transformed by Translator and Illuminator[1]

Roger S. Wieck

Although *The Visions of Tondal* was the most widely read story in Northern Europe of a journey to the next world, Margaret of York's copy of the *Visions* is the only known manuscript with a cycle of illustrations.[2] No other illustrated manuscripts have survived and none are known to have existed.[3] Thus the first and fundamental step in understanding the twenty miniatures is to read the text itself. Indeed, this is what Simon Marmion, Margaret's artist, had to do when faced with a commission to illustrate a text that had no pictorial tradition. The resulting relationship between text and picture in Margaret's book is thus a very close one, and it is possible to experience this relationship, as Margaret did, by viewing the reproduced miniatures and reading the excerpts from the text provided in the Getty Museum's 1990 publication of the *Tondal*.

The excerpted texts in this recent publication are, it must be stressed, from the version of *The Visions of Tondal* to be found in the Getty manuscript. The original treatise was composed in Latin at Regensburg around 1149 by a monk named Marcus for Gisila, abbess of the Benedictine convent of Saint Paul in that city.[4] The Getty translation into old French was done in the fifteenth century by a person whom I suspect, but yet cannot prove, was David Aubert himself, the scribe who signed the *Tondal* and its sister manuscript, *The Vision of the Soul of Guy de Thurno*, also in the Getty Museum.[5] Whether or not the Getty translator was Aubert does not matter to this article; what does matter is that a comparison of the Getty French text with the Latin original reveals a number of differences. And it is an awareness of these differences between the original twelfth-century Latin and its fifteenth-century French translation that enables one to understand more fully the iconography of Marmion's cycle, more fully than if one read either the original Latin or the French translation alone. These differences, of course, are not self-evident in the Getty's 1990 publication, but can be gleaned from a comparison of the Getty version with the original Latin.[6] Thus the first theme I will discuss is the transformation of *The Visions of Tondal* by the translator. The second theme, which will also increase our understanding of the Getty miniatures, is a by-product of the first: the transformation of the *Visions* by the illuminator.

Transformation of *The Visions of Tondal* by the Translator

The differences between the twelfth-century Latin text of the *Visions* and the fifteenth-century French translation can be categorized into three types: additions, omissions, and errors.

Certain sections of text in the Getty version do not exist in the Latin. The translator composed, for example, a new prologue (fols. 7–7v). The themes of the original Latin prologue, with its specific references to Abbess G., to whom the text was dedicated, were deemed unsuitable for Margaret of York.[7] At the end of the

Latin *Tondal* there is also a prayer, addressed in the name of Abbess G., that Margaret's translator omitted, adding one of his own composition.[8] There are also, as might be expected, numerous small additions peppered throughout the body of the text. In the dramatic opening scene, where Tondal suffers his seizure, the Latin merely says that the knight was unable to retract his extended hand. In the Getty version, the translator specified that Tondal had extended his *right* hand.[9] And this is what took pictorial form in Marmion's picture; but this detail is insignificant, for Marmion might just as easily have made Tondal right-handed without any textual specificity. On the whole, in other words, the additions to be found in the Getty translation of the *Visions* are of little importance to the pictures.

The passages in the twelfth-century Latin that the fifteenth-century French omitted are more noteworthy. In Margaret's manuscript, Tondal's final vision concerns the realm of Virgins and the Nine Orders of Angels. After this experience, the Latin original describes, in two short chapters, how Tondal encounters Saint Ruadhan and then meets with Saint Patrick and four Irish bishops.[10] The Getty translator deleted these two sections. The fact that these episodes are more concerned with twelfth-century Irish religious politics than matters of faith relevant to the fifteenth century may have encouraged the translator to omit them.[11] Not included by Margaret's translator, they were, of course, not illustrated by Marmion. But their absence has another, more subtle, but quite profound influence on the cycle of pictures, which I will return to in the second part of this paper in the discussion of the transformation of the *Visions* by the illuminator.

It is in the category of translation errors, however, that we hit pay dirt. Margaret's translator had a good grasp of Latin, but his hold was not perfect. The errors he made are relatively small and few, and they would not even be worthy of discussion were it not for the fact that, ironically enough, some of these very errors seem to have caught Marmion's eye during his reading of the text. A few of them end up having a pivotal influence on the *Tondal* pictures.

There are a few mistakes in hell. There is the large, birdlike creature who consumes the unchaste monks, nuns, and priests and, a little later, according to the Latin original, gives birth to these unfortunate souls into a freezing lake. Margaret's translator changed the verb to "defecate," and this very means of conveyance from the beast's stomach into the glacial surface of the lake is the one Marmion illustrates.[12] The valley wherein are punished the Perversely Proud and Presumptuous in the Latin original had, as its main feature, a river that was the source of the sulphurous stench; the translator missed this and the resulting illustration evokes the foul odor but not, subsequently, its source.[13]

More significant is the translator's misreading of the description of Lucifer. In the Latin original, the Prince of Darkness, chained to a burning gridiron, is equipped with *one* thousand hands with which to grab and crush the damned souls. Margaret's translator increases the hands to *ten* thousand, and says that Satan has *as many* feet.[14] With just *one* thousand hands, an artist might easily utilize a more or less standard image of Lucifer when illustrating the *Tondal* text. This is what the Limbourg brothers did in their *Tondal*-inspired miniature in the *Très Riches Heures*. Satan is depicted, following details mentioned in the *Tondal* text, on a burning gridiron while exhaling a huge breath in which swirl numerous souls. The Limbourgs, however, ignored the textual detail of the thousand hands.[15] The designer of the woodcuts accompanying the printed edition of the *Tondal*, *De raptu anime Tundali*, circa 1483, also was able to consolidate a traditional Satan with the bizarre one described by Marcus by grafting to both sides of a common hellmouth an extra series of hands, although the result looks more like a pair of wings than a multitude of hands (fig. 72).[16] Marmion, however, not reading the Latin original but the translator's adaptation, did not really have these choices. Faced with a text that, radically veering from tradition, described a Satan with ten thousand hands and, in addition, ten thousand feet, Marmion had little choice but to depict a Satan bristling with an array of limbs similar to that of a caterpillar (fig. 73).

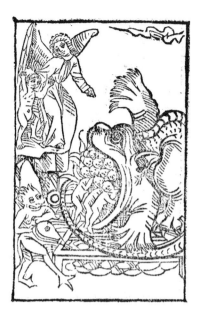

Figure 72.
Hellmouth, in *De raptu anime Tundali* (Speyer, Johann and Konrad Hist, circa 1483). New York, Pierpont Morgan Library, PML 189, leaf 17.

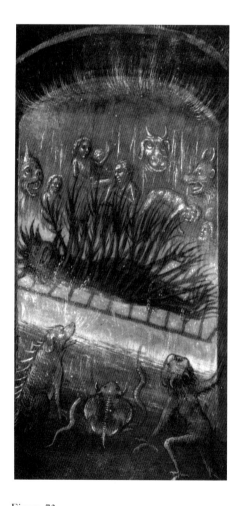

Figure 73.
Simon Marmion. *Lucifer, Prince of Darkness* in *The Visions of Tondal.* Malibu, J. Paul Getty Museum, Ms. 30, fol. 30v (detail).

The errors of greatest significance in Margaret's *Visions of Tondal*, however, occur after the knight and his guide have emerged from hell, and it is on these mistakes that I wish to concentrate because their effect on the pictures is not just in specific details but on this part of the cycle as a whole.

After Tondal and his guide leave Lucifer, the French text tells us that "they passed through much darkness until they found themselves out of it and in a clear place, for light appeared to them, followed by a great radiance. . . . They walked a long way until they came upon a wall, very high. *Ensconced in the wall*, on the side they were approaching, was a great multitude of men and women who, night and day, were exposed to the wind and rain and felt great pain, especially from hunger and thirst" (italics mine).[17] "Ensconced in the wall" is how Dr. McDermott and I translated the phrase in old French, "dedens le mur," for it was clear to us, as it was to Marmion, that "dedens" was meant literally as "within." The original Latin phrase is "infra murum ex illa parte, qua ipsi venerant."[18] Marcus used "infra" to mean "below," which in his text means "at the bottom of" the wall. Jean-Michel Picard, capturing the genuine sense of the original, translated this section as "they [Tondal and his guide] saw an extremely high wall, and on the near side of the wall, in the direction they were coming from, there was a very large multitude of men and women enduring wind and rain."[19] Medieval Latin, however, stretched the definition of "infra" to also mean "within," and this is the sense, mistakenly, that Margaret's translator found in the word.[20] He is guilty, in this case, of translating words and not meaning.[21] Marmion innocently took the phrase "dedens le mur" literally and ensconced the Bad But Not Very Bad within the substance of the wall (fig. 74). The result was probably not as peculiar looking to fifteenth-century eyes as it may be to our own. The Bad But Not Very Bad are positioned like sculpture on a Romanesque facade or, as my colleague William Voelkle has observed, like the ten painted statues of personified Vices that the lover encounters on the exterior of the Garden of Mirth in the opening passages of the *Roman de la rose*.[22] Verification that this interpretation on the part of Margaret's translator was indeed erroneous can be found in a contemporaneous source. This is the circa 1483 printed edition, *De raptu anime Tundali*. The Bad But Not Very Bad in the printed book are shown "infra murum" according to Marcus's original meaning: a mass of rather bedraggled-looking souls, piled up in a heap, is shown "at the bottom of" and not "within" the wall (fig. 75).

Tondal and his guide continue along this wall and, entering it through doors that open of their own accord, come to the fields inhabited by the Good But Not Very Good.[23] There, as described in the subsequent chapter, they see also Kings Conchober and Donatus.[24] Margaret's translator committed no major errors here and the Latin original, French translation, and Marmion's pictures are in accord. Tondal and the angel then witness King Donatus's temporary torment: for three hours each

Figure 74.
Simon Marmion. *The Bad But Not Very Bad*, in *The Visions of Tondal*. Malibu, J. Paul Getty Museum, Ms. 30, fol. 33v.

Figure 75.
The Bad But Not Very Bad, in *De raptu anime Tundali* (Speyer, Johann and Konrad Hist, circa 1483). New York, Pierpont Morgan Library, PML 189, leaf 19v.

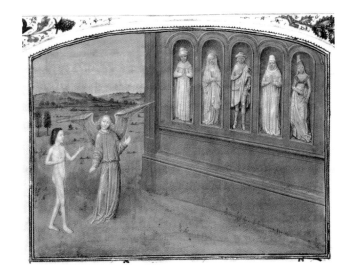

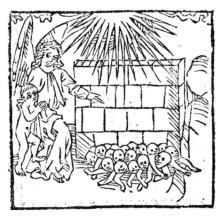

day he must wear a hair shirt and burn in fire up to his navel.[25] This episode, however, Marmion did *not* illustrate; the reason for this omission will be explained below.

Tondal and his guide then come to another wall, this time wrought of silver and, although there is no door, they pass through to the other side, according to the Latin text, and visit the Faithfully Married. Here, however, Margaret's translator commits another error.[26] The original Latin, from Picard's translation, reads, "When they had progressed a while further, they saw an extremely high and very bright wall. This wall was of silver, very dazzling and beautiful. *Although the soul could not see any door in it, without knowing by which divine power he entered, he found himself inside* and, looking around, he saw choirs of saints singing in exultation . . . " (italics mine).[27] Margaret's version, in translation, reads, "When they had proceeded a little they came upon a wall, very tall and shining. The wall was all of solid silver, well wrought and very handsome. But the soul could see no door. *And (I know not how) he then looked around and saw* a beautiful and large assembly of saints . . . " (italics mine).[28] The sense of the Latin original is interpreted correctly in the circa 1483 woodcut for this chapter. The Faithfully Married are clearly inside their wall, and, with the fourth wall imagined although not depicted, the space suggested is a completely enclosed one (fig. 76).[29] Margaret's translator completely misunderstood the mysterious passage of Tondal and his angel *through* the silver wall. In the Getty manuscript, the pair approach the wall and then "mysteriously" see the assembly. They do not pass through the wall. This is reflected, albeit subtly, in Marmion's illustration (fig. 77). The Faithfully Married are definitely on the *outside* of their wall. The sky, here painted gold, is alongside the silver wall, and, in the viewer's imagination, descends to the horizon. The assembly clearly stands on the outside of whatever the silver wall is enclosing and not inside as the twelfth-century text describes.

Tondal and his guide next visit the Glory of Martyrs and the Pure.[30] The original Latin, in Picard's translation, reads, " . . . they beheld another wall as high as the first one and made of the purest and brightest gold. . . . *They passed through it in the same way as for the first wall.* They could see before them many seats of gold and gems . . . on which elders were seated . . . " (italics mine).[31] Margaret's inaccurate French translation reads, "they chanced to see from afar another great wall, very high and long, rather similar to the first one already spoken of. But this wall was entirely made of fine gold. . . . *When they had passed this very noble wall,* they came upon several very sumptuous thrones. . . . Upon these thrones were sitting men and women . . . " (italics mine).[32] As before, Tondal and his angel, in the fifteenth century, are not permitted to pass through the wall as they did in the twelfth; they simply come to it and walk along its exterior. Marmion, of course, follows the translator's error and seats the Martyrs and the Pure on the outside of the gold wall (fig. 78). This is clearly

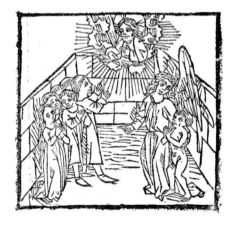

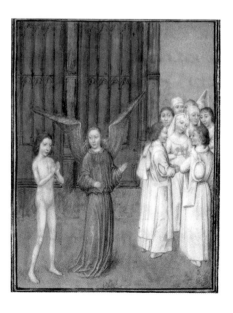

Figure 76.
The Faithfully Married, in *De raptu anime Tundali* (Speyer, Johann and Konrad Hist, circa 1483). New York, Pierpont Morgan Library, PML 189, leaf 22.

Figure 77.
Simon Marmion. *The Faithfully Married,* in *The Visions of Tondal.* Malibu, J. Paul Getty Museum, Ms. 30, fol. 37.

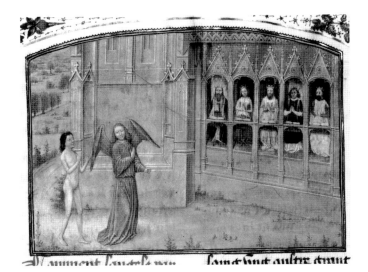

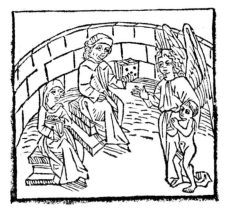

not the case in the circa 1483 woodcut, where, again, the wall forms an enclosure within which the blessed reside (fig. 79). There is another difference between this woodcut and Marmion's miniature. Neither the Latin original nor the French translation specify the location of the thrones occupied by the Martyrs and the Pure. The woodcut correctly reflects the sense of the Latin original, that is, thrones simply set here and there within the walled enclosure. Marmion, however, introduces an imaginative innovation and ensconces the Martyrs and the Pure *within* their gold wall, a positioning obviously paralleling that of the Bad But Not Very Bad (fig. 74). While the latter must glumly stand in Romanesque niches, the Martyrs and the Pure get to relax on golden Gothic thrones.

Tondal and the angel proceed to the Glory of Good Monks and Nuns, where twelfth-century and fifteenth-century texts are in general harmony.[33] The next chapter describes their visit to the Tree of the Confessors, the second episode Marmion chose not to illustrate, again for reasons I will relate below.[34]

Tondal and his guide then come to the Glory of Virgins and the Nine Orders of Angels.[35] Did fatigue plague Margaret's translator, or haste to complete the commission hound him? Curiously, he left out one of the Nine Orders of Angels.[36] He also made a more serious error. The Knight Tondal and his angel arrive at the final wall of their journey, this one made of precious stones and mortar that was like gold. The original Latin, from Picard's translation, tells us, " . . . they saw a wall whose height, beauty and brightness were unlike the others. . . . This wall . . . aroused great love for it in the minds of those who saw it. As they climbed the wall, *they saw* without a doubt that the eye has not seen nor ear heard nor has it entered into the heart of man what things God has prepared for those who love Him. For, there *they saw* the nine orders of blessed spirits. . . . *They also heard* words that cannot be told . . . " (italics mine).[37] Margaret's translator, however, provides this version: "This wall was so bright and shiny that it would ward off any displeasure or trouble, and it would inspire with consolation and joy the hearts of those who would look upon it. O how great are the things prepared by Our Lord God for those who love Him, because they *will see* the orders of the blessed angels. . . . They *will hear* the secret words that cannot nor must not be told" (italics mine).[38] The beatific vision, to which Tondal is treated in the Latin original of the twelfth century, is mistakenly withheld from him by the fifteenth-century French translator who changed the verb tense from the past to the future. This difference between the original text and its translation can be instantaneously grasped by comparing the circa 1483 woodcut with the Getty miniature. As the cut shows, Tondal, lifted up by his angel, receives his glimpse of Virgins and the Nine Orders of Angels over the wall of gems (fig. 80). Marmion's picture reflects the text from which he was working and shows Tondal's frustrating confrontation with the wall; indeed, it is this concealing wall that is the real subject of the miniature (fig. 81).

Figure 78.
Simon Marmion. *The Martyrs and the Pure*, in *The Visions of Tondal*. Malibu, J. Paul Getty Museum, Ms. 30, fol. 38v.

Figure 79.
The Martyrs and the Pure, in *De raptu anime Tundali* (Speyer, Johann and Konrad Hist, circa 1483). New York, Pierpont Morgan Library, PML 189, leaf 23.

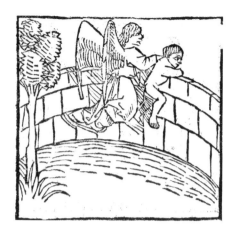

Transformation of *The Visions of Tondal* by the Illuminator

The next world described by the twelfth-century *Visions of Tondal* was a very different place from the hereafter believed to exist in the fifteenth century. A greater understanding of Marmion's cycle emerges from an awareness of how the illuminator carefully managed to wed the twelfth-century eschatology with that of his own time.

The next world described in *The Visions of Tondal* is divided into five unequal parts: Upper Hell, where torments are temporary; Lower Hell, the seat of Lucifer, where torment is unending; the exterior wall of Terrestrial Paradise, where the Bad But Not Very Bad endure temporary pain; Terrestrial Paradise, inhabited by the Good But Not Very Good and a place of both temporary pleasure and punishments; and, finally, Celestial Paradise, a series of places of eternal reward. The fifteenth-century hereafter, on the other hand, had a much simpler topography: hell, purgatory, and heaven. Purgatory, as the fifteenth century was to know it, was not born until about 1170, that is, about twenty years after the monk Marcus wrote his *Visions of Tondal*.[39] Thus Marmion was commissioned to illustrate a vision of the next world that was very much out-of-date and seriously at odds with codified eschatology. Had he followed the text precisely, his pictures might have looked quaint, more likely a little odd, and even more likely heretical. He was, however, able to camouflage the twelfth-century vision, cleverly reshaping it in his miniatures to make it fit a fifteenth-century mold.

The first thing Marmion did was to unite Upper and Lower Hell. Although the text tells us that Upper Hell's torments are temporary (and hence somewhat purgatorial in nature), the pictures reveal no difference, in essence, between the tortures suffered there or in Lower Hell, where torment is unending. The pains of Upper Hell appear as malodorous, take place in environments as dark, and thus seem as unending as those meted out by Lucifer himself. The Cistern of Sorrows, Lower Hell's release valve through which Lucifer's soul-filled breath escapes, is positioned in the miniature on an incline, where Tondal and his guide begin their descent, and marks the division between the two Hells; but there is no indication that the travelers have crossed any boundary separating temporary from permanent punishment, a point specifically mentioned in the text.[40]

In a parallel manner, Marmion unites Terrestrial and Celestial Paradise, fusing them into a single heaven. He does this by judiciously *not* illustrating two episodes. The first is that describing King Donatus's enduring fire up to his navel while dressed in a hair shirt.[41] This torturous episode takes place within the pleasantly verdant fields inhabited by the Good But Not Very Good. Had Marmion illustrated this episode, however—a fiery torment in a green field—this part of Terrestrial Paradise would have looked, to fifteenth-century eyes, confusingly like purgatory. And purgatory, in the fifteenth century, was a site only of torment; there is no

Figure 80.
The Glory of Virgins and the Nine Orders of Angels, in *De raptu anime Tundali* (Speyer, Johann and Konrad Hist, circa 1483). New York, Pierpont Morgan Library, PML 189, leaf 26.

Figure 81.
Simon Marmion. *The Glory of Virgins and the Nine Orders of Angels*, in *The Visions of Tondal*. Malibu, J. Paul Getty Museum, Ms. 30, fol. 42.

place in late medieval eschatology that is both part pain and part pleasure. By not illustrating Donatus's torment, Marmion made Terrestrial Paradise look entirely a part of heaven, its front lawn, so to speak, hiding, at least visually, its purgatorial conditions (fig. 82).

The second episode Marmion also purposefully omitted was the entire chapter describing the Tree of the Confessors, a huge tree filled with flowers, fruit, and birds, beneath which sit the Confessors.[42] Tondal and his guide visit this arboreal marvel immediately before their final stop, the wall of Virgins and the Nine Orders of Angels. Heaven, by the fifteenth century, had become a very urbanized place; it was typical for artists, especially in the North, to depict heaven as a man-made city.[43] With this tradition behind him, Marmion decided to use the text's emphasis on walls to unify his heaven by rendering it (except for the tents inhabited by the Good Monks and Nuns) as a series of increasingly fine walls: that enclosing the Good But Not Very Good, that of the Faithfully Married; that of the Martyrs and the Pure; and, finally, that of Virgins and the Nine Orders of Angels. Illustrating the chapter describing the Tree of the Confessors would have destroyed this unifying theme of walls and reintroduced a dominant green element into the cycle of miniatures, a greenness that Marmion has Tondal leave way back with the Good But Not Very Good. Marmion's picture for this chapter, had he painted one, might have looked something like the miniature of the *Tree of Life* in Margaret of York's *Apocalypse*, Morgan 484, a book also written by David Aubert (though illustrated by an artist related to the Master of Mary of Burgundy) around the same time as the *Tondal* (fig. 83).[44] Trees might have their place in heaven, even in the fifteenth century, but not as the second highest place of celestial reward.

This emphasis on heavenly "murality," as it may be called, in Margaret's *Tondal* illustrations derives not only from predominant fifteenth-century conceptions of heaven, but also from the translator's errors, which reinforced the late medieval predisposition to celestial walls by giving them a more significant role than they had in the Latin original: the errors that ensconced the Bad But Not Very Bad *into* their wall; that positioned the Faithfully Married *before* their wall, not behind it; that, having ensconced the Not Very Bad into their wall led to the ensconcement of the Martyrs and the Pure into theirs; and, finally, that robbed Tondal of his view of the beatific vision. The translated *Tondal* emphasizes the walls of heaven in a way the original text does not.

Marmion had one serious problem in fashioning, out of *The Visions of Tondal*, a pictorial cycle of the hereafter that would be acceptable to his fifteenth-century reader. This was the peculiar situation of the Bad But Not Very Bad. These souls, to Marmion as to any contemporaneous reader, were obviously in a purgatorial state; but purgatory's purifying flames, the torment traditional by the late Middle Ages for that place, are not to be found in the twelfth-century text for these Not Very Bad. (They are exposed to wind and rain and must endure hunger and thirst.) Marmion

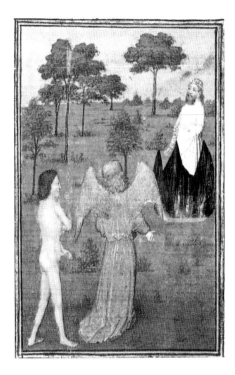

Figure 82.
Torment of King Donatus, author's construction of the miniature Simon Marmion might have painted for this unillustrated episode in *The Visions of Tondal*.

Figure 83.
Circle of the Master of Mary of Burgundy. *The Tree of Life*, in the *Apocalypse* of Margaret of York. New York, Pierpont Morgan Library, M. 484, fol. 114v.

illustrated what he read; he could not obfuscate the torments described in this important chapter. The illuminator, as well as his patron, Margaret of York, might have been troubled by the paucity of discussion of purgatorial states in *The Visions of Tondal* had this manuscript stood alone on the shelf. But it did not. The sister manuscript to the *Tondal* is *The Vision of the Soul of Guy de Thurno*, the story of a citizen of Verona who, after his death in 1324, returns from purgatory to haunt his widow. Written by David Aubert a month before the *Tondal* and also illustrated by Simon Marmion, *The Vision of the Soul of Guy de Thurno*, is identical in dimensions and number of lines, and contains a nearly identical colophon. At one time, if not always, the manuscripts were also bound together.[45] *The Visions of Tondal* and *The Vision of the Soul of Guy de Thurno* were meant as a pair, containing texts that complement each other. The *Tondal* text, concentrating on hell and heaven, hardly deals with purgatory; the *Guy* text nothing but.[46]

The subject of this paper could be summarized under the heading, "text-picture relationship." But with a masterpiece like Margaret's *Visions of Tondal*, this relationship is not a simple two-way affair. Thus we can understand the Getty text better by reading it in conjunction with Marcus's original work. We also begin to understand Marmion's interpretation of the story not only by examining the very text he read, but also by recognizing the different theological mind-sets represented by an author and an illuminator separated by three hundred medieval years. Finally, we also begin to understand more about a book when we stop to consider where its patron might have put it on the shelf.

Notes

1 This article is dedicated to the memory of Philip Hofer who, as owner of *The Visions of Tondal* in the early 1980s, introduced me to the manuscript and let me begin my study of it. My thanks also to the private collector who acquired the *Tondal* after Hofer's death and who also gave me continued access; to Harvard College Library for a Douglas W. Bryant Fellowship in 1982 that enabled me to study Simon Marmion manuscripts in European collections; to Madeleine Mc-Dermott, my collaborator on the *Tondal* translation; and to Jean-François Vilain.

2 See Malibu 1990. This publication contains color reproductions of all twenty miniatures from Getty Ms. 30 and, pp. 37–59, excerpts from a translation of the text by M. Mc-Dermott and R. Wieck. The pertinent bibliography on the *Tondal*, as well as its sister manuscript, *The Vision of the Soul of Guy de Thurno* (J. Paul Getty Museum, Ms. 31), can be found in "Acquisitions/1987," *GettyMusJ* 16 (1988), pp. 152, 154.

3 Palmer 1982 gives the most recent and complete list of all known, as well as lost, *Tondal* manuscripts. Palmer has, more recently, discovered an incunabular edition of the text embellished with three illuminations; see his essay, p. 157, below.

4 The critical edition of the Latin text can be found in Wagner 1882.

5 R. Verdeyen, "La date de la *Vision de Tondale* et les manuscrits français de ce texte," *Revue celtique* 28 (1907), pp. 411–12, believed that the translation in Getty Ms. 30 was indeed the work of David Aubert. For Aubert's career, see P. Cockshaw, "Aubert (David)," *Biographie nationale* 37 (1971), p. 11. The single miniature from *The Vision of the Soul of Guy de Thurno* is reproduced in Malibu 1990, fig. 19. Professor Joseph Donatelli of the University of Manitoba is presently preparing a critical edition, accompanied by a translation into modern English, of the Latin text, *De spiritu Guidonis*.

6 In comparing the twelfth-century Latin text with the fifteenth-century French translation, I have used, as a control, the recent translation into modern English by Jean-Michel Picard, in Picard/de Pontfarcy 1989. The only other version of *Tondal* in modern English, Gardiner 1989, should be used with caution.

7 The Getty prologue is not published; see Wagner 1882, pp. 3–5, and Picard/de Pontfarcy 1989, pp. 109–10. The Getty prologue does utilize one theme from the Latin original, namely, that the text offered is a translation that makes the story more easily available to the reader. The Getty version contains the phrase, "Pour ce vous voulons racompter et mettre de latin en franchois . . . " ("For this reason we want to recount and translate from Latin into French for you . . . "), which is based on the Latin " . . . noster stilus licet ineruditus de barbarico in

latinum transferret eloquium vestreque diligentie mitteremus transscribendum."

8 Fol. 43v. The translation of this prayer is not published; see Wagner 1882, p. 56, and Picard/de Pontfarcy 1989, pp. 156–57.

9 Fol. 9v: ". . . car tout incontinent il fut feru en son bras destre lequel il avoit estendu au plat pour prendre a mengier tellement que a luy retraire ne le povoit." See Malibu 1990, p. 38 and pl. 1: "All of a sudden, Tondal was struck in his right arm, which he had extended toward a platter of food to help himself, and he could not withdraw it." Wagner 1882, p. 8: "Nescio namque cita qua occasione percussus manum, quam extenderat, replicare non poterat ad os suum." Picard/de Pontfarcy 1989, p. 112: "For, struck by I know not what sudden occurrence, he was not able to lift to his mouth the hand he had stretched in front of him."

10 Wagner 1882, pp. 53–54, and Picard/de Pontfarcy 1989, pp. 154–55.

11 See de Pontfarcy's chapter, "The Political Dimension," in Picard/de Pontfarcy 1989, pp. 29–47, and J.S. Emerson, "The Vision of Tundal and the Politics of Purgatory," Ph.D. diss., Brown University, Providence, 1990.

12 Fol. 25: "Et quant elle avoit aucunes ames devorees & mengies, et quen son ventre elles estoient a neant devenues, elle les reiettoit par derriere sur la glace, et estoient illec leurs tourmens renouvellez." Malibu 1990, p. 49 (where the text is slightly abridged) and pl. 10: "When it had devoured and eaten some souls, and they had been reduced to nothing in its belly, the beast would defecate them onto the ice where their torments were renewed." Wagner 1882, pp. 27–28: ". . . et dum in ventre ejus per supplicia redigerentur ad nihilum, pariebat eas in stagnum glacie coagulatum, ibique renovabantur iterum ad tormentum." Picard/de Pontfarcy 1989, p. 130: ". . . when they had been tortured and reduced to nothing in its belly, it gave birth to them in the lake congealed with ice and there they were again subjected to the same torment."

13 Fols. 15–15v: "Si vindrent assez tost apres a une grande vallee a merveilles, terriblement infecte et puante et moult horrible et hideuse. Celle vallee estoit si tres parfonde que lame du chevallier Tondal ne povoit regarder jusques aufons. Mais elle ouoit tresbien en bas ung grant bruit et ung espoventable ton, ansi comme dune bien grant flambe et dun grant vent estruians lun contre lautre. Et venoit de cel abisme en hault une telle puanteur de souffre et dautres corruptions comme de charroignes. . . ." Malibu 1990, p. 43 (where the text is somewhat abridged) and pl. 6: "Soon after they arrived at a great valley, awesomely and terribly noxious and stinking, very horrible and hideous. This valley was so very deep that the soul of the Knight Tondal could not even see the bottom. But he was hearing quite well, from below, a great noise and an awe-inspiring thunder, as if coming from a great conflagration

and a great wind, the one struggling against the other. Out of this abyss arose such a stench of sulphur and other corruption, as if from carrion. . . ." Wagner 1882, pp. 14–15: ". . . venerunt ad vallem valde profundam, putridam nimis ac tenebrosam, cujus profunditatem ipsa quidem anima videre non poterat, sonitum autem sulphurei fluminis et ululatus multitudinis in imis patientis audire valebat. Fumus vero de sulphure et de cadaveribus sursum insurgebat fetidus. . . ." Picard/de Pontfarcy 1989, p. 119: ". . . they arrived at a very deep valley, most stinking and dark, the depth of which the soul could not see at all, but he could hear the sound of a sulphurous river and the howling of the multitude suffering below. A fetid smoke reeking of sulphur and corpses rose to the heights. . . ."

14 Fol. 31: "Et avoit fourme dhomme depuis les pies jusques a la teste, mais elle avoit plusieurs mains et pies. Car elle avoit dix mille mains. . . . Et avoit autant de dois et de ongles es pies. . . ." Malibu 1990, p. 52 and pl. 13: "He had the shape of a man from the feet to the head, but he had many hands and feet. In fact, he had ten thousand hands. . . . And he had as many toes and toenails." Wagner 1882, p. 36: ". . . habens formam humani corporis a pedibus usque ad caput, excepto, quod illa plurimas habebat manus et caudam. Habet quoque illud horrible monstrum non minus mille manibus . . . et in pedibus totidem ungulas. . . ." Picard/de Pontfarcy 1989, p. 138: ". . . and had the shape of a human body from head to toe, except that it had many hands and a tail. This horrible monster had no less than a thousand hands . . . the nails on his feet were likewise."

15 Chantilly, Musée Condé, Ms. 65, fol. 108, reprod. in Meiss 1974, fig. 581. The miniature marks the end of the Office of the Dead.

16 De raptu anime Tundali (Speyer, Johann and Konrad Hist, circa 1483); F.R. Goff, Incunabula in American Libraries: A Third Census (New York, 1964), T-498. The copy in the Pierpont Morgan Library (PML 189) is described in Catalogue of Manuscripts and Early Printed Books from the Libraries of William Morris, Richard Bennett, Bertram, Fourth Earl of Ashburnham, and Other Sources, Now Forming Portion of the Library of J. Pierpont Morgan: Early Printed Books. Volume 1: Xylographica, Germany and Switzerland (London, 1907), no. 189. Although Palmer 1982, p. 284, says that only the Speyer editions of circa 1488 and circa 1495 are complete, the Morgan copy of the circa 1483 edition does have the complete set of twenty-one woodcuts, and in their proper order. The cuts are: 1) Tondal in Amour (entitled Tondolus der Ritter); 2) Tondal Suffers a Seizure at Dinner; 3) Tondal's Guardian Angel Comes to His Aid; 4) The Valley of Homicides; 5) The Valley of the Perversely Proud and Presumptuous; 6) The Beast Acheron, Devourer of the Avaricious; 7) The Nail-Studded Bridge for Thieves and Robbers; 8) The House of Phristinus: Punishment for Gluttons and Fornicators; 9) The Beast That Eats Unchaste Priests and Nuns; 10) The Valley of Fires, for Those Who Commit Evil upon Evil; 11) The Cistern of Hell; 12) Lucifer, Prince of Hell; 13) The Bad But Not

Very Bad; 14) King Cormac in Torment; 15) The Joy of the Faithfully Married (incorrectly entitled De Visione glorie Sanctorum); 16) The Glory of the Martyrs and the Pure; 17) The Glory of Good Monks and Nuns; 18) The Tree of the Confessors; 19) The Glory of Virgins and the Nine Orders of Angels; 20) Tondal Visits the Four Irish Bishops and the Empty Throne; 21) Tondal's Soul Is Returned to His Body.

17 Malibu 1990, p. 53 (where the text is abridged). Fols. 33–34: "Si passerent tant de tenebres quilz sen retrouverent dehors et en lieu cler, car la clarte leur apparu et puis leur revint moult grant lumiere. . . . Ilz cheminerent si longuement quilz vindrent a ung mur moult hault. Et dedens le mur de la part dont ilz venoient avoit grant multitude de hommes et de femmes quy nuyt et iour estoient au vent et a la pluye et avoient grant douleur et par especial de fain & soif."

18 Wagner 1882, p. 40: "Euntes autem viderunt murum nimis altum et infra murum ex illa parte, qua ipsi venerant, erat plurima multitudo virorum ac mulierum pluviam ac ventum sustinentium. Et illi erant valde tristes, famem et sitim sustinentes. . . ."

19 Picard/de Pontfarcy 1989, p. 141.

20 J.H. Baxter and C. Johnson, Medieval Latin Word-List (London, 1943), p. 223.

21 It may also be possible that Margaret's translator encountered a poorly written text where, instead of "infra," he saw, or thought he saw, "intra," which means "in" or "within."

22 For Romanesque statues ensconced within niches in a wall, see, from many possible examples, those dating to circa 1150 at Santa Maria at Ripoll, in northeastern Spain, reprod. in R. Salvini, Medieval Sculpture (New York and Greenwich, 1969), fig. 119. For the ensconced statues in the Roman de la rose, see, for instance, those depicted in a midfourteenth-century French manuscript in New York, Pierpont Morgan Library, M. 324, fol. 1, reprod. in G. de Lorris and J. de Meun, The Romance of the Rose, H. W. Robbins, trans., C. W. Dunn, ed. (New York, 1962), frontispiece. Interesting examples of the painted statues of the Roman de la rose dating after Margaret's Tondal include London, British Library, Harley Ms. 4425, a Flemish example of about 1490 probably made for Engelbert of Nassau, reprod. in Malibu 1983, fig. 6b, and New York, Pierpont Morgan Library, M. 948, a French example of about 1525 made for King Francis I of France, reprod. in W.M. Voelkle, The Pierpont Morgan Library. Masterpieces of Medieval Painting: The Art of Illumination (Chicago, 1980), microfiche 14G9.

23 Fols. 34–35; Malibu 1990, p. 55 and pl. 15; Wagner 1882, p. 41; Picard/de Pontfarcy 1989, p. 142.

24 Fols. 35–35v; Malibu 1990, p. 55 and pl. 16; Wagner 1882, p. 42; Picard/de Pontfarcy 1989, p. 143.

25 Fols. 35v–37; Malibu 1990, p. 55; Wagner 1882, pp. 42–45; Picard/de Pontfarcy 1989, pp. 144–45. In the Latin original, it is a third king, named Cormac, who endures the temporary torment. The Getty translator, conflating Kings Donatus and Cormac, identifies the ruler who suffers the hair shirt and fire as Donatus.

26 Fols. 37–38; Malibu 1990, p. 56 and pl.17; Wagner 1882, pp. 45–47; Picard/de Pontfarcy 1989, pp. 146–47.

27 Wagner 1882, p. 45: "Erat enim murus argenteus, splendidus multum atque decorus. Et anime quidem nulla in eo apparebat porta, nesciens tamen, quomodo eam divina introduxit potentia, intravit et circumspiciens vidit choros sanctorum exultantium deo et dicentium. . . ."

28 Fol. 37: "Et quant ilz eurent ung petit ale avant, ilz choisirent ung mur moult hault et tres reluisant. Ledit mur estoit tout massif dargent bien ouvre et tres plaisant. Mais lame ny perchevoit nulle porte. Si ne scay pas comment elle regarda entour delle, adont vey une belle et grosse compaignie de sains et de saintes. . . ."

29 Picard/de Pontfarcy 1989, p. 146, reproduce the woodcut of the Martyrs and the Pure instead of the cut of the Faithfully Married.

30 Fols. 38v–39; Malibu 1990, p. 57 and pl. 18; Wagner 1882, pp. 47–48; Picard/de Pontfarcy 1989, p. 148.

31 Wagner 1882, p. 47: ". . . apparuit alius murus tam altus, ut primus, de auro purissimo et preclarissimo. . . . Set cum simili modo pertransissem illum ut primum, apparuerunt illis plurima sedilia de auro et gemmis . . . in quibus sedebant seniores viri et femine. . . ."

32 Fols. 38v–39: ". . . ilz choisirent de loing ung aultre grant mur moult hault et long et assez semblable au premier dont ia est touchie. Et estoit cel mur tout de fin or. . . . Et quant ilz eurent passe ce tant noble mur, ilz choisirent plusieurs tres riches sieges . . . En iceulx sieges estoient seans hommes et femes. . . ."

33 Fols. 39v–40v; Malibu 1990, p. 58 and pl. 19; Wagner 1882, pp. 48–50; Picard/de Pontfarcy 1989, pp. 149–50.

34 Fols. 40v–41v; Malibu 1990, p. 58; Wagner 1882, pp. 50–51; Picard/de Pontfarcy 1989, p. 151.

35 Fols. 41v–42v; Malibu 1990, p. 59 and pl. 20; Wagner 1882, pp. 51–53; Picard/de Pontfarcy 1989, pp. 152–53.

36 Fol. 42: ". . . car ilz verront les ordes des beneoits angeles et des archangeles, les vertus, les poestez, les seigneuries, les throsnes, les cherubins, les seraphins." Malibu 1990, p. 59: ". . . because they will see the orders of the blessed angels, the archangels, the virtues, the powers, the dominations, the thrones, the cherubim, and the seraphim." Wagner 1882, p. 52: "Viderunt namque ibidem novem ordines beatorum spirituum, videlicet angelos, archangelos, virtutes, principatus, potestates, dominationes, thronos, Cherubin, Seraphin." Picard/de Pontfarcy 1989, p. 152: "For, there they saw the nine orders of the blessed spirits, that is, angels, archangels, virtues, principalities, powers, dominations, thrones, cherubim and seraphim."

37 Wagner 1882, pp. 51–52: ". . . viderunt murum altitudine, pulchritutide et splendore ceteris dissimilem . . . murus . . . multum in sui amorem videntium mentes provocabat. Ascendentes ergo murum videre procul dubio, quod oculus non vidit nec auris audivit nec in cor hominis ascendit, que preparavit deus diligentibus se. Viderunt namque ibidem novem ordines . . . [rest of sentence quoted in note 36]. Audierunt autem inenarrabilia verba, que nec potest homo nec licet homini loqui."

38 Fol. 42: "Celluy mur tant cler et reluisant estoit que toute desplaisance et ennuy il bestournoit et a consolation et leesse esmouvoit les courages de ceulx quy le regardoient. O comme grant chose a nostreseigneur dieu appareillie pour ceulz quy layment, car ilz verront les ordes des beneoits angeles . . . [rest of sentence quoted in note 36]. Et orront paroles secretes que lon ne poeult ne doit racompter."

39 Le Goff 1984, pp. 154–76. The word "purgatory" does not occur in the original Latin text of The Visions of Tondal. Margaret's translator, however, added it three times to her manuscript: in the table of contents on fol. 4 in the rubricated summation of the prologue; on fol. 7 in the repetition of this summation preceding the prologue itself; and on fol. 10v in the chapter describing Tondal's repentance, in a sentence where the translator quotes his earlier expression. These three insertions of the word represent the translator's attempt, if rather feeble, to structure the twelfth-century hereafter along fifteenth-century lines.

40 Malibu 1990, pl. 12.

41 See note 25, above.

42 See note 34, above.

43 See C. McDannell and B. Lang, Heaven: A History (New Haven and London, 1988), pp. 70–80, where the conception of heaven as a city, a Gothic cathedral, or a castle, is discussed. Marcus's twelfth-century text of The Visions of Tondal is itself an early expression of the notion of heaven as an urbanized place. Pictorially, too, in the high and late Middle Ages, heaven is visualized as a building or city, a conception reaching a climax in the fifteenth century. For manuscripts, see, for example, heaven as an elaborate city in the Last Judgment by the Master of Evert Zoudenbalch in the Hours of Jan van Amerongen in Brussels, Bibliothèque Royale, Ms. II 7619, fol. 139v, reprod. in L.M.J. Delaissé, "Le livre d'heures de Mary van Vronensteyn," Scriptorium 3 (1949), pl. 24c; heaven as a Gothic cathedral in the miniature of Jean de Berry Received into Heaven by the Bedford Master in that duke's Grandes Heures in Paris, Bibliothèque Nationale, Ms. lat. 919, fol. 96, reprod. in M. Thomas, The "Grandes Heures" of Jean, Duke of Berry (New York, 1971), pl. 93; and heaven as a castle in the miniature of David Praying Before the Lord by the Boucicaut Master in the Hours of Joseph Bonaparte in Paris, Bibliothèque Nationale, Ms. lat. 10538, fol. 116, reprod. in C. Sterling, La peinture médiévale à Paris 1300–1500 (Paris, 1987), vol. 1, fig. 278. Heaven depicted as an elaborate Gothic structure can also be seen in many fifteenth-century Flemish panels.

44 For Margaret of York's Apocalypse, see Suzanne Lewis's essay in the present volume.

45 The two manuscripts were together in a nineteenth-century Parisian Trautz-Bauzonnet binding when Philip Hofer owned them. Hofer (as he related to this author) gave the codex for rebinding to a man who, instead of pulling the text block of the Tondal, sliced its leaves from the binding. Today the Tondal exists as a group of forty-five single sheets tabbed into a modern calf binding commissioned by the Getty Museum. (This binding replaces a similar one commissioned by Sotheby's of London, through whom the Museum bought the manuscript by private treaty; see R.S. Wieck, "Tondal's Vision," Sotheby's Art at Auction 1987–88 [London, 1988], pp. 228–31). The Vision of the Soul of Guy de Thurno is still bound in the Trautz-Bauzonnet covers.

46 The Getty manuscript of The Vision of the Soul of Guy de Thurno offers, in twenty-six chapters plus a prologue, an exhaustive discourse on purgatory. There are chapters, for example, discussing the location of "common" purgatory (the center of the earth); whether or not it is possible for anyone to avoid purgatory (it is not); what is the most efficacious means to offer relief to souls in purgatory (the celebration of masses); what are the most efficacious prayers to be offered for souls in purgatory (the psalter, especially the Seven Penitential Psalms with the Litany); and how efficacious is the Office of the Dead in helping souls in purgatory (very much so).

IMAGE FOLLOWS TEXT?

THE VISIONS OF TONDAL AND ITS RELATIONSHIP TO DEPICTIONS OF HELL AND PURGATORY IN FIFTEENTH-CENTURY ILLUMINATED MANUSCRIPTS*

Dagmar Eichberger

V isions and visionary literature have for a long time been identified as sources of major importance for early Netherlandish art of the fifteenth century.[1] Many panel paintings and book illuminations from this period depict saints and other individuals in the process of experiencing a vision,[2] or simply represent the object of their vision, for example, a *Man of Sorrows* or a *Virgin and Child*. This general interest in visions and in their pictorial representation in particular has been interpreted as a by-product of late medieval religiosity, which was strongly affected by an upsurge in private piety and the longing of the individual for intense religious experiences.[3] Such developments in late medieval spirituality are also reflected in one of Margaret of York's manuscripts, *Le dialogue de la duchesse de Bourgogne à Jésus Christ*. The introductory miniature in this manuscript (see fig. 16) portrays the duchess not in a traditional dedication scene but in her bedchamber kneeling in front of an apparition of the resurrected Christ.[4] This unusual illumination suggests to the beholder that Margaret of York is having a vision of Christ. It was chosen in response to the actual text of the manuscript, an imaginary dialogue between the duchess and Christ, which had been written by Nicolas Finet for her religious instruction. Margaret of York's fascination with visions as a spiritual experience and as a literary genre can be gauged not only from the frontispiece in the *Dialogue* manuscript but also from three other manuscripts associated with her: *Saint Patrick's Purgatory* in Brussels,[5] *The Vision of the Soul of Guy de Thurno*, and *The Visions of Tondal* in Malibu.[6] In these works, Margaret is not depicted, but her ownership is expressed visually through the inclusion of her initials, device, or inscription.

Many patrons of late medieval art felt a strong urge to participate in visionary experiences not just by reading accounts of individuals such as Tondal and Saint Patrick, but also by looking at images based on descriptions of their visions and revelations. This applies to images of hell and purgatory in particular since, under normal circumstances, this realm cannot be experienced by mortal beings, who must depend on the detailed descriptions provided by visionary literature. Pictorial representations of the underworld consequently had to be constructed from a range of different literary sources, from visions as well as from biblical and theological texts. We know that many panel paintings—especially those depicting the *Last Judgment*—draw heavily on medieval literature concerning the Four Last Things.[7] However, in the case of panel paintings, it is often difficult to identify a specific treatise or vision as the single source for a *Last Judgment* scene because in this medium iconographic motifs of heaven and hell often develop a life of their own. Furthermore, these images were frequently copied, altered, and rearranged by later artists, who had lost touch with the textual source.

One might assume that such circumstances did not apply to illuminated manuscripts. Miniatures, by their very nature, are usually placed next to the written word and thus seem more likely to enter into a close relationship with the accompanying

text. This assumption is certainly justified for *The Visions of Tondal*, a manuscript which displays a detailed sequence of narrative images juxtaposed with a visionary text. As Roger S. Wieck convincingly demonstrates, the individual miniatures illustrate in great detail the narrative of the written account.[8] One of the most fascinating aspects of this manuscript is the ingenuity with which the artist—let us call him Simon Marmion for the time being[9]—has translated the vividly written description of the underworld into visual images of equal power of expression.[10] The *Tondal* manuscript, with its twenty superbly painted miniatures, is remarkable for several reasons. So far, no earlier example of an illuminated *Tondal* has been found. Given the peculiarities of the translation, it seems likely that Marmion had to invent a whole new set of images for this particular commission. The iconographic program of the miniatures is original, and it is the closeness of image and text which demonstrates its innovative character.

However, the fact that Simon Marmion's illustrations are faithful to the text should not lead us to believe that such practice is standard for infernal imagery in manuscripts of this period. As in panel painting, one can find examples of hell scenes in illuminated manuscripts which use pictorial motifs rather freely, that is, with little or no direct reference to the accompanying text.

In this paper we shall look at two kinds of hell imagery in illuminated manuscripts, one that is essentially faithful to the text and one that is not. The first category begins with another example of illuminated vision literature and the relationship of its pictorial conventions to the *Tondal* miniatures. Then we shall consider an entirely different kind of text, the unusual *Le livre de la vigne de Nostre Seigneur*, a non-narrative compendium of learning and beliefs about hell. Although its relationship to infernal vision literature is more incidental than substantive, it lends itself readily to illustration, much like the vision texts, due to its wealth of narrative and detail about the inferno. In the second part of the paper, I will look at another, more common genre of hell imagery. This comprises illustrations to certain religious texts that enjoyed even greater popularity than vision literature in the fifteenth century: the book of hours, Saint Augustine's *City of God*, and the *Cordiale de quattuor hominus novissimis* of Gerard van Vliederhoven. The illustrations in these works tend to be somewhat independent of the text.

Although a large number of infernal vision texts circulated in written form, few were accompanied by illustrations, either single images or cycles of miniatures. Illuminated editions of *Saint Patrick's Purgatory* and the *Voyage of Saint Brendan*, for instance, are the exception rather than the rule.[11] There are, however, a small number of visions for which extensive cycles of illuminations were provided, namely, the Apocalypse of Saint John,[12] Dante's *Divina Commedia*,[13] and the *Pèlerinage de l'âme* by Guillaume de Deguileville. We will take a close look at the third of these because—with the exception of biblical texts—it is one of the few vision texts from Northern Europe that survives in more than one or two examples with extensive illumination.

The *Pèlerinage de l'âme* was often richly illustrated. Its popularity in England, France, and the Netherlands can be compared with the popularity of Dante's *Divina Commedia* in Italy.[14] Moreover, whereas many visions from the fifteenth century are illustrated with pen-and-ink drawings of a mediocre quality, a few *Pèlerinage de l'âme* manuscripts contain excellent colored drawings or illuminations.[15] This indicates that at least some of these visions were produced for wealthy clients. A fine French edition from about 1400, for instance, once belonged to the dukes of Burgundy. This particular manuscript is mentioned for the first time in Philip the Good's inventory of 1467 and, a second time, in the inventory of 1487.[16] Thus it is possible that Margaret of York knew this copy.

The *Pèlerinage de l'âme* constitutes the second part of a trilogy composed by the French Cistercian monk Guillaume de Deguileville between 1355 and 1358.[17] It covers four different topics, beginning with a lengthy description of a court case against the soul of the pilgrim. After the final judgment is passed, the angel and the soul

travel through purgatory, where they observe different forms of torture. This is followed by a detailed description of Satan, the location of hell, and the ways in which different groups of sinners are punished for their wrongdoings on earth. Finally, at the end of the story, the soul is led to paradise.

The text of the *Pèlerinage de l'âme* has certain elements in common with *The Visions of Tondal*. The two authors, Guillaume de Deguileville and Marcus, were both clerics. Each of the texts comprises chapters which vividly describe how specific sins will bring about certain forms of punishment. Both visions use the motif of the journey of an angel and a soul through the underworld as a narrative device, which determines the structure of the text and the images. Both texts have a clear intention to entertain and spiritually instruct the reader. Deguileville's trilogy, however, can be described as a much more ambitious theological text written in response to the *Roman de la rose*. The *Pèlerinage de l'âme* is full of allegorical figures and personifications, a characteristic not paralleled in *The Visions of Tondal*. Although the *Tondal* text was written by a monk, the story itself takes place in a courtly environment.[18] On fol. 7, the knight Tondal is described as a worldly nobleman who enjoys drinking, eating, and fighting. Despite these differences, it is the notion of the soul's personal experiences in hell that brings the *Pèlerinage de l'âme* and *The Visions of Tondal* closer together than most other illuminated texts from the late Middle Ages. The analysis of a selection of miniatures from several *Pèlerinage* manuscripts will show that the similarities between these two manuscripts do not end at the textual level.

The following analysis of hell images in the *Pèlerinage de l'âme* will concentrate on three different manuscripts from the first half of the fifteenth century: Ms. 10176–8 in the Bibliothèque Royale, Brussels; Ms. Douce 305 in the Bodleian Library, Oxford; and Ms. 096/G94 in the State Library of Victoria, Melbourne. All three manuscripts were decorated with a detailed sequence of images. The Melbourne manuscript portrays hell in eighteen illustrations, the manuscript in Brussels contains thirty-two framed drawings, and the Oxford *Pèlerinage* has fifty-five miniatures of hell.[19] A simple pen-and-ink drawing in the Melbourne manuscript (fig. 84)[20] depicts the barely dressed soul of the pilgrim between his guardian angel, who shows him the way, and the devil who approaches with outstretched claws. There is a similar incident in *The Visions of Tondal*, where an almost identical subject appears on fol. 11v. Despite considerable differences in quality and style, the basic idea in both miniatures is the same: the defenseless soul faces representatives of good and evil at the outset of his journey.

Like *The Visions of Tondal*, the *Pèlerinage de l'âme* attributes certain punishments to specific groups of sinners. On fol. 158 of the Brussels manuscript, for example, the artist portrays the fate of lecherous men (fig. 85); on fol. 149 of the same manuscript we get a glimpse of hell's location in the center of the earth, with the devils and the damned in one large pit. Among the fifty-five illustrations in the richly decorated Oxford manuscript are depictions such as "the avaricious devoured by wolves" or "usurers forced to drink molten bronze."[21] Fol. 43v, which shows human souls tied

Figure 84.
Anonymous master. *Soul Taken to Judgment*, in Guillaume de Deguileville, *Pèlerinage de l'âme*. Melbourne, State Library of Victoria, Rare Books Collection, Ms. 096/G94, fol. 97v.

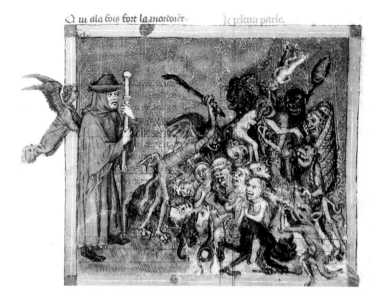

Figure 85.
Anonymous master. *Pain for Lecherous Men*, in Guillaume de Deguileville, *Pèlerinage de l'âme*. Brussels, Bibliothèque Royale, Ms. 10176–8, fol. 158.

Figure 86.
Anonymous master. *Punishment of the Lazy*, in Guillaume de Deguileville, *Pèlerinage de l'âme*. Oxford, Bodleian Library, Ms. Douce 305, fol. 43v.

to a wheel of hell, illustrates the punishment for the lazy, who are awakened from their sleep each time their heads hit the stone column (fig. 86). These fairly simple pen drawings, which have been colored with red ink and tinted with pale washes, create a lively picture of what people expected to encounter after they died.

These illustrations, as in *The Visions of Tondal*, seem to aim at rousing the reader emotionally by visualizing the horrors of hell. Visionary texts had fulfilled a similar function for several centuries,[22] but the fifteenth century intensifies this experience by providing the already explicit texts with even more expressive images. In most pictorial cycles of the *Pèlerinage de l'âme*, the hell scenes also represent the soul and the guardian angel within the infernal environment. Through the presence of the pilgrim's soul, the story acquires a human dimension. The soul experiences hell on behalf of the reader, and the horrors of hell become more real through his reactions.

This idea of one man's personal experience with hell is taken to the extreme in *The Visions of Tondal*. Here the soul not only observes what is happening, but literally lives through some of the torments before being rescued by the angel. The immediacy of the story, as told by the Irish monk Marcus, is matched by Marmion's remarkable degree of realism and his mastery in creating a hell-like atmosphere. There is a second reason for the presence of the angel and the soul in the illustrations of the *Pèlerinage de l'âme* and *The Visions of Tondal*: their appearance establishes the narrative character of the illuminations. By including the same two figures in most of the miniatures, the progress of the narrative is expressed visually; the story un-

folds in front of the reader through a combination of image and text. However, in order to achieve this effect, the artist either had to duplicate the layout of a scene or portray the central figures in almost every picture. This happens to a tedious extreme in the extensive cycle of illustrations that decorates the *Pèlerinage* in Oxford. On fols. 39, 44v(a) and 44v(b), for example, the soul and the angel are standing each time at the right side of the picture watching the punishments being suffered in an open fiery pit. The artist responsible for the decoration of this manuscript obviously cared little about the repetitiveness of his illustrations, whereas Simon Marmion tried to overcome this problem by frequently altering the position of the two main figures and by changing the viewpoint.[23]

Le livre de la vigne de Nostre Seigneur,[24] which contains a most unusual group of hell images, treats in great detail the events that the faithful believed would take place at the end of the world. The codex in the Bodleian Library is the second volume of the manuscript and seems to be the only surviving copy of this portion of the text.[25] Unfortunately, nothing is known about the author, and the text itself still awaits careful study. It is largely a compendium of information and moral teachings about hell that focuses on five topics: the appearance of the Antichrist, the fifteen signs before the Last Judgment, the Last Judgment proper, the torments of hell, and the bliss of heaven. The section on life in hell is of particular interest for this investigation. It fills approximately fifty folios and was provided with twenty-six illuminations.[26] Among the various topics addressed are punishments for cardinal sins, torments for specific groups of damned souls, and detailed descriptions of Lucifer and the devils, who administer the divine judgment. Most of the text is written in French and offers the reader a lively description of the various forms of torture. Frequently, the main text is enriched by Latin quotations from the Bible, whose purpose is to give more authority to the images and to the French prose text. Apart from more familiar elements such as the jaws of hell, one can also find subjects rarely depicted— the four rivers of hell, Styx, Phlegeton, Lethe, and Cocytos.[27]

The volume is decorated with an extensive cycle of illustrations which, in sheer number, realism, and obsession with devils and hell, surpasses most of the imagery produced in the first half of the fifteenth century. The episodic nature of the illuminations reflects the structure of this text which, for didactic purposes, focuses dramatically on numerous individual aspects of hell, almost as if directing a spotlight on a stage. As in *The Visions of Tondal* and the *Pèlerinage*, the author attributes certain forms of punishment to certain sins. Fol. 82v, for example, shows devils burning the souls of those who broke the Commandments; fol. 101 demonstrates how devils scourge and beat the sinners (fig. 87).

A typical feature of all the illustrations is the concentration on a single episode or incident, each of which is closely linked to the chapter in which it appears. Other scenes within this group of twenty-six illustrations depict such cruelties as "thieves hung over fire" on fol. 121v (fig. 88) or "the proud and vainglorious broken on a wheel" on fol. 83 (see fig. 107). Although the chapter on hell starts with a paragraph entitled "De la descendue des mauvais en enfer," the idea of the journey through the underworld is not developed any further.[28] *Le livre de la vigne* is a compendium, with no hero and no narrative. The author finishes the chapter with three paragraphs that underline the didactic nature of the text: "About the advantages of reflecting upon hell," "The reasons why people go to hell," and "What one has to do to avoid hell."[29]

Comparing the pictorial cycle in *The Visions of Tondal* with that in *Le livre de la vigne*, differences as well as similarities become apparent. The wealth of descriptive detail in both manuscripts lends itself to an extensive cycle of illumination; hell is clearly a rich pictorial subject matter. In each manuscript, the illustrations represent the texts of the relevant subchapters fairly faithfully, and the images are integrated into these texts at irregular intervals. However, the miniatures in *Le livre de la vigne* lack the narrative continuity of those in *The Visions of Tondal*. And, unlike the *Tondal* illuminations, the scenes in *Le livre de la vigne* depict the torture of the damned souls

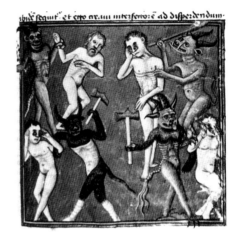

Figure 87.
Anonymous master. *Devils Scourging the Damned*, in *Le livre de la vigne de Nostre Seigneur*. Oxford, Bodleian Library, Ms. Douce 134, vol. 1, fol. 101.

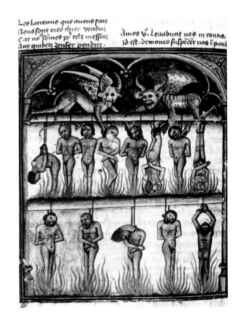

Figure 88.
Anonymous master. *Thieves Hung over Fire*, in *Le livre de la vigne de Nostre Seigneur*. Oxford, Bodleian Library, Ms. Douce 134, vol. 1, fol. 121v.

in a direct way, with a tendency to highlight the brutal and gory aspects of the text. In contrast, the artist in the *Tondal* manuscript pays more attention to the physical and atmospheric quality of the setting. Smoke, fire, and fumes, which are all part of the iconography of hell, are depicted with particular care and at times obscure the suffering sinners. On fol. 27, the devils and their victims are silhouetted against the background of the scene rather than portrayed with cruel attention to the details of torture.[30]

A second group of manuscripts offers a different type of text-image relationship. These manuscripts contain only a single illustration of hell, usually at the beginning of a chapter or book. The relationship between single infernal images and their texts will be discussed here in terms of a devotional manuscript, the Salting Hours; a theological text, the *City of God*; and a compendium on the Four Last Things, *Le livre des quatres dernières choses*. These three different types of text enjoyed great popularity in the fifteenth century and were both copied and illuminated far more frequently than either *The Visions of Tondal* or *Le livre de la vigne de Nostre Seigneur*. This frequency may have had an effect on the availability of models in contemporary workshops and may indeed be one of the reasons why single representations of hell in these manuscripts seem to be linked more loosely to the text than sequential images in illuminated visions.

A comparative analysis of a miniature in the Salting Hours depicting the vision of hell and earthly paradise (see fig. 143)[31] with the illuminations in *The Visions of Tondal* clearly shows that images of purgatory and hell in illuminated manuscripts could play distinctively different roles, depending on the nature of the text and the type of miniature.[32] The Salting miniature has been identified by some as the work of the artist who illuminated the *The Visions of Tondal*,[33] but was attributed more recently to the anonymous Master of Fitzwilliam 268.[34] The depiction of hell and paradise has been placed at the beginning of the Office of the Dead, together with two further miniatures, the *Last Judgment* on fol. 152v and the *Raising of Lazarus* on fol. 153v. It offers a synoptic image of hell and earthly paradise: the souls' various punishments in the underworld—in a hellmouth, an infernal river, and on fiery mountains; their progress over a bridge leading to paradise; and, finally, the fountain of life. Formally, this particular miniature can be singled out from the rest of the illustrations in the same manuscript by its use of a plain frame without any marginal decorations. It is also set apart from the text of the Office of the Dead by its position between two other miniatures.

There is a considerable discrepancy between this miniature and the text it accompanies. The text of the Office of the Dead bears no relation to visionary literature of the kind found in *The Visions of Tondal*. This section of a book of hours consists of lessons, taken from Job, of psalms, cantica, and antiphons. Although brief references are made to the Last Judgment and the resurrection of Lazarus, this devotional text does not provide the artist or the reader with a detailed description of paradise, purgatory, or the underworld.[35] Hence, the illuminator, unable to rely on information provided by the text itself, decided to use pictorial material from other sources for the decoration of this page.[36] This hypothesis reinforces the initial impression that the miniature on fol. 153 of the Salting Hours in no way attempts to be a literal translation of the text. Rather it stands separately, more linked to the general idea of death and afterlife than to the actual lessons and prayers. One could perhaps say that this miniature admonishes the reader not to neglect the performance of prayers and devotions, which may influence the fate of the soul after corporeal death. In other words, the miniature extends the meaning of the text rather than illustrates it in a strict sense.

Many depictions of purgatory and hell also appear in fifteenth-century illuminated manuscripts of the *Cordiale de quattuor hominis novissimis*, or *Le livre des quatre dernières choses*, by Gerard van Vliederhoven, and of Saint Augustine's *City of God*. Both were very popular in the late Middle Ages and could be found in many

fifteenth-century libraries.[37] Not only Philip the Good, Margaret's father-in-law, but also Louis de Gruuthuse from Bruges, a close friend of Margaret's brother, Edward IV, owned at least one copy of each text.[38] The *Cordiale* was written around 1400 in the sphere of the *Devotio Moderna* and deals exclusively with the Four Last Things.[39] In this context, it is worth mentioning that the *Cordiale* was frequently bound together in one volume with *The Visions of Tondal* and other texts.[40]

Illuminated copies of the *Cordiale* usually contain a single miniature at the beginning of each of the four books, depicting the main theme of that book—corporeal death, the Last Judgment, hell, and heaven.[41] Depictions of hell can be found, for instance, in two slightly different versions of the French *Cordiale*, both now in the Bibliothèque Royale, Brussels. One manuscript dates from about 1455 and was made for Duke Philip the Good (fig. 89).[42] The other copy was made for Charles de Croy some time after 1472 and later entered Margaret of Austria's library (fig. 90).[43] The rubric text below the two miniatures indicates that both representations of hell introduce the third part of the Four Last Things. In this section the author discusses the different names used for hell in the Bible and comments on the various tortures by which the damned will be punished. At the end of the third book, Gerard explains how valuable and profitable it is to constantly remember the gravity of these matters. The literary format for these expositions is not a vision, but rather a theological compendium containing passages from the Bible and the writings of medieval theologians, which have been loosely strung together according to their subject matter. On several occasions, Gerard van Vliederhoven also mentions visions experienced by knights and monks. He refers to these visions either to provide further evidence for the atrociousness of the devils or to serve as *exempla* demonstrating that awareness of the horrors of hell can lead to a better life.[44]

Despite the fact that the two examples discussed here are quite different in style and technique, they reflect the intention of the illuminator to pack as many individual scenes into the picture as possible. There is the whole gamut of infernal punishments: damned skewered on a spit or carried through the air; souls grilled on an open fire or beaten on an anvil next to a forge; men cut into pieces or boiled in a cauldron. All these scenes take place in an infernal landscape which has been equipped with the usual tools and trappings. Although the text itself contains a few detailed references—the threshing and beating of the damned and devils stirring the fire of a furnace[45]—the *Cordiale* does not describe individual scenes in as much detail as *The Visions of Tondal*. No mention is made, for instance, of the grill, the anvil, or the cauldron.

By virtue of their placement, the miniatures in the *Cordiale* manuscript function as a kind of frontispiece rather than as an illustration of the text. We must thus

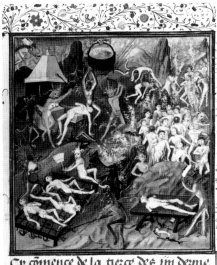
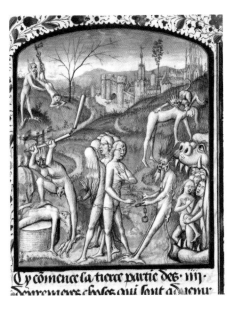

Figure 89.
Attributed to Jean Le Tavernier. *The Torments of Hell*, in Gerard van Vliederhoven, *Cordiale de quattuor hominis novissimis* (or *Le livre des quatre dernières choses*), translated by Jean Miélot. Brussels, Bibliothèque Royale, Ms. 11129, fol. 90.

Figure 90.
Anonymous master. *The Torments of Hell*, in Gerard van Vliederhoven, *Cordiale de quattuor hominis novissimis* (or *Le livre des quatre dernières choses*). Brussels, Bibliothèque Royale, Ms. 9048, fol. 90.

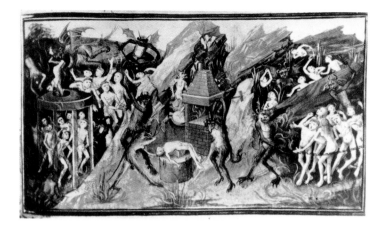

Figure 91.
Anonymous master. *Hell*, in Saint Augustine, *Cité de Dieu*. Strasbourg, Bibliothèque Universitaire et Municipale, Ms. 523, fol. 290.

ask where the artist got his pictorial ideas. The answer to this difficult question can only be conjectural. On the basis of the observations made so far, it seems that a single image of hell that introduces larger sections of text can depict the underworld in general terms, without necessarily following the text for which it had been chosen. If, as in the case of the *Cordiale*, it was sufficient to signify the content of a whole chapter by using a generic image of hell, some of these composite images could have been transmitted independently of a specific textual source. In other words, artists or workshops obviously used these illuminations consciously as generic images, paying little attention to the congruity between individual motifs and the written text. One could even go a step further and suggest that these generic images became almost as detached from specific textual sources as were some contemporaneous panel paintings. However, before investigating the use of these images in more detail, it is necessary to clarify the sources that book illuminators could have used for such infernal imagery. A generic image of the underworld represents the tortures and landscape of hell by combining a number of common motifs that can be easily recognized as pertaining to hell. Although the individual motifs can derive from literary sources of the kind discussed here, they could equally draw inspiration from oral accounts, such as sermons, or from visual material such as wall paintings and panel paintings, or indeed other book illuminations. In addition, generic images of hell are not limited to material from one source, but can combine a range of motifs of diverse origin.

Taking into account the loose text-image relationship in illuminated *Cordiale* manuscripts, it is therefore not surprising to discover that some of these designs and motifs reappear with slight variations in a different kind of text. Illustrations of hell in Saint Augustine's *City of God* are a good case in point. Illuminated versions of this popular text usually contain one frontispiecelike miniature at the beginning of each of the twenty-two books. The three last books are dedicated, respectively, to the Last Judgment, hell, and heaven. One copy of the French edition belonged to Guy Guilbaut, Philip the Good's treasurer, and was later acquired by the duke.[46] Another copy of the same text, now in Strasbourg (fig. 91)[47] contains a depiction of hell which is similar in style to the illumination of one of the *Cordiale* manuscripts (fig. 90). Whereas the text of the *Cordiale* still offered the artist a number of clues as to how the devils and hell should be visualized, book XXI of the *Cité de Dieu* is much more abstract and less descriptive about the underworld. Saint Augustine discusses a number of theories about hell that he considers to be wrong, among them, "Whether justice requires that the time of punishment should not be longer than the time of sinning," and "Of those who think that sins committed amid works of alms are not called into judgment of condemnation."[48] For this reason, no direct references can be found in the text of the Strasbourg manuscript for most of the motifs depicted in the opening miniatures.[49]

The clustering of separate scenes into a single picture frame can be found in early as well as in late versions of the *Cité de Dieu*. The well-known depiction of hell

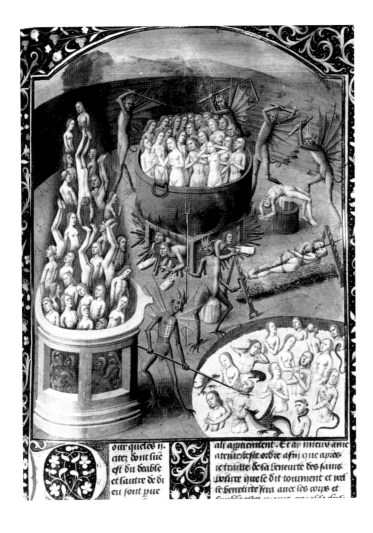

Figure 92.
Maître François. *Hell*, in Saint Augustine, *Cité de Dieu*. Nantes, Bibliothèque Municipale, Ms. fr. 8, fol. 377.

by the Boucicaut Master in the *Cité de Dieu* manuscript in Baltimore, for instance, includes different forms of punishment, many of which recur in illuminations of later copies of the *Cité de Dieu*, often by Maître François or his shop.[50] Scenes such as the damned hanging from gallows or the souls in a cauldron are used frequently by Maître François and his assistants.[51] The frontispiece to book XXI in the *Cité de Dieu* manuscript in Nantes (fig. 92) is a typical example of a certain type of miniature produced in the 1470s by this workshop. Similar to the composite illustrations in the *Cordiale*, these miniatures also convey a comprehensive rendition of the underworld in one frame. These "frontispiece" illuminations can equally be described as generic images of hell, as they reproduce popular motifs that stem from a range of different sources.

Two factors may have contributed to the similarities found among *Cordiale* and *Cité de Dieu* illuminations. Firstly, the popularity of both texts in the late Middle Ages led to a prolific production of illuminated manuscripts. In the case of the *Cité de Dieu*, it is obvious that the workshop of Maître François specialized in producing copies of this text, which in turn contributed to the repetition of certain iconographic motifs. Second, both these manuscript types contain one composite representation of hell which is always placed at the beginning of the relevant chapter of the book. This means that the miniature often functions as a visual marker for a larger section of text. An intimate relationship between the miniature and the text that follows is therefore not essential, especially since the text itself does not convey a vivid image of hell. In the case of single composite images of hell, it was obviously adequate for the book illuminator to make use of existing models available in the workshop or elsewhere.

The contrast between this type of miniature and Simon Marmion's illustrations can be exemplified by juxtaposing, say, *The Cistern of Hell* from *The Visions of Tondal* (see cover) with a representation of hell in the *Cité de Dieu* (fig. 92). Although both

images show souls blasted through the air in a whirlwind of fire and smoke, there are noticeable differences between the function and the structure of the illuminations. While the miniature in the *Tondal* manuscript reinforces the narrative of the main text—the fate of the individual soul—and illustrates the central image of one chapter, the *Cité de Dieu* miniature focuses on the landscape of hell and its torments. Tondal's journey through hell is an utterly personal experience dominated by his own encounters with the devils and imbued with his personal fears and anxieties. Most of the dissimilarities in the structure and the layout of these two miniatures can be explained by the different nature of the texts. It appears that the plan of illumination for the *Cordiale* and *Cité de Dieu* called for a graphic image of hell, details of which the text did not provide. As a result, the illuminators who created the "frontispiece" miniatures were obviously free to choose suitable motifs even if they came from different literary or visual sources; thus the interchangeability of designs between the *Cordiale* and the *Cité de Dieu*.

It is apparent from this small selection of examples that in the late Middle Ages a wide variety of texts was embellished with illustrations of purgatory and hell. The preceding analysis of contrasting text-image relationships has shown that Simon Marmion's pictorial interpretation of *The Visions of Tondal* clearly operates within the framework of a specific genre, the illustrated infernal vision. By faithfully expressing the highlights of the narrative in the language of a book illuminator, Marmion arrives at solutions similar to those of the artists who had provided other infernal visions with detailed sequences of images.

The two characteristics which distinguish *The Visions of Tondal* from all the hell scenes discussed in this paper, however, are the style and quality of its miniatures. One of Marmion's most important artistic contributions to hell imagery in fifteenth-century illuminated manuscripts is his method of creating eerie pictures of the underworld by capturing the properties of natural phenomena, such as darkness and fire, smoke and ice. Apart from these stylistic considerations,[52] Marmion is particularly inventive in modifying and altering the narrative pattern that underlies his cycle of illuminations, thus keeping the use of stereotype compositions to a minimum. His illuminations of hell are subtle representations of a world revealed to us by the visions of a knight called Tondal. In this they stand apart from most infernal imagery that appears in illuminated manuscripts from Northern Europe during the late Middle Ages.

Notes

* I wish to thank Professor J. Trapp and the Warburg Institute, London, for supporting my work on this paper during my stay as a Frances Yates Fellow in May and June 1990. I am also grateful for discussions with Michael Koortboijan and Hilary Maddocks, which helped me clarify some aspects of this paper.

1 E. Panofsky, *Early Netherlandish Painting: Its Origins and Character* (Cambridge, Massachusetts, 1953), vol. 1, p. 143; C. Harbison, "Visions and Meditations in Early Flemish Painting," *Simiolus* 15 (1985), pp. 87–118; S. Ringbom, "Devotional Images and Imaginative Devotions," *Gazette des Beaux-Arts* 73 (1969), pp. 159–70.

2 For example, Simon Marmion's *Saint Bernard's Vision of the Virgo Lactans*, Malibu, J. Paul Getty Museum, Ms. 32.

3 Harbison (note 1), p. 88.

4 London, British Library, Add. Ms. 7970, fol. 1v. This scene seems to be modeled on the apparition of Christ to Mary Magdalene, although the meaning of the scene has changed due to the text which follows; see Harbison (note 1), pp. 93–94.

5 Brussels, Bibliothèque Royale, Ms. 9030–37, fols. 223–42v; see Appendix no. 22(f).

6 J. Paul Getty Museum, Mss. 31 and 30.

7 D. Eichberger, *Bildkonzeption und Weltdeutung im New Yorker Diptychon des Jan van Eyck* (Wiesbaden, 1987), and A. Châtelet, "Sur un Jugement dernier de Dieric Bouts," *Nederlands kunsthistorisch jaarboek* 16 (1965), pp. 17–42.

8 See Wieck's essay in the present volume.

9 The problems surrounding the historical figure Simon Marmion and the body of works attributed to the artist are still unresolved. I have decided to accept the attribution of *The Visions of Tondal* to Marmion until we have more evidence about who illuminated the group of manuscripts under discussion.

10 The remarkable close relationship between text and image is made evident in Malibu 1990 and is discussed in more detail in Wieck's essay.

11 Occasionally, one can find a small miniature at the beginning of *Saint Patrick's Purgatory* in legendaries, e.g., in the *Golden Legend* in Brussels, Bibliothèque Royale, Ms. 9228, fol. 87, or the *Legendary* in Oxford, Queen's College, Ms. 305, fol. 137. An exceptionally detailed cycle of fifteen colored pen drawings occurs in a German edition of *Saint Patrick's Purgatory*, a manuscript which has been bound together in one volume with an illustrated version of the *Voyage of Saint Brendan* and several other texts (Heidelberg, Universitätsbibliothek, Cod. Pal. Germ. 60); for further information on this manuscript, see H. Wegener, *Bilderhandschriften* (Leipzig, 1927), and G.E. Sollbach, ed., *St. Brandans wundersame Seefahrt: Nach der Heidelberger Handschrift Cod. Pal. Germ. 60* (Frankfurt, 1987). The illustrations in *Saint Patrick's Purgatory* show the saint's journey through the underworld and were executed slightly earlier than those in *The Visions of Tondal*. The images in the Heidelberg manuscript visualize in a fairly detailed sequence how the protagonist of the story experiences hell, being observer and victim at the same time. Since this book and its illustrations belong to a different cultural context, it will not be analyzed here.

12 I will not discuss illuminated Apocalypse manuscripts in this context because Saint John's vision deals only in passing with hell and therefore bears less relationship with *The Visions of Tondal* than the *Pèlerinage de l'âme*. The text-image relationship in Apocalypse manuscripts is discussed in Suzanne Lewis's essay in the present volume.

13 Although it is well known that Christine de Pisan recommended the *Divine Comedy* for reading, it was not translated into French during the fifteenth century. We know of an illuminated Italian edition, which belonged to a French nobleman, Jean Cossa, the great Seneschal of Provence; for Cossa's copy, see *Dix siècles d'enluminure italienne*, exh. cat. (Bibliothèque Nationale, Paris, 1984), p. 114. Another Italian manuscript, with three miniatures by the Coëtivy Master, belonged to Charles de France, brother of Louis XI, and dates from about 1465; see P. Durrieu, "Dante et l'art français du XVe siècle," *Académie des inscriptions et belles-lettres: Comptes rendus des séances de l'année 1921* (Paris, 1921), pp. 214–24.

14 In his article on the importance of Dante manuscripts for French bibliophiles, Durrieu suggests that the *Divina Commedia* can be found less frequently in French libraries of the fifteenth century because the Italian version was not particularly popular among French collectors, who preferred Latin or French editions. The text was not translated into French until the beginning of the sixteenth century, by François Bergaigne; see Durrieu (note 13), pp. 218–19.

15 For example, New York Public Library, Spencer Collection, Ms. 19, the second half of which is in Oxford, Bodleian Library, Ms. Laud 740; British Library, Egerton Ms. 615, an illuminated copy also from the first half of the fifteenth century.

16 Brussels, Bibliothèque Royale, Ms. 10176–78; see L.M.L. Delaissé, "Les miniatures de *Pèlerinage de la vie humaine* de Bruxelles et l'archéologie du livre," *Scriptorium* 10 (1956), pp. 233–50.

17 The first and third parts of the trilogy are the *Pèlerinage de la vie humaine* and the *Pèlerinage de Jésus Christ*, respectively. For de Deguileville, see S.L. Galpin, "On the sources of Guillaume de Deguileville's *Pèlerinage de l'âme*," *Publications of the Modern Language Association* 25 (1910), pp. 275–308; J.J. Sturzinger, ed., *Le Pèlerinage de l'âme de G. de Deguileville* (London, 1895); R. Tuve, *Allegorical Imagery: Some Medieval Books and Their Posterity* (Princeton, 1966), pp. 145–49. I wish to thank Hilary Maddocks, University of Melbourne, for letting me read her unpublished honors thesis, "The *Pilgrimage of the Life of Man* in the State Library of Victoria (Ms. 096/G94, fols. 1r–95v)"; see also M. Manion and V. Vines, *Medieval and Renaissance Illuminated Manuscripts in Australian Collections* (New York, 1984), pp. 110–12.

18 In the case of the *Pèlerinage de l'âme*, the man experiencing the vision is a cleric. R. Bergmann, *Die Pilgerfahrt zum himmlischen Jerusalem* (Wiesbaden, 1983), p. 10, even suggests that Guillaume is identical with the pilgrim.

19 In the Melbourne manuscript, subheadings appear in most cases, either above or below the pen drawings. The Bodleian *Pèlerinage* seems to be decorated less systematically, as the titulus is rarely placed next to the drawing.

20 The Melbourne manuscript comprises an English prose version of the *Pèlerinage de la vie humaine* and *Pèlerinage de l'âme* in one volume.

21 These two scenes are portrayed on fol. 42 of the Oxford manuscript.

22 Dinzelbacher 1981, pp. 233–65.

23 See, for instance, the crossing of a bridge on fols. 15v and 20 of the *Tondal* and, to a certain extent, the depiction of a valley on fols. 13v and 27.

24 Oxford, Bodleian Library, Ms. Douce 134; see *The Douce Legacy*, exh. cat. (Bodleian Library, Oxford, 1984), no. 248.

25 According to the recent findings of Martin Kauffmann and Nigel Palmer, the first part of this manuscript has been identified with Ms. 408 in Grenoble; see Thomas Kren's essay, p. 143 and n. 19, below.

26 Ms. Douce 134, fols. 77–129v.

27 Ibid., fols. 87v–88.

28 This chapter is illustrated by a depiction of the *Fall of the Damned* on fol. 77v, which does not single out any individuals but describes the sinners entering the realm of hell.

29 Ms. Douce 134, fols. 126–29v.

30 Whether these differences are only due to the different modes of expression of the individual illuminators or to the taste of the patron is a question which deserves a separate study.

31 London, Victoria and Albert Museum, Ms. Salting 1221, fol. 153.

32 Individual scenes such as the jaws of hell, the bridge, the beasts and devils in a fiery landscape, and the four rivers of paradise suggest that the image is inspired by literary visions, such as *The Vision of Saint Paul* or *The Visions of Tondal*, and is therefore another important example in book illumination of the significance of such literary texts for the visual arts in the Middle Ages. The appearance of a narrative progression of incidents from the depths of hell to paradise in the Salting Hours prompted one scholar to connect this miniature directly with the text of *The Visions of Tondal*, although the suggestion is unconvincing.

33 Hindman 1977, p. 193.

34 Bodo Brinkmann, pp. 185–86, below, argues convincingly that this miniature, on the reverse of Simon Marmion's *Raising of Lazarus*, forms part of a later stage of decorating the manuscript and should for stylistic reasons not be attributed to Simon Marmion, but to the Master of Fitzwilliam 268.

35 G. Bartz and E. König, "Die Illustration des Totenofficiums in Stundenbüchern," in H. Becker et al., eds., *Pietas Liturgica 3: Im Angesicht des Todes* (Sankt Ottilien, 1988), vol. 1, pp. 497–98.

36 This situation might apply even more so to illuminations commissioned independently of the text and possibly from different towns within the Burgundian Netherlands; ·see Brinkmann, pp. 188–91, below.

37 R. Byrn, "Late Medieval Eschatology: Gerard van Vliederhoven's Cordiale de IV novissimis," *Proceedings of the Leeds Philosophical and Literary Society* 17 (1979), pp. 55–65; M. Dusch, *De Veer Utersten—Das Cordiale des Gerard van Vliederhoven in mittelniederdeutscher Überliefung* (Cologne, 1975); J.A. Mulders, *The Cordyal by Anthony Woodville, Earl Rivers* (Nijmegen, 1962); A. de Laborde, *Les manuscrits à peintures de la Cité de Dieu de Saint Augustin*, 2 vols. (Paris, 1909).

38 Brussels 1967b, p. 47, no. 61, and *Vlaamse kunst op pergament*, exh. cat. (Gruuthusemuseum, Bruges, 1981), p. 227, no. 91.

39 The popularity of this text is also reflected by the fact that Jean Miélot prepared a French translation in 1455, which was printed in Bruges by Colart Mansion in 1476. An English version, printed by William Caxton, followed in 1479.

40 Palmer 1982, nos. 3, 4, 6, 15, 17.

41 M. Debae, *La librairie de Marguerite d'Autriche*, exh. cat. (Bibliothèque Royale, Brussels, 1987), p. 96, and Brussels 1967b, p. 47, no. 61.

42 Brussels, Bibliothèque Royale, Ms. 11129, fol. 90; see Brussels 1967b, p. 47, no. 61, and J. Deschamps, *Cinq années d'acquisitions: 1974–78*, exh. cat. (Bibliothèque Royale, Brussels, 1979), pp. 117–19, no. 51.

43 Brussels, Bibliothèque Royale, Ms. 9048, fol. 90; see Debae (note 41), pp. 96–98, no. 28.

44 Mulders (note 37), pp. 99, 108.

45 Ibid., pp. 101, 106.

46 Brussels, Bibliothèque Royale, Ms. 9006, fol. 265v; see Brussels 1967b, pp. 27–28, and Dogaer 1987, pp. 33–36.

47 Strasbourg, Bibliothèque Universitaire et Municipale, Ms. 523, fol. 290; Brussels 1967b, pp. 70–76.

48 W.M. Green, trans., *Saint Augustine, The City of God Against the Pagans*, vol. 7 (Cambridge, Massachusetts, 1972), book XXI, 11 and 22.

49 One of the most detailed descriptions can be found in book XXI, 13, where Saint Augustine quotes a passage from Virgil's *Æneid*: "Ergo exercentur poenis ceterunque malorum supplicia expendentur; aliae pandantur inanes supensae ad ventos, aliis sub gurgite vasto infectum eluitur scelus aut exurgitur igni"; ibid., pp. 76–78.

50 See, for example, Baltimore, Walters Art Gallery, Ms. 770, fol. 227; Meiss 1968, pp. 76–77. Most of the illuminations by Maître François and his workshop have been described by de Laborde (note 37).

51 Nantes, Bibliothèque Municipale, Ms. fr. 8, fol. 377; see de Laborde (note 37), vol. 2, pp. 423–48. Geneva, Bibliothèque Publique et Universitaire, Ms. fr. 79, fol. 479; see F. Gagnebin, *L'enluminure de Charlemagne à François Ier*, exh. cat. (Musée Rath, Geneva, 1976), pp. 127–30, no. 54.

52 The style of the miniatures by Simon Marmion is discussed in more detail in other essays in this volume, e.g., those by Roger S. Wieck, pp. 119–28, above, and Thomas Kren, pp. 141–56, below.

Some Illuminated Manuscripts of *The Vision of Lazarus* from the Time of Margaret of York*

Thomas Kren

T he popularity of visions of the otherworld during the Middle Ages, espe-
cially from the twelfth century, is well known.[1] Not only *The Visions of Ton-
dal*, but *The Vision of Saint Paul, Saint Patrick's Purgatory*, and many others
survive in hundreds of copies both in Latin and in vernacular translations. However,
with the notable exception of the biblical Apocalypse, illuminated manuscript cycles
of infernal visions are rare.[2]

By the later Middle Ages, depictions of hell became more common in French
and Flemish manuscripts, as Dagmar Eichberger has shown[3]—even though with the
exception of the Apocalypse, they did not usually appear in religious literature con-
cerning visions of hell. The interest in infernal imagery extended, moreover, beyond
manuscripts into other media, especially paintings. The evocative and immediate
character of hell's torments in Margaret of York's *Visions of Tondal* anticipates Bosch's
underworld. Although Bosch almost certainly did not know Getty Ms. 30, within a
decade of its completion he began to make such subjects a staple of his repertory.
Despite this proliferation of infernal imagery, the number of vision texts in French
that received these cycles remained few, even at the end of the Middle Ages. These
include illuminated manuscripts of Deguileville's *Pèlerinage de l'âme*, cited by Eich-
berger, and, of course, the Getty *Tondal* manuscript, which is the only surviving copy
of this text to receive an extensive cycle of miniatures.[4] This paper will introduce
another, less familiar, example of an illuminated infernal vision in manuscripts from
the time of Margaret of York, *The Vision of Lazarus*.

The Vision of Lazarus recounts Lazarus's experiences in the brief period be-
tween his death and his resurrection by Christ. During Margaret's lifetime, the
French text of this apocryphal tale was one of the few infernal visions that was re-
peatedly illustrated. Baltrušaitis and Mâle discuss its importance at the end of the
fifteenth century and cite illustrations of it in printed books and frescoes.[5] Both au-
thors, however, mention only one illuminated manuscript, in a volume of penitential
writings, Bibliothèque Nationale, Ms. fr. 20107 (figs. 95–97, 103, 106), which Bal-
trušaitis alone discusses, but only in a footnote.[6] This manuscript was likely pro-
duced, as I shall argue here, in northern France in the mid-1480s. A total of six manu-
scripts of the French text, all dating from the second half of the fifteenth century,
are known today, and three of these are illustrated.[7] In addition, two books printed
in Paris (also in French and illustrated) contain the text; they were issued in the 1490s
in the first of numerous editions. The printed texts appear in *L'art de bien mourir*
(Paris, Antoine Vérard, 1492) and the *Kalendrier des bergiers* (Paris, Guy Marchant,
1493; fig. 102).[8]

The three illuminated manuscript copies of the texts in French are Bodleian
Library, Douce 134, Bibliothèque Nationale, nouv. acq. fr. 16428, and fr. 20107.
The text of nouv. acq. fr. 16428, a fragment inserted in a prayer book made for Philip
the Good (figs. 94, 98, 100, 104, 109), is so close to fr. 20107 that the two transcrip-

tions, which are both in Latin and in French, must derive from a common model.[9] Nouv. acq. fr. 16428 was probably made during the 1490s, also in northern France or Flanders and, like the *Tondal*, probably for a noble family of the region. Although its naturalistic miniatures are not stylistically related to those of the Getty manuscript, together these evocative scenes demonstrate that infernal subject matter inspired the illuminators of Flanders and France to paint pictorial cycles of extraordinary originality and expressiveness. A third example, which belongs to the early 1460s, appears in *Le livre de la vigne de Nostre Seigneur*, probably made in southeastern France (figs. 93, 105, 107, 108). Thus *The Vision of Lazarus* offers a rare example of the text of an infernal vision that was illuminated a number of times in the era of Margaret's *Tondal* manuscript, including several copies from the general region where it was made.

Max Voigt provided the fundamental study of *The Vision of Lazarus* text, its various recensions and their history.[10] The best-known version of the Lazarus narrative—and that which appears in the manuscripts under discussion here—focuses on the seven punishments connected with the Seven Deadly Sins.[11] Voigt identifies the earliest surviving Latin example of this text in the account of the Hungarian knight George who, in 1353, visited Saint Patrick's Purgatory and subsequently recorded what he saw and learned.[12] George claims that his account is based on Lazarus's own, as it was read in the churches of Marseilles. But no trace of the original vision survives. It is noteworthy that as early as the thirteenth century other accounts of the torments of hell and purgatory were also organized didactically around the number seven, and sometimes they too were specifically linked to the Seven Deadly Sins.[13]

All but one of the aforementioned French and Latin manuscript versions have a prologue which establishes that an account of Lazarus's vision from his death to his resurrection follows. Lazarus proceeds to describe the seven torments he witnessed, each one directed toward one of the Seven Deadly Sins. The story ends abruptly after the description of the seventh torment. There is no epilogue or denouement in any of the surviving French manuscript versions. Lazarus functions in this narrative merely as a witness to the horrifying events. Unlike Tondal, Saint Paul, or the knight Owein, he does not succumb to any of the punishments; nor does he relate his responses to the torments he witnesses. He begins each section with the words, "Then I saw," echoing the phrasing of the apocalyptic vision of Saint John, and the ensuing account is concise. (The printed texts are similar to fr. 20107 and nouv. acq. fr. 16428 in content, but they contain extensive supplementary didactic material not found in the manuscript versions.)

Thus *The Vision of Lazarus* lacks a substantial narrative, especially compared to *The Visions of Tondal* or, for that matter, *Saint Patrick's Purgatory* and *The Vision of Saint Paul*.[14] These three works, unlike the *Lazarus* text, also have the character of a journey. They represent true visionary experiences, during which, as noted, the narrators themselves witness and endure diverse torments. *The Vision of Lazarus*, especially in the fifteenth-century French versions, comes closer to a laundry list of punishments. Lazarus's presence is indicated only by the aforementioned phrase, "Then I saw." Indeed, in one of the illuminated French versions, Douce 134, each of the seven torments is described, but all references to Lazarus are omitted; the text is merely an account of the infernal torments for the Seven Deadly Sins.[15] In Douce 134 and the printed *Kalendrier des bergiers*, the sections featuring *The Vision of Lazarus* are entitled "On the Different Torments of Hell" and "The Torments of Hell," respectively.

The French texts as well as the fourteenth-century Latin text of the knight George are short. In the two illuminated examples from northern France or Flanders (fr. 20107 and nouv. acq. fr. 16428), the complete story in French is only about 270 words—and one third of them are taken up by the prologue. Each torment is described in only a sentence or two, and hence is well suited to receive the complement of a miniature. Although the text provides the reader with a vivid, even highly pic-

torial account of hell's torments, as do the more popular and longer established visions of Tondal, Saint Patrick, and Saint Paul, it lacks the narrative structure, variety of detail, and the sympathetic, human component of the older tales.[16] But during the lifetime of Margaret of York, it was the *Lazarus* text and not the three more celebrated visions that was often illustrated.

The earliest and textually the most complex of the three illuminated transcriptions appears in the Bodleian manuscript, Douce 134.[17] Among other things, it has several torments that differ from the seven in all the other fifteenth-century French texts. *Le livre de la vigne de Nostre Seigneur* is an illustrated treatise on the Antichrist, the Last Judgment, heaven, and hell, some of whose infernal imagery Eichberger has analyzed.[18] It is probably the second of two volumes, the first of which M.E. Shields and subsequently Martin Kauffmann and Nigel Palmer have proposed to identify with Ms. 408 (337) in Grenoble.[19] The dimensions of both manuscripts, the character of the script, and the initials are very similar, and their styles of illumination are consistent with the general dating between 1450 and 1470 proposed by Pächt and Alexander, which is certainly correct.[20] The Grenoble volume is dated 1463 and its text specifies that the second volume was completed before the first was begun.[21] The Bodleian volume identifies itself as the last book of *Le livre de la vigne*, i.e., probably the second one; thus it would have been written first. And I would suggest, albeit provisionally, that the two books were produced in southeastern France.[22]

The version in Douce 134, even though it omits any reference to Lazarus, is elaborate. It describes each sin and reports something about the behavior of the sinner, recounting in detail the tortures to be endured, which are then lent biblical authority through the citation of a comparable or identical biblical punishment. For example, for the sin of Envy the text cites Job 24: 19: "Let him pass from the snow waters to excessive heat, [and his sin even to hell]" (fig. 93). The compiler may have omitted the participation of Lazarus expressly because he wanted to ground his account in biblical testament, and the Bible fails to mention Lazarus's experience of hell.

Envy is one of the sins in Douce 134 that departs significantly from the Lazarus iconography of the other French texts. In the other seven copies, the envious are punished by being lodged in ice up to their navels and then struck by a cold wind (fig. 94). Torment of the envious by heat is elsewhere mentioned only in the fourteenth-century Latin text, which, however, makes no reference to ice or cold.[23] Was the torture of the envious by "snow water" thus introduced by the compiler of Douce 134 purely to adapt it to biblical sources, or did he follow another now-lost redaction that mentioned a cold punishment? For the purposes of our discussion, it will suffice here to note that in Douce 134 the torments for Pride, Greed, Lust, and Gluttony are substantially the same as in the other French texts, while those for Anger and Sloth are, like Envy, related but not identical.

Figure 93.
Anonymous master. *Punishment of the Envious*, in *Le livre de la vigne de Nostre Seigneur*. Oxford, Bodleian Library, Ms. Douce 134, vol. 1, fol. 83v.

Figure 94.
Follower of the Master of the Dresden Prayer Book. *Punishment of the Envious*, in the Prayer Book of Philip the Good. Paris, Bibliothèque Nationale, Ms. nouv. acq. fr. 16428, fol. 36.

Fr. 20107, the next of the three illuminated copies in chronological sequence, contains in addition to *The Vision of Lazarus* a number of devotional texts and catechetical writings. Whereas the elaborate, discursive *Livre de la vigne de Nostre Seigneur* is concerned with myriad aspects of hell and the Antichrist—it is practically an encyclopedia of hell—this manuscript was compiled primarily for lay religious instruction and recitation. In addition to the Ave Maria and Pater Noster, it includes enumerated rules and guides for the conscience: the Ten Commandments, the Twelve Articles of the Faith, the Five Commandments of the Holy Church, along with the punishments for the Seven Deadly Sins witnessed by Lazarus. This version of the Lazarus text also has a number of distinctive features. One is the prologue, not found either in the older Latin text or in Douce 134, in which Christ, dining in the house of Simon the Leper, invites the resurrected Lazarus to recount his experience of death. Fr. 20107, alone among the manuscript copies, illustrates this passage (fig. 95). It also is unique in illustrating the appropriate sins alongside each torment (fig. 96): the sin appears under the pertinent text passage in a bas-de-page opposite the full-page torment scene.

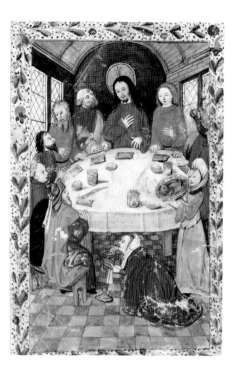

Figure 95.
Anonymous master. *Christ in the House of Simon the Leper*, in a collection of penitential writings. Paris, Bibliothèque Nationale, Ms. fr. 20107, fol. 10v.

Fr. 20107 is difficult to localize based upon the curious, naive style of the miniatures alone. The few published references have merely called the book French.[24] But the coat of arms of the male patron (fig. 97), while not precisely identifiable, has as its central motif the *marteau* (hammer), which is found only north of Rouen, in Artois, Picardy, and in parts of Flanders.[25] In addition, certain orthographic practices are particular to Flanders, the Hainaut, and the Artois, as Geneviève Hasenohr has kindly advised me—words such as "dimences" for "dimanches" and "flesses" for "fleches."[26] And the style of costume, while generally found in France and Flemish Burgundy during the 1480s, has certain features, such as the woman's partlet in the miniature of *Lust* (fig. 96), which are most common to Flanders.[27]

Finally, whereas Mâle dated the manuscript circa 1480, it is probably somewhat later.[28] Some details of costume, among them the round-toed shoes of the man in the *Lust* illumination, are not documented before 1484.[29] And the slim silhouettes of the men's costumes start to disappear at the beginning of the 1490s. So the manuscript was likely written and illuminated in northern France, or perhaps Flanders, around the middle of the 1480s and probably not later than the end of the decade.

The artistically more refined and ambitious version of *The Vision of Lazarus* found in nouv. acq. fr. 16428 is no more than a single gathering of eight leaves. It was inserted, along with a miscellaneous group of prayers, probably by the end of the sixteenth century, into a collection of devotions written and illuminated for Philip the Good. We do not know to what volume *The Vision of Lazarus* originally belonged, although the leaves' small dimensions (trimmed to 420 × 340 mm), together with their elegant illusionistic borders (figs. 100, 109), call to mind the private devotional books manufactured in large number in northern France and Flanders for an international clientele of noblemen and wealthy merchants. It may thus have belonged originally to a prayer book for meditation or a collection of catechetical texts and writings for religious instruction, whose contents may, for example, have corresponded to the admonitory subject matter of fr. 20107. The curious history of nouv. acq. fr. 16428, along with its elegant borders and illumination style, suggest that it was made for a prominent aristocrat, possibly someone within the circle of noble families formerly around the Burgundian court. Indeed, baptismal notes written on flyleaves in the late sixteenth and early seventeenth century (fols. i–ii), when the fragment seems already to have found its way into the older prayer book, identify first the owner's marriage and then the baptism of the children. These baptisms took place, successively, in Chimay, Philippeville, Beaumont, and Fumay, all in the Hainaut, between 1593 and 1615, i.e., roughly during the lifetime of the great bibliophile Charles de Croy (1560–1612), Prince of Chimay and Duke of Arschot and Croy, whose principal residence and library was in Beaumont.[30] The notes, unfortunately, do not give us the owner's family name.

In the fifteenth century, the Croy were among the closest advisers to Dukes

Figure 96.
Anonymous master. *Lust*, in a collection of penitential writings. Paris, Bibliothèque Nationale, Ms. fr. 20107, fol. 17v.

Philip and Charles, and for a time Charles's antagonists. Margaret of York was godmother to a son born in 1500 to Charles de Croy, Prince of Chimay (d. 1521).[31] The Croy family's bibliophilia endured for generations, especially the taste for richly illuminated books, inspired by the ducal family. In fact, the two families occasionally presented deluxe manuscripts to each other.[32] Indeed, the late sixteenth-century library of Charles de Croy contained fine illuminated manuscripts from the Burgundian court made during the time of Margaret of York.[33] Through such bibliophilic gifts and inheritances, Philip's prayer book and the mysterious fragment may have found their way to their anonymous owner in the territory of Charles de Croy by the end of the sixteenth century. He or she may have belonged to a family in the retinue of either a Burgundian courtier, such as the Croy, or a descendant of Charles the Bold. As we shall see below, the decorated borders of this *Lazarus* especially call to mind decorative motifs in a book of hours made for Philip the Fair, grandson of Charles (fig. 101).

The primary evidence for localizing and dating the *Lazarus* text inserted in nouv. acq. fr. l6428 is the style of its miniatures. The manuscript was first published by François Avril in 1978 as by the Master of the Dresden Prayer Book, circa 1470–80, and this attribution is accepted by Brinkmann.[34] Although pictorially nothing nearly as stark or foreboding appears in the best work of the Master of the Dresden Prayer Book, a variety of manuscripts attributed to the artist or his circle show marked similarities in the figure and facial types and the decorative motifs. The facial types show an especially strong resemblance to those in a group of manuscripts produced in Amiens, where the Master of the Dresden Prayer Book is thought to have sojourned. An example is the Gospel-lectionary of Antoine Claibault, Mayor of Amiens, in which the ruddy facial types particularly recall the types in the *Lazarus* miniatures (figs. 98, 99).[35] Unlike Brinkmann, I am inclined to think that the illuminator of this manuscript was an artist working in the circle of the Master of the Dresden Prayer Book rather than the Master himself.[36] Among the distinguishing features of the miniatures is the vividly conveyed anguish suffered by the damned (figs. 98, 100, 104, 109), which in my view finds no correspondence in the art of the Master of the Dresden Prayer Book. Thus the fragment may have been produced in Amiens, where our artist was probably active.

Finally, although the fragment has been dated circa 1480, it most likely originates more than a decade later, as certain motifs of its borders appear in such manuscripts as the Hours of Philip the Fair, probably made about the time of Philip's marriage to Joanna of Castile in 1496 or a bit later (figs. 100, 101).[37] Moreover, as

Figure 97.
Coat of arms of male and female patrons, in a collection of penitential writings. Paris, Bibliothèque Nationale, Ms. fr. 20107, fol. 2.

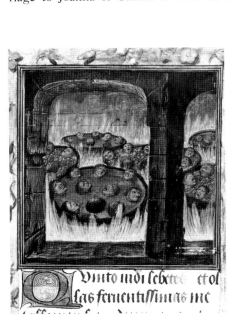

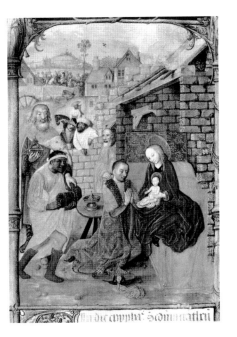

Figure 98.
Follower of the Master of the Dresden Prayer Book. *Punishment of the Greedy*, in the Prayer Book of Philip the Good. Paris, Bibliothèque Nationale, Ms. nouv. acq. fr. 16428, fol. 39.

Figure 99.
Follower of the Master of the Dresden Prayer Book. *Adoration of the Magi*, in the Gospel-lectionary of Antoine Claibault. Paris, Bibliothèque de l'Arsenal, Ms. 661, fol. 17v.

Figure 100.
Follower of the Master of the Dresden Prayer Book. *Punishment of the Proud*, in the Prayer Book of Philip the Good. Paris, Bibliothèque Nationale, Ms. nouv. acq. fr. 16428, fol. 35.

Figure 101.
Master of the Dresden Prayer Book. Border decoration, in the Hours of Philip the Fair. London, British Library, Add. Ms. 17280, fol. 43v. Reproduced by kind permission of the British Library Board.

Brinkmann has noted, the illustrations of the text of the *Kalendrier des bergiers* that first appeared in 1493 probably also had some influence on the miniatures of nouv. acq. fr. 16428 (figs. 100, 102).[38] The *Kalendrier* was so popular that it was reprinted six times between 1493 and 1500. Certain details, such as the manner in which the souls are tied to the axle and the wheels' placement on the axle between two peaks, may have been copied by the illuminator of the fragment. In addition, the text of the manuscript describes "une montaigne," while both the miniature and the woodcut show more than one peak. Thus the manuscript must be datable after 1493. The sophisticated naturalism of the woodcuts, which were influenced by Italian art, offered an appropriate model for this artist, although his miniatures retain a quite different, indeed more Northern character.

 The two manuscripts in the Bibliothèque Nationale could not be more pictorially dissimilar, but they contain striking textual similarities. The texts of fr. 20107 and the illuminated fragment, nouv. acq. fr. 16428, are not only the shortest, but also the closest, word for word, among all the fifteenth-century versions. They are even closer to each other than nouv. acq. fr. 16428 is to the text of *Kalendrier des bergiers*, a book that, as we have seen, the illuminator may have known.[39] Alone among the surviving French fifteenth-century *Lazarus* texts, fr. 20107 and nouv. acq. fr. 16428 include both the Latin and French transcriptions. On the other hand, whereas the illumination of nouv. acq. fr. 16428 represents the most fashionable style of its time, if far from the most refined example, and the book also reflects patronage from the ranks of the high nobility, fr. 20107 is in a decidedly provincial style of illumination. It was made outside the lively circle of artists working for the court. The coat of arms suggests that it was produced for a merchant or member of the lower nobility.

We have examined three illuminated manuscripts of *The Vision of Lazarus* from the time of Margaret of York, all in French, including two from northern France or Flanders, along with two illustrated printed editions from Paris. Is there any continuity within this pictorial tradition? Decidedly little. Even though the artist of nouv. acq. fr. 16428 seems to have known the printed *Kalendrier des bergiers*, his borrowings were more incidental than substantive. Moreover, the expressive character of the three sets of miniatures was achieved by quite different stylistic means. There is little evidence, in other words, of shared models or of any one illuminator being cognizant of the others' *Lazarus* miniatures. All the artists, however, remain largely faithful to their texts, even if, as in the two manuscripts in Paris, they illustrate nearly identical

Figure 102.
Attributed to Pierre Le Rouge. *Punishment of the Proud*, in *Le Compost et Kalendrier des bergiers* (Paris, Guy Marchant, 1493), fol. 33v.

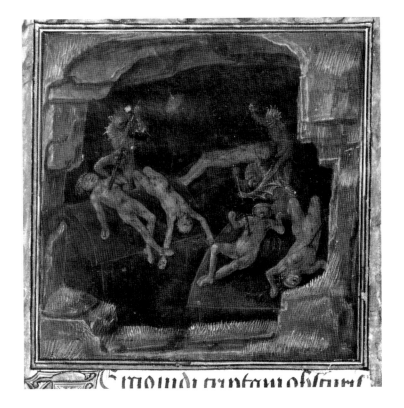

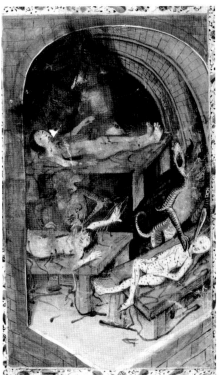

texts in different ways. The Latin word "criptam" was translated into French as "cave"; since both words appear in the texts describing the punishment for anger, the artist could depict either a crypt or a cave. Accordingly, in fr. 20107, we find a crypt, while in nouv. acq. fr. 16428 there is a cave (figs. 103, 104). In Douce 134, the text rarely mentions settings, so the artist does not provide them (fig. 105).

In miniatures that illustrate the punishment of the proud in the northern French examples, we see the iron clamps described in the text along with the wheels, situated high up on mountains (figs. 100, 106). In fig. 106, the provincial artist emphasizes the devils and the punished at the expense of the setting and convincing scale; in fig. 100, scale and setting are used in a sophisticated manner to heighten the drama and the terror of the punishment. In the Douce manuscript, the text specifically mentions that the wheels are turned by devils and the artist complies (fig. 107). In fr. 20107, devils are not mentioned in this passage, though they appear in the illumination. Its text—and hence that of the textually related nouv. acq. fr. 16428—frequently implies the presence of a tormenting agent, presumably a devil, by the nature of the punishment, but devils are illustrated noticeably more often in

Figure 103.
Follower of the Master of the Dresden Prayer Book. *Punishment of the Angry*, in the Prayer Book of Philip the Good. Paris, Bibliothèque Nationale, Ms. nouv. acq. fr. 16428, fol. 37.

Figure 104.
Anonymous master. *Punishment of the Angry*, in a collection of penitential writings. Paris, Bibliothèque Nationale, Ms. fr. 20107, fol. 14.

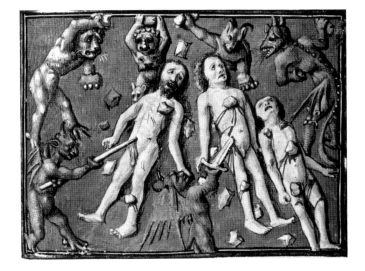

Figure 105.
Anonymous master. *Punishment of the Angry*, in *Le livre de la vigne de Nostre Seigneur*. Oxford, Bodleian Library, Ms. Douce 134, vol. 1, fol. 84.

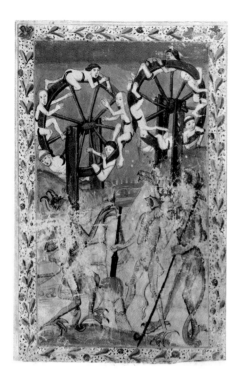

fr. 20107 than in the fragment. In the latter, they are physically less conspicuous, especially when the text does not give them a specific animal form (for example, in the scene in which they appear as serpents attacking the slothful).

A single miniature among the three illuminated *Lazarus* texts departs significantly from the passage it illustrates: the punishment for Greed in Douce 134, *Le livre de la vigne de Nostre Seigneur* (fig. 108). The burning cauldron at left contains a pope, a cardinal, and a bishop, while the other holds a monarch—none of whom are mentioned in the text. The fourteenth-century Latin *Lazarus* text makes a few rare references to a particular class of sinner, as in the monks who are guilty of Sloth for failing to rise to recite their devotions. It is conceivable, therefore, that both the fourteenth-century *Lazarus* and the imagery of Douce 134 reflected a more detailed redaction that was supplanted by the abridged and "glossed" one.[40] But it is just as likely that the artist borrowed his imagery from a type of infernal punishment illustration where society's various stations, especially its clergy and ruling class, suffer the same ignominious punishment as ordinary damned souls.[41]

What then is the point of comparing illustrated cycles of *The Vision of Lazarus* that are so pictorially independent of one another? As Roger Wieck has pointed out, the illustrations of Margaret's *Visions of Tondal* reflect the unique and idiosyncratic

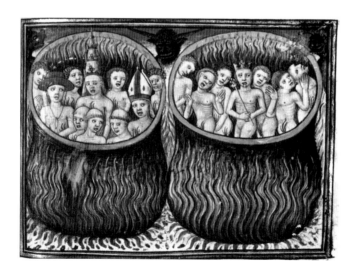

French translation of the text that is found only in the Getty manuscript.[42] Similarly the broad differences among the miniatures in the various *Lazarus* cycles offer compelling evidence that each artist was obliged to illustrate the version of the text in front of him. It appears that the individual transcriptions of the *Lazarus* texts determined closely the content of their illustrations.

Let us now take a closer look at the illustrated *Visions of Tondal* and the *Lazarus* fragment, which are linked historically, in their circle of patronage, and pictorially, in their naturalism. Within their shared artistic idiom, the differences between these novel sets of miniatures are more striking than their similarities. The contrasting texts explain many of the differences: one relates an elaborate journey and a visionary experience, the other offers a terse account of hell's torments. However, other factors deserve consideration, such as the artists' response both to nature and—perhaps along with the patron's—to the story itself.

The Amiens artist has given the *Lazarus* scenes a brooding and expressive character, isolating the figures high up, so that their isolation in the barren landscape contributes to the terrifying quality of the torment (fig. 100). As a result, the miniatures have a psychological tension and a pathos that contrasts with the *Tondal* miniatures, where the scenes of hell, such as *The Valley of Homicides*, seem almost dreamlike.[43] This effect may also be enhanced by the fact that Tondal appears in all the miniatures illustrating the pains of hell, intervening between the viewer and the depicted torments. Lazarus, who in the text is more an observer and narrator than a protagonist, is not depicted at all; lacking his surrogate presence, the viewer's engagement with the horrors is more immediate, as the Amiens illuminator understood. Finally, there is considerable human suffering in *The Visions of Tondal*, but the illuminator often distracts us by the strange beauty of the punishments and their spectacular character.

In the *Lazarus* miniature where the envious are punished in a lake of ice, the anonymous artist also uses the grayness of the sky and the chilly whiteness of the snow to convey the frightening nature of the torture (fig. 94). Although the artist is not always very inventive—diagonal lines in the sky indicate the motion of the wind mentioned in the text—the tonal subtleties reveal expressive possibilities for the pictorial description of nature that subsequent generations of European artists would exploit to great effect. As in the miniature illustrating the punishment of the proud (fig. 100), the landscape itself strongly contributes to the frightening impact of the penalty. It is an ominous and forbidding place. Such gloomy, desolate settings are novel in the art of this time; the destructive forces seem to reside not merely in devils and instruments of torture but in the bleak landscape itself. And even where the landscape does not register as a force of punishment, it—or the gloomy darkness of a chamber—still evokes a mood of foreboding (fig. 109).

In *The Visions of Tondal*, we frequently read how Tondal himself was cruelly tormented;[44] however, this torture is not depicted graphically in the miniatures, nor is the anguish of other souls usually given visual prominence. Marcus, the author of the *Tondal* text, has conceived the inferno dramatically and on a large scale. The illuminator exploits this character, so that hell acquires grandeur. As I have remarked elsewhere, the depiction of fire, its bold colors, vibrant glow, and dynamism, seemed to offer a particular challenge to the gifted colorist.[45] In his subtle response, the flames and smoke seem more entrancing than alarming; they inspire awe more than fear. Marmion has created an otherworldly experience suited to a great adventure. Thus Margaret's illuminated *Visions of Tondal* appears to complement the dreamlike and epic character of her richly illustrated *Apocalypse*.[46]

In the *Lazarus* fragment, the punishments of hell are more frightening because the settings appear more earthbound (figs. 94, 100, 104). It is a more familiar, if bleaker world, where human souls suffer intensely. If both the *Lazarus* and *Tondal* miniatures are intended to warn the reader of the wages of sin, the *Lazarus* fragment probably does the job more effectively. Marmion's hell is too alluring and fantastic. The text of Margaret's *Tondal* conveys the actual torments and the hero's suffering

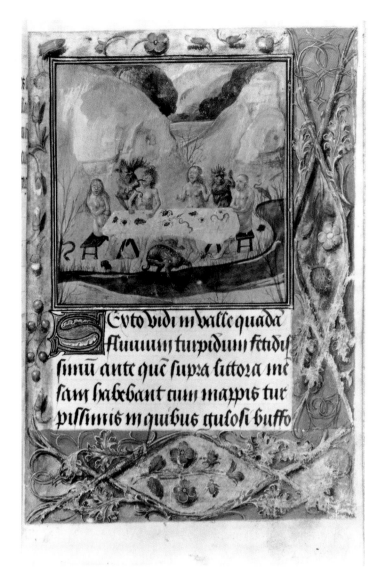

Figure 109.
Follower of the Master of the Dresden Prayer Book. *Punishment of the Gluttonous*, in the Prayer Book of Philip the Good. Paris, Bibliothèque Nationale, Ms. nouv. acq. fr. 16428, fol. 40.

more directly than the miniatures. Yet, though their impact is distanced, they retain a spiritual dimension.

The three French illuminated manuscripts of *The Vision of Lazarus* reveal more about the taste for graphically moralizing imagery at the end of the Middle Ages than about the interest in infernal vision literature. The *Lazarus* text itself was didactic, being included in books of moral instruction about virtue and vice or about preparations for death and the Last Judgment. Its concise moral lessons are easily grasped, but the violent, often disturbing illustrations convey the same message more directly. These images are probably the more effective teachers here. It would thus not be accidental that five of the eight copies of this text in French manuscripts and printed books from the second half of the fifteenth century are illustrated. The text's popularity undoubtedly was fed by widespread French interest in the Seven Deadly Sins and the torments of hell.[47] (Hieronymus Bosch also depicted the Seven Deadly Sins in these years, but not their punishments.)

The growing taste for images of hell and its punishments was surely encouraged by the rise of pictorial naturalism in fifteenth-century European art. Images of hell executed in the naturalistic style of nouv. acq. fr. 16428, the woodcut cycles from Paris, Bosch's altarpieces, or, finally, Margaret's *Visions of Tondal* not only offered the artist a departure from the devotional subject matter he routinely depicted, but they offered the devout a window onto another world. They are vivid images of the un-seeable, of a world that seemed close at hand at a time when both direct and vicarious religious experience was strongly valued. Through their familiarity with Marmion's

work,[48] either Margaret or her advisers may have understood that an illuminator of Marmion's rare abilities was ideally suited to make Tondal's world immediate and accessible. The illustrations draw us into the next world as boldly as does the text. (An infernal vision text in the library of an English person was not rare, but an illuminated copy, of course, was.)

However, *The Vision of Lazarus* manuscripts stand nearer to the beginning of one pictorial tradition than at the end of another.[49] The most beautiful and original among the illuminated copies, the one inserted in the Prayer Book of Philip the Good, betrays an awareness of a woodcut cycle in a printed book. The Getty *Visions of Tondal* and the earlier *Lazarus* cycles anticipate a demand for illustrations of these texts—a demand soon met by such printed books. The *Kalendrier des bergiers* continued to be reprinted throughout the sixteenth century, appearing in a popular English edition as well as Scottish and German ones. A *Shepheard's Calendar*, with illustrations that copy the original *L'art de bien mourir* of 1492, appeared in London as late as 1656.[50] Thus the popularity of the seven-torment *Vision of Lazarus* in France in the second half of the fifteenth century went hand-in-hand with its illustration; it emerged only at the end of the medieval era but continued well beyond that time.

Appendix: The Vision of Lazarus *Texts*

The transcriptions below of the three illuminated copies in French were prepared with the assistance of Nigel Palmer and Geneviève Hasenohr.

Oxford, Bodleian Library, Ms. Douce 134, fols. 82–86

Fol. 82, bottom: De la difference des tourmens d'enfer . . . Ores est a veoir de la difference des tourmens selon la diversité des pechiés. Dont est a savoir que en [fol. 82v] enfer sont mal gouvernez ceulx qui ont trespassé les commandemens de Dieu. Car pour celle offense ilz sont en une fournaise ardant et de la force du feu ilz sont come estaintz et fonduz sans nul refrigere.

> Pour ce que avons trespassez
> De Dieu les saints commandemens
> En ceste fournaise entassez
> Sommes en horribles tourmens.

Ezechielis xxii°. Omnes isti es et stannum, et ferrum et plumbum in medio fornacis.

Fol. 82v: Les orgueilleux qui onte esté sourprins de vaine gloire, et par oultrecuidance se sont reputez haulx et de grant valeur, et ont voulu avoir honneurs et dignités sur les aultres et ont eu plaisance en hault estat et dignité [et s'en sont reputez plus dignes que les aultres et ont desprisé les aultres et tousjours ont voulu faire leurs volentés et ont esté presumptueux fiers et despiteux seront (later hand over erasure)] atachez par les piez a la roe d'enfer qui est grande et haulte merveilleusement. Celle roe sera viree et tournee par les dyables tant soudainement qu'il semblera quelle soit tousjours en un point sans mouvoir, en tant que les gens qui y seront ne pourront estre discernez l'un de l'aultre. Ce torment par le jugement de Dieu leur est tauxé et adjugé. Car come tout homme qui s'eslieve en hault doye estre tresbusché du hault au bas, les orgueilleux qui ont voulu monter trop hault seront mis en celle roe afin que du plus hault de la roe soient mis a bas. Et ainsi tousjours [fol. 83] d'en bas seront eslevez en hault pour estre ruez aval. Et ainsi par celle roe ilz seront tempestez, derompez et froissez, et ce leur sera un tourment tant grant qu'il n'est homme qui le peut estimer ne penser.

> Motion tres merveilleuse
> De roe impetueuse
> Fera orgueilleux ululer
> Et moult horriblement crier.

Ysaie xvi°. Audivimus superbiam Moab. Superbus est valde. Idcirco ululabit Moab ad Moab. Universus ululabit.

Fol. 83v: Les envieux qui ont eu tristesse du bien d'aultruy et joye du mal et ont empesché le bien d'aultruy et pourchacé ou desiré son mal et dommage, seront mis en lieu de glaces et de froidures. Et yla de force de froit seront tous transiz et comme mors. Et de celle froidure seront mis en feu ardant, et de feu ardant seront remis en glaces, et de glaces en feu devourant. Ce tourment leur est appareillé car, pour ce qu'ilz ont esté maintenant refroidez du bien et honneur d'aultruy, maintenant esjoiz du son mal, ilz seront maintenant en froidure qui les transira et amortira, maintenant en feu horrible qui les eschaufera et ardra.

> Pour ce que sommes envieux
> De charité tous refroidez,
> Avons glace jusques aux yeulx
> Et puis tantost en feu getez.

Job xxiiij°. Ad nimium calorem transeat ab aquis nivium.

Fol. 84: Les ireux qui se couroucent trop ligierement, et pour peu de chose qu'on dise ou face oultre leur gre sont hors de pacience et esmeuz a fureur et tous forcenez et bourrouflez et promptz a mauldire menacer ou batre et a nommer le dyable, seront durement tourmentez, car ils seront oppressez et aggraventez de pierres et percez de glaives par le corps. Ces tourmens leur seront donnez comme convenables a leur coulpe, car pour ce qu'ilz ont este forcenez de ire et par leur couroux ont trouble les aultres, les dyables espandront leur fureur sur eulx et les agraventeront de pierres et perceront de glaives cruellement comme chiens sans les espargner en rien.

> La parole de Ezechie
> Sur les ireux est acomplie
> De pierres serez lapidez
> Et de glaives trespercez.

Ezechielis xvj°. Lapidabunt te lapidibus et trucidabunt te gladiis suis.

Fol. 84v: Les paresceux et oyseux qui pour espargner leurs corps ont plus voulu reposer que labourer et dormir que veiller et ont esté tardiz et negligens a faire les euvres de leur saulvement, seront mal traictez en enfer, car ilz seront mengez et devourez de bestes et d'oyseaulx de diverses figures. Ce tourment leur est approprié par droit, car ainsi come nous voions en ce monde que ou il y a une charongne morte, chiens, bestes et oyseaulx y courent pour la menger et devourer, ainsi en enfer bestes et oyseaulx mengussent et devourent les paresceux qui ont esté sans vigueur d'esperit quant a bienfaire, et comme mors, privez de la vie de grace.

> Vray est ce que prophetise
> Des paresceux le saint Moyse,
> Car les bestes les mengeront
> Et oyseaulx les devoureront.

Deuteronomii xxxii°. Devorabunt eos aves morsu amarissimo. Dentes bestiarum immittam in eos, cum furore trahentium super terram atque serpentium.

Fol. 85: Les avaricieux de ce monde qui ont esté tant couvoiteux et enflambez a gaigner, acquerir et amasser richesses, or et argent, et ont mis leur cueur en leurs richesses plus qu'en Dieu, seront horrible-ment puniz en enfer, car ilz seront mis en grandes chaudieres toutes plaines de metal fondu tout bouillant qui les ardra a force. Ce tourment leur est adjugé de par Dieu, pour ce que quant ilz estoient ou monde, ilz estoient tous ardans et embrasez du feu d'avarice. Et se tousjours eussent vescu, tousjours eussent esté enflambez d'avarice. Et pourtant a tousjours mais ilz seront bouilliz en enfer sans remede.

> Villaine mort avons trouvee
> En ces grans olles ou sommes mis,
> Pour avarice reprouvee
> A tousjours mais ainsi bouilliz.

Amos propheta iiii°. Levabunt vos in contis et reliquias vestras in ollis ferventibus.

Fol. 85v: Les gourmans qui ont esté du tout abandonnez au vice de gloutonnie et ont fait leur Dieu de leur ventre, et ont este prestz a gourmander, rifler, boire et menger a toutes heures oultre mesure sans nulle rigle, et pour acomplir les desirs de goule ont rompu les jeunes commandees de saincte Eglise, seront puniz selon la vie qu'ilz ont menee, car ilz seront serviz d'aultres metz de viande qu'ilz n'ont acous-tumé, c'est a savoir de viandes venimeuses et abominables, et seront contrains d'en menger et de boire bevrages mortelz pour les faire forcener. Ce tourment leur est deu a fin que qui se sont delitez en boire et menger oultrageusement et en savourer delicieusement, soient rempliz d'amertume de fiel et de viandes abominables et de venin mortel pour leur faire crever le cueur.

> Devant gloutons est table mise,
> Crapaux, serpens en mainte guise,
> Fiel de dragons en leur bevrage
> Et venin d'aspicz en leur potage.

Deuteronomii xxxii°. Fel draconum vinum eorum et venenum aspidum insanabile.

Fol. 86: Les luxurieux du monde qui ont corrumpu nature sans redoubter le commandement de Dieu et n'ont tenu compte de rompre le sacrement de mariage et ont fine leur vie en tel ordure auront horrible tourment, c'est qu'ilz seront gettez dedens le puiz d'enfer qui est grant et parfont et yla seront tourmentez de feu ardant et de souffre puant, qui est le tourment des tourmens. Celle paine leur est deue, car pour ce qu'ilz ont esté ardans en concupiscence charnelle et puans en l'explet de luxure, en tant que l'air a esté infect et corrumpu de leur punaisie, ilz auront double tourment correspondant a leur coulpe, c'est a savoir feu ardant et souffre puant tout ensemble.

> La punaisie et grant fumee
> Du puiz d'abysme ou suys posee
> Comme d'une fournaise monte,
> Car de luxure n'eu oncques honte.

Apocalipsis ix°. Ascendit fumus putei sicut fumus fornacis magne.

Paris, Bibliothèque Nationale, Ms. fr. 20107, fols. 11–17v

Fol. 11: Cum recumberet in domo Simonis leprosi suscitato a morte Lazaro, de cuius suscitacione idem Simon dubitabat, de precepto Domini ipse Lazarus narravit coram convivis que in inferno viderat.

Nostre Seigneur et Redempteur Ihesus ung peu avant sa benoite passion estant en Bethanie entra en la maison de ung qui avoit a nom Simon le lepreux pour prendre sa reffection corporelle. Et comme il estoit a table avec ses disciples et apostles et le Lazare frere de Marie Magdalaine et Marthe, qu'il avoit resuscité de mort a vie de laquelle chose doubtoit ledit Simon, commanda Nostre Seigneur audit Lazare qu'il deist devant la compaignie ce qu'il avoit veu en l'autre monde. Adonc icellui Lazare racompta comment il avoit veu en enfer en grandes paines premierement les orguilleux et orguilleuses,* secondement les envieux et envieuses et consequemment les aultres entachiés d'aucun pechié mortel, comme se monstre par les escriz cy aprés, empres les personnaiges.

*From here until the end of the page this passage is scraped and rewritten by a crude hand.

Fol. 11v: Primo, ait, vidi in inferno altissimas rotas in monte scituatas in modum molendinorum continue girantes cum impetu vehementi appendiculos habentes ferreos in quibus superbi stabant suspensi.

Premierement j'ay veu, dist le Lazare, des roues en enfer tres haultes en une montaigne scituees, en maniere de molins continuelement et en grande impetuosité tournant; lesquelles roues avoient crampons de fer ou estoient les orguilleus et orguilleuses pendus.

Fol. 12v: Secundo vidi fluvium congellatum in quo invidi videbantur immergi usque ad umbiculum et de super a vento frigido percussi, quem evitare volentes in glaciem infundebantur.

Secundement j'ay veu ung fleuve engellé auquel les envieulx et envieuses estoient plongiez jusques au lombril, et par dessus les frapoit ung vent moult froit; et quant vouloient icellui vent eschiever, se plongeoient dedens la glace du tout.

Fol. 13v: Tercio vidi criptam obscurissimam mensis ut macellariorum plenam in quibus iracundi gladiis transver berantur acutis.

Tiercement j'ay veu une cave et lieu tres obscur, plain de tables et de hestaulx comme une boucherie, ou les ireulx et yreuses estoient transperchees de glaves et de couteaulx agus.

Fol. 14v: Quarto vidi aulam horridam et tenebrosam, in qua erant serpentes quam plurimi magni et parvi, ubi accidiosi diversis morsibus impetebantur, modo in faciem modo alibi in diversis partibus corporis; et regionem cordis parvi velut sagitte perforabant.

Quartement, j'ay veu une salle horrible et tenebreuse ou estoient moult de serpens, grans et menus, ou les paresseus et paresseuses estoient assaillis de diverses morsures et navrez maintenant au visaige, aprés ailleurs; et les petis serpens et menus perchoient a partie et region du coer, comme sayettes* et flesses.

*The last two words added in a crude hand.

Fol. 15v: Quinto vidi lebetes et ollas ferventissimas metalorum liquidorum in quibus avari usque ad os cogebantur immergi.

Quintement, j'ay veu des olles et chaudieres tres boulantes de metail liquié et fondu, ou estoient les avaricieulx et avaricieuses plongiez jusques a la gorge.

Fol. 16v: Sexto vidi in valle quedam [sic: subsequently corrected in black ink to *quadam*] fluvium turpidum et fetidissimum, ante quem supra littora mensam habebant cum mappis turpissimis, in quibus gulosi buf-fonibus cum ceteris venenosis pasci [sic: for *pasterant* or *pascebantur?*] aqua predicti fluvii potabantur.

Sextement, j'ay veu en une valee ung fleuve ort et trespuant au rivaige duquel avoit une table avec toilles deshonnostes [sic] ou les gloutons et les gloutes estoient paissus de crapaulx et autres bestes venimeuses, et abuvres de l'eaue dudit fleuve.

Fol. 17v: Septimo vidi in quodam plano puteos ignitos et sulphureos fumum turpidum et fetidum emit-tentes in quibus luxuriosi erant collocati.

Septimement, j'ay veu une plane de puits plains de feu et de souffre, dont issoit fumee tourble et puante, esquelz les luxurieus et luxurieuses estoient plongiez.

Paris Bibliothèque Nationale, Ms. nouv. acq. fr. 16428, fols. 34–41

Fol. 34: Cum dominus recumberet in domo Symonis leprosi suscitato a morte Lazaro, de cuius suscita-cione Symon dubitabat, de precepto Domini ipse Lazarus narravit coram conviviis que in inferno viderat.

Nostre Sauveur et Redempteur Ihesus ung peu avant sa benoite passion estant en Bethanie entra en la maison d'ung qui avoit nom Symon pour prendre refection corporelle. Et comme il estoit a table avec ses disciples et apostres et le [fol. 34v] Lazare frere de Marie Magdalene et Marthe qu'il avoit resuscité de mort a vie, de la quelle chose doubtoit ledit Symon, commanda Nostre Seigneur audit Lazare qu'il dist devant toute la compaignie ce qu'avoit veu en l'autre monde. Adonc ycellui Lazare reconta comment il avoit veu en enfer en grandes poines premierement les orguilleux et orguilleuses, secondement les en-vieux et envieuses, et consequamment les autres entachés d'aucun pechié mortel, comme se monstre par les escripz cy aprés, emprés les personnaiges.

Fol. 35: Primo, ait, vidi rotas in inferno altissimas in monte scituatas in modum molendinorum continue girantes cum impetu vehementi appendiculos habentes fer[fol. 35v]reos in quibus superbi stabant suspensi. . . .

Premierement j'ay veu, dit le Lazare, des roues en enfer tres haultes en une montaigne situees, en ma-nieres de molins continuellement en grande impetuosité tournans, lesquelles roes avoient crampons de fer ou estoient les orguilleux et orguilleuses pendus.

Fol. 36: Secundo vidi fluvium congellatum in quo invidi videbantur immergi usque ad umbillicum et de super a vento frigido percussi, quem evitare volen[fol. 36v]tes in glaciem infundebantur.

Secundement j'ay veu ung fleuve engelé, auquel les envieux et envieuses estoient plongiés jusques a lombril, et per dessus les frappoit ung vent moult froit; et quant vouloient ycellui vent echiver [subsequently corrected to *es chêver*] et eviter, se plongoient dedens la glace.

Fol. 37: Tercio vidi criptam obscurissimam mensis ut macellariorum plenam, in quibus iracundi gladiis transverberabantur acutis.

Tiercement j'ay veu une cave et lieu tresobscur, plain de tables et d'estauz comme d'une boucherie, ou les yreux et yreuses estoient transpersés de gleves et coutiaux agus.

Fol. 38: Quarto vidi aulam horridam et tenebrosam, in qua erant serpentes magni et parvi, ubi accidiosi diversis morsibus impetebantur, modo in faciem, modo alibi [fol. 38v] in diversis partibus corporis; et regionem cordis pervi velud sagitte perforabant.

Quartement j'ay veu une sale horrible et tenebreuse ou estoient moult de serpens grans et menus, ou les paresseux et paresseuses de diverses morsures estoient assaillis et navrés, maintenant au visaige, aprés ailleurs en diverses parties du corps; et les petis et menus serpens perçoient le partie et region du cueur come sayettes.

Fol. 39: Quinto vidi lebetes et ollas ferventissimas metallorum liquidorum in quibus avari usque ad os cogebantur immergi.

Quintement j'ay veu les olles et chaudieres tres boullantes de metal liquide [*de* is a correction] et fondu ou estoient les avaricieux et avaricieuses plongiés jusques a la gorge.

Fol. 40: Sexto vidi in valle quadam fluvium turpidum fetidissimum, ante quem supra littora mensam habebant cum mappis turpissimis, in quibus gulosi buffo [fol. 40v] nibus et ceteris venenosis pasci [*sic*: for pascebantur]; aqua predicti fluvii potantur [*sic*: for potebantur].

Sextement j'ay veu en une valee ung fleuve ort et tres puant au rivaige duquel estoit une table avec touailles tres deshonnestes ou les gloutons et gloutes estoient paissus de crapaux et autres bestes venimeuses et abuvrés de l'eaue dudit fleuve.

Fol. 41: Septimo vidi in quodam plano puteos ignitos et sulphureos fumum turpidum et fetidum emittentes, in quibus luxuriosi erant collocati.

Septimement j'ay veu en une plaine des puis plains de feu et de souffre dont yssoit fumee trouble et puante, esquels les luxurieux et luxurieuses estoient logies.

Notes

* For assistance and advice on a broad range of methodological issues I am indebted to Geneviève Hasenohr and the staff of the Section romane of the Institut de Recherche et d'Histoire des Textes (IRHT), Paris, to Nigel Palmer, Michel Pastoureau, and Anne van Buren. Further assistance in gathering information was provided by Anne-Marie Legaré, Jennifer Haley, Anne Huyghes-Despointes, and Ranee Katzenstein.

1 For the modern literature on this richly studied field, see the following recent publications and their bibliographies: Owen 1970; Palmer 1982; Dinzelbacher 1981. For examples of the more popular medieval texts, see P. Dinzelbacher, ed., *Mittelalterliche Visionsliteratur: Eine Anthologie* (Darmstadt, 1989), and Gardiner 1989.

2 In his study of late medieval religious iconography, Emile Mâle surveys the imagery of medieval visions, but he emphasizes media other than manuscripts; E. Mâle, *Religious Art in France: The Late Middle Ages. A Study of Medieval Iconography and Its Sources* (Princeton, 1986), esp. pp. 420–33, originally published as *L'art religieux de la fin du moyen âge en France* (Paris, 1922), pp. 461–75. Jurgis Baltrušaitis discusses a number of manuscript cycles of visions of hell in *Réveils et prodiges: Le gothique fantastique* (Paris, 1960), pp. 275–87.

3 See Dagmar Eichberger's essay in the present volume.

4 Ibid., pp. 130–33. Baltrušaitis (note 2), p. 279, also mentions the *Pèlerinage de l'âme*.

5 Mâle 1986 (note 2), pp. 429–33; Mâle 1922 (note 2), pp. 471–74; Baltrušaitis (note 2), pp. 286–87, fig. 14.

6 Mâle 1986 (note 2), p. 430, n. 95; Mâle 1922 (note 2), p. 471, n. 4; Baltrušaitis (note 2), p. 362, n. 45. Both editions of Mâle fail to note that the manuscript is illuminated.

7 Paris, Bibliothèque Nationale, Ms. nouv. acq. fr. 16428, fols. 34–41; M. Thomas, "Le Livre de Prières de Philippe le Bon: Premier bilan d'une découverte," *Les dossiers de l'archéologie* 16 (May–June 1976), p. 86. Bibliothèque Nationale, Ms. fr. 450, fols. 181v–82v; *Catalogue des manuscrits français: Anciens fonds*, vol. 1 (Paris, 1868), p. 45. Bibliothèque Nationale, Ms. fr. 923, fols. 115v–16; ibid., p. 157. Bibliothèque Nationale, Ms. nouv. acq. fr. 10032, fols. 175–76v; H. Omont, *Catalogue des manuscrits français de la Bibliothèque Nationale: Nouvelles acquisitions françaises*, vol. 4 (Paris, 1918), pp. 6–7. Oxford, Bodleian Library, Ms. Douce 134, fols. 82v–86; Pächt/Alexander 1966, no. 710.

8 J. MacFarlane, *Antoine Vérard* (Illustrated Monographs Issued by the Bibliographical Society, 7) (London, 1900), nos. 18, 24. For a facsimile of the fourth edition, see P. Champion, ed., *Compost et kalendrier des bergiers* (Paris, 1927); for an English edition of circa 1518, based on the Marchant edition of 1493, see *The Kalendar and Compost of Shepherds* (London, 1930). For the French *Kalendrier*, see also Nigel Palmer's essay, pp. 161–62, below.

9 For other examples of parallel texts in Latin and the vernacular, see N. Palmer, "Zum Nebeneinander von Volkssprache und Latein in spätmittelalterlichen Texten (1)," *Literatur und Laienbildung im Spätmittelalter und in der Reformationszeit: Symposium Wölfenbüttel* (Stuttgart, 1981), pp. 579–603, and idem, "Latin and Vernacular in the Northern European Tradition of the *De Consolatione Philosophiae*," in M. Gibson, ed., *Boethius: His Life, Thought and Influence* (Oxford, 1981), pp. 362–409.

10 M. Voigt, *Beiträge zur Geschichte der Visionenliteratur im Mittelalter: I. II* (Palaestra: Untersuchungen und Texte aus der deutschen und englischen Philologie, 146), vol. 1 (Leipzig, 1924; repr. New York and London, 1967), pp. 1–118.

11 Ibid., esp. pp. 1–7.

12 Ibid., pp. 4–6; L.L. Hammerich, ed., *Visiones Georgii: Visiones quas in purgatorio Sancti Patricii vidit Georgius Miles de Ungaria* A.D. MCCCLIII (Det. Kgl. Danske Videnskabernes Selskab: Historisk-filologiske Meddelelser, 18/2) (Copenhagen, 1930), pp. 169–76.

13 See, for example, the writings of Robert Grosseteste and a sermon of Jean de la Rochelle, cited in R.J. Relihan, Jr., "A Critical Edition of the Anglo-Norman and Latin Versions of 'Les peines de purgatoire,'" Ph.D. diss., University of Iowa, Iowa City, 1978, pp. 23, 55, 56.

14 For all three texts in English translation, see Gardiner 1989, pp. 149–96, 135–48, and 13–46, respectively.

15 See the appendix of transcriptions (pp. 151–54) for the sins and their respective torments in the three illuminated manuscripts under consideration.

16 It is also worth noting that nearly all the torments in *The Vision of Lazarus* are familiar from earlier vision narratives; see Baltrušaitis (note 2), pp. 286 and 362, n. 44.

17 In addition to Pächt/Alexander 1966, see A.G. and W.O. Hassall, *Treasures from the Bodleian Library* (London, 1976), pp. 137–38, pl. 32, and *The Douce Legacy*, exh. cat. (Bodleian Library, Oxford, 1984), no. 172.

18 See Eichberger, pp. 133–34, above.

19 P. Fournier et al., *Catalogue général des manuscrits des bibliothèques publiques de France*, vol. 7 (Grenoble and Paris, 1889), no. 408.

M.E. Shields, "An Old French Book of Legends and Its Apocalyptic Background," Ph.D. diss., Trinity College, Dublin, 1967, pp. 200–03, 248ff., 489–93, first suggested that volume one of the work may be preserved in Grenoble Ms. 408. I am grateful to Nigel Palmer for this reference and to the IRHT in Paris for assistance with research on the Grenoble manuscript.

20 Pächt/Alexander 1966, no. 710.

21 "Cy finist le premier livre de la Vigne Nostre Seigneur/et fut accompli le ve jou de mars l'an m cccc lxiii/ Et est a savoir que le second livre fut premierement fait et accompli que cestuy qui est le premier . . ." (fol. 171v). The compilers of Samaran/Marichal question whether this date refers to the original text or specifically to the Grenoble manuscript. It would seem more likely to refer to the Grenoble copy since various evidence such as the watermark and the style of the miniatures appears to fit this dating. It may, of course, apply to the text as well; see M. Garand, M. Mabille, and J. Metman, compilers, C. Samaran and R. Marichal, *Catalogue des manuscrits en écriture latine portant des indications de date, de lieu, et de copiste. VI: Bourgogne, Centre, Sud-est, et Sud-ouest de la France* (Paris, 1968), p. 471.

22 Although more investigation is required, preliminary research on the watermarks and the binding of Ms. 408 (337) suggests that the book was produced in Grenoble or the vicinity. It is composed of both paper and parchment, and the watermark, a flower with eight equal petals, most closely resembles Briquet 6588, 6591, 6592, 6597, and 6602, all of which come from Lombardy; certain of these watermarks are also found in German incunables; see C.M. Briquet, *Les filigranes*, 2nd ed. (repr. New York, 1966), pp. 373–64. Moreover, Mme. Marie-Pierre Laffitte of the Bibliothèque Nationale kindly advises me that some of the tooled motifs in the original binding, which also has French elements, are more common in Lombardy. However, the style of the first campaign of illumination seems more French than Italian and shows some links to Savoyard illumination. Taken together with the fact that the earliest recorded provenance of Ms. 408 (337) is the Grande Chartreuse near Grenoble, and that the only other copy of this text also has an old Grenoble provenance (Grenoble, Bibliothèque Municipale, Ms. 409 [399]), one cannot help but wonder whether the manuscript was produced in Savoy, perhaps with the collaboration of itinerant craftsmen. The provenance of Ms. 409 (399) is the Frères Precheurs in Grenoble; see Fournier et al. (note 19), p. 147.

23 Hammerich (note 12), pp. 174–75.

24 *Catalogue des livres de la bibliothèque de feu M. le duc de la Vallière*, part 1, vol. 2 (Paris, 1783), no. 148, where it is called *Le livre de Jhesus historiée*; H. Omont and C. de la Roncière, *Catalogue des manuscrits français: Ancien petits fonds français*, vol. 1 (Paris, 1898), pp. 8–9;

Mâle 1986 (note 2), p. 43; Baltrušaitis (note 2), pp. 286, 362, n. 45.

25 I am indebted to Michel Pastoureau for his research on this coat of arms and its companion.

26 Correspondence with the author, May 2, 1990.

27 I am grateful to Anne van Buren, who generously shared the results of her extensive research on French and Flemish costumes.

28 Mâle 1986 (note 2), p. 430.

29 Van Buren points out that the earliest dated image of such shoes is found in Jacques Miller, *La destruction de Troye* (Lyons, J. Bonhomme, 1484).

30 A. Boinet, "Un bibliophile du XVe siècle: Le Grand Bâtard de Bourgogne," *Bibliothèque de l'Ecole des Chartes* 67 (1906), pp. 255–69; E. van Even, "Notice sur la bibliothèque Charles de Croy, duc d'Arschot," *Bulletin du bibliophile belge* 9 (1852), pp. 380–83, 436–51. The catalogue of the sale of his library was published: *Catalogus universalis seu designatio omnium librorum qui sub auctione publica bonorum mobilium quondam illustrissimi D. Ducis Croy et Archotani Brussels, 19 augustus hujus anni 1614 divendi incipientur* (ex officina Rutger Velpii et Huberti Antonii, Brussels, 1614).

31 Galesloot 1879, pp. 293–94. For a manuscript owned by Charles de Croy, see Eichberger, p. 135, above.

32 The arms of the Croy family appear in a manuscript illuminated by Simon Marmion, *Les sept âges du monde* (Brussels, Bibliothèque Royale, Ms. 9047), which found its way to the library of Philip the Good not long after it was illuminated (Brussels 1959, no. 49). The Getty Museum owns a copy of *Les faits d'Alexandre le Grand*—whose French translation Charles the Bold commissioned. The Getty copy (Ms. Ludwig XV 8) has the arms of the Croy family and was perhaps commissioned by them to honor Charles after returning to his favor.

33 He owned, for example, *Le livre de bonne moeurs* of Anthony of Burgundy; Boinet (note 30), p. 261.

34 F. Avril, "Nouvelles acquisitions latines et françaises du Département des manuscrits (1972–1976)," *Bibliothèque de l'Ecole des Chartes* 136 (1978), p. 295; B. Brinkmann, "Der Meister des Dresdner Gebetbuches und sein Kreis: Leben und Werk eines burgundischen Buchmalers zwischen Utrecht, Brügge und Amiens," Ph.D. diss., Freie Universität, Berlin, 1990, p. 406. De Schryver, in Ghent 1975, no. 597, suggested that the miniatures were executed at Ghent circa 1480 but he did not attribute them to a particular artist.

35 H. Martin and P. Lauer, *Les principaux manuscrits à peintures de la Bibliothèque de l'Arsenal à Paris* (Paris, 1929), pp. 62–63.

36 Although I disagree with his conclusion, Brinkmann (note 34), pp. 406–07, discusses with admirable clarity some of the stylistic links of these miniatures to those of the Master of the Dresden Prayer Book.

37 Brinkmann and I came to this conclusion independently; see his thesis (note 34), pp. 407–08.

38 Ibid.

39 Differences in the dialect indicate that the *Lazarus* text of nouv. acq. fr. 16428 was not necessarily copied directly from fr. 20107; the two texts could have derived from a common model.

40 Hammerich (note 12), pp. 175–76. Nigel Palmer cites an example of a German printed edition of *The Visions of Tondal* that embellishes the original text with the names of specific stations in society that endure certain punishments; N.F. Palmer, ed., *Tondolus der Ritter: Die von J. und C. Hist gedruckte Fassung* (Kleine deutsche Prosadenkmäler des Mittelalters, 13) (Munich, 1980); see also Palmer's essay, p. 159, below.

41 For example, in a miniature of hell in an illuminated Saint Augustine, *Cité de Dieu* (Paris, Bibliothèque Nationale, Ms. fr. 9186, fol. 298v), members of the higher stations of society, both spiritual and secular, are being punished; see Baltrušaitis (note 2), p. 282, fig. 11.

42 See Roger Wieck's essay in the present volume.

43 Malibu 1990, pl. 4.

44 Ibid., pp. 44, 47, 49, 50, 51.

45 Malibu 1990, p. 19.

46 See Suzanne Lewis's essay in the present volume.

47 W. Voelkle, "Morgan Manuscript M. 1001: The Seven Deadly Sins and the Seven Evil Ones," in A. Farkas, P.O. Harper, and E. Morrison, eds., *Monsters and Demons in the Ancient and Medieval Worlds: Papers Presented in Honor of Edith Porada* (Mainz, 1987), p. 110.

48 See the introduction to the present volume, pp. 15–16.

49 See Nigel Palmer's essay in the present volume.

50 Alexander Barclay, trans., *The Shepheards Kalender: Newly Augmented and Corrected* (London, "by Robert Ibbitson, and are to be sold by Francis Grove," 1656).

Illustrated Printed Editions of *The Visions of Tondal* from the Late Fifteenth and Early Sixteenth Centuries

Nigel F. Palmer

T he first printed edition of the *Visio Tnugdali* was published in Cologne about 1472 by the "Printer of the *Historia Sancti Albani.*"[1] It was an edition of the Latin text, not the full, "long version" of Marcus from the mid-twelfth century, but rather the abridgement that had been prepared by Helinand of Froidmont in the early thirteenth century for insertion into his chronicle of the world to the year 1204.[2] This text became widespread through its inclusion by Vincent of Beauvais in book 27 of his *Speculum historiale.*[3] The abridged text also circulated in manuscript, especially in Western Europe, in France and England, and the choice of a copy of this version by the printer as the source for the *editio princeps* reveals the cultural connections between Cologne and the area to the west. It was followed by two editions with a cycle of woodcut illustrations published on the Upper Rhine in Speyer by Johann and Konrad Hist just over ten years later (circa 1483–84) and by further non-illustrated editions printed in Antwerp (circa 1486–91) and Cologne (1496).[4] The same Latin text was also available in the complete printed editions of the *Speculum historiale*, first published in Strasbourg circa 1473 by Adolf Rusch and reprinted several times in the following years; one of the early printed editions was produced in the monastery of Saints Ulrich and Afra in Augsburg in 1474.[5]

There is no doubt that the appeal of *The Visions of Tondal* in the first half century of its dissemination as a printed book was to a lay audience with a preference for vernacular versions—and with a preference for illustrated editions. Whereas in France and Burgundy this aspect of literary and devotional lay culture becomes manifest in individually made vernacular and bilingual manuscript books of fine quality, in Germany it led to multiple editions of *The Visions of Tondal* in German with simple woodcut illustrations.[6] In Italy a vernacular recension of the "uisione di Tantolo" was included in an appendix to the printed edition of the *Uite de sancti patri*, a translation of the *Vitaspatrum*.[7] From the Iberian peninsula we have records of a copy of a Spanish edition printed in Seville in 1508, now lost; a second edition of the same version was printed in Toledo in 1526.[8] From England and France there are only manuscript copies of the *Visions* as a separate work, but a French vernacular text was available in the printed edition of Vincent of Beauvais, *Miroir historial*, translated by Jean de Vignay and first published in 1495.[9]

The British Library possesses a presentation copy of Antoine Vérard's 1495 edition of the *Miroir historial*, printed on vellum, to which illuminations have been added in place of the principal woodcuts and in many of the spaces that were left for chapter headings: three of these portray scenes from *The Visions of Tondal* (fig. 110).[10] Such lavish, illuminated presentation copies, mostly commissioned by Vérard for royal recipients, are preserved for a good number of Vérard's publications, and the *Tondal* illustrations, which may have been executed by Jacques de Besançon, take their place within this broader context.[11]

From the Low Countries, five separately published Netherlandish vernacular editions are known, printed between about 1482 and 1515.[12] The Dutch editions do

not contain illustrations of *The Visions of Tondal*, but there is generally an illustrated title page. The Delft edition printed by Christian Snellaert in 1495 has an elaborate title-page design (fol. 1) showing souls tormented in a bestial mouth of hell, on whose nose is seated a devil blowing a long bugle. Behind this is a burning house in which souls suffer various torments. The table of contents in this edition is accompanied by a deathbed scene depicting the "Temptatio de desperatione," derived from the *Ars moriendi* tradition (fol. 1v). The undated Antwerp edition by Govaert Back, circa 1496–99, has a title page showing souls tormented in the mouth of hell, into which they are propelled by devils.

Figure 110.
Attributed to Jacques de Besançon. *Lucifer, the Prince of Hell*, in Vincent of Beauvais, *Miroir historial*, translated by Jean de Vignay (Paris, Antoine Vérard, 1495), presentation copy on vellum. London, British Library, C 22 d 5, vol. 5, fol. 45. Reproduced by kind permission of the British Library Board.

In Germany both of the prose translations of the *Visio Tnugdali* that had circulated most widely in manuscript came to be printed. Recension C of the German *Visio Tnugdali*, based on the unabridged Latin text, was printed twice, in 1473 and 1476, in an appendix to the *Dialogues* of Gregory the Great, translated by Johann von Speyer. It is a handsome quarto volume published by Johann Bämler in Augsburg, with no illustrations other than the title page to the *Dialogues*.[13] Bämler's press was situated in the monastery of Saints Ulrich and Afra, where in 1474 the first Augsburg edition of the *Speculum historiale* was printed. So in Augsburg there were parallel printings, within the walls of the same monastery, of the *Visio Tnugdali* in Latin and German. They were in no sense popular editions, but rather spiritual classics published in the context of the Christian humanism of the late fifteenth-century Benedictine reforms. Tondal's experiences in the otherworld documented the extension of God's presence in this world, mediated by revelation to individuals, from the time of the Fathers into the present era.

The most significant development in the circulation of *Tondal's Visions* in Germany came with the publication of an illustrated octavo edition in German in the 1480s.[14] The first edition was that of Johann and Konrad Hist in Speyer (figs. 111, 112), datable on the basis of an ownership inscription in the Uppsala copy to not after 1483.[15] This book was published again and again: on the Upper Rhine in Speyer and Strasbourg, in the Swabian cities of Augsburg and Ulm, and then at the beginning of the sixteenth century on the Lower Rhine in Cologne. In all, twenty editions have survived from between 1483 and 1521, and all but the four editions published in Cologne have a cycle of illustrations. Thirteen of these editions have come down to us in only a single copy, the other seven survive in just two copies. Such popular illustrated books evidently had poor chances of survival, and we must assume that there were in fact many more than the twenty editions known to us today. At the most conservative estimate, somewhere between three and five thousand copies of the illustrated German *Tondolus* must have been produced over a period of about thirty-five years.[16]

The recension of *Tondal's Visions* that was published in the German octavo editions is translation D, based on the unabridged Latin text. In the printed version of this recension, the preface—and the introduction with the account of Tondal's wicked life and his apparent death when visiting a debtor—have been replaced by a new translation of the corresponding passage in Vincent of Beauvais's abridged version. It is possible that this was due to a printer's exemplar that was defective at the beginning, but it seems more likely that the printers were concerned to make their German edition match, at least superficially, the Latin version, of which the Hists published a parallel edition with the same cycle of woodcuts.[17] The woodcut for the title page, used in both the Latin and the German editions, is inscribed in German, *Tondol° der Ritter*. The earliest Latin and German editions from Speyer, all undated, seem to have been printed by Johann and Konrad Hist about 1483.

Recension D of the German *Visio Tnugdali* was well suited to the needs of a popular audience. Of the twelve recorded German and Dutch prose translations of the *Visions*, it stands out as a free rendering into effective German prose, with numerous small additions designed to enliven or reinforce the moral of the text. The best example of this is the description of the souls tormented by Lucifer in the bottommost hell.[18] The Latin text reads:

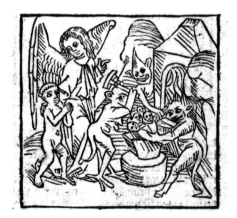

Figure 111.
The Torment of Souls in the Smithy, in *Tondolus der Ritter* (Speyer, Johann and Konrad Hist, circa 1483). Munich, Bayerische Staatsbibliothek, Inc. c.a. 382ᵗ-/1, fol. 7.

Hic quoque prelati et potentes seculi, qui desiderant preesse, non ut prosint, set ut presint, patiuntur sine fine. . . .[19]

(Here the prelates and powerful men of the world who desire to rule not as an example to others but rather to have power over others are tormented without end. . . .)

In the German printed edition, this rather theoretical account of the rulers who have abused power is expanded and made much more concrete:

Auch komment in dise iemerlich pin brieffelscher vnd alle die bischoff/ Epte Dechen Probst Prior pfaffen vnd alle glaubigen diser welt keiser kunig Hertzogen Grafen Fursten Ritter knecht Schultheissen Burgenmeister Amptman Schoffen Richter furminder vnnd der gelich nieman vsgenommen bed geistliche vnd welt-liche Die das mit irem suntlichen leben verdinet vnd got iren schopfer nit erken-nen Vnd herin kommen werdent ewiglich verlorn Darumb das sie mit fremdem gut vmb gont vnd sich des gebruchent mit vnrecht vnd gebent dz nit wider.[20]

(Others who are subjected to this torment are forgers of charters and all bishops, abbots, deans, provosts, priors, priests, and those who exercise power in the world—emperors, kings, dukes, counts, princes, knights, serving men, sheriffs, mayors, bailiffs, lawyers, judges, advocates and the like, every one of them, lay-man and cleric alike, who have deserved this by their sinful lives and have re-jected God their creator and end up here, they are all eternally damned, because they make use of the property of others and use it unjustly for their own ends and do not give it back.)

It is clear that this passage was not reformulated simply for the benefit of any prince or highly placed ecclesiastic who might read the work. Generally, a twofold principle governs the description of Tondal's visions of the otherworld: they are reported in order to give a factual, realistic picture of the fate of the soul after death, and also as a warning and encouragement to the living to heed the moral lessons implicit in the joys and torments.[21] The German translation goes beyond this by adding an element based on a popular audience's delight in hearing that the afterlife will be a more just place than this world, a place where all those who now hold positions of power will be punished for their misuse of it. That is to say, the German version feeds on the social discontent which we know from other sources to have been a marked feature of the period.[22]

The printed editions by Johann and Konrad Hist in Speyer are illustrated by a cycle of twenty woodcut illustrations, which are integrated into the body of the text, some of them repeated and used for more than one scene. These illustrations, of which ten are devoted to the torments of hell and purgatory and eight to the joys of heaven, were designed specifically for *The Visions of Tondal* and therefore include all those striking images of the otherworld for which the *Visio Tnugdali*, throughout the whole latter part of the Middle Ages, was the principal literary transporter:[23] the smi-thy where souls are hammered by a devil on an anvil (fig. 111); the monster Acherons; a monstrous mouth of hell propped open by two Irish giants in armor, Fergus Mac Roich and Conall Cearnach, one of them standing on his head; the monstrous dragon on the icy lake which devours the souls it will subsequently emit as vomit; the Irish king in paradise, Cormac Mac Carthaigh, who has to spend three hours a day burning in fire up to his navel. In the original editions, the woodcuts are almost square, slightly shorter in the vertical dimension than they are broad; only one picture is larger and designed to occupy a whole page, that of Lucifer, who is portrayed as a monster with many hands, taloned feet and a long tail roasting on a gridiron, with a small devil merrily fanning the flames (fig. 112). The soul of the visionary is always portrayed as a naked child accompanied by a winged adult angel, underlining the process of revelation whereby the disembodied soul witnesses tableaux of the joys

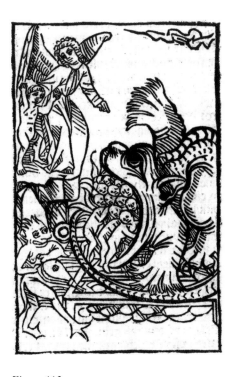

Figure 112.
Lucifer, the Prince of Hell, in *Tondolus der Ritter* (Speyer, Johann and Konrad Hist, circa 1483). Munich, Bayerische Staatsbibliothek, Inc. c.a. 382ᵗ-/1, fol. 21.

and torments, which are interpreted in the speeches made by the angel.

In every case the principal function of the illustration is to record visually the salient features of the scene witnessed by Tondal in the text: the illustrations offer no guide to interpretation. Apart from a single problematic passage where there is confusion between the representation of the narrow bridge crossed by a pilgrim and the hot-and-cold path (or bridge) across the mountain that precedes it,[24] every scene witnessed by the visionary in the otherworld is illustrated by a woodcut, and so the illustrations take on a secondary function in helping to clarify the narrative sequence of the text.

The Hists published a number of other German prose texts that belong to the same broad category as the *Tondolus*, such as the ghost story *Arnt Buschmans Mirakel*, the *Dyalogus Salomonis et Marcolfi*, and later the story of Saint Brendan,[25] but in 1483 the octavo illustrated editions were something new. The first illustrated printed books in German were produced in the early 1460s in Bamberg, but the genre did not become established until the 1470s when a series of handsome illustrated quarto editions of works such as *Belial* (1472), *Melusine* (1474), *Herzog Ernst* (1475), *Apollonius* (1476), and *Brandan* (circa 1476) were printed in Augsburg.[26] *Brandan* and *Herzog Ernst* were precursors of the more simply produced *Tondolus* editions in that their illustrations depicted a journey through the otherworld or through the wonders of the Orient.[27] The *Belial* editions contained numerous scenes with devils, which could have provided a model for the depiction of the anatomy of devils in the *Tondolus*, for example, Bämler's angry devils clamoring to God, which parallel those in the first scene of the vision, where the angel rescues Tondal from the devils.[28] The only other German vision of the otherworld to be published in an early printed edition with illustrations was *Saint Patrick's Purgatory*, which found its way into the *Seelenwurzgarten* (Ulm, 1483), where it was accompanied by a general illustration depicting the torment of souls in purgatory, but not by individual representations.[29]

It seems that the decision to provide a cycle of illustrations for the Latin and German printed editions of *The Visions of Tondal* arose from the printers' recognition that the text had a popular appeal, which could be enhanced by images, and that its content would lend itself to illustration in the manner of such popular illustrated books as *Brandan* and *Belial*; that is to say, it can be understood from within the history of printing. No illustrated manuscripts of *The Visions of Tondal* are known in German or in Latin,[30] and illuminated German manuscripts of visions of the otherworld are rather rare. One of the German translations of the visions of Georgius Grissaphan of Hungary in Saint Patrick's Purgatory (*Visiones Georgii*) survives in illustrated manuscripts,[31] and a fifteenth-century Heidelberg manuscript from the library of the Counts Palatine contains illustrated texts of both the visions of Owein in Saint Patrick's Purgatory and the Brendan legend in German.[32]

We know just two editions of *Tondolus der Ritter* from the 1480s, five or six from the 1490s, five or six from the first decade of the sixteenth century, six more from the second decade, and a final edition of 1521. The woodcuts from the Speyer editions were copied by several Swabian printers in Augsburg and Ulm in the period leading up to 1500, and there were further reprints in Speyer. During the first two decades of the sixteenth century there continued to be reprints in Augsburg, and the Augsburg woodcuts were copied and used by two Strasbourg printers (Mathis Hupfuff and Johann Knobloch).[33] In this period there were also some non-illustrated Cologne editions, printed in the Ripuarian dialect.

The most significant new development in the history of the printing of *Tondal's Visions* came about 1500. The book to be considered here has a particular relevance to the theme of this volume in that the iconography of one of the woodcuts (fig. 118) derives from a manuscript closely related to an extant book from the library of the dukes of Burgundy (see note 57, below). The artist and printer responsible for this development was Bartholomäus Kistler in Strasbourg, originally a painter by trade, who established himself about 1497 as a printer and was responsible, between about 1497 and 1510, for the publication of some fifty books and pamphlets.[34] Most of his

publications were vernacular illustrated books, and all his work was aimed at a popular market. His first printed book was the *Epistola de insulis nuper inventis* of Christopher Columbus in a German translation from Spanish or Catalan published in 1497,[35] and his publishing program included prognostics, saints' lives, Apuleius, *Mandeville's Travels*, the Trojan War, Lirer's chronicle, the *Lucidarius*, medical texts, popular songs, adventure stories from the heroic epic, and just one surviving edition of the *Tondolus*.[36] A characteristic Strasbourg style of woodcut book illustration had developed in the course of the 1490s, principally associated with Johann Grüninger, which used shading somewhat in the manner of metalcuts and elaborate designs that contrive to fill the whole of the space available. Often a design was made up of several blocks, whose separate parts could be repeated in a number of different pictures.[37] Kistler's woodcuts clearly stand in this tradition, but they are sufficiently distinctive in style to make it probable that the designs were the work of a single artist, the printer and former painter himself.

Kistler's *Tondolus* edition, which has generally been dated circa 1500, is remarkable in that it contains seven additional full-page woodcuts which combine distinctive elements from Tondal's visions with other well-known visionary motifs, such as the torment on the wheel, deriving from the vision of Saint Paul, and the punishment of gluttons who are forced to eat toads and snakes, as for example in Bosch's depiction of the punishment of the Seven Deadly Sins on a painted tabletop now in the Prado.[38]

The seven additional woodcuts were made not as illustrations of Tondal's visions, but rather for a composite German book, *Das Büchlein von den peinen*, describing the visions of Lazarus, which Kistler must originally have put together at the very end of the fifteenth century. This book has a special importance for the history of *Tondal* illustrations in German and deserves to be considered in some detail.

Two editions of *Büchlein von den peinen* are recorded. The first is that dated March 24, 1506, of which two copies are known; the second, similarly preserved in only two copies, is dated 1509.[39] It is possible that there was an earlier edition of circa 1500, for the title-page woodcut showing Lazarus in the house of Simon the Leper was used, apparently out of context, in a pamphlet also published by Kistler and dated October 17, 1500.[40] On the other hand, a woodcut used on fol. 11v of the 1506 edition is printed from a trimmed woodblock that had been used in its original state in an edition of Lichtenberger's *Practica* dated September 22, 1500 (see note 52, below). There is also a stylistic difference to be observed between the title page and main sequence of woodcuts in the book. As long as no further evidence comes to light, the 1506 edition must be regarded as the *editio princeps*. As a result, Kistler's *Tondolus* edition must be redated circa 1506.

Lazarus was not a commonly treated theme in Germany;[41] elaborations of the Lazarus story were better known in France, where the resurrection of Lazarus was often used to introduce the Office of the Dead in books of hours, as for example in the Salting Hours in the Victoria and Albert Museum, where a picture of the resurrection of Lazarus follows a picture of heaven and hell with motifs reminiscent of *The Visions of Tondal*.[42]

The principal source of Kistler's *Vision of Lazarus* narration was a French text, the *Traité des peines d'enfer*, in the version which was first published as part of the full, augmented text of the *Kalendrier des bergiers* on April 18, 1493, by Guy Marchant in Paris (see fig. 102).[43] Whereas there is little doubt that Kistler derived his German text and the depictions of the torments in his woodcuts from the French version contained in this or one of several later printed editions of the *Kalendrier des bergiers*, the borrowing should be seen in the broader context of the literary embellishment of the theme of the Seven Torments in French manuscripts and printed books. This theme was most commonly treated in the context of *The Vision of Lazarus*. Whereas Lazarus's vision of the sevenfold torment of the sinners is first attested in the *Visiones Georgii*, a Latin text from the fourteenth century,[44] it is not until the second half of the fifteenth century that we encounter the theme in the vernacular.[45]

In the 1490s, *The Vision of Lazarus* was twice incorporated, as the *Traité des peines d'enfer*, into an illustrated French printed book, first in an appendix to the French vernacular *Ars moriendi* printed on behalf of Antoine Vérard by Gillet Couteau and Jean Menard (July 18, 1492) and then, a year later, in a modified form, in the fourth printed edition of the famous *Kalendrier des bergiers*.[46] Both works were provided with superb woodcut illustrations which, notwithstanding striking stylistic differences, were attributed by Monceau to Pierre Le Rouge.[47] The two recensions of the *Traité* are quite distinct, although both are based on the *Visio Lazari*. That in the *Kalendrier des bergiers* begins each section by quoting Lazarus's vision of the torments appropriate to that particular sin and follows with a discussion of the sin itself. The version in the *Ars moriendi* editions takes the same account from the *Visio Lazari* as the base text but expands it and adds an elaborate description, for each torment, of the chief devil who is "captain" of that particular sin, and of his speech to the souls in his charge. Each section is completed by a consideration of biblical testimonies to the particular mode of torment and in some cases of prophetic parallels in the writings of classical authors. The seven captains are named Leviathan, Beelzebub, Baalberith, Astaroth, Mammona, Belphebor, and Hasmodeus. An especially notable feature of the elaboration of the torments in this text is that for each sin a passage from the description of the torments in the *Visio Tnugdali* is quoted verbatim and integrated into the new context of Lazarus's vision.[48]

Kistler took the text of Lazarus's vision from the version of the *Traité des peines d'enfer* contained in the *Kalendrier des bergiers*[49] and then augmented the description of the punishment for each sin by adding extensive texts extracted from the German text of *The Visions of Tondal*. For these texts he used the German translation from the printed *Tondolus* edition that he himself published, i.e., recension D. The possibility cannot be excluded that Kistler's use of this material was in some way inspired by the extended text of the *Traité des peines d'enfer* contained in Vérard's *Ars moriendi*

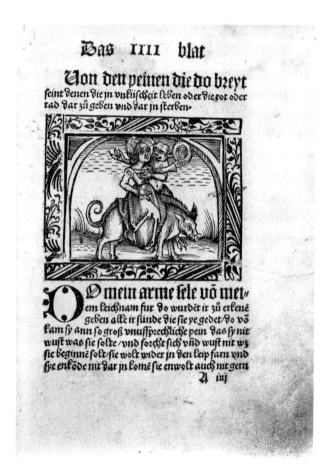

Figure 113.
Lechery Riding a Pig, in *Das Büchlein von den peinen* (Strasbourg, Bartholomäus Kistler, 1506). Oxford, Collection of N.F. Palmer, fol. 4.

edition, but there is no identifiable textual association, and the choice of material from *The Visions of Tondal* is quite different. The parallel may therefore be fortuitous. The German edition makes much more extensive use of the *Tondal* text than its French precursor.

The *Büchlein von den peinen* begins with an introduction, translated from the French text, with an added prayer. Then follow seven sections devoted to the punishment of the Seven Deadly Sins, with appropriate headings: in sequence, Superbia, Luxuria, Avaritia, Ira, Invidia, Gula, Acedia, all but Luxuria including the appropriate torments from the *Traité des peines d'enfer* integrated into the narrative of the German *Tondolus*. Each section is accompanied by two woodcuts: first an allegorical representation, which generally depicts the appropriate sin as a man or woman riding on an animal, and secondly a full-page woodcut depicting Lazarus's vision of the appropriate purgatorial torment. The allegorical representations of the sins show a young falconer and his lady seated astride the same horse for Pride, a woman riding a pig and holding a mirror for Lechery (fig. 113), a merchant riding a goat and carrying a bag of coins for Avarice, a knight riding backwards on a dragon and stabbing himself for Anger (fig. 114), a man riding a dog and clutching food for Envy, a woman astride a donkey, whose tail and ears are pulled by devils, for Sloth. These illustrations are clearly related to a well-known set of French manuscript illustrations of the Vices riding animals[50] and to a German printed broadside in Vienna,[51] but the iconography is distinct and an exact parallel is not recorded. There is no allegorical rider depicting Envy; in its place is a scene showing a battlefield with men and animals fighting (fol. 11v), which seems originally to have belonged to Kistler's second Latin edition of Johann Lichtenberger's *Prognostic* (or *Practica*), where it serves as a title page.[52] It also seems possible that the allegory of Pride is taken from a different series, as the design is quite distinct in style and of a different size.

Pride (fig. 115) is illustrated by a picture of a pilgrim crossing a high bridge over a mountain valley, as described in the *Tondolus*, and in the foreground is a great number of souls spiked on two wheels, which are turned on their vertical axle by a devil. At the foot of the wheel an individual prostrate soul is tormented by a black devil with a birdlike head. The scene is closely based on the accompanying text and does not seem to be in any way inspired by the corresponding illustration of the wheels in the *Traité des peines d'enfer* (see fig. 102). The angel in the foreground, who turns the wheel, does not figure in the text or in the illustrations of the source: he is the "angelus tartareus," who in the widespread recension IV of the *Visio Sancti Pauli* turns the wheels of torment.[53] In the German text, the short section translated from the French is allocated a separate paragraph inserted into the account of the pilgrim crossing the bridge:

[fol. 2v] Hie nach volgent die peinen denen die jn hoffart sterbent/ vnd rat oder that dar zu thunde.

[Woodcut: allegory of Pride as a man and woman on horseback]

DO kamen wir vber denn berg jn einen tyffen tal der erkund jch czu grund nit gesehen. Jn dem berg hort jch ein jemerliche geschrey von selen die do jn branten jn hitzen vnd jn rauch vber den grimen tal/ von einem berg zu dem andern gieng ein steg der was tusent schrit lang vnd eins fuß breyt/ vber den steg kund nyman kommen dann den got erwelt hat. Von dem steg fiel manig sele jn grund des tals.

[fol. 3, full-page woodcut; fig. 115]

[fol. 3v] ZU dem ersten hab jch gesehen vast hohe reder vmb loffen schneligklichen. Als die mül reder/ mit ysin hogken dar an die hoffertigen hyngen ellenklich on end.

§. Vff dem steg wie vorstat/ sahe jch ein priester gan jn forchten/ der selb priester was schon gecleidet vnd trug ein palmen reyß jn seiner hant/ do jch sahe den engen steg vnd vnder dem steg die grosse pin do sprach jch zu dem engel.

Figure 114.
Anger Riding a Dragon, in *Das Büchlein von den peinen* (Strasbourg, Bartholomäus Kistler, 1506). Oxford, Collection of N.F. Palmer, fol. 8.

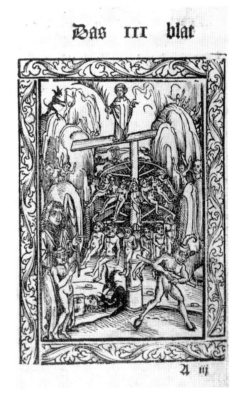

Figure 115.
The Torment of the Proud, in *Das Büchlein von den peinen* (Strasbourg, Bartholomäus Kistler, 1506). Oxford, Collection of N.F. Palmer, fol. 3.

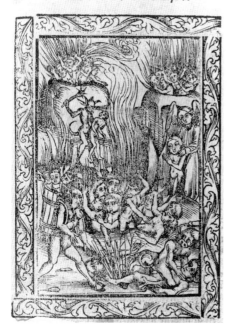

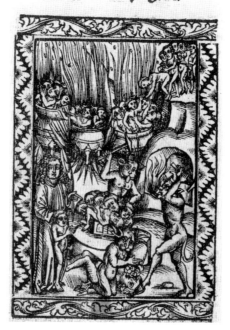

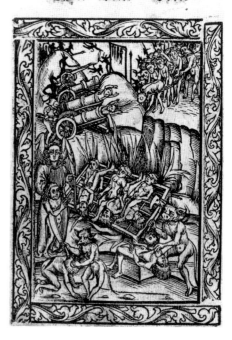

The outer narrative here is derived from *Tondolus der Ritter*, ll. 215–24 and 224–39 combined with 540–46, whereas the added section about the wheels is translated from the first vision in the *Traité des peines d'enfer*:

> Premiere⟨ment⟩ dit le Lazare. ⟨iay⟩ veu des roues e⟨n⟩ enfer treshaultes en vne montaigne situees en maniere de molins continuellement en grant impetuosite tournans. lesquelles roues auoient crampons de fer. ou estoient les orguilleuz et orguileuses pendus et attaches (fol. 33v).[54]

The second sin is Lechery (fig. 116), which is illustrated in the German edition by a picture of souls tormented in burning cauldrons and in a burning pool, as described and illustrated in the *Traité des peines d'enfer*, but these details have not been incorporated in the German text. It seems that the French source used as a basis for Lazarus's vision in the text was directly available to the artist; indeed, it is quite possible that author and artist are one and the same person, i.e., Kistler himself. This scene also contains some individual vignettes of torment: a soul beaten by a devil with a spiked club, a naked woman who has dropped her mirror and is lying in a thornbush in the foreground, by her side a prostrate male soul throttled by a devil.

The third picture of the sequence depicts the punishment of Avarice (fig. 117). In the background, the souls are tormented in flaming cauldrons, as described in the text, based here on the *Traité des peines d'enfer*. In the foreground, we see the distinctive *Tondal* motif of the smithy, possibly derived from the corresponding illustration in the German printed editions (fig. 111), and an individual prostrate soul forced by a devil to swallow a great quantity of coins. The woodcut showing the smiths, which belongs in a later section of the text in *Tondolus der Ritter* (ll. 659–94), was repeated without adequate motivation in some of the early editions,[55] and the newly written passage in the German text on which Kistler's picture of Avarice is based seems to derive from this illustration in the German source rather than from any particular text passage. This chapter, which is the shortest in the *Büchlein von den peinen*, consists of six lines of text from *Tondolus der Ritter* (ll. 242–47), to which have been added the description of the boiling cauldrons from the *Traité des peines d'enfer* and a brief mention of the smiths derived from the *Tondolus* illustration:

Figure 116.
The Torment of Lechery, in *Das Büchlein von den peinen* (Strasbourg, Bartholomäus Kistler, 1506). Oxford, Collection of N.F. Palmer, fol. 6v.

Figure 117.
The Torment of Avarice, in *Das Büchlein von den peinen* (Strasbourg, Bartholomäus Kistler, 1506). Oxford, Collection of N.F. Palmer, fol. 7v.

Figure 118.
The Torment of Anger, in *Das Büchlein von den peinen* (Strasbourg, Bartholomäus Kistler, 1506). Oxford, Collection of N.F. Palmer, fol. 8v.

[fol. 7] Hye noch volget von der pin der Geytigen Wucherer vnd Rauber der Dieb/ die jn den tod sünden sterbent/ rod oder dat dar zu dunt.

[Woodcut: allegory of Avarice as a merchant riding a goat carrying a bag of coins]
DO sprach der engel. Nun müssen wir fürbas gan zu anderen peinen die wir noch für vns hant. Do gieng jch dem engel noch gar eynen schweren vnd ruhen berg mit grosser arbeit vnd do/ sahe jch kessel vnd ander hafen vol gluwenden zerlossem pley vnd anderm geschmeid. Dar jn die geytigen sassen/ jngesenckt vns an den mund. Vnd sahe vil schmit die/ dye selen mit iren homeren vff einem anpiß jemerlich zu samen slagen do von ein groß geschrey erhort wart.

The corresponding section in the *Traité des peines d'enfer* reads:

Quintement dit le lazare iay veu des chauderons et chaudieres pleines du huiles boullians et de plomb et autres metaulx fondus esquelx estoient plongies les auaricieux et auaricieuses iusques a la gorge (fol. 35v).

The fourth picture, representing the torment appropriate to Anger (fig. 118), corresponds closely to the German passage of text which translates and expands the French account of Lazarus's vision: two individual souls are butchered here with knives rather than with lances as in the illustrations of the *Traité des peines d'enfer*;[56] they are roasted on a gridiron; they are shot from cannons and hanged. The motif of the gridiron, which the translator has added, recurs later in this chapter in a passage derived from the *Tondolus*, whereas the motif of the cannons is an added motif to be found in neither source:

Do kamen wyr in ein iemmerlichenn tal/ oder ein huli vast fünster dar jn die Zornigen gepeinget werden/ mit swertren zerhawen vß bochßen geschosen/ vnd gebroten vff einem rost/ vnd sunst viel mer grosser erschregklicher peinen die sy auch waren lyden als her nach stot (fol. 8).

This passage, which is interpolated into the description of the burning valley from Tondal's vision (ll. 166f.), derives only some of its motifs from the corresponding vision of Lazarus in the French text:

Tiercement dit le lazare iay veu vne caue et lieu tresobscur plain de tables et destaux comme dune boucherie ou les ireux ert les ireuses estoient transpersez de glaiues tranchans. et couteaux agus (fol. 34v).

It seems that the artist (and compiler) of the *Büchlein von den peinen* made use of an additional source for this picture, namely a French or Flemish miniature very closely related to an illustration of the torments of hell in a Brussels manuscript of the *Cordiale de quattuor hominis novissimis* of Gerard van Vliederhoven, translated into French by Jean Miélot, which was made for Philip the Good in or shortly after 1445 (see fig. 89).[57] The illustrations in this manuscript are the work of a Netherlandish artist and were attributed by F. Winkler to Jean Le Tavernier. This parallel affords conclusive proof that Kistler's woodcuts were inspired by Franco-Flemish miniature painting.

The fifth picture in the series, the torment of Envy (fig. 119), shows in the foreground the Irish giants in the mouth of the monster Acherons from the *Tondolus*[58] and in the background the torment of the envious from the *Traité des peines d'enfer*, where, as in the *The Vision of Saint Paul*, they are immersed in a frozen river; the thunder and lightning in the background is a motif added by the compiler of the *Büchlein von den peinen*.

The sixth picture, the torment of Gluttony (fig. 120), corresponds to a passage in the text which derives from the *Traité des peines d'enfer* alone. In the foreground the souls are punished by being forced to eat toads and snakes; in the background can be seen the filthy river from which these creatures are taken by the devils.

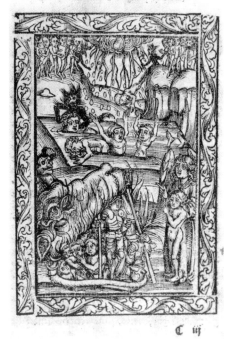

Figure 119.
The Torment of Envy, in *Das Büchlein von den peinen* (Strasbourg, Bartholomäus Kistler, 1506). Oxford, Collection of N.F. Palmer, fol. 13.

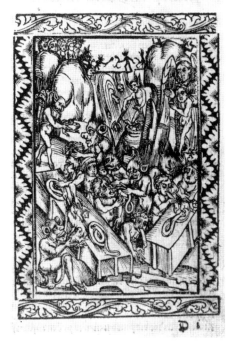

Figure 120.
The Torment of Gluttony, in *Das Büchlein von den peinen* (Strasbourg, Bartholomäus Kistler, 1506). Oxford, Collection of N.F. Palmer, fol. 17.

The final picture (fig. 121) shows the slothful in a subterranean vault wrestling with snakes; three souls are being swallowed by winged dragons. There is very little similarity to the corresponding picture in the *Traité des peines d'enfer*, where the souls run to and fro, plagued by flying reptiles. In the background can be seen the torment of souls in a pit, as described in *Tondolus der Ritter* (l. 736ff.), where they are hurled up into the air in a cloud of fire and smoke.

After the vision of the punishment of the Seven Deadly Sins, the text continues with a new heading: "Uon der Hellen" (fol. 22v). Whereas the sevenfold torments were those of purgatory, there now follows the description of Lucifer tormented in hell from *The Visions of Tondal*. Then follows the vision of paradise, which is presented *in extenso* and taken verbatim from the German *Tondolus*, with no additional material. At one point the redactor has even forgotten to excise the name of Tondolus and to replace it with Lazarus.[59] The sections devoted to hell and paradise are illustrated by woodcuts re-engraved by Kistler from the usual cycle of *Tondolus* illustrations; two pictures from this cycle are also used as additional illustrations in the first part of the book.

This is the end of the illustrated part of the book, which extends over thirty-six leaves. It is followed by a second part, which contains seventeen exempla, drawn from a range of Latin sources, demonstrating the existence of purgatory (fols. 36v-44), and ten exempla illustrating the horrors of hell (fols. 44v-49v). A single Latin source for this material has not been found.

The *Büchlein von den peinen* is remarkable as an example of the work of an enterprising publisher and woodcut designer who brought together material from a French and a German source to produce a German *Vision of Lazarus* that could be issued as a parallel publication to his *Visions of Tondal*. In its period it seems to be unique.

In conclusion, two aspects of the illustrated visionary texts considered here seem to have a broader bearing on the interpretation of the genre.

The Lazarus of the *Traité des peines d'enfer* simply sees the torments for the Seven Deadly Sins in hell. Each vision begins "iay veu," and the illustrations present tableaux of the collective torments suffered by the perpetrators of a particular sin, from which the visionary himself is excluded. In *The Visions of Tondal*, and in the German *Lazarus* text based on *Tondal*, the soul of the visionary repeatedly has to undergo the torments himself, being saved each time by the angel. Furthermore, in the illustrations of the *Büchlein von den peinen*, which principally depict the collective torments of the souls that Tondal sees in purgatory, a certain prominence is given to individual souls tormented by devils who are not specifically mentioned in the text, for example, the soul lying at the foot of the wheel in the torment of the Proud (fig. 115) or the prostrate souls in the foreground of the torment of Lechery (fig. 116). Thus an individual perspective comes to be integrated into the broader, collective perception of torment in the otherworld.[60]

The second point relates to the moralizing aspects of the work. In *The Visions of Tondal* most, but not all, of the torments and joys are related to particular failings or qualities that the souls have shown on earth. But these are not clearly separated from one another. So, for example, the torment in the smithy in *Tondolus der Ritter* is reserved for those who have lived "a sinful life of pride, avarice, lechery, anger, hatred, gluttony and drunkenness," and the soul is accused, after suffering the torment, of having lived "a proud and lecherous life," of "lewdness and unspeakable malice."[61] In *The Vision of Lazarus*, this disorganized mixing of sins punished by a given torment is replaced by a schematic list from the catechism, the Seven Deadly Sins, and in the *Kalendrier des bergiers* this catechetic pattern is evident in a broader context in the book: the *Traité des peines d'enfer* follows the trees of the Vices and Virtues. The moral lessons of the vision of hell are therefore filtered here through traditional patterns of teaching, as an aid to instruction, meditation, or the examination of the conscience. In the *Büchlein von den peinen*, a further such doctrinal framework is imposed on the conception of the otherworld in Tondal's vision through

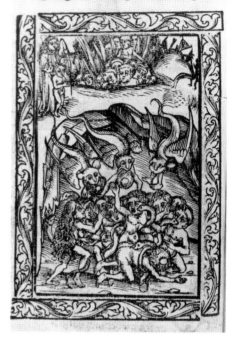

Figure 121.
The Torment of Sloth, in *Das Büchlein von den peinen* (Strasbourg, Bartholomäus Kistler, 1506). Oxford, Collection of N.F. Palmer, fol. 20v.

the bold tripartite subdivision of the otherworld into purgatory, hell, and paradise.[62] This doctrinal aspect is also apparent in the exempla collection that follows, which is divided into sections concerning purgatory and hell. Thus the presentation of facts about what awaits the soul after death is linked with a moral perspective which demands that the material should be so ordered that it can be studied and taken to heart by the reader. The communal aspect of the torment to be suffered is filtered through an awareness of its significance for individual sinners, who are invited to reflect on their own deaths and entry into purgatorial torment.

Appendix:
Separate Editions of the Visio Tnugdali
Printed in Germany and the Netherlands

A. Latin Editions

Cologne, printer of the *Historia Sancti Albani*, circa 1472
Speyer, Johann and Konrad Hist, not after 1483
Speyer, Johann and Konrad Hist, circa 1484
Antwerp, Mathias van der Goes, circa 1486–91
Cologne, Hermann Bungart, 1496

B. German Editions

Speyer, Johann and Konrad Hist, circa 1483
Speyer, Johann and Konrad Hist, circa 1488
Augsburg, Johann Schobser, circa 1494
Augsburg, Lucas Zeissenmeyer, 1494
Speyer, Johann Hist, circa 1495
Speyer, Johann Hist, circa 1495
Augsburg, Johann Schobser, 1496
Ulm, Johann Zainer, circa 1500
Strasbourg, Mathis Hupfuff, 1500
Strasbourg, Bartholomäus Kistler, circa 1506
Strasbourg, Mathis Hupfuff, 1507
Augsburg, Johann Froschauer, 1508
Cologne, Heinrich von Neuss, circa 1509–10
Cologne, Heinrich von Neuss, 1514
Strasbourg, Mathis Hupfuff, 1514
Augsburg, Johann Froschauer, 1515
Cologne, Heinrich von Neuss, 1516
Cologne (S. Kruffter?), after 1516
Strasbourg, Johann Knobloch, 1519
Augsburg, Johann Froschauer, 1521

C. Dutch Editions

Antwerp, Mathijs van der Goes, circa 1482
's-Hertogenbosch, Gerardus Leemt, 1484
Delft, Christian Snellaert, 1495
Antwerp, Govaert Back, circa 1496–99
Antwerp, Henrick Eckert van Homberch, 1515

Notes

1 Not after December 1, 1472. See L. Hain, *Repertorium bibliographicum* (1826–38; repr. Milan, 1948), no. 15542; E. Voulliéme, *Der Buchdruck Kölns bis zum Ende des fünfzehnten Jahrhunderts* (Publikationen der Gesellschaft für rheinische Geschichtskunde, 24) (Bonn, 1903), p. 335, no. 748; I have used London, British Library, IA. 3425. For the identity of the printer (Johann Guldenschaff?), see S. Corsten, *Die Anfänge des Kölner Buchdrucks* (Arbeiten aus dem Bibliothekar-Lehrinstitut des Landes Nordrhein-Westfalen, 8) (Cologne, 1955), pp. 13–18.

2 For Helinand, see M. Paulmier-Foucart, "Ecrire l'histoire au xIIIe siècle: Vincent de Beauvais et Helinand de Froidmont," *Annales de l'est: Revue trimestrielle* 33 (1981), pp. 49–70, and E.R. Smits, "Helinand of Froidmont and the A-text of Seneca's Tragedies," *Mnemosyne*, ser. 4, 36 (1983), pp. 324–58, esp. pp. 328–34.

3 Palmer 1982, p. 19f. For the transmission and circulation, ibid., pp. 5–10 (154 manuscripts cited) and 15–19. Where the prologue is counted as book 1 the *Visio Tnugdali* is contained in book 28, rather than 27.

4 References for these four editions are: 1) Speyer, Johann and Konrad Hist, not after 1483 (Hain [note 1], no. 15541; British Library, IA. 8715); 2) Speyer, Johann and Konrad Hist, circa 1484 (Hain, no. 15540; British Library, IA. 8712 and 8713); 3) Antwerp, Mathias van der Goes, circa 1486–91 (W.A. Copinger, *Supplement to Hain's Repertorium bibliographicum* [1895–1902; repr. Milan, 1950], no. 5835; British Library, IA. 49918); 4) contained in a collective volume printed in Cologne, Hermann Bungart, 1496 (Hain, no. 15543; Voulliéme [note 1], p. 275f., no. 611; British Library, IA. 5083). For the Speyer editions, see H. Engel and G. Stalla, "Die Brüder Johann and Conrad Hist und Ihre Drucke," *Archiv für Geschichte des Buchwesens* 16 (1976), cols. 1649–80, esp. 1653, 1655 (ill. 2 from Hain, no. 15541), 1657; for the illustrations in these works, see note 6, below.

5 There are five Latin incunable editions of the *Speculum historiale*: 1) "R-printer" (Adolf Rusch), Strasbourg, circa 1473 (Copinger [note 4], no. 6245; Oxford, Bodleian Library, Auct. Q sub fen. 1.1, 2); 2) Strasbourg, Johann Mentelin, 1473 (Copinger, no. 6246; British Library, IC. 547); 3) Augsburg, Sankt Ulrich und Afra, 1474 (Copinger, no. 6247; British Library, IC. 5774); 4) Nuremberg, Anton Koberger, 1483 (Bodleian Library, Inc. b. G 6. 1483.1); 5) Venice, Hermann Liechtenstein, 1494 (Copinger, no. 6241; British Library, IB. 22010).

6 See my edition of the most influential German prose text, N.F. Palmer, ed., *Tondolus der Ritter: Die von J. und C. Hist gedruckte Fassung* (Kleine deutsche Prosadenkmäler des Mittelalters, 13) (Munich, 1980). For the illustrations, see A. Schramm, *Der Bilderschmuck der Frühdrucke*, vol. 16 (Leipzig, 1933), ills. 623–43; W.L. Strauss and C. Schuler, eds., *The Illustrated Bartsch: German Book Illustration Before 1500*, vol. 84 (New York, 1983), pp. 60–63, ills. 1483/156–76. The captions in *The Illustrated Bartsch* are grossly inaccurate, especially in the confusion of hell, purgatory, and paradise, and should be ignored; see my list of illustrations in Palmer 1982, p. 284f.

7 For example, the edition printed by Antonio di Bartolomeo da Bologna, Venice, 1476 (Hain [note 1], no. 8617; British Library, IB. 20445). Further editions are mentioned by P. Villari, *Antiche leggende e tradizioni che illustrano la Divina Commedia* (Pisa, 1865), p. 23, n. 1; Villari prints the text of an edition printed in Vicenza in 1479.

8 Toledo, Remon de Petras, 1526. See J.K. Walsh and B. Bussell Thompson, eds., *Historia del virtuoso cavallero don Túngano (Toledo 1526)* (New York, 1985). The title page, described by Walsh and Bussell Thompson, p. 6, has a woodcut illustration depicting the death of Tondal and the consternation caused thereby.

9 Paris, Antoine Vérard, 1495 (Copinger [note 4], no. 6250; British Library, IC. 41169). The *Mirouer historial* published in 1479 by Barthélemy Buyer in Lyons is a different work and does not contain a text of Tondal's vision (information courtesy of P. Gasnault, Bibliothèque Mazarine, Paris).

10 British Library, C 22 d 5 (formerly IC. 41170), vol. 5, fols. 40–48v. The miniatures are on fols. 41v ("De la vallee horrible et du pont estroict chapitre lxxxxj"), 42v ("Du fleuue tempestueux et du pont perilleux chapitre xciij"), 45 ("Du prince de tenebres et de ses compaignons es paines Chappitre xcviij" [fig. 110]). See the brief description in *Catalogue of Books Printed in the xvth Century Now in the British Museum*, vol. 8 (London, 1949), p. 85f. In the first illustration, Tondal's soul is portrayed as a naked male child, in the second and third as a naked woman with breasts.

11 J. MacFarlane, *Antoine Vérard* (Illustrated Monographs Issued by the Bibliographical Society, 7) (London, 1900), p. 20f., no. 42. For illuminated presentation copies on vellum, including a copy of the *Miroir historial* in the Bibliothèque Nationale (but not this copy), see M.B. Winn, "Antoine Vérard's Presentation Manuscripts and Printed Books," in J.B. Trapp, ed., *Manuscripts in the Fifty Years After the Invention of Printing: Some Papers Read at a Colloquium at the Warburg Institute on 12–13 March 1982* (London, 1983), pp. 66–74. Jacques de Besançon was also the artist of the miniatures in a four-volume manuscript of the *Miroir historial*, now split between Paris and Chantilly; see P. Durrieu, *Jacques de Besançon et son oeuvre: Un grand enlumineur parisien au xveme siècle* (Paris, 1892), no. xxvi–xxvi bis.

12 1) Antwerp, Mathijs van der Goes, 1472 (really circa 1482); 2) 's-Hertogenbosch, Gerardus Leemt, 1484 (unique copy destroyed); 3) Delft, Christian Snellaert, 1495; 4) Antwerp, Govaert Back, circa 1496–99; 5) Antwerp, Henrick Eckert van Homberch, 1515. For full bibliographical details, see Palmer 1982, p. 355f. See also Brussels 1973, p. 363f., no. 165.

13 Hain (note 1), nos. 7970–71; British Library, IB. 5653 and IB. 5670; see also Palmer 1982, pp. 225–29. For the printer, see I. Leipold, "Das Verlagsprogramm des Augsburger Druckers Johann Bämler," *Bibliotheksforum in Bayern* 4 (1976), pp. 236–52. For Johann von Speyer, see K. Ruh, "Gregor der Grosse," *Die deutsche Literatur des Mittelalters: Verfasserlexikon*, vol. 3 (Berlin and New York, 1981), col. 239, and H. Kraume, "Johannes von Speyer," ibid., vol. 4 (Berlin and New York, 1983), cols. 757–60.

14 See the table of German editions on p. 167, above. For full bibliographical details, see Palmer 1982, pp. 278–94, and Palmer (note 6), pp. 19–21. The earliest surviving edition seems to be that of Johann and Konrad Hist, circa 1483, surviving in two copies: Munich,
Bayerische Staatsbibliothek, 4° Inc. c.a. 382ᵗ (this copy cited); Washington, Library of Congress, Rosenwald Collection, defective and with a rubricator's date of 1485.

15 I. Collijn, *Katalog der Inkunabeln der kgl. Universitäts-Bibliothek zu Uppsala* (Uppsala and Leipzig, 1907), p. 375, no. 1459; see also p. 61. The volume containing the *Tondal* edition and G. Barzizius, *Epistolae* (Reutlingen, Johann Otmar, n.d.; Hain [note 1], no. 2673) comes from the cathedral library in Frombork (West Prussia, Poland) and belonged in 1483 to Thomas Wernerus de Brunszberg (Braniewo).

16 These figures are speculative, assuming editions of between 150 and 300 copies, with twenty percent of the editions lost. See F. Geldner, *Inkunabelkunde: Eine Einführung in die Welt des frühesten Buchdrucks* (Elemente des Buch- und Bibliothekswesens, 5) (Wiesbaden, 1978), pp. 155–57, and S. Corsten, "Auflagenhöhen," in S. Corsten et al., *Lexikon des gesamten Buchwesens*, vol. 1, 2nd ed. (Stuttgart, 1987), p. 167f.

17 The German title page is reproduced in Palmer 1982, p. 6; for the Latin title page, see Engel and Stalla (note 4), col. 1655, ill. 2.

18 For a more detailed account, see Palmer 1982, pp. 78–81.

19 Wagner 1882, p. 38.

20 Palmer (note 6), p. 73, ll. 853–64.

21 The penitential and didactic aspects are well expressed by H. Spilling, *Die Visio Tnugdali: Eigenart und Stellung in der mittelalterlichen Visionsliteratur bis zum Ende des 12. Jahrhunderts* (Münchener Beiträge zur Mediävistik und Renaissance-Forschung, 21) (Munich, 1975), pp. 159–66, "Paränetische Grundlagen in der Visio Tnugdali."

22 A useful account, with generous bibliography, is that contained in K. Arnold, *Niklashausen 1476: Quellen und Untersuchungen zur sozialreligiösen Bewegung des Hans Behem und zur Agrarstruktur eines spätmittelalterlichen Dorfes* (Saecula spiritalia, 3) (Baden-Baden 1980), esp. pp. 1–36.

23 The illustrations are cited according to the numbering in *The Illustrated Bartsch*, vol. 84 (note 6), pp. 60–62 (1483/156–76).

24 The first German edition illustrates the hot-and-cold path (Palmer [note 6], ll. 192–214) with the illustration of the corn thief (*The Illustrated Bartsch*, vol. 84 [note 6], no. 1483/162), which properly belongs to a later passage (ll. 320–425), where it is repeated. The scene with the pilgrim (ll. 215–41) is inappropriately illustrated by the picture of the smiths (no. 1483/165). The second German edition introduces a new picture of the soul threatened by demons with a plank bridge in the background (no. 1483/160) to illustrate ll. 192–214, and illustrates the pilgrim scene with the smiths (no. 1483/165). The bridge in illustration no. 1483/162 may be a mis-

reading of the "mountain path" ("steg," l. 196), or, more plausibly, it may anticipate the bridge ("steg") which the pilgrim will cross in the following scene (cf. ll. 221–27). No. 1483/162 is found only in the three later German editions printed by the Hists and in that of Bartholomäus Kistler (Strasbourg, circa 1506), for which see note 36, below. The Latin editions published by the Hists (note 4) contain the complete set of wood-cuts with no repeats.

25 For details, see Engel and Stalla (note 4), cols. 1656, 1658, 1665.

26 H. Kunze, *Geschichte der Buchillustration in Deutschland: Das 15. Jahrhundert* (Leipzig, 1975), text volume, pp. 203–12 (Bamberg), 233–51 (Augsburg).

27 E. Geck, ed., *Herzog Ernst—Sankt Brandans Seefahrt—Hans Schiltbergers Reisebuch*, facsimile ed. (Wiesbaden, 1969).

28 W.L. Strauss, ed., *The Illustrated Bartsch*, vol. 80 (note 6) (New York, 1981), nos. 1472/10–141, esp. no. 1472/141; N.H. Ott, *Rechtspraxis und Heilsgeschichte: Zu Überlieferung, Ikonographie und Gebrauchssituation des deutschen 'Belial'* (Münchener Texte und Untersuchungen, 80) (Munich, 1983), pp. 210–24.

29 *Der selen wurczgart* (Ulm, Konrad Dinkmut, 1483), British Library, IB. 9335; for later editions, Hain (note 1), nos. 14584–87. Concerning the *Seelenwurzgarten*, see W. Williams-Krapp, in W. Haug and B. Wachinger, eds., *Exempla und Exempelsammlungen* (Fortuna vitrea, 2) (Tübingen, 1991). For the picture of the souls in purgatory, see *The Illustrated Bartsch*, vol. 84 (note 6), p. 46, ill. 1483/121. The Dublin fragments mentioned in my article "Fegfeuer des hl. Patricius," *Verfasserlexikon* (note 13), vol. 2 (Berlin and New York, 1980), cols. 715–17, are from a copy of the *Seelenwurzgarten*.

30 Berlin, Staatsbibliothek Preussischer Kulturbesitz, Ms. germ. oct. 60, contains on fols. 194v–96 an illustrated *Tondal* exemplum derived from a sermon by Martin Luther; see Palmer 1982, p. 210. Stuttgart, Württembergische Landesbibliothek, Cod. HB V 86, fols. 111–22v, with recension C of *Tondal's Vision* in German, possibly associated with Count Eberhard the Bearded of Württemberg, has some blank spaces for illustrations that were not executed; Palmer 1982, pp. 268–73.

31 B. Müller, "Die illustrierten *Visiones Georgii*-Handschriften," in S. Füssel and J. Knape, eds., *Poesis et Pictura: Studien zum Verhältnis von Text und Bild in Handschriften und alten Drucken. Festschrift für Dieter Wuttke zum 60. Geburtstag* (Saecula spiritalia, Sonderband) (Baden-Baden, 1989), pp. 49–76. For the German translations of the *Visiones Georgii*, see Palmer 1982, p. 419f.

32 The *Brandan* illustrations are published in G.E. Sollbach, ed., *St. Brandans wundersame Seefahrt: Nach der Heidelberger Handschrift Cod. Pal. Germ. 60* (Frankfurt, 1987). For a

list of German versions of both texts and their manuscript transmission, see Palmer 1982, p. 403f., 410–12.

33 For the interrelationship of the printed editions, see the stemma in Palmer 1982, p. 74. The Strasbourg editions of Mathis Hupfuff (1500, 1507, 1514) appear to be derived from that of Johann Zainer in Ulm (circa 1500), which was in turn derived from the Augsburg editions by Johann Schobser (circa 1494, 1496).

34 P. Kristeller, *Die Strassburger Bücher-Illustration im XV. und im Anfange des XVI. Jahrhunderts* (Beiträge zur Kunstgeschichte, N.F. 7) (Leipzig, 1888), pp. 11f., 51–53; F. Ritter, *Histoire de l'imprimerie alsacienne aux XVe et XVIe siècles* (Publications de l'Institut des hautes études alsaciennes, 14) (Strasbourg, 1955), pp. 137–44. For lists of Kistler's publications, see Kristeller, pp. 107–10; C. Schmidt, *Répertoire bibliographique strasbourgeois jusque vers 1530*, vol. 4 (Strasbourg, 1893), pp. 1–10; Schramm (note 6), vol. 20 (Leipzig, 1937), pp. 16–18. See also M.U. Chrisman, *Bibliography of Strasbourg Imprints, 1480–1599* (New Haven and London, 1982), p. 406f. (index s.v. Kistler); idem, *Lay Culture, Learned Culture, Books and Social Change in Strasbourg, 1480–1599* (New Haven and London, 1982).

35 September 30, 1497. Hain (note 1), no. 5493; *Gesamtkatalog der Wiegendrucke* (henceforth cited as *GW*), vol. 6 (Leipzig, 1934), no. 7179; British Library, IB. 2425. K. Haebler, ed., *Der deutsche Kolumbusbrief* (Drucke und Holzschnitte des XV. und XVI. Jahrhunderts in getreuer Nachbildung, 6) (Strasbourg, 1900).

36 Copinger (note 4), no. 5838; F. Ritter, *Catalogue des incunables ne figurant pas à la Bibliothèque Nationale et Universitaire de Strasbourg* (Strasbourg, 1960), no. 655; Chrisman, *Bibliography* (note 34), p. 172. Two copies are preserved: Budapest, Országos Széchényi Könyvtár, no. 875; Colmar, Bibliothèque Municipale, no. 1262 (this copy cited). The additional woodcuts of this edition are listed in Palmer 1982, p. 287.

37 Kristeller (note 34), pp. 24–41.

38 M. Cinotti and G. Martin, *The Complete Paintings of Bosch* (London, 1969), pls. 2–3.

39 *Disz büchlin saget von den peine so do bereyt seind* . . . (Strasbourg, 1506): Schmidt (note 34), p. 10, Kistler, no. 25; Oxford, Bodleian Library, Douce L. 189. The second copy (wanting fol. 1), formerly A. Rosenthal Ltd., is now in my possession. *DJs büchlin saget von den peine so do bereit seint* . . . (Strasbourg, 1509): Schmidt, p. 10; Kistler, no. 26; Basel, Öffentliche Bibliothek der Universität, E VI 22 no. 3, and Munich, Bayerische Staatsbibliothek, 4o Asc. 159 m. Both editions are listed by Chrisman, *Bibliography* (note 34), p. 22. For a preliminary discussion, see Palmer 1982, pp. 206–09.

40 *Hie noch folgen gůt hübsch vnd schöne leren/ Wie man sol guts thun vnd von besőm* [!] *sich keren*

(Strasbourg, Bartholomäus Kistler, 1500): Kristeller (note 34), no. 233; Schmidt (note 34), p. 5, Kistler no. 8; Chrisman, *Bibliography* (note 34), p. 172. The only recorded copy of this book is Berlin, Staatsbibliothek Preussischer Kulturbesitz, Inc. 2551 8° (formerly Yg 6004). The woodcut of Lazarus is illustrated in Schramm, vol. 20 (note 34), pl. 261, ill. 2049.

41 M. Voigt, *Beiträge zur Geschichte der Visionenliteratur im Mittelalter: I. II.* (Palaestra: Untersuchungen und Texte aus der deutschen und englischen Philologie, 146) (Leipzig, 1924; repr. New York and London, 1967); Palmer (note 3), p. 409 (three versions); W. Williams-Krapp, *Die deutschen und niederländischen Legendare des Mittelalters: Studien zu ihrer Überlieferungs-, Text- und Wirkungsgeschichte* (Texte und Textgeschichte, 20) (Tübingen, 1986), p. 432.

42 London, Victoria and Albert Museum, Ms. Salting 1221, fol. 153r-v; Harthan 1977, p. 147. The scenes depicted on fol. 153r are not taken from *The Visions of Tondal*, but rather, as Peter Dinzelbacher suggested at the Getty "Visions of Tondal" symposium, from the *Vision of Salvius* in Gregory of Tours. For the attribution of fol. 153r, see Bodo Brinkmann's essay, pp. 185–86, below.

43 This is the fourth printed edition of the *Compost et kalendrier des bergiers*, *GW*, vol. 7 (Leipzig, 1938), no. 5909. For other incunable editions, see ibid., nos. 5906–08 (without the *Traité des peines d'enfer*) and 5910–14; and for a detailed description (without the *editio princeps* of May 2, 1491, unique copy in the Bibliothèque Mazarine), H. Monceaux, *Les Le Rouge de Chablis: Calligraphes et miniaturistes, graveurs et imprimeurs* (Paris, 1895), pp. 282–307. I cite the work from the facsimile edition of *GW*, no. 5909, P. Champion, ed., (Paris, 1927).

44 Voigt (note 41), chap. 1; L.L. Hammerich, ed., *Visiones Georgii: Visiones quas in purgatorio Sancti Patricii vidit Georgius Miles de Ungaria A.D. MCCCLIII* (Det. Kgl. Danske Videnskabernes Selskab: Historisk-filologiske Meddelelser, 18/2) (Copenhagen, 1930), pp. 169–76.

45 A group of these manuscripts in French are discussed by Thomas Kren in his essay in the present volume.

46 The *Traité des peines d'enfer* is also known under the title *Aiguillon [Leguyllon] de crainte divine*. For the *Ars moriendi*, see *GW*, vol. 2 (Leipzig, 1926), no. 2586; Monceaux (note 43), pp. 159–63; *Catalogue of Books* (note 10), vol. 8 (London, 1949), pp. 110, 168 (British Library, IB. 40027). The first part of the book was printed by Pierre Le Rouge; for reprints, *GW*, nos. 2587, 2589, 2590. For the French publisher Antoine Vérard, see note 11, above. I cite the text from the copy of *GW*, no. 2587 in Oxford, Bodleian Library, Douce 169.

47 The illustrations in the *Ars moriendi* edition are published in Monceau (note 43), vol. 1, pp. 162, 165, 167, 266, 268, 270, 272, 274.

For those of the *Kalendrier des bergiers*, see the facsimile edition (note 43), and Monceau, vol. 1, pp. 293, 295, 297, 299, 302. The original set of woodcuts is probably that contained in the *Ars moriendi* edition, which preserves the motif of stoning for Gula (Ezech. 16: 40 and note 56, below).

48 For Superbia, the description of Acherons is integrated; for Ira, the smiths; for Acedia, the winged monster on the frozen lake; for Avaritia, the fiery pit; for Luxuria, the description of the many-handed Lucifer. No material from *The Visions of Tondal* is included in Invidia and Gula.

49 See, for example, "Als die mül reder" (ed. 1506, fol. 3v), "en maniere de molins" (*Kalendrier*, fol. 33v), and "grande quantite de roes a moulins" (*Ars moriendi*, fol. 236). Also: "ein kalt gefroren wasser" (fol. 12), "vng fleuue engele" (*Kalendrier*, fol. 34), and "certains fleuues en enfer esquelz . . ." (*Ars moriendi*, fol. 238). None of the additional material contained in the *Ars moriendi* edition has found its way into the German text.

50 E. Mâle, *L'art religieux de la fin du moyen âge en France* (Paris, 1922), pp. 329–33 (with illustrations of Paris, Bibliothèque Nationale, Ms. fr. 400). For the related tradition of the *Etymachia* in Latin and German, with numerous illustrated copies, see N. Harris, "The Latin and German "Etymachia": Introduction, Edition and Commentary," Ph.D. diss., University of Oxford, 1988, to be published in the Münchener Texte und Untersuchungen series.

51 *Der Teufel und die sieben Todsünden*, circa 1470, Vienna, Graphische Sammlung Albertina, Röttinger 26, 20; S.M. 1865a, reprod. in *Primitive Holzschnitte: Einzelbilder des XV. Jahrhunderts*, with an introduction by P. Heitz (Strasbourg, [1913]), pl. 52.

52 The full picture is used in Kistler's second Latin edition of Lichtenberger, printed after December 31, 1499 (cited here from British Library, IA. 2546): Hain (note 1), no. 10084, and Schramm, vol. 20 (note 34), p. 29, and pl. 229, ill. 1758. It was reused in the German edition of September 22, 1500 (Schramm, vol. 20, pp. 17, 29).

53 T. Silverstein, *Visio Sancti Pauli: The History of the Apocalypse in Latin Together with Nine Texts* (Studies and Documents, 4) (London, 1935), p. 76f.: "Mille vicibus uno die ab angelo tartareo volvitur, et in unaquaque vice mille anime cruciantur in ea" (recension IV). The "angelus tartareus" is shown turning the wheel in the first illustration to the Seven Torments in Oxford, Bodleian Library, Ms. Douce 134 (fig. 107) and Owen 1970, pl. 1.

54 Quoted from the facsimile edition of the *Compost et kalendrier des bergiers* (note 43).

55 See note 24, above.

56 Old French "glaiues" (from "gladius") means both knife and lance. The motif is based on Ezech. 16: 40: "Et lapidabunt te lapidibus et trucidabunt te gladiis suis."

57 Illustrated in C.D. Cuttler, "Two Aspects of Bosch's Hell Imagery," *Scriptorium* 23 (1969), pl. 103. For the manuscript, see Brussels 1967b, p. 47, no. 61; *Manuscrits datés conservés en Belgique*, vol. 3 (Brussels and Ghent, 1978), p. 123, no. A 254. I am indebted to Dagmar Eichberger for the correct identification of the text, which has been repeatedly misidentified as the *De quattuor hominis novissimis* of Dionysius the Carthusian.

58 *The Illustrated Bartsch*, vol. 84 (note 6), no. 1483–161.

59 "Do Tundalus vor dem künig tormaco stunde. . . ." (fol. 27 = *Tondolus der Ritter*, l. 988f.). Other passages too are inappropriate to the time of Lazarus, and an early sixteenth-century annotator in my copy has noticed some of the discrepancies, e.g., "auch vor dem leyden Christi seindt munch v[nd] pfaffen gewesen" (fol. 10v = *Tondolus der Ritter*, l. 476f.); "NB Die meß ist auch vor Christi leiden gewesen" (fol. 27 = *Tondolus der Ritter*, l. 990f.).

60 See A.M. Haas, *Todesbilder im Mittelalter: Fakten und Hinweise in der deutschen Literatur* (Darmstadt, 1989), especially p. 31ff., with important observations about the relationship between the individual and the collective experience of death in the Middle Ages.

61 "ein sundig leben/ an hochfart/ an geitikeit an vnkuscheit/ an zorn/ an haß/ an vberessen vnd an vber trincken," ll. 652–54; "wirt dir din hochfertiges vnd vnkusches leben vnd grosser wollust. vnd vnusprechlicher mutwil nit gebusset," ll. 696–98.

62 On the significance of the compartmentalization of the otherworld in the *Visio Tnugdali*, see Le Goff 1984, pp. 190–92. See also P. Dinzelbacher, "Klassen und Hierarchien im Jenseits," in A. Zimmermann, ed., *Soziale Ordnungen im Selbstverständnis des Mittelalters* (Miscellanea mediaevalia, 12/1) (Berlin and New York, 1979), pp. 20–40.

THE LOUTHE MASTER AND THE MARMION CASE

Antoine de Schryver

I n commenting upon the delicate miniature of the *Virgin and Child with Music-Making Angels* (fig. 122) in the Hours of Mary of Burgundy in 1969, I pointed out the similarity of its style to that of a major portion of the illumination in the book of hours executed for a member of the noble English Louthe family.[1] The attribution of these miniatures and of those in an identical or closely related style in several other manuscripts seemed to me to pose a problem. Although Winkler had included these works in the list of the presumed oeuvre of Simon Marmion, I wondered whether they might not be the work of a distinct master, whom I proposed to call the Louthe Master.[2] The particular character of the style of these miniatures and the fact that their artist could be shown to have collaborated on a number of occasions with illuminators established or working at Ghent led me to ask further whether he might belong to the Ghent milieu of the circle of the Master of Mary of Burgundy.

I am pleased that the present occasion enables me to return to these questions and, in particular, to correct or modify some of the things I stated in my previous publications about them. There are two questions at the heart of the Louthe Master problem, the first being the localization of his artistic production. The second concerns how we place the work of the Louthe Master in relationship to those works that are believed to be attributable to Marmion—starting with the foundation of the oeuvre, the wings of the Saint Bertin altarpiece.

I would like to recall first of all that, with regard to the question of Simon Marmion, I had adopted a skeptical attitude. I had not acknowledged the basic attribution of the Saint Bertin altarpiece and of the *Grandes Chroniques de France* in Leningrad to Simon Marmion, since these attributions struck me as lacking a solid foundation.[3] My objections were more or less along the lines of those expressed by Edith Warren Hoffman.[4] Like Hoffman, I chose to restrict myself to the simple designation—"Master of the Altarpiece of Saint Bertin."[5] No document indicates that the panels in Berlin and London were painted in Valenciennes, as is sometimes said.[6] I was in agreement with Martin Davies, who noted that the Saint Bertin panels were generally accepted without any proof as key works by Marmion.[7] Dehaisnes's initial suggestion that the altarpiece be attributed to Marmion had been very explicitly advanced as a *hypothesis*.[8] Dehaisnes himself, however, then went on—in the same work—to speak of the attribution as if it were an established fact!

Art historians then followed Dehaisnes; among the earliest were Winkler, Friedländer, and Hulin de Loo, all of whom made contributions that are of course useful for the study of the works in question.[9] We all understand the satisfaction that art historians feel in being able to connect a work with a name, especially when that name belongs to an artist whose biography is well known and whose fame is proclaimed in literary sources. Ten years after he published his important article on Simon Marmion's activity as illuminator, Winkler tried to place Marmion in a broader context and to characterize what he understood as northern French painting.[10] The

argument presented by Winkler concerning this point has never struck me as compelling. In this regard, Friedländer cleverly observes: "We must be on our guard against the fallacy of considering certain characteristics to be French because they are found in the work of an artist who is considered to be French because of these very characteristics."[11] This warning against the way Winkler attempted to define the "French" character of works attributed to Marmion did not prevent Friedländer from making his own contribution to the corpus of works presumed to be by Marmion.[12] Among the panels he was inclined to attribute to him is the *Lamentation* (see fig. 237) in the Lehman Collection (Metropolitan Museum of Art, New York), on the reverse of which are found the coat of arms and the initials of Charles the Bold and Margaret of York.[13] But let us return to what Winkler has called the painting of northern France. The attempts to better define the characteristics of the artistic style in the region Marmion came from, namely Amiens, and where he worked, namely Valenciennes, have made considerable progress since Winkler, particularly in several relatively recent studies, most notably the important contribution by Charles Sterling.[14]

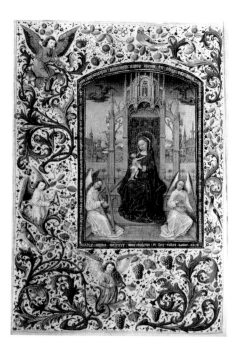

Figure 122.
The Louthe Master. *Virgin and Child with Music-Making Angels*, in the Hours of Mary of Burgundy. Vienna, Österreichische National-bibliothek, Cod. 1857, fol. 35v. © A.C.L. Brussels.

My own reservations with regard to the Simon Marmion hypothesis have diminished, and I now wonder if it was not an error to reject the group of works—or at least a part of them—that were attributed to Simon Marmion, starting with the Saint Bertin altarpiece and the *Grandes Chroniques de France*. The oeuvre that has traditionally been assembled has the advantage of corresponding rather well with the biographical data concerning Marmion. In the absence of decisive evidence, these chronological links make the hypothesis all the more seductive. But from the standpoint of historical criticism, I cannot agree with Pächt when he claims that if we were to cease identifying the Master of the Saint Bertin Altarpiece with Simon Marmion, we would be required to point to a stylistic group among extant art works that would be more acceptable as Marmion's oeuvre.[15] In our discipline of changing and relative truths, I think it can be allowed—indeed, it may even be necessary to say—that sometimes we simply do not know.

It nevertheless remains a rather delicate matter to define the precise contours of this oeuvre and, in particular, to decide to what degree it may include the works I have suggested grouping around the Louthe Hours. Let us return to the Louthe Hours now.

It is first necessary to recall the well-established fact that the book of hours at Louvain-la-Neuve was commissioned at the outset—circa 1480—for a member of the Louthe family. The proof of this lies in indisputable heraldic evidence. In addition, the calendar and the contents confirm that the manuscript was intended for an Englishman: several English saints appear in the calendar; both Saint Thomas of Canterbury and Saint Thomas of Hereford are referred to in the suffrages; and each of them is represented in a miniature (fols. 106v, 113v).

Three artists executed the illuminations in the Louthe Hours. The calendar at the beginning of the manuscript was illuminated by the Master of the Dresden Prayer Book. The recto of the folio for each month is accompanied by a border that decorates both the right-hand and the lower margins. In each case a medallion appears in the lower margin to illustrate the labors of the months.

The most important parts of the manuscript, namely, the prayers to the Virgin, the Hours of the Virgin, the prayer to the Holy Trinity, the Five Joys of the Virgin, and the Penitential Psalms, were illuminated by one hand—that of the Louthe Master.

In the suffrages, the illumination was divided between the Louthe Master, the Master of the Dresden Prayer Book, and the third hand. As is the case everywhere in the manuscript, the illumination of a given page seems to have been carried out by one and the same hand. The author of each miniature is thus also the author of the border that surrounds it. Ten of the folios of the suffrages were also carried out by two collaborators whose style is very different from that of the Louthe Master. One of them is the Master of the Dresden Prayer Book, who executed the calendar

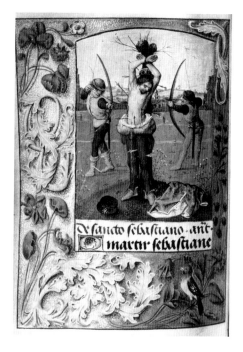

Figure 123.
Master of the Dresden Prayer Book. *Martyrdom of Saint Sebastian*, in the Louthe Hours, Louvain-la-Neuve, Université Catholique de Louvain, Ms. A. 2, fol. 103v. © A.C.L. Brussels.

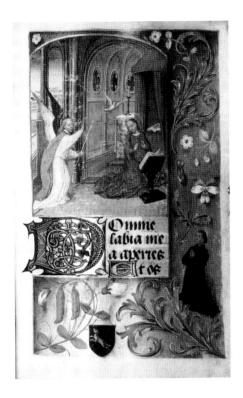 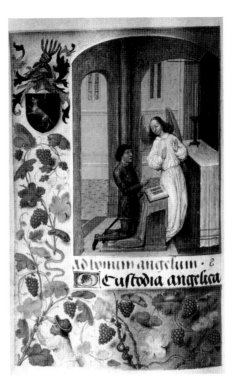

Figure 124.
The Louthe Master. *Annunciation*, in the Louthe Hours, Louvain-la-Neuve, Université Catholique de Louvain, Ms. A. 2, fol. 13. © A.C.L. Brussels.

Figure 125.
The Louthe Master. *Thomas(?) Louthe with His Guardian Angel before an Altar*, in the Louthe Hours. Louvain-la-Neuve, Université Catholique de Louvain, Ms. A. 2, fol. 100v. © A.C.L. Brussels.

and, among other miniatures, the *Martyrdom of Saint Sebastian* (fig. 123) and *Archangel Gabriel* (see fig. 134). Some of the other folios, for example, the miniature with *Saint Michael Slaying the Devil* (see fig. 137), are probably to be attributed to an assistant who, one might add, was himself not lacking in talent.

The Louthe Master, the artist responsible for the majority of the miniatures in the Louthe Hours, was the master who was entrusted with the commission for this very personalized manuscript. We find among the miniatures he executed two portraits of the recipient of the manuscript, in each case in prayer and kneeling: in the border of the *Annunciation* (fig. 124), which illustrates the beginning of the prayers to the Virgin; and within the miniature itself on fol. 100v (fig. 125), where he is represented in armor before an altar in the presence of his guardian angel, who seems to be inviting him to prayer. The Louthe coat of arms appears in the borders of these two folios.

The suggestion I made in 1969 that the Louthe Master be distinguished from Simon Marmion and a distinct oeuvre attributed to him arose in part from the fact that I did not feel bound by the data contained in the traditional theory regarding Marmion. I had some difficulty in finding in the subgroup of works I connected with the Louthe Master—works to my eye so precious, almost saccharin, and of a delicacy that might even be called feminine—the hand of the author of the panels of the Saint Bertin altarpiece. In addition, I wondered whether the oeuvre attributed to Marmion was in any case too extensive and whether part of it was not better attributed to illuminators in his circle.[16] In several manuscripts of splendid quality by the Master of Mary of Burgundy and his circle, we come across the hand of the Louthe Master.[17] I only mention here the famous book of hours with the motto "Voustre Demeure" (today divided between Madrid and Berlin), which was produced at Ghent, as was, without doubt, the Hours of Mary of Burgundy in Vienna.[18] It is this evidence which led me to believe that the Louthe Master worked at Ghent.[19]

However, it was an error to imagine that the miniatures of the Louthe Master were produced in Ghent. I took into account elements from a number of manuscripts that I was only able to view briefly, or which I did not otherwise know sufficiently well. Such was the case, for example, with the Berlaymont Hours in the Huntington Library.[20] The book of hours in the Pierpont Morgan Library in New York, M. 6, and that in two volumes in the Bibliothèque de l'Arsenal in Paris, Mss. 638–639,

should also have been considered. When I pointed out their relationship with the Louthe Hours in the catalogue of the exhibition held at Ghent in 1975,[21] I ought to have indicated that the two manuscripts have characteristics that do not accord with a localization to Ghent, but suggest rather an origin that is more nearly French.

The French character of the manuscript in New York is not difficult to recognize: in the script, the initials, the line endings, and the borders of the text pages. The large miniatures, on the other hand, have quite a different facture: here the style of the Louthe Master is evident. However, the style of the *Mass of Saint Gregory*, fol. 153v, is different from that of the other large miniatures. This is perhaps also the case, to a lesser degree, with the *Annunciation*, fol. 21. It has been thought that another hand intervened here.[22] If it is indeed the Louthe Master who is responsible for the large miniatures in this manuscript, it must also be acknowledged that this artist's conception of the borders and layout of the page has obviously evolved and that he has abandoned the characteristic acanthus leaves that appeared in the Louthe Hours and in the Berlaymont Hours, which are akin to those in the borders of *The Visions of Tondal* in the J. Paul Getty Museum.

On the other hand, the style of the Arsenal manuscript is similar to the style of the Louthe Hours, although it does not achieve the same quality (compare figs. 126 and 127). The manuscript is later in date, and we find here once again a remarkable calendar by the Dresden Master. The fact that virtually no blank spaces are left in the succession of the feasts is indicative of French origin. Complete or nearly full calendars seem to have been common in the region of Paris,[23] as well as elsewhere, e.g., Picardy,[24] in the fifteenth and sixteenth centuries. In Flanders, on the other hand, full or nearly full calendars are not the norm.[25]

The more French character of this calendar is confirmed by the mentions of Saints Exuperius (September 28), Lupus (October 17), Serapion (October 30), Maclovius (Maclou; November 15), Agricola and Vitalis (November 27), and Correntinus (December 12), most of whom were venerated in different parts of France, particularly Brittany, but also in Amiens, Arras, Cambrai, Rouen, and Reims.[26] There is also a mention, on June 16, of the Feast of Saint Iulita and her son Ciricus. This feast also appears in the calendar of the Louthe Hours. Although these two latter saints were particularly revered in France, Italy, and Spain,[27] they are often mentioned in Flanders because they were venerated in the diocese of Tournai.[28] They are, however, seldom represented in Flemish manuscripts. In the Louthe Hours, fol.

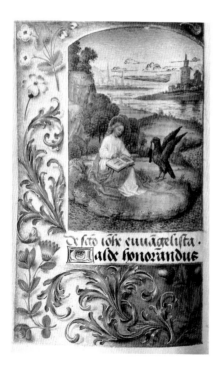

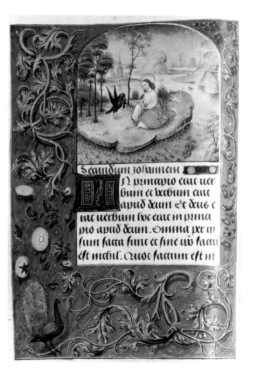

Figure 126.
The Louthe Master. *Saint John the Evangelist on Patmos*, in the Louthe Hours. Louvain-la-Neuve, Université Catholique de Louvain, Ms. A. 2, fol. 96v. © A.C.L. Brussels.

Figure 127.
Circle of the Louthe Master. *Saint John the Evangelist on Patmos*, in a book of hours. Paris, Bibliothèque de l'Arsenal, Ms. 638, fol. 14v. © A.C.L. Brussels.

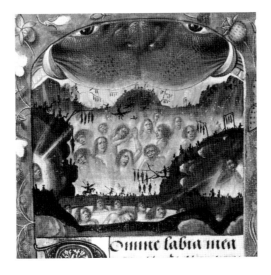

Figure 128.
Circle of the Louthe Master. *Mouth of Hell*, in
a book of hours. Paris, Bibliothèque de
l'Arsenal, Ms. 638, fol. 48. © A.C.L. Brussels.

107v, they are represented in a miniature of the suffrages.[29]

The illustration cycles in the Bibliothèque de l'Arsenal manuscript are extensive,[30] but I would like to discuss here only the illustration of the Office of the Dead. It depicts the *Mouth of Hell*, with the torments of its inhabitants (fig. 128), and shows some remarkable analogies with scenes in the *Tondal* manuscript. It may have been inspired by or derived from the same source as the illustrations of Tondal. However, this is not a unique case. As Sandra Hindman has pointed out, the Tondal codex also inspired one of the three miniatures preceding the Office of the Dead in the Salting Hours,[31] a manuscript that is particularly interesting in the present context. In the Arsenal miniature, the illuminator made ample use of the motif of the damned hanging on the gallows. Their dark silhouettes against the light emitted by the fires of hell resemble in a way the two demons jammed between the teeth and lips of the infernal mouth on fol. 17 of *Tondal*.[32] The heads of the damned, emerging from the flames, from the fire-bursting abysses, or from the icy ponds and lakes in which they have fallen recall their counterparts in the miniatures on fols. 13v, 14v, and 24v of *Tondal*.

It seems obvious that a rather close link exists between the illuminator of the Arsenal hours and the one responsible for the illustration of *Tondal*. The relationship between the Arsenal illuminations, the production of the Louthe Master, and the illustration of *Tondal* can hardly be denied. At least one may deduce that they evolved from the same milieu—and this may have been the milieu in which the art of Marmion blossomed.[33]

The findings presented here concerning the manuscripts in New York and in the Arsenal suggest that the style of the Louthe Master developed south of the Hainaut or in Picardy. That an artist originating in this area collaborated, as we have seen, in the execution of several Ghent manuscripts implies contacts and exchanges between Ghent and the artist. Commissions from Margaret of York may have helped to bring these about. It is possible that the artist who received the commission to illuminate *The Visions of Tondal* for the duchess was called to Ghent in March 1475, when David Aubert had completed his transcription of the text there.[34] This might have also occurred in the case of other manuscripts, such as *La vie de Sainte Catherine* by Jean Miélot, also made for Margaret and probably also copied at Ghent by David Aubert. This manuscript, which has been almost completely overlooked until now,[35] is only known to me through an old photograph (fig. 129). It is sufficient to compare the script, the layout, and the decorated borders of this manuscript to those in the *Tondal*. The style of the miniature of the *Martyrdom of Saint Catherine* also seems to be close to the miniatures of the *Tondal*. In relation to the *Tondal* and to the problems dealt with here, this manuscript is even more significant since it includes twelve

Figure 129.
Circle of Simon Marmion (?). *Martyrdom of Saint Catherine*, in Jean Miélot, *La vie de Sainte Catherine*. Location unknown.

more pages with large miniatures and illuminated borders analogous to those shown here. It is possible that these manuscripts were painted in Ghent. In either case, the evidence offered here implies contacts between Ghent and the illuminator's region of origin.

The painting of the *Miracle of the True Cross* in the Louvre (fig. 130), which has often been attributed to Marmion, may also be the product of such contacts, and of the resultant artistic exchanges and cross influences. In 1903, Benoit considered this painting to be a work from Picardy and perhaps Valenciennes.[36] It was subsequently attributed to Simon Marmion and has been commented on or reproduced with this attribution in numerous publications, those by Winkler and Friedländer among others.[37] Friedländer even wrote that the attribution left no room for doubt, and he dated the painting more or less from the same period as the Saint Bertin altarpiece, which, he said, it resembled a great deal.

On the other hand, I have felt that the painting belongs to the Ghent school.[38] As a matter of fact, the figure holding her left hand in front of her breast resembles the figure of Caterino Zeno in the background of the *Communion of the Apostles* at Urbino, a work by Joos van Ghent. But it also seems to me that there is a striking relationship between the young woman who is brought back to life and the Eve in van der Goes's Vienna *Fall of Man* (figs. 131, 132). These findings have led me to conclude that the painting must belong to the school of Ghent. No doubt this opinion should be more nuanced. Evidently Friedländer was mistaken in thinking that the painting could be of approximately the same date as the Saint Bertin panels, which were installed in 1459. The panel of the *Miracle of the True Cross* must have been painted in the 1470s and would thus date roughly to the same period as the miniatures of the *Tondal* or of *La vie de Sainte Catherine*, with which it may be compared.

If one compares the miniature of the *Martyrdom of Saint Catherine* and that of

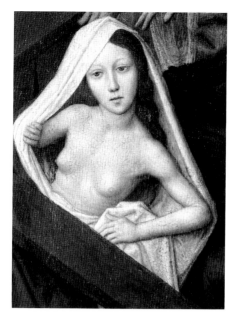

the *Tondal* (fol. 7, and the miniature of *The Vision of the Soul of Guy de Thurno* from the companion text) with the painting in the Louvre, one notices that certain figure types are rather similar, as are the manner of accurate rendering of the facial volumes and the bright touches of light on the nose and at the top of the cheeks. The play of folds in the white robes of Saint Catherine and those on the shroud of the resuscitated young woman is also quite similar.

The painting belonged to Joan d'Huyvetter (1770–1833), whose collection was famous in Ghent in the early nineteenth century. At that time, it was considered to be a work by Joos van Ghent, who was known as the author of the *Communion of the Apostles* at Urbino.[39] The figure resembling Caterino Zeno in the *Communion* proves sufficiently that this attribution was not totally unfounded, although it can no longer be accepted. Perhaps the painting is a work by a master from the circle of Marmion who had contacts with Ghent painters or who may even have worked at Ghent for some time. Moreover, there is a fair chance that the painting had never left Ghent prior to its acquisition by Joan d'Huyvetter[40] and may originally have had a Ghent destination. If this is the case, it increases the chance that it might also have been painted in Ghent.

The complex stylistic character of the painting may have resulted from those interregional contacts that were so profitable to many artists and which were often incidentally made on the occasion of commissions that necessitated traveling. The manuscripts made jointly by Ghent miniaturists and the Louthe Master resulted perhaps from similar contacts. From this perspective, we can understand how Ghent painters and illuminators could have assimilated influences from Marmion and his circle.[41]

As at Bruges, the local Ghent production was undoubtedly enriched by external contacts which are often difficult to isolate and evaluate. The qualifications offered by such distinguished connoisseurs as Winkler and Delaissé in discussing possible attributions to Marmion or the Master of Mary of Burgundy probably reflect such contacts and influences. Winkler initially attributed to Marmion the *Virgin and Child with Music-Making Angels* in the Hours of Mary of Burgundy,[42] but subsequently he thought that it could have been retouched and finished by the Master of Mary of Burgundy.[43] Delaissé compared the style of those grisailles miniatures attributed to Marmion in the so-called Hours of Henry VIII in Tournai and the Rolin Hours in Madrid with that of the Master of Mary of Burgundy.[44] These stylistic links may be explained by various artistic exchanges. The Master of Mary of Burgundy and other Ghent illuminators of the 1470s and 1480s may have studied especially those illuminators such as Marmion who were currently in favor at the court. The delicate,

Figure 130.
Attributed to Simon Marmion (or workshop). *The Miracle of the True Cross*. Paris, Musée du Louvre, R.F. 1490. © A.C.L. Brussels.

Figure 131.
Detail of figure 130.

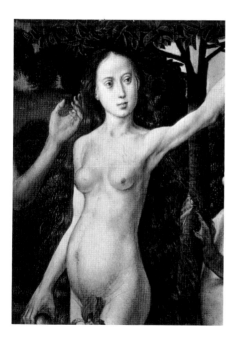

Figure 132.
Hugo van der Goes. *The Fall of Man* (detail). Vienna, Kunsthistorisches Museum, no. 945, 5822a.

small strokes of the Master of Mary of Burgundy may reflect the refined technique found in manuscripts attributed to Marmion. The suave color and graceful figures in the works that I, perhaps too generously, once attributed to the Louthe Master, may also have inspired some Ghent illumination.[45]

Marmion, who lived and worked at Amiens and Valenciennes and whose activity and presence at Lille, Cambrai, and Tournai is documented, illustrates the mobility of the artists of this era, without which these exchanges could not occur. If he is indeed the painter of the Saint Bertin altarpiece and the illuminator of Jean Mansel's *La fleur des histoires* (Brussels 9231–32), we should add Saint-Omer and Hesdin to the list of places that Marmion visited and frequented. Given this mobility—not only of artists but also of patrons—it seems to me useful to discuss here the historical geography of the region (see fig. 133). The manner in which scholars have discussed those towns where Marmion's career could have unfolded has often been extremely imprecise, if not misleading. Indeed, it is not altogether justified to assume, as has been done, that Saint-Omer or Hesdin enjoyed relations with Valenciennes simply because the three cities were close to one another. Moreover, some scholars seem to consider them to have been in close contact solely on the basis of their present geographical situation in northern France. It appears that scholars have sometimes misjudged the distances that separate these towns and failed to study carefully the political map of the time. Admittedly, if an artist of talent was required in Hesdin or Saint-Omer, it was easy enough to find one, say, at Amiens or Valenciennes. But a patron could also try Tournai, or indeed one of the other artistic centers of the Burgundian provinces, to which the region under discussion belonged at the time. Ypres is halfway between Saint-Omer and Bruges, and Bruges is hardly farther from Saint-Omer or Hesdin than from Valenciennes. On the other hand, Valenciennes in the Hainaut is closer to such centers of Flanders or Brabant as Lille, Bruges, Ghent, or Brussels than to Hesdin or Saint-Omer.

In examining the relationships between the centers for the production of manuscripts and the books' destinations, it is less important to consider the physical distances that separate them than to discover the role played by economic, political, and ecclesiastical factors. There have, for example, always been numerous contacts among the artists of Ghent and Tournai, the seat of the bishopric, which includes Ghent and the entire left bank of the Scheldt River. Tournai is located on the border of the Hainaut and is relatively close to Valenciennes. The two cities enjoyed numerous contacts. Since relations between Tournai on the one hand and Ghent and Valenciennes on the other seem to have been equally close, would it not be conceivable that contacts between Ghent and Marmion and his circle were transmitted via Tournai? After all, Mille Marmion was established at Tournai, where he belonged to the guild of Saint Luke, which his brother Simon joined in 1468. I would even suggest that the Louthe Master could be identifiable with Mille Marmion. But it might be better to state the question differently. Our difficulty in defining the boundaries of the presumed production of Simon Marmion and the size of the oeuvre ascribed to him may result from the fact that several artists of a common artistic training participated in the illumination of these manuscripts. Simon Marmion would be the most important and celebrated among them, but his brother, and others, would have played a role in this production. Although this is only a hypothesis, current research may be able to test its validity.

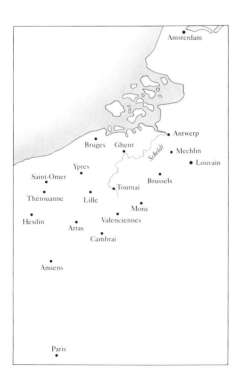

Figure 133.
Map of the southwestern part of the Burgundian Netherlands.

Notes

1 De Schryver/Unterkircher 1969, pp. 149–55.

2 The eponymous Louthe Hours are in Louvain-la-Neuve, Université Catholique de Louvain, Ms. A. 2.

3 De Schryver, in Ghent 1975, vol. 2, pp. 331–32, 364–66, nos. 596, 597, pp. 375–76, no. 612.

4 Hoffman 1973.

5 A designation that had already been proposed by Hénault 1907–08, vol. 9, p. 291.

6 Dom Charles de Witte, the last archivist of the abbey in the eighteenth century, cited *in extenso* in Dehaisnes 1892, pp. 48–49, had noted in his *Grand cartulaire de l'abbaye de Saint Bertin* that the Abbot Guillaume Fillastre "fit faire le retable à Valenciennes." However, he makes no reference to the painted wings and, in the context and wording, the remark seems to apply only to the metalwork *retable* whose elaborate character he emphasized. This central and principal portion of the altarpiece is the only part that de Witte seemed to be interested in. Nothing denies or confirms that the wings were painted at Valenciennes, even if Dehaisnes, pp. 51–52, made a hardly convincing attempt to prove that they were. He then attributed the wings to Marmion because he felt he had shown that they were painted at Valenciennes.

7 M. Davies, *The National Gallery, London* (Les primitifs flamands. I: Corpus de la peinture des anciens Pays-Bas méridionaux au quinzième siècle, 3) (Brussels 1970), p. 23. This author also gives the text of Dom de Witte on the altarpiece, pp. 25–26.

8 Dehaisnes 1892, p. 55: "rapprochements qui sont loin d'être des preuves," "conjectures vraisemblables. . . ."

9 Winkler 1913; Friedländer 1923; G. Hulin de Loo, "La vignette chez les enlumineurs gantois entre 1475 et 1500," *Académie Royale de Belgique. Bulletin de la Classe des Beaux-Arts* 21 (1939), p. 177; Hulin de Loo 1942.

10 Winkler 1923.

11 "Wir müssen uns vor dem Trugschluss hüten, Eigenschaften für französisch zu halten, weil ein Meister sie zeigt, der eben wegen dieser Eigenschaften als Franzose gilt"; Friedländer 1923, p. 170.

12 Friedländer 1923.

13 Ibid., figs. 6 and 11.

14 C. Sterling, "La peinture sur panneau picarde et son rayonnement dans le nord de la France au XVe siècle," *Bulletin de la Société de l'histoire de l'art français* (1979), pp. 7–49.

15 Pächt 1979, p. 14. Following this line of reasoning, one could not have rejected the older hypothesis of Winkler, Durrieu, and others that attributed to Philippe de Mazerolles the Prayer Book of Charles the Bold (Getty Museum, Ms. 37) and other manuscripts, if chance had deprived us of the documents that today prove the attribution of these works to Liévin van Lathem (see de Schryver, in de Schryver/Unterkircher 1969, pp. 23–34, 42–45).

16 See also the essays by Gregory T. Clark and Anne-Marie Legaré in the present volume.

17 Hoffman 1969, p. 268.

18 De Schryver, in Ghent 1975, pp. 377–78, no. 615, with bibliography on the "Voustre Demeure" Hours; for the Hours of Mary of Burgundy, see idem, in de Schryver/Unterkircher 1969, passim, and Ghent 1975, pp. 372–74, no. 609.

19 Hoffman 1969, p. 268, also commented on the relationship with the Ghent production. Sterling (note 14), p. 9, alluded to the influence of Marmion in the milieu of Bruges and Ghent. For the erroneous localization of the Louthe Master in Ghent, see de Schryver, in de Schryver/Unterkircher 1969, p. 152; idem, in Ghent 1975, p. 376, no. 612.

20 San Marino, Henry E. Huntington Library and Art Gallery, HM. 1173; for color reproductions of the seventeen decorated leaves, see Thorpe 1976.

21 Ghent 1975, pp. 377, no. 614, 385, no. 625. I was only able to look briefly at these manuscripts before the publication of the catalogue. For Morgan M. 6, see Brussels 1959, p. 161, no. 205; *Flanders in the Fifteenth Century: Art and Civilization*, exh. cat. (Detroit Institute of Arts, 1960), pp. 395–96, no. 210; Hindman 1977, figs. 2, 4–6; W. M. Voelkle, *The Pierpont Morgan Library. Masterpieces of Medieval Painting: The Art of Illumination* (Chicago, 1980), pp. 1–2, figs. IB3 and IC2; Malibu 1983, p. 31 and note 12.

22 Voelkle (note 21).

23 V. Leroquais, *Les livres d'heures manuscrits de la Bibliothèque Nationale*, vol. 1 (Paris, 1927), pp. XV–XVI; idem, *Les bréviaires manuscrits des bibliothèques publiques de France*, vol. 1 (Paris, 1934), pp. LXIV–LXV.

24 For example, in a book of hours in Amiens, London, British Library, Add. Ms. 31835.

25 It would be easy to assemble a list of French calendars without empty spaces and another of Flemish calendars with many blank spaces corresponding to the absence of a particular commemoration. As a result, Flemish calendars tend to be more useful even though French calendars can also be informative. Leroquais 1927 (note 23), p. XV, judged full calendars harshly, but he subsequently implicitly revised and nuanced his view; see Leroquais 1934 (note 23), p. LXV. This peculiarity of French calendars constitutes an interesting instance where the function of the calendar and the content of the manuscript are subordinated to aesthetic consideration in the page design.

26 Leroquais 1927 (note 23), passim, and Leroquais 1934 (note 23), passim. Serapion, who was venerated in Arras, was one of the Seven Sleepers of Ephesus; see M. Lechner and S. Squarr, "Siebenschläfer [sieben Kinder] von Ephesus," in E. Kirschbaum et al., eds., *Lexikon der christlichen Ikonographie*, vol. 8 (Rome, Freiburg, etc.), 1976), col. 345. The cult of Saint Maclou was popular in Brittany as well as in Rouen and Picardy; see L. Réau, *Iconographie de l'art chrétien*, vol. 3, 2 (Paris, 1958), pp. 864–65. Relics of saints Agricola and Vitalis were venerated in Rouen; see L. Schütz, "Vitalis und Agricola von Bologna," in Braunfels et al. (as above), col. 578.

27 Réau (note 26), vol. 3, 1, pp. 361–62; G. Kaster, "Julitta und Cyricus (Quiricus) von Tarsus," in E. Kirschbaum et al., eds., *Lexikon der christlichen Ikonographie*, vol. 7 (Rome, Freiburg, etc., 1974), cols. 241–45.

28 They were also venerated in the dioceses of Arras, Cambrai, and Thérouanne; E.I. Strubbe and L. Voet, *De chronologie van de middeleeuwen en de moderne tijden in de Nederlanden* (Antwerp and Amsterdam, 1960), pp. 174–75. They were particularly venerated in the abbey of Saint Amand, near Valenciennes; Réau (note 26), p. 362.

29 One finds them more often represented in France in, among others, several important breviaries, such as those of Philip the Good, Charles V, and the Duke of Bedford; Leroquais 1934 (note 23), vol. 1, p. 320; vol. 2, p. 472; vol. 3, pp. 49, 56; vol. 5, p. 325.

30 H. Martin, *Catalogue des manuscrits de la Bibliothèque de l'Arsenal*, vol. 1 (Paris, 1885), pp. 482–84, has described the subjects of the calendar medallions and the forty-three miniatures.

31 Hindman 1977, pp. 192–93, with the three miniatures illustrated. On the *Hell* miniature in the Salting Hours, see also Thomas Kren's introduction, p. 19, above, and Dagmar Eichberger's essay, p. 134, above.

32 Malibu 1990, pl. 7 and cover. Bosch used the motif of silhouettes hanging from a gallows and set off against the flames many times; see R.H. Marijnissen and P. Ruyffelaere, *Hiëronymus Bosch* (Antwerp, 1987), pp. 231–32, 345. One should recall that the descrip-

tions in *The Visions of Tondal* seem to have inspired Bosch, who could have known the first editions of the text in Dutch; ibid., pp. 19–20, with the reproduction of the title page of the Delft edition, 1495, which depicts the mouth of hell, with a damned soul suspended by his feet at the left. See also H. Dollmayr, "Hiëronymus Bosch und die Darstellung der Vier letzten Dinge," *Jahrbuch der kunsthistorischen Sammlungen des allerhöchsten Kaiserhauses in Wien* 19 (1898), pp. 342–43; C.C. Cuttler, "Two Aspects of Bosch's Hell Imagery," *Scriptorium* 23 (1969), pp. 313–19; Hindman 1977, p. 193, n. 28.

33 It is perhaps appropriate to recall here that Simon Marmion was not the only painter in his family; see Hénault 1907–08.

34 Until now the manuscript has been erroneously dated to 1474: Brussels 1959, p. 153, no. 191; Ghent 1975, p. 331; Malibu 1990, p. 31. Pierre Cockshaw argues for the correct date, pp. 58–59, above.

35 De Schryver, in Ghent, 1975, p. 331; C. Dehaisnes, "Etude sur la Passion de Saint Adrien et de Sainte Nathalie, ms. du XVe siècle," *Mémoires de la Sorbonne. Archéologie, 1864* (Paris, 1865), pp. 171–82; *Fédération archéologique et historique de Belgique. Congrès Archéologique et Historique tenu à Bruges . . .*, part 3 (Bruges, 1902), pp. 33–34. The manuscript belonged to the Waziers Collection in northern France. Manuscripts in this collection disappeared during World War I; some can be found today in collections in the United States. The photograph reproduced here was made from an old glass negative (apparently partially broken toward the bottom) that may have been made at Bruges in 1902. It is the only visual documentation of the manuscript known to me.

36 C. Benoit, "Le tableau de l'invention de la vraie croix et l'école française du nord dans la seconde moitié du XVe siècle (Musée du Louvre)," *Fondation Eugène Piot: Monuments et mémoires* 10 (1903), p. 268.

37 Winkler 1923, p. 248, and Friedländer 1923, p. 167.

38 A. de Schryver, "De Gentse schilderkunst na de Van Eycks," in *Justus van Gent, Berruguete en het hof van Urbino*, exh. cat. (Ghent, Museum voor Schone Kunsten, 1957), p. 25, where I suggested that the painting belongs to the circle of Daniel de Rijke and Joos van Ghent. In cat. no. 67, p. 134, the attribution of the painting to Daniel de Rijke is mistaken.

39 "Collection d'objets d'art et de curiosité recueillis par M. Joan d'Huyvetter . . .," *Messager des sciences et des arts, recueil publié par la Société royale des beaux-arts et des lettres . . . de Gand* (Ghent, 1824), pp. 364–66; L. de Bast, "Série inférieure de la grande composition peinte, pour l'église de St. Jean à Gand, par Jean van Eyck," *Messager des sciences et des arts . . .* (1825), p. 155, note 2, with engraving reproducing the painting (*Justus van Gent pinxit, Ch. Onghena sculpsit*); A. Voisin, "No-

tice sur le cabinet d'antiquités nationale de feu Mr. Joan d'Huyvetter," *Messager des sciences et des arts de la Belgique . . .*, vol. 3 (Ghent, 1835), pp. 189–99. The attribution to Joos van Ghent was mentioned in 1824 and again in 1835, and may have been proposed to *Messager* by G.F. Waagen, the great connoisseur, who maintained close contacts with the journal. This at least may be inferred from the sales catalogue of d'Huyvetter's collection, *Description des antiquités et objets d'art qui composent le cabinet de feu M. Joan d'Huyvetter* (Ghent, 1851), pp. 65–66, no. 658, in which Waagen's authority is used to endorse the attribution. It is possible, in my view, that Waagen knew the attribution from an older tradition and simply considered it correct. W. H. J. Weale also drew attention to the attribution in a "Letter to the Editor" published in *Burlington Magazine* 3 (1903), p. 114.

40 Thanks to a donation made by the descendants of J. d'Huyvetter, I was able to return some remaining works from this collection to the Bijlokemuseum when I was the curator there; see A. de Schryver and C. Van de Velde, *Oudheidkundig Museum, Abdij van de Bijloke: Catalogus van de Schilderijen* (Ghent, 1972), pp. 26, 48–49, no. 11, 190–91, no. 146, etc. Nothing is known of the origins of the painting. J. d'Huyvetter also owned a precious small diptych (of which there is no longer any trace) that was attributed to Gerard Horenbout and came from the abbey of Saint Bavo at Ghent; see "Diptique peint par Gérard Horenbout," *Messager des sciences et des arts* (1833), pp. 12–16. However, his collection was above all a collection of stained glass, glass, and ceramics. The "Old Master Paintings" category in the sale of his collection in 1851 consisted only of twenty-one lots out of 938. In 1843 James de Rothschild in Paris and the Belgian government were both interested in acquiring the entire collection. Various circumstances prevented the negotiations from reaching a successful conclusion.

41 Sterling (note 14), p. 7, alluded to the influence of Marmion in the milieu of Bruges.

42 Winkler 1913, p. 255, n. 6.

43 Winkler 1925, p. 204.

44 Delaissé, in Brussels 1959, pp. 173–74, nos. 236–37. I had thought that these grisailles could be by the Louthe Master; see de Schryver/Unterkircher 1969, pp. 151–52, and Ghent 1975, pp. 364–65, no. 596. They are at least related to the style found in the Louthe Hours, which Delaissé had suggested is related, along with Morgan M. 6, to the style of the Master of Mary of Burgundy; see Brussels 1959, pp. 161, 191–92, nos. 205 and 271.

45 I have also felt that there is a relationship between the colors of the Calvary triptych in Ghent Cathedral and those of the Louthe Master; see de Schryver/Unterkircher 1969, p. 152.

The Contribution of Simon Marmion to Books of Hours from Ghent and Bruges

Bodo Brinkmann

W hen art historians began to review the case of Simon Marmion about two decades ago, they challenged the identification of the documented artist with the painter of the Saint Bertin altarpiece, an identification based on circumstantial evidence. This challenge led to a remarkable disintegration of the corpus of works associated with the name of a major northern French painter and illuminator.[1] Scholars started to isolate groups of works from Marmion's oeuvre and to reattribute them to anonymous painters named after one of the works in the new group. Thus Antoine de Schryver created the Louthe Master in 1969, an artist whom he named after a book of hours made for the Louthe family and now in Louvain-la-Neuve; he described the artist as a close follower of Marmion active at Ghent. Since then, both de Schryver himself and others have expanded the grouping.[2]

It is worth keeping in mind that scholars of the rank of the late Otto Pächt and the late Charles Sterling had always strongly objected to the breakup of Marmion's oeuvre. Thomas Kren inaugurated a shift in opinion in his entries on Marmion in the exhibition catalogue *Renaissance Painting in Manuscripts*.[3] He argued for a reintegration of the Louthe Master group into the oeuvre of the author of the Saint Bertin altarpiece and for the identification of this painter with Simon Marmion. Essays in the present volume largely support Kren's views.[4]

The problem in the case of Simon Marmion is, of course, that no signed or documented work by this artist has been preserved. So the evidence for the identification is based on the often striking coincidence between the career of a fairly productive artist as outlined in the documents and a body of extant works, datable and localized mostly on the basis of style. If the body of attributed works is expanded or contracted, our picture of their maker obviously changes. When we argue about the identification we are comparing this artistic picture to the picture that emerges from the documents.

In this paper I shall address one instance, in which at first sight the two pictures do not seem to match. Miniatures that were once ascribed to Marmion and are now counted among the works of the Louthe Master occur in books of hours produced in Ghent and Bruges in the late 1470s and 1480s. According to the documents, during these years Simon Marmion remained in Valenciennes; there is no indication of a notable period of absence from his hometown.[5] In fact, this discrepancy seems to have been the implicit reason for the introduction of the anonymous Louthe Master, conceived by de Schryver more or less as a Ghent-based stylistic double of Marmion.

In his essay in this volume, however, Gregory T. Clark makes a strong case for considering the whole Louthe Master group as late works by Simon Marmion, and I find his suggestion convincing. In my view, too, the similarities with earlier works and the consistency in facial and figure types outweigh the progressive innovations in the works grouped around the Louthe Hours. Therefore, we have to find a different approach to the problem of comparing Marmion miniatures to illuminations by Ghent and Bruges artists in a number of books of hours. By taking a closer look at some of these manuscripts, we will see that it may be possible to reconcile our two

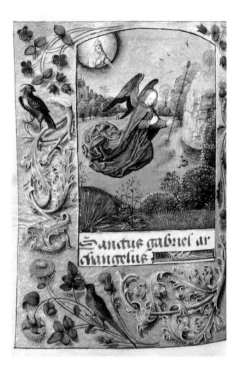

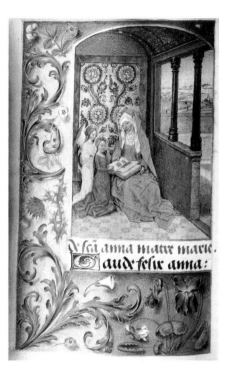

Figure 134.
Master of the Dresden Prayer Book. *Archangel Gabriel*, in the Louthe Hours. Louvain-la-Neuve, Université Catholique de Louvain, Ms. A. 2, fol. 109v. © A.C.L. Brussels.

Figure 135.
Simon Marmion. *Saint Anne*, in the Louthe Hours. Louvain-la-Neuve, Université Catholique de Louvain, Ms. A. 2, fol. 97v. © A.C.L. Brussels.

pictures of Marmion's activity in the late 1470s and 1480s, the one emerging from the documents and the other from the works themselves.[6]

I begin with the Louthe Hours itself. As de Schryver has already noted, the calendar and some of the suffrages were illuminated by the Master of the Dresden Prayer Book.[7] Two styles can be distinguished not only in the miniatures but also in the border decoration (figs. 134, 135). Every miniature by the Dresden Master is surrounded by a border with thick acanthus leaves and solid trunks quite distinct from the much longer and more elegantly curved leaves and stems in the borders framing Marmion's miniatures. Moreover, the borders belong to different types. Marmion uses a quite unusual three-sided border layout, the Dresden Master the more common four-sided one.[8] The two miniature and two border styles coincide exactly with the respective artists, i.e., all the Dresden Master's miniatures are framed by borders of one kind, all of Marmion's miniatures by borders of the other kind. This suggests that the manuscript was in the hands of two workshops operating apart from each other.

The Louthe Hours poses yet another problem. The Dresden Master has re-touched some of Marmion's faces; for instance, the loose brushstrokes in the hair of Saint Leonard and the highlighting on the forehead are his work (fig. 136). And he has even completed miniatures begun by Marmion. *Saint Michael Slaying the Devil* (fig. 137) is clearly one of the solid and energetic figures so characteristic of the Dresden Master, while the trees in the background are Marmion's. They differ from the bulbous, almost perfectly spherical forms used by the Dresden Master in a rather idiosyncratic manner, yet are virtually identical to trees rendered by Marmion, for example, in his miniature of *Saint Anthony in the Wilderness* (fig. 138). The most obvious explanation for these phenomena is that the Louthe Hours was left unfinished by Marmion and later completed by the Dresden Master. This could easily have happened at two different places, most likely Valenciennes and Bruges.

Codicological evidence supports this theory. The portion of the manuscript between the Office of the Virgin and the Penitential Psalms shows remarkable irregularities. Quires 15 and 16 each have two leaves, quires 17 and 18, four leaves each, which are singletons, that is, not parts of a regular bifolio. These quires contain the Five Joys of the Virgin and the suffrages. The sequence of the suffrages is highly unusual, switching several times between male and female saints. As mentioned above, the Dresden Master illustrated ten of the suffrages.[9] Though his miniatures as well as Marmion's occur both on bifolios and on singletons, there is not a single

Figure 136.
Simon Marmion (retouched by the Master of the Dresden Prayer Book). *Saint Leonard*, in the Louthe Hours. Louvain-la-Neuve, Université Catholique de Louvain, Ms. A. 2, fol. 112v (detail). © A.C.L. Brussels.

intact bifolio combining miniatures by both artists. In addition, two of the miniatures in this section are accompanied only by a two-line rubric, with the respective text missing on the following page, which is left empty.[10] All this suggests that extensive remodeling has taken place here, probably including the cutting up of bifolios and insertion of additional suffrages.[11]

Furthermore, there is at least one leaf, hitherto unpublished and now in the collection of Mark C. Morris, that appears to have once been part of the Louthe Hours (fig. 139). Its layout and dimensions correspond almost exactly with the features of the manuscript.[12] The miniaturist is doubtlessly Simon Marmion and both border style and script are virtually identical to those of the Louthe Hours, as is revealed, for instance, by a comparison with the beginning of the suffrage to Saint Catherine (fig. 140). Even the ruby color and somewhat varying intensity of the ink are the same. The fact that the two-line rubric leaves no space for the initial and the

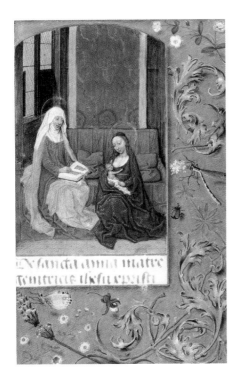

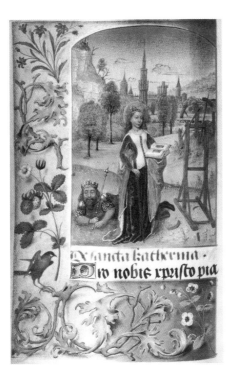

beginning of text itself is an oddity that also recurs in the Louthe Hours, as noted above.

The subject of the Morris miniature is Saint Anne with the Virgin and Child. At first sight, this seems to create a problem since there is already a representation of Saint Anne in the Louthe Hours (fig. 135). But, most unusually, the miniature cycle of the book in its present state already comprises other duplicates: there are two *Annunciations*, two *Nativities*, and two *Coronations of the Virgin*, because some subjects from the cycle for the Office of the Virgin are needed to illustrate the Five Joys. The compositions of these duplicate miniatures differ, however, as do the two depictions of Saint Anne in question. A prayer to the mother of the Virgin may have figured as an introduction to the Five Joys outside the regular sequence of suffrages. If this is so, the miniature in the Morris collection could have followed fol. 88 in the Louthe Hours, originally forming a bifolio with fol. 96, now a singleton.

However, there are still more complicated puzzles to solve. One of them is a charming little volume in the Victoria and Albert Museum, Ms. Salting 1221.[13] To judge by content, script, initials, penwork, and the characteristic threefold blue- and red-tipped blossoms, it is a typical Bruges book of hours (fig. 141). The large initials in black, gold, and silver at major text beginnings seem at first surprising (fig. 144b), but exactly this type of initial recurs in the Black Prayer Book in Vienna and, more generally speaking, in grisaille manuscripts.[14] In a recent exhibition in Brussels organized by Pierre Cockshaw, there were a number of books of hours combining elements of grisaille and full-color decoration.[15] Does the Salting Hours follow this trend, too? In fact it has a two-page opening near the beginning, where a Vrelantish illuminator provided a miniature of the *Martyrdom of Saint Catherine* in a semi-grisaille style with proper grisaille borders.[16]

Up to this point, therefore, the Salting Hours appears to be an entirely normal Bruges book of hours like dozens of others. But the *Martyrdom of Saint Catherine* is the only miniature by that follower of Willem Vrelant. All but three of the other miniatures are again in the style of Simon Marmion. The borders surrounding them and the borders on the facing text pages, however, were executed by the Dresden Prayer Book Master (figs. 144a–b) and by a third Bruges hand, whom I call the Master of Fitzwilliam 268.[17]

The appearance of Marmion's style literally side by side with Bruges work is hard to explain, given the fact that Marmion's name does not figure in the Bruges guild records and that the marketing and sale of illuminated single leaves imported from outside Bruges was prohibited in 1457, except when they were bound in complete books.[18] I would nevertheless suggest that the Valenciennes atelier of Simon Marmion delivered a set of miniatures to the Bruges illuminators or, perhaps more likely, to one of the "librariers," the book dealers so frequently mentioned in the guild documents, who then had the volume completed. My assumption is that these

Figure 141.
"Octo versiculi sti bernardi," in the Salting Hours. London, Victoria and Albert Museum, Ms. Salting 1221, fols. 237v and 238. Reproduced by kind permission of the Board of Trustees.

miniatures were delivered without borders and that either each one was painted on a separate leaf or several were grouped together on a larger sheet of vellum.[19] After their arrival in Bruges they were cut up and borders were added. It can in fact be seen in the Salting Hours that pigments applied by the Dresden Master frequently overlap the gold-leaf frame of Marmion's miniatures (figs. 142, 144a–b). I am tempted to compare the process of production to modern car manufacturers who order and assemble ready-made parts like exhausts, carburetors, and shock absorbers—all highly sophisticated objects produced by independent firms not only owned by someone else but possibly even located in different places.

But are borderless miniatures at all possible? It is interesting that they occur in books of hours in both Marmion's oeuvre and the oeuvre of one of his followers, the Master of Antoine Rolin, while they are quite exceptional in hours from Ghent and Bruges.[20] So it may not have been too unusual for Marmion's atelier in Valenciennes to deliver miniatures without borders. This very absence of borders may have permitted the importation of those leaves to Bruges, for they could be regarded as unfinished. The policy of the guild and city council clearly aimed at establishing a monopoly for Bruges illuminators. But if my assumption is correct, Salting 1221 did not really challenge this monopoly, since Bruges illuminators worked on all the imported leaves before they were bound up. And they did ambitious work indeed: the acanthus ornament and the lively droleries in the borders added by the Dresden Master are of outstanding quality.[21]

What is the advantage of such a complicated theory? Quite simply, it provides an explanation for what Sandra Hindman has rightly called a "strikingly unusual feature" of Salting 1221—the sequence of three miniatures following immediately after each other on two inserted folios at the beginning of the Office of the Dead (figs. 142–144a–b).[22] While the two miniatures on versos, the *Last Judgment* and *Raising of Lazarus*, are by Marmion, the spectacular full-page representation of hell and paradise on the recto of the *Lazarus* leaf (fig. 143) was not painted by Marmion but by

Figure 142.
Simon Marmion. *Last Judgment* (border by the Master of the Dresden Prayer Book), in the Salting Hours. London, Victoria and Albert Museum, Ms. Salting 1221, fol. 152v. Reproduced by kind permission of the Board of Trustees.

Figure 143.
Master of Fitzwilliam 268. *Hell and Paradise*, in the Salting Hours. London, Victoria and Albert Museum, Ms. Salting 1221, fol. 153. Reproduced by kind permission of the Board of Trustees.

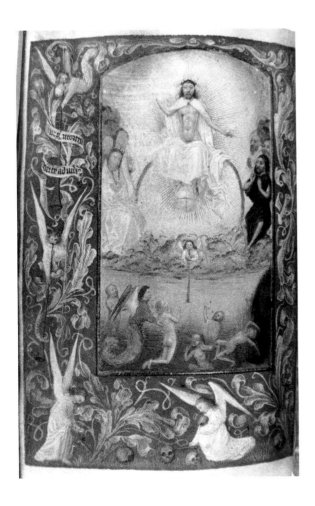
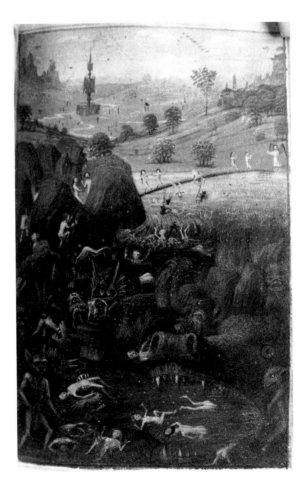

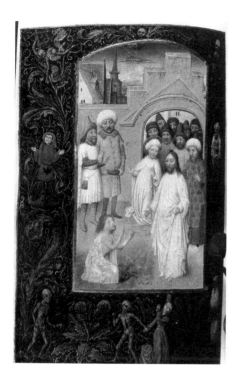

Figure 144a.
Simon Marmion. *Raising of Lazarus*, in the Salting Hours. London, Victoria and Albert Museum, Ms. Salting 1221, fol. 153v. Reproduced by kind permission of the Board of Trustees.

Figure 144b.
Border by the Master of the Dresden Prayer Book. Office of the Dead in the Salting Hours. London, Victoria and Albert Museum, Ms. Salting 1221, fol. 154. Reproduced by kind permission of the Board of Trustees.

the Bruges Master of Fitzwilliam 268. One comparison will suffice: the landscape in the background of the paradise scene and that painted by the same hand elsewhere in the manuscript are remarkably similar (figs. 143, 145). Trees are structured the same way, slopes wind down equally smoothly, and, above all, the pigments are the same, including a grayish tonality that gives the sky a more realistic look than in Marmion's miniatures.

I suggest the following hypothesis: the set of miniatures delivered by Marmion's atelier included a *David in Prayer* along with a *Last Judgment*, the two most common choices to illustrate the Penitential Psalms. The delivery of both scenes was either an error or intended to give the Bruges workshop an option. When assembling the book, the workshop picked the *David* miniature, which is still in its place at the Penitential Psalms (fol. 129v). However, the shop wanted to use the *Last Judgment* as well and decided to insert it at the second appropriate place, the Office of the Dead, preceding the *Lazarus* miniature. Consequently, in order to avoid the unpleasant blank page between the two images, one of the Bruges illuminators involved in the project, the Master of Fitzwilliam 268, had to add the thematically related hell and paradise landscape to the back of Marmion's *Lazarus* leaf.

This theory can be tested with another example, the famous "Voustre Demeure" Hours, from which twenty miniatures were cut out and pasted into an album now in Berlin, while the bookblock is in Madrid.[23] G.I. Lieftinck's reconstruction of the manuscript is unacceptable, since it even places miniatures between two successive Hours of the Virgin, right in the middle of text.[24] I was thus prepared to find

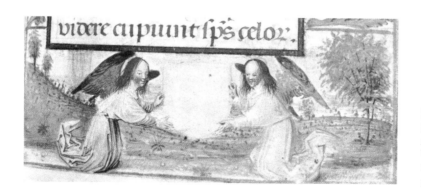

Figure 145.
Master of Fitzwilliam 268. *Angels Holding a Blank Shield*, in the Salting Hours. London, Victoria and Albert Museum, Ms. Salting 1221, fol. 13 (detail). Reproduced by kind permission of the Board of Trustees.

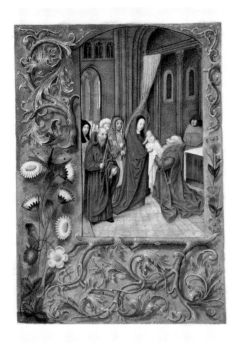

Figure 146.
Circle of the Master of Mary of Burgundy. *Presentation in the Temple*, removed from the "Voustre Demeure" Hours. Berlin, Staatliche Museen Preussischer Kulturbesitz, Kupferstichkabinett, Ms. 78 B 13, no.7. Photo: Jörg P. Anders.

Figure 147.
Circle of the Master of Mary of Burgundy. Terce in the "Voustre Demeure" Hours. Madrid, Biblioteca Nacional, Ms. Vit. 25–5, fol. 150.

in Madrid a rather disturbed and complicated volume.[25] To my great surprise, the manuscript turned out to be more or less intact, except for the missing pictures, and to provide appropriate places for all the Berlin leaves and for a miniature of the same size, now in Philadelphia, representing the *Pietà*.[26] The Office of the Virgin of the "Voustre Demeure" Hours has a regular structure and apparently once had the canonical cycle of illustrations from the *Annunciation* at matins to the *Coronation of the Virgin* at compline.

Even more astonishing is the fact that Lieftinck's bizarre conclusion grew out of a quite reasonable assumption. Lieftinck observed that in some cases the borders surrounding the Berlin miniatures exactly correspond with borders in the Madrid book.[27] The brocade border framing the miniature of *Saint John the Baptist*, the pure flower border at the beginning of the Penitential Psalms, or the pure white flower border surrounding the miniature of the *Ascension* are obviously designed to match the one on the facing page.[28]

Initially, this seems to be the underlying principle throughout the Office of the Virgin as well. Matins and lauds both show "matching" borders.[29] At prime it is somewhat hard to decide.[30] Then Lieftinck placed the *Presentation in the Temple* at terce and we now understand why (figs. 146, 147): both borders share characteristic features such as the same acanthus style and the presence of straight-lined trunks.[31] This assumption forced him, however, to assign a position somewhere in the text of prime to the two preceding miniatures, the *Annunciation to the Shepherds* and the *Adoration of the Magi*. Of course this is almost impossible. Given that both the text and the cycle of miniatures are regular and complete, it seems more reasonable to base the reconstruction on the long-standing and well-established iconographic tradition for the illustration of the Office of the Virgin. Thus, the *Shepherds* at terce and the *Magi* at sext would have preceded, as usual, the *Presentation* at nones. In this reconstruction, the borders at the beginning of terce would no longer match. But, toward the end of the Office, further mismatches occur that also break this rule.[32]

On the other hand, one has the distinct impression that the borders of the *Presentation* and of the beginning of terce were intended as matching borders, for they are the only ones in both the Berlin set of miniatures and the Madrid book with those straight-lined trunks. Could it be that it was not Lieftinck who was wrong, but the workshop that assembled the "Voustre Demeure" Hours? The considerable stylistic differences among the Berlin miniatures accord with this theory. It has long been noticed that the miniatures seem to come from three or more fundamentally differ-

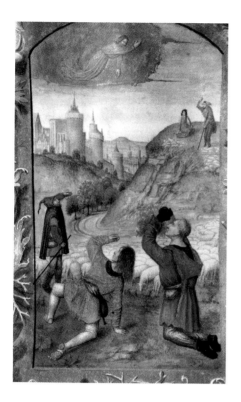

Figure 148a.
Circle of the Master of Mary of Burgundy.
Annunciation to the Shepherds, removed from
the "Voustre Demeure" Hours. Berlin,
Staatliche Museen Preussischer Kulturbesitz,
Kupferstichkabinett, Ms. 78 B 13, no. 5.
Photo: Jörg P. Anders.

Figure 148b.
Detail of figure 148a.

ent ateliers.[33] Again, if we assume that each atelier delivered its miniatures sepa-
rately and perhaps even from another place to the workshop where the book was
assembled, little errors in the general harmony of the border decoration would not
be so unexpected. If miniatures on separate leaves or sheets came into the shop from
different sources, this could easily have caused disorder or misunderstandings during
the planning and execution of the decoration.[34]

It is worth noting that a number of the Berlin leaves provide evidence for bor-
ders being in fact painted later than miniatures. This contradicts some experiences
with earlier material.[35] A close examination of the upper right corner of the *Annun-
ciation to the Shepherds*, for example, reveals that a small area of sky-blue pigment
projects into the border and is clearly overpainted with the sand color of the border
ground (figs. 148a–b). This could only have happened if the sky was painted before
the border was there. In addition, there is another manuscript from our group which
definitely proves that miniatures could precede borders. The Huth Hours in the
British Library contains images of two kinds: full-page miniatures with and without
borders.[36] Once again, all but two of them are attributable to Simon Marmion.[37] On
a number of folios with miniatures, strips of parchment have been pasted to the outer
margin to enlarge the page (fig. 149). This was certainly done because the miniature

Figure 149.
Diagram showing full page miniatures with
and without borders as they occur in the
Huth Hours. London, British Library,
Add. Ms. 38126. © Bodo Brinkmann.

was already there; otherwise, the empty leaf could simply have been exchanged for a larger one. The border decoration on these pages, however, is painted over the strips, so it must have been executed after their addition and after the miniature was painted.

The distribution of these added strips exactly coincides with the two categories of miniatures in the Huth Hours. None of the borderless miniatures has the parchment additions; but they occur on all pages with miniatures that are framed by borders.[38] Therefore the most probable explanation for the added strips is that two sets of miniatures were used, and for some unknown reason the second set followed a different layout.

I shall briefly touch upon a third manuscript belonging to the same group as the "Voustre Demeure" and Huth Hours: the two-volume book of hours in the Houghton Library at Harvard.[39] One of the problems with this book is that it is severely mutilated; Roger Wieck estimates that it is wanting between twenty-three and forty full-page miniatures.[40] We thus have to deal with an unknown factor when separating hands and discussing workshops. Nevertheless, there are still three full-page miniatures and some small, square pictures on text pages by Simon Marmion in the book. As Hindman and Kren have pointed out, the Houghton Hours is like a missing link between the "Voustre Demeure" and the Huth Hours.[41] Connected with the latter by codicological and layout features, it also contains repetitions of the highly original historiated borders from the Madrid manuscript.

Though sorting out hands in the group of works associated with the name of the Master of Mary of Burgundy still remains a risky undertaking, there are remarkable parallels between the best styles in the "Voustre Demeure" and the Houghton Hours. The famous miniature (no. 10) from the Berlin set combining a Gethsemane scene with a *Crucifixion* is as beautiful as the *Saint Anthony* in the Houghton Hours. Moreover, both miniatures share ways of depicting trees and other background motifs and, most important, a special technique of stippling brushwork. An extremely fine layer of darker spots is applied over a thin, translucent ground of the same color to achieve modeling and shading.[42] Since this very elaborate technique is exceptional even among the leaves from the Berlin series, the Berlin *Crucifixion* and the Houghton *Saint Anthony* might well be by the same hand. In addition, the border strips with acanthus and flowers are stylistically very close in the "Voustre Demeure," Huth, and Houghton Hours. Finally, their calendars were all illustrated by the same artist, the Master of the Dresden Prayer Book, who also contributed historiated initials to the Houghton Hours.

It is tempting, therefore, to regard the three books of hours as products of the same workshop. The multitude of styles in the Berlin miniatures from "Voustre Demeure" could be explained, as we have seen, by the assumption that they were delivered from other ateliers.

In the Houghton Hours, the procedure seems to have been slightly different. On a number of pages on which a text begins, the height of the border has been enlarged by adding between 3 and 6 mm of painted area at the bottom (fig. 150).[43] The most obvious explanation for this correction is that it was undertaken to equalize the differing dimensions of the facing miniatures. This would mean that those borders in the bookblock were painted before the miniatures were available. But, more important in our context, it also could mean that the miniatures again came into the shop from an outside atelier.[44]

Where can the workshop that assembled the actual volumes be localized? Scholars have always tended to assign the "Voustre Demeure" and the Houghton Hours to Ghent and the Huth Hours to Valenciennes. All the miniatures in the latter manuscript are in fact attributable to Marmion's atelier. But there are several irritating discrepancies. First, the Huth Hours has a contemporaneous binding that points to Ghent or Bruges, not to Valenciennes. Exactly the same binding covers Douce 223, which is practically the only book of hours from the Master of Mary of Burgundy group that can be localized with some certainty: it has unusual saints whose relics

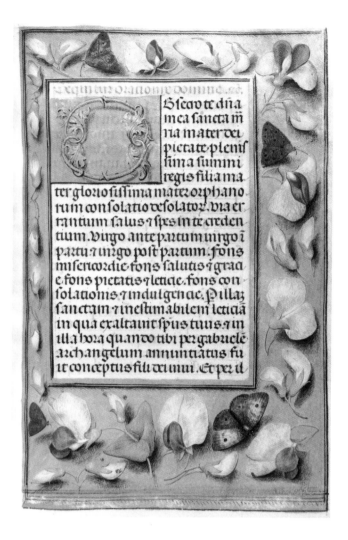

Figure 150.
Circle of the Master of Mary of Burgundy.
Text page with decorated border from
the Houghton Hours. Cambridge, Harvard
University, Houghton Library, Ms. Typ. 443,
fol. 85.

belonged to the Ghent abbey of Saint Peter Blandin.[45] And, surprisingly, in Douce
223 we find a *Nativity* by a Ghent illuminator that is clearly derived from Marmion's
composition in the Huth Hours.[46] Second, the so-called Master of the David Scenes
of the Grimani Breviary, probably also active at Ghent, draws on the Huth miniatures
as well. In at least two manuscripts, he uses not only the same patterns but rather
successfully imitates Marmion's typical palette.[47] Third, in the Huth Hours itself,
Marmion's miniature of the *Raising of Lazarus* has been overpainted (fig. 151). As a
comparison with Marmion's Berlin *Lazarus* scene reveals, composition, figure types,
and background are his, but the extraordinary physical presence of figures, their plas-
ticity, soft shading, and warm coloring, including *couleur changeant* effects, and the
impressive loose brushwork in the faces reach far beyond anything Marmion ever
painted.[48]

I have gone through the Huth Hours time and again seeking other contribu-
tions by this hand, but all I have found is what may seem at first a strange comparison:
some superb borders, such as the two reproduced here (figs. 152, 153), have the same
pigments, warm coloring, vibrating surface, and astonishing plasticity of the *Lazarus*
miniature. I assume that this border painter did the overpainting of the *Lazarus* scene
in the Huth Hours and that this is rather unlikely to have happened under Marmion's
eyes.[49] Hence it seems to me not entirely impossible that even the Huth Hours re-
ceived its border decoration at Ghent.

Artists traveled, books traveled, and so did even miniatures on single leaves. The
problem is to find out in each case which of the three possibilities is the most likely.
The peculiarities in the Salting, "Voustre Demeure," and Huth Hours provide, as I
have tried to point out, arguments for single leaves being delivered from different
sources and possibly from different places to a workshop that assembled and prob-

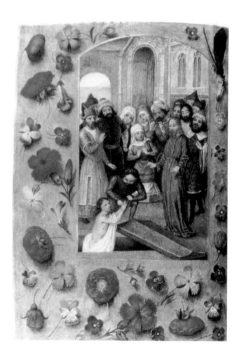

Figure 151.
Simon Marmion (overpainted by Ghent [?]
illuminator). *Raising of Lazarus*, in the Huth
Hours. London, British Library, Add. Ms.
38126, fol. 150v. Reproduced by kind permis-
sion of the British Library Board.

Figure 152.
Ghent (?) artist. Decorated border, in the Huth Hours. London, British Library, Add. Ms. 38126, fol. 27. Reproduced by kind permission of the British Library Board.

Figure 153.
Ghent (?) artist. Decorated border, in the Huth Hours. London, British Library, Add. Ms. 38126, fol. 78v. Reproduced by kind permission of the British Library Board.

ably sold the book. Admittedly, this remains a hypothesis, and it surely raises new questions. But its virtue is to explain some phenomena that are left unexplained by the assumption of an independent artist working in Marmion's style at Ghent.

Notes

1 See especially Hoffman 1973 and Hindman 1977.

2 For the Louthe Hours see, among others, J. Casier and P. Bergmans, *L'art ancien dans les Flandres: Mémorial de l'exposition organisée à Gand en 1913* (Brussels and Paris, 1921), vol. 2, pp. 67–75, figs. 232–45; Ghent 1975, p. 375f., no. 612. The grouping was first suggested by A. de Schryver, in de Schryver/Unterkircher 1969, pp. 150–54, and Ghent 1975, pp. 331f., 364, 366, 373, divided further by Hindman 1977, pp. 188–91, and accepted by Dogaer 1987, p. 140.

3 See Pächt 1979; Sterling 1981; Malibu 1983, pp. 31–39.

4 See, for instance, Kren's remarks in the Introduction to this volume as well as the contributions of Gregory T. Clark, Sandra Hindman, and de Schryver himself, who has revised his earlier opinions.

5 See Hénault 1907–08, vol. 9, p. 128f., and the documents in vol. 10, pp. 108–12.

6 I shall not, however, discuss the following three works: 1) the single page depicting an enthroned Virgin and Child that Marmion contributed to the Vienna Hours of Charles the Bold or Mary of Burgundy (Vienna, Österreichische Nationalbibliothek, Cod. 1857, fol. 35v); 2) his *Crucifixion* in the Prayer Book of Philip the Good (Paris, Bibliothèque Nationale, Ms. nouv. acq. fr. 16428, fol. 84); 3)

Cambridge, Fitzwilliam Museum, Founder's Ms. 165, comprising *L'instruction d'un jeune prince*, with a miniature by Marmion (fol. 10v) and *La mortifiement de vaine plaisance*, illustrated by Loyset Liédet. All three manuscripts belong to other artistic circles and pose different problems from those discussed here. See, respectively, de Schryver/Unterkircher 1969, p. 149f., and Vienna 1987, pp. 52–56, no. 16, fig. 8; Ghent 1975, p. 365f., no. 597, and M. Thomas, "Le Livre de Prières de Philippe le Bon: Premier bilan d'une découverte," *Les dossiers de l'archéologie* 16 (1976), p. 93f., figs. 4f.; Hindman 1977, pp. 191–93, figs. 10f.

7 Ghent 1975, p. 375f. Dogaer 1987 reproduces four miniatures from the Louthe Hours as works of the Louthe Master; three of them (his figs. 86, 88, 89) are by Simon Marmion, one (fig. 87) is by the Master of the Dresden Prayer Book.

8 At present, only four other manuscripts with three-sided border layouts are known to me. All of them point to the area of Cambrai or Valenciennes:
 1) the Hours of Jean de Gros (Chantilly, Musée Condé, Ms. lat. 1175), illuminated by Simon Marmion. See Clark, pp. 197–98, below.
 2) a now dispersed book of hours for the use of Cambrai, single leaves of which are preserved in Frankfurt (Historisches Museum, C. 85–89, 754–59, 6439–41). Others, including thirteen leaves with miniatures,

were recently auctioned at Paris (Hôtel Drouot, Paris, *Manuscrits du XIIe au XVIIIe siècles*, May 19, 1976, lot 26). In addition, the illustrated calendar leaves of that hours are in Munich (Staatliche Graphische Sammlungen, 40051–62). The style is very close to Marmion.

3) London, British Library, Harley Ms. 1211, a book of hours for the use of the convent of Saint Hermes near Cambrai (fol. 21).

4) a book of hours by the Master of Antoine Rolin, discovered by James Marrow in the Houston Public Library, Ms. de Ricci 6. On this artist, see Anne-Marie Legaré's essay in the present volume.

9 A brief description of this part of the manuscript may be useful: 15^{6+2}: +89, 90–95, +96; 16^{2+2}: +97, 98–99, +100; 17^{4+4}: +101, +102, 103, +104, 105–06, +107, 108; 18^{6+4}: +109, +110, 111–12, +113, 114–15, +116, 117–18. Miniatures (those by the Dresden Master are marked with an asterisk): fol. 89, *Trinity*; 90v, *Annunciation*; 91v, *Nativity*; 92v, *Resurrection*; 93v, *Ascension*; 94v, *Coronation of the Virgin*; 95v, *Beheading of John the Baptist*; 96v, *Saint John on Patmos*; 97v, *Saint Anne*; 98v, *Saint Catherine*; 99v, *Saint George*; 100v, guardian angel with owner praying; 101v, *Saint Anthony*; 102v, *Saint Eligius*; 103v, *Saint Sebastian* *; 104v, *Saint Fabian*; 105v, *Saint Christopher* *; 106v, *Saint Thomas of Canterbury* *; 107v, *Saints Ciricus and Iulita* *; 108v, *Saint Michael* *; 109v, *Saint Gabriel* *; 110v, *Saint Erasmus* *; 111v, *Saint Barbara*; 112v, *Saint Leonard*; 113v, *Thomas of Hereford*; 114v, *Niclas* *; 115v, *Saint Margaret* *; 116v, *Saint Luke* *; 117v, *Mary Magdalene*. On fol. 90v, the Five Joys of the Virgin begin, ending on fol. 95. All other texts are short suffrages ending on the page following the miniature. The sequence ends on fol. 118, its verso being left empty.

10 Fols. 110 and 114 are lacking text.

11 At present I am unable to decide whether the portions of text related to the miniatures by the Dresden Master could have been added slightly later by another hand that skillfully imitates the *lettre bâtarde* of the rest of the book or if they were written by the same scribe. If the latter is true, Marmion may have not completed the corresponding miniatures. In this case, bifolios consisting of one folio illuminated by Marmion and another one left empty might have been cut apart before the Dresden Master worked on them in order to save the finished half from wear and tear in the workshop.

12 The border areas of the Marmion miniatures in the Louthe Hours measure circa 133×85 mm, compared to 131×84 mm on the Morris leaf. The justification is 90×61 mm in the Louthe Hours, 89×60 mm on the leaf. Though the text on the back has been erased, it can still be seen to have occupied only approximately nine lines. This feature explains why the leaf could have disappeared without leaving the text in the book incomplete. This explanation also accords with the fact that prayers in that portion of the Louthe Hours are unusually short.

I would like to thank Mr. Morris for kindly providing very detailed information on his leaf as well as giving me permission to reproduce it here.

13 On this manuscript, see Winkler 1925, p. 180; Hoffman 1969, p. 245; Hoffman 1973, p. 273; Hindman 1977, p. 193; Harthan 1977, pp. 146–49; J. Harthan, *An Introduction to Illuminated Manuscripts* (London, 1983), p. 34, pl. 21; Dogaer 1987, pp. 103, 131, 141.

14 For the Black Prayer Book (Vienna, Österreichische Nationalbibliothek, Cod. 1856), see the facsimile edition by U. Jenni and D. Thoss, *Das Schwarze Gebetbuch (Gebetbuch des Galeazzo Maria Sforza): Codex 1856 der Österreichischen Nationalbibliothek in Wien* (Frankfurt, 1982), and Vienna 1987, pp. 48–50, no. 14, fig. 6.

15 See P. Cockshaw, *Miniaturen in Grisaille*, exh. cat. (Bibliothèque Royale, Brussels, 1986), passim, and p. 41, no. 20 (Brussels, Bibliothèque Royale, Ms. IV, 91) for an initial closely resembling the ones in the Salting Hours.

16 Fols. 15v–16, color reprod. in Harthan 1977, p. 146.

17 The Dresden Master has decorated the borders on fols. 18v–19, 27, 47, 152v, and 153v–54. All remaining borders were done by the Master of Fitzwilliam 268, who also executed the miniatures not by Marmion: fols. 85v, 97v, and 153.

The artist is named after the book of hours in the Fitzwilliam Museum, Cambridge, Ms. 268, on which see F. Wormald and P.M. Giles, *A Descriptive Catalogue of the Additional Manuscripts in the Fitzwilliam Museum Acquired Between 1895 and 1979* (Cambridge, 1982), pp. 211–15. The following works are attributable to this illuminator: 1) Fitzwilliam 268; 2) book of hours, location unknown; ex-coll. René Héron de Villefosse (attributed by Wormald and Giles); 3) London, British Library, Add. Ms. 36619; this and nos. 4) and 5) all Ordinances of Charles the Bold; 4) The Hague, Rijksmuseum Meermanno-Westreenianum, Ms. 10. C. 3; 5) Munich, Bayerische Staatsbibliothek, Cod. gall. 18; 6) a Virgil in Holkham Hall, Library of the Earl of Leicester, Ms. 311, vol. 1, fol. 9, only the miniature of the first campaign for Jan Crabbe, dated 1473; probably also by this artist are 7) *Histoire de César*, Pommersfelden, Gräflich Schönbornsche Schlossbibliothek, Ms. 310; 8) New York, Pierpont Morgan Library, M. 232, Petrus de Crescentiis, *Livre des profits ruraux*; the same work in 9) Paris, Bibliothèque de l'Arsenal, Ms. 5064.

18 The passage reads: "dies ne zullen de voorseide persoonen beildekins van verlichterien makende, noch ooc de voorseide librariers tooch maghen maken binnen der voorseide stede van Brugghe van eeneghe vreimde beildekins buten der stede ghemaect, of die binnen vercoopen, ten zii in ghebondene bouken van buten inghebrocht"; see W.H.J. Weale, "Documents inédits sur les enlumi-

neurs de Bruges," *Le Beffroi* 4 (1872–73), p. 250.

19 It should be mentioned that all full-page miniatures in the Salting Hours are painted on single leaves *inserted* into the gathering, not an integral part of it. This is also true of all the other full-page miniatures I am going to discuss. Inserted singletons are a common and well-known feature of Flemish books of hours and also of those produced by the Marmion atelier.

20 The two hours by Marmion with borderless miniatures are Madrid, Biblioteca Nacional, Ms. Res. 149, and Turin, Museo Civico, Ms. 558. For the Madrid Hours, see Ghent 1975, p. 364f., no. 596; Domínguez Rodríguez 1979, pp. 16–20, no. 2; *Burgund im Spätmittelalter, 12. bis 15. Jahrhundert*, exh. cat. (Ingelheim, 1986), p. 46f., no. 20. For the Turin manuscript, Brussels 1959, p. 173. The hours for an unrecorded use resembling that of Amiens illuminated by the Master of Antoine Rolin is in a private collection in Belgium; see Legaré, p. 218, below.

21 On the aesthetic aims and possible artistic roots of the marginal decoration in the Salting Hours, see my paper in the *Acts of the Congress on Medieval Manuscript Illumination in the Northern Netherlands*, December 10–13, 1989 (in press).

22 Hindman 1977, p. 193.

23 Berlin, Staatliche Museen Preussischer Kulturbesitz, Kupferstichkabinett, Ms. 78 B 13, and Madrid, Biblioteca Nacional, Ms. Vit. 25–5. On the "Voustre Demeure" Hours, see, among others, Winkler 1925, pp. 103f., 113, 159, 183; P. Wescher *Beschreibendes Verzeichnis der Miniaturen—Handschriften und Einzelblätter—des Kupferstichkabinetts der Staatlichen Museen Berlin* (Leipzig, 1931), pp. 167–72, figs. 170–75; G. Hulin de Loo, "La vignette chez les enlumineurs gantois entre 1475 et 1500," *Académie Royale de Belgique. Bulletin de la Classe des Beaux-Arts* 21 (1939), pp. 162–64, 177f.; Pächt 1948, p. 67f., and passim, nos. 15f.; Lieftinck 1969, pp. 77–108, figs. 114–64; Van Buren 1975, pp. 292, 306; Ghent 1975, p. 377f., no. 615; Domínguez Rodríguez 1979, pp. 125–30, pls. 15f.; Dogaer 1987, pp. 131, 137, 145, 149.

24 Lieftinck 1969, p. 105f. Van Buren 1975, p. 292, already noted that the reconstruction is impossible. Since then, Domínguez Rodríguez 1979, p. 125f., has published a mostly correct but incomplete reconstruction. However, the *Annunciation to the Shepherds* belongs to terce and the *Adoration of the Magi* to sext. Furthermore, Domínguez Rodríguez has simply omitted three of the leaves from the Berlin series that are difficult to place. They are the *Virgin and Child* (no. 1), the *Elevation of the Host* (no. 16), and the *Noli me tangere* (no. 20), and they preceded the Obsecro te (fol. 54; see Lieftinck 1969, fig. 136), the Mass of the Virgin (fol. 31; ibid., fig. 120), and the Mass for Easter (fol. 78), respectively.

25 As suggested by Lieftinck 1969, p. 83.

26 Philadelphia Museum of Art, John G. Johnson Collection, 343. The leaf was attributed to Marmion by Winkler 1923, p. 255, fig. 275. Hulin de Loo (note 23), p. 177, was the first to relate the miniature in Philadelphia to the "Voustre Demeure" Hours. His suggestion, however, has apparently escaped scholars' notice ever since. More recently, see Sweeny 1972, p. 52f., no. 343, fig. 111.

 The dimensions and shape of the Philadelphia miniature (119×89 mm) correspond very well with the two borderless miniatures by Marmion from the Berlin set (no. 1, 118×88 mm; no. 20, 117×86 mm). Furthermore, the hierarchy of decoration in the "Voustre Demeure" Hours demands a full-page miniature preceding the Stabat Mater (fol. 64; see Lieftinck 1969, fig. 115), and the Pietà is a common subject in Flemish hours at this place in the text.

27 Lieftinck 1969, pp. 80–87.

28 No. 17 would face fol. 187; no. 14 would face fol. 214; and no. 11 would face fol. 66. Lieftinck 1969, figs. 151 and 141, 163 and 148, 128 and 129, respectively.

29 Matins: no. 2 facing fol. 114; lauds: no. 3 facing fol. 129. Lieftinck 1969, figs. 155 and 140, 156 and 142.

30 Prime: no. 4 facing fol. 144. Lieftinck 1969, figs. 157 and 143.

31 Ibid., p. 84.

32 The rest of the cycle is to be reconstructed as follows. Terce: no. 5 before fol. 150; sext: no. 6 before fol. 156; none: no. 7 before fol. 162; vespers: no. 8 before fol. 168; compline: no. 13 before fol. 179. At sext, a sand-colored border faces a gray one, at vespers a sand-colored border faces one with a unique olive green ground that is probably unfinished. At compline, borders match comparatively well again. See Lieftinck 1969, figs. 160 and 144, 146 and 121, 150 and 145, 158 and 147, 162 and 139.

33 See, for instance, Winkler 1925, p. 159, and Lieftinck 1969, pp. 98–105.

34 The more so since the book seems to have been produced in a short time because its text was probably written by at least two hands and all rubrics are missing (though the scribes left space for them) in a part of the Office of the Virgin, fols. 146–68.

35 For instance, the well-known unfinished hours in the Pierpont Morgan Library, M. 358; see R.G. Calkins, "Stages of Execution: Procedures of Manuscript Illumination as Revealed in an Unfinished Book of Hours," *Gesta* 17 (1978), pp. 61–70. An unfinished English hours from the beginning of the fifteenth century in Boulogne-sur-Mer (Bibliothèque Municipale, Ms. 93/101) reveals a similar process.

36 British Library, Add. Ms. 38126; on this manuscript, see Malibu 1983, pp. 31–39, no. 4, with full bibliography.

37 The two full-page miniatures not by Marmion are the *Visitation* (fol. 66v) and the *Disputation of Saint Barbara* (fol. 145v). Both were executed by the same artist. They are remarkably progressive in style, e.g., in the detailed rendering of landscape and architecture, and exceptional in their technical execution—reminiscent of both watercolor and drawing techniques. Winkler tentatively attributed them first to Simon Bening (Winkler 1925, pp. 40, 178) and later to Gerard Horenbout ("Neuentdeckte Altniederländer, II: Gerard Horenbout," *Pantheon* 31 [1943], p. 60, figs. 6f.), thus merely indicating their high quality and surprising style. However, as Kren notes (Malibu 1983, p. 37f.), neither attribution is convincing and the artist still appears to be unique in many respects.

 It is tantalizing, though admittedly hypothetical, to think of the two miniatures as works of the young Jan Provost. The fact that Provost married Marmion's widow, Jeanne de Quaroube, sometime before September 5, 1491 (Hénault 1907–08, vol. 10, p. 113, no. 80), less than two years after her husband's death, almost certainly indicates that the painter spent some time in Marmion's workshop. Because lauds is recited following matins without an interruption, the *Visitation* miniature was apparently considered less important by illuminators and its execution often left to an assistant. Historical circumstances would thus make Provost a possible author of the two illuminations in question.

 The art historical side of the question is somewhat puzzling, since Provost's early period is still rather unclear. However, it is worth noting that the highly original composition of the *Barbara* miniature, with the figures in the foreground set as if on a proscenium, has an analogy in a miniature of the Mayer van den Bergh Breviary attributed to Provost by Winkler, "Buchmalereien von Jan Provost," in *Miscellanea Prof. Dr. D. Roggen* (Antwerp, 1957), pp. 285–89 and fig. 1; color reprod. in C. Gaspar, *The Breviary of the Mayer van den Bergh Museum at Antwerp* (Brussels and New York, 1932), fol. 536v. In addition, the facial types, with their stereometric contours of the head and tiny black pupils, are quite similar, and they occur in panel paintings by Provost as well; see, for instance, the angels and saints in the *Last Judgment* in Detroit (M.J. Friedländer, *Early Netherlandish Painting*, vol. 9b [New York and Washington, 1973], no. 157, pl. 171). As Winkler notes, a reversed version of the Mayer van den Bergh composition recurs in a panel attributed to Provost (Winkler's fig. 3) and dated circa 1485–90 by G. Ring, "Additions to the Work of Jan Provost and Quentin Massys: I. Jan Provost: A Series of Panels from His Early Period," *Burlington Magazine* 79 (1941), pp. 156–60.

 In my view, there is sufficient evidence for at least a tentative attribution of the two outstanding images from the Huth Hours to Jan Provost. (I would like to thank Diane Scillia and Matthias Weniger for discussing this suggestion with me.)

38 Strips are added on fols. 83v, 109v, 135v, 143v, 148v, 150v, 209v. Since the parchment is extremely fine, the additions are clearly visible in the original, though hardly so in reproductions. The only reproduction known to me that shows the strip is in F.G. Kenyon, *Catalogue of the Fifty Manuscripts and Printed Books Bequeathed to the British Museum by Alfred H. Huth* (London, 1912), pl. 14d (fol. 148v).

39 Cambridge, Harvard University, Houghton Library, Ms. Typ. 443–443.1. On this book of hours, see, among others, Hulin de Loo (note 23), pp. 167f., 179f., pl. 6; Pächt 1948, p. 71f., no. 31; Hindman 1977, pp. 189–91; Malibu 1983, p. 33f.; Dogaer 1987, pp. 131, 141, 149; R.S. Wieck, *Late Medieval and Renaissance Illuminated Manuscripts 1350–1525 in the Houghton Library* (Cambridge, 1983), pp. 50f., 133f., no. 24, with full bibliography.

40 Wieck (note 39), p. 50.

41 Hindman 1977, pp. 189–91, and Malibu 1983, p. 33f.

42 The Berlin leaf is reproduced in color in G. Achten, *Das christliche Gebetbuch im Mittelalter*, exh. cat. (Staatsbibliothek Stiftung Preussischer Kulturbesitz, Berlin, 1987), pl. 19; a good black-and-white reproduction of the Houghton miniature (fol. 99v) is found in Hulin de Loo (note 23), pl. 6b.

43 On fols. 15, 68, 85, 98, 124, 132, 153, 160.

44 It should be noted, however, that in this respect the Houghton Hours is not unique. The same phenomenon was observed by Andreas Grote and Hinrich Sieveking in the Grimani Breviary, on fols. 14v, 51v, 75, 162v, 205v, 213v, 286v, 310v, 321v, 348v, 357v, 407v, 432v, 468v, 478v, 500v, 514v, 530v, 538v, 579v, 602v, 610v, 632v, 635v, 646v, 719v, 756v; see A. Grote, ed., *Breviarum Grimani: Faksimileausgabe der Miniaturen und Kommentar* (Berlin, 1973), pls. 25, 29, 33, 36, 40, 42, 45, 48f., 51f., 54, 56, 59, 62, 64–67, 69, 72, 74, 79f., 83, 91, 98, and the related commentaries. It also occurs in the Rothschild Hours in Vienna (Österreichische Nationalbibliothek, Cod. ser. no. 2844, fols. 29, 66, 113); see E. Trenkler, *Rothschild-Gebetbuch: Vollständige Faksimileausgabe im Originalformat des Codex Vindobonensis Series Nova 2844 der Österreichischen Nationalbibliothek* (Codices Selecti, 67) (Graz, 1979).

45 Lieftinck 1969, pp. 157–64, figs. 271–83; Van Buren 1975, p. 308, no. 19; Ghent 1975, p. 378f., no. 616.

46 For the *Nativity* in Douce 223, see Lieftinck 1969, fig. 277; for the miniature of the same subject in the Huth Hours, see Malibu 1983, fig. 4d, or the color reproduction in J. Backhouse, *Books of Hours* (London, 1985), fig. 23.

47 In the Hours of Joanna of Castile (British Library, Add. Ms. 18852), the David Master not only copies the two full-page miniatures of *Saint James* (fol. 411v) and *Saint George* (fol. 413v) from the Huth Hours, but he also takes over an important layout feature, namely,

the use of small square pictures instead of large initials at all significant beginnings of text. A comparison of the cycles of such square pictures illustrating the Hours of the Cross in both books proves that it was indeed no other manuscript than the Huth Hours that served as a model, since the patterns and even the coloring are the same in Add. Ms. 18852.

As already noticed by E.G. Millar, "Les manuscrits à peintures des bibliothèques de Londres: Les manuscrits à peintures du Sir John Soane's Museum et du Royal College of Physicians de Londres," *Bulletin de la Société français de reproductions de manuscrits à peinture* 4 (1914–20), p. 97, six miniatures in a book of hours in Sir John Soane's Museum in London (Ms. 4) copy their respective counterparts from the Huth Hours: the *Visitation* (fol. 65v); *Saint Anthony* (fol. 113v); the *Noli me tangere* (fol. 115v); *Saint Catherine* (fol. 116v); *Saint Barbara* (fol. 117v); and the *Last Judgment* (fol. 118v). It is remarkable that the two miniatures here attributed to the young Provost are among those copied and that the illuminator of Soane's 4 manages to emulate the quite different palettes of both artists with some success. This also supports the assumption that he saw the actual book instead of merely working from model drawings.

The *Crucifixion* miniature on fol. 18 of the Soane's book of hours may be added to the list of miniatures taken from the Huth Hours. Its tonality is clearly different from the subsequent *Crucifixion* scenes in the manuscript, which appear to be genuine inventions of the artist. Fol. 18 is essentially a repetition of the Huth *Crucifixion*, omitting only the group of soldiers on horseback to the right, probably due to the different format.

The copies after Marmion in Soane's 4 are so distinctive that the manuscript can even be used to reconstruct a lost miniature from the Huth Hours. The *Annunciation* on fol. 50 of Soane's 4 clearly is another copy. It has the Marmionesque tonality of the other copies, and its composition also points to Marmion. But the pattern does not correspond exactly to any preserved *Annunciation* by Marmion, and in all other cases the Marmionesque miniatures in Soane's 4 literally repeat miniatures from the Huth Hours. Therefore, it may be concluded that the *Annunciation* in Soane's 4 copies that of the Huth Hours.

In my view, Soane's 4 is a key work by the Master of the David Scenes in the Grimani Breviary. It is datable after 1498, since the miniature on fol. 35v copies the *Vision of Saint John* from Dürer's *Apocalypse* woodcuts first published in that year.

A more detailed investigation of these copies and the light they throw on the role of the Master of the David Scenes will be found in my forthcoming commentary to the facsimile of Biblioteca Apostolica Vaticana, Cod. Vat. lat. 10293.

48 A good reproduction of the Berlin leaf (no. 9) is Wescher (note 23), fig. 172.

49 The term "overpainting" is not entirely correct since I cannot determine the degree of completion the miniature had reached before the actual surface was painted. Facial and figure types are Marmion's, so he must have at least executed the underdrawing. In addition, the architectural background and the sky seem to have been painted by Marmion since the pigments and handling of the brush in these areas still reveal his hand. This suggests that in the figures as well color may already have been applied, though it is possible that the miniature was not completed. Thanks are due to Maryan Ainsworth for clarifying my ideas in this respect.

The Chronology of the Louthe Master and His Identification with Simon Marmion*

Gregory T. Clark

In honor of John Plummer

T his paper addresses the chronology, localization, and attribution of a controversial group of ten books of hours which have all been ascribed at one time or another to Simon Marmion of Valenciennes. In 1969, Antoine de Schryver reattributed five of the ten to a second artist whom he named after a book of hours made for a member of the Anglo-Flemish Louthe family.[1] De Schryver believed that the Louthe Master worked in Ghent, a conviction he reaffirmed in a 1975 catalogue in which the miniatures in two more books of hours were added to the artist's oeuvre.[2]

In 1983, Thomas Kren ascribed the illuminations in three additional books of hours to the master. Because he believed the artist to be identical with Simon Marmion, Kren tentatively and tacitly localized the master's books in Valenciennes. He also offered a chronological sequence for the manuscripts based largely on changing border styles and a perceived increase in landscape sophistication.[3] On the basis of the borders and certain details of costume, Kren dated his eleven books of hours between about 1470 and 1490.

In this study I would like to look more closely at nine of Kren's eleven manuscripts, in which the master was the sole or principal illuminator, and a tenth book of hours entirely by the artist, as identified by Nicole Reynaud.[4] While Kren was right to observe that the borders provide valuable evidence for the ordering and dating of the ten codices, at least one or two highly sophisticated landscapes can be found in every one of those books.

What does appear to develop along with the borders, however, is the complexity of the artist's architectural interiors and their spaciousness in relation to the actors set within or before them. That development and the constantly changing figural arrangements and *mise-en-scènes* in those miniatures make it clear that we are looking at a master of the first caliber, who treated each new commission for a book of hours as an opportunity to recast his predetermined subjects in increasingly ambitious settings.

In the following paragraphs I will propose a new chronological sequence for the artist's ten books of hours based on this compositional and spatial development. I will then show that marks of ownership, changing border styles, and stylistic parallels with the work of other artists both help to corroborate this sequence and make it possible to propose dates of manufacture between about 1450 and 1490 or slightly later for the ten codices. I will conclude with some additional stylistic and textual observations which, when taken together with the evidence already presented, strongly suggest that the traditional ascription of the ten manuscripts to Simon Marmion is correct.

The miniatures in the first two books of hours are painted entirely in grisaille heightened with gold and are enframed by blank vellum borders. However, the illuminations' delicacy and sophistication more than compensate for the relative austerity of the pages. The earliest of the two manuscripts is probably the book of hours, written for use in the region of Cambrai or Mons, which is now in the Museo Civico, Turin

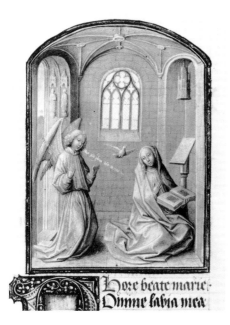
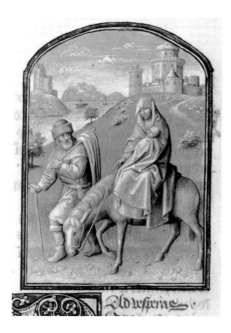
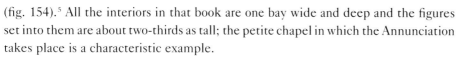
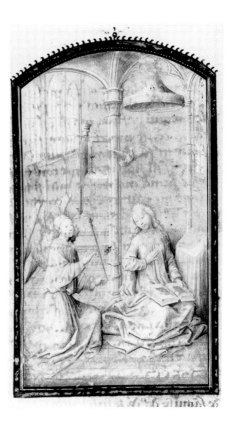

(fig. 154).[5] All the interiors in that book are one bay wide and deep and the figures set into them are about two-thirds as tall; the petite chapel in which the Annunciation takes place is a characteristic example.

Already at this stage of his career, however, the artist is masterful in his use of subtle shades of gray to describe the Virgin and archangel and such ancillary elements as the sculpted voussoirs over the doorway, the ribs and bosses of the vaulting, the tracery and leading of the window, and the book in the Virgin's lap. Gold highlights are confined to Gabriel's staff, the rays around the heads of both figures and the dove of the Holy Spirit, and the knobs of the vault bosses. The physiognomies of the archangel and Virgin are also already characteristic of the master: long and ovoid, with carefully rounded foreheads and cheeks and heavy upper eyelids.

The setting of the Turin *Flight into Egypt* demonstrates that our master was by this time an accomplished landscapist as well (fig. 155). A river or inlet between the two rises in the deep middle ground behind the Holy Family leads the eye to a large body of water dotted with boats and a rocky bluff in the distant background.

Our artist's apparent determination to fashion ever more spacious interior settings is already evident in the second book of hours, now in Madrid, written for use in the Burgundian center of Autun for a member of the Rolin family (fig. 156).[6] In contrast to the Turin *Annunciation*, where the figures, if standing, would be about two-thirds the height of their small architectural enclosure, the Rolin archangel and Virgin Annunciate occupy the partially immured antechamber of a multibayed Gothic chapel at least twice as tall as they are. The painter introduces additional variety by draping the previously uncovered lectern and by repositioning Gabriel's hands.

The third book of hours—and the first with polychromed miniatures and foliate borders—is probably the Berlaymont codex in the Huntington Library (fig. 157).[7] To judge from its calendar and one of its prayers, the book was written for use in Amiens. In the Berlaymont *Annunciation*, the square-ended chapel of the corresponding Rolin miniature has been replaced by a considerably more spacious, hemicircular apse engirded by a fenestrated ambulatory. Both interiors have a bipartite elevation of immured ground floor and clerestory and are about twice the figures' height. While the pose of the archangel is very close to that of his counterpart in the Rolin Hours, the Berlaymont Madonna now sits on the ground in her humility before a canopied throne and directly faces the messenger with both hands raised in wonder.

To the fourth manuscript, the Salting Hours in the Victoria and Albert Museum, the artist contributed nine full-page miniatures on single leaves (fig. 158).[8] The inclusion of an illumination in the style of Willem Vrelant of Bruges (fol. 15v)

Figure 154.
Simon Marmion. *Annunciation*, in a book of hours. Turin, Museo Civico, Ms. 558, fol. 37.

Figure 155.
Simon Marmion. *Flight into Egypt*, in a book of hours. Turin, Museo Civico, Ms. 558, fol. 77.

Figure 156.
Simon Marmion. *Annunciation*, in the Hours of Jean Rolin II. Madrid, Biblioteca Nacional, Ms. Res. 149, fol. 34v.

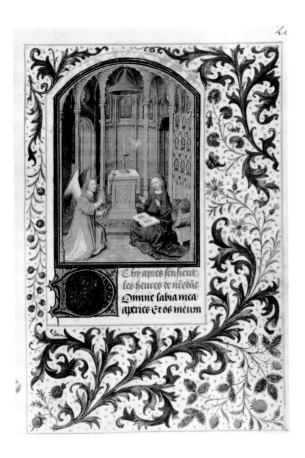

Figure 157.
Simon Marmion. *Annunciation*, in the Berlaymont Hours. San Marino, Huntington Library, HM. 1173, fol. 28.

and the gold-letter feasts for Bruges in the calendar suggest that the book was assembled in that center.[9]

The most sophisticated interior in the Salting codex is the cloister of seven arcaded bays in which Jerome removes the thorn from the lion's paw. The passageway, although still only about twice the height of the saint, is deeper than any of the architectural enclosures in the Turin, Rolin, or Berlaymont Hours. The impression of expansiveness is increased by the inclusion of parts of two adjacent cloisters and a standing monk beyond a doorway at the end of the passageway.

The book of hours in Chantilly with a calendar for Cambrai or Mons, made between 1475 and 1484 for the Burgundian official Jean Gros, was probably the fifth manuscript to be illuminated by our master (fig. 159).[10] Like the same subject in the Berlaymont manuscript (fig. 157), the Gros *Annunciation* shows Gabriel and the Madonna in the foreground of an ecclesiastical interior set at a ninety-degree angle to the picture plane. Whereas the Berlaymont figures are placed in the apse itself, the Gros archangel and Virgin Annunciate occupy a groin-vaulted bay which is separated by a wider bay or corridor from the structure's apse, the latter partly closed off by freestanding columns and a rood screen. The height of this screen and the truncation of the apices of the clerestory windows in the apse by the far archway of the foreground bay make it clear that the apse is many times taller than the sacred figures. Instead of sitting on the floor, the Madonna now kneels before a draped lectern and turns at the waist to face Gabriel, who for the first time kneels rather than genuflects; the hand gestures of the two figures also mirror each other.

In the Turin and Rolin *Pentecosts*, the artist arranged the Virgin and apostles to form the hemicircle or horseshoe favored by earlier Parisian and Flemish illuminators.[11] The broken ellipse established by the same figures in the Gros *Pentecost* is both novel and considerably more dynamic (fig. 160).

The sixth codex, the so-called Hours of Henry VIII in Tournai, appears to be the last illuminated entirely by the master, the last with miniatures in grisaille, and the last with border foliage painted on raw vellum grounds (fig. 161).[12] Its texts point even more strongly than those of the Berlaymont codex in the direction of Amiens.

Like the same figures in the Gros manuscript (fig. 159), the Tournai archangel

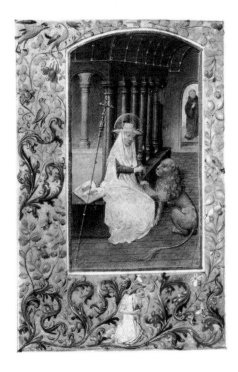

Figure 158.
Simon Marmion. *Saint Jerome and the Lion*, in the Salting Hours. London, Victoria and Albert Museum, Ms. Salting 1221, fol. 213v. Reproduced by kind permission of the Board of Trustees.

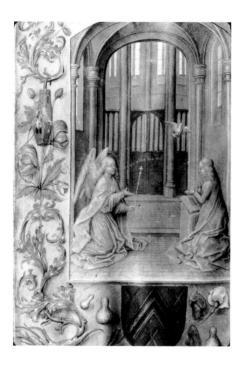 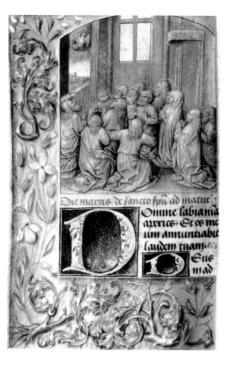 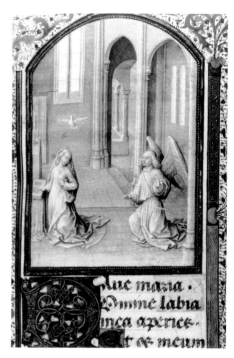

and Virgin Annunciate occupy an ecclesiastical interior two bays deep and with arch-
ways barely twice the height of the figures were they to stand. But while the low
vault of the foremost Gros bay is only as tall as the four archways which support it,
the Tournai archways form merely the first story of a space considerably loftier than
the miniature's hemicircular frame. In the Gros *Annunciation*, only the wider second
bay provides some relief from the closeness of the near one; in the Tournai rendition,
both bays open onto a spacious side aisle which is connected by a doorway to a clois-
ter like that housing the Salting *Saint Jerome* (fig. 158). Like her counterpart in the
Gros Hours, the Tournai Madonna is shown kneeling before a draped lectern upon
which her open devotional text rests. The earlier figure, however, needs only to turn
her head and torso some forty-five degrees to confront the archangel, whereas the
later one must turn an additional forty-five degrees to see Gabriel, who has landed
behind her in a posture of genuflection, with bent arms spread apart.

The master's considerable development both as a craftsman and as a student
of natural phenomena can be seen by comparing the Tournai *David in Prayer* with
the *Flight* in the Turin codex (figs. 155, 162). In the first painting, the surfaces are
stippled, the cast shadows restrained, and the definition of objects relatively consis-
tent throughout; in the second, the surfaces seem almost polished, the château in
the middle ground casts a remarkably convincing shadow onto the surrounding water,
and atmospheric haze gently softens the contours of the objects in the background.

Our artist collaborated with the Master of the Dresden Prayer Book in the sev-
enth book of hours, written for Sarum use for a male member of the Louthe family.[13]
In the more ambitious of the two *Annunciations* in the Louthe Hours (fig. 163) and
the same subject in the Gros manuscript (fig. 159), Gabriel and the Virgin are placed
in the nearest of two foreground bays separated by a rood screen from a towering
apse. However, the two Louthe bays are as lofty as the apse and are enlarged by an
adjoining space comparable to the side aisle in the Tournai *Annunciation* (fig. 161).
But while the side aisle in the Tournai miniature is squatter than the two principal
bays, the transept and side aisles which flank the crossing and easternmost nave bays
of the Louthe church appear to be as tall as both the nave and apse. The Louthe
setting is also the first to truly dwarf the figures set into it. Gabriel kneels as he did
in the Gros Hours and holds his arms like his counterpart in the Tournai codex; the
Madonna readopts the pose first seen in the Rolin Hours (fig. 156). Although the
pages of the Virgin's devotional book lie flat in the Rolin miniature, they are starting
to fan in the Louthe one.

Figure 159.
Simon Marmion. *Annunciation*, in the Hours of
Jean Gros. Chantilly, Musée Condé, Ms. 85,
fol. 92v.

Figure 160.
Simon Marmion. *Pentecost*, in the Hours of
Jean Gros. Chantilly, Musée Condé, Ms.
85, fol. 26v.

Figure 161.
Simon Marmion. *Annunciation*, in the so-called
Hours of Henry VIII. Tournai, Bibliothèque
de la Ville, Ms. 122, fol. 36.

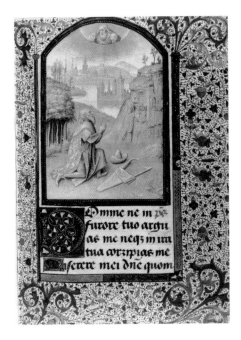
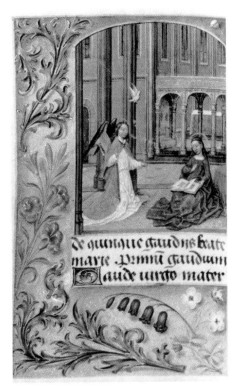
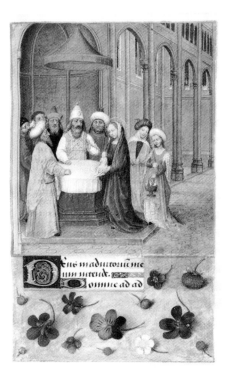

The eighth book of hours is probably the codex in the Morgan Library (fig. 164).[14] Although written for use in Paris or western France, the style of the manuscript's second, unidentified illuminator is clearly Flemish.[15] The same is true of the illusionistic borders beneath the miniatures, which specifically resemble ones like that enframing the *Flight into Egypt* in the Hastings Hours (fig. 178).[16] Like the Louthe *Annunciation* (fig. 163), the Morgan *Presentation* takes place in the nave of an ecclesiastical interior flanked by a side aisle and set at a forty-five-degree angle to the picture plane. In both works the figures are dwarfed by the cavernous nave, whose ceiling is too lofty to be included within the miniature. The Louthe church's bipartite elevation of largely immured ground floor and clerestory is like that in all the master's earlier *Annunciations* save the Turin one; the Morgan church, in contrast, is the earliest to feature a tripartite elevation of nave arcade, triforium, and clerestory.

In all the master's earlier *Presentations*, the figures' approaches to the altar run parallel to the picture plane (fig. 169).[17] The positions of the two women behind the Virgin in the Morgan painting suggest instead that they—and perhaps some or all of the other figures ringing the altar—had walked outward toward the viewer from the considerable depths of the background nave to reach the altar in the foreground.

Our artist again collaborated with the Dresden Prayer Book Master on the illumination of the ninth manuscript, the book of hours with a calendar for Germany given by Alfred Huth in 1912 to the British Library (fig. 165).[18] Both the Huth and Morgan *Presentations* take place in churches with tripartite elevations. Yet only a tiny fraction of the clerestory can be seen in the Morgan depiction, whereas a considerable part of it is included in the Huth miniature. The small canopy hanging over the Morgan altar has given way to a magnificent Gothic baldachino behind the Huth altar in which the high priest and his cohort stand.

In the Huth Hours, the painter also broke with the traditional frontal presentation of the historical Crucifixion by turning all three victims at varying forty-five-degree angles to the picture plane (fig. 166).[19] In his rendition of the penitent Jerome before the crucified Savior, the painter took the extraordinary step of obscuring the two behind a screen of foliage (fig. 167). By forcing the viewer to seek out the sacred figures, the artist seems to encourage the viewer to draw closer to the objects of devotion. Our master also uses the dramatic close-up for the first time in a few of the

Figure 162.
Simon Marmion. *David in Prayer*, in the so-called Hours of Henry VIII. Tournai, Bibliothèque de la Ville, Ms. 122, fol. 131.

Figure 163.
Simon Marmion. *Annunciation*, in the Louthe Hours. Louvain-la-Neuve, Université Catholique de Louvain, Ms. A.3, fol. 90v.

Figure 164.
Simon Marmion. *Presentation in the Temple*, in a book of hours. New York, Pierpont Morgan Library, M. 6, fol. 48.

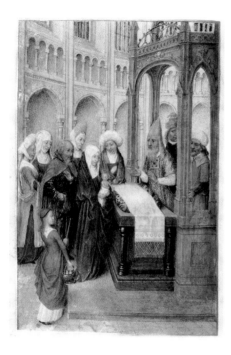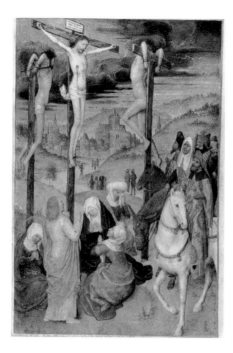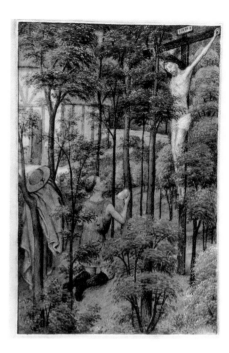

Huth miniatures (fig. 168).[20] All these compositional innovations strongly suggest that the Huth Hours was painted after the Morgan manuscript.

Dramatic close-ups predominate in the so-called "La Flora" Hours in Naples (see fig. 202).[21] All our artist's miniatures there are on single leaves inserted into the book, which appears to have been written for use in Bruges or Ghent; a majority of the remaining illuminations are the work of the Master of the Older Prayer Book of Maximilian.[22] While the similar styles of "La Flora" and the Huth miniatures suggest that the two codices were painted around the same time, the architectural borders in "La Flora"—to be considered below—raise the possibility that it is the last of the ten books of hours.

I begin my dating of the ten manuscripts with the fifth one, the Gros Hours, for its provenance and border style make it possible to place with some precision (figs. 159, 160). First, the death of the book's original owner in 1484 provides us with a firm *terminus ante quem.* That the manuscript was executed after about 1475 is suggested by its borders' opaque grounds, the earliest appearances of which seem to date from the mid-1470s.[23]

Fortunately, the border styles of the fourth and sixth books of hours—the Salting and Tournai manuscripts, respectively—enable us to narrow the date for the Gros codex even further. On the one hand, the border foliage surrounding the Tournai miniatures is painted onto raw vellum grounds, a support which seems by about 1485 to have been largely superseded by the kinds of opaque grounds seen in the Gros manuscript (figs. 161, 162).[24] On the other hand, the predominance of opaque borders in the Salting Hours makes it most likely that it, like the Gros manuscript, was produced after about 1475 (fig. 158). Given these circumstances, and taking into account the sequence proposed above, the Salting Hours may be roughly dated between around 1475 and 1480, the Gros codex about 1480, and the Tournai manuscript between around 1480 and 1485.

The last four books of hours are considerably more difficult to date. While the *Annunciation* in the seventh, the Louthe manuscript (fig. 163), invites comparison with the same subjects in the fifth and sixth, the Gros and Tournai codices (figs. 159, 161), the greater expansiveness of the Louthe interior indicates a slightly later date, perhaps around 1485, for the codex as a whole.

A manufacture in the 1490s or even the early sixteenth century for the last of the ten, "La Flora," is suggested by the resemblance between the architectural frames around its full-page miniatures and those in Flemish manuscripts of the same

Figure 165.
Simon Marmion. *Presentation in the Temple,* in the Huth Hours. London, British Library, Add. Ms. 38126, fol. 87v.

Figure 166.
Simon Marmion. *Crucifixion,* in the Huth Hours. London, British Library, Add. Ms. 38126, fol. 39v.

Figure 167.
Simon Marmion. *Saint Jerome in Penitence,* in the Huth Hours. London, British Library, Add. Ms. 38126, fol. 227v.

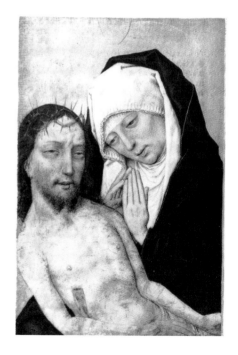

Figure 168.
Simon Marmion. *Pietà,* in the Huth Hours. London, British Library, Add. Ms. 38126, fol. 240v.
Illustrations above reproduced by kind permission of the British Library Board.

two decades (see fig. 202).[25] If the proposed dates for the Louthe and "La Flora" codices are more or less correct, the eighth and ninth books of hours—the Morgan and Huth codices, respectively—should probably be assigned to the late 1480s or early 1490s (figs. 164–68).

The artist's first three books of hours are best considered in reverse order. A date in the 1470s for the third, the Berlaymont Hours (fig. 157), is suggested by the close similarity of the encadrements to those in the Getty *Tondal* and *Thurno* manuscripts, both written in Ghent in 1474 and illuminated by our artist for Margaret of York.[26] At the same time, the Berlaymont codex contains no settings as ambitious as the cloister housing Saint Jerome in the fourth book of hours, the Salting manuscript (fig. 158). As the latter was most likely painted between about 1475 and 1480, an execution in the first half of the decade for the Berlaymont codex seems most probable.

Given their even simpler interiors, the first and second books of hours—the Turin and Rolin manuscripts, respectively—were most likely painted before about 1470 (figs. 154, 156). A number of resemblances between the Turin *Presentation* and *Pentecost* and the same subjects in three books of hours made in or near Amiens between about 1440 and 1460 specifically suggest dates in the 1450s or 1460s for both the Turin and Rolin codices. As we will see shortly, similarities between our master's eight later books and other French and Flemish manuscripts offer further support for the chronology and dating I have already proposed.

In most French and Flemish *Presentations* of the first half of the fifteenth century, the Virgin and high priest are situated to either side of an altar set at a forty-five-degree angle to the picture plane.[27] In contrast, the altar in the Turin *Presentation* parallels the picture plane, and a man standing frontally behind it fills the space between Mary and the high priest (fig. 169). This unusual arrangement is also found in the Hours of Hugues de Mazinghem in Leeds (fig. 170).[28] Made probably somewhere between Amiens and Lille in the 1450s, its miniatures are the work of the Mansel Master, a distant disciple of the Bedford Master, with whom our artist may have collaborated in the 1450s on a richly illustrated copy of Jean Mansel's *Fleur des histoires* in Brussels.[29] On the other hand, the frontal pose, headdress, and facial expression of the handmaiden bearing a taper and basket of doves behind the Virgin in the Turin *Presentation* recall those of the same figure in an hours made in Amiens or Tournai in the 1440s and now in the Philadelphia Museum of Art (fig. 171).[30] Finally, the architectural enclosure and the seating arrangement of the foremost apostles in the Turin *Pentecost* (fol. 30) resemble the same elements in an Amiens book of hours made between about 1450 and 1460, now in the Morgan Library.[31]

Figure 169.
Simon Marmion. *Presentation in the Temple*, in a book of hours. Turin, Museo Civico, Ms. 558, fol. 73.

Figure 170.
Mansel Master. *Presentation in the Temple*, in the Hours of Hugues de Mazinghem. Leeds, University Library, Brotherton Collection MS 4, fol. 76.

Figure 171.
Master of the Collins Hours. *Presentation in the Temple*, in the Collins Hours. Philadelphia, Museum of Art, Ms. 45–65–4, fol. 83v. Given by Mrs. Philip S. Collins in memory of her husband.

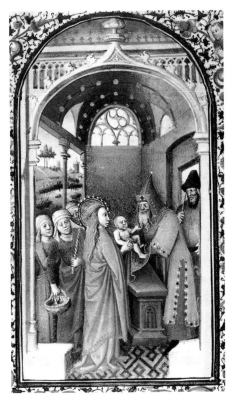

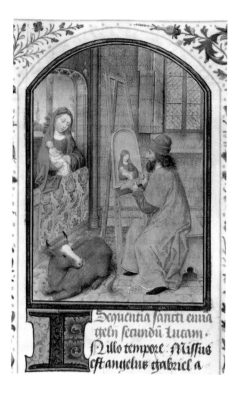
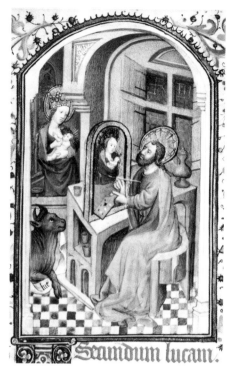

Figure 172.
Simon Marmion. *Saint Luke Painting the Virgin*, in the Berlaymont Hours. San Marino, Huntington Library, HM. 1173, fol. 15v.

Figure 173.
Master of Walters 281. *Saint Luke Painting the Virgin*, in a book of hours. Baltimore, Walters Art Gallery, Ms. W. 281, fol. 17.

Compositional parallels can also be drawn between Amiens illuminations and miniatures in the Berlaymont and Salting Hours, our master's third and fourth codices, both painted probably in the 1470s. The Gospel reading from Luke in the former is illustrated with the then unusual subject of *Saint Luke Painting the Virgin* (fig. 172). In a small chamber with shuttered, leaded-glass windows, the evangelist sits with a palette in his left hand and a brush in his right before an arch-topped panel on which he renders the Virgin and Child; his subjects pose for him in an antechamber separated from his studio by a low dado. The only comparable composition known to me is found in a book of hours made probably in Amiens or the Tournai

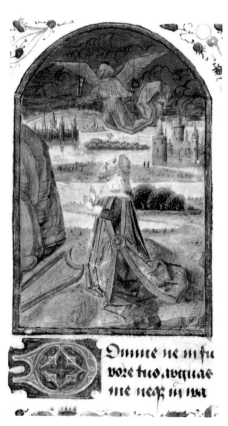

Figure 174.
Simon Marmion. *David in Prayer*, in the Salting Hours. London, Victoria and Albert Museum, Ms. Salting 1221, fol. 129v. Reproduced by kind permission of the Board of Trustees.

Figure 175.
Master of Amiens 200. *David in Prayer*, in a book of hours. New York, Pierpont Morgan Library, M. 194, fol. 65.

region between about 1425 and 1435 and now in the Walters Art Gallery (fig. 173).[32]

The Salting depiction of *David in Prayer*—kneeling and in profile next to a promontory and before a deep valley landscape with a serpentine river—specifically recalls the similar treatment of the subject in a book of hours in the Morgan Library illuminated in Amiens or Hesdin about 1460 by the Master of Amiens 200 (figs. 174, 175).[33]

A small number of miniatures produced by our master after about 1480 invites comparison with the illuminations of the Dresden Prayer Book and Older Maximilian Prayer Book Masters, two of the Flemish miniaturists with whom our artist began collaborating around the same time.

In the fifth book of hours, the Gros manuscript of about 1480, our master placed Gabriel and the Virgin Annunciate in an antechamber separated by an archway and a rood screen from a towering apse beyond (fig. 159). The same arrangement is also found in a book of hours in Brussels written in 1478 and illuminated by the Dresden Prayer Book Master for Colart Pingret, procurer general for the cathedral of Cambrai (fig. 176).[34]

In most depictions of the *Flight into Egypt*, the Holy Family proceeds along a foreground road which parallels the picture plane.[35] In contrast, the path followed by the figures in the seventh book of hours, the Louthe manuscript of about 1485 (fig. 177), takes them around a rocky outcropping, an innovation also seen in the hours illuminated by the Older Maximilian Prayer Book Master in the late 1470s for William Lord Hastings (fig. 178).[36] Both the Louthe and Hastings compositions almost certainly derive from the group of the Virgin and Joseph in the left wing of Hugo van der Goes's Portinari altarpiece, completed in Ghent about 1476.[37]

In the four *Pentecosts* in the first seven books of hours, our artist fit the Madonna and all the apostles into an interior or enclosure as wide as the miniature itself (fig. 160).[38] In the *Pentecost* in the eighth codex, the Morgan Hours made probably in the late 1480s, the figures are shown spilling out of a structure with two arched openings and onto a paved courtyard beyond (fig. 179). This same device is also found in the eponymous manuscript of the Dresden Prayer Book Master, a book of hours made probably in the late 1470s (fig. 180).[39]

We have seen that the ten books of hours by our master were written for use in regions as far-flung as Germany, England, western France, Autun, Amiens, and the

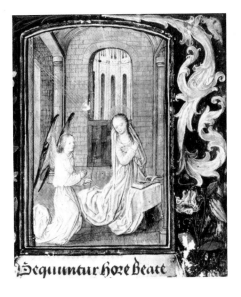

Figure 176.
Master of the Dresden Prayer Book. *Annunciation*, in the Hours of Colart Pingret. Brussels, Bibliothèque Royale, Ms. II. 7604, fol. 37. © Bibliothèque Royale Albert Ier.

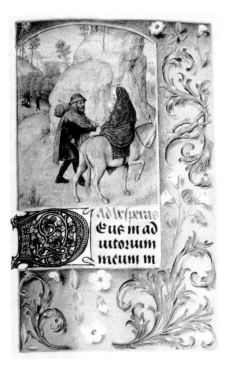

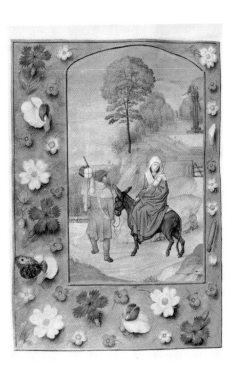

Figure 177.
Simon Marmion. *Flight into Egypt*, in the Louthe Hours. Louvain-la-Neuve, Université Catholique de Louvain, Ms. A. 3, fol. 72.

Figure 178.
Master of the Older Prayer Book of Maximilian. *Flight into Egypt*, in the Hastings Hours. London, British Library, Add. Ms. 54782, fol. 131v. Reproduced by kind permission of the British Library Board.

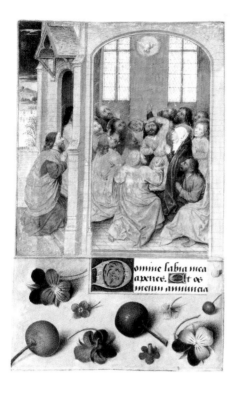
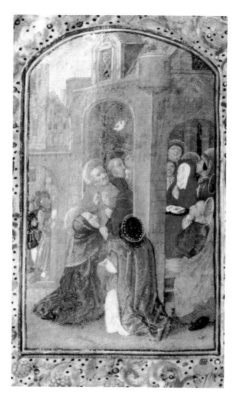

Figure 179.
Simon Marmion. *Pentecost*, in a book of hours. New York, Pierpont Morgan Library, M. 6, fol. 72v.

Figure 180.
Master of the Dresden Prayer Book. *Pentecost*, in a book of hours. Dresden, Sächsische Landesbibliothek, Ms. A. 311, fol. 19v.

dioceses of Cambrai and Tournai. The artist also illustrated two manuscripts—the Getty *Tondal* and *Thurno* codices—which had been transcribed in Ghent. Unfortunately, the books' disparate destinations give no clear indication as to the master's place of work. However, there is compelling indirect evidence to suggest that he was in fact based somewhere in the diocese of Cambrai. That evidence is the group of eleven miniatures known to me to have been clearly inspired by our master's compositions.[40] Ten of these appear in books of hours written for use in the diocese of Cambrai, and more specifically the region of Cambrai or Mons; the eleventh is found in a Ghent Hours illuminated in the 1480s by the Master of the Older Prayer Book of Maximilian, the painter with whom our artist collaborated on "La Flora."[41]

The majority of these miniatures are the work of relatively routine artists: a representative example is the *Raising of Lazarus* in a Mons Hours of the 1470s in Brussels (fig. 181), which copies the same composition in the Berlaymont codex (fig.

Figure 181.
Mons or Cambrai artist. *Raising of Lazarus*, in a book of hours. Brussels, Bibliothèque Royale, Ms. 15080, fol. 98. © Bibliothèque Royale Albert Ier.

Figure 182.
Simon Marmion. *Raising of Lazarus*, in the Berlaymont Hours. San Marino, Huntington Library, HM. 1173, fol. 84.

182).[42] However, the group also includes the more imaginative *Crucifixion* in an hours for Cambrai use made in the 1490s for Isabelle de Lalaing, dame of Boussu near Mons (fig. 183).[43] The inspiration for the diagonal placement of the three crosses in the foreground and the serpentine path which leads from Calvary to the cityscape nestled between rolling hills in the background was almost certainly the *Crucifixion* in the Huth manuscript (fig. 166).

The evidence I have presented thus far suggests that our artist was active from the 1450s or 1460s to the 1490s or early 1500s. Up until the late 1470s he usually worked alone, producing miniatures which frequently betray a familiarity with Amiens illumination. In the late 1470s, he began collaborating with Flemish miniaturists, and his later work sometimes invites comparison with theirs. While these parallels indicate only that our master worked in northern France or Flanders, the overwhelming majority of his imitators produced books specifically for use in the diocese of Cambrai.

The circumstances of our artist's career strongly suggest that he is identical with Simon Marmion.[44] A native of Amiens, Marmion's presence there is recorded from 1449 to 1454, when Philip the Good called him to Lille to make decorations for the Feast of the Pheasant. In 1458 Marmion bought a house in Valenciennes, midway between Cambrai and Mons in the diocese of Cambrai. Marmion's next recorded ducal commission came in 1467, when he began an unidentified breviary for Philip the Good; the book was completed in 1470 for Philip's son, Charles the Bold. In 1468 Marmion joined the Tournai painters' guild, presumably to guarantee his access to the lucrative Flemish market. Marmion is also recorded as working in Cambrai on several occasions before his death in Valenciennes in 1489. The esteem in which he was held is made clear by the posthumous praise awarded him by the poet Jean Lemaire de Belges, who called him the "very prince of book illumination."[45]

The correspondences between Marmion's career and that of our master are numerous and striking. The latter's earliest books of hours date from the 1450s or 1460s; Marmion's activity is documented from the late 1440s. Marmion's death in 1489 might initially seem to be at odds with the evidence of "La Flora," whose borders are characteristic of Flemish manuscripts of the 1490s and early 1500s. However, such architectural enframements are already encountered in French manuscripts by the 1480s and thus could have been known in Flanders by the end of that decade; it is also possible that the borders around the inserted miniatures in "La Flora" were added at a later date.[46] If our master and Marmion are indeed one and the same, the surviving books of hours suggest that the artist's production of such codices increased markedly in the last decade of his career.

Affinities with Amiens illumination are most evident in our artist's earlier hours. Marmion was born in Amiens and worked there into the 1450s. Once our master began collaborating in the mid- or late 1470s with illuminators based in nearby Flanders, however, his miniatures begin to invite comparison with theirs rather than with works from Amiens ateliers.

Our artist painted unflaggingly inventive books of hours destined for use in widely scattered Northern European centers; if any master were to be sent codices written in other regions for illumination or be asked to send leaves to other centers for insertion into finished manuscripts, it would be a painter of Marmion's caliber and reputation. Furthermore, as noted, all but one of the books of hours by our artist's imitators were written for use in Cambrai or Mons; although no variable liturgical texts for the use of Valenciennes have yet been identified, one would expect codices written for that center or neighboring ones to include saints from the two closest major centers in the same diocese.[47]

While the evidence I have brought together here is admittedly circumstantial, I nonetheless believe that it strongly supports the identification of our master with Simon Marmion. But whoever he may have been, there can be little doubt that he was one of the Burgundian Netherlands' most accomplished and innovative miniaturists and a worthy candidate for the title of "prince of book illumination."

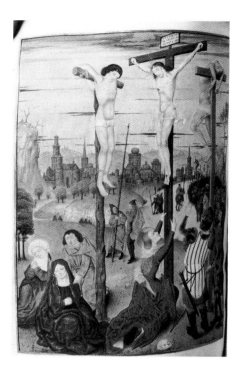

Figure 183.
Master of Antoine Rolin. Crucifixion, in the Boussu Hours. Paris, Bibliothèque de l'Arsenal, Ms. 1185, fol. 198v.

Notes

* For their editorial suggestions and help with photographs, I would especially like to thank Thomas Kren, Ranee Katzenstein, Jennifer Haley, Myra Orth, Martha Steele, and the staff of the Getty Center for the History of Art and the Humanities. A grant from the Faculty Development Fund of the University of the South helped defray the cost of additional prints.

1 Louvain-la-Neuve, Université Catholique de Louvain, Ms. A.2; de Schryver/Unterkircher 1969, pp. 149–55. In addition to the Louthe manuscript, de Schryver ascribed to the Louthe Master the Rolin, Salting, Tournai, Huth, and "Voustre Demeure" Hours, together with the *Virgin and Child Enthroned* on fol. 35v of the Hours of Mary of Burgundy (Vienna, Österreichische Nationalbibliothek, Cod. 1857) and the *Christ Appearing to His Mother* in an hours in Munich (Bayerische Staatsbibliothek, Clm. 28345 [formerly 3505], fol. 230). For the "Voustre Demeure" Hours (Madrid, Biblioteca Nacional, Ms. Vit. 25–5, and Berlin, Staatliche Museen Preussischer Kulturbesitz, Kupferstichkabinett, Ms. 78 B 13), see note 18, below; for the Munich Hours, see note 21, below.

2 The books are the Turin and Morgan Hours; see Ghent 1975, pp. 364–65, 375–77.

3 Kren, in Malibu 1983, pp. 31–39. The additions are the Berlaymont, Houghton, and "La Flora" Hours; for the Houghton Hours, see note 18, below. In Kren's view, the first book was the Berlaymont manuscript, followed by the Tournai, Salting, Rolin, Turin, Louthe, Morgan, Houghton, "La Flora," "Voustre Demeure," and Huth Hours.

4 This is the Gros Hours; see N. Reynaud, "Un tableau du XVe siècle provenant d'Abbeville: La translation de la châsse de saint Foillan," *Bulletin de la Société de l'histoire de l'art français* (1980), p. 27, n. 21.

5 Turin, Museo Civico, Ms. 558. The Turin Hours was first associated with our artist by de Schryver, in Ghent 1975, p. 364; the Rogierian *Virgo Lactans with Music-Making Angels* on fol. 111 is illustrated in color in S. Mitchell, *Medieval Manuscript Painting* (New York, 1965), fig. 131.

The manuscript comprises 192 leaves (205×145 mm); with twenty-nine half-page grisaille miniatures. Hours of the Virgin: unidentified use; Office of the Dead: unidentified use, but identical to that in the "Voustre Demeure" Hours (see note 18, below); calendar: overwhelmingly Cambrai-Mons (Firminus, in red [January 15]; Autbertus [January 24]; Waldetrudis [February 3]; Aldetrudis [February 25]; Ursmarus [April 18]; Antonius [April 27]; Landelinus [June 15]; Vincent [July 14]; Anna [July 19]; Hunegundis [August 25]; Humbertus [September 6]; Aycardus [September 15]; Geremarus [September 24, Beauvais]; Senatoris

[September 26, Paris]; Ragenfredis [October 8]; Guislenus [October 10]; Donatianus [October 14, Tournai]; Lucianus [October 16, Beauvais]; Amatus [October 19]; Desiderius [October 27]; Winnocus [November 6]; Maxellendis [November 13]); litanies: Bavo (confessors), Walburgis (virgins).

Here and in all the manuscripts examined in this study, the texts of the Hours of the Virgin and Office of the Dead were checked against the readings for specific liturgical centers compiled largely from printed texts by the Abbé Leroquais in an unpublished manuscript in the Bibliothèque Nationale, Ms. nouv. acq. lat. 3162. For Leroquais and his determination of various liturgical uses, see J. Plummer, "'Use' and 'Beyond Use,'" in Baltimore 1988, pp. 149–50. The listed regional feasts from the calendar are those described as peculiar to only one or a few dioceses by H. Grotefend, *Zeitrechnung des deutschen Mittelalters und der Neuzeit* (Hannover, 1891–98); all the listed feasts are for the cited center unless stated otherwise next to the feast date. Dimensions and numbers of miniatures are provided if these are not given in the cited literature.

6 Madrid, Biblioteca Nacional, Ms. Res. 149; fully described in Domínguez Rodríguez 1979, pp. 16–20, no. 2, pl. 2. Hours of the Virgin: Rome; Office of the Dead: Rome; calendar: Autun (Julianus [February 27]; Baudelius [May 20]; Maximinus [June 8]; Martialis [July 7]; Quintinus [July 13]; Lazarus [September 1]; Valerianus [September 15]; Andochius [September 24]; Leonardus [October 15]); litanies: general.

The confined interiors in three sets of cuttings by our artist suggest that they should be dated around the same time. These are: 1) the six arch-topped grisaille miniatures from a book of hours in Paris, Bibliothèque de l'Ecole des Beaux-Arts, M. 2236a-f; see *L'art graphique au moyen âge*, exh. cat. (École Nationale Supérieure des Beaux-Arts, Paris, 1953), p. 17, no. 31, pl. 5; 2) the four tiny rectangular grisailles in a private collection also possibly from an hours; see S. Hindman, *Medieval and Renaissance Miniature Painting* (Akron and London, 1988), pp. 74–75, 135, no. 35); and 3) the four polychromed miniatures with arched tops from a book of hours in Amsterdam, Rijksprentenkabinet, 70:44–46 and 61:100; see K.G. Boon, *Netherlandish Drawings of the Fifteenth and Sixteenth Centuries* (The Hague, 1978), pp. 3–4, nos. 4–7, pls. 2–3. The resemblance of a number of the figure types in the Amsterdam cuttings to certain of those in the Berlaymont Hours (see note 7, below) suggests that the Amsterdam set is the latest of the three.

7 San Marino, Huntington Library, HM. 1173; fully described in C. Dutschke, *Guide to Medieval and Renaissance Manuscripts in the Huntington Library*, vol. 2 (San Marino, 1989), pp. 523–26, fig. 124. Hours of the Virgin, Office of the Dead: unidentified use;

calendar: two red-letter feasts for Amiens (Honoratus [May 16], Firminus [September 25]) and one black-letter feast for Cambrai (Aldegundis [November 13]); litanies: general. The prayer known from its incipit as the Obsecro te contains a large number of unusual readings which I have encountered in only one other manuscript, a routine Amiens Hours of the 1440s sold recently at Christie's, London, December 2, 1987, lot 33, formerly Skelmersdale, Lancashire, Upholland College Library, Ms. 99; for the Obsecro te and its employment in the localization of manuscripts, see Baltimore 1988, p. 152.

A border and initial virtually identical to those in the Berlaymont Hours enframe a roughly contemporary miniature by our master of a bishop-saint, possibly Nicholas, presenting a donor to the enthroned Virgin and Child on an unpublished bifolio from a book of hours in Paris (Bibliothèque de l'Ecole des Beaux-Arts, M. 130; kindly brought to my attention by François Avril).

8 London, Victoria and Albert Museum, Ms. Salting 1221; see Harthan 1977, pp. 146–49, 183–84, reproducing four leaves, and Hindman 1977, pp. 192–93, figs. 12–14. Hours of the Virgin, Office of the Dead: Rome; calendar: two gold-letter feasts for Bruges (Basilius [June 14], Donatianus [October 14]), one for Ghent (Bavo [October 1]), and one for the archdiocese of Reims (Nichasius [December 14]); litanies: general.

The richly traceried gold thrones in the Salting and Berlaymont *Coronation of the Virgin* miniatures (fols. 118v and 61, respectively) and in the first of the two Berlaymont depictions of the *Virgin and Child* (fol. 20) seem to anticipate the more refined one in the miniature by our master of the *Virgin and Child with Music-Making Angels* inserted in the late 1470s into the Hours of Mary of Burgundy (Vienna, Österreichische Nationalbibliothek, Cod. 1857, fol. 35v; see Vienna 1987, pp. 52–56, no. 16, fig. 8. The Salting *Coronation* is illustrated in J. Harthan, *An Introduction to Illuminated Manuscripts* (London, 1983), fig. 21b, and the Berlaymont *Virgin and Child* and *Coronation* are reproduced in Thorpe 1976, pls. 5, 14.

9 The life and work of Willem Vrelant have been most recently summarized in Dogaer 1987, pp. 98–105.

10 Chantilly, Musée Condé, Ms. lat. 85. The Gros Hours is described and illustrated in J. Meurgey, *Les principaux manuscrits à peintures du Musée Condé à Chantilly* (Paris, 1930), pp. 169–72, no. 81, pls. 113–14. Hours of the Virgin: unidentified use; Office of the Dead: lacking; calendar: one red-letter feast each for Mons (Waldetrudis [April 9]) and Cambrai (Gaugericus [August 11]), one black-letter feast for Cambrai (Ursmarus [April 18]), and two black-letter feasts for

Liège (Domitianus [May 7], Rumoldus [October 27]); litanies and suffrages: Gaugericus (confessors) and Waldetrudis (virgins).

A number of the borders contain the arms of the Gros family, a two-wheeled pulley, and the letter G. Given the reference in the Obsecro te to *[famulo] tuo iohanni* (fol. 158), there can be no doubt that the book was made for Jean Gros, who married Guye de Messey in 1471 and died in Dijon in 1484.

The collaboration of our artist and the Older Maximilian Prayer Book Master on the book of hours formerly in the Korner collection should probably also be dated around the same time (Sotheby's, London, May 4, 1953, lot 68; formerly London; present location unknown). While the Korner *Crucifixion* (fol. 13v) recalls the same subject in the Salting codex (fol. 18v), the style and cast shadows of the Korner borders anticipate those in the slightly later Louthe Hours (see note 13, below).

11 The Turin and Rolin *Pentecosts* are found on fols. 30 and 104v, respectively. For earlier examples, see Meiss 1968, figs. 38, 224, 248, 252, 292, 321, 330; Meiss, *The "De Lévis Hours" and the Bedford Workshop* (New Haven, 1972), fig. 44; Meiss 1974, figs. 824, 873; Baltimore 1988, pl. 11, fig. 57. All fourteen of the *Pentecosts* known to me by Flemish artists working between about 1420 and 1460 in the styles associated with the Gold Scrolls, Guillibert de Mets, and Ghent Privileges Masters are of this type; the same is the case for the seventeen *Pentecosts* known to me that were painted by Amiens illuminators between about 1430 and 1460.

12 Tournai, Bibliothèque de la Ville, Ms. 122; first ascribed to our artist by de Schryver, in Ghent 1975, p. 364. The manuscript comprises 193 leaves (230×162 mm), with twelve half-page miniatures. Hours of the Virgin: Rome; Office of the Dead: short (three lessons); calendar: Amiens (Ulphia [January 31]; Nicander [June 17]; Victoricus [June 27]; Vincent, in gold [July 14, Cambrai]; Theophilus [October 13]; Domitius [October 23]; Serapion [October 30]; Fuscianus [December 18]); litanies: general; suffrages: Quintinus.

13 For the Louthe Hours, see Ghent 1975, pp. 375–76, no. 612. Hours of the Virgin: Sarum; Office of the Dead: lacking; calendar: Sarum (David, in gold [March 1]; Richardus [April 3]; Dunstanus [May 19]; Edmundus [June 9]; Edwardus, in gold [June 20]); litanies: Cedde (confessors); suffrages: Thomas à Becket and Thomas of Hereford.

The oeuvre of the Dresden Prayer Book Master is discussed in Malibu 1983, pp. 40–42, and Dogaer 1987, pp. 129–31.

14 Pierpont Morgan Library, M. 6; see Ghent 1975, p. 377, no. 614, and Malibu 1983, p. 38, n. 12. Hours of the Virgin: Rome; Office of the Dead: unidentified use; calendar: Paris (Paula [January 29]; Metrannus [January 31]; Eleutherius [February 20, Tournai]; Honorina [February 27]; Justinus [February 28]; Regulus [March 30, Senlis]; Maturinus [May 10]; Landericus [June 10]; Clodoaldus [September 7]; Wulfram [October 15,

Amiens]; Cerbonius [October 17]; Gratianus [October 23, Amiens]; Lucanus [October 30]; Marcellus [November 3]; Maturinus [November 9]; Genevieve [November 26]; Burgundofara [December 7]; Corentinus [December 12, Tours]; Maximinus [December 15]; Perpetuus [December 30, Tours]); litanies: Renatus of Angers; Maurilius, presumably the bishop of Angers; and Gatian of Tours (confessors).

While a number of the zodiac signs in the Morgan manuscript (fols. 2–13, versos) closely resemble their counterparts in the Gros Hours (fols. 1–12, rectos), the settings in the former book tend to be more developed than those in the latter. Both the zodiac signs and the Labors of the Months in the Morgan codex invite comparison with those on the twelve roughly contemporary calendar leaves cut from a book of hours in Munich, Staatliche Graphische Sammlung, Mss. 40051–62; see Hoffman 1969, p. 245, n. 8.

15 That artist was responsible for the *Annunciation* (fol. 21) and the *Mass of Saint Gregory* (fol. 154). The *Mass* closely resembles a number of miniatures and panel paintings of the same subject attributed to Simon Marmion or artists in his entourage; see Sterling 1981, pp. 3–18.

16 For the Hastings Hour and its artist, see note 36, below.

17 To the Turin example should be added those in the Rolin, Berlaymont, Tournai, and Louthe Hours (fols. 67v, 53, 85, and 67v, respectively). For the Berlaymont version, see Thorpe 1976, pl. 12.

18 London, British Library, Add. Ms. 38126; see Malibu 1983, pp. 31–39, no. 4. Hours of the Virgin, Office of the Dead: Rome; calendar: Germany (Quintianus, in black [April 1, Hamburg]; Servatius, in blue [May 13, Liège, Utrecht]; Erasmus, in blue [June 3]; Gallus, in blue [October 16]; Elisabeth, in blue [November 19]. The calendar is written in black with blue for feasts of higher grading and gold for feasts of highest grading); litanies: general.

Our artist worked around the same time with the Older Maximilian Prayer Book Master on the so-called Hours of Juana la Loca, in Harvard University, Houghton Library, Ms. Typ. 443–443.1; R.S. Wieck, *Late Medieval and Renaissance Illuminated Manuscripts 1350–1525 in the Houghton Library* (Cambridge, 1983), pp. 50–51, 133–34, no. 24. As Kren rightly observed (Malibu 1983, pp. 34–35), the Harvard *Saint Jerome in Penitence* (fol. 14v) resembles the same subject in the Huth Hours (fig. 167). However, the absence of obscuring foreground foliage in the Harvard *Jerome* and the reminiscence of the Louthe *Magdalene* (fol. 117v) in the arch-topped Harvard depiction of *Apollonia* (fol. 108v) suggest a slightly earlier date for the Harvard codex; for an illustration of the Harvard *Apollonia*, see Wieck, p. 51.

The presence of a half-length depiction of the *Virgo Lactans* (no. 1) among the four leaves by the master removed from the "Voustre Demeure" Hours (nos. 1, 9, 11, 20;

see note 1, above) indicates that those leaves were painted around the same time as the Huth codex; for this hours, see Lieftinck 1969, pp. 77–108, no. 7, figs. 114–64). The half-length format of a detached miniature of *Saint Bernard's Vision of the Virgo Lactans* points to a comparable date for that painting as well (Malibu, J. Paul Getty Museum, Ms. 32; see Malibu 1990, pp. 33, 35, fig. 22).

While the landscape setting of the *Betrayal of Christ*, sold at Sotheby's, London, July 8, 1970, lot 16, resembles that in the Morgan *Visitation* (fol. 29), the full-page format of the Sotheby's painting is like that of a number of the miniatures in the Huth Hours. The similarity between the full-page *Pentecost* in Fitzwilliam Museum, Ms. 304, and the Huth *Pentecost* (fol. 45v) suggests a like date for the two; for the Fitzwilliam leaf, see *Treasures from the Fitzwilliam*, exh. cat. (National Gallery of Art, Washington, D.C., 1989), p. 35, no. 39. The same is true of the framed *Pietà* on vellum in the Philadelphia Museum of Art (Sweeny 1972, pp. 52–53, 111, no. 343), which resembles the same subject in the Huth Hours, fol. 240v.

19 The crucified Savior parallels the picture plane in the Rolin Hours (fol. 117v), the Berlaymont Hours (fol. 24; Thorpe 1976, pl. 6), the Salting Hours (fol. 18v), the Korner Hours (fol. 13v; see note 10, above), and the Gros Hours (fol. 35; Meurgey [note 10], pl. 113).

20 This development is discussed in Malibu 1983, pp. 36–37, and Malibu 1990, p. 33.

21 Naples, Biblioteca Nazionale, Ms. I B 51; see Malibu 1983, p. 38, n. 14, and Malibu 1990, pp. 33–35, figs. 20–21. Hours of the Virgin, Office of the Dead: Rome; calendar: one red-letter saint for Ghent (Bavo [October 1]); litanies: Donatianus, Erasmus (martyrs); Bavo, Audomarus, Bertinus, Livinus (confessors).

To judge from its similar architectural enframements, a book of hours in Munich, Bayerische Staatsbibliothek, Clm. 28345, with miniatures by our artist and the Older Maximilian Prayer Book Master, is of approximately the same date; see *Thesaurus librorum: 425 Jahre Bayerische Staatsbibliothek* (Wiesbaden, 1983), pp. 155–56, no. 63.

The full-page depiction of the *Holy Virgins Being Received into Paradise* in the Robert Lehman Collection should probably also be counted among our artist's latest works; see C. Gómez-Moreno, *Medieval Art from Private Collections*, exh. cat. (Metropolitan Museum of Art, New York, 1968), no. 10. In that painting, the continuation to the right of the principal scene beyond its narrow gold arch-topped frame anticipates the more thoroughgoing illusionism of early sixteenth-century Flemish miniatures like those by Simon Bening in the Vienna *Hortulus animae*, painted between 1510 and 1524, Österreichische Nationalbibliothek, Cod. 2706; see Vienna 1987, pp. 119–21, no. 78, fig. 20.

22 For the Older Maximilian Prayer Book Master, see note 36, below.

23 The origins of this type of border are discussed in Malibu 1983, p. 15 and n. 14. The two earliest dated Flemish manuscripts with opaque-ground borders to be published in the *Manuscrits datés* series were both written in 1477; see G.I. Lieftinck, ed., *Manuscrits datés conservés dans las Pays-Bas. 1: Les manuscrits d'origine étrangère* (Amsterdam, 1964), pl. 232a, and F. Masai and M. Wittek, eds., *Manuscrits datés conservés en Belgique. IV: 1461–1480, Manuscrits conservés à la Bibliothèque Royale Albert Ier, Bruxelles* (Brussels and Ghent, 1982), pl. 914.

24 The latest dated Flemish codices with floral borders on raw-vellum grounds to be included in the *Manuscrits datés* volumes are both dated 1482; see F. Masai and M. Wittek, eds., *Manuscrits datés conservés en Belgique. V: 1481–1540, Manuscripts conservés à la Bibliothèque Royale Albert Ier, Bruxelles* (Brussels, 1987), pl. 953, and A.G. Watson, *Catalogue of Dated and Datable Manuscripts c. 700–1600 in the Department of Manuscripts, the British Library* (London, 1979), fig. 827.

25 This type of architectural frame is discussed in Malibu 1983, pp. 59–60.

26 The Getty *Tondal* (Ms. 30) and *Thurno* (Ms. 31) codices are discussed and their miniatures reproduced in Malibu 1990.

27 For a number of examples, see Meiss 1968, figs. 184, 229, 239, 266, 287, 318; Meiss 1972 (note 11), figs. 3, 24; Meiss 1974, figs. 637, 842, 869; Baltimore 1988, pl. 6, fig. 34f. The twenty-two *Presentations* known to me by artists painting in Flanders between about 1420 and 1460 in the styles associated with the Gold Scrolls, Guillibert de Mets, and Ghent Privileges Masters are all of this type; the same is true of the thirteen *Presentations* known to me that were produced by Amiens artisans between about 1430 and 1460.

28 Leeds, University Library, Brotherton Collection MS 4; see Brussels 1959, p. 64, no. 57. The Mansel Master and his place of work are most recently discussed in Dogaer 1987, pp. 43–47. The Hours of the Virgin and Office of the Dead in the Leeds codex are for Rome use and the calendar is missing. However, the litanies include Gaugericus of Cambrai and Vedast of Arras.

29 The Brussels *Fleur des histoires* (Bibliothèque Royale, Ms. 9231–32) is fully described in F. Lyna, *Les principaux manuscrits à peintures de la Bibliothèque Royale de Belgique*, vol. 3 (Brussels, 1989), pp. 215–26, 447–50, nos. 301–301.2. For the miniatures' attribution to our master, see Malibu 1990, pp. 22–24.

30 Philadelphia Museum of Art, Ms. 45–65–4; see J. Plummer, *The Last Flowering: French Painting in Manuscripts, 1420–1530*, exh. cat. (Pierpont Morgan Library, New York, 1982), p. 11, no. 15, and, more recently, Baltimore 1988, p. 187, no. 37.

31 Pierpont Morgan Library, M. 1066, fol. 96v. The Morgan codex is included in Plummer (note 30), p. 13, no. 18, and C. Ryskamp,

ed., *Twenty-First Report to the Fellows of the Pierpont Morgan Library 1984–1986* (New York, 1989), pp. 4–5, 19–20.

32 Walters Art Gallery, Ms. W. 281. John Plummer (note 30), p. 9, no. 12, localized the Walters Hours in Tournai or northern France. However, there is strong stylistic and textual evidence to support an origin in Amiens for the book; see G. Clark, "The Master of Morgan 453: An Illuminator in Paris and Amiens, 1415–1440," Ph.D. diss., Princeton University, 1988, pp. 136–55, 196–200.

33 Pierpont Morgan Library, M. 194; see Plummer (note 30), p. 14, no. 19, fig. 19.

34 Brussels, Bibliothèque Royale, Ms. II. 7604; see Masai and Wittek (note 23), p. 82, no. 575, pls. 925–26.

35 This is true of the *Flights* in the Madrid and Berlaymont Hours, fols. 74v and 56, respectively; the Berlaymont example is reproduced in Thorpe 1976, pl. 13. For earlier examples, see Meiss 1968, figs. 35, 194, 241, 249, 273, 288; Meiss 1972 (note 11), fig. 8; Baltimore 1988, pls. 7, 24, and fig. 34g. Also of this type are the twenty-nine *Flights* known to me to have been executed between about 1420 and 1460 both by Amiens illuminators and by Flemish artists painting in the styles linked with the Gold Scrolls, Guillibert de Mets, and Ghent Privileges Masters.

36 British Library, Add. Ms. 54782; see Malibu 1983, pp. 21–30, no. 3. The codex is fully described and illustrated in D.H. Turner, *The Hastings Hours* (London, 1983).

37 For the Portinari altarpiece and Hugo's influence on the Older Maximilian Prayer Book Master, see P. de Winter, "A Book of Hours of Queen Isabel la Católica," *Bulletin of the Cleveland Museum of Art* 67 (1981), pp. 377, 385–86.

38 In addition to the Gros *Pentecost*, there are the examples in the Turin, Rolin, and Tournai Hours (fols. 30, 104v, and 156, respectively).

39 Dresden, Sächsische Landesbibliothek, Ms. A. 311. The most comprehensive study of the manuscript remains F. Winkler, "Der Brügger Meister des Dresdener Gebetbuches und seine Werke," *Jahrbuch der Königlich Preussischen Kunstsammlungen* 35 (1914), pp. 225–44.

40 Three of the eleven miniatures will be discussed here. The remaining eight are: 1) the *Annunciation* in a Mons Hours of the 1470s (Brussels, Bibliothèque Royale, Ms. 15080, fol. 26), which duplicates the same subject in the Berlaymont Hours (fig. 157); see Lyna (note 29), pp. 376–79, 473–74, no. 342; 2) and 3) the *Visitations* in two Cambrai hours of the 1490s (Pierpont Morgan Library, M. 33, fol. 72v; M. 1053, fol. 48v), which ultimately derive from the *Visitation* in the Louthe Hours (fol. 26); for M. 33, see *Flowers in Books and Drawings ca. 940–1840*, exh. cat. (Pierpont Morgan Library, New York, 1980),

no. 21; for M. 1053, see Ryskamp (note 31), pp. 11–12; 4) and 5) the *Nativities* in the same two Morgan Hours (M. 33, fol. 88v; M. 1053, fol. 61v), both of which resemble the Berlaymont *Nativity* (fol. 47; Thorpe 1976, pl. 10); 6) the *Adoration* in a third Cambrai Hours of the 1490s (Copenhagen, Kongelige Bibliotek, Ms. Thott 542, 4°, fol. 87v), which resembles the same subject in the Morgan Hours (M. 6, fol. 44v; Hindman 1977, fig. 5); see *Gyldne Bøger*, exh. cat. (Copenhagen, Nationalmuseet, 1952), p. 83, no. 162; 7) the *Visitation* in a fourth Cambrai Hours of the 1490s (Hôtel Drouot, Rive Gauche, May 19, 1976, lot 26), which largely duplicates the Morgan *Visitation* (fol. 29); and 8) the *Pietà* in a fifth Cambrai Hours of the 1490s (Baltimore, Walters Art Gallery, Ms. W. 431, fol. 77v), which resembles the leaf in the Philadelphia Museum of Art, John G. Johnson Collection, no. 343; see note 18, above, and Baltimore 1988, p. 217, no. 101, fig. 75.

41 The eleventh minature is the *Nativity* in a book of hours in Oxford, Bodleian Library, Ms. Douce 223, fol. 57v; see Pächt/Alexander 1966, p. 27, no. 360, which generally resembles the same subjects in the Berlaymont, Tournai, and Huth Hours (fols. 47, 75, and 75v, respectively; the Huth and Berlaymont pages are reproduced in Malibu 1983, figs. 4d and 4e, respectively). I would like to thank Bodo Brinkmann for bringing this miniature to my attention.

42 Brussels, Bibliothèque Royale, Ms. 15080; see note 40, above.

43 Paris, Bibliothèque de l'Arsenal, Ms. 1185. The Boussu Hours was last discussed by F.O. Büttner, "Ikonographisches Eigengut der Randzier in spätmittelalterlichen Handschriften: Inhalte und Programme," *Scriptorium* 39 (1985), pp. 218–26, pl. 23.

44 The most recent consideration of Simon Marmion is in Malibu 1990, pp. 19–36. For the documents, the principal secondary sources remain Dehaisnes 1892 and Hénault 1907–08.

45 The epithet appears in Jean Lemaire's early sixteenth-century poem "La couronne margaritique"; see Stecher 1882–91, vol. 4, p. 162.

46 For a number of comparable French enframements dating from the 1480s, see Plummer (note 30), figs. 99, 100a–b, and color pl. 103. The proposed dates for "La Flora" range between about 1486 and 1493; see Malibu 1983, p. 39, n. 30.

47 To judge from his two exhaustive notebooks recording various liturgical uses (Paris, Bibliothèque Nationale, Mss. nouv. acq. lat. 3162–63), the Abbé Leroquais never encountered a text for the use of Valenciennes; nor have I. For the abbé and his notebooks, see note 5, above.

THE MASTER OF ANTOINE ROLIN

A HAINAUT ILLUMINATOR WORKING IN THE

ORBIT OF SIMON MARMION

Anne-Marie Legaré

S imon Marmion exercised an important influence not only on the art of his contemporaries but also on that of the succeeding generation, especially in the Hainaut. One of his principle followers is the so-called Master of Antoine Rolin, who served the court of Philip the Fair and his sister Margaret of Austria and shared in the illumination of an impressive number of literary and religious books between about 1490 and 1510. The Rolin Master's oeuvre, previously confined to four secular manuscripts, is enlarged here by twenty new attributions, mostly books of hours made for devotion in the diocese of Cambrai. The expanded corpus yields a wealth of new details concerning the dating, localization, and patronage of the Rolin Master.[1]

The Hainaut region as a center of manuscript illumination has received only passing attention.[2] A brief excursus concerning its geographic, historical, and political climate at the end of the fifteenth century is indispensable in order to understand the emergence of this new wave of patronage and manuscript production.

In the last decade of the fifteenth century, the long war between France and Flanders that had impoverished Hainaut was drawing to a close.[3] The treaty of Senlis, signed on May 22, 1493, ended hostilities with France: Charles VIII surrendered the counties of Artois and Burgundy to the regent Maximilian and renounced his marriage to Margaret of Austria, who at last could return to the Netherlands; less than a month later, she made a joyous entry at Mons. The boundaries of medieval Hainaut were different from those of today and included territory now situated in France. Ecclesiastically, virtually all of Hainaut belonged to the diocese of Cambrai. The city of Mons, then the administrative capital of Hainaut, was less than an hour's ride on horseback from Valenciennes, the economic heart of the region. Mons asserted its recent economic resurrection by spending lavishly on feast days and on public celebrations, such as the week given over to the playing of the *Mystère de la Passion* by Arnoul Greban in 1501.

On December 31, 1494, Philip the Fair, swearing on the Gospels and the reliquary of Saint Waudru, was installed as Count of Hainaut at Mons. His councillors, like those of his sister at a later date, were lords of the *comté*. Among them figured Antoine Rolin, *grand bailli et capitaine général du Hainaut*, son of the famous chancellor Nicolas Rolin. Following the royal example, the aristocrats at the court of Hainaut sought to own fine books. Antoine Rolin, Philippe de Clèves, Gilles de Berlaymont, and Pierre de Hennin, lord of Boussu, are among those who possessed at least one manuscript illuminated by the Master of Antoine Rolin.[4]

Otto Pächt attributed the first books to the Master of Antoine Rolin in 1953, when three of the manuscripts were exhibited at the Royal Academy of Arts in London: two *Annales du Hainaut* from the Bodleian Library (Handlist nos. 2 and 3; figs. 186, 187)[5] and one of the only two illuminated copies of *Le Livre des Echecs amoureux moralisés* from the Bibliothèque Nationale in Paris (Handlist no. 4; figs. 184, 185).[6]

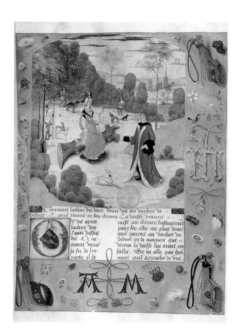

Figure 184.
Master of Antoine Rolin. *The Author in Conversation with the Goddess Diana*, in Evrart de Conty, *Le Livre des Echecs amoureux moralisés*. Paris, Bibliothèque Nationale, Ms. fr. 9197, fol. 202.

Figure 185.
Master of Antoine Rolin. *Mercury and Argus*, in Evrart de Conty, *Le Livre des Echecs amoureux moralisés*. Paris, Bibliothèque Nationale, Ms. fr. 9197, fol. 136v.

In 1976, on the occasion of an exhibition devoted to illuminated manuscripts from the Bibliothèque Publique in Geneva, a *Pèlerinage de la vie humaine* (Handlist no. 1; fig. 188) was added to the oeuvre of the artist, again on the basis of Pächt's attribution. However, some miniatures in this manuscript are executed by a second artist, and these were chosen as illustrations in the catalogue.[7] More recently, the two manuscripts belonging to Antoine Rolin (fr. 9197 and Douce 205) were included in the exhibition *Le livre au siècle des Rolin*,[8] but the other two manuscripts by the Rolin Master were not mentioned, even in passing. This fitful emergence of the works helps to explain why the Master of Antoine Rolin has drawn little attention up to now. This paper will argue that although the secular works give valuable information about the essential character of the Master's style, the religious manuscripts newly attributed here offer strong evidence of Simon Marmion's stylistic and iconographic influence on his production.

The Secular Manuscripts

We take as our point of departure the history and style of the four secular manuscripts brought together by Otto Pächt and recognized as the work of the Master of Antoine Rolin. Two of these bear the arms of Antoine Rolin and his wife, Marie d'Ailly, hence the eponym. Paul Durrieu suggested that the couple is portrayed in one of the miniatures of *Le Livre des Echecs amoureux moralisés* (fig. 184). The border displays their monogram and emblem: a dog collar and leash, decorated with the family arms.[9] Rather original in its mythographic iconography (fig. 185), this imposing didactic work, of which twenty-four miniatures are still extant, is painted entirely by the Master of Antoine Rolin. The text was composed at the beginning of the fifteenth century by Evrart de Conty and is known in six copies. A copy dating to the mid-fifteenth century has been identified as the model of our manuscript; not surprisingly, it belonged to the Châtelain d'Ath in the Hainaut.[10]

The second manuscript made for the Ailly-Rolin couple is the *Annales du Hainaut* (Handlist no. 2), written by Jacques de Guise and translated by Jean Wauquelin, a chronicle highly prized at the court of Burgundy. Only thirty-four leaves of the third volume, bound in disorder, have survived in this manuscript. All nine images, eight of which occupy two-thirds of the page, are by our Master (fig. 186); the borders are typically Flemish, and one folio displays the family monogram AR, Ailly-Rolin.[11]

Another *Annales du Hainaut* in four volumes has been attributed to our artist (Handlist no. 3). Although similar in its script and decoration to the preceding *Annales*, the manuscript presents a different textual recension.[12] It is dated September

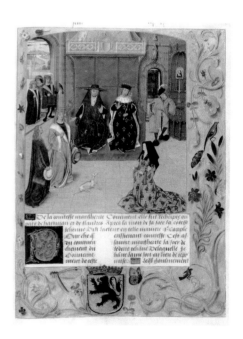

Figure 186.
Master of Antoine Rolin. *Marguerite, Countess of Flanders Pleading before the King of France and Odo of Tusculum*, in Jacques de Guise, *Annales du Hainaut*, translated by Jean Wauquelin. Oxford, Bodleian Library, Ms. Douce 205, fol. 28.

18, 1490, and bears the monogram of an unidentified scribe.[13] The volumes have been severely vandalized; five of the remaining nine miniatures are by our Master (fig. 187).[14] The manuscript probably belonged to Gilles de Berlaymont, whose daughter married Louis, a son of Antoine Rolin.[15]

Otto Pächt has attributed to our Master a beautifully illustrated codex with Guillaume de Deguileville's *Pèlerinage de la vie humaine* (fig. 188) and *La danse aux aveugles* by Pierre Michaut (Handlist no. 1).[16] The manuscript bears the arms, motto, and emblems of Charles-Alexandre de Croy, dated 1618. At least three artists shared the task of thirty-one large and 112 small miniatures, and their work is distributed by quire. Each artist practices his own style of painted initial; each change of hand in the images corresponds coherently with a change of hand in the painted initials. The nine unfinished miniatures drawn in pen and ink are by the Master of Antoine Rolin, and they permit a glimpse of his draftmanship and style at their strongest and simplest: assured, dry, dynamic.[17]

The ensemble of stylistic traits that distinguishes the Rolin Master from his close contemporaries has never been enumerated or analyzed. The four secular manuscripts illustrate several of his distinctive qualities in the construction of landscape, choice of color and value, figure types, and ornamental vocabulary. Some of these traits are the fruit of his emulation of Simon Marmion; others are original and were quickly reproduced and stereotyped by his own imitators. Due to the number of manuscripts under consideration here and the limitations of space, pertinent examples of the individual stylistic traits will be cited from the illustrations throughout the discussion. Further brief remarks about individual attributions will be made in the handlist.

The landscapes of the Rolin Master are easily recognizable. They are composed of broad expanses of space with little relief and rendered in light, remarkably luminous colors, of which the most distinctive is a delightful apple green (figs. 184, 190). The ground often occupies two-thirds of the image and is dotted with small, round bushes, some of which delimit the foreground (figs. 184, 188, 190). Marmion's influence is most strongly noticeable in the sinuous pathways or streams that guide the eye into the distance toward the expanses of water, which gleam like bright filaments on the horizon in gradually dissolving pastel tonalities (figs. 191, 196). Other reminiscences of Marmion are the far-away architectural ensembles, set off against powder-blue hills that fade into an almost atmospheric gray. Huge, "frowning" rocks and tall, thinly garnished trees stand out against the sky (figs. 188, 196).

The conventions used by the Rolin Master for cloud formations are virtually a signature and were rapidly adopted by other artists in his circle.[18] Across a sky of pale blue drift parallel striations in dark blue that follow more or less the ruling of the text, visible beneath the layer of paint. Other filaments as well as puffs of cumulus clouds are painted in silver, now blackened by oxydation (figs. 187, 191–93). Wherever there is an opening to the sky, no matter how small, our Master introduces his play of blue and silver lines (figs. 184–86, 188–91).

The pastel tonalities of the landscapes contrast with the saturated colors of the costumes. The artist prefers the color combinations green-red, blue-red or blue-pink, or a close association of all four, especially when he represents a tight group of figures (figs. 186, 192).

Drapery falls in a cascade of boxlike folds highlighted by painted gold hatchings. Half-kneeling or sitting postures accentuate the play of hump and hollow in the fabrics (figs. 184, 186, 191, 192, 198, 206). A characteristic overpainted brushstroke that softly rubs the surface of the paint creates a velvety texture (fig. 189). The overall treatment of the figures is rather flat, more linear than sculptural. Like other artists of his caliber and time, the Rolin Master has difficulty working out the relative size of figures in his receding landscapes and interiors (figs. 195, 206). These limitations mark the artistic boundary between the Rolin Master and Simon Marmion.

When standing still or involved in conversation, the male figures are imposingly

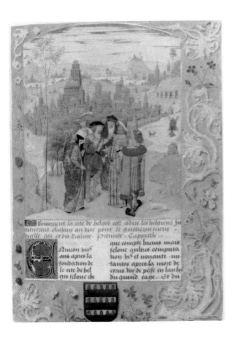

Figure 187.
Master of Antoine Rolin. *The Belgians Discussing How They Should Govern Their City*, in Jacques de Guise, *Annales du Hainaut*, translated by Jean Wauquelin. Oxford, Bodleian Library, Holkham misc. Ms. 51, fol. 161.

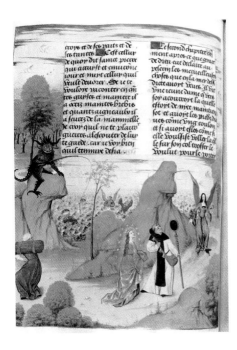

Figure 188.
Master of Antoine Rolin. *The Apparition of the Winged Lady to the Pilgrim*, in Guillaume de Deguileville, *Le Pèlerinage de la vie humaine*. Geneva, Bibliothèque Publique et Universitaire, Ms. fr. 182, fol. 167v.

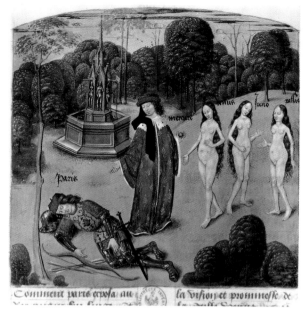

large, static, and rather wooden (figs. 187, 189, 191). The melancholic head that leans toward the shoulder is often a bit too large for the body; the face tends to have a ruddy complexion, strong linear definition, and a somewhat vacant, downcast expression (figs. 189, 191, 192). When in motion, the gentlemen kneel, walk, or even pirouette, but the result is not natural and gives the impression of instability. The figures float across the page; nothing holds them to the earth, not even the discreet shadows attached to their feet (figs. 186, 192). Ladies adopt dancing poses, supple and light, with an elegant *déhanchement*. Heads are coiffed with an abundance of curly hair, the oval faces are white and smooth. The facial expressions are somewhat comical: under skeptically arched eyebrows, tiny black eyes gaze modestly aside; a slightly puffy lower lip pouts above a small round chin (figs. 190, 192). On certain occasions, the Rolin Master does not hesitate to add a humorous touch by exaggerating postures.[19]

Flashes of yellow, highlighted with red and bright orange for the boots, turbans, and costumes, denote the Flemish influence in a palette where soft tonalities of mauve, gray, salmon, and light green are more the property of the French aesthetic used by Simon Marmion. Interiors are sober, with broad surfaces painted in gray tones, and articulated by thin columns. The numerous arcades opening to the exterior are crowned with thin moldings that fold back at the extremities (figs. 185, 186, 189, 192, 199), recalling the vocabulary of Marmion in *The Visions of Tondal*.[20]

The same ornamental vocabulary for trompe l'oeil borders, decorated initials, paragraph signs, and line endings is employed in nearly all the Rolin Master manuscripts. Particularly recognizable are the decorated initials, composed of featherlike sprays in white or gold *camaïeu* that camouflage the contours of the letter (figs. 185, 191). The backgrounds in brown or turquoise are most often stippled in snowy gold or white (figs. 184, 193); those that have two tones—blue and raspberry pink—are usually lightly dusted with gold or silver arabesques (figs. 186, 189, 190). Identical pigments are used for the miniatures and the secondary decoration. The feathery initial, in a harder, more stylized form, was already well implanted in the Hainaut by 1470 and was part of Marmion's vocabulary.[21]

On the basis of these stylistic traits, three other manuscripts may be added to the secular corpus of the Rolin Master. The first, undoubtedly the most important addition to the group, is a *Recueil des histoires de Troie* (Handlist no. 18),[22] which again bears the monogram and arms of the Ailly-Rolin couple,[23] overpainted with those of Oettingen.[24] Its 122 miniatures are of exceptional quality and stylistic homogeneity (figs. 189, 190). The manuscript bears a colophon dated 1495, in which the scribe identifies himself as Pierret Gousset.[25]

Figure 189.
Master of Antoine Rolin. *Anthenor Purchases the "Palladium"; the Greeks Sacrifice to Minerva*, in Raoul Lefèvre, *Le recueil des histoires de Troie*. Paris, Bibliothèque Nationale, Ms. fr. 22552, fol. 275v.

Figure 190.
Master of Antoine Rolin. *Paris Dreaming of the Judgment He Must Make*, in Raoul Lefèvre, *Le recueil des histoires de Troie*. Paris, Bibliothèque Nationale, Ms. fr. 22552, fol. 214v.

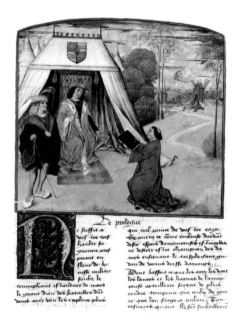

Figure 191.
Master of Antoine Rolin. *Jean Molinet Presents His Book to Philippe de Clèves*, in Jean Molinet, *Le Roman de la Rose moralisé et translaté de rime en prose*. The Hague, Koninklijke Bibliotheek, Ms. 128 C 5, fol. 1.

The second manuscript, the *Roman de la Rose moralisé et translaté de rime en prose*, was written by Jean Molinet for Philippe de Clèves in 1500 (Handlist no. 11);[26] it is the only manuscript in the corpus written on paper. The dedicatory miniature is well known to specialists of Molinet for its vivid rendering of the author's legendary ugliness (fig. 191).[27]

The last manuscript is an anonymous treatise composed according to the rules of artificial memory, the *Allégorie de l'homme raisonnable et de l'entendement humain* (Handlist no. 17). Here our artist has invented eleven images, some of which are quite striking; they respond to the challenge of the *Ars memoriae*, an unusual mnemonic technique borrowed from antiquity and exploited during the fifteenth and sixteenth centuries.[28] The *Allégorie*, from the collection of Margaret of Austria,[29] is one of the latest manuscripts in the corpus and may well date to the second decade of the sixteenth century.[30] The compositional and technical habits of our artist are clearly recognizable: the raised viewpoint, facial attitudes, drapery conventions, unstable postures, even the camping of a group of people in the corner of the image (fig. 192).

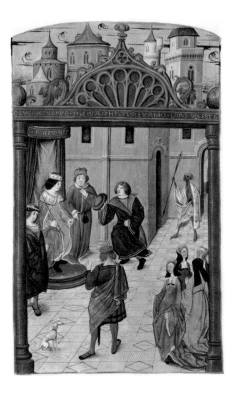

Figure 192.
Master of Antoine Rolin. *The Monarch and His Courtiers Visited by Four Allegories and Death*, in *Allégorie de l'homme raisonnable et de l'entendement humain*. Paris, Bibliothèque Nationale, Ms. fr. 12550, fol. 29v.

Books of Hours

The Rolin Master's books of hours are less accomplished artistically than the secular manuscripts, although there are a few outstanding exceptions.[31] The Master's production here reveals a varied range of quality (and probably price), which corresponds to a clientele that included both the aristocracy and the bourgeoisie. Given the uneven quality and the large number of books produced, it is likely that the artist enjoyed the support of several assistants. These books of hours also demonstrate the strong influence that Simon Marmion exercised on the Master of Antoine Rolin. It is worth noting that the style of the Master was previously known only through secular iconography, which restricted possible comparisons with major religious works attributed to Marmion.

Most of the manuscripts have conventional Ghent-Bruges borders with trompe l'oeil acanthus, flowers, insects, etc. (figs. 193, 201). Only three books have the old-fashioned and rather mechanically executed borders with the ink-drawn comma forms dotting the parchment ground and a style of acanthus leaf that are typical of the region (fig. 206).[32] The suffrages are usually decorated with small miniatures in grisaille, a technique used from time to time for the full-page miniatures and sometimes for an entire manuscript (Handlist no. 10; fig. 193).[33] Present in each manuscript are the striated skies and feathery initials (except Handlist no. 20), traits that underscore the homogeneity of the corpus.

Figure 193.
Master of Antoine Rolin (or assistant). *Pentecost*, in a book of hours. The Hague, Koninklijke Bibliotheek, Ms. 76 F 16, fol. 31.

The most spectacular work is a book of hours that belonged to a member of the illustrious family de Boussu,[34] namely, Isabelle de Lalaing, who had the book made sometime in the years following the death of her husband, Pierre de Hennin, in 1490. The figure of Isabelle (also called Isabeau or Elizabeth) kneeling before her prie-dieu is nearly identical to that of the countess Marguerite in Douce 205, both in attitude and brocaded attire (figs. 186, 194).[35] The hours are for the use of Rome; the calendar (in French) and the litanies are for Cambrai, with Saints Waudru and Gery given special prominence.[36] Indeed, it was in the church in the village of Boussu near Mons that Saint Gery appeared in a vision to Saint Waudru, urging her to found the famous Collégiale de Chanoinesses at Mons.[37]

In the Boussu Hours, many of Marmion's iconographic motifs reappear among the twenty-six large miniatures executed by the Rolin Master, for example, in *Christ on the Mount of Olives* (fig. 195), which recalls the grisaille image in the Hours of Rolin in Madrid.[38] The group of sleeping apostles has been transferred to the right, but the artist maintains the same pose for the apostle stretched out on the ground, cradling his head on his arm. The Rolin Master borrows selectively from Marmion's composition and redistributes the figures and motifs.

The Annunciation to the Shepherds (fig. 196) also finds an echo in the Madrid

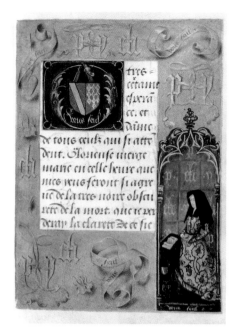

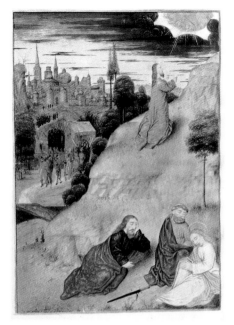

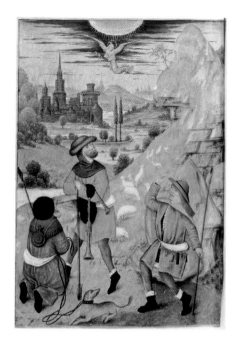

Hours (fol. 59v), especially in the landscape. Similarities include the rocky escarpment to the right, the tufts of grass, the stratified layers of rock, and the spatial plunge to the left toward a distant architectural complex, a formula often employed in the Berlaymont Hours.[39]

The Madrid as well as the Louthe Hours[40] provide models for the image of the *Trinity* in the Boussu manuscript, both in the iconography and in the dry flat style used for the figures and their garments. Our Master also freely adapts the flamboyant decoration and pinnacles of the throne (figs. 197, 198). The *Nativity* (fig. 199) is based on models from Marmion's circle: Joseph with his lantern recalls the Louthe[41] and the Huth Hours (fig. 200).

A similar comparative series can be built around two Marmion *Pietàs*, one in Philadelphia,[42] the other in the "La Flora" Hours, and a *Pietà* in a book of hours in

Figure 194.
Master of Antoine Rolin. *Isabelle de Lalaing in Prayer*, in the Boussu Hours. Paris, Bibliothèque de l'Arsenal, Ms. 1185, fol. 54.

Figure 195.
Master of Antoine Rolin. *Christ on the Mount of Olives*, in the Boussu Hours. Paris, Bibliothèque de l'Arsenal, Ms. 1185, fol. 186v.

Figure 196.
Master of Antoine Rolin. *The Annunciation to the Shepherds*, in the Boussu Hours. Paris, Bibliothèque de l'Arsenal, Ms. 1185, fol. 113v.

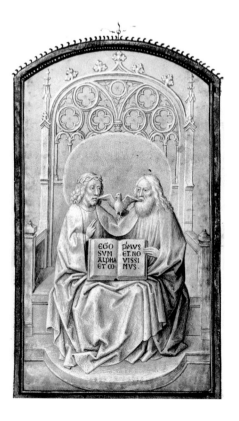

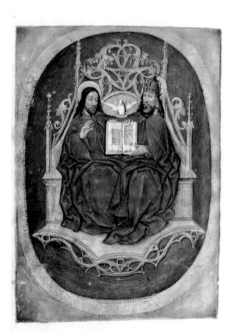

Figure 197.
Simon Marmion. *Trinity*, in the Rolin Hours. Madrid, Biblioteca Nacional, Ms. Res. 149, fol. 199v.

Figure 198.
Master of Antoine Rolin. *Trinity*, in the Boussu Hours. Paris, Bibliothèque de l'Arsenal, Ms. 1185, fol. 249v.

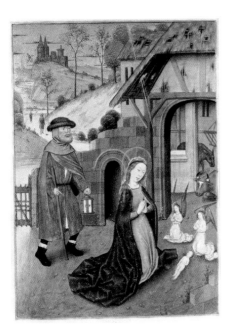

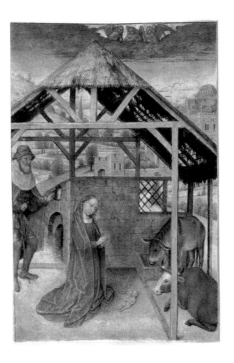

Figure 199.
Master of Antoine Rolin. *Nativity*, in the
Boussu Hours. Paris, Bibliothèque de l'Arse-
nal, Ms. 1185, fol. 105v.

Figure 200.
Simon Marmion. *Nativity*, in the Huth Hours.
London, British Library, Add. Ms. 38126,
fol. 75v. Reproduced by kind permission of
the British Library Board.

Baltimore,[43] also linked to Mons[44] and here attributed to the Rolin Master (Handlist
no. 6). The tilt of Christ's head, the position of his right arm, which parallels the
angle of the frame, as well as the gold background are features common to all three
miniatures (figs. 201, 202). A somewhat awkward *Virgin and Child* in the Walters
book[45] presents affinities with the same subject in the Huth Hours, but the closest
resemblances can be drawn from one of the Rolin Master's finest achievements, the
Virgin and Child in the Munich Hours (Handlist no. 13; figs. 203, 204).

Another book of hours (Handlist no. 20),[46] which Otto Pächt classed as "School
of Marmion," is also by the Rolin Master and presents a number of correlations with
Marmion's work in Pierpont Morgan Library, M. 6. Following the model of the *Ad-
oration of the Magi* in M.6, the artist centers his action at the foot of the bed, adapts
the small Joseph figure entering on the Virgin's left, and repeats the rare motif of a
softly hung drapery over the bed (figs. 205, 206).[47]

Quite unusual in iconography is the *Pentecost* where, under a porch, are crowded

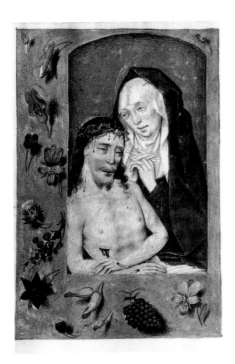

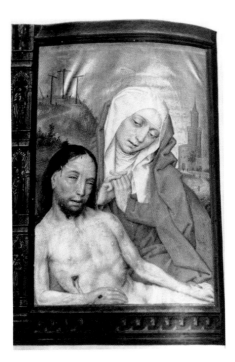

Figure 201.
Master of Antoine Rolin. *Pietà*, in a book of
hours. Baltimore, Walters Art Gallery, Ms. W.
431, fol. 77v.

Figure 202.
Simon Marmion. *Pietà*, in the "La Flora"
Hours. Naples, Biblioteca Nazionale, Ms. I B
51, fol. 165v.

the apostles, one of whom reads a book posed on the foreground wall. This disposition occurs not only in the Stuttgart manuscript, but in several other books of hours by the Rolin Master (fig. 193).[48] The iconography is not a borrowing from Marmion, but rather another hallmark of our artist. He frequently uses this porch, with its steps, two columns, and pointed roof, in his secular works (fig. 185).

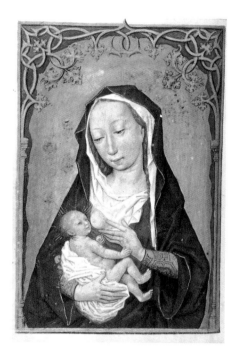

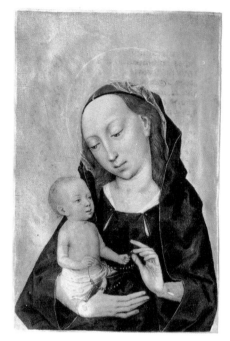

Figure 203.
Master of Antoine Rolin. *Virgin and Child*, in a book of hours. Munich, Bayerische Staatsbibliothek, Clm. 23240, fol. 14v.

Figure 204.
Simon Marmion (or workshop). *Virgin and Child*, in the Huth Hours. London, British Library, Add. Ms. 38126, fol. 102v. Reproduced by kind permission of the British Library Board.

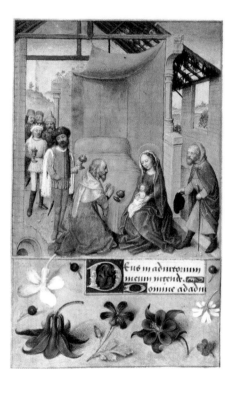

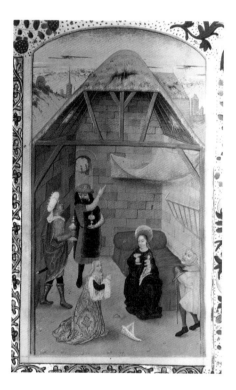

Figure 205.
Simon Marmion. *Adoration of the Magi*, in a book of hours. New York, Pierpont Morgan Library, M. 6, fol. 44v.

Figure 206.
Master of Antoine Rolin. *Adoration of the Magi*, in a book of hours. Stuttgart, Württembergische Landesbibliothek, Cod. Brev. 3, fol. 83v.

Localizing the Rolin Master's Activity

The secular and liturgical books that have been grouped together on the basis of their stylistic and ornamental relationships also share prosopographic, linguistic, and liturgical features that link them to Hainaut and its episcopal diocese, Cambrai. All the original owners that have been identified come from this region; the texts in French are almost exclusively in the Picard dialect; and much of the liturgical evidence is for the use of Cambrai.

Other, more precise indications point to Mons as the most likely place of activity for the Rolin Master. At least five books of hours in the corpus mention Saint Waudru, whose cult is centered in Mons.[49] Furthermore, the book of hours in The Hague (Handlist no. 10) has two indications of Mons provenance. First, its calendar for the diocese of Cambrai mentions Saint Waudru (February 3); second, its binding, which is original and typical of the north,[50] is almost identical to the binding of another book of hours made for the use of Cambrai with a Mons calendar (Saint Waudru).[51]

Several of the owners of the Rolin Master's books were related to Mons directly or indirectly. Marguerite Crohin came from an old noble Mons family.[52] Two of the daughters of Pierre de Hennin and Isabelle de Lalaing received a prebend from the Collégiale de Sainte-Waudru.[53] For our purposes, however, by far the most important resident of the city was none other than the *grand bailli*, Antoine Rolin, who lived in the Hôtel d'Aymeries near the Collégiale.[54] He conducted most of his affairs from Mons,[55] where he lived until his death on September 4, 1497.[56]

Finally, the activity of Pierre Gousset, who was the scribe (and perhaps also the illuminator) of one of Antoine's books, the *Recueil des histoires de Troie* (Handlist no. 18), can be firmly localized at Mons. The colophon of this manuscript reads: "Escript et furni en l'an mil IIIIc IIIIxxXV environ le jour de Toussaint, par Pierret Gousset escriptvain" (fol. 293v). The word "furni" has the meaning of "finishing," or "accomplishing," and implies that Pierret Gousset did more than write the book.[57] Simon Marmion in 1467 is entitled "écrivain"; his itemized intervention, however, includes "historier, enluminer et mettre en fourme un breviaire."[58] The hypothesis that Pierret Gousset was an illuminator was first proposed by Léopold Devillers in 1878 in *Le passé artistique de Mons*, on the basis of an account for funeral cloths for the Collégiale de Sainte-Waudru in 1519, which reads: "A Piere Gouset, pour avoir fait aucuns offices d'escriptures comme dessains, etc., a esté payet L soles. Audit Pière, pour le parfait du grez [a gradual] par luy acomply, a esté payet XXXVII livres."[59] The activity of Pierre Gousset[60] is also attested in two accounts from two Mons institutions: for the chapter of Saint Waudru in 1501 and for the Hôpital Saint-Jacques in Mons in 1507–08, where he is said to have received 30 soles for a quire in parchment in order to complete a missal.[61]

The four mentions of Pierre Gousset (1495, 1501, 1507, 1519) are spread over a twenty-five year period, and the latter three place him in Mons. Since Antoine Rolin was residing in Mons in 1495, when he commissioned the *Recueil des histoires de Troie* from Pierre, it is quite likely that Gousset spent his entire life in that city. Our only evidence at present for Pierre as illuminator is the payment for "dessains, etc." in the accounts of the Collégiale de Sainte-Waudru. Pierre Gousset may thus have participated in the illumination of some of Antoine Rolin's books, but the equation of his name with our artist—whether that of the Rolin Master or a lesser master—will require further proof. Here only the groundwork has been laid: the definition of a homogeneous corpus of manuscripts painted by the Rolin Master and collaborators, the localization of this activity in Hainaut and probably at Mons, and the identification of the Master's major patrons, notably Antoine Rolin.

*Preliminary Handlist of Works Attributed to the Master of Antoine Rolin**

Works Attributed by Otto Pächt

1 Geneva, Bibliothèque Publique et Universitaire, Ms. fr. 182: *Le pèlerinage de la vie humaine* by Guillaume de Deguileville, and *La danse aux aveugles* by Pierre Michaut. 232 fols., 435 × 310 mm; 31 large and 112 small miniatures (fig. 188); several hands; decoration unfinished; 9 drawings in plummet; historiated borders; typical feathery initials; arms of Charles-Alexandre de Croy (1618).

2 Oxford, Bodleian Library, Ms. Douce 205: *Annales du Hainaut* by Jacques de Guise, translated by Jean Wauquelin (fragments). v + 34 fols.; 373 × 267 mm; 8 large and 1 small miniatures (fig. 186); trompe l'oeil borders; typical feathery initials; monogram of Antoine Rolin and Marie d'Ailly; arms replacing those of Rolin not identified; belonged to the comte de Lalaing in 1600.

3 Oxford, Bodleian Library, Holkham misc., Ms. 50–53: *Annales du Hainaut* by Jacques de Guise, translated by Jean Wauquelin, parts I and II. Part I (Ms. 50–51), 364 fols.; part II (Ms. 52–53), 305 fols.; 400 × 280 mm; 9 miniatures, all in part I, 5 by the Master of Antoine Rolin (fols. 90, 161 [fig. 187], 229, 331, 349); trompe l'oeil borders; typical feathery initials; part I ends with scribe's (?) monogram (fol. 364); part II, dated September 18, 1490, at the end (fol. 305v); arms of the Berlaymont family sometimes impaled with the arms of Ligne.

4 Paris, Bibliothèque Nationale, Ms. fr. 9197: *Le Livre des Echecs amoureux moralisés* by Evrart de Conty. 13 + 442 fols.; 440 × 325 mm; 4 large and 20 small miniatures (figs. 184, 185); trompe l'oeil borders; typical feathery initials; arms and monogram of Antoine Rolin and Marie d'Ailly.

New Attributions

5 Antwerp, collection of Dominique Hertoghe: hours for the use of Liège(?). 116 fols.; 144 × 94 mm; 11 inserted miniatures (2 missing); no border; typical feathery initials; belonged to the baron de Crassier in 1713. *Pentecost* (fol. 24v) and *Nativity* (fol. 51v) comparable to Paris, Arsenal 1185 (fols. 207 and 105v [fig. 199]).

6 Baltimore, Walters Art Gallery, Ms. W. 431: hours for the use of Rome; calendar for the use of Cambrai; prayers in Picard dialect. 146 fols.; 114 × 88 mm; 8 large miniatures (6 in color [fig. 201] and 2 in grisaille, fols. 17v, 26v) and 13 small grisaille miniatures; trompe l'oeil borders; typical feathery initials. *Pentecost* comparable to The Hague 76 F 16 (fig. 193); *Death with a Mirror* (fol. 115) comparable to Morgan M. 33 (fol. 181) and Munich Clm. 23240 (fol. 155).

7 Cambrai, Bibliothèque Municipale, Ms. A 107: hours for the use of Rome; calendar for the use of Cambrai; calendar and rubrics in Picard dialect. 120 fols.; 198 × 149 mm; 10 large miniatures (2 missing), two hands; 12 historiated initials in grisaille on blue background (see Handlist nos. 8, 10, 13); up to fol. 100, borders with traditional acanthus on parchment ground dotted with comma forms in ink (see also Handlist nos. 20, 30); from fol. 100v on, typical feathery initials and contemporary borders in the same style as the older ones. *Pentecost* (fol. 20v) comparable to The Hague 76 F 16 (fig. 193).

8 Copenhagen, Kongelige Bibliotek, Ms. Thott 542 4°; hours for the use of Cambrai; calendar and rubrics in Picard dialect. 171 fols.; 220 × 153 mm; 12 large miniatures; 1 small grisaille miniature in Gothic niche (fol. 48) (see Handlist no. 6); 3 historiated initials in grisaille (see Handlist nos. 7, 10, 13); trompe l'oeil borders; typical feathery initials; original binding similar to Stockholm Hours (Handlist no. 19); arms and monogram of Jacques Chrétien and Marguerite Crohin de Salmonsart; in a late sixteenth-century hand, list of possessors up to 1670. *Pentecost* (fol. 20v) comparable to The Hague 76 F 16 (fig. 193); *Nativity* (fol. 78v) comparable to Huth Hours (fig. 200). *Adoration of the Magi* (fol. 87v) comparable to Stuttgart Brev. 3 (fol. 83v; fig. 206); *Massacre of the Innocents* (fol. 102v) comparable to The Hague 76 F 16 (fol. 60); *Resurrection of Lazarus* (fol. 124v) comparable (when reversed) to Arsenal 1185 (fol. 293v).

9 Frankfurt, Stadt- und Universitätsbibliothek, Ms. lat. oct 107: hours for the use of Cambrai; rubrics in French. II + 104 + IV fols.; 185 × 125 mm; 16 large and 15 small miniatures; trompe l'oeil borders; typical style and palette, iconographic models, striated skies, and feathery initials. Reproductions in H. Wolf, *Kostbarkeiten flämischer Buchmalerei* (Berlin, 1985), figs. 9, 12, 13, 16, 17, 20, 21, 24, 25, 28, 29, 32.

10 The Hague, Koninklijke Bibliotheek, Ms. 76 F 16: hours for the use of Rome; calendar for the use of Cambrai; calendar rubrics and prayers in Picard dialect. I + 133 + II fols.; 154 × 112 mm; 13 large and 2 small grisaille miniatures by an assistant of the Rolin Master; 4 historiated initials in grisaille on blue background (see Handlist nos. 7, 13); trompe l'oeil borders in grisaille; typical feathery initials; *Pentecost* under a porch (fig. 193).

11 The Hague, Koninklijke Bibliotheek, Ms. 128 C 5: *Le Roman de la Rose moralisé et translaté de rime en prose* by Jean Molinet. 240 fols.; 365 × 270 mm; one dedicatory miniature (fig. 191); no border; typical feathery initials; arms of Philippe de Clèves, who ordered the work in 1500.

12 Houston Public Library, Finnigan Collection, Ms. de Ricci 6: hours. 137 fols.; 200 × 140 mm; 6 large and 22 small miniatures; by an assistant of the Rolin Master; trompe l'oeil borders; typical feathery initials; *Pentecost* comparable to The Hague 76 F 16 (fig. 193).

13 Munich, Bayerische Staatsbibliothek, Clm. 23240: prayer book, calendar, and rubrics in French. 250 fols.; 138 × 100 mm; 2 large miniatures inserted (fig. 203); historiated initials in grisaille (see Handlist nos. 7, 10); small grisaille miniature on blue background (see Handlist nos. 6, 10); numerous birds, bunches of flowers, etc. in margins; trompe l'oeil borders; typical feathery initials; portrait of owner (?) (fol. 15); unidentified arms and inscription "Pour sa bonté. J. K." (fol. 37v); *Death with a Mirror* in initial D (fol. 255) identical to Morgan M. 33 (fol. 181) and comparable to Walters 431 (fol. 115).

14 New York, Pierpont Morgan Library, M. 116: hours for the use of Thérouanne (Hours of the Virgin) and of Cambrai (Office of the Dead); calendar in French for the use of Cambrai. II + 173 fols.; 190 × 140 mm; 16 large and 20 small miniatures by an assistant of the Rolin Master; trompe l'oeil borders; typical feathery initials. *Crucifixion* (fol. 19v) comparable to Copenhagen Thott 542 4° (fol. 13v); *Resurrection of Lazarus* (fol. 100v) comparable to Morgan M. 1053 (fol. 127v) and Handlist no. 22 (fol. 112v, reversed). *Pentecost* (fol. 23v) comparable to Stuttgart Brev. 3 (fol. 22v) and Copenhagen Thott 542 4° (fol. 20v).

15 New York, Pierpont Morgan Library, M. 1053: hours for the use of Rome; calendar for the use of Cambrai (?). 195 fols.; 154 × 105 mm; 11 large and 22 small miniatures; 24 calendar roundels; one border historiation; original binding; *Adoration of the Magi* (fol. 70v) comparable to Copenhagen Thott 542 4° (fol. 87v) and Stuttgart Brev. 3 (fig. 206); *Resurrection of Lazarus* comparable to Morgan M. 116 (fol. 100v) and Handlist no. 22 (fol. 112v, reversed). Reproductions in Joseph Baer, *Codices manuscripti saeculorum IX. ad XIX. Incunabula, xylographica et typographica*, sales cat. 675 (Frankfurt, 1921), no. 51, pls. XVIII–XIX.

16 Paris, Bibliothèque de l'Arsenal, Ms. 1185: hours for the use of Rome; calendar for the use of Cambrai; calendar and prayers in Picard dialect. 378 fols.; 160 × 112 mm; 26 large (figs. 194–96, 198, 199) and 38 small miniatures; 9 historiated initials, 2 borders with historiated medallions; 24 calendar roundels; trompe l'oeil borders; typical feathery initials; arms and monogram of Pierre de Hennin, lord of Boussu, and Isabelle de Lalaing.

17 Paris, Bibliothèque Nationale, Ms. fr. 12550: *Allégorie de l'homme raisonnable et de l'entendement humain*. 51 fols.; 265 × 190 mm; 5 large (fig. 192) and 6 half-page miniatures inserted; no decorated initials; belonged to the library of Margaret of Austria.

18 Paris, Bibliothèque Nationale, Ms. fr. 22552: *Le recueil des histoires de Troie* by Raoul Lefèvre. IV + 293 fols. (+ 215a); 382 × 270 mm; 117 large (figs. 189, 190) and 6 small miniatures (4 by a collaborator: fols. [206v, unfoliated leaf preceding fol. 207], 216, 223v, 228); 3 trompe l'oeil borders (at the beginning of each book); typical feathery initials; dated November 1, 1495, and signed by the scribe Pierret Gousset at the end; monogram of Antoine Rolin and Marie d'Ailly; arms of the Oettingen of Swabia overpainted on the arms of Rolin.

19 Stockholm, Kungl. Biblioteket, Ms. A. 233: hours for the use of Rome, written for a pilgrim from Jerusalem; calendar for the use of Cambrai; some rubrics in French. I + 115 fols. (= 25–29v); 102 × 70 mm; 12 large miniatures of which 5 are by the Rolin Master (fols. 2, 86v, 87, 96v, 97); 7 historiated initials; trompe l'oeil borders; typical style, palette, striated skies and feathery initials; original binding similar to Copenhagen Hours (Handlist no. 8); portraits of an unidentified owner and his wife (?): fols. 2, 57, 86v, 103, 103v, 107v.

20 Stuttgart, Württembergische Landesbibliothek, Cod. Brev. 3: hours for the use of Rome; Franciscan litanies. 186 fols.; 240 × 175 mm; 12 large and 6 small miniatures; borders with traditional acanthus (see Handlist nos. 7, 30; fig. 206). Iconographic comparisons with Handlist no. 25. *Pentecost* comparable to The Hague 76 F 16 (fig. 193).

21 Location unknown (Sotheby's, London, July 10, 1967, lot 99): hours of the Holy Sacrament and of Saint Anne followed by an abridged version of the Penitential Psalms and abridged litany, memorials for Saint Susanna and Saint Adrian, and a hymn to the Holy Ghost; some rubrics in French. 29 fols. + IV flyleaves; 134 × 92 mm; 4 large miniatures on two pairs of facing pages; trompe l'oeil borders; typical feathery initials; arms and name of Adrienne de Stavele (wife of Robert de Melun). Typical velvety texture comparable to Paris, fr. 22552 (fig. 189).

22 Location unknown (Hôtel Drouot, Paris, March 21, 1973, *Manuscrits enluminés et livres rares*, lot 10, 1 color reprod., from the collection of Robert Danon): hours for the use of Rome; incomplete calendar (July to December); calendar, rubrics, and prayers in French; two hands. 270 fols.; 135 × 95 mm; 15 large miniatures (7 in blue and green *camaïeu* grisaille); 38 small miniatures (9 in grisaille), 12 calendar roundels in grisaille; trompe l'oeil borders; typical style, palette, iconography, striated skies, and feathery initials; arms and motto of a member of the Somaing family in Hainaut (Valenciennes?); original binding. *Resurrection of Lazarus* (fol. 112v) comparable (when reversed) to Morgan M. 116 (fol. 100v) and M. 1053 (fol. 127v). Reproductions in P. Béres, *Manuscrits et livres rares du quatorzième au seizième siècle* (Paris, 1959) and Hôtel Drouot, Paris, December 7, 1959, lot 1).

23 Location unknown (ex-coll. Montserrat de Pano, Saragossa): hours; 5 large miniatures; trompe l'oeil borders (see J. Domínguez Bordona, *Manuscritos con pinturas: Notas para un inventario de los conservados en colecciones públicas y particulares de España*, vol. 2 [Madrid, 1933], p. 355, no. 2142, pl. 739). *Pentecost* comparable to The Hague 76 F 16 (fig. 193).

24 Location unknown (W. S. Kundig, expert, Geneva, June 23–24, 1948, *Très précieux manuscrits enluminés et incunables provenant de la bibliothèque privée de feu M. Léo-S. Olschki et d'une collection princière. Livres anciens des XVIe, XVIIe, XVIIIe siècles et du début du XIXe siècle*, cat. no. 95, lot 20, p. 16, pl. XVII): hours; calendar for the use of Lobbes near Charleroi; 210 fols.; 110 × 75 mm; 15 large miniatures; 5 historiated initials; trompe l'oeil borders; typical style, iconography, striated skies, and feathery initials; on flyleaves, sixteenth-century notes concerning the Vrohin family (Hainaut), original binding, clasp bearing initials PM.

25 Auxerre, Trésor de la Cathédrale, Ms. 11: hours for the use of Rome and Tournai (Office of the Dead); calendar in French. 133 + II fols.; 192 × 148 mm; 9 large and 2 small miniatures; trompe l'oeil borders on colored grounds dotted with gold, some with compartments. Certain miniatures, although in a completely different style, are based on iconographic models in the Stuttgart Hours (Handlist no. 20).

26 Beloeil, Belgium, collection of the prince de Ligne: hours for the use of Rome; calendar for diocese of Utrecht(?). Not collated; 140 × 103 mm; 3 large and 1 small historiated initial of poor quality; trompe l'oeil borders as in Morgan M. 1053 (Handlist no. 15); on first flyleaf, "Dono Antonii Guillet/ 1712."

27 Cambridge, Massachusetts, Harvard University, Houghton Library, Ms. lat. 275: hours for the use of Rome; calendar for the use of Cambrai; rubrics and prayers in Picard dialect. 219 fols.; 140 × 100 mm; 7 large miniatures (one in gold *camaïeu*) of poor quality by an imitator of the Rolin Master (at least 6 missing); 20 small miniatures in grisaille; trompe l'oeil borders; typical feathery initials.

28 New York, Pierpont Morgan Library, M. 33: hours for the use of Rome; calendar in French for the use of Cambrai (Mons). 262 fols.; 133 × 96 mm; 14 large, 17 half-page and 1 small miniatures in grisaille heightened with gold, green, and blue in a style different from that of the Rolin Master; 4 historiated initials, 1 historiated border in grisaille; trompe l'oeil borders in grisaille; typical feathery initials. Some stylistic affinities with Handlist no. 31. *David Slaying Goliath* (fol. 151) based on Paris, Arsenal 1185 (fol. 219v); *Death with a Mirror* in initial D (fol. 181) identical to Munich Clm. 23240 (fol. 155) and comparable to Walters 431 (fol. 115).

29 Paris, Bibliothèque Nationale, Ms. fr. 6440: *Histoire d'Alexandre le Grand*, French version of the *Vita Alexandri* by Quintus Curtius Rufus. XV + 242 fols.; 480 × 370 mm; 17 large and 1 small miniatures, some in the style of the Master of Antoine Rolin (fols. 13, 15v, 62v, 149, 171); trompe l'oeil borders; typical feathery initials on illuminated folios only; another ornamentation for the written folios; arms and monogram of Philippe de Vere and Marguerite de Lannoy; belonged to the library of Margaret of Austria.

30 Location unknown (J.M. Plotzek, *Andachtsbücher des Mittelalters aus Privatbesitz*, exh. cat. [Schnüt-gen-Museum, Cologne, 1987], no. 60, pp. 193–95): hours for the use of Rome; calendar in Picard dialect for the use of Cambrai; calendar and rubrics in Picard dialect. 154 fols.; 245 × 170 mm; 12 large and 19 small miniatures; borders with traditional acanthus (see also Handlist nos. 7, 20; *Pentecost* [fol. 20v] under a porch).

31 Location unknown (Sotheby's, London, July 1? 1948, lot 60): hours for the use of Rome; calendar for the use of Cambrai; rubrics in Picard dialect. 302 fols.; 220 × 155 mm; 13 large and 37 small miniatures in grisaille heightened with gold, green, and blue in a style different from that of the Master of Antoine Rolin; trompe l'oeil borders in grisaille; typical feathery initials; "Ce livre apartien a moy Vincent Guichard" stamped in gold on the lower edge of both covers of the binding. Some stylistic affinities with Handlist no. 28.

32 Location unknown (Sotheby's, London, June 20, 1989, lot 70, pp. 124–26, and E. König and H. Tenschert, Berlin, *Leuchtendes Mittelalter*, sales cat. 21 [1989], no. 40, pp. 244–50): hours (perhaps second part of a longer manuscript). 82 fols.; 175 × 122 mm; 8 large and 14 small miniatures; borders of colored flowers and acanthus leaves. *Pentecost* under a porch (see reprod. in *Leuchtendes Mittelalter*).

Notes

* This corpus is far from being exhaustive and will continue to grow and open up many new avenues for our knowledge of late fifteenth-century illumination in the Hainaut region. I have studied the manuscripts either personally or on the basis of photographic evidence. Handlist nos. 8, 9, 18, and 22 were kindly brought to my attention by Bodo Brinkmann. Marguerite Debae and Bruno Roy deserve my gratitude for adding two manuscripts to my grouping (Handlist nos. 24 and 29, respectively). I am also indebted to Gregory Clark for bringing to my attention the hours belonging to the prince de Ligne (Handlist no. 26). The book of hours in Houston (Handlist no. 12) was identified by James Marrow (unpublished reference in the manuscript descriptions of the Pierpont Morgan Library). Finally, I should like to thank Maurits Smeyers and Bert Cardon of the Centrum voor de studie van het verluchte handschrift in de Nederlanden at the Katholieke Universiteit Leuven, who gave me full access to the rich photographic and bibliographic material in the center.

1 I wish to acknowledge the assistance I have received in this research. From the outset, François Avril has generously drawn my attention to several important manuscripts (Handlist nos. 11, 14–16, 27, 28) and discussed problems of style and dating. Nicole Reynaud has also shared her special insights on technique as it pertains to Simon Marmion and added one manuscript to this corpus (Handlist no. 20). The assistance of the members from the Section de Codicologie at the Institut de Recherche et d'Histoire

des Textes (IRHT), Paris, and especially that of Patricia Stirnemann, who helped with the English translation, is gratefully acknowledged.

2 See Brussels 1959, pp. 42–62; L. Gilissen, "La miniature en terre wallonne au temps des ducs de Bourgogne," in *La Wallonie. Le pays et les hommes. Lettres—arts—culture, 1: Des origines à la fin du XVe siècle* (1977), pp. 455–62; B. Cardon, "Saint Betremieu en andere heiligen: Over Henegouwse verluchte gebeden- en getijdenboeken uit de tweede helft van de 15 de eeuw," in M. Smeyers, ed., *Leuvens Palet: Arca lovaniensis artes atque historiae reserans documenta, jaarboek* 18 (1989), pp. 41–62.

3 Most of the historical notes on Hainaut have been taken from G. Bohy, *Histoire du Hainaut* (Charleroi, 1971), vol. 1, pp. 199–219.

4 Previous studies devoted to late Burgundian illumination have ignored the special complexity of the region and have applied, with undue haste, the "Flemish" label to an art more imbued with French pictorial characteristics than with those of Flemish-speaking regions. This created what has been called a "cultural microclimate"; see A. Châtelet, "Art français et art flamand: Les échanges dans le domaine pictural. Colloques internationaux CNRS (1983)," in *La France de la fin du XVe siècle: Renouveau et apogée* (Paris, 1985), pp. 225–35.

5 A Preliminary Handlist of Works Attributed to the Master of Antoine Rolin appears as an appendix to this essay, pp. 217–20.

6 See Pächt, in *Flemish Art, 1300–1700*, exh. cat. (Royal Academy of Arts, London, 1953), pp. 163–64, no. 612 (Oxford, Bodleian Library, Ms. Douce 205), no. 613 (Bodleian Library, Holkham misc., Ms. 51), no. 614 (Paris, Bibliothèque Nationale, Ms. fr. 9197).

7 F. Gagnebin, *L'enluminure de Charlemagne à François Ier*, exh. cat. (Musée Rath, Geneva, 1976), no. 75, pp. 171–73 (Geneva, Bibliothèque Publique et Universitaire, Ms. fr. 182).

8 M.J. Perrat, *Le livre au siècle des Rolin*, exh. cat. (Bibliothèque Municipale, Autun, 1985), p. 43f.

9 P. Durrieu, *La miniature flamande au temps des ducs de Bourgogne (1415–1530)* (Brussels and Paris, 1921), pp. 79–80, pl. LXX. A monograph on *Le Livre des Echecs amoureux moralisés* has just been published: A.-M. Legaré, F. Guichard Tesson, and B. Roy, *Les Echecs amoureux* (Paris, 1991).

10 The Hague, Koninklijke Bibliotheek, Ms. 129 A 15; see F. Guichard Tesson, "La Glose des Echecs amoureux d'Evrart de Conty: Les idées et le genre de l'oeuvre d'après le commentaire du verger de Déduit," Ph.D. diss., Université de Montréal, 1980, pp. 24–25. Guichard Tesson and B. Roy are preparing the critical edition of this huge encyclopedia (Presses de l'Université de Montréal-Vrin). Paris, Bibliothèque Nation-

ale, Ms. fr. 143 is the only other illuminated copy of this text; it was illuminated by Robinet Testart.

11 Though some other arms were added later, the initials of Antoine and Marie found in the decoration throughout the manuscript are original. The arms which have replaced those of the Rolins are still unidentified; see Pächt/Alexander 1966, p. 29, no. 388.

12 I. Arnold, "Notice sur un manuscrit de la traduction des *Annales du Hainaut* de Jacques de Guise par Jean Wauquelin (Brit. Mus., Lansdowne 214)," *Romania* 55 (1929), pp. 382–400.

13 This monogram is written in red and seems to be in the hand of the scribe. For a tentative, although not conclusive, reading of it, see A.C. de la Mare, "Further Manuscripts from Holkham Hall," *Bodleian Library Record* 10, part 6 (1982), p. 336, pl. XXIc.

14 The miniatures are on fols. 90, 161, 229, 331, 349.

15 F. V. Goethals, *Dictionnaire généalogique et héraldique des familles nobles du royaume de Belgique*, vol. 1 (Brussels, 1849), s.v. "Berlaimont."

16 Gagnebin (note 7).

17 These drawings appear on fols. 138, 139v, 140v, 143, 144v, 145v, 146v, 147v, and 155v. One of them is reproduced in Gagnebin (note 7), p. 173; it represents *The Pilgrim Addressing Lechery* (fol. 147v).

18 See Handlist nos. 26–29.

19 B. Roy has proposed an allegorical interpretation of a humorous posture in a scene in *Le Livre des Echecs amoureux moralisés* (Handlist no. 4). On fol. 237, the lover, while fascinated by Oiseuse, fights her attractive power. To express this paradox, the artist represents him walking in her direction and at the same time pulling back his robe with such determination that he is about to lose both his balance and his sandal; see B. Roy, "Sur une image allégorique: Le corps divisé contre lui-même," in D. Buschinger, ed., *Les images au moyen âge* (Cöppingen, in press).

20 J. Paul Getty Museum, Ms. 30, fols. 33v, 34v.

21 As testified in *The Visions of Tondal*; *The Vision of the Soul of Guy de Thurno*, J. Paul Getty Museum, Ms. 31, fol. 7; and the Morgan Hours, Pierpont Morgan Library, M. 6, fols. 41, 44v, 57v, 85, etc.

22 Paris, Bibliothèque Nationale, Ms. fr. 22552; [J. van Praet], *Catalogue des livres de la bibliothèque de feu M. le duc de La Vallière*, vol. 2 (Paris, 1783), no. 4087, p. 630, and H. Omont, *Catalogue général des manuscrits français anciens: Petits fonds français I, 20065–22884* (Paris, 1902), p. 522. One miniature representing *Jupiter Vanquishing Saturn* is reproduced in J. Seznec, *The Survival of the Pagan Gods* (Princeton, 1972), p. 34, fig 9.

23 Their monogram AM, for Antoine and Marie, occurs twenty-eight times.

24 The arms of the Oettingen family appear on fols. 1, 119, 207, 293v; see C. Lemaire, "Les manuscrits Oettingen: Pour en finir avec une légende," in *Mélanges Martin Wittek* (Brussels, 1991, in press).

25 Bénédictins du Bouveret, *Colophons de manuscrits occidentaux, des origines au XVIe siècle*, vol. 5 (Spicilegii Friburgensis Subsidia, 6) (Freiburg, 1979), no. 15555, and J.W. Bradley, *A Dictionary of Miniaturists, Illuminators, Calligraphers and Copyists*, vol. 2 (London, 1888), p. 60.

26 The Hague, Koninklijke Bibliotheek, Ms. 128 C 5; A.S. Korteweg and C.A. Chavannes-Mazel, *Treasures from the Royal Library, The Hague*, exh. cat. (Koninklijke Bibliotheek, The Hague, 1980), no. 42; a color reproduction appears in the Dutch version of the catalogue, p. XX, pl. IV.

27 N. Dupire, *Jean Molinet, la vie, les oeuvres* (Paris, 1932), pp. 72–75, and J. Lemaire, "Jean Molinet et le thème de la vieillesse," in *Vieillesse et vieillissement au moyen âge* (Nice, 1987), pp. 169–70.

28 F. Yates has studied this phenomenon in depth in *The Art of Memory* (Chicago, 1966); A.-M. Legaré, "Allégorie et arts de mémoire: Un manuscrit enluminé de la librairie de Marguerite d'Autriche," *Bulletin du bibliophile* 2 (1990), pp. 314–44, with reproductions of all the miniatures.

29 M. Debae gives arguments for this provenance in her forthcoming catalogue, *La bibliothèque de Marguerite d'Autriche: Edition commentée de l'inventaire de 1523–24*.

30 I should like to thank Nicole Reynaud for having suggested this late dating, which is based on certain details in costume, such as the undulating feminine headdress that hugs the ears of the ladies in fig. 192.

31 Among the most accomplished executions are the Boussu Hours (Handlist no. 16); other examples include Handlist nos. 5–8, 15, 20.

32 See Handlist nos. 7, 20, 30. The regional characteristics of these borders have recently been described and studied by B. Cardon (note 2).

33 The Hague, Koninklijke Bibliotheek, Ms. 76 F 16; this work of Mons provenance shows a difference in the quality of the execution. The use of the grisaille technique makes it difficult to determine whether it is a production of the Master himself or that of a lesser artist. Present, however, are the striated skies and the feathery initials typical of the corpus.

34 See M. Capouillez, *Histoire et généalogie des seigneurs de Boussu de la famille de Hennin-Liétard (1202–1285)* (Boussu, 1991), pp. 22–26, figs. 5–6.

35 Paris, Bibliothèque de l'Arsenal, Ms. 1185; H. Martin and P. Lauer, *Les principaux manuscrits à peintures de la Bibliothèque de l'Arsenal à Paris* (Paris, 1929), p. 56, pls. LXXVII–LXXVIII; *Trésors de la Bibliothèque de l'Arsenal* (Paris, 1980), no. 105, p. 61, with an incorrect attribution to the use of Cambrai; H. Martin, "'Les Heures de Boussu' et leurs bordures symboliques," *Gazette des Beaux-Arts* 1 (1910), pp. 115–38.

36 Saint Waudru appears twice in the calendar: on February 3 and August 12 ("Translation s. Waudru"). Saint Gery appears three times: on August 11 (rubricated), August 18 ("Decolation s. Gery"), and on September 24 ("Elevation s. Gery"). Both saints are represented in two small miniatures: fol. 272v (Saint Gery) and fol. 281v (Saint Waudru).

37 Concerning the cult of Saint Waudru in Mons, see L. Tondreau, "Iconographie de sainte Waudru," *Annales du Cercle archéologique de Mons* 70 (1976–77), pp. 207–82, and G. Kiesel, "Waldetrudis," in E. Kirschbaum et al., eds., *Lexikon der christlichen Ikonographie*, vol. 6 (Rome, Freiburg, etc.), 1976), cols. 589–91. See, more generally, J.-M. Cauchies, ed., *Sainte Waudru devant l'histoire et devant la foi: Recueil d'études publié à l'occasion du treizième centenaire de sa mort* (Mons, 1989), especially the article by A. Noirfalise, keeper of the Collégiale de Sainte-Waudru and of the Treasure, "Une traduction de la 'Vita Waldetrudis,'" pp. 47–72. On the history of the Collégiale and its chapter, see Noirfalise, "Le chapitre noble et royal des chanoinesses de Sainte-Waudru à Mons," *Publication de la Société d'histoire régionale de Rance, 1961–1962*, vol. 1 (Rance, 1964), pp. 105–25.

38 Madrid, Biblioteca Nacional, Ms. Res. 149, fol. 25v; see Domínguez Rodríguez 1979, pp. 16–20, no. 2.

39 The kneeling shepherd is also found in the same Berlaymont Hours; reprod. in Thorpe 1976, pl. 9.

40 Louvain-la-Neuve, Université Catholique de Louvain, Ms. A. 2, fol. 89.

41 Ibid., fols. 51 and 91v.

42 See Malibu 1983, p. 39, n. 27. This work is reproduced in S. Ringbom, *Icon to Narrative: The Rise of the Dramatic Close-Up in Fifteenth Century Devotional Painting* (Åbo, 1965), pl. 95.

43 R. Wieck, in Baltimore 1988, p. 105, fig. 75, first associated the Baltimore illumination (fig. 201) with Simon Marmion, attributing it to his shop.

44 The calendar mentions Saint Waudru on February 3.

45 However, in this miniature (fol. 98), which is still unpublished, the affectionate gesture of the Infant is taken from the only miniature attributed to Marmion in the Hours of Mary of Burgundy in Vienna, Österreichische Nationalbibliothek, Cod. 1857, fol. 35v; see F.

Unterkircher, *Bürgundisches Brevier: Die schönsten Miniaturen aus dem Stundenbuch der Maria von Burgund, Codex Vindobonensis 1857* (Graz, 1974), p. 76.

46 Stuttgart, Württembergische Landesbibliothek, Cod. Brev. 3; V.E. Fiala and W. Irtenkauf, *Die Handschriften der Württembergischen Landesbibliothek Stuttgart, Codices Breviarii* (Wiesbaden, 1977), pp. 6–7.

47 Many of the miniatures in the Stuttgart manuscript have been copied by a mediocre artist in the Office of the Dead in a book of hours made for the use of Rome and Tournai (Handlist no. 25; Auxerre, Trésor de la Cathédrale, Ms. 11). However, the style of the images and secondary ornament is not related to the corpus of the Master of Antoine Rolin. The same motif of the drapery over the bed appears in two other books of hours by the Rolin Master; see Handlist nos. 8, 15.

48 This architectural layout is present in manuscripts attributed to the Rolin Master as well as in works from his circle; see Handlist nos. 6–8, 10, 12, 14, 20, 23, 25, 30, 32. François Avril drew my attention to this motif.

49 Saint Waudru appears in Handlist nos. 6, 10, 14, 16, 28.

50 The tooling of the chainstich band at the head and tail of the spine is typical of Flemish, Rhenish, and some Burgundian bindings of the late fifteenth and early sixteenth century. The highly raised chainstich band, as in the present example, is particularly characteristic in Flanders. For another example, see the book in Memling's famous portrait of *Martin van Nieuwenhove Adoring the Virgin and Child*, Bruges, Memlingmuseum. I would like to thank Marie-Pierre Laffitte for the identification of this type of binding.

51 Mons, Bibliothèque Universitaire, fonds Puissant 34; P. Faider, *Catalogue des manuscrits de la Bibliothèque publique de la ville de Mons* (Ghent, 1931).

52 The Crohin family was renowned in Mons for its numerous aldermen; see A. de Behault, "Histoire généalogique de la famille de Boussu, de Mons," *Annales du Cercle archéologique de Mons* 22 (1890), p. 396.

53 The daughters were Isabeau and Gabrielle; see L. Devillers, *Les chartes du chapitre de Sainte-Waudru de Mons*, vol. 3 (Brussels, 1908), pp. 336, 343–44.

54 See H. Léonard, "La ville de Mons en 1550," *Annales du Cercle archéologique de Mons* 22 (1890), p. 251. The hôtel was kept in the family until 1611. In 1501, it served as the headquarters of the *Mystère de la Passion* and as the warehouse for the stage props, showing the sustained interest of the Rolin family in the arts; see G. Cohen, *Le livre de conduite du régisseur et le compte des dépenses pour le Mystère de la Passion joué à Mons en 1501* (Strasbourg, 1925), pp. XLII and 482, n. 7.

55 Various acts and letters dating from 1480 to 1495 acknowledge the interventions of An-

toine Rolin as *grand bailli* in Mons; see, for example, Devillers (note 53), nos. MDLVII, MDLXII, and MDCXXX.

56 C. Mathieu, in *Biographie nationale . . . de Belgique* 29 (1957), cols. 800–03, s.v. "Rolin, A."

57 The diminutive form (here "Pierret" for Pierre) was common at that time to indicate a young artist. Simon Marmion was also called "Simonnet" in his earlier career, as noticed by Dehaines 1892, p. 64.

58 Ibid., p. 138.

59 L. Devillers, *Le passé artistique de Mons* (Mons, 1878), p. 433. In this same account, Jean Gaillet is paid 4 livres for having bound the gradual, and Goddefroy du Pont 18 soles for the "clouants," or studs. The activity of these two artisans at Mons is relatively well documented, especially in the "Notes d'archives recueillés par Gonzalès Descamps," at Mons, Maison Losseau. These unpublished notes from the Mons archives that perished in a fire during World War II are filed in a series of fifty-seven "cartons," which are divided into "parts" and "sections," all unpaginated. Jean Gaillet is paid for services as "ecrivain" in 1494–95 (carton 38: *La grande aumône de Mons*, part 3, "comptes de 1470 à 1520"). He also appears four times as "ecrivain" in various transactions (1484, 1495, and twice in 1496), such as the purchase of a house in 1495 (carton 37: *Greffe scabinal de Mons*, part A, section 2, "embrefs de 1431 à 1502"). In 1506 (June 13) and 1508, he receives payments for bookbindings (carton 7: *Chapitre de Ste Waudru à Mons. Compte des draps de morts*). Goddefroy du Pont appears in the accounts of 1502 for the stage props of the *Mystère de la Passion de Mons*; see Cohen (note 54), pp. 498, 533; he is also mentioned between 1517 and 1520 in the accounts of *La Grande aumône de Mons* (carton 38, part 3).

60 Up to now, there is no evidence of Gousset's possible Mons origin, as he is not mentioned in the list of minor children of Mons from 1450 to 1507; see "Notes d'archives . . . (note 59), carton 2: *Enfants mineurs de Mons. Fourmortures*, part 1, "de 1392 à 1507," 3 "recueils." In "recueil" 3, however, a certain "Pi. Ghousset," remarried to Je. Phicenier, is identified as a saddler on April 26, 1493. There is no mention of Gousset in M.A. Arnould, *Les dénombrements de foyers dans le comté de Hainaut (XIVe–XVIe s.)* (Brussels, 1956).

61 "Pierrot Guiset escrinier, legue fut lué . . ." on August 8, 1501, in an account for funeral cloth for the chapter of Saint Waudru; see "Notes d'archives . . ." (note 59), carton 7: *Chapitre de Ste Waudru à Mons. Compte des draps de morts*. "A Pierart Ghouset, pour son sallaire de avoir escript ung cayer en parchemin pour servir au messel la ou on doit journalment mené, a esté payet pour le parchemin la somme de 30 s."; carton 12: *Hôpital St Jacques à Mons. Comptes de 1401 à 1595*.

Two Leaves from an Unknown Breviary

The Case for Simon Marmion[1]

Sandra Hindman

s has frequently been acknowledged, all attributions to Simon Marmion, however resolutely accepted, rest on circumstantial evidence.[2] Until now, no surviving works attributed to the prolific Franco-Burgundian artist match any of the works credited to him in the numerous extant documents.[3] Two little-known leaves, however, may help us settle with more confidence the identity of the work of Marmion, who executed, among other commissions, a grand breviary for the dukes of Burgundy. The first leaf, in the Robert Lehman Collection in the Metropolitan Museum of Art, depicts scenes of the Holy Virgins (figs. 207, 208).[4] The second leaf depicts scenes from the life of Saint Denis (fig. 209).[5] Although both leaves—unanimously identified as *membra disjecta* from a lost book of hours—have been casually studied over the past three decades, and at least one scholar has attributed them to Marmion, their potential importance has not been adequately recognized.[6] Reexamination of the text on the verso of both leaves demonstrates that they come from a breviary, not a book of hours, and this new information thus raises the possibility that they may once have formed part of the documented ducal breviary that has long been assumed to be lost.

My paper will follow three lines of inquiry: first, the place of the leaves in the original reconstructed manuscript; second, a stylistic comparison between the miniatures and related works by Marmion; and third, a reexamination of the document for the ducal breviary and its possible correlation with the two leaves.

A closer examination of the leaf displaying the Holy Virgins leads to two conclusions. First, an identification of the text proves that the leaf comes from a breviary. The text is the conclusion of the Common of the Confessors, which, being part of the divine office of the Common of the Saints, is only found in breviaries, where it follows the other two principal sections of the breviary, the temporale and the sanctorale.[7] In the Common of the Saints, which includes a series of offices composed for different categories of saints (apostles, martyrs, confessors, and virgins), the Common of the Confessors precedes the Common of the Virgins. Second, the text, coupled with the composition of the border decoration, confirms that this side of the leaf is a recto (fig. 208). Since the Common of the Confessors precedes the text of the Common of the Virgins, the miniature depicting the Holy Virgins must have illustrated the text for the Common of the Virgins that once faced it on the next recto. The wider border decoration on the text side of the leaf confirms that the page was oriented within the book with the text on its verso and the miniature on its recto.

The decoration of the text page is unusually lavish. The thirteen lines of text are surrounded by a full border of silver-gray and gold sprays of acanthus. Interspersed among the acanthus sprays are bell-like flowers, pears, circles, and trilobed flowers, whose predominant colors are also gold and silver-gray. Both one- and two-line initials, also composed of silver-gray acanthus on a gold ground, appear within the area of the text. The written space is separated from the decorative border by a

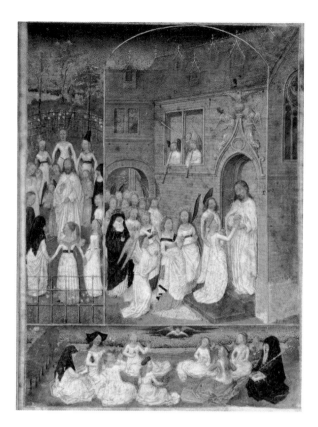

thin frame executed in gold leaf, and another thin gold frame isolates the border from the margins.

The miniature on the verso of the leaf illustrates three scenes pertaining to the entrance of the Holy Virgins into paradise (fig. 207). Because the text was never correctly identified and because of the rarity of the subject of the miniature, it has not previously been realized that the miniature is an appropriate illustration of the content of this part of the breviary, which focuses on the marriage of the Wise Virgins to Christ.[8] In the text of this office, the response at the first nocturn at matins provided the inspiration for the subject both of the miniature in the center and of the border scene on the left: "Come, Bride of Christ, and take the everlasting crown, which the Lord hath prepared for thee, even for thee who for the love of Him hast shed thy blood, and art entered with angels into His garden."[9] The responses repeated at the third nocturn identify the virgins as the Wise Virgins: "This is one of those wise virgins, whom the Lord found watching, for when she took her lamp, she took oil with her. And when the Lord came, she went in with him to the marriage." Throughout the office, the versicles refer to the lamps as the attributes of the Wise Virgins, who are repeatedly heralded with the words, "Trim your lamps, O ye wise virgins." The response at the third nocturn supplies the words that appear in the sky in the lower border: "Come all you virgins." Even the number of the virgins—ten in the central miniature and in the left border (but nine in the lower border)—corresponds with the number mentioned in the text, specifically in the seventh lesson at the third nocturn: "At that time: Jesus said to His disciples: The kingdom of heaven shall be likened unto ten virgins, which took their lamps, and went forth to meet the Bridegroom and the Bride" (Matthew 25: 1). The miniature thus closely follows the text of the breviary for the office of the Common of the Virgins.

This page comes from a book that must have been remarkable. The original book was probably profusely illustrated, since the use of a full-page miniature to illustrate any part of the Common is unusual. In near-contemporary breviaries, even lavishly illustrated ones such as the Breviary of Philip the Good, the Breviary of Isabella of Castile, and the Breviary of Eleanor of Portugal, no such miniature occurs at this juncture.[10] Moreover, the very use of full-page miniatures to illustrate a breviary is rather uncommon. The sumptuous Breviary of Isabella of Castile, for ex-

Figure 207.
Attributed to Simon Marmion. *Holy Virgins Entering Paradise*, from a breviary. New York, Metropolitan Museum of Art, Robert Lehman Collection, Ms. 80, verso.

Figure 208.
"Common of the Confessors," text page from a breviary. New York, Metropolitan Museum of Art, Robert Lehman Collection, Ms. 80, recto.

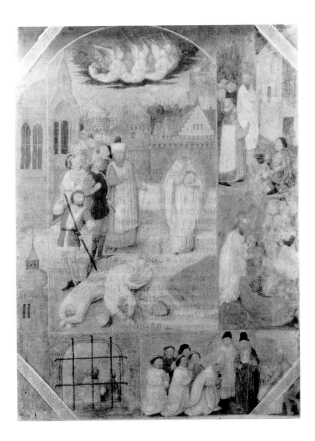

Figure 209.
Attributed to Simon Marmion. *Scenes from the Life of Saint Denis*, miniature from a breviary. Formerly New York, Robert Lehman Collection. Location unknown. Photo: FARL.

ample, has no full-page miniatures, but is decorated instead with forty-five half-page illuminations, along with more than one hundred smaller miniatures. Thus, if an infrequently illustrated portion of the breviary received a full-page illustration in the book from which the Lehman miniature was removed, then other portions of the breviary, those more commonly illustrated, were probably also accompanied by full-page miniatures in the original manuscript.

The existence of a second full-page miniature from the same breviary provides some evidence in support of this hypothesis. Depicting scenes from the life of Saint Denis, this miniature illustrated the section of the sanctorale devoted to Saint Denis. The scenes are a little unusual in that they concentrate on the period before Denis came to France: the customary martyrdom of Saint Denis and his companions, Eleutherius and Rusticus, is at center; the surrounding scenes, clockwise, are Saints Denis and Paul in Rome approached by a blind man whose sight Saint Denis restores, the baptism of Saint Denis, Saint Denis as a bishop and Saints Eleutherius and Rusticus as deacons appearing before Pope Clement, who sends them to France, and the communion of Saint Denis and his companions in prison.[11]

Some idea of the original appearance of the breviary—its length, illumination, and decoration—can be gleaned from the evidence so far presented. If we calculate its length on the basis of the Breviary of Isabella of Castile, whose pages are of dimensions somewhat larger than those of our two leaves, the original volume would most likely have had more than six hundred folios.[12] It is more difficult to judge how many miniatures it might have had. One hundred and forty-five miniatures, counting the one hundred small pictures, decorate the Breviary of Isabella of Castile, but a cycle of this extent is uncommon.[13] The secondary decoration of the last breviary volume must have been unusually lavish. A full border, such as that which appears on the recto of the Lehman leaf, normally occurs at the opening of a section of the text when the facing page is a full-page miniature. Yet since the text on the Lehman leaf includes only the last portion of the Common of the Confessors, the page facing the Lehman leaf must also have been a text page. Even without reconstructing exactly how many pages the Common of the Confessors would have filled, it is virtually certain that a full border was used for a text page that faced another text page, which presumably was similarly decorated (fig. 210). The same system of decoration was

Figure 210.
Reconstruction of a section of the breviary, including the miniature of *Holy Virgins Entering Paradise* (fig. 207). Drawing by Christine Nurse.

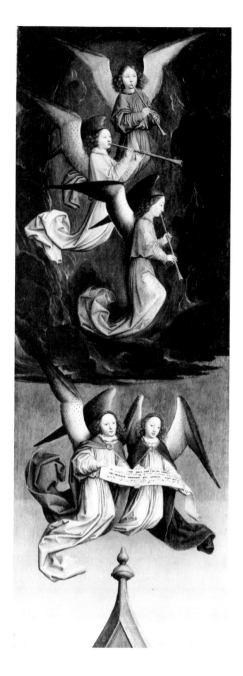

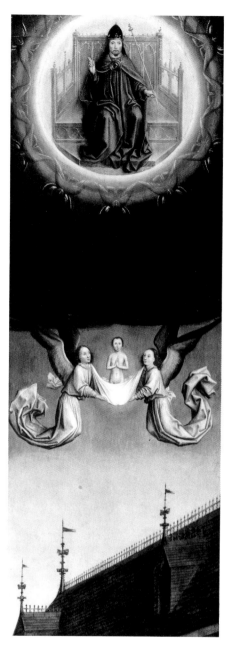

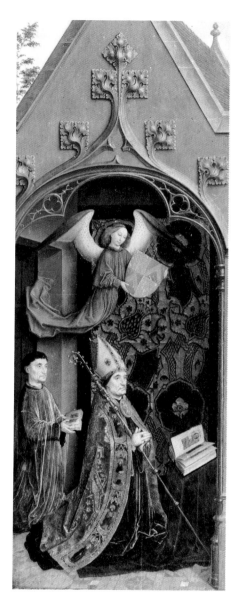

likely used for the section of the Common of the Saints in which the text and min-
iature of Saint Denis appear. The use of this system of decoration for the section of
the Common of the Saints means that it was probably also used for the entire text
of the breviary. Such a lavish system of decoration, entailing the illumination of
every page of a sizable volume, was usually reserved for the most luxurious com-
missions ordered by patrons of the highest social rank.

A few other features of the Lehman leaf contribute to our appreciation of the
appearance and quality of the original book. The extremely fine, transparent parch-
ment is exceptional. It not only confirms in a general way the luxuriousness of the
commission, but also indicates that careful attention was paid to the nature of the
commission, since the thin material was well suited to the length required of a bre-
viary. The generous use of gold leaf on the text pages is again exceptional. It must
indeed have been an expensive book, with a double frame executed in gold leaf on
every text page to set off the border decoration both from the margins and from the
written space.

Comparison of the two breviary leaves, especially the miniature of the Holy
Virgins, with works attributed to Marmion suggests that they are by the same artist.
Bearing in mind that both leaves have condition problems (probably caused by water
staining or dampness) and that the media are different, the leaves nonetheless share

Figure 211.
Simon Marmion. *Angels*, end panel from the
Saint Bertin altarpiece. London, National
Gallery.

Figure 212.
Simon Marmion. *Ascent of Saint Bertin's Soul to
Heaven*, end panel from the Saint Bertin
altarpiece. London, National Gallery.

Figure 213.
Simon Marmion. Detail of the interior of the
left wing from the Saint Bertin altarpiece.
Berlin, Staatliche Museen Preussischer
Kulturbesitz, Gemäldegalerie.

with the altarpiece of Saint Bertin, dated between 1454 and 1459, common figural types and architectural forms. The trumpeting angels at the windows and above the doorway in the miniature of the Holy Virgins are direct quotations from the altarpiece (figs. 211, 212). The flamboyant Gothic structure in this miniature likewise finds an analogy in the panel's Gothic buildings (figs. 213, 219). Particularly close is the door in which Christ stands in the miniature, which should be compared to the opening in which the donor appears in the altarpiece. Nearly identical also is the miniature's steeply slanted roof with ornamented dormer windows, clearly related to that in one of the London panels of the altarpiece. The artist of the Saint Bertin altarpiece, who is most probably the painter of our miniatures, has been credited with the development of elaborate architectural settings to organize his narratives, a characteristic also found in miniatures by the Master of Mansel, with whom the altarpiece painter collaborated in manuscripts such as *La fleur des histoires*.[14]

The Saint Denis leaf recalls not only the style of the Saint Bertin altarpiece, but also that of the Pontifical of David of Burgundy, which is normally dated in the same decade, since David took office as bishop in 1451.[15] The tonsured prelates, the bishop, and the abbot, who all appear in the lower margin of the Saint Denis miniature, find their counterparts in the Berlin panels of the altarpiece. These figures, along with others in the miniature, also resemble those in the pontifical, although the latter are somewhat more squat than those in the altarpiece (fig. 214).

Many stylistic differences confirm, however, that the breviary leaves were executed later than either the altarpiece or the manuscripts most closely related to it. The two leaves employ heightened spatial illusionism, characterized by a more sophisticated arrangement of architecture to accommodate the figures in the main miniatures and by figural borders that extend the space. They also utilize a greatly reduced palette with predominant white tones accompanied by lime greens, pale blues, and salmons, imparting an overall muted tonality that is nonetheless surprisingly atmospheric. Moreover, the artist has become more adept at storytelling, particularly evident in the endearing sweetness with which the Wise Virgins are portrayed. These are all features that Kren has recently associated with Marmion's style in the last two decades of his career, especially beginning in the 1470s, from which period the splendid *Visions of Tondal* dates.[16]

Before discussing the *Tondal* manuscript, I will examine one other, later work attributed to Marmion that emerges as particularly close to the leaves in the breviary: the Salting Hours.[17] Some of its miniatures display the same pale tonality as in the Lehman leaf, resulting from the use of white pigment for the figures and gray, blue, and green pigment for the backgrounds. For example, in the miniatures of the *Coronation of the Virgin* and the *Raising of Lazarus* (figs. 215, 216), the figures of God the Father and Christ, respectively, are extremely close to the figure of Christ standing at the gates of paradise in the Lehman leaf. The Virgin in the *Coronation* resembles the Wise Virgins, and the onlookers in the *Raising of Lazarus* are similar to those in the Saint Denis leaf.

Not only does the style of the miniatures in the Salting Hours resemble that of the Lehman leaf, but the system of secondary decoration is also similar. The silver-gray and gold acanthus leaves that decorate the recto of the Lehman leaf are found on many leaves in the Salting Hours, where they are intermingled with colored backgrounds (fig. 217). Microscopic examination of the Lehman leaf reveals traces of blue pigment among the acanthus, which is similar in appearance to that on the Salting Hours. Moreover, some of the same unusual decorative motifs, such as pear-shaped ornaments and trilobed flowers, appear amidst the acanthus sprays in the Salting Hours. It thus seems likely that the same group of artisans must have collaborated on the Salting Hours and the breviary.

In order to propose a date for the leaves of the breviary, it is important to arrive at a date for the Salting Hours, which cannot be dated with precision on the basis of internal evidence (its patron is unknown, since the shield held by the angels in the beginning of the book is left unpainted). The fact that the silver-gray and gold acan-

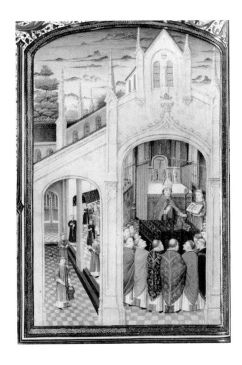

Figure 214.
Simon Marmion. *Bishop Addressing His Congregation*, in the Pontifical of David of Burgundy, 1451–56. Haarlem, Teylers Museum, Ms. 77.

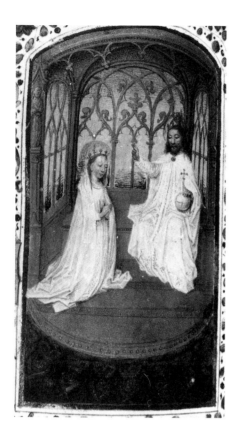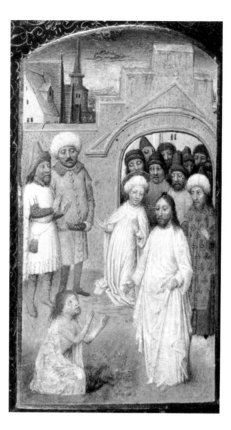

thus border in the Salting Hours is used alongside other types of borders, such as the older, colored acanthus border, suggests that this work should be regarded as transitional, forming a bridge between earlier works, such as *La fleur des histoires* and the Pontifical of David of Burgundy, and later ones, such as the Huth Hours and the Morgan Hours, in which fully illusionistic borders occur.[18] While admitting that the whole question of dating works of the middle and late periods of Marmion's activity remains problematic because of the absence of works that can be dated by external means, I would cautiously endorse the chronology that Kren has proposed, in which the Huntington Hours, followed by the Salting Hours, come at the beginning of a series of devotional works that start in the early 1470s and end with the "La Flora" Hours in the late 1480s.[19]

The recent entry of *The Visions of Tondal* into the public domain now makes possible comparison of the Lehman leaves with a manuscript securely dated 1474 by a colophon. The figures, the architecture, and the tonality in the leaf of the Holy Virgins compare well with miniatures such as *The Bad But Not Very Bad*, *The Good But Not Very Good*, *The Joy of the Faithfully Married*, and *The Glory of Martyrs and the Pure*.[20] Figural types in the leaf of Saint Denis are similar to those in *King Conchober and King Donatus*.[21] Although the illusionistic borders of the breviary leaves might at first suggest a date in the later 1470s, contemporary with such great experiments at illusionism as the Hours of Mary of Burgundy,[22] the scale of the figures, a certain lingering awkwardness in their groupings, and the absence of fully developed atmospheric backgrounds still leave open the intriguing possibility that the breviary leaves date as early as 1470.

Having established that the leaves from a breviary appear to be stylistically coherent with the works that are assembled under the name of Marmion, it is worth reviewing briefly the problem concerning Marmion, which revolves around the lack of direct correspondence between the documented career and the attributed works.[23] According to documents, Marmion worked in Amiens between 1449 and 1454, before taking up permanent residence in Valenciennes in 1458. Well established in Valenciennes by 1460, he founded and headed the municipal painters' guild, and in 1468 he joined the already existing guild in Tournai. Between 1454 and 1470, he worked for the successive courts of Burgundy—for Philip the Good, then Charles the Bold

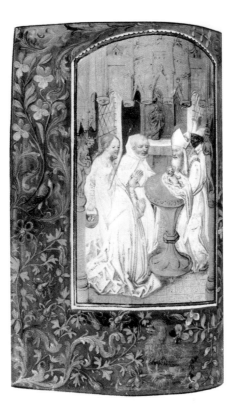

Figure 217.
Simon Marmion. *Presentation in the Temple*, in the Salting Hours. London, Victoria and Albert Museum, Ms. Salting 1221, fol. 97v. Reproduced by kind permission of the Board of Trustees.

and Margaret of York. Documents record his work on commissions in a variety of media, including not only panel paintings and miniatures but also painted banners and polychromed statuary, not a single one of which can be identified with certainty. When he died in Valenciennes in 1489, he was heralded as the "very prince of book illumination."[24] He was also praised by his contemporaries especially for his depiction of nature and natural effects, "sky, sun, fire, air, sea, land, metals . . . woods, wheat, fields," and of death, "sleeping their heavy slumber . . . [and] resuscitated by living art. . . ."[25]

In spite of the apparent irreconcilability between the documents and the extant works, "a body of circumstantial evidence supports associating Simon Marmion with the highly original and distinctive style of *The Visions of Tondal*,"[26] and, I would argue, with a coherent body of works that dates from the 1450s through the 1480s. Briefly stated, the work that we have come to accept as Marmion's corresponds to what we know about the artist in the following respects: it is executed in diverse media; it can be localized in Amiens and Valenciennes; it demonstrates the enthusiastic patronage of the Burgundian court under both Philip the Good and Charles the Bold, including the patronage of Guillaume Fillastre, who commissioned the altarpiece of Saint Bertin; it is roughly circumscribed within the dates of Marmion's documented activity; and it evinces an extraordinary ability in the depiction of nature and death imagery.

For scholars still seeking to find a firmer basis of attribution, however, one of the most tantalizing documents remains the records of payment from the dukes of Burgundy to Marmion for an extensively illuminated breviary, which is described in unusually complete detail. Marmion was paid for a breviary, begun in 1467 for Philip the Good and completed in 1470 for Charles the Bold and Margaret of York, which contained either ninety-five or 105 miniatures. No such manuscript has been discovered, and it has been assumed that the breviary for which Marmion was paid is lost.[27] Could the leaves depicting the Holy Virgins and Saint Denis come from this breviary?

In order to consider this question, it is necessary first to review the text of one of the documents:[28]

A Simon Marmion enlumineur, la somme de vijxxxviij l. xv. solz de xl. gros pour

pluseur parties distoires, vignettes lettres et autres parties par luy faites ou bré-
viaire de Monseigneur, ainsi qu'il s'ensieult. Et premierement, pour avoir historié
et vignetté le calendrier dudit bréviaire et fait le signetz y partinens en chascun
des douze mois de l'an, au pris de xxiiii solz pour chascun mois, font xiij livres
viij s. Item pour lxxviij quayers vignetées et furniz de histoires pour ledit bré-
viaire, contenant chascun quayer huit feuillez, au pris de xl. s. pour chascun
quayer, font: vjxxxvj. liv. Item pour unze histoires de couleurs faittes oudit bré-
viaire, au pris de iiij livres x. s. chascune histoire, font: xlix liv. x. s. Item pour
iiijxxiiij histoires d'autres couleurs faittes oudit bréviaire, au pris de lx. s. piece,
font ijcxlix. livr. Item pour ijmvc lettres de deux poins faiz oudit bréviaire, au pris
de vj. x. le cent, font vij l. x. s. Item pour vmviijclix lettres dung point faites audit
bréviaire, au pris de iij s. le cent, font: xj. liv. xiij s. vj. d. Et pour cv lettres de
v. vi et viij poins servans emprez les histoires oudit bréviaire, au pris de vj deniers
chascune lettre, font lij. s. vj. d. Montent ensemble touttes lesditttes parties à la
somme de iiijciiijxxx. liv. xv solz, sur quoy ledit Simon a receu en prest par les
mains de Monseigneur et de l'évesque de Salubruye iijcxxxij liv.[28]

We thus know that the breviary was made to the following specifications. It was a
lengthy volume composed of 624 folios (seventy-eight quires of eight folios each). It
began with an illuminated calendar, which had both border decoration and minia-
tures (apparently roundels of the zodiac signs and labors of the month). It was also
illustrated with eleven miniatures in "colors" and eighty-four [*sic?*] "in other colors,"
making a total of ninety-five (or perhaps 105) miniatures.[29] Introducing these minia-
tures were 105 three-, four-, and five-line initials. Within the text were 2,500 two-
line initials and 5,859 one-line initials.

The hypothetical reconstruction of the breviary from which the Lehman leaves
were removed does share certain features with the one described in the document.
The number of folios and the number of miniatures in the reconstructed breviary
roughly match those detailed in the document. I tentatively suggest that the minia-
tures "in other colors" in the duke's breviary could refer to the pale tonality in min-
iatures such as those of the Holy Virgins or Saint Denis, as compared with miniatures
painted with full pigment (the miniatures "in other colors" are roughly three-
quarters the cost of miniatures "in colors"). The presence of border decoration on
each page would seem to conform with the document, which indiscriminately spec-
ifies border decoration for all the quires. I have indicated, moreover, that a date in
the range of the late 1460s or early 1470s is possible for the leaves from the breviary.
As noted, the reconstructed breviary must have been made for a patron of consid-
erable rank, and it does relate to a body of works attributed to Simon Marmion, the
artist credited with the execution of the duke's breviary. The fact that the text of
the breviary from which the two leaves were removed appears to be for the use of
Paris is a further argument in favor of its identity with that of Philip of Burgundy,
since his only extant breviary follows the same use.

To this argument one further observation needs to be tentatively advanced: the
very choice of the subject of the Holy Virgins and the inclusion of an abbess from a
religious order seem in line with Margaret of York's intense personal piety.[30] We know
that her piety found expression in an exceptional interest in and attention to local
religious foundations, including the Poor Clares, the Carthusians, the Black Sisters
of the Augustinian Order, and the Franciscans.[31] It was also expressed in the choice
of texts and illuminations commissioned by or given to her. For example, she com-
missioned a *Vie de Sainte Colette* for presentation to the convent of the Poor Clares in
Ghent before 1477 (Appendix no. 27).[32] There is, in addition, the *Benoit seront les
miséricordieux*, with miniatures of Margaret practicing the Seven Acts of Mercy (see
fig. 2; Appendix no. 1).[33] Could the unusual miniature of the Holy Virgins, the sub-
ject of which appears to be entirely unprecedented, thus owe its inclusion in a bre-
viary of Charles the Bold to his wife's interest in female piety?

Coupled with the new evidence provided by the two Lehman leaves, the accumulation of circumstantial evidence relating a body of works to Simon Marmion acquires renewed force. Yet in order to verify that the breviary from which the leaves come is identical with the Breviary of Philip the Good and Charles the Bold, we still need to uncover further miniatures that can be grouped with them. A review of their provenance offers some cause for optimism about the recovery of other leaves. They were purchased in different years and in different countries, the miniature of the Holy Virgins in 1930 from Drey in Munich and that of Saint Denis in 1931 from Rappaport in Rome.[34] The further realization that they are probably not from the same portion of the breviary decreases the chances that the remainder of the book was irretrievably damaged. The knowledge that this breviary must have been extensively illuminated simultaneously increases the odds that, even if the text pages were discarded, other full-page miniatures may have survived and will now be identified. When, or if, this occasion occurs, additional evidence may emerge in support of the case *for* Simon Marmion.

Notes

1 A version of this paper will appear in the author's forthcoming catalogue of the Robert Lehman Collection of miniatures in the Metropolitan Museum of Art, published by the Metropolitan Museum of Art and Princeton University Press.

2 See especially, in chronological order, Winkler 1913; E.W. Hoffman, "Simon Marmion," Ph.D. diss., Courtauld Institute, University of London, 1958; Hoffman 1969; Hoffman 1973; Hindman 1977; Pächt 1979; Sterling 1981; Malibu 1983; Malibu 1990.

3 For the published documents, see Dehaisnes 1892, esp. pp. 129–49, and Hénault 1907–08.

4 New York, Metropolitan Museum of Art, Robert Lehman Collection, Ms. 80, recorded in S. de Ricci and W. J. Wilson, *Census of Medieval and Renaissance Manuscripts in the United States and Canada*, vol. 2 (New York, 1937), p. 1716.

5 Ibid., as New York, Robert Lehman Collection.

6 The miniature of the Holy Virgins has been exhibited frequently, although never as a work associated with Marmion; see, in chronological order: S. Béguin, *La collection Lehman de New York*, exh. cat. (Musée de l'Orangerie, Paris, 1957), no. 162, p. 111; *The Lehman Collection, New York*, exh. cat. (Cincinnati Art Museum, 1959), no. 340, p. 32; C. Gómez-Moreno, *Medieval Art from Private Collections*, exh. cat. (Metropolitan Museum of Art, New York, 1968), no. 10; J.L. Schrader, *The Waning of the Middle Ages*, exh. cat. (Nelson-Atkins Museum of Art, Kansas City, 1969), no. 24, pp. 26–27. The miniature of Saint Denis has never been exhibited or published except by Hoffman 1958 (note 2), p. 177, along with the miniature of the Holy Virgins, both of which she attributed to Marmion and dated circa 1480.

7 For a published text close to that on the Lehman leaf, see *The Colbertine Breviary* (Henry Bradshaw Society, 43–44) (London, 1912–13), pp. 567–75.

8 No examples of an illustration at this juncture in a breviary are listed by V. Leroquais, *Les bréviaires manuscrits des bibliothèques publiques de France*, 5 vols. (Paris, 1934).

9 For this and the following textual references, see the translation of this office in *The Colbertine Breviary* (note 7).

10 On the Breviary of Isabella of Castile (London, British Library, Add. Ms. 18851), see Malibu 1983, no. 5, pp. 40–48; on the Breviary of Eleanor of Portugal (New York, Pierpont Morgan Library, Ms. M.52), see J. Plummer, *Liturgical Manuscripts for the Mass and the Divine Office*, exh. cat. (Pierpont Morgan Library, New York, 1964), no. 43, pl. 15, and P. de Winter, "A Book of Hours of Queen Isabel la Católica," *Bulletin of the Cleveland Museum of Art* 67 (1981), pp. 342–427, esp. p. 346.

11 For a concordance of text and illustration of the life, see I. Bahr, *Saint Denis und seine Vita im Spiegel der Bildüberlieferung der französische Kunst des Mittelalters* (Worms, 1984), pp. 236–41. These events all appear in the French prose and verse lives edited by C. Liebman, *Etude sur la vie en prose de Saint Denis* (Geneva, 1942), chaps. v, p. 9; vi, p. 10; xvi, p. 22; xxx, p. 44; xxxiii, pp. 48–49. These same scenes are illustrated in Paris, Bibliothèque Nationale, Ms. nouv. acq. fr. 1098 (circa 1250), fols. 31v, 34r, 42r, 44r.

12 My calculations are based on the following comparative data: the Breviary of Isabella of

Castile comprises 523 folios of circa thirty lines per page, measuring 232 × 159 mm; the Breviary of Eleanor of Portugal comprises 590 folios of thirty-two lines per page, measuring 240 × 170 mm. Both books are thus larger than the breviary from which the Lehman leaf was removed, which was written on twenty-seven lines per page, measuring 161 × 119 mm.

13 The Breviary of Eleanor of Portugal has twenty-five full-page miniatures and thirty-one smaller miniatures.

14 On this manuscript (Brussels, Bibliothèque Royale, Ms. 9231–32) as well as on the nature of the collaboration between Marmion and the Master of Mansel, see Brussels 1959, nos. 58–59, pp. 64–66, and L. Gilissen, *La librairie de Bourgogne et quelques acquisitions récentes de la Bibliothèque Royale Albert Ier* (Brussels, 1970), nos. 22–23, pp. 29–32.

15 Published in partial facsimile in *Bulletin de la Société française de reproduction de manuscrits à peintures* 15 (1931), pp. 25–28, pls. VI-IX, and Brussels 1959, no. 60, pp. 66–67.

16 Malibu 1990, p. 27ff.

17 London, Victoria and Albert Museum, Ms. Salting 1221; described and reproduced in color in Harthan 1977, pls. on pp. 146–47.

18 On these later manuscripts (British Library, Add. Ms. 38126 and Pierpont Morgan Library, M.6), see Malibu 1983, no. 4, pp. 31–39, and Ghent 1975, vol. 2, p. 37.

19 Malibu 1983, p. 31.

20 Malibu 1990, pls. 14, 15, 17, 18.

21 Ibid., pl. 16.

22 See de Schryver/Unterkircher 1969.

23 See Dehaisnes 1892 and Hénault 1907–08.

24 Jean Lemaire de Belges, in Stecher 1882–91, vol. 4, p. 162.

25 Quoted from his epitaph by Jean Molinet, published and discussed by Dehaisnes 1892, pp. 72–74.

26 Malibu 1990, p. 21.

27 None of the attempts to link the document with a manuscript has been successful, because no one has uncovered a breviary that matches the specifications. A. Michiels, *Histoire de la peinture flamande*, 2nd ed. (Paris, 1866), vol. 3, p. 383, suggested that the documented breviary corresponds with a book of hours with grisaille miniatures made for Philip the Good and now in The Hague (Koninklijke Bibliotheek, Ms. A A 271), but this identification has never been accepted. Dehaisnes 1892, p. 99, disputed the identification of the volume in The Hague as the ducal breviary, although his own attempts to discover the breviary were unsuccessful. Winkler 1925, p. 178, n. 1, suggested that the Huth Hours (British Library, Add. Ms.

38126) might be identical with the breviary on the basis of the initials MY (Margaret of York?) found in the borders.

28 Archives Générales du Royaume à Bruxelles, Fonds de la Chambre des Comptes du duc de Bourgogne, Reg. no. 1925, fols. 47v and 454, which is fully published by Hénault 1907–08, no. 35, p. 419. In two related documents, Hénault, no. 27, p. 419, and Dehaisnes 1892, p. 140, Marmion was, in 1467, advanced the sum of 100 livres for his work on the breviary and, in 1470, the Bishop of Salubrye, who oversaw the earlier work, was paid for having had it rebound, repaired, and gilded (? = *tympaniser*).

29 The discrepancy in the number of miniatures comes from the fact that the document specifies ninety-five miniatures, but 105 initials introducing the miniatures (*servans emprez les histoires*), which raises the possibility of an error in transcription.

30 The abbess has been alternatively identified as a member of the Order of the Poor Clares in Béguin (note 6), p. 111, and Hoffman 1958 (note 2), p. 177, and as a member of the Order of the Brigittines, in Gómez-Moreno (note 6), no. 10. On Margaret's piety, see Hughes 1984 and Wim Blockmans's essay in the present volume.

31 Hughes 1984, p. 16.

32 Edited and reproduced by Corstanje et al. 1982.

33 Brussels, Bibliothèque Royale, Ms. 9296, in L.M.J. Delaissé, *Medieval Miniatures from the Department of Manuscripts (formerly the Library of Burgundy), The Royal Library of Belgium* (London, 1965), pp. 196–99, ill.

34 Robert Lehman must have been mistaken when he made a note, now included in the files, that he bid $300 on a page from the same book in a sale in Leipzig in 1930. Reference to the entry in the catalogue by Boerner, Leipzig, *Handzeichnungen*, May 9–10, 1930, no. 254, ill., reveals a miniature by the Master of Jacques of Luxembourg that was removed from a book of hours now in New York (Pierpont Morgan Library, M.1003), described and illustrated in J. Plummer, *The Last Flowering: French Painting in Manuscripts, 1420–1530*, exh. cat. (Pierpont Morgan Library, New York, 1982), no. 80, pp. 60–61. I thank Nicole Reynaud for identifying the manuscript from which this leaf was cut.

Simon Marmion and the Saint Bertin Altarpiece

Notes on the Genesis of the Painting

Rainald Grosshans

The wings of the altarpiece from the Benedictine abbey of Saint Bertin at Saint-Omer in northern France (figs. 218, 219) are among the most outstanding achievements of Franco-Flemish art of the mid-fifteenth century.[1] Since the late nineteenth century, they have been attributed to Simon Marmion. The altarpiece, completed in 1459, was donated by Guillaume Fillastre, Bishop of Verdun, Toul, and Tournai, Abbot of Saint Bertin, Chancellor of the Order of the Golden Fleece, and confidant of Philip the Good, the powerful Duke of Burgundy.[2]

The abbey of Saint Bertin was devastated during the French Revolution in 1793. The central shrine of the altarpiece, richly ornamented with statuettes of gilded silver, was destroyed and melted down, leaving only the wings.[3] In 1824 the art dealer Nieuwenhuys, who removed the battlementlike superstructures from their ends, sold the truncated wings to William II of the Netherlands.[4] They were acquired for the Berlin Museums in 1905; the fragments of the disassembled superstructures have been in the London National Gallery since 1860.

The wings really cannot give more than a hint of the original altarpiece and its monumental effect.[5] In its open position, it was more than 6 meters wide. The altar shrine bore an image of the *Crucifixion* at its center, flanked by statuettes representing the *Annunciation*, *Visitation*, *Noli me tangere*, and the *Incredulity of Saint Thomas*. Above the shrine rose an elaborate superstructure from which depended a golden dove containing the Holy Sacrament. At the very top was a nestling pelican, symbol of Christ's sacrifice and resurrection.

The two exterior wings have paintings in grisaille.[6] Together they make up a sequence of five niches, each of which contains two figures painted in imitation of sculpture. At the left are Mark and Micah, John and Solomon, and the Archangel Gabriel, who is associated with the Virgin of the Annunciation on the right wing. The paired figures of David and Matthew and Isaiah and Luke appear on the right. Rendered in a richly gradated range of light and dark, the painted sculptures seem to live in a silent, timeless realm. The purpose of the grisailles was to prefigure the program on the interior of the altar wings.

Since the Saint Bertin altarpiece stands at the center of Marmion's oeuvre, an analysis of the artist's working method in the altarpiece will provide valuable insights for the study of other paintings connected with him. Insights into aspects of artistic creation hidden to the naked eye are provided by various technical aids, especially by infrared photography, infrared reflectography, and X-radiography.

Let us look first at the exterior sides of the altar wings, including the fragments now in London. Immediately striking is the fact that the niches were apparently drawn without the aid of auxiliary construction; there is hardly any discernable underdrawing, since it corresponds exactly with the contours of the painted rendering. The inscriptions beneath the grisaille figures are accompanied by two parallel lines

Figure 218a.
Simon Marmion. Exterior of the left wing of
the Saint Bertin altarpiece. Berlin, Staatliche
Museen Preussischer Kulturbesitz,
Gemäldegalerie.

Figure 219a.
Simon Marmion. Interior of the left wing of
the Saint Bertin altarpiece. Berlin, Staatliche
Museen Preussischer Kulturbesitz,
Gemäldegalerie.

Figure 218b.
Simon Marmion. Exterior of the right wing of
the Saint Bertin altarpiece. Berlin, Staatliche
Museen Preussischer Kulturbesitz,
Gemäldegalerie.

Figure 219b.
Simon Marmion. Interior of the right wing of
the Saint Bertin altarpiece. Berlin, Staatliche
Museen Preussischer Kulturbesitz,
Gemäldegalerie.

scratched into the primer, a technique frequently used to mark the edges of the gilded ground in such compositions. Apart from this, incised drawing was employed in much the same way as underdrawing in chalk or pen.

The *Annunciation* at the center of the two wings was originally crowned by two Gothic baldachins in grisaille—elaborate examples of trompe l'oeil architecture—which appear on the reverse of the London fragments. The dimensions of these two architectural renderings are absolutely identical.[7] To achieve this conformity, a perforated cartoon was used to transfer the contours of the preparatory drawing onto the primed panel.[8] As the infrared reflectogram assembly shows, a cartoon was employed for the right-hand baldachin (fig. 220), where the pouncing is clearly visible.[9] This is the only area of the altar wings in which such marks were found. Evidently, the technique was used here because extreme precision was required in the depiction of the two architectural canopies. Any divergence in proportion would have created a noticeable disharmony in the painted architectural framing.

Almost every figure on the outside of the panels reveals underdrawing of a calligraphic character. That of Saint Mark (fig. 221) is sketched in delicate parallel hatching. Changes in the underdrawing are seen beneath the left arm, the hem of the cloak, and the position of the left foot, which was originally set more to the side. Since the X-ray photographs reveal no *pentimenti*, all the alterations must have been made during the process of underdrawing. This holds true, apart from scattered details, for almost all the figures on the exterior side of the panels. In the case of the next figure, the prophet Micah (fig. 221), alterations were made, for instance, in the shape of the sleeve openings of the cloak.

In the underdrawing of Saint John, light parallel hatching again predominates. Here, too, the cloak hem originally extended further down before receiving its final, diagonal termination. Also altered were the position of the head and the neckline of the garment. The upper clasp of the book was initially closed. The underdrawing of Solomon is less strikingly defined, while that of the angel (fig. 222) is stronger and evinces a greater number of changes. Again we find parallel hatching, but of a greater density than in the previous figures. The folds of the garment where it meets the floor have been sketched in with energetic strokes. A considerable alteration is evident in the angel's head, which originally was turned more toward a profile position. The pupils of all the figures' eyes were drawn in beforehand and left unpainted to increase the illusion of sculptural form.

The underdrawing of the Virgin is especially striking (fig. 223). Here parallel hatching is used to indicate shadows, but also to work up, model, and clarify forms. This is the only figure in which the cast shadow on the wall is indicated by parallel hatching. Changes are apparent in the Virgin's garment, whose folds were extended to the right; final corrections in this passage were not made until the process of painting was underway. The *Annunciation* group differs from the prophets and evangelists in having looser, more fluent underdrawing. A comparison with the remaining figures on the right wing corroborates this impression. The figures of David, Matthew, Isaiah, and Luke are characterized by a careful underdrawing in thin, parallel hatching and cross-hatching, which appears more vivacious and confident only in those areas where corrections were made.

The somewhat timorous style of most of the underdrawing suggests that the exteriors of the altar wings were laid out by an assistant, while the master himself apparently sketched in the *Annunciation* scene and made some of the more striking corrections. It has been frequently noted that the grisailles were probably not executed by Marmion himself but by one of his assistants. Despite their high artistic quality, they evidently took second place to the depictions on the interior. This division of labor was common practice in late medieval workshops, permitting a master whose work was much in demand to concentrate on more important tasks. In the present case, the task was the execution of the inside panels, which together with the gilded shrine they originally flanked formed the main display side of the altarpiece.

Figure 220.
Grisaille architecture, detail of exterior of right wing (fig. 218b). Infrared reflectogram assembly. London, National Gallery. Assembly courtesy Painting Conservation Department, Metropolitan Museum of Art, New York.

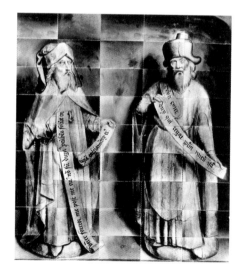

Figure 221.
Saints Mark and Micah, detail of exterior of left wing (fig. 218a). Infrared reflectogram assembly showing underdrawing.

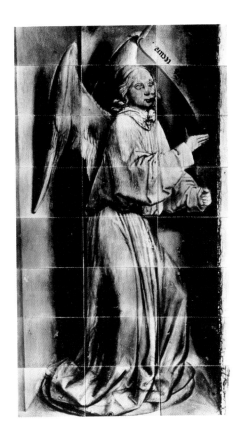

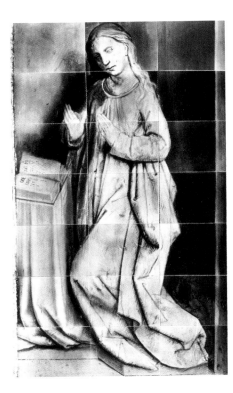

Figure 222.
The Archangel Gabriel, detail of exterior of left wing (fig. 218a). Infrared reflectogram assembly showing underdrawing.

Figure 223.
The Virgin Annunciate, detail of exterior of right wing (fig. 218b). Infrared reflectogram assembly showing underdrawing.

The images on the inside of the wings constitute a cycle that records events from the life of Saint Bertin, the titular saint of the monastery.[10] So naturally does each episode lead to the next that we can easily underestimate the skill and effort required to achieve this effect. In this regard, technical investigations can provide deeper insights into the painting process.

Beginning with the first scene on the left wing (fig. 219a), where the donor, Guillaume Fillastre, is accompanied by a chaplain, traces of underdrawing are visible in the peaked roof, in the coat of arms, and especially in the donor's robe. Energetic parallel hatching is used to indicate surfaces, contours, and areas of shadow. The underdrawing is best seen in the rendering of the donor's head: the eyes and pupils were originally sketched in a lower position, resulting in a slightly lowered gaze. The effect of this change is to increase Fillastre's concentration on the episodes from Saint Bertin's life. Visible at the height of the donor's shoulder are two horizontal lines, which show up very clearly in the infrared and X-ray photographs. These lines represent the top of a low balustrade or parapet, behind which the view was originally open into the shadowy depths of the room. The brocade curtain, introduced at some later point, serves to lend the room a greater intimacy and make the composition more self-contained. On the London fragment, representing angels singing and playing instruments, the underdrawing is largely congruent with the contours of the painting. An interesting feature is that the artist used simple circles to indicate the contours of the eyes.

In the following scene, showing the birth of Saint Bertin, underdrawing is visible in the canopy and the bedcover in the foreground. Emendations were made in the right shoulder of the nurse as well as in her headdress, which was initially of a winged or horned type. The mother's gaze, as the initial position of the pupils indicates, was lowered even further than in the final rendering. Slight alterations are detectable in the figure of the child. The underdrawing of the wall extending across the compartment above included four blind windows capped with trefoil arches (fig. 224). The roof eave originally had a latticework grille with quatrefoil ornament. Although the eave lattice and blind windows were both drawn and painted, the artist finally deleted the windows entirely, probably in order to lend the architectural motif

greater concision. At the same time, however, he replaced the simple eave lattice with an elaborate tracery gallery.

The next scene, depicting the investiture of Saint Bertin in the monastery at Luxeuil, shows no clearly detectable underdrawing. It is nevertheless noteworthy that the arched portal was constructed with a compass, the point of which, as seen in the X-ray photograph, stood at about the middle of the globe at Christ's feet. The tracery arcs were similarly constructed, as indicated by two compass points visible in the X-ray.

Underdrawing is again only vaguely detectable in the adjacent depiction of Saint Omer receiving Saint Bertin and his two companions on their pilgrimage. Still, there is evidence of an interesting change made in Saint Omer's face: strokes leading from his left eye to ear indicate the edge of a submiter, the cap worn under the miter.[11] That the saint originally wore a miter is evident even with the naked eye. The miter was replaced during the painting process by the turbanlike headgear of red cloth which Saint Omer raises in greeting. Thanks to the deletion of the miter, Bertin's reception by Saint Omer takes on a more personal, less official character. The portal enclosing the scene is capped by a round arch that was again constructed with a compass. Above it is a niche with the figure of an angel displaying a coat of arms. As the infrared reflectogram assembly (fig. 225) and the X-ray show, the angel was added later, over a large coat of arms placed against an unbroken expanse of wall. The frieze ran uninterrupted from one end of the eave to the other, and the present gable had not yet been added. The transformation of the coat of arms into an angel holding a coat of arms represents a convincing, logical development of the pictorial conception. A further emendation is seen in the roofline, which was extended to connect with the main building on the left.

In the concluding episode on the left altar wing, which depicts the founding and construction of the new monastery, underdrawing is clearly evident in various passages (fig. 226). Differences between underdrawing and painting are seen, for example, in the figure of the notary holding the document. The position of eyes, nose, and cheek is slightly shifted, and small changes were also made in the position of the left hand. Definite divergences between underdrawing and painting are found especially in the architecture of the monastery under construction. Initially depicted near the right edge of the panel was the facade of a tall building with a tracery frieze and two round-arched windows; there was also originally a wooden porch over the door. Drawn in adjacent to this building was a framework with platform on which a winch was mounted. The two crossed lever arms used to turn the winch are clearly visible. A rope dangles from the cylinder with a basket attached to its end.[12] While the winch framework is present only in the underdrawing, the tall building at the right edge is visible in the paint layer as well, indicating that the monastery was not reduced to an earlier stage of construction until well into the painting process. The

Figure 224.
Architecture above *The Birth of Saint Bertin*, detail of interior of left wing (fig. 219a). Infrared reflectogram showing underdrawing.

Figure 225.
Architecture above *Saint Omer Receiving Saint Bertin*, detail of interior of left wing (fig. 219a). Infrared reflectogram assembly showing underdrawing.

Figure 226.
Dedication and Construction of the Monastery,
detail of interior of left wing (fig. 219a).
Infrared reflectogram assembly showing
underdrawing.

elaborate winch framework was replaced by the motif of a laborer operating a hand
winch—this too is a logical development of the original conception. The episode of
the voyage on the river guided by the angel who caused the boat to stand motionless
at the divinely ordained site of the monastery at first occupied a larger area; as the
infrared photograph shows, the boat took up almost half the width of the river. The
motif was reduced step by step to its present scale, thus preserving the size rela-
tionships within the landscape as a whole. Further traces of underdrawing that di-
verges from the painted contours are found above the portal of the castle and in the
bridge guard's cottage. Near the upper edge of the painting there are arched con-
centric lines, whose meaning is difficult to explain. Their shape corresponds to that
of the niches on the reverse of the panel, suggesting that the underdrawing of the
niches for the grisaille figures conceivably was begun in this area but that the work
was soon interrupted.

The depictions on the right wing begin with the episode of the miracle of wine:
Sir Waldbert has fallen from his horse while hunting. He sends his servant to Saint
Bertin for a consecrated drink. When the servant arrives at the monastery, an empty
cask miraculously fills with wine. In the landscape, a number of trees were rapidly
sketched in, then deleted in the course of painting (fig. 227). The crucifix, located
halfway up the hill in the underdrawing, was shifted to its summit. Minor alterations
can be seen in the horsemen and their mounts. In the faces of the figures in the
foreground, shadows are indicated by parallel hatching. Slight changes were made
in the direction of the gaze and position of the hands of the monk kneeling before
the wine cask. The underdrawing in the head of the servant is clearly visible. The
positions of his left hand and the finger with which he points to the cask were some-
what altered during the execution. A definite change is apparent in the protecting
roof under which the wine casks are stored. It was larger in both the underdrawing
and initial paint layers, having a pointed gable that projected far above the wall, as
is evident from the X-ray photograph. The subsequent size reduction of the roof
permitted a more unimpeded view of the background landscape.

Figure 227.
The Miracle of the Wine, detail of interior of
right wing (fig. 219b). Infrared reflectogram
assembly showing underdrawing.

Figure 228.
Saint Bertin Receiving Winnoc and His Brothers,
detail of interior of right wing (fig. 219b).
Infrared reflectogram showing underdrawing.

Figure 229.
The Temptation and Death of Saint Bertin, detail
of interior of right wing (fig. 219b). Infrared
reflectogram assembly showing underdrawing.

The following scene shows the healed and converted knight entering the monastery together with his son. Here again the underdrawing is easily seen in the faces of some of the figures. Infrared photographs reveal the underdrawing of the heads of Saint Bertin, his companions, and the notary with the document. Alterations are noticeable in the tracery gallery at the upper edge of the compartment. On the dark wall of the interior, a groined vault was roughly sketched in but left unexecuted.

In the next scene—the four noblemen being welcomed into the monastery by Saint Bertin—alterations made during the painting process include a decrease in the height of the wall surrounding the cloister courtyard (fig. 228). The columns are somewhat shorter than in the final state. These corrections were made during the painting process. In addition, the two onlookers at the right edge of the scene were originally separated by a wall from the group of monks. This low wall, which would have rendered the cloister inaccessible, was deleted by Marmion during the course of painting, making it a true *pentimento*.

The two final scenes on the right wing depict the temptation and the death of Saint Bertin. Considerable changes are found in the architectural elements (fig. 229): the tracery gallery extending across both compartments was originally drawn in a much more simplified form, and the roof was somewhat shorter, leaving room for a rectangular door opening in the wall of the building rising at the right. The evidence for the gradual formal development of the two portals is remarkable. The pointed arch above the temptation scene originally ended in the frieze below the gallery and was embellished with crockets. The arch above the deathbed scene passed through

several variations—notations for a round arch, keel arch, and the final flat arch are detectable, either sketched in or incised into the primer. In the London fragment that originally capped the compartment, underdrawing in the figures of the angels, in God the Father, and the throne is visible. The circular aureole is marked by a compass stroke. A remarkable alteration is the deletion of a monk who was originally present at Saint Bertin's deathbed. Due to the aging of pigments, the layers of varnish over the head have become translucent, so that the once-obscured face is detectable to the naked eye. The infrared photograph further shows (fig. 230) that the monk's facial features were serious and quite striking, which suggests that the figure may well have been a portrait. The deletion of the head left a considerable gap in the group of mourners, so it can hardly have been artistic considerations that led Marmion to remove the figure from the scene. Why he did so remains a question about which we can only speculate.

Figure 230.
The Temptation and Death of Saint Bertin, detail of interior of right wing (fig. 219b). Infrared photograph showing the overpainted head of a monk.

The technical investigations of the altar wings have revealed a number of differences between the underdrawing on the obverses and reverses. The calligraphic underdrawing on the exterior is probably attributable to an assistant, though the master himself apparently sketched in the *Annunciation* scene. The drawing of the interior appears stronger, more distinctive, and more assured. The faces of the figures are laid in with parallel strokes, and the features, worked out in detail, are not often corrected. On the other hand, the excellently composed figure groups have been left unaltered, indicating that they were carefully determined beforehand in separate drawings. The landscape and architecture, in contrast, evince liberal underdrawing, and most of the emendations made during the painting process are concentrated in these two areas. In the underdrawing of the half-finished monastery, with its daring winch, we even find that carelessness which is characteristic of the autonomous, creative artist. A number of formal notations were drawn freehand, including the first version of the tracery gallery over the two final scenes on the right wing. In addition to chalk and pen drawing, incised lines are used to indicate architectural elements, and a number of the arches are constructed with the compass. The combination of freehand and implement-assisted drawing was common practice at the period and has been found, in the work of, among others, Rogier van der Weyden.[13]

As the technical investigation indicates, the work process took place in several distinct stages. Alongside corrections made in the underdrawing stage, we find changes that were not made until the final phase of the painting process. In every case, the artist's intention is clear—to enrich the extremely complex depictions and bring them into overall harmony. If special effort was devoted to the configuration of the architecture, this is understandable in view of its significance for the composition as a whole. It should be recalled that Marmion was an innovator in relating architecture to landscape. As a miniaturist he followed the example of the Mansel Master,[14] who organized his architectural and figure scenes along the lines of the Bedford Master. Though Marmion shared with the Mansel Master a preference for complex structures, his organization of the pictorial space was a great deal more logical and convincing.

Marmion's painting style was formed by Netherlandish art, especially that of Rogier van der Weyden, Dieric Bouts, Hugo van der Goes, and Vrancke van der Stockt. This is corroborated by the very few panel paintings that have been attributed to Marmion on the basis of stylistic analysis.[15] Particularly important for Marmion was his confrontation with the art of van der Weyden. He was influenced by Rogier's Saint John altarpiece and his panels of *Justice* once in the Brussels Town Hall, and yet surpassed these in terms of spatial conception.[16] This is especially true of Marmion's landscapes, which are based on the laws of aerial perspective and whose calm, elegiac moods contribute to the distinctive charm of his works.

Notes

1 Staatliche Museen zu Berlin, *Beschreibendes Verzeichnis der Gemälde im Kaiser-Friedrich-Museum und Deutschen Museum* (Berlin, 1931), pp. 278–80, nos. 1645, 1645A; Berlin, Staatliche Museen Preussischer Kulturbesitz, Gemäldegalerie, *Katalog der ausgestellten Gemälde des 13.–18. Jahrhunderts* (Berlin, 1975), pp. 252–53; Berlin, Picture Gallery, *Catalogue of Paintings, 13th–18th Century*, 2nd rev. ed. (Berlin, 1978), pp. 258–59.

2 A. Wauters, *Biographie Nationale*, vol. 7 (Brussels, 1880–83), cols. 61–70; J. du Teil, *Un amateur d'art au XVe siècle: Guillaume Fillastre, évêque de Tournai, abbé de Saint-Bertin, chancelier de la Toison d'or* (Paris, 1920); J. du Teil, C. de Pas, and E. van Steenberghe, "Le testament de Guillaume Fillastre, abbé de Saint-Bertin et évêque de Tournai," *Bulletin de la Société des antiquaires de la Morinie* 13 (1922), pp. 694–728.

3 For the history of the altarpiece, see Dehaisnes 1892; M. Davies, *National Gallery Catalogues: Early Netherlandish School* (London, 1968), pp. 85–87; idem, *The National Gallery, London* (Les primitifs flamands I: Corpus de la peinture des anciens Pays-Bas méridionaux au quinzième siècle, 3, 11) (Brussels, 1970), pp. 18–26.

4 C.J. Nieuwenhuys, *Description de la collection des tableaux qui ornent le palais de S.A.R. Mgr. le prince d'Orange à Bruxelles* (Brussels, 1837), p. 10. On the collection of William II, see E. Hinterding and F. Horsch, "A Small But Choice Collection: The Art Gallery of King Willem II of the Netherlands (1792–1849)," *Simiolus* 19 (1989), p. 10, fig. 7, p. 57, nos. 6–7.

5 See E.W. Hoffman, "A Reconstruction and Reinterpretation of Guillaume Fillastre's Altarpiece of St.-Bertin," *Art Bulletin* 60 (1978), pp. 634–49.

6 M. Grams-Thieme, *Lebendige Steine: Studien zur niederländischen Grisaillemalerei des 15. und frühen 16. Jahrhunderts* (Böhlau Verlag: Dissertationen zur Kunstgeschichte, 27) (Cologne and Vienna, 1988), p. 265ff.

7 Davies 1970 (note 3), p. 19, pl. XXII.

8 On the practice of pouncing in a painting by Gerard David, see K. Arndt, "Gerard Davids Anbetung der Könige nach Hugo van der Goes: Ein Beitrag zur Kopienkritik," *Münchner Jahrbuch der bildenden Kunst* 12 (1961), p. 156f.

9 I would like to thank Maryan Ainsworth (Metropolitan Museum of Art, New York), who has recently studied the fragments in London through infrared reflectography. She and Susan Foister (National Gallery, London) generously enabled me to present the results of their examination.

10 For the life of Saint Bertin, see *Acta Sanctorum Belgii*, vol. 5 (Brussels and Tongerloo, 1792), pp. 626–33; Pontificia Università Lateranense, *Bibliotheca Sanctorum*, vol. 2 (Rome, 1963), pp. 101–03.

11 J. Braun, *Die liturgische Gewandung im Occident und Orient nach Ursprung und Entwicklung, Verwendung und Symbolik* (Freiburg i. Br., 1907), p. 509f.

12 A very similar winch is to be found in a miniature of Marmion's *Grand Chroniques de France* in Leningrad; see S. Reinach, "Un manuscrit de Philippe le Bon à la bibliothèque de Saint-Pétersbourg," *Gazette des Beaux-Arts* 30 (1903), ill. p. 61; for more examples of winches and cranes, see *Les bâtisseurs des cathédrales gothiques*, exh. cat. (L'Ancienne Douane, Strasbourg, 1989).

13 See R. Grosshans, "Rogier van der Weyden: Der Marienaltar aus der Karthause Miraflores," *Jahrbuch der Berliner Museen* 23 (1981), pp. 49–112, esp. p. 92f., ill. 13.

14 The principal work of the Mansel Master is the first volume of Jean Mansel's *La fleur des histoires* (Brussels, Bibliothèque Royale, Ms. 9231–32). The illuminations in the second volume, beginning with fol. 351, are by Simon Marmion. They are among the finest miniatures Marmion created.

15 See Friedländer 1923, pp. 167–70; F. Winkler, "Simon Marmion," in *Thieme-Becker Künstler-Lexikon: Allgemeines Lexikon der bildenden Künstler*, vol. 24 (Leipzig, 1930), pp. 122–23; idem, "Simon Marmion," *Pantheon* 13 (1934), pp. 65–72; Hulin de Loo 1942; Ring 1949, pp. 31–33, 219–23; Hoffman 1969; Hoffman 1973; Hindman 1977; Sterling 1981. Through the years more than thirty pictures of very different quality have been attributed to or connected with Simon Marmion. Apart from the Saint Bertin altarpiece and its fragments in London, only a few paintings can truly be ascribed to him. These include the *Mass of Saint Gregory* in Toronto (Art Gallery of Ontario, 79–121), the *Lamentation* in New York (Metropolitan Museum of Art, Robert Lehman Collection, 75.128), and *Saint Jerome with a Donor* in the Philadelphia Museum of Art (John G. Johnson Collection, 1329). The *Crucifixion* in the Philadelphia Museum of Art (Johnson Collection, 318) was always regarded as a work by Marmion. This attribution has been called into question by Maryan Ainsworth, p. 253, below. All the other attributions are clearly remote from Marmion and the style of the Bertin altarpiece.

16 A.M. Cetto, "Der Berner Traian- und Herkinbald-Teppich," *Jahrbuch des Bernischen Historischen Museums* 43–44 (1963–64), p. 33.

New Observations on the Working Technique in Simon Marmion's Panel Paintings*

Maryan W. Ainsworth

I n his *Plainte du désiré*, Jean Lemaire equated Simon Marmion with two others who excelled in the sister arts of manuscript illumination and panel painting, Jean Fouquet and Jan van Eyck, and he was later to extol Marmion as the "very prince of book illumination" in his poem "La couronne margaritique."[1] But it was the sixteenth-century historian Louis de la Fontaine who itemized Marmion's talents in his *Antiquitez de la ville de Valenciennes* of 1551–54: he noted that Marmion was skillful and expert in drawing, giving perfection to his rendering of architecture, landscape, draperies, and other features; and that he painted personages after life so well that they only lacked a soul and living breath.[2] Given these accolades, it is baffling that Marmion's works, especially his paintings on panel, are so little known and ill-defined. Unfortunately, no surviving panel can be linked to any of the significant number of extant documents concerning Marmion's artistic activities.[3]

In addition to the Saint Bertin altarpiece, a small group of panel paintings was originally attributed to Marmion by scholars, including Friedländer, Hulin de Loo, Winkler, Ring, and Hoffman; the core group was subsequently expanded by Sterling.[4] These attributions have been based upon stylistic comparisons with the Saint Bertin altarpiece and with some of the more generally accepted manuscript illuminations. However, as in the case of the manuscript illuminations, there is no consensus regarding the authorship of these panel paintings. Therefore, it is my aim to review the attributions of panel paintings to Marmion based on new physical evidence, primarily revealed through infrared reflectography and X-radiography, thereby defining further the distinct characteristics of Marmion's art. My remarks depend upon the firsthand investigation of eighteen panels attributed to Marmion, with special attention to the analysis of working procedures,[5] as well as the direct study of as many illuminated manuscripts attributed to Marmion as possible.

As the general tendency of late medieval and Renaissance art was to maintain the status quo in terms of composition or motifs rather than to deviate from it, the rediscovery of the particular working procedures of a given artist enables us to distinguish his work from that of others. A thoroughgoing investigation of Marmion's working methods for manuscript illumination is somewhat hampered by the fact that preliminary working stages are not readily observable. Marmion apparently made his underdrawings on vellum in brown ink, a material made transparent by infrared reflectography. However, evidence of his underdrawing can sometimes be seen beneath the thin, transparent paint layers on top, outside the painted contours of figures. For example, a preliminary sketch in brown ink is clearly visible beyond these contours in the figure at the far left in the *Raising of Lazarus* (fig. 231) from a book of hours at the Pierpont Morgan Library.

Further details about Marmion's working procedures may perhaps be discovered in a few leaves cut from a book of hours now in the Rijksprentenkabinet, Am-

 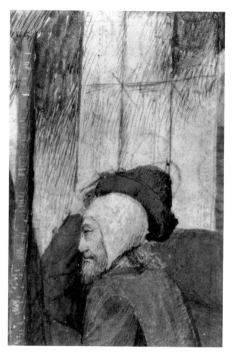 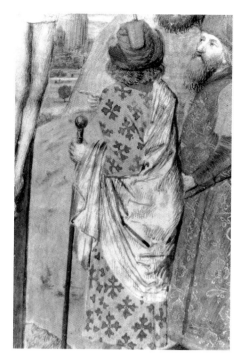

sterdam. When Boon catalogued the four illuminations, he attributed them all to Marmion and related them to fragments from a prayer book in Berlin.[6] Of the four, the *Adoration of the Magi* and the *Crucifixion* are the most convincing attributions to Marmion, appearing to be later, closeup variations of illuminations of the same subjects in Huntington HM. 1173.[7] Boon apparently did not notice that the Rijksprentenkabinet sheets had been left unfinished. In the *Adoration of the Magi*, the preliminary brown ink underdrawing is visible at the right behind Joseph, whose hat shape and body contours have been slightly adjusted (fig. 232); underdrawing also reveals that other figures or heads were originally planned. In addition, a decorative border was planned for the cloth of honor. The architecture as well as the figures of the Virgin, Christ Child, Joseph, and the kneeling king show a mid-stage of the working procedure; heads and hair are left unfinished and draperies have not yet received their final touches.[8] Though the *Crucifixion* is somewhat more finished, certain red draperies (those of John and an onlooker with his back to us) were interrupted midway through the modeling of the forms (fig. 233), thus revealing Marmion's particular graphic handling.

In the limited discussion here, I would like to review the panel paintings most clearly associated with Marmion, emphasizing characteristics of their technique and some particular features of execution which are paralleled in Marmion's illuminations. From the underdrawing to the modeling of forms to the final surface quality, Marmion was consistent in his approach to manuscript illumination and panel paintings alike. The consideration of Marmion's idiosyncratic procedures in both media helps to clarify the question of attribution in each group.

First, it is important to review certain features of the Saint Bertin altarpiece (see figs. 219a–b), the work most closely associated with the artist. As Rainald Grosshans has discussed, the painted portion of the altarpiece, completed by 1459, shows summary underdrawing used to lay out the rough compositional sketch. Here and there, Marmion made adjustments of scale or position in the paint layers alone, that is, without redrawing them—for example, in the changed position of the finial of the rooftop or in the angel, whose instrument changes from a bagpipe to a trumpet and whose draperies are enlarged (figs. 211, 234). Occasionally, there is close parallel hatching in draperies or faces that suggests the lighting system to be employed, but there is little or no attention given in the underdrawing to the modeling of forms. The faces of figures are often changed in position, the underdrawn circles or brief dashes for eyes signaling the altered pose.

Figure 231.
Simon Marmion. *Raising of Lazarus* (detail), in a book of hours. New York, Pierpont Morgan Library, M. 6, fol. 100.

Figure 232.
Attributed to Simon Marmion. *Adoration of the Magi* (detail), from a book of hours. Amsterdam, Rijksprentenkabinet, no. 70:45.

Figure 233.
Attributed to Simon Marmion. *Crucifixion* (detail), from a book of hours. Amsterdam, Rijksprentenkabinet, no. 70:46.

On close examination, the execution in paint has a matte, chalky look, with individual brushstrokes quite apparent in the fleshtones as well as in the draperies (fig. 235). This suggests a possible mixture of tempera and oil media since individual strokes are clearly visible, that is, unblended, and the final surface quality is matte, not enamel-like.[9] Marmion's method of painting, therefore, was not to work up a fully finished underdrawing and then paint over it, as was customary for most panel painters, but to do as he had done in his manuscript illuminations: produce a very summary sketch and model or make changes in the paint layers as he went along.

What also links the Saint Bertin altarpiece to Marmion's manuscript illumination is the impressive array of subtle emotional states of the characters involved in each scene (figs. 219a–b). In the scene of the birth of Saint Bertin, the female attendant expresses a sense of mild insouciance and the mother, one of weary concentration. The psychological content of Marmion's narrative is enhanced by his use of directional glances and of gesture, which not only pull together the rhythm of a composition but also punctuate the import of the narrative. In the scenes of the miracle of the wine and the demon-woman appearing to the saint, both gesture and pose mutely reflect the emotional state of the figures.

Demonstrating the virtuosity acclaimed by de la Fontaine, the attire of the figures is executed with skillful precision. Among the most extraordinary traits of Marmion's rendering are the transparent draperies (as in those of Fillastre's chaplain, fig. 236, and Saint Omer), a tour de force effect he often includes as a trademark of his work. Like drizzled sugar glaze, the white strokes of the gauzelike material appear to melt and run over the surface of the painting. What is consistently remarkable is Marmion's effective study and rendition of the fall of light through the garment.

Marmion's depiction of landscape in the Saint Bertin altarpiece (figs. 219a–b) and that in his illuminated pages as well sets him apart from his contemporaries, for he achieved a perfect balance of structural clarity and rendering of individual motifs, informed by close observation of nature. Marmion's deliberate juxtaposition of landscape forms (the carefully placed hillocks and winding road at the center of the *Dedication and Construction of the Monastery*) to achieve an easy resolution of spatial relationships never seems contrived because of his attention to natural phenomena: the subtle change of color and light for atmospheric effects into the distance, the convincing diminution of the scale of features, and, above all, the variety of types of trees represented as they appear in nature.

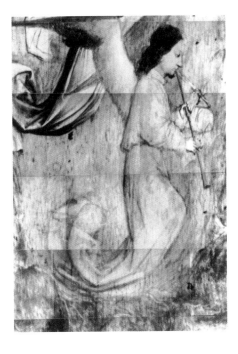

Figure 234.
Simon Marmion. *Angels* (detail), end panel from the Saint Bertin altarpiece. London, National Gallery. Infrared reflectogram assembly showing underdrawing of angel. Assembly courtesy Painting Conservation Department, Metropolitan Museum of Art, New York.

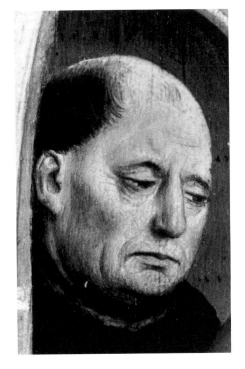

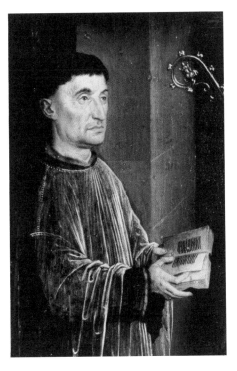

Figure 235.
Simon Marmion. *Saint Omer Receiving Saint Bertin* (detail, male attendant), interior of the left wing of the Saint Bertin altarpiece. Berlin, Staatliche Museen Preussischer Kulturbesitz, Gemäldgalerie.

Figure 236.
Simon Marmion. *The Donor* (detail, Fillastre's chaplain), interior of the left wing of the Saint Bertin altarpiece. Berlin, Staatliche Museen Preussischer Kulturbesitz, Gemäldgalerie.

Lamentation
(New York, Metropolitan Museum of Art, Robert Lehman Collection)

Given to Marmion by Ring, Friedländer, and Hoffman, but rejected by Sterling, this small, charming panel (fig. 237) has a more or less secure dating.[10] It represents on its reverse side the interlaced initials of Duke Charles the Bold and Margaret of York as well as their coat of arms. Since the couple married in 1468, the painting must date after that time, perhaps around 1473, when the ducal couple was in Valenciennes on the occasion of the meeting of the Order of the Golden Fleece. Marmion was also present, enlisted to supply decorations for the festivities.[11] The dendrochronological date of after circa 1467 determined by Peter Klein accords well with the proposed date, that is, around ten years after the completion of the Saint Bertin altarpiece.[12]

Though not universally accepted as an autograph work, the *Lamentation* reveals technical traits consistent with the Saint Bertin altarpiece. If one begins at the ground level, characteristic features of Marmion's preparatory drawing are at once apparent (a partially traced overlay of the drawing, fig. 238, clarifies its form). A summary compositional sketch locates the figures—the three to the right are painted farther away from Christ than originally drawn in order to emphasize his languorous pose. A number of changes in the contours or positions of figures are made in the paint layers alone, and there is relatively little modeling of the forms with parallel hatching.[13] Again, positions for facial features are noted with simple circles for eyes and dashes for the nose and mouth. This underdrawing parallels Marmion's working methods for manuscript illuminations. For example, the modeling of the back side of Nicodemus (fig. 239) corresponds to the preliminary shading along the back right side of the figure in the *Crucifixion* in the unfinished Rijksprentenkabinet leaf (fig. 233).

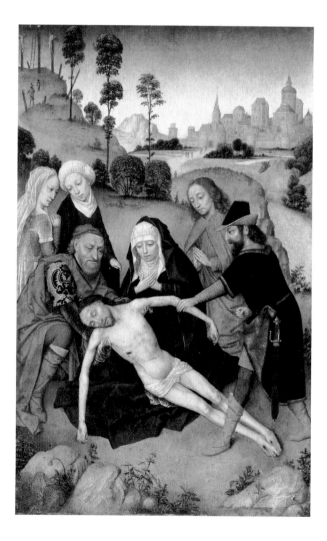

Figure 237.
Simon Marmion. *Lamentation*, oil on panel.
New York, Metropolitan Museum of Art,
Robert Lehman Collection.

Figure 238.
Infrared reflectogram assembly (detail of
figure 237). Assembly courtesy Painting
Conservation Department, Metropolitan
Museum of Art, New York.

Figure 239.
Infrared reflectogram assembly showing
underdrawing of Nicodemus in the *Lamentation*
(fig. 237). Assembly courtesy Painting
Conservation Department, Metropolitan
Museum of Art, New York.

Beyond similarities in the style and function of the underdrawing in the *Lamentation* and Marmion's other works, elements of the handling of paint are also related. Most notable is the rendition of the transparent, gauzelike material found in the cloth used to envelop the body of Christ and the dress of Mary Magdalene at the far left in the *Lamentation*. This is familiar to us from various examples in the Saint Bertin altarpiece, such as the figures of Saint Omer and a chaplain (fig. 236).

In like manner in the *Lamentation*, Marmion considered the fall of light on brocade, how it is broken up into different directions by the structure or form it covers. He therefore angled his strokes in many directions to simulate the effect of scattered light—a technique found both in the sleeve of Joseph of Arimathea (fig. 240) in the Lehman painting and in the brocade of the nobleman from the Saint Bertin altarpiece (fig. 241). In each, a tinge of pink at the sleeve edge masterfully reflects the red draperies nearby.

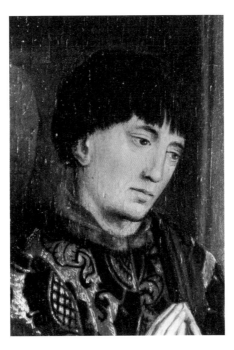

Figure 240.
Detail of figure 237 (sleeve of Joseph of
Arimathea).

Figure 241.
Simon Marmion. *Death of Saint Bertin* (detail,
nobleman), interior of the right wing of the
altarpiece of Saint Bertin. Berlin, Staatliche
Museen Preussischer Kulturbesitz,
Gemäldegalerie (see fig. 219b).

There are many similarities in facial types and hand gestures between the *Lamentation* and the Saint Bertin altarpiece. Comparing the attendant of Saint Omer (fig. 235) with Joseph of Arimathea (fig. 242), we find in both clearly visible brushstrokes and similar modeling of the face—specifically in the ears, the bags beneath the eyes, the three lines at the outside corner of the eye, the pinched flesh at the top of the broad nose, and the articulation of jowls. Equally related is the modeling of the hands, where one long, unblended light stroke on top of the fingers suggests the highlights.[14] All these forms have in common a matte rather than glossy finish, and one sees disengaged rather than blended strokes, features typical of manuscript illumination observed in detail, and not of paintings fully worked up exclusively in oil glazes to an enamel-like surface. In other words, Marmion carried over his illumination technique and handling to his execution of panel paintings.

Figure 242.
Detail of figure 237 (head of Joseph of Arimathea).

Mass of Saint Gregory
(Art Gallery of Ontario, Toronto)

Many of these same characteristics may be identified in the small panel (451×294 mm) of the *Mass of Saint Gregory* (fig. 243).[15] Certainly recognizable are the mainstays of Marmion's style: faces with bulbous eyes, prominent long, broad noses, slightly down-turned mouths, all features found in the Saint Bertin altarpiece. There is as

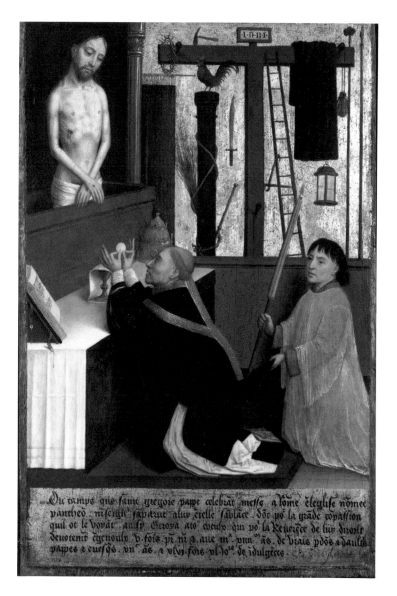

Figure 243.
Simon Marmion. *Mass of Saint Gregory*, oil on panel. Toronto, Art Gallery of Ontario.

well a pasty, matte quality of the paint in similarly modeled forms (though appearing slightly different in the Toronto painting due to the heavy-handed cleaning of the flesh areas). The body of Christ is comparable to that in the Lehman *Lamentation* in the delineation of the chest cavity and the triangular area between the shoulder and collarbone. Both figures have long, skinny arms and small hands with unarticulated, tubelike fingers. In addition, the rendering of the transparent surplice of the acolyte recalls those found in the Saint Bertin altarpiece or the Lehman *Lamentation*.

The relationship of the *Mass of Saint Gregory* to other Marmion paintings can be demonstrated further by underdrawing details. Due to the use of black or gray, not all areas could be penetrated by infrared reflectography. However, the figure of Christ (fig. 244) and of the acolyte both show typically Marmion underdrawing as we have come to know it in the Saint Bertin altarpiece or Lehman *Lamentation*. Insofar as it is visible, the simple brush underdrawing in the *Mass of Saint Gregory* maps out the composition (it can be seen in the figures as well as in the sarcophagus, ladder, and wooden wall at the back) and defines the contours of figures and draperies. As in previous examples, the contours are slightly adjusted—for example, the arm positions of the Christ and the contour of his torso. Moreover, as in the Christ figure of the Lehman *Lamentation* (fig. 245), these adjustments were apparently made in the paint layers alone and not in the underdrawing.

The similarities of the execution of the *Mass of Saint Gregory* with the Saint Bertin altarpiece as well as with features of the Lehman *Lamentation* confirm the attribution of the *Saint Gregory* to Marmion. The stylistic proximity of the Toronto painting to both the Saint Bertin altarpiece and the *Lamentation* suggests that its date probably falls between the two, around 1460–65, as Sterling proposed.[16]

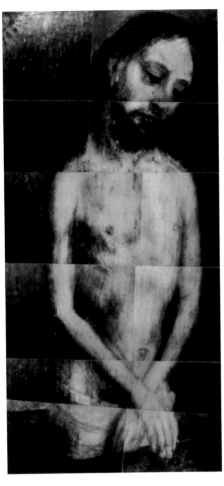

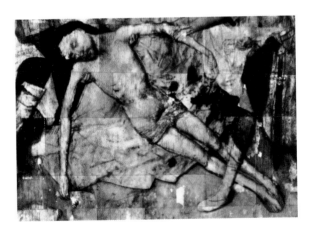

Figure 244.
Infrared reflectogram assembly showing underdrawing of Christ in the *Mass of Saint Gregory* (fig. 243). Assembly courtesy Painting Conservation Department, Metropolitan Museum of Art.

Figure 245.
Infrared reflectogram assembly showing underdrawing of Christ in the *Lamentation* (fig. 237). Assembly courtesy of Painting Conservation Department, Metropolitan Museum of Art, New York.

Saint Jerome and a Donor
(Philadelphia Museum of Art, John G. Johnson Collection)

If the Toronto *Mass of Saint Gregory* and the Lehman *Lamentation* are indicative of Marmion's panel paintings of the late 1460s and early 1470s, what can be expected of his work in the latter part of his career? What I believe to be a linchpin for this period, though in some ways difficult to reconcile with our notion of Marmion, is the Johnson Collection *Saint Jerome and a Donor* (fig. 246).[17] Certainly the left wing of a diptych or triptych, this painting has attracted a variety of attributions, not all of them to Marmion. For most scholars, the conceptual and visual leap from miniature paintings, or even panel paintings on a diminutive scale, to this large-scale work (651×490 mm) of half-length figures is irreconcilable.

The identity of the donor has not been established irrefutably, but the date of the painting is more secure.[18] Peter Klein's dendrochronological estimate of 1447 provides only a *terminus post quem*.[19] However, within the work itself is a more telling

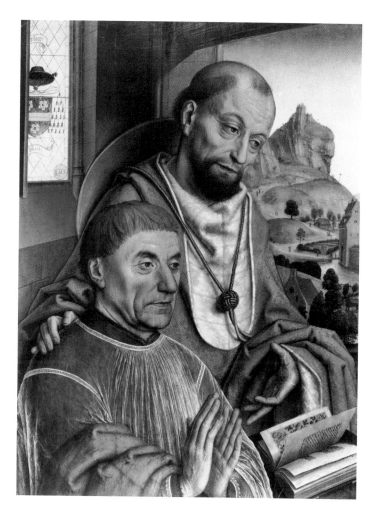

clue—the border of the illuminated page of the donor's open book. It is quite similar to the borders of books illuminated in Marmion's own workshop, for example, the Huth Hours of the 1480s, so that this illusionistic pattern of leaves, flowers, and fruits strewn across the page can only date after circa 1475.

Sterling noted that Marmion is not mentioned in Valenciennes between 1475 and 1478 and posits that he made a trip to Ghent at that time, where he would have seen the works of Hugo van der Goes, dean of the guild of painters since 1474.[20] The illuminations of the "La Flora" Hours (fig. 247), with their references to Hugo's art, particularly the *Death of the Virgin*, are hardly imaginable without the influence of the Ghent master. Certainly in keeping with some of the mannerisms of Marmion's *Saint Jerome and a Donor* is Hugo's *Death of the Virgin*, a painting most scholars date before 1475 and which is known to have been not far from Ghent, at the abbey of the Dunes in Bruges, at least since the sixteenth century.[21] It was widely copied, one early sixteenth-century version formerly belonging to the abbey of Vicoigne, a very short distance from Valenciennes.[22] If Marmion saw Hugo's painting, he may have been especially inspired by the bold use of ruddy tones for the complexions of the disciples as well as the careful study of light on the veined and bony hands (fig. 248). Hugo depended upon hand gestures for meaning in his painting, often to evoke a kind of restless anticipation. In the Philadelphia *Saint Jerome*, the donor's hands are about to meet in prayer, similar in attitude to the disciple to the left of the Virgin in Hugo's painting (figs. 246, 249).

If one makes allowances for the large size of the Johnson Collection painting and the possible influence of Hugo, then the salient characteristics of Marmion's style can be more easily identified. We cannot rely in this case on further information from the underdrawing since the paint layers were not penetrated by infrared reflectography (due perhaps to the thickness of the layers or to an intermediate gray layer which blocks the infrared rays). However, other features of the painting suggest an

Figure 246.
Simon Marmion. *Saint Jerome and a Donor*, oil on panel. Philadelphia Museum of Art, John G. Johnson Collection.

Figure 247.
Simon Marmion. *Saint James the Greater Preaching*, in the "La Flora" Hours. Naples, Biblioteca Nazionale, Ms. I B 51, fol. 318v.

attribution to Marmion. The half-length format was favored by Marmion in the last decade of his life and the facial types of the Johnson Collection painting are typical of those found in his illuminated manuscripts—the high cheekbones and broad-bridged noses are readily compared to examples from the "La Flora" Hours, such as *Saint James the Greater Preaching* from the 1480s (figs. 246, 247). The antecedents of these types in panel painting are found in the Saint Bertin altarpiece. Though of a vastly different scale, and separated from each other by about twenty years, the mannerisms of modeling the flesh are the same (figs. 235, 250), particularly in the form-defining daubs of paint at the ears, in the folds of flesh beneath the eyes and creases at the outside edge of the eye, in the long straight brushstroke which high-lights the broad nose, and in the slightly off-center mouth. As in the examples discussed previously, there is less effort here to make brushstrokes invisible or the surface entirely enamel-like.

Though again of disparate scale, the gauzelike overgarments worn by the donor in the *Saint Jerome* panel and figures in the Saint Bertin altarpiece (fig. 236) or the Lehman *Lamentation* (fig. 237) are very similar in execution. The landscape, too, with its winding road dotted by single trees as markers, as well as figures which re-alistically move within nature and the studied rocky cliffs are entirely within Mar-mion's repertory of motifs. They perhaps have an antecedent in the earlier *Sept âges du monde* illuminations.[23]

Figure 248.
Hugo van der Goes. *Death of the Virgin* (detail, two disciples), oil on panel. Bruges, Groeningemuseum.

Figure 249.
Hugo van der Goes. *Death of the Virgin* (detail, Virgin and disciples), oil on panel. Bruges, Groeningemuseum.

Figure 250.
Detail of figure 246.

Crucifixion
(Philadelphia Museum of Art, John G. Johnson Collection)

The *Crucifixion* (fig. 251) in the Johnson Collection is nearly universally accepted as by Marmion because of a suggested relationship to various illuminated *Crucifix-ions* by him and a tradition that the painting came from the abbey of Saint Bertin at Saint-Omer.[24]

There is no denying that the Johnson Collection *Crucifixion* is a beautiful and well-preserved northern French painting of the 1470s (Peter Klein's dendrochron-ological date situates it sometime after circa 1447).[25] However, the comparisons made with *Crucifixions* in the Pontifical of Sens or Prayer Book of Philip the Good are gen-eral, not specific, and, after close examination of the Johnson Collection painting, I find it impossible to include it in the body of Marmion's panel paintings.

In a general way, some of the individual figures (such as the two Marys, Christ, and the soldiers) are reminiscent of Marmion's types. Even the passage into the dis-tance by a winding road dotted with trees recalls familiar landscape formulae. How-ever, two specific features of the painting belie the hand of the master: the emotional detachment of the figures and the specific handling or execution of the paint.

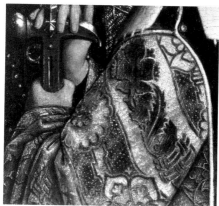

Though the figures are Marmion-like, they do not share the same sense of psychological engagement united by gaze and gesture which is an overriding feature of Marmion's works. John, the Virgin Mary, Mary Magdalene, and the soldiers are stock types plugged into a foreground plane, devoid of any particular interrelationship or affective appeal. The result is the disjointed and vapid expression of a subject normally charged with emotion.

A closer look at the execution of these figures and the landscape further illustrates the point. The detectable underdrawing in the infrared reflectogram computer assembly is limited to the dress of the Virgin (fig. 253) and shows a very controlled delineation of the drapery folds that appears to be followed closely in the painted layers. There is no spontaneity in the drawing, no shifts of contour, or Marmion's characteristic shorthand indication of facial features. Furthermore, the execution of

Figure 251.
Follower of Simon Marmion. *Crucifixion*, oil on panel. Philadelphia Museum of Art, John G. Johnson Collection.

Figure 252.
Brocade of soldier's garment, detail of figure 251.

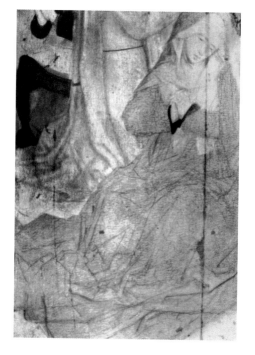

Figure 253.
Detail of figure 251. Infrared reflectogram assembly showing underdrawing of Virgin. Assembly courtesy Painting Conservation Department, Metropolitan Museum of Art, New York.

the painted surface shows that the *Crucifixion* was not made by a manuscript illuminator on a larger scale, but by a panel painter well versed in the application of glazes to produce a fully blended, enamel-like quality. Marmion's typical matte, chalky painted surface that reveals individual brushstrokes is absent, as is readily apparent in a comparison of the head of Christ with that from the *Lamentation* (figs. 254, 255) or the two Virgins from the same works (figs. 256, 257).

The painter of the Philadelphia *Crucifixion* is an artist interested in patterning and surface. His observation of natural phenomena, moreover, is different from Marmion's. Compare, for example, the rendering of the brocade of the soldier (fig. 252) at the left with that of Joseph of Arimathea in the *Lamentation* (fig. 240). The *Crucifixion* artist considers the surface, although exquisitely painted, as a flat plane of patterning, with the area rendered as an isolated study of brocade; Marmion considered his brocade more illusionistically, suggesting movement and the phenomenon of light reflected in different directions over a concave surface. A comparison of the landscape from the Philadelphia painting with that in the Saint Bertin *Dedication and Construction of the Monastery* again shows the first to be formulaic, with undifferentiated bands of color from foreground to background—not the lively tonal and coloristically diverse representation in the Saint Bertin altarpiece, which is based on observation of natural phenomena.

Through these brief observations about Marmion's painting technique and working procedure, I hope to have clarified the characteristics of the core group of paintings which can be attributed to him. The works discussed here are distributed chronologically and evenly over the artist's entire career. Therefore, their characteristics may in turn be used to evaluate other Marmion attributions not yet investigated by this method.[26]

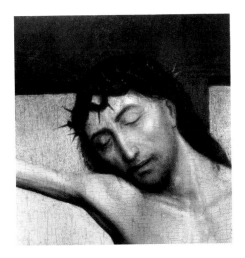
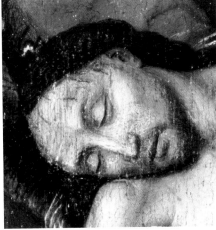

Figure 254.
Head of Christ, detail of figure 251.

Figure 255.
Head of Christ, detail of figure 237.

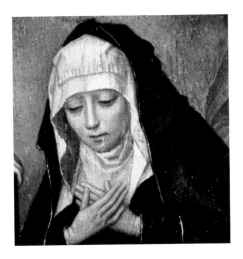
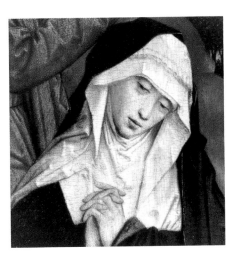

Figure 256.
Virgin's head, detail of figure 237.

Figure 257.
Virgin's head, detail of figure 251.

Appendix:
The Panel Paintings of Simon Marmion

This list comprises all the known panel paintings previously or currently associated with the name of Simon Marmion. It is hoped that readers will help revise this list with additional information about other attributions. An asterisk indicates a work not yet studied firsthand.

Accepted Paintings

—Saint Bertin altarpiece (Marmion and workshop), Berlin, Staatliche Museen Preussischer Kulturbesitz, Gemäldegalerie, 1645, and London, National Gallery, 1302–1303; completed 1459
—*Mass of Saint Gregory*, Toronto, Art Gallery of Ontario, 79–121; circa 1460–65
—*Lamentation*, New York, Metropolitan Museum of Art, Robert Lehman Collection, 1975.1.128; circa 1468–73
—*Saint Jerome and a Donor*, Philadelphia Museum of Art, John G. Johnson Collection, 1329; circa 1480

Possible Attributions

—*Virgin and Child*, Melbourne, National Gallery of Victoria, 3079/4
—*Mater Dolorosa* and *Christ as Man of Sorrows*, Strasbourg, Musée des Beaux-Arts, 513
—*Saint Dominique de Guzman*, private collection, U.S.A.

Rejected Paintings

POSSIBLY MARMION WORKSHOP OR AFTER MARMION

—*Mater Dolorosa* and *Christ as Man of Sorrows*, Bruges, Groeningemuseum, 0.201–02
—*Mass of Saint Gregory*, Burgos, Cathedral, Capilla del Condestable
—*Virgin and Child with Saints and Donors*, triptych, London, National Gallery, 2669, and Lugano, Thyssen-Bornemisza Collection
—*Miracle of the True Cross*, Paris, Musée du Louvre, R.F. 1490
—*Crucifixion*, Philadelphia Museum of Art, John G. Johnson Collection, 318
—*Pietà*, Sotheby's, New York, January 17, 1985, lot 29
—*Saints Matthew and Mark*, Valenciennes, Musée des Beaux-Arts
—*Mater Dolorosa*, location unknown, J. Paul Getty Museum Photo Archives

NOT WORKSHOP-RELATED

—*Virgin and Child with Saints and a Donor*, London, National Gallery, 1939
—*Two Saints and a Donor*, New York, Metropolitan Museum of Art, Linsky Collection, 1982.60.19
—Two martyrdom scenes, New York, Metropolitan Museum of Art, 22.60.56–57
—*Pietà*, Oxford, Ashmolean Museum, 261
—*Portrait of Margaret of York*, Paris, Musée du Louvre, R.F. 1938–17
—*Christ Before Caiphas*, Philadelphia Museum of Art, John G. Johnson Collection, 763
—*Crucifixion*, Rome, Galleria Nazionale d'Arte Antica (Palazzo Barberini), 1137, F.N. 756
—*Saint Benedict in His Cell* and *Saint Benedict Rescues Placidus from Drowning*, Washington, D.C., National Gallery of Art, 1952.5.45

Location Unknown

—*Virgin and Child*, formerly Amsterdam, Goudstikker Collection
—*Virgin and Child*, formerly Blaricum, Kleiweg de Zwaan Collection
—*Mass of Saint Gregory*, Christie's, London, July 15, 1977, lot 23
—*Preaching of Saint Francis*, Christie's, London, July 10, 1981, lot 85
—*Saint George Slaying the Dragon*, formerly Cologne
—*Portrait of a Young Gentleman*, England, private collection
—*Virgin and Child*, formerly Montpellier, D'Albenas Collection
—*Abraham and Melchisedek*, formerly New York, Seligmann Collection
—*Virgin and Child*, formerly Paris, Musée du Louvre (according to Ring 1949, p. 221)
—*Virgin and Child*, formerly Stuttgart, Oberlenningen, Heinrich Scheufelen Collection
—*Virgin and Child*, formerly Zurich, private collection

Notes

* I am particularly grateful to Rainald Grosshans for a fruitful collaboration on the study of the Saint Bertin altarpiece in Berlin and to Thomas Kren for many helpful discussions concerning Marmion as a manuscript illuminator. For their permission and help in studying paintings and illuminated books in their collections, I am indebted to the following curators, conservators and photographers: Janet Backhouse, David Bomford, Marigene Butler, Susan Foister, Eleanor Garvey, Eva Irblich, Lawrence Kanter, Mary Robertson, Sandra Lawrence, Joseph Mekuliak, Nancy Minty, Nicole Reynaud, Joseph Rishel, William Robinson, Peter Schatborn, Gerald Schultz, Alistair Smith, Frauke Steenbock, Mark Tucker, Roger Wieck, and Martin Wyld; Jeffrey Jennings and Katie Crawford

Luber, two art historian interns, helped to document technical information from the paintings; Teresa Russo provided assistance with the infrared reflectogram computer assemblies. Finally, I thank Peter Klein for allowing me to include information from his dendrochronological research of Marmion paintings in this paper.

1 Stecher 1882–91, vol. 4, p. 162.

2 This is a paraphrase of portions of de la Fontaine's manuscript, as quoted in Dehaisnes 1892, p. 122.

3 See Hénault 1907–08.

4 Friedländer 1923; Hulin de Loo 1942; F. Winkler, "Simon Marmion," in *Thieme-Becker Künstler-Lexikon: Allgemeines Lexikon der bildenden Künstler*, vol. 24 (Leipzig, 1930), pp. 122–23; Ring 1949, pp. 219–22; Hoffman 1969; Hoffman 1973; Sterling 1981.

5 Unfortunately, the Melbourne *Virgin and Child* and the Strasbourg *Mater Dolorosa* and *Christ as Man of Sorrows* could not be included in the current study. They are discussed in U. Hoff and M. Davies, *The National Gallery of Victoria, Melbourne* (Les primitifs flamands. I: Corpus de la peinture des anciens Pays-Bas méridionaux au quinzième siècle, 12) (Brussels, 1971), pp. 51–55, and H. Haug, *Musée des Beaux-Arts de la ville de Strasbourg: Catalogue des peintures anciennes* (Strasbourg, 1938), p. 56, nos. 72a and b. A late fifteenth-century copy of the Strasbourg panels is in the Groeningemuseum, Bruges, discussed by D. de Vos in *Bruges, Musées Communaux: Catalogue des tableaux du 15e et du 16e siècles* (Bruges, 1982), pp. 136–37. For a listing of the paintings I have studied as well as those attributed to Marmion that are known to me, see the appendix following this essay.

6 K.G. Boon, *Netherlandish Drawings of the Fifteenth and Sixteenth Centuries* (The Hague, 1978), vol. 2, pp. 3–4. Berlin, Staatliche Museen Preussischer Kulturbesitz, Kupferstichkabinett, Ms. 78 B 13.

7 For illustrations of the Huntington Berlaymont Hours (HM. 1173), see Thorpe 1976, esp. pls. 6 and 11. The *Martyrdom of Apollonia* and the *Annunciation to the Shepherds* in the Rijksprentenkabinet leaves may be workshop efforts. These are illustrated in Boon (note 6), pl. vol., p. 3, nos. 4 and 7.

8 Certain anomalies, such as the rather crudely painted gold highlights of the Virgin's dress, the voluminous sleeve of Joseph's green costume, and the odd brown color of the bed cover, may be later additions by a different hand to make the illuminations appear more finished.

9 This question of mixed media in Northern Renaissance paintings is still relatively unstudied. However, it is interesting to note that a work by a contemporary French painter, the Master of Saint Giles, has shown a mixture of oil and tempera in the paint layers; see D. Bomford and J. Kirby, "Two Panels by the Master of Saint Giles," and J. Mills and R. White, "Analyses of Paint Media," both in *National Gallery Technical Bulletin* 1 (1977), pp. 49–56, 57–59.

10 Ring 1949, p. 221; Friedländer 1923, pp. 168–69; Hoffman 1969, p. 244, n. 7; Sterling 1981, p. 12, n. 28.

11 Duke Charles had already employed Marmion for another commission, the completion of a sumptuous breviary, begun under Duke Philip the Good, for which he was paid in 1470; see Sandra Hindman's essay, pp. 229–31, above.

12 Letter to the author, December 1989.

13 This underdrawing has some counterparts in Marmion's manuscript illuminations. The *Raising of Lazarus* folio (fig. 231) reveals precisely the kind of contour shift and adjustment of pose which we find in the Lehman *Lamentation*, particularly in the figures of Nicodemus and Joseph of Arimathea.

14 Marmion's keen observation of light in nature pervades his representations of landscape as well. In the Lehman *Lamentation* and the Saint Bertin altarpiece, individual trees dot the hillside and rounded hillocks, marking the transition from foreground to background beside a winding road. Of note is the particular type and method of painting of the trees. One type of tree favored by Marmion is tall with a branch or two cropping out at a lower level from the rest. There are also short, clumped bushes painted in arced strokes in a base green pigment and then dotted with highlights which, by their placement, suggest the movement of the branches and changing light effects. This latter effect can also be seen in the *Saint Jerome in Penitence* from the Huth Hours (fol. 277v; Malibu 1983, pl. IV).

15 Sterling 1981. While in fairly good condition, the *Mass of Saint Gregory* has suffered from a heavy-handed cleaning which removed some of the final modeling in the fleshtones, particularly in the hands; in addition, certain areas, such as the background around the Christ figure and the hanging green curtain, have been repainted. A copy of the Toronto painting, perhaps from Marmion's workshop, is in Burgos, in the Capilla del Condestable of the cathedral; see J. Lavalleye, *Collections d'Espagne* (Les primitifs flamands. II: Répertoire des peintures flamandes du quinzième siècle, 1–2), vol. 2 (Antwerp, 1958), p. 37, no. 89, pl. XXIV. Furthermore, there is an illuminated page in the Huth Hours (fol. 125v) which is quite close, particularly in the composition and the figures of Christ and Saint Gregory. The acolyte, however, expresses a certain crudeness in handling which may indicate workshop participation. On the interrelatedness of the Toronto and the Burgos paintings, see Sterling 1981, esp. p. 10.

16 Sterling 1981, p. 16.

17 For opinions regarding the attribution of this painting, see Sweeny 1972, p. 53.

18 Weale identified the coat of arms on the stained glass window as those of the well-known Busleyden family. However, the donor cannot be Canon Jerome Busleyden, the founder of the University of Louvain, since he lived from circa 1470 to 1517, too late for the general style of the painting. Bouchot alternatively suggested the arms of the French family of Baradat, a seemingly more plausible identification; see Ring 1949, p. 221, no. 181.

19 Letter to the author, December 1989.

20 Sterling 1981, p. 14, n. 37. Though the matter is little discussed, there is reason to believe that Marmion also had influence on Bruges and Ghent artists, further substantiating his presence in the north for a period of time. In particular, Marmion's *Mater Dolorosa* and *Christ as Man of Sorrows* were copied by an anonymous Bruges artist in paintings now in the Groeningemuseum, Bruges, 0.201–02; they also inspired a *Christ as Man of Sorrows* by Colijn de Coter in the Musée de Brou in Bourg-en-Bresse. Furthermore, Antoine de Schryver had noted that the *Miracle of the True Cross* (Louvre), previously attributed to Marmion, was in Ghent collections for most of its history and has suggested that it was painted by a Ghent artist, Daneel de Rijke, under the influence of Marmion; see *Justus van Gent, Berruguete en het hof van Urbino*, exh. cat. (Ghent, Museum voor Schone Kunsten, 1957), p. 134, no. 67. For de Schryver's subsequent opinion on this painting, see p. 176 and 180, n. 38, above.

21 The opinions concerning the date of this painting are given in de Vos (note 5), pp. 210–13.

22 Sterling 1981, p. 14, n. 37.

23 I am grateful to Thomas Kren for suggesting this link. For the *Sept âges du monde* illustrations, see L.M.J. Delaissé, *Miniatures médiévales de la Librairie de Bourgogne au Cabinet des manuscrits de la Bibliothèque royale de Belgique* (Geneva, 1959), p. 153.

24 Hulin de Loo related the Philadelphia *Crucifixion* to the Pontifical of Sens illumination; see Sweeny 1972, p. 52. Sterling 1981, p. 13, n. 33, further suggested its relationship to Marmion's *Crucifixion* in the Prayer Book of Philip the Good (Paris, Bibliothèque Nationale, Ms. fr. 16428, fol. 84). Only a few dissenting voices (among them Bernath, Destrée, and Valentiner) have supported an earlier tradition that related this painting to the works of Justus van Ghent (see Sweeny, p. 52). The tradition that this painting came from the abbey of Saint Bertin was stated in an auction catalogue of the Kums Collection (Antwerp, May 18, 1893, lot 77).

25 Letter to the author, December 1989.

26 The appendix to this article presents another possible attribution to Marmion, a fragment representing *Saint Dominique de Guzman* which is in a private American collection. An opportunity to study this panel firsthand would clarify the question of attribution.

Appendix

The Library of Margaret of York and Some Related Books

This appendix is based on data compiled independently by Wim Blockmans, Pierre Cockshaw, and Nigel Morgan, and originally presented as appendices to their respective papers. In the unified format here, the list of manuscripts associated with Margaret is divided into categories that explain *how* the books were connected with her: 1) those she commissioned for her own library; 2) those she received as gifts; 3) those she owned but whose path to her library cannot be determined with certainty; 4) those she presented as gifts to others; and 5) books associated in some way with Margaret's patronage, although the surviving copy may not have belonged to her library. The entries on individual manuscripts indicate the evidence (physical or otherwise) that determined its placement under a particular heading. Marks of Margaret's ownership—coat of arms, the initials of Charles and Margaret, Margaret's signature, and her device, *Bien en aviengne*—are noted. The colophons and dedications quoted here are only those which specifically mention Margaret herself and thus indicate her ownership or donation or (as in no. 11) those which name the donor of a work commissioned for Margaret.

This is a provisional list. We have not been able to check all transcriptions against the manuscripts themselves and therefore have sometimes relied on standard catalogue entries. It should be noted that some of the colophons and dedications include scribal errors and inconsistencies. The first category includes only those books that contain colophons or dedications which specifically state that the manuscript was commissioned by Margaret. In the second category, Margaret's receipt of the books can be determined through documents or the evidence of the book; most of these books have not survived. In the third category, books owned but not necessarily commissioned by Margaret, circumstantial evidence, such as similarities in format to other books she commissioned, sometimes suggests that they were also made at her request (nos. 18 and 19, for example). But even in these cases the possibility that the book was ordered by another patron and presented as a gift cannot be ruled out. There are also two manuscripts in this category (nos. 15 and 16) that originally came from the ducal library of Philip the Good. While these may have been given to Margaret as gifts, there is no hard evidence in the form of an inscription to confirm their status. We have decided to err on the side of caution when the evidence of commission or presentation is not incontrovertible. In the fourth category, it is again uncertain how Margaret acquired the books before presenting them as gifts—by commission, purchase, or deaccession from her own library. As a result of these uncertainties, the papers in this volume express a broad range of views about Margaret's ownership; no attempt has been made to reconcile divergent opinions.

The second purpose of this appendix is to remedy a lacuna in previous lists of Margaret's books, which tended to describe devotional miscellanies only by the most well-known works contained within them. To give the reader a fuller sense of what Margaret read, we have here listed all the titles in each manuscript. In these cases,

the old French is retained since the titles often represent incipits rather than proper titles. True titles for entire books appear in modern French while generic titles (such as breviary or register) are listed in English, as are descriptive identifications.

There are three colophons (nos. 4, 5, and 8) that include dates, but these are old style dates, calculated in the Burgundian tradition from the style of Easter (see Cockshaw's essay, pp. 58–59, above, and Blockmans's essay, n. 54, above). For these three manuscripts, the new style date is also provided. Bibliography on individual manuscripts can be found in Dogaer 1975, pp. 109–11, and Hughes 1984 (Hughes numbers are included in most of the entries here). The papers in this volume should be consulted for more recent bibliography. We have provided further references in notes when a fuller account of the manuscript or our sources seemed warranted.

<div style="text-align: right">Kurtis A. Barstow</div>

I. Margaret's commissions for her own library

1. Nicolas Finet, *Benoit seront les miséricordieux*, circa 1468–77
Parchment, 213 fols., 370×260 mm, 2 miniatures
Brussels, Bibliothèque Royale, Ms. 9296
Margaret's device on fols. 1 and 17 and Margaret's arms on fols. 1, 2, and 17, the initials CM throughout, and Margaret's signature on fol. 213v. Dedication by Nicolas Finet.
Hughes no. 12

Fol. 1v: A la requeste de tres grande et tres excellente dame et tres redoubtee princesse madame Marguerite d'York, seur du roy Edouard roy d'Engleterre et femme et espeuse de tres grand et tres redoubte prince Charles, par la grace de dieu duc de Bourgongne. . . . Je, Nicolas Finet, maistre es ars, chanoine de Cambray et aumosnier de ma ditte tres redoubtee dame, ay entrepris de translater de latin en franchois une compilacion de pluiseurs auctorites extraites tant du Nouveau Testament, des evangiles, epistres de saint Pol et canoniques et des fais des appostres comme du Vieux Testament et des ditz et auctorites des saintz docteurs de nostre mere Saincte Eglise et de pluiseurs exemples notables, en prendant ce qui sera a la fin et pourpos de ceste compilacion, comme il appara cy apres en poursievant la matere, laquelle compillacion est issue du couvent des chartrois nomme la maison de la chapelle Nostre Dame en la ville de Herines empres Enguien ou pays de Hainault. Et ceste dicte compilacion est intitulee et nommee "Benois seront les misericordieux."

2. Nicolas Finet, *Le dialogue de la duchesse de Bourgogne à Jésus Christ*, circa 1468–77
Parchment, 140 fols., 200×140 mm, 1 miniature
London, British Library, Add. Ms. 7970
Margaret's device, coat of arms, and the initials CM on fol. 1v.[1]
Hughes no. 13

Fol. 3v: J'ay empris cest present ouvraige a la requeste de tres puissant et excellente dame et princesse Marguerite d'Yorck, femme et espeuse de Charles par la grace de Dieu duc de Bourgogne, de Lothrijck, de Brabant, de Lembourg, de Luxembourg et de Guldres, conte de Flandres, d'Artois, de Bourgogne, palatin de Haynault, de Hollande, de Zellande, de Namur et de Zutephene, marquis du Saint Empire, seigneur de Frise, de Salins et de Malines etc. Lequel ouvrage conduit et manie a la vye contemplative et est intitule "le dyalogue de la duchesse de Bourgogne a Ihesucrist."

3. Devotional writings by Jean Gerson, circa 1468–77
Parchment, 158 fols., 380×270 mm, 3 miniatures
Brussels, Bibliothèque Royale, Ms. 9305–06
Margaret's signature on the last folio, the initials CM on fol. 7.
Hughes no. 15

Fol. 158v: Ce livre cy est a tres haulte, tres excellante et puissante princesse Madame Margarete de Yorke, ducesse de Bourgoigne, de Brabant etc.

 a) Jean Gerson, *Traictie de mendicite spirituelle* (*Le secret parlement de l'homme comtemplatifz a son ame et de l'ame a l'omme sur la povrete et mendicite espirituelle*), fol. 7
 b) Jean Gerson, *La montaigne de contemplacion*, fol. 76
 c) Jean Gerson, *La medicine de l'ame* (*La forme et maniere de bien mourir*), fol. 123

4. *La vision de l'âme de Guy de Thurno*, Ghent, February 1, 1474 (new style, 1475)
Parchment, 34 fols., 363×257 mm, 1 miniature
Malibu, J. Paul Getty Museum, Ms. 31
Margaret's device and the initials CM on fol. 7; written by David Aubert.
Hughes no. 16

Fol. 33: Cy fine le livre intitule vision de l'ame de Guy de Thurno, lequel livre a este escript et ordonne par le commandement et ordonnance de tres haulte et tres excellente princhesse, madame Marguerite de Yorch, par la grace de dieu duchesse de Bourgoigne, de Lothrijck, de Brabant, de Lembourg, de Luxembourg et de Guelres, contesse de Flandres, d'Artois, de Bourgoigne, palatine de Haynnau, de Hollande, de Zeelande, de Namur et de Zutphen, marchise du Saint Empire, dame de Salins et de Malines. A este escript en sa ville de Gand par David son escripvain, l'an de grace mil CCCC soixante et quatorse, le premier du mois de fevrier.

5. *Les visions du chevalier Tondal*, Ghent, March 1474 (new style, 1475)
Parchment, 45 fols., 363×262 mm, 20 miniatures
Malibu, J. Paul Getty Museum, Ms. 30
Margaret's device and the initials CM throughout; written by David Aubert.
Hughes no. 17

Fol. 43v: Cy fine le livre intitule les Visions que recheu l'esperit d'un chevallier des marches d'Irlande nomme monseigneur Tondal, lequel livre a este escript et ordonne par le commandement et ordonnance de tres haulte, tres excellente et tres puissante princhesse, madame Marguerite de Yorch, par la grace de dieu duchesse de Bourgoigne, de Lothrijk, de Brabant, de Lembourg, de Luxembourg et de Guerles, contesse de Flandres, d'Artois, de Bourgoingne, palatine de Haynnau, de Hollande, de Zeellande, de Namur et de Zuutphen, marquise du saint empire, dame de Salins et de Malines. A este, en sa ville de Gand, par David son tres petit, indigne escripvain escript ou mois de mars l'an de grace mil CCCC soixante et quatorse.

6. Frère Laurent, *La somme le roi* and devotional texts (compilation entitled *La somme de perfection*), Ghent, 1475
Parchment, 256 fols., 380×250 mm, 1 miniature
Brussels, Bibliothèque Royale, Ms. 9106
Miniature with Margaret's device and coat of arms on fol. 9; written by David Aubert.
Hughes no. 18

Fol. 256v: Cy fine le livre intitule la somme de perfection traitant de vices et vertuz par maniere de ampliation sur les visions de l'Apocalipse saint Iehan, qui au commandement de tres haulte, tres excellente et tres puissant princhesse et ma tres redoubtee dame, madame Marguerite de York duchesse de Bourgoingne et de Brabant etc, a este escript et ordonne comme il appert en sa ville de Gand, l'an de grace mil CCCC LX et quinze. / David Aubert manu propria.

 a) Frère Laurent, *La somme le roi* (first two parts missing), fol. 9
 b) *Comment Jhesu Crist enseigna ses appotres*, fol. 199v
 c) *La Patre Nostre en francoiz*, fol. 201v
 d) *Comment l'on doit se confesser*, fol. 202
 e) *Comment chascune creature doibt avoir en luy vraye cognoissance de son createur*, fol. 205v
 f) *Les dix commandemens de la loy* (from *La somme le roi*), fol. 208v
 g) *Aucuns bons motifs des sains de paradis*, fol. 212v
 h) *Plusieurs beaulz exemples, en declairant d'une vertu qui s'apelle fontaine d'humilite*, fol. 227v
 i) *Ung exemple de moral sur une fiction du corps et de l'ame*, fol. 230
 j) *Le signifiement et ordonnance de la sainte messe*, fol. 232
 k) *Plusieurs beaulz exemples et enseignemens*, fol. 233v
 l) *La vertu et proufit que dessert la personne quy est en l'amour de Nostre Seigneur*, fol. 234v
 m) *Des branches du pommier*, fol. 236v
 n) *Signes de l'amour de Nostre Seigneur*, fol. 242v
 o) Albert of Cologne, *Neufs articles*, fol. 244
 p) *Dits de Saint Pol*, fol. 245v
 q) *Six maistres de tribulation*, fol. 246
 r) Rutebeuf, *Ave Maria*, fol. 247
 s) *Ung exemple moult notable sur l'euvangile touchant a chascune creature*, fol. 248v
 t) *De la nativite de Antecrist*, fol. 251
 u) *Des quinzes signes qui advendront devant le grant jugement*, fol. 253
 v) *Des peines des damnes et de la gloire des bienheureux*, fol. 253

7. Boethius, *La consolation de philosophie*, Ghent, 1476
Parchment, 135 fols., 375×270 mm, 1 miniature
Jena, Universitätsbibliothek, Ms. El. f. 85
Margaret's device and coat of arms on fol. 13v; written by David Aubert.
Hughes no. 11

Fol. 148v: Explicit le cinquieme et dernier livre partial d'un volume intitule "Boece, De consolation," lequel, par le commandement et ordonnance de tres haulte, tres excellente et tres puissant princesse et ma tres redoubtee dame, madame Marguerite d'Engleterre, duchesse de Bourgoingne, de Lothrijk, de Brabant, de Leimbourg, de Luxembourg, de Gueldres et de Loheraine, contesse de Flandres, d'Artois et de Bourgoingne, palatin de Haynnau, de Hollande, de Zeellande, de Namur et Zuutphen, marquise du Saint Empire, dame de Frise, de Salins et de Malines, a este escript et ordonne, comme il appert, en sa ville de Gand, en l'an grace mil quatre cens LX et seze.
David Aubert manu propria.

8. Moral and religious treatises, Ghent, March 1475 (new style, 1476)
Parchment, 267 fols., 360×280 mm, 4 miniatures
Oxford, Bodleian Library, Ms. Douce 365
Margaret's coat of arms on fol. 155 (and a coat of arms painted over with black pigment on fol. 1); written by David Aubert.
Hughes no. 20

Fol. 267v: Cy finent aucuns moult devots traitties moralz et aultrement comme par la table des rubrices de ce volume appert en brief, lequel volume a este escript et ordonne comme il s'ensieult par le commandement de tres haulte, tres excellente et tres puissante princesse et ma tres redoubtee et souveraine dame, Madame Marguerite de Yorke, duchesse de Bourgoingne, de Lothrijk, de Brabant, de Lembourg, de Luxembourg, de Gueldres et de Loheraine, contesse de Flandres, d'Artois, de Bourgoingne, de Zutphen, palatin de Haynau, de Hollande, de Zeellande, de Namur et de Vaudemont, marquise du Saint Empire, dame de Frise, de Salins et de Malines, en sa ville de Gand ou mois de mars l'an de grace nostre seigneur mil CCCC soixante et quinze, par David Aubert son escripvain indigne.

 a) L'abbaye du Saint Esprit, fol. 1
 b) Attributed to Peter of Luxembourg, Traite, fol. 17
 c) Peter of Luxembourg, Livret, fol. 23
 d) Du gouvernement cotidien, fol. 63
 e) Attributed to Peter of Blois, Les douze fleurs de tribulation, fol. 115
 f) Gerard of Liège or Hugh of Saint Cher, La garde du coeur et de l'ame, fol. 139
 g) Des remedes de fortune (attributed to Seneca), fol. 155
 h) Des quatres vertus cardinalz (attributed to Seneca), fol. 171
 i) Le miroir des pecheurs [Speculum peccatoris], fol. 193

II. Books Margaret received as gifts

9. La vie de Saint Gommaire
Location unknown
Presented by the canons of the collegiate church at Lier in 1475.[2]
Hughes no. 3

10. Breviary
Location unknown
Received presumably sometime in 1477 or later from Louise de Laye, the widow of Guillaume Hugonet, Chancellor of Burgundy, who was executed in Ghent on April 3, 1477.[3]
Hughes no. 9

11. Les chroniques des comtes de Flandre, Ghent, 1477
Parchment, 293 fols., 400×290 mm, 20 miniatures
Holkham Hall, Library of the Earl of Leicester, Ms. 659
Margaret's signature on the last folio. Commissioned by Mary of Burgundy for Margaret, with Margaret's arms (for example, on fol. 2) and device.
Hughes no. 24

Fol. 1v: Par le commandement et ordonnance de tres haulte, tres excellente et tres puissante, ma tres redoubtee princesse Marie, par la grace de Dieu duchesse de Bourgoigne . . . ont ces presentes croniques . . . este apres la translation faicte de latin en cler francois grossees. . . . , en l'an de grace mil quatre cens soycante et seze que maditte tres redoubtee princesse apres le trespas de feu monseigneur Charles . . . print la saisine de sa conte de Flandres . . . ; et tost apres en l'an . . . mil quatrecens soycante et dix sept print la tres noble princesse la possession de ses duchie de Brabant. . . .

III. Books owned but not necessarily commissioned by Margaret

12. Brunetto Latini, Le livre du trésor, book 1
Parchment, 184 fols., 350×229 mm, 1 miniature
Saint Quentin, Bibliothèque Municipale, Ms. 109
Signature of Margaret at the end, her arms on the clasp; written in Lille by Jehan du Quesne.

13. Book of hours (use of Rome), before 1468
Parchment, 232 fols., 231×158 mm, 34 miniatures
Private collection; London, Christie's, May 26–27, 1965, lot 195
This manuscript was originally made for Charles and his second wife, Isabella of Bourbon. Margaret's arms are painted on fols. 34v and 231. However, the blazon of England in the arms on fol. 34v is painted over another blazon, presumably that of Isabella of Bourbon; fol. 231, which contains a prayer to Saint Susanna and a miniature, is likely an addition made by Margaret after she acquired the manuscript.[4]
Hughes no. 5

14. Book of hours (use of Rome), circa 1488
Parchment, 161 fols., 180×125 mm, 54 miniatures
Destroyed; formerly Metz, Bibliothèque Municipale, Ms. 1255 (Salis 104)
Arms and device of Margaret on fol. 10v.[5]
Hughes no. 6

15. Devotional writings by Jacobus van Gruytrode, Saint Bonaventure, Jean Gerson, and Thomas à Kempis (the first two texts forming the second part of a compilation entitled *Le miroir d'humilité*), Bruges and Brussels, 1462[6]
Parchment, 8 and 234 fols., 390×280 mm, 10 miniatures
Valenciennes, Bibliothèque Municipale, Ms. 240
Copied by David Aubert for Duke Philip the Good. Signature of Margaret on fol. 444v.[7]
Hughes no. 14

 a) Jacobus van Gruytrode, *La vieulte de condition humaine* [*Specula omnis status humanae vitae*, part 4, *Speculum saecularium*], fol. 211
 b) Saint Bonaventure, *La noblesse de la creation de l'ame humaine* [*Soliloquium de quatuor mentalibus exercituis*], fol. 227v
 c) Jean Gerson, *Sermons sur la Passion*, fol. 273
 d) Jean Gerson, *Ung petit traitie pour traire a moralite toute la Passion de Jesus Christ*, fol. 344
 e) Thomas à Kempis, *Imitation de Jesus Christ*, fol. 345

16. Jean Mansel, *La fleur des histoires*, vol. 4, Hesdin
Parchment, 220 fols., 470×340 mm, 3 miniatures
Brussels, Bibliothèque Royale, Ms. 9233
From the library of Philip the Good.[8] Margaret's signature on the last leaf.
Hughes no. 25

17. Guide to the pilgrimage churches of Rome, circa 1470–80.
Parchment, 47 fols., 127×88 mm, 7 miniatures
New Haven, Yale University, Beinecke Rare Book and Manuscript Library, Ms. 639
With Margaret's arms on fol. 1.[9]

18. Jean Miélot, *La vie de Sainte Catherine*, circa 1475
Parchment, number of leaves and dimensions unknown, 13 miniatures
Location unknown, formerly Waziers Collection
The initials CM.[10]

19. *Apocalypse* and *La vie de Saint Edmonde le Martyr*, Ghent, circa 1475
Parchment, 124 fols., 360×260 mm, 79 miniatures
New York, Pierpont Morgan Library, M. 484
Script attributed to David Aubert. Margaret's coat of arms on fol. 10.
Hughes no. 2

 a) *Apocalypse* (with commentary), fol. 10
 b) *La vie de Saint Edmonde le Martyr* (from the *Golden Legend*), fol. 120

20. Breviary (use of Sarum), Ghent, before 1477
Parchment, 263 fols., 250×170 mm, 7 miniatures, many others removed
Cambridge, St. John's College, Ms. H. 13
Margaret's device and the initials CM throughout.
Hughes no. 8

21. Moral treatises, Ghent, mid-1470s
Parchment, 307 fols., 380×270 mm, 5 miniatures
Brussels, Bibliothèque Royale, Ms. 9272–76
Margaret's coat of arms on fol. 9.
Hughes no. 19

 a) Attributed to Thomas à Kempis, *Une bonne et necessaire doctrine de toute nostre foy*, fol. 9
 b) Thomas à Kempis, *Imitation de Jesus Christ*, fol. 55
 c) Jean Gerson, *Traictie de mendicite spirituelle* (*Le secret parlement de l'homme comtemplatifz a son ame et de l'ame a l'omme sur la povrete et mendicite espirituelle*), fol. 165
 d) Jean Gerson, *La medicine de l'ame* (*La forme et maniere de bien mourir*), fol. 182
 e) *Meditations de Saint Bernard*, fol. 216v
 f) *Une devote, humble et salutaire visitation*, fol. 233v
 g) Jean Gerson, *Meditation de la mort* (*Lamentacion de la personne qui se trouve en l'article de la mort*), fol. 238v
 h) *Trattie de l'ame embrasee d'amour et du feu de charite*, fol. 245
 i) *Admonestement de vivre contre la vanite de ce monde*, fol. 249
 j) Saint John Chrysostom, *Reparation du pecheur* [*De reparatione lapsi*], fol. 251

22. *Bible moralisée* (extract) and texts of devotion and instruction, Ghent, circa 1475
Parchment, 269 fols., 370×270 mm, 4 miniatures
Brussels, Bibliothèque Royale, Ms. 9030–37
With arms and devices of Charles and Margaret on fol. 9. Script attributed to David Aubert by Delaissé.[11]
Hughes no. 4

 a) *Exodus* (from the *Bible moralisée*), fol. 9
 b) *Moralitez des philosophes*, fol. 99
 c) *La Passion Jesus Christ*, fol. 129
 d) *Plusieurs moult belles auctoritez de aulcuns sains de Paradis*, fol. 147
 e) *Lucidaire*, fol. 161
 f) *Purgatoire de Saint Patrice*, fol. 223

g) *Des douze jeusnes que tous chretiens doibvent jeusner devant leur mort*, fol. 242v

h) *Pourquoi l'en doibt plus tost jeusner le venredi que les aultres jours en la septmaine*, fol. 243

i) *Traitie de confession*, fol. 243v

j) *Cy parle de nostre creance tres appertement selon Dieu*, fol. 252v

k) Robert Grosseteste, *Chasteau d'amour*, fol. 255

23. Two breviaries (or possibly, two volumes of a breviary)
Location unknown
Bought by Margaret in 1477 from Louise de Laye.[12]
Hughes no. 9

IV. Books Margaret presented as gifts

24. Quintus Curtius Rufus, *Les faits d'Alexandre le Grand*, circa 1470–80
Parchment, 219 fols., 170×130 mm, 49 miniatures
London, British Library, Royal Ms. 15 D IV
This book was presented by Margaret and Mary of Burgundy as indicated by their double inscription. It was presumably given to Sir John Donne, whose coat of arms was erased from the area (which now bears a later, Tudor coat of arms) adjacent to the signatures on fol. 219.[13]
Hughes no. 26

Fol. 219: Foryet not har that ys on of your treu frendes, Margarete of York
 Prenez moi a jamés pour votre bonne amie, Marie de Bourgogne

25. Gradual (fragment)
Parchment, 442×299 mm, one historical initial
London, British Library, Arundel Ms. 71, fol. 9
This is a single illuminated leaf from a gradual inserted at fol. 9 in Charles Soillot's *Le livre de félicité en vie*.[14] On the verso is a note in an early seventeenth-century hand indicating that it was donated to the Observant Grey Friars of Greenwich.[15] Margaret's coat of arms on the recto.
Hughes no. 10

26. Justinus, *In Trogi Pompei historias libri XLIV*, Ferrara, circa 1465–70
Parchment, 180 fols., 260×185 mm
Madrid, Biblioteca del Escorial, Ms. e.III.22
This manuscript contains the same text twice. The first transcription (fols. 1–98) is the one presented by Margaret, probably to her stepdaughter's husband, Maximilian of Austria, and dated circa 1465–70. The second, dated June 10, 1432 in the colophon, is not associated with Margaret. With Hapsburg arms (fol. 1) and autograph dedication.[16]

Fol. 96v: Voter lealle mere Margarete

27. Pierre de Vaux, *La vie de Sainte Colette*, circa 1468–77
Parchment, 166 fols., 260×180 mm, 25 half-page miniatures and 6 historiated initials
Ghent, Convent of the Poor Clares, Ms. 8
Device and coat of arms of Margaret on fol. 1. Initials CM also on fol. 1 and throughout. Presented by Margaret to the convent of the Poor Clares at Ghent (with autograph dedication).
Hughes no. 21

Fol. 163: Votre loyale fylle Margarete d'Angleterre, pryez pour elle et pour son salut

27a. Choir books
A seventeenth-century life of Saint Ursmer, cited by Galesloot, refers to some choir books ("livres de chant") donated by Margaret to the church of Saint Ursmer in Binche.[17] These books have not been included in any of the previous lists of books associated with Margaret or in the lists compiled by the authors of this volume. Therefore, they are not reflected in the count of Margaret's books to be found in some of the present papers.

V. Books related to Margaret but neither commissioned nor owned by her

28. Register of the guild of Saint Anne at Ghent, Ghent, after August 15, 1476[18]
Parchment, 270×200 mm, 1 miniature
Windsor Castle, Royal Library, no shelf mark
Margaret's name listed in the register on fol. 3, but not as a mark of ownership.

29. Saint Augustine, *Contemplation pour attraire la personne de Dieu* and devotional works (?) attributed to Saint Bernard
Destroyed; formerly Saint Petersburg, Imperial Library, Ms. fr. o.v.I.2[19]
Hughes no. 1
a) Saint Augustine, *Manuale (Contemplation pour attraire la personne de Dieu)*, fol. 1
b) *Meditations de Saint Bernard*, fol. 25
c) Saint Bernard, *Traite de l'amour de Dieu*, fol. 57

30. Raoul Lefèvre, *The Recuyell of the Historyes of Troye*
Translated by William Caxton under Margaret's patronage (completed September 19, 1471) and printed by him circa 1473.[20] None of the surviving copies can be certainly identified as being owned by Margaret.

Notes

1 At the end of the manuscript there is an autograph note concerning the presentation of the book in 1500 to Jean de Halewyn, governess of Philip the Fair, son of Mary of Burgundy.

2 Galesloot 1879, pp. 244–45.

3 For the document concerning Margaret's receipt of this breviary and the two in Appendix no. 23, see Pierre Cockshaw's essay, p. 61, n. 7, above. See also Galesloot 1879, pp. 265–66.

4 For this manuscript, see Nigel Morgan's essay, p. 64, above.

5 See P. Durrieu, "Livre d'heures de Marguerite d'York à Metz," *Bulletin de la Société nationale des antiquaires de France* (1919), p. 182, and Morgan, p. 64, above, for additional references.

6 The first part of the book (to fol. 272) was copied by David Aubert in Bruges. The rest of the book was written by Aubert in Brussels.

7 A manuscript in the Biblioteca Nacional in Madrid (Ms. Vit. 25–5), ordered by Philippe de Croy from David Aubert, has been cited as the first part of the Valenciennes manuscript, which is clearly a second volume since the foliation begins on fol. 211. See M.A. Molinier, *Catalogue général des manuscrits des bibliothèques publiques de France*, vol. 25 (Paris, 1894), no. 240, pp. 295–96. However, in addition to the obvious difference in the patronage of the Madrid manuscript, Delaissé remarks that it is of a completely different type and the miniatures are executed by a different artist; see Brussels 1959, pp. 122–23, no. 142.

8 See J. Barrois, *Bibliothèque protypographique ou librairies des fils du roi Jean, Charles V, Jean de Berry, Philippe de Bourgogne et les siens* (Paris, 1830), no. 719.

9 See Walter Cahn's essay in the present volume.

10 Only one leaf is known through a photograph; see fig. 129 and n. 35 of Antoine de Schryver's essay in the present volume.

11 Brussels 1959, no. 197.

12 See Appendix no. 10, above.

13 See J. Backhouse, "Founders of the Royal Library: Edward IV and Henry VII as Collectors of Illuminated Manuscripts," in D. Williams, ed., *England in the Fifteenth Century* (Proceedings of the 1986 Harlaxton Symposium) (Woodbridge, Suffolk, 1987), pp. 30–31.

14 The Soillot book was thought to have been owned by Margaret. The leaf from the gradual, however, was likely inserted only when it came into the Arundel Collection. The dedication demonstrates that the book was made for Charles the Bold while he was Count of Charolais, and the leaf is now mounted separately. See Morgan, p. 72, n. 16, above.

15 The inscription says, "Ther was a Booke called a graile given unto the grai observant friers at greenwich by Margaret duchesse of Bourgoine sister unto K: Edward: 4: the booke was made beyond the seas." This is written over an erased inscription. The foundation of the Grey Friars in Greenwich was established in 1482; see A. G. Little, "Introduction of the Observant Friars into England," *Proceedings of the British Academy* 10 (1921–23), pp. 458–61. This date has been included, without explanation, in the literature on the gradual leaf itself; though uncertain, it is not implausible. The leaf is rejected (without explanation) as having belonged to the Grey Friars in N. Ker, *Medieval Libraries of Great Britain: A List of Surviving Books* (London, 1964), p. 93.

16 See Albert Derolez's essay in the present volume.

17 Galesloot 1879, p. 243, citing G. Waulde, *La vie et miracles de Saint Ursmer, et de sept autres SS., avec la chronique de Lobbes* (Mons, 1628), p. 472.

18 For the date of this manuscript, see Blockmans's essay, p. 39, above. See also Van Buren 1975, p. 290.

19 The copy of the text by Saint Augustine formerly in the Imperial Library in Saint Petersburg begins with the following dedication: "A tres hault, tres puisante et tres excellente Princesse, Mme. Marguerite d'Angleterre, duchesse de Bourgogne." From the available description of the book, which has no miniatures, it is not certain whether this was Margaret's own copy or whether it is another patron's copy of a translation that she commissioned. However, it seems apparent that even if the Saint Petersburg manuscript was not Margaret's copy, she probably owned a copy of the Augustine text, since it was dedicated to her. The catalogue entry indicates that the third text was translated by Vasco da Lucena, Margaret's translator. See A. de Laborde, *Les principaux manuscrits à peintures conservés dans l'ancienne Bibliothèque impériale publique de Saint-Petersbourg* (Paris, 1938), vol. 2, no. 102. The book was destroyed in Poland in 1944, according to D. Gallet-Guerne, *Vasque de Lucène et la cyropédie à la cour de Bourgogne (1470)* (Geneva, 1974), p. 20.

20 See Martin Lowry's essay, p. 103, above.

INDEX OF MANUSCRIPTS BY LOCATION

INDEX OF PERSONS